ALBRECHT DÜRER

ARTIST RESOURCE MANUALS
VOLUME 3
GARLAND REFERENCE LIBRARY OF THE HUMANITIES
VOLUME 2177

ALBRECHT DÜRER
A GUIDE TO RESEARCH

JANE CAMPBELL HUTCHISON

GARLAND PUBLISHING, INC.
A MEMBER OF THE TAYLOR & FRANCIS GROUP
NEW YORK & LONDON
2000

Published in 2000 by
Garland Publishing, Inc.
A member of the Taylor & Francis Group
29 West 35th Street
New York, NY 10001

10 9 8 7 6 5 4 3 2 1

Library of Congress Cataloging-in-Publication Data

Hutchison, Jane Campbell.
 Albrecht Dürer: a guide to research / Jane Campbell Hutchison.
 p. cm. -- (Artist resource manuals ; v. 3) (Garland reference
 library of the humanities ; vol. 2177)
 Includes bibliographical references and index.
 ISBN 0-8153-2114-7 : (alk. paper)
 1. Dürer, Albrecht, 1471–1528--Criticism and interpretation--
 Bibliography. I.Title. II. Series. III. Series: Garland reference library
 of the humanities ; vol. 2177

Z826 .H88 2000
[N6888.D8]
016.76'0092--dc21 00-025906

Printed on acid-free, 250-year-life paper.
Manufactured in the United States of America

Contents

Foreword and User Notes vii

Series Editor's Foreword ix

Ehrlich gehalten nah und feren": Five Centuries of Dürer Reception
Albrecht Dürer (1471–1528) in German History 1

Annotated Bibliography 25

The Dürer House
Chronology (after Matthias Mende) 341

Chronology 347

Location Guide 355

Index
Persons, Places, and Works of Art Mentioned in the Bibliography 367

Foreword and User Notes

The present volume supplements, but by no means replaces the excellent *Dürer-Bibliographie* published by Matthias Mende in honor of the artist's five hundredth birth anniversary in 1971 (q.v.). Since that time some of Dürer's lost watercolors have been found, two of his portraits have been returned to the Weimar Museum, and two of the three religious works from the Alte Pinakothek, attacked by a vandal in 1988, have been restored. During this time the oeuvre of Hans Hofmann has grown, while the number of Dürer's nature studies has grown smaller. Changes of ownership, physical condition, attribution, and questions of the artist's reception have been of primary importance here. Only the most basic items from the pre-1971 literature have been included here, together with certain works of historic interest, and works published in the United States that were not available to Mende. Bearing in mind that some users of this work may be curators whose own specialties may lie in other areas than German art, generous summaries of the most important works are given; these are intended merely as guides to the literature, and should in no case be regarded as substitutes for the original documents.

The serious researcher also will need ready access, at a minimum, to Mende's bibliography, as well as to the corpus of Dürer's written work edited by Hans Rupprich (*Dürers schriftlicher Nachlass*, q.v.); Fedja Anzelewsky's catalogue of the paintings (2nd edition, 1990, q.v.); one of the several catalogues of the artist's prints, such as those by Josef Meder, Karl-Adolph Knappe, or Walter Strauss's volume for *The Illustrated*

Bartsch series (q.v.), each of which is useful for different reasons; Friedrich Winkler's catalogue of the drawings, or Walter Strauss's more inclusive but controversial one.

The best single work on Dürer's critical and literary reception is Jan Bialostocki's *Dürer and His Critics* (q.v.), while the final chapter of my *Albrecht Dürer: A Biography* ("The Celebrated Albrecht Dürer") summarizes the artist's posthumous public reception as reflected in the various celebrations organized to mark his birth and death anniversaries.

Jane Campbell Hutchison
Madison, Wisconsin
July 9, 1999

Series Editor's Foreword

*"Our ideas about the past are the results of an
immense cooperative effort."*

(E. H. GOMBRICH, *THE STORY OF ART*)

Each generation sees any important artist differently. The Garland series
Artist Resource Manuals offers a new kind of reference guide that traces
the history of the critical reception of major artists by tracing the literary
evidence. Collecting and presenting the facts on how artists were re-
ceived and how their oeuvre was perceived will provide the foundations
for a better understanding of the masters. Each volume has as its core a
historical essay or reception history that deals with the fame and fortune
of the artist from his or her own time through successive ages to the
present. This is followed by a critical annotated bibliography that com-
prises a listing of essential primary sources as well as selections from the
secondary literature. Primary sources may include the artist's program-
matic, theoretical, and autobiographical writings. Secondary sources in-
clude monographs as well as oeuvre and exhibition catalogues. Auction
sale catalogues, commemorative volumes of collected essays
(*Festschriften*), museum bulletins and yearbooks, and learned papers
published in scholarly journals, as well as occasional articles published
in newspapers and reflections in other creative media, including those of
popular culture, are given due consideration commensurate with their
importance.

The present volume differs from the two in the series that precede it
in that it is both an independent reference tool and the supplement to an
earlier work which it brings up-to-date. Coincident with the worldwide
quincentennial celebration of Albrecht Dürer's birth, Matthias Mende
published his comprehensive bibliography in 1971 (*q.v.*) With the two

earlier bibliographies by Singer* and Bohatta,** published in 1928 on the occasion of the four hundredth anniversary of the artist's death, Mende's work shares a major shortcoming of all "occasional" publications of this sort: it misses the avalanche of new publications that the event itself engenders. Jane Hutchison's book fulfills the essential function of closing that gap.

Wolfgang M. Freitag

*Hans Wolfgang Singer, *Versuch einer Dürer Bibliographie* (Strassburg: Heitz, 1928).
**Hanns Bohatta, *Versuch einer Bibliographie der kunsttheoretischen Werke Albrecht Dürers* (Wien: Gilhofer & Ranschburg, 1928).

ALBRECHT DÜRER

"Ehrlich gehalten nah und feren": Five Centuries of Dürer Reception

Albrecht Dürer (1471–1528)
in German History

In 1526, two years before Dürer's death, Beatus Rhenanus (ca. 1485–1547) in his notes on Pliny's *Historia Naturalis* pointed with pride to the fact that "as in days of the Ancients" Germany now excelled in the visual arts that "bear witness to a nation's honor," and that first among German artists was Albrecht Dürer.[1] Furthermore, noting emphatically that "honor nourishes the arts," he looked forward to the day when German art would be praised as highly by contemporary writers as Greek and Roman art had been in ancient times. Already in 1505 Jakob Wimpfeling (1450–1528), the first German historian, had reported that "pictures" by Dürer (he seems to have meant prints) were being marketed in Italy, where they were "as highly prized as paintings by Parrhasius and Apelles."[2] Dürer's contracts with two sales agents charged with selling his prints abroad have been preserved in Nuremberg's Stadtarchiv,[3] lending a certain credibility to this statement—although, of course, no work by either Parrhasius nor Apelles has survived.

Like Beatus Rhenanus, Wimpfeling was an Alsatian living in Strassburg at the time of writing; it should perhaps come as no great surprise that the first stirrings of nationalist sentiment should have been expressed by writers living at the westernmost edge of German-speaking territory, on the left bank of the Rhine, where the Holy Roman Empire was bounded by France. Wimpfeling, a former professor of poetry at Heidelberg, was a friend of the "arch-humanist" Conrad Celtis (1459–1508), Germany's first native-born Imperial poet laureate and a friend of both Dürer and Willibald Pirckheimer, His address at the University of Ingolstadt (August 31, 1492) had been a call for a new German culture. Celtis

1

challenged his countrymen that, "having taken over the rule of the Italians and having cast off your vile barbarity, [you] must strive after the Roman arts. Take away that infamy of the Germans among the Greek, Latin and Hebrew writers who ascribe to us drunkenness, barbarism, cruelty and whatever is bestial and foolish. . . ."

Beatus Rhenanus, the man whom Erasmus of Rotterdam called his "alter ego," was also in correspondence with Pirckheimer, as well as with the Augsburg classicist Konrad Peutinger, the Nuremberg theologian-poet Johann Cochläus, and Benedictus Chelidonius (né Schwalbe), author of the Latin poetry that served as text to Dürer's *Marienleben*. All were personal friends of the artist. The Reformer Philipp Melanchthon (1497–1560), founder of Nuremberg's new humanistic Gymnasium (1526) and the owner of a complete collection of Dürer's graphic art, characterized his friend's work as comparable to the highest form of rhetoric—rich in variety and classical allusions[4]—while the Imperial poet and knight-errant Ulrich von Hutten (1488–1523) noted in 1518 that Dürer had earned the respect of "the Italians, who do not easily praise a German, whether because of envy . . . or because of the old idea that . . . we are stupid and good-for-nothing."[5]

Indeed, an unflattering image of the Germans as drunkards and savages pervaded both ancient and modern literature written in Italy. Tacitus, whose newly recovered *Germania* Celtis had edited for publication, had claimed that the ancient Germans slept "until a late hour of the day," that they went everywhere armed to the teeth, and that "to pass an entire night in drinking disgrace[d] no one."[6] Moreover, the Italians were not alone in taking a dim view of the Germans, for the *furor teutonicus* had been reviled during the Middle Ages by even such erstwhile fellow barbarians as the English and French.[7] John of Salisbury, the twelfth-century Bishop of Chartres, had stigmatized the Germans as both *bruti* (unreasoning) and *impetuosi* (lacking in control), two failings that Dürer's art seems almost deliberately calculated to negate, just as his nearly superhuman productivity ran directly counter to the popular stereotype of "the" Teutonic barbarian as a pathological wastrel.

Dürer's early and short-lived activity as creator of engravings and drawings of *recherché* subjects from ancient literature—despite his own minimal formal education—is proof of his compliance with Celtis's plan to cultivate and publicize the arts in Germany, as are his landscape watercolors of the Nuremberg area dating from the time of Celtis's *Norimberga* (mid-1490s), and his contracts with two traveling sales agents to market his prints in "foreign" lands.[8] If more proof were needed, it is

supplied by the inscription on the artist's famous *Self Portrait* of 1500 (Munich, Alte Pinakothek), composed by Celtis's personal secretary, as well as by the flattering *laudatio* that Celtis himself penned in Dürer's honor:

> *To the Painter Albrecht Dürer of Nuremberg.*
> *Albrecht, most famous painter in German lands*
> > *Where the Frankish town raises its lofty head up to the stars,*
> *You represent to us a second Phidias, a second Apelles*
> > *And others whom ancient Greece admires for their sovereign hand.*
> Neither Italy nor versatile France has seen his equal
> > Nor will anyone find him in the Spanish domain.
> You leave the Hungarians behind as well as the dwellers
> > within the German confines
> And those who dwell around the Black Sea . . .[9]

The Nuremberg lawyer Christoph Scheurl (1481–1552)[10] who was related to Dürer's clients the Tucher family, had been a student at the university of Bologna during the artist's second trip to Italy. He reported that in Venice as well as in Bologna Dürer had earned the soubriquet "the second Apelles." He further claimed that, rivaling Parrhasius, whose painting of grapes was said to have deceived the birds, one of Dürer's self portraits had been kissed by the artist's dog, who mistook it for his master—an anecdote first reported by Celtis.[11] Scheurl, whose nephew Albrecht was Dürer's godson, went on to quote three flattering poems in praise of Dürer penned by the wandering north-Italian poet Ricardus Sbrulius (Riccardo Sbroglio), who not only compared him to Apelles but declared him worthy of Olympus.[12] Sbrulius had met Dürer in Italy in 1506, before leaving to become a member of the faculty of Wittenberg's new university in 1508.

The Silesian neo-Latin poet Caspar Ursinus Velius (a.k.a. Kaspar Bernhard, ca. 1493–1539) penned epigrams in praise of Dürer's *Adam and Eve* (presumably the 1504 engraving (M.1)[13] Erasmus of Rotterdam compared the artist to Pamphilus, the ancient Macedonian mathematician in a Latin dialogue of 1528, declaring also that he had bested Apelles by his ability to work only in black lines, and repeatedly referred to him as "our Apelles" in his correspondence with Pirckheimer after 1523.[14]

Dürer's death in 1528 prompted a veritable avalanche of obituary poetry written by his humanist friends, as well as a letter of condolence to Pirckheimer from Martin Luther,[15] who had received a gift of prints

from the artist and was aware of Dürer's avid interest in his own early pamphlets. Three days after the burial a belated attempt was made by Nuremberg's humanists to immortalize Dürer's face and one of his hands in plaster casts, in imitation of the Italian vogue for death masks.[16] A lock of the artist's hair, clipped and sent to his former journeyman and friend Hans Baldung, whom Dürer had called "Grien Hans" (1484/1485–1545) was treasured as a holy relic by a succession of artists ever afterward until 1873 when it was donated to the Vienna Academy, where it remains today.[17]

The 1532/1534 Latin edition of Dürer's *Four Books of Human Proportion* was prefaced with a full-dress biography of the artist written by the Bamberg philologist Joachim Camerarius (Kammermeister) (1500–1574), a colleague of Luther's and Philipp Melanchthon's on the Wittenberg faculty and Melanchthon's choice as Rector and Professor of Greek at the new Nuremberg Gymnasium (1526–1532).[18] Camerarius praised Dürer's own elegantly proportioned body and Grecian nose as well as his high moral character, highly placed patrons, and mathematical and scientific ability and his matchless ability to recreate the effects of nature.[19]

Albrecht Dürer is still acknowledged to be, not simply first among the Germans, but one of a half-dozen of the world's most renowned artists—none of whom was more acutely aware than he of the power of history and of the press. In 1498, with the aid of his godfather's typefaces, he became the first artist in history to act as his own publisher. None has been more widely and consistently admired, quoted and copied than Dürer, whose life's work has never suffered the periods of critical neglect that at one time or another befell even such masters as Raphael and Rembrandt, both of whom owned works by Dürer. His contemporary Raphael (1483–1520), who is alleged by Ludvico Dolce to have kept a Dürer drawing taped to his wall,[20] was idolized throughout the seventeenth through the early nineteenth centuries, when art academies were in fashion, but conversely has always been reviled by subsequent anti-academics. Rembrandt (1606–1669), who owned an edition of the *Four Books of Human Proportion* and clearly was influenced by a number of Dürer's prints, such as his woodcut of he *Death of the Virgin*, was already being severely criticized within a generation of his own death for his supposed failure to finish many of his late paintings, as well as for such supposed ethical lapses as having made small alterations to his etching plates "in order to sell old prints as new ones."[21] Rembrandt posthumously became a hero in the eyes of Goethe's generation, where he was compared to Shakespeare in his ability to deal with reality and the human

psyche, but Goethe and his friends also were avid collectors of Dürer's prints.

Carl Neumann, whose Rembrandt monograph of 1902 extolled Rembrandt as *"der Maler der Seele"* (soul painter),[22] also held a sympathetic view of Dürer, whom he classed with Dante, Leonardo, and, of all people, St. Francis of Assisi, as "nourished by the heart's blood and the spiritual soul of the Middle Ages"—an accolade that surely would have surprised the artist. Far from steeping himself in the heart's blood of the Middle Ages, of course, Dürer had deliberately sacrificed years of his creative life in order almost singlehandedly to bring the Renaissance to Germany.

The saintly paradigm does have a precedent of sorts in the writings of no less a person than Cardinal Gabriele Paleotti (1522–1597), Archbishop of Bologna,[23] who helped shape the Counter-Reformation's position on the uses of the visual arts. In his chapter, "Examples of some painters, sculptors and other image-makers who have been accepted among the saints and blessed, or who had the repute of the most exemplary life," the Cardinal includes Dürer "the German painter and geometrician" in the company of Pietro Cavallini and two artists in holy orders, Fra Angelico and Fra Bartolommeo. Paleotti was particularly gratified that the German artist (whose Lutheran sympathies were probably unknown to him) had refused to stoop to the manufacture of pornographic prints, unlike many other engravers of his day and later. Indeed, Dürer's moral rectitude was such that his graphic works were recommended by Francisco Pacheco (1571–1654) author of the *Arte de la Pintura* (1649) and censor of paintings for the Spanish Inquisition.

The odor of sanctity was destined to escalate in certain of the religious paintings of the seventeenth-century "Dürer Renaissance", where copies of the Christ-like 1500 *Self Portrait* sometimes were used as depictions of the Savior himself,[24] and further in the quasireligious Dürer festivals of the early nineteenth century, when the artist's biography would be illustrated in a series of Christianized typological parallels, and when specially composed "oratorios" were sung at his grave on Easter morning in Nuremberg's Cemetery of St. John.[25]

Dürer's graphic art played an important role in the training of young artists in both Europe and the New World for centuries to come. Giorgio Vasari, the first foreign author to publish a comprehensive discussion of Dürer's work[26] particularly admired the *Prodigal Son* and *Meerwunder* engravings—although he mistakenly declared their creator to have been Flemish. He also told the unsubstantiated story of Dürer's vain attempt to obtain a restraining order from the Venetian Senate against Marcantonio

Raimondi's copperplate copies of his Life of the Virgin and other wood-cut series—a case that resulted only in the prohibition against Raimondi's use of Dürer's monogram on such pirated copies. In Latin America his prints, due to the endorsements of Paleotti and Pacheco, were sent to accompany Spanish missionaries.

Dürer's paintings were less influential, perhaps in part because so many had been acquired by Rudolph II and the Archduke Maximilian, but also because their lack of idealism made them less attractive to Italian, English and French collectors who preferred Italian works. In those areas where his paintings were not found, however, the artist's fame was kept alive by his stature as scientist and mathematician, and he was considered Leonardo da Vinci's equal in such matters. Sebastiano Serlio's *Book IV: On the Five Roman Orders* (Venice, 1537) was based on Dürer's *Befestigung der Stett, Schloss und Flecken* (1527: Treatise on Fortification), the first book on architecture ever to be published with illustrations.[27] To the Milanese theoretician Giovanni Paolo Lomazzo (1538–1600), whose work on human proportion was heavily indebted to Dürer, he was "il gran Druvido Alberto Durero," who could have become the best painter in the world if only he had been privileged to study in Italy with Raphael.[28] Lomazzo singled out for special praise the German artist's "sure mathematical procedure . . . and . . . his knowledge of sciences, which he possessed to the highest degree . . . and which must accompany art and must be connected with it." Dürer's method for constructing a regular pentagon inspired a host of Italian mathematicians, and was the subject of a special treatise by Pietro Antonio Cataldi of Bologna (1570),[29] cited later with respect by both Galileo and Johannes Kepler. Lomazzo's treatise reappeared in the English translation by Richard Haydocke (Oxford, 1598),and was an inspiration to the Elizabethan miniaturist Nicholas Hilliard, who composed his own *Treatise concerning the Arte of Limning* (ca. 1600).[30]

Carel van Mander (1548–1606), who had traveled widely in Italy and Germany before settling in Haarlem, was the first to publish a list of Dürer's paintings (he declared the artist's woodcuts and engravings too well known among both artists and collectors to need enumerating).[31] He had seen fourteen of the paintings, including the *Adoration of the Magi* (1504) now in the Uffizi; the *Virgin with the Siskin* (1506: Berlin); the *Adam and Eve* (1507: Madrid); the Landauer Altarpiece (1511: Vienna); the Heller Altarpiece (commissioned 1508: destroyed: then still in the Dominican monastery in Frankfurt); the idealized portraits of Charlemagne and Sigismund (Nuremberg); the so-called *Four Apostles* (Munich); the *Self Portrait* of 1500 (1526: Munich); and a portrait of the

artist's mother, identified by the late Lotte Brand Philip with the painting of a heretofore unknown woman in Nuremberg's Germanisches Nationalmuseum.[32] He also mentioned a painting of Lucretia in the collection of Melchior Wijntgis in Middelburg, which seems not to be identifiable with the one now in Munich (date 1518: Alte Pinakothek). In Chapter 10 ("On Clothes and Drapery") of the theoretical section of his book, he praised Dürer's engraved drapery for variety of fabrics and excellent effects of lighting and of drapery in motion.

Van Mander's book appeared at the apogee of what Hans Kauffmann was later to identify as the "Dürer Renaissance,"[33] when such influential collectors as the Holy Roman Emperor Rudolph II and the Elector Maximilian I of Bavaria were assembling the works that today form the nucleii of the Kunsthistorisches Museum in Vienna and the Alte Pinakothek in Munich. Joachim von Sandrart (1606–1688) in his *Teutschen Akademie* (1675: Nuremberg) relates how Rudolph, having purchased the *Feast of the Rose Garlands* from the church of St. Bartolommeo in Venice, ordered that it be carefully wrapped in rugs, padded with cotton-wool and baled in waterproof waxed cloth before being "carried on poles by a group of strong men all the way to the Imperial Residence in Prague in order to avoid its being jolted, shaken or injured on a cart." Rudolph also acquired the *Landauer Altarpiece* (Vienna, Kunsthistorisches Museum), the *Adam* and *Eve* panels (Madrid, Prado) and the majority of the watercolors (Vienna, Albertina).

Rudolph's obsession with Dürer's work was exceeded only by that of the Elector, Maximilian I of Bavaria (1573–1651), head of the Catholic League in the Thirty Years' War. From the Dominican cloister in Frankfurt he purchased the *Heller Altar* (unfortunately destroyed later in a palace fire); from the Imhoff collection in Nuremberg the *Glimm Lamentation*; and the *Paumgartner Altarpiece* from the church of St. Catherine. He also acquired the so-called *Four Apostles* from the City Hall, ordering that the extensive Biblical quotations in Luther's German be sawed off and returned to Nuremberg with the replacement copies of the paintings. Among other purchases, some of them also destroyed in the fire, he acquired the *Hercules and the Stymphalian Birds* (Nuremberg, Germanisches Nationalmuseum). As head of the Catholic League, he was in the fortunate position of being able to exert political pressure on Protestant Nuremberg to part with its treasures. In another case Field Marshall Johann Graf von Tilly (1559–1632) and the Bavarian Commissioner of War Hans Christoph von Reupp were pressed into service to obtain Dürer's *St. Jerome* from the *Marienkirche* in Stendal (Brandenburg) for Maximilian; unfortunately it was sent by supply train by way of Hesse and was lost in transit.

In 1681 Sandrart purchased the tomb in Nuremberg's Cemetery of St. John that had originally held the artist's body, renovating the original Latin epitaph composed by Willibald Pirckheimer ("Whatever was mortal of Albrecht Dürer is covered by this stone"), and augmenting it with a coat-of-arms and a new and more florid inscription comprised of a verse in German followed by a Latin eulogy:

"Hier ruhe
 Künstlerfürst
Du mehr als grosser Mann!
 In Vielkunst hat es dir
noch keiner gleich getan.
 Die Erd war ausgemalt
der Himmel dich jetzt hat;
 du malest heilig nun
dort an der Gottestatt
 Die Bau-Bild- und
Malerkunst
Die nennen dich Patron
und setzen dir nun auf
 im Tod
die Lorbeerkron."

"Rest here, oh artist prince
Thou more than worthy man!
In mastering all arts
None equalled thee.

Thy work on earth complete
In heaven is thy home;
Thou paintest, saintly now,
 Beside God's sacred throne,
The builders, sculptors, painters
 Call thee Patron (saint)
In death they now award thee
The (artist's) laurel crown."

"Vixit Germaniae suae Decus
ALBERTVS DVRERVS
Artium Lumen, Sol Artificium
Urbis Patr. Nor. Ornamentum
Pictor, Chalcographus, Sculptor
Sine Exemplo, quia Omniscius
Dignus Inventus Exteris,
Quem imitandum censerent.
Magnes Magnatum, Cos ingeniorum
Post Sesqui Seculi Requiem
Qui Parem non habuit
Solus Heic cubare jubetur
Tu flores sparge Viator.
A.R.S. MDCLXXXI
 J.De S."

"The glory of Germany is dead.
 ALBERTUS DURERUS
Light of the arts, Sun of the
 artists
Ornament of Noris, his native
 town,
Painter, Graphic artist, Sculptor
 Without precedent because
 omniscient,
Found worthy by foreigners who
Recommend to imitate him.
Magnet of Magnates, grindstone
for talents,
After one hundred fifty years
No one having been equal to him
He must repose here alone.
Traveller, strew flowers.
In the year of Salvation 1681
 J.D S."

In lamenting that the artist must "repose here alone," Sandrart, who had moved to Nuremberg only in 1674, presumably was unaware that Albrecht Dürer no longer reposed there at all; his grave had been cleared of its original contents after 1550, by which time both his own family and that of his wife Agnes Frey Dürer had died out, and had subsequently been recycled to hold the remains of various assorted clergymen from Nuremberg's Heilig-Geist-Spital. In any case, Sandrart donated the renovated tomb to Nuremberg's newly founded Academy of Art—Germany's first such institution. (The grave was destined to be opened yet again in 1811—this time in the name of phrenology, in the hope of retrieving his skull as palpable evidence of his genius. Regrettably, however, the tomb yielded up only a recently deceased engraver named Bärenstecher and a heap of miscellaneous skulls of assorted sizes, and so was quietly closed up again.)

Sandrart, who was familiar with the collections of Maximilian and that assembled by Rudolph II among others, devoted an entire chapter of his *Teutsche Academie* to Dürer, whom he considered one of the founding fathers (with Michael Wolgemut, Martin Schongauer, and Israel van Meckenem) of German art, and included in his book a "portrait" of the artist engraved by Philipp Kilian after his (Sandrart's) own design. His commentary on Dürer's life owes much to Van Mander, Vasari, and Ridolfi, but his first hand knowledge of the *oeuvre* is quite extensive. He also was the first to publish the Family Chronicle that Dürer had written in 1524, using his father's notes.

Although he was highly respected everywhere for his moral probity and his theoretical publications, Dürer's reputation as a painter was never as high in France and England as in Germany. Roger de Piles (1635–1709), himself a painter/engraver/theoretician, championed color as superior to line, and awarded Dürer a niggardly eight for composition on a scale of one to twenty; tens for both drawing and color; and an eight for "expression" (or roughly the same scores as he gave to Michelangelo).[34] Dürer was, however, one of only two German artists whom he thought worth rating at all, the other being Hans Holbein.

As the two hundredth anniversary of the artist's death approached, Henrich Conrad Arend (1692–1738), a Lutheran pastor in the Harz mountain village of Grund bei Clausthal, published *Das Gedächtnis der Ehren Albrecht Dürers* (1728: Goslar, Johann Christoph König), the first monograph on Dürer, It was dedicated to Ludwig Rudolph, Duke of Braunschweig and Lüneburg, whose father, Anton Ulrich, had amassed a major collection of Dürer's prints.[35] Although his biographical chapters

owe much to the literature already in print, Arend had made a great effort, with the limited means of a pastor, to see as many original works by Dürer as possible. These, naturally, were prints and drawings, some of which he had painstakingly copied, since the great princely (and Catholic) collections of paintings and watercolors were not open to him.

In 1778 Goethe's friend Heinrich Sebastian Hüsgen (1745–1807), the current owner not only of the famous lock of Dürer's hair, but of an important collection of his works on paper (101 engravings plus the great woodcut books and seventy of the single-sheets), compiled the first *catalogue raisonné* of the prints.[36] This was to be tremendously influential, and would remain the definitive work until the publication of the seventh volume of Adam Bartsch's *Le peintre-graveur* (Vienna, 1808) and Joseph Heller's *Das Leben und die Werke Albrecht Dürers*, in two volumes (Bamberg: E.F. Kunz, 1827).

Arend's monograph was followed in 1779 by Christoph Gottlieb von Murr's publication of Dürer's Netherlandish travel diary, and later by his edition of the letters from Venice to Pirckheimer (1748).[37] Three years earlier he had recognized and described Dürer's iron etchings in his *Journal zur Kunstgeschichte und zur allgemeinen Literatur.*

The eighteenth century also produced Johann Heinrich Merck's "Einige Rettungen für das Andenken Albrecht Dürers gegen die Sage der Kunstliteratur" (Some Attempts to Rescue Dürer's Memory from the Legend Created by Art Literature), in Wieland's *Der Teutsche Merkur*, 3 (1780), 3ff.), a serious attempt to define the artist's style. Merck (1741–1791), who belonged to the circle of Goethe, Herder, and Wieland, was one of the first to draw distinctions between genuine Dürer prints and the many copies and forgeries in circulation; he was employed in Weimar by Duke Carl August and Duchess Ana Amalia as purchasing agent for their collection of prints and drawings. Merck also made the distinction between features of Dürer's personal style and those common to the period in which he worked, pointing out also that there are various traditions and local schools, none of which should be judged better or worse than any other. Wilhelm Heinse's (1746–1803) fictitious Ardinghello,[38] the first artist to be featured as the hero of a novel, was eloquent in the praise of Dürer, and also endorsed the idea that "every Folk and every climate has its own beauty." Stopping in Nuremberg on his way from Weimar to Italy, Johann Gottfried Herder (1744–1803) wrote enthusiastically to his wife about the works by Dürer that he had seen there (which included the copies of the *Four Apostles* by Georg Gaertner and that of the *Adam and Eve* by Juveneel).[39] Johann Kaspar Lavater

(1741–1801), the Zurich pastor whose essay on physiognomy as an index to character and genius led to the abortive attempt to recover Dürer's skull for posterity (1811), devoted special praise to the *Four Apostles*, which he erroneously assumed to have been commissioned as an altarpiece "for a great church or a rich cloister."[40] Goethe, whose publications contain many references to Dürer throughout his career, had high praise for Dürer's "wood-carved manliness" as antidote for the artificiality of his French Rococo contemporaries. Perhaps most poignant, however, was his identification with Dürer's situation as a German in Italy during his own first Italian journey (1786–1788), which he undertook with Christoph Gottlieb von Murr's editions of Dürer's travel diary (1779) and letters from Venice (1781) in hand.[41] Goethe, in self-imposed exile from Weimar politics, felt a kinship with Dürer, who had so reveled in being treated as a gentleman in Venice and Bologna, feeling himself insufficiently appreciated at home in Germany.

The liberal publicist Christian Daniel Schubart (1739–1791), who had been driven out of Augsburg by the Jesuits, recalled in his memoirs written in prison in the Hohen Asperg that as a schoolboy he had wept at the grave of Dürer, and elsewhere cited him as the father of German painting, who had been guided only by his own genius and not by study of the Antique. Calling him "the Michelangelo of the Germans," he credited Dürer with having invented the arts of woodcut and engraving, and also with having written books.[42]

Nuremberg had always been a mecca for travelers, as it lay at the center of the Holy Roman Empire at the crossroads of the great trade routes from north, south, east, and west, but the late eighteenth century brought visitors for cultural more than commercial reasons. Most momentous among them were the young Wilhelm Wackenroder (1773–1798) and his friend Ludwig Tieck (1773–1853), who, apparently having neglected to fortify themselves with any of the three eighteenth-century monographs on Dürer and unaware of the vogue among the Strassburg *Stürmer und Dränger* for collecting his graphic art, were responsible for spreading the extraordinary notion that Albrecht Dürer had been forgotten.[43] Wackenroder's *Ehrengedächtnisz unsres ehrwürdigen Ahnherrn Albrecht Dürers von einem kunstliebenden Klosterbruder*[44] and the more widely circulated *Herzensergiessungen eines kunstliebenden Klosterbruders* (Berlin, 1797) changed the view of Dürer from that of an artist who, if he had only been born in Italy could have been truly great, to that of an artist truly great precisely because he was German. Wackenroder's Dürer also was the teacher of the title character in Tieck's *Franz*

Sternbalds Wanderungen (1798). Johann Domenico Fiorillo (1748–1821) published the first volume of his monumental *Geschichte der zeichnenden Künste in Deutschland und den Vereinigten Niederlanden* in the same year, with the help of his friend Wilhelm Schlegel. Dürer, who appears in volume two (Hannover, 1817), receives high praise indeed.

Tieck and the Schlegel brothers were prominent among the sponsors of the Romantic movement, a development that the post-Italian Goethe deplored for its crypto-Catholic and "klosterbruderisierende, sternbaldisierende Unwesen." But for Friedrich Schlegel, Dürer was "the Shakespeare, or, if you prefer, the Jakob Böhme of painting."[45] His brother August Wilhelm was the first to note the artist's transitional position, his art "in einem katholischen Gemüt geboren . . . wiewohl er selbst Luthers Unternehmungen zugetan war . . ." but also spread abroad Pirckheimer's opinion that Agnes Dürer's greed had caused her husband to die of overwork.[46]

DÜRERFEIERN: THE CELEBRATED ALBRECHT DÜRER

The failure of the War for Independence (1813–1815), when the Congress of Vienna had dashed the hopes of German liberals for autonomous government after the dissolution of the Holy Roman Empire in 1806, was a contributing factor in the establishment of the custom of celebrating birth and death anniversaries of Germany's cultural heroes, a practice that still endures. In part, too, these celebrations helped to compensate for the secularization of the calendar, with its resultant loss of many religious holidays. An annual Albrecht Dürer Day, like the feast day of a saint, was observed by German artists from 1815 until the end of the nineteenth century, with tri-through quincentennial celebrations of his birth and death dates reaching national and even international proportions. Although anniversary observances also would be held in memory of Luther, Goethe, Schiller, and others, Dürer was the eldest hero to be so honored. His Christ like *Self Portrait* of 1500 (Munich), and the existence of such material remains as his house, tomb, and lock of hair lent themselves admirably to the establishment of his cult—the logical consequence of Wackenroder's sacramental view of art.

It was the expatriate Nazarenes who held the first *Dürerfeier*, in Peter Cornelius's room in their headquarters at the former monastery of San Isidoro in Rome (May 20, 1815). The affair, which had been suggested by the newest member of the brotherhood, and its one veteran of the War of Independence, J. E. Scheffer von Leonhardshoff, is fully de-

scribed in a letter from Friedrich Overbeck to Joseph Sutter, dated July 17. The ceremony took place in front of a portrait of the artist (apparently an engraving), which was surrounded by a thick oak wreath—one of the most familiar symbols of the War for Independence. Inserted into the wreath were the tools of the various arts that Dürer practiced, and on a table below the arrangement lay "the best of his engravings and woodcuts that we all had collected." One of their number read from a biography of the artist "to the great joy and edification of all." Then, "to the tinkle of glasses," they resolved to celebrate the occasion every year, to "kindle inspiration in German hearts anew . . . as well as to stimulate a new German art."[47]

Establishment of "a new German art," of course, was exactly the cause to which Dürer had devoted a singularly generous proportion of his working life. Far from keeping his own hard-won knowledge of Renaissance perspective and human proportion to himself, he set out to publish this material in German to make it readily available to younger artists both present and future. Although the Tyrolean artist Michael Pacher clearly had mastered linear perspective while Dürer was still a child, he kept the secret within his own workshop in Bruneck, and it followed him to the grave in 1498. Leon Battista Alberti, who died in 1472 when Dürer was one year old, had written the first modern treatise on painting as early as 1436. It was circulated only in manuscript form to a limited circle of readers even after the invention of printing from movable type, however, and was published only in 1540, when Dürer's theoretical works had already been on the market for a dozen years. Dürer's *Unterweysung der Messung* and *Vier Bücher von menschlicher Proportion* (both Nuremberg, Hieronymus Andreae), which appeared in 1525 and 1528 respectively, were the first such works published in the vernacular, and the original German editions were quickly republished in French, Italian, English and Spanish translations. (An unpublished Portuguese translation also was made.)

Alberti's information on color in the *De pictura* was inaccurate from the start, since the author was a dilettante rather than a painter, and his mathematics became outdated rather quickly, but Dürer's publications simply gained in interest for such later mathematicians as Johannes Kepler, because some of the constructions he included were not treated elsewhere in the professional literature of geometry.[48] Dürer had probably been inspired by the pioneering mathematical publications of Matthäus Roriczer (1486 and ca.1498), who in his youth had worked on

the church of St. Lorenz in Nuremberg and had been the first to make public the secret knowledge of the Bauhütte.[49] After 1509, of course, Dürer had become the neighbor and friend of the priest at St. John's Church, Johannes Werner (1468–1522), the mathematician who pioneered the study of conic sections, who wrote his groundbreaking treatise on the subject between 1514 and 1522, using the scientific library of his former mentor, the astronomer Bernhard Walther, which was still shelved in Walther's house after Dürer purchased it in 1509. The equivalent of a modern research institute, this library, which had been bequeathed to the city of Nuremberg, remained open to the scientific community until 1523, when the city fathers decided to liquidate the collection.[50]

A feature of Dürer's uniqueness is the affection with which he has been viewed by generation after generation of younger artists. This has more to do with his sense of mission and civic responsibility than even with his remarkable technical skill. His generosity of spirit and commitment to the future education and well-being of young German apprentices, and thereby to the betterment of Germany's cultural reputation is made clear in the dedication page from the 1525 edition of *The Manual of Measurement*. In it he points to the art of measurement, or proportion, as "the foundation of all painting," and criticizes the current apprenticeship system as "without real foundation other than what they learn by daily usage." Realizing that this is the fault of the master painters rather than of the apprentices themselves, he declares that he has "decided to provide to all those who are eager to become artists a starting point and a source for learning about measurement with ruler and compass . . ."

His unpublished notes for a further book, to be titled *Speiss für Malerknaben* (Food for Young Painters), reveal that he had planned to give advice on treating apprentices with kindness so that they would "retain the pleasure of learning," placing them in "pleasant and quiet living quarters," and providing for medical help and musical antidotes to melancholy as needed.[51] His concern for the welfare of young artists bore fruit when, as part of the celebration of the three hundredth anniversary of his death (1828), the first museum devoted entirely to modern art was founded in Nuremberg, and has occasioned the exhibition of works by living artists created in his honor as a regular feature of Dürer festivals in Germany. Dürer's house by the Tiergartner Tor, now maintained as a museum, owns a large and growing collection of such works.[52]

Dürer was the first, as well as the eldest, artist to have a publicly subscribed monument featuring a full-length portrait erected in his honor (Christian Daniel Rauch's bronze, commissioned in 1828 for the rechristened Albrecht-Dürer-Platz in Nuremberg.) He also was the first northern artist whose house and tomb were restored in the name of historic preservation. And he is certainly the only artist to have been honored by art historians with his own eponymous epoch—the *Dürerzeit*—and to have undergone a personal Renaissance fifty years after his death.[53] He clearly holds the world record for the number of societies, *Bündes,* and *Vereine* named in his honor.[54]

He became a cult object for the Romantic age, when his *Melencolia I* was particularly popular in England and France, serving as a source of inspiration for William Blake, Alexander Pope, James Thompson, Theophile Gauthier, Victor Hugo, and Gérard de Nerval, among others.[55] In Germany, however, the *Knight, Death, and Devil* became much more famous, and had more sinister offspring in the writings of Friedrich de la Motte-Fouqué,[56] Friedrich Nietzsche,[57] Ernst Bertram,[58] and Momme Nissen ("Dürer als Führer," in *Der Kunstwart* 17 (1904), 93ff.). A peculiarly saber-rattling Dürer had already begun to emerge with the Prussian victory over the French at Sedan in 1871, when the cultural hero was dubbed "the most German of German artists," and the corollary to this Second Reich Dürer included anti-German sentiments that were to linger in western Europe following both world wars.

Dürer Year 1928, however, thanks to the Spirit of Locarno and to the efforts of Nuremberg's liberal Mayor, Hermann Luppe, produced in Nuremberg's Germanisches Nationalmuseum the first exhibition of international importance ever to be held in a German museum—and one of the world's first monographic exhibitions—reuniting for the first time many of the artist's important paintings and drawings that had found their way to foreign countries. The exhibition presented unprecedented problems in security and insurance, but brought a record two hundred thousand visitors to the city. Heinrich Wölfflin gave the festival address, and Hans Wolfgang Singer compiled and published a complete bibliography of the literature to date. The Hungarian roots of Albrecht Dürer the Elder were acknowledged with an Albrecht Dürer *Ostpolitik*, with festivals and a historic marker in Gyula and a Hungarian Order of Merit for Luppe. The year-long celebration in Nuremberg temporarily overshadowed those of the reactionary *Deutsche Tag* of 1923, with its militaristic parades of S. A. (Nazi Storm Troopers) and *Stahlhelm* (veterans of World

War I), as well as the National Socialist Party Congress of 1927. Within five years, however, in 1933, Mayor Luppe was placed under arrest by the Nazi *Gauleiter* Julius Streicher, who brought notoriety to the city with the promulgation of the anti-Semitic Nuremberg Decrees.

Albrecht Dürer, despite his father's Hungarian origins, was deemed so racially pure that he literally became the poster boy for Aryanism when his 1493 *Self Portrait* (Paris, Louvre) was featured on the cover of the Nazi magazine *Volk und Rasse* (February 1942). No centenary of his birth or death fell during the twelve years of the Thousand Year Reich, however, and even his annual spring days of remembrance were supplanted by the celebrations of Adolf Hitler's birthday (April 20), and by the annual Nazi Party rallies held on Nuremberg's mammoth new parade ground. Hitler's attempt to legitimate his regime by restoring Nuremberg as the center of the Reich included even the return of the Imperial regalia from Vienna to "the most German of German cities." It was in this role that Nuremberg was described in an R.A.F. Bomber Command report of 1943 as "a political target of the first importance, and one of the Holy Cities of the Nazi creed," and that it was marked for destruction by Air Chief Marshall Sir Arthur Harris in the raids of 1944 and 1945, in which the aiming point was the medieval city rather than the industrial suburbs. It was also in this capacity that Nuremberg was selected as the site of the war criminals' trials of 1945–1946.

Although both his boyhood home and the workshop of his teacher, Michael Wolgemut, had been destroyed, and with them the City Hall with Dürer's murals, and although Dürer's large house by the Tiergartner Tor had sustained serious structural damage, his portrait statue and his erstwhile tomb still stood. His artistic reputation, however, had begun to erode under the excessive admiration of the Nazis. Adolf Hitler, who as a would-be art student had once in his Vienna days, painstakingly copied a reproduction of Dürer's *Pond House* watercolor, was known to have a special fondness for "the most German of all German artists," with the result that copies and forgeries of the *Knight, Death, and Devil* were at an all-time high. The gigantic painting by the Tyrolean fascist Hubert Lanzinger of the Führer himself on horseback, dressed in silver armor and carrying the swastika banner had hung over Albert Speer's desk. Most damaging of all, however, was the fact that Dürer, Lukas Cranach, and Albrecht Altdorfer—often only in reproduction—had been pressed into service to fill the void when German museums were stripped of their "degenerate" works of art in 1937. In the spirit of the tastemakers of the

early twentieth-century Dürerbund, the Nazi women's magazine *N.S. Frauenwarte* in that year published a list of 122 "approved" works by fifty-three artists that were considered apppriate for domestic decoration: One fourth of them were by Albrecht Dürer.

The 1930s did produce serious connoisseurship in Friedrich Winkler's indispensable catalogue of the drawings,[59] and Joseph Meder's catalogue of the prints taking the posthumous editions into account,[60] but the Dürer monograph of the Third Reich, by Wilhelm Waetzoldt,[61] retained the bellicose rhetoric and xenophobic air that pervaded German society during these years. The antidote for this Dürer was the enduring two-volume *Albrecht Dürer* (Princeton, 1948), written by Erwin Panofsky, which disclosed the humanistic aspects of Dürer and his art, as well as the artist's debt to Italian culture, and that has remained the staple "life and art" book on the artist for English speakers from that day to the end of the twentieth century. It was finally translated into German in 1977.

The 1950s produced two invaluable documentary works, the first volume of Hans Rupprich's *Dürer: Schriftlicher Nachlass* (Berlin, 1956), the definitive edition of the artist's own writings and of original sources mentioning him; and *Dürer und die Nachwelt*, a selection of readings illustrating the reception of Dürer from Jakob Wimpfeling to Thomas Mann, edited by two East German scholars, Heinz Lüdecke and Susanne Heiland (Berlin, 1955).

Dürer's five hundredth birthday occured 1971, in the teeth of the postwar craze for op, pop, and concept art, blue jeans, happenings, student rebellion, and counterculture, and was commemorated in reconstructed Nuremberg with the lengthiest and most expensive anniversary festival in history. Three years and six million marks in the planning, it began with an "Advent" ceremony in December 1970, on Willibald Pirckheimer's birthday, and featured the most splendid Dürer exhibition ever held. To compensate for the loss of the city's architectural heritage, and for the continuing presence of the American army of occupation after one quarter of a century, there was a new emphasis on the reception of Dürer over time, with a total of seventeen satellite exhibitions in Nuremberg's other museums and exhibition halls in addition to the main one in the Germanisches Nationalmuseum featuring Dürer's own works and family documents. One of the most delightful was the international invitational exhibition of works by modern artists created to honor Dürer, which featured entries by such artists as Picasso, Marino Marini, Graham Sutherland, Ferdinand Botero, Salvador Dali, Max Bill, Otto

Dix, and Joseph Albers. Another, sponsored appropriately by the firm of Faber-Castell, displayed the work of younger artists who had received grants to retrace one or more of Dürer's travels.[62]

As had been the case with past centenary celebrations, the five hundredth birth anniversary provided a stimulus for extensive new scholarship, the most important items being the catalogue of the Germanisches Nationalmuseum's exhibition, *Albrecht Dürer 1471–1971*, with its essays by prominent scholars in the field, the first edition of a new catalogue raisonné of the paintings, by Fedja Anzelewsky, and the splendid *Dürer-Bibliographie* edited by Matthias Mende, carefully cross-indexed for a total of ten thousand references. Monographic Dürer exhibitions—largely of prints and drawings—also were held for the first time in the principal museums of Great Britain, the Soviet Union, and the United States.

Advances in research made possible by the Nuremberg catalogue and Mende's bibliography have continued to appear. Matthias Mende's many innovative studies have included a superb facsimile edition of the woodcuts accompanied by a revisionist essay pointing up the extreme unlikelihood of Dürer's having cut his own woodblocks (*pace* William Ivins), and also has contributed definitive works on the Dürer house and the Nuremberg City Hall, among much else of value. Walter Strauss's many volumes on the prints and drawings, some of which have been quite controversial, have had the virtue of inclusiveness, containing reproductions of some works that were unknown to Winkler or were rejected by him. Anzelewsky has published both a useful "life and art" book and a new edition of the catalogue of paintings.[63] Peter Strieder, the emeritus Director of the Germanisches Nationalmuseum, has published both an excellent "life and art" book and a much-needed volume on Nuremberg panel painting.[64] The late Jan Bialostocki's *Dürer and His Critics* (Baden-Baden: Koerner, 1986) is indispensible for its overview of the artist's reputation, complete with generous quotations from many works difficult of access. My own biography of the artist (1990) and that by Ernst Rebel (1986) attempt to deal with his life in terms of the documentary evidence, in order better to portray Dürer's situation among Nuremberg's humanists and artisans as well as his relationship to Luther and his circle. There are important new studies of the Dürer watercolors (Fritz Koreny's Vienna, 1985 exhibition catalogue); of the altarpieces (Doris Kutschbach's dissertation, Stuttgart/Zurich, 1995); of the important early collections of the artist's work, particularly those on the Praun collection (Katrin Achilles-Syndram; Nuremberg, 1994, and elsewhere).

The watercolors missing from the Bremen Kunsthalle since World

War II have been disclosed as residing in Russia.[65] One of the most important publications since 1971, however, is the catalogue of the 1998 exhibition in Munich, displaying the three restored altarpieces that had been damaged by acid ten years earlier. They were displayed with all of the Bavarian Dürers, together with the complete laboratory reports on the stages of stabilization and restoration undertaken by Munich's team of conservators, and with valuable essays by Gisela Goldberg, Bruno Heimburg and Martin Schawe.[66]

NOTES

1. *Beatus Rhenanus Selezestadiensis in C. Plinium.* (Basel: 1526), 29f. Quoted in Heinz Lüdecke and Susanne Heiland, *Dürer und die Nachwelt,* (Berlin: Rütten & Loehning, 1955), 46.
2. *Epithoma Germanorum Jacobi wimpfelingij.* (Strassburg:1505), Chap. 68. This was a relatively safe statement to make since, of course, none of the works of Parrhasius and Apelles has survived.
3. Nuremberg, Stadtarchiv, Lib. Cons. K, fol. 132v. (See Hans Rupprich, ed. *Dürer: Schriftlicher Nachlass,* 3 vols., Berlin, Deutscher Verein für Kunstwissenschaft, 1956, vol. 1, p. 244, and III, p.448.)
4. Philipp Melanchthon, *Elementorum Rhetorices Libri Duo* (Wittenberg, 1536). Book I. (First edition 1532).
5. Ulrich von Hutten, in a letter to Pirckheimer dated December 25, 1518. (Quoted in full in Lüdecke and Heiland, 25.)
6. Cornelius Tacitus, *De origine et situ Germanorum*, ed. Conrad Celtis (Vienna: Johannes Winterburger, ca.1498). [The first edition printed in Germany had appeared in Nuremberg, 1473/74.] This quotation is found in the Modern Library edition, ed. Moses Hadas (New York: 1942), 720.
7. See Ludwig Schmugge, "Über 'nationale' Vorurteile im Mittelalter," *Deutsches Archiv für Erforschung des Mittelalters* 38 (1982): passim.; and Horst Fuhrmann, "Quis Teutonicus constituit iudices nationem,? The Trouble with Henry," *Speculum* 69 (1994):344–358.
8. Kunz Schweizer and Stephan Kober; contracts dated July 8, 1497 and July 26, 1497 respectively. (Nürnberg, Stadtarchiv Lib. Cons.K, fol. 132v. (See Hans Rupprich, ed., *Dürer. Schriftlicher Nachlass,* vol. 3. (Berlin: Deutscher Verein für Kunstwissenschaft, 1969), 448.
9 . "Ad pictorem Albertum Durer Nurnbergensem.
 Alberte, Almanis pictor clarissimae terris
 Norica ubi urbs celsum tollit in astra caput,

Alter ades nobis Phidias et alter Apelles
 Et quos miratur Grecia docta manu.
Italia haud talem nec lubrica Gallia vidit
 Et neque in Hispanis quisque videbit agris.
Pannonios superas et quos modo Teutanus ora
 Continet et si quis Sarmatis ora colit . . ."
[Dieter Wuttke, "Unbekannte Celtis-Epigramme zum Lobe Dürers,"
Zeitschrift für Kunstgeschichte 30 (1967): 321–325. English transla-
tion by W. S. Heckscher, published in Jan Bialostocki, *Dürer und
His Critics* (Baden-Baden: Valentin Koerner, 1986), 17.]

10. In *Libellus de laudibus Germaniae et ducum Saxoniae* (Leipzig,
 1508), quoted in Lüdecke and Heiland, 19–21.

11. See Dieter Wuttke, "Unbekannte Celtis-Epigramme zum Lobe Dür-
 ers," *Zeitschrift für Kunstgeschichte*, 30 (1967), 321–325.

12. *Ibid*, p. 21.

13. Velius, quoted in Lüdecke and Heiland, 25–26.

14. Lüdecke and Heiland, 255–256.

15. *Dr. Martin Luthers Werke. Kritische Gesamtausgabe. Tischreden 6,*
 Weimar, 1921, p. 350, no. 7036.

16. Reference to the death mask seems to have been based on the inven-
 tory (ca. 1620) of a collection belonging to the copyist of the Heller
 Altarpiece, Friedrich von Falkenburg, which listed the two casts
 (Item 11: Lüdecke and Heiland, 248).

17. The lock of hair is pictured in Jan Bialostocki, *Dürer and His Critics*
 (1986), 103, fig. 37.

18. *Alberti Dureri clarissimi Pictoris et Geometrae de Symmetria par-
 tium humanorum corporum Libri quatuor, e Germanica lingua in
 Latinum versi.* (Nuremberg: 1532/34).

19. Peter Parshall, "Camerarius on Dürer," in Frank Baron, ed., *Beiträge
 zur Geschichte des Humanismus im Zeitalter der Reformation* (Mu-
 nich, 1978), 11–29.

20. Ludovico Dolce, *Dialogo della Pittura* (Venice, 1557), German
 translation by Cajetan Cerri in *Quellenschriften für Kunstgeschichte
 und Kunsttechnik des Mittelalters und der Renaissance*, 2 (1871):
 41ff.

21. Arnold Houbraken, *De Groote Schouburgh der Nederlandtsche
 Konstschilders en Schilderessen*, 1 (Amsterdam, 1718), 258–259,
 305.

22. Carl Neumann, *Rembrandt*, Berlin/Stuttgart, 1902.

23. Gabriele Cardinal Paleotti, *Discorso interno alle imagini sacre et profane.* (Bologna, 1582), 34.

24. See, for example Georg Vischer's *Christ and the Woman Caught in Adultery* (1637) (Munich, Alte Pinakothek).

25. See *Nürnberger Dürerfeiern 1828–1928* (Exhibition catalogue), Nuremberg, Dürerhaus, 1971; and Matthias Mende, "Die Transparente der Nürnberger Dürerfeier, " *Anzeiger des Germanischen Nationalmuseums Nürnberg* (1969): 177–209.

26. In his biography of Marcantonio Raimondi (Giorgio Vasari, *La vite de più eccellenti pittori, scultori ed architettori*, ed. Gaetano Milanesi, 9 vols., Florence, 1878–1881, vol. 5 (1880), 398–409).

27. See Myra Nan Rosenfeld, "Sebastiano Serlio's Drawings in the Nationalbibliothek in Vienna for his *Seventh Book on Architecture*," *The Art Bulletin* 56, no. 3 (Sept.) (1974): 400–409.

28. Lomazzo, *Idea del Tempio della Pittura*, Milan, 1590, Chap. 31, 111f.

29. Cataldi, *Trattato geometrico . . . dove si essammina il modo di formare il pentagono sopra una linea retta, descritto da Alberto Durero.* Bologna, 1570.

30. See the modern edition edited by R. K. R. Thornton and T. G. S. Cain (Manchester: Carcanet New Press, 1981); and especially Horst Vey, "Nicholas Hilliard und Albrecht Dürer," in *Anzeiger des Germanischen Nationalmuseums* 1940–1953 (1954), 159–164.

31. Carel van Mander, *Het Schilder-Boeck waer in voor Eerst de Leerlustighe Iueght den Grondt der Edel Vry Schilderconst in Verscheyden Deelen Wort Voorghedraghen.* Haarlem: Paschier van Wesbusch, 1604. (See also Walter Melion, *Shaping the Netherlandish Canon: Karel van Mander's Schilder-boeck*, University of Chicago Press, ca. 1991.)

32. Philip (with research and commentary by Fedja Anzelewsky), "The Portrait Diptych of Dürer's Parents," *Simiolus* 10 (1978/1979), 5–18. The identification has been widely but not universally accepted.

33. Hans Kauffmann, "Dürer in der Kunst und im Kunsturteil um 1600," *Anzeiger des Germanischen Nationalmuseums, 1940–1953*, (1954), 18–60.

34. Roger de Piles, *Abrégé de la vie des peintres.* Paris, 1699, pp. 351ff.

35. This work was made available in a modern edition edited by Matthias Mende (Unterschneidheim, Verlag Dr. Alfons Uhl: 1978), in honor of the 450th anniversary of Dürer's death.

36. *Raisonnierendes Verzeichnis aller Kupfer- und Eisenstiche, so durch die geschickte Hand Albrecht Dürers selbsten verfertigt worden,* published anonymously as by a "Mitglied verschiedener patriotischer Gesellschaften" (Member of Various Patriotic Societies). He also planned to issue a French translation of this work. On Hüsgen, see O. Heuer, "Heinrich Sebastian Hüsgen, ein Jugendfreund Goethes (1746–1807), in *Jahrbuch des Freien Deutschen Hochstifts,* 1902, 347–350.

37. Christophe Gottlieb von Murr. "Reisejournal Albrecht Dürers von seiner niederländischen Reise," *Journal zur Kunstgeschichte und zur allgemeinen Literatur,* 7 (1779) 53ff; and "8 Briefe A. Dürers an W. Pirckheimer aus Venedig," also in *Journal zur Kunstgeschichte und zur allgemeinen Literatur,* 10 (1781), 3 ff.

38. Wilhelm Heinse, *Ardinghello und die glückseligen Inseln,* (1787). See Heinse, *Sämtliche Werke.* Carl Schüddekopf, ed., vol. 4, Leipzig, 1902, p. 40.

39. Lüdecke and Heiland, 332.

40. Lüdecke and Heiland, pp. 131ff, and 337–340.

41. Lüdecke and Heiland, 344.

42. C. D. Schubart, *Vorlesungen über Mahlerey, Kupferstecherkunst, Bildhauerkunst, Steinschneidekunst und Tanzkunst, von Herrn Professor Schubart.* Münster, 1777, 14.

43. See Dieter Bänsch,"Zum Dürerbild der literarischen Romantik," *Marburger Jahrbuch* 19 (1974), 259–274.

44. Wackenroder, in *Deutschland,* Vol. 7 Stück, Berlin, 1796, p. 60ff.

45. Friedrich Schlegel, "Vom Raffael," *Europa, eine Zeitschrift,* Frankfurt 1803, vol. 1, no. 2, p. 19.

46. A. W. Schlegel, *Vorlesungen über schöne Literatur. Gehalten zu Berlin in den Jahren 1801 bis 1804.* Part 3 (1803–1804). *Geschichte der romantischen Literatur.* Heilbronn, 1834, p. 24.

47. Lüdecke and Heiland, 168–169.

48. Leonardo Olschki, *Geschichte der neusprachlichen wissenschaftlichen Literatur der Technik und der angewandten Wissenschaften vom Mittelalter bis zur Renaissance.* (Heidelberg: Carl Winter, 1919; reprinted Vaduz: Kraus Reprint, 1965, p. 429.

49. Matthäus Roriczer, *Das Büchlein von der Fialen Gerechtigkeit* ([Regensburg]: Matthäus Roriczer, June 28, 1486); and *Geometria Deutsch* (Nuremberg: Peter Wagner, ca.1498).

50. Hans Rupprich, *Dürers schriftlicher Nachlass,* vol. 2 (Berlin: Deutscher Verein für Kunstwissenschaft, 1960), 235.

51. Rupprich, vol. 2, p. 84.

52. See in particular *Düreriana: Neuerwerbungen der Albrecht-Dürer-Haus-Stiftung e.V. Nürnberg*, ed. Matthias Mende. (Nuremberg: Verlag Hans Carl, 1990).

53. In Prague, at the court of Rudolph II (who also was the patron of Kepler).

54. See Gerhard Kratzsch, *Kunstwart und Dürerbund* (Göttingen: Vandenhoeck & Ruprecht, 1969), and the various publications of the Dürer Society (London).

55. See Ulrich Finke,*Französische und englische Dürer-Rezeption im 19. Jahrhundert*, Renaissance Vorträge 4/5 (Nuremberg: Stadtgeschichtliche Museen, 1975); Hartmut Böhme, *Melencolia I im Labyrinth der Deutung* (Frankfurt: Fischer, 1989); and Jan Bialostocki, *Dürer and His Critics*, Saecula Spiritalia 7 (Baden-Baden: Verlag Valentin Körner, 1986), 189–211.

56. "Sintram und seine Gefährten. Eine nordische Erzählung nach Albrecht Dürer," in *Jahreszeiten. Eine Vierteljahrsschrift für romantische Dichtungen*. Winter (1814).

57. Nietzsche cites Dürer's *Knight, Death, and Devil* out of context in *The Birth of Tragedy* as the harbinger of Schopenhauer. Following his lead, this engraving was soon transformed in the work of Hans F. K. Gunther, Willibald Hentschel, and Ernst Bertram into the quintessential symbol of the *völkisch* hero. (Schwerte, *Faust und das Faustische*, 243–278; and George L. Mosse, *The Crisis of German Ideology*, New York, 1972, 240 ff.)

58. See Bialostocki, 211–242; also Hans Schwerte, *Faust und das Faustische. Ein Kapitel deutscher Ideologie,* (Stuttgart: E. Klett, 1962); and Heinrich Theissing *Dürers Ritter, Tod und Teufel. Sinnbild und Bildsinn* (Berlin:Gebr. Mann Verlag, 1978).

59. Winkler, *Die Zeichnungen Albrecht Dürers*, 4 vols., Berlin, 1936–1939.

60. Meder, *Dürer-Katalog*, 1st ed. Vienna: Gilhofer, 1932.

61. *Dürer und seine Zeit* (Vienna: Phaidon, 1935), later translated into English by Ronald H. Boothroyd (*Dürer and His Times;* London: Phaidon, 1950).

62. Albrecht-Dürer-Gesellschaft. *Mit Dürer Unterwegs*. Nuremberg, Germanisches Nationalmuseum, September 12–November 28, 1971.

63. *Albrecht Dürer. Das malerische Werk*. 2nd rev. ed., 2 vols. (Berlin: Deutscher Verlag für Kunstwissenschaft, 1991).

64. Strieder, *Tafelmalerei in Nürnberg* (Könisgstein: Langwiesche, 1993).

65. Konstantin Akinsha and Grigorii Kozlov, *Beautiful Loot: The Soviet Plunder of Europe's Art Treasures*, New York: Random House, 1995.

66. Munich, Bayerische Staatsgemäldesammlung. *Albrecht Dürer. Die Gemälde der Alten Pinakothek*, 1998.

Annotated Bibliography

1. Achilles, Katrin. "Naturstudien von Hans Hoffmann in der Kunstsammlung des Nürnberger Kaufmanns Paulus II Praun." *Jahrbuch der Kunsthistorischen Sammlungen in Wien* 82/83 (1986): 243–259.

One of the papers presented at the Albertina symposium (see Koreny 1986/87). Hoffmann's and Georg Hoefnagel's copies after Albrecht Dürer have survived—and, it is to be hoped, have been identified—in fairly large numbers, unlike those by Georg Gärtner, Jobst Harrich, or Paul Juvenal. When the Nuremberg collector Paulus Praun died in Bologna (1591) his younger brother Jakob made an inventory of his collection prior to shipping it home to Nuremberg, where Paulus had planned to create *"Museumsräume"* in the new house he was having built. (In the event, the works were never unpacked until the collection was sold after its owner's death.) The author, who is the recognized authority on the Praun collection, discusses Paulus Praun's will and Jakob's inventory, which reveal ownership of thirty-five works by Hoffmann. Watercolors included a seated grayhound, lions, and dead blue roller—an album of Hoffmann's work. Achilles traces the subsequent history of the Hoffmann volume, citing von Murr's inventory (1797), made before the collection was consigned to the Nuremberg art dealer Frauenholz (sale closed 1801). After 1804 many of the Praun drawings, including most of the Hoffmanns, were acquired by Prince Miklós Esterházy and are now in the Budapest Museum. Achilles has identified as many of the Hoffmanns as pos-

sible (twenty-two) using the descriptions and measurements from the three inventories (including Esterházy's). A useful list of previous literature on Hoffmann appears in Note 1 in this work.

2. Achilles-Syndram, Katrin. *Die Kunstsammlung des Paulus Praun. Die Inventare von 1616 und 1719*, Quellen zur Geschichte und Kultur der Stadt Nuremberg, 25. Nuremberg: Stadtrat, 1994.

The catalogue of the 1994 exhibition held at the Germanisches Nationalmuseum (*Kunst des Sammelns. Das Praunsche Kabinett. Meisterwerke von Dürer bis Carracci*) was to have had a supplement containing the full transcription of the two inventories. Due to lack of funds it could not be printed in that form, but was produced as a cooperative undertaking by the Museum and the Stadtarchiv, which possesses the original inventories. Included also are essays by Kurt Löcher, Rainer Schoch, Christian Kruse, Herman Maué, Silvia Glaser, Erika Zwierlein-Diehl, and Eduard Ispherding, in addition to Achilles-Syndram's commentary on the inventories themselves. (Reviewed by Ulrike Swoboda in *Mitteilungen des Verein für Geschichte der Stadt Nürnberg*, 83 (1996), 355–357).

3. ———. "Die Zeichnungssammlung des Nürnberger Kaufmanns Paulus II. Praun (1548–1616)." Ph.D. dissertation, Berlin, 1990.

The author's dissertation, dealing only with the drawings and watercolors collected by Paulus II Praun, including important works by both Dürer and the most skillful of his later imitators, Hans Hoffmann, which are found today in the Albertina and in the Museum of Fine Arts in Budapest.

4. Achilles-Syndram, Katrin. " '. . . und sonderlich von grossen stuckchen nichts bey mir vorhanden ist." Die Sammlung Praun als kunst- und kulturgeschichtliches Dokument." *Kunst des Sammelns. Das Praunsche Kabinett. Meisterwerke von Dürer bis Carracci*, 35–55. Ed. Katrin Achilles-Syndram. Nuremberg: Verlag des Germanischen Nationalmuseums, 1994.

Examines the significance of Praun's drawing collection, which, in addition to its prime Northern works, included fine drawings by Bolognese and Emilian artists, in the context of the history of such collections, which are contrasted to the older "kunst- und wunderkammern." The principles and procedures of Rudolf II, as well

as of bourgeois collectors such as Basilius Amerbach (1533–1591), and of the artist/theoretician Giorgio Vasari are discussed in this connection, and original correspondence between Rudolf II and Paulus Praun is cited.

5. Acton, David. "The Northern Masters in Goltzius's *Meisterstiche.*" *Bulletin, Museums of Art and Archaeology, University of Michigan* 4 (1981): 40–53.

Discusses Goltzius's motivation in engraving the *Circumcision* in the style of Dürer and the *Adoration of the Magi* in the style of Lucas van Leyden—two of his so-called *Meisterstiche* from the series done in 1594, suggesting that together the two prints illustrate "the sensibilities of self-appraisal and artistic proclamation" that were the inspiration for the series. Examines the Dutch artist's response to Dürer and Lucas in the context of his knowledge of the Italian masters, arguing that in imitating Dürer and Lucas, Goltzius was transferring behavior that he had observed as part of the Mannerist movement during his travels in Italy to the north.

6. Ahlborn, Joachim. *Die Familie Landauer, Vom Maler zum Montanherrn*, Nürnberger Forschungen, Einzelarbeiten zur Nürnberger Geschichte, 11. Nuremberg: 1969.

A detailed and excellent study of the family of Matthias Landauer, the patron of Dürer's *Adoration of the Trinity* altarpiece of 1511, and founder of the retirement home and chapel for which the work was designed. The Landauers had progressed from the craftsman class in the early decades of the fifteenth century (Berthold, Matthäus' grandfather, the first Landauer mentioned in Nuremberg archives was a painter), to the patrician (*ehrbar*) class within one generation. His sons Matthäus and Markus engaged in international trade—the prereqisite for elevation to the ruling class—and Matthäus the Younger, Dürer's client was the owner of a metal refinery in Thuringia. His establishment of a retirement home for twelve elderly, unmarried men carried certain less than altruistic restrictions: no blind, lame, bedridden or mentally disturbed old men were allowed, and no beggars or propertyless need apply; those fortunate enough to be admitted must bathe every three weeks. Also discussed in this volume are other Landauer commissions, including Adam Kraft's Schreyer-Landauer monument in St. Sebald's church.

7. Akinsha, Konstantin, and Grigorii Koslov. *Beautiful Loot: The Soviet Plunder of Europe's Art Treasures*, New York: Random House, 1995.

 Akinsha is a Ukrainian art historian formerly on the staff of the Museum of Western and Oriental Art in Kiev; Kozlov was an official in the Department of Museums of the Ministry of Culture of the former USSR. Although there are many published accounts of the rape of western European collections of old master artworks by agents of the Third Reich, this important piece of investigative journalism published with the aid of Sylvia Hochfeld, an editor at large for *ARTnews* is the only reliable account of the secret Soviet "trophy brigades" (operative from 1945 to 1948) acting under specific instructions from Stalin to remove artworks from Germany for shipment to the USSR. The looted works include the collection of Dürer watercolors and the *Salvator Mundi* painting from the Bremen Kunsthalle. The drawings have been returned to the German Embassy in Moscow, but at the time of writing have still been barred by the Russian government from leaving the country.

8. Allihn, Max. "Dürer-Studien. Versuch einer Erklärung schwer zu deutender Kupferstiche Albrecht Dürers von culturhistorischem Standpunkte." Leipzig: Rudolf Weigel, 1871.

 An early iconographic study of a selection of the artist's prints which the author deemed most difficult to understand: that is, *The Large Fortune* (pp. 9-38); the *Four Nude Women* and the *Witches* (pp. 39-56); the *Offer of Love*, the *Woman on Horseback*, and *Envy* (pp. 57-78); the prints dealing with peasants, including the *Dancing Peasants* and *Bagpiper* (pp. 79-94); and *Melencolia I* (95–115).

9. Amsterdam: Museum "het Rembrandthuis." *Rembrandt en zijn Voorbeelden*, Text Ben Broos. 1986.

 Catalogue of the exhibition "Rembrandt and his Sources," held at the Rembrandt House from November 2, 1985–January 5, 1986, comprising sixty-eight objects. Prints and drawings by Rembrandt were paired with the prints from which he drew his inspiration, including works by Dürer. Catalogue entries with commentaries and illustrations of all exhibited works.

10. Amt für Schrifttumspflege (Reichsstelle zur Förderung des deutschen Schrifttums). *Nürnberg, die deutsche Stadt. Von Stadt*

der Reichstage zum Stadt der Reichsparteitage. Eine Schau in Schriften, Urkunden, Bildern und Kunstwerken, Nuremberg: 1937.

Catalogue of an exhibition held in the Germanisches Nationalmuseum celebrating Nuremberg's role as the quintessential German city, from its onetime role as meeting place of the Diet of the Holy Roman Empire to its position during the Third Reich as locus of the annual rallies of the Nazi Party. Items by Dürer that were highlighted included the artist's idealized portraits of Charlemagne, the first Holy Roman Emperor, and of subsequent emperors Sigismund and Maximilian I; his portrait of his teacher, the Nuremberg artist/entrepreneur, Michael Wolgemut, and his drawings for a pokal and a chandelier in the form of a dragon. The point of all this was, of course, an attempt to legitimize the Nazi regime by portraying it as the successor to the Holy Roman Empire. The exhibition was scheduled in order to coincide with the Nazi rally of 1937. (It should be recalled that the "Nuremberg Laws" calling for racial purity had been officially announced by Julius Streicher in the previous year, and that this exhibition coincides with the 1937 cleansing of German museums of all works of so-called degenerate art).

11. Andersson, Christiane. "The censorship of images in Nuremberg 1521–1527." *Dürer and His Culture*, 164–178. Eds. Dagmar Eichberger and Charles Zika. Cambridge/New York/Melbourne: Cambridge University Press,

Andersson is the Samuel H. Kress Professor of Art History at Bucknell University. Although she does not deal directly with Dürer, this essay is of interest as general background for the last years of the artist's life, as the Imperial Free City of Nuremberg attempted to deal with rising sympathies for Luther's reforms without giving unnecessary offense to Charles V after the Edict of Worms. Under the terms of the Edict, all antipapal texts and images were to be burned, holding author, artist, and printer equally guilty. In Nuremberg, the City Council also decreed that the offending woodblocks would be confiscated, and the guilty were to be penalized either by heavy fines, or, in some cases, exclusion from the printing profession. Andersson shows that these punishments were often either commuted or ameliorated in some way. Among the items banned by the Edict were all likenesses of Luther; in Nuremberg this was moderated simply to forbid sale of portraits of Luther "with the Holy Spirit" (March 3, 1521), a stric-

ture that was apparently ignored after 1525 in Nuremberg, where
Lazarus Spengler is presumed to have been the local censor. Dis-
cusses works by Hans Sebald Beham, and Erhard Schön. Corrects
a mistake in Parshall and Landau arising from mistranslation of the
early sixteenth-century usage of the German word "Gemäl" as
paintings (p. 175), when the true meaning was "pictures."

12. ———. "Polemical Prints in Reformation Nuremberg." *New Per-
spectives on the Art of Renaissance Nuremberg: Five Essays*,
40–62. Ed. Jeffrey Chipps Smith. Austin, TX: University of Texas–
Archer M. Huntington Art Gallery, 1985.

Discusses the proliferation of popular woodcuts and broadsheets
in early sixteenth-century Nuremberg as a function of the lack of
restrictive guild regulations. Includes interesting archival refer-
ences to the refusal of the City Council to issue such regulations,
despite the petitions of numerous local *Briefmaler* and *Karten-
maler*, many of whom were forced to take on second jobs, such as
dealing in rags (presumably for sale to paper mills). Generously il-
lustrated with examples of popular imagery, including Siamese
twins, natural disasters, defamatory cartoons of both Lutheran and
Catholic origin, such as the *Monk Calf* and *Papal Ass* (both 1523)
from the Cranach workshop, based on Wenzel von Olmütz's *Roma
Caput Mundi* of 1496; Hans Brosamer's (attributed) *Seven-
Headed Martin Luther*; Hans Rudolph Manuel Deutsch's trick
woodcut showing a monk robbing a widow, devouring a lamb, and
devouring the widow's house; Erhard Schoen's *Twelve Pure and
Twelve Sinful Birds* and *Devil Playing a Bagpipe*; and many
anonymous works.

13. Andrews, Keith. *The Nazarenes, A Brotherhood of German
Painters in Rome*, 13, 15, 25, 31. Oxford: 1964.

Discusses Dürer's impact on the Romantic writers Tieck and
Wackenroder, and on the Nazarene painters Peter Cornelius and
Franz Pforr.

14. Anonymous. "Dürers Säkularfeier in Nürnberg." *Kunstblatt* 31,
32, 34, 35, 37 (April 1828).

Contemporary descriptions of the festivities held in Nuremberg
honoring Dürer's three hundredth death anniversary in 1828 were
reported in series: vol. 31, pp. 121–123 (April 17—contains Ernst

Förster's lyrics for the "hymn" to Dürer sung at his grave at sunrise on Easter morning); vol. 32, pp. 125–129 (April 21– a list of the fourteen items inserted in the cornerstone of the Dürer monument); vol. 34, pp. 133–135 (April 28—describes the arrival in Nuremberg of the Munich artists with their cartoons for the transparencies relating an idealization of Dürer's life); vol. 35, pp. 137–140 (May 1); vol. 37, pp. 145–147 (May 8).

15. Anzelewsky, Fedja. *Albrecht Dürer. Das Malerische Werk*, Berlin: Deutscher Verein für Kunstwissenschaft, 1971.

The author (now retired from the directorship of the Berlin Kupferstichkabinet) had studied with Friedrich Winkler. His catalogue raisonné of Dürer's paintings published during Dürer Year 1971 has won acceptance—some of it grudging—as the standard catalogue. Superseded by the 2nd revised edition (1991), q.v. Beginning with a useful overview of the connoisseurship of the past, Anzelewsky included an extensive chronological survey of the paintings, as well as essays on iconography, technique, and materials, collectors, copyists, and imitators, ending with the catalogue raisonné of the complete works. In reconstructing the artist's early work, several new items were admitted to the oeuvre that did not find complete acceptance. (See the reviews by Dieter Kuhrmann, in *Kunstchronik* 1973; John Rowlands, in *Zeitschrift für Kunstgeschichte* 36 (1973), 209-213, and especially those by Wolfgang Stechow in *The Art Bulletin*, 56 (1974) 2, 259-263; and Gisela Goldberg in *Pantheon*, 30 (1972), 518–520. Also reviewed by Walter L. Strauss in *Art Journal*, 34 no. 4 (Summer 1975), 374–376.) Anzelewsky rejected Kurt Bauch's attribution of the painting (now in Frankfurt) of the *Raising of the Cross*, and Friedländer's attribution of the anonymous Upper Rhenish work known as the Weber diptych (Berlin). He accepted Alfred Stange's attribution of the *Miracle of the Drowned Boy from Bregenz* and Basel's *Adoration of the Magi*; Karlsruhe's *Man of Sorrows*, which he dates to 1493–1494; and the *Penitent St. Jerome*, the *Madonna of Bagnacavallo*.

16. ———. *Albrecht Dürer. Das Malerische Werk*, 2, revised ed. 2 vols. Berlin: Deutscher Verlag für Kunstwissenschaft, 1991.

Replaces the 1971 one-volume edition (long out of print) as the new standard catalogue of Dürer's paintings. Completely revised

and updated by the author, the retired director of the Berlin print room (1977–1984), who also taught at the Free University. Takes into consideration the new scholarship produced since 1971. Volume 1 is text; Volume 2 illustrates in color each of the surviving paintings accepted by the author as autograph works, in some cases accompanied by black-and-white details. The general organization of the text volume is the same as in 1971: an analysis of Dürer as painter; a biographical section; sacred and secular iconography; technique and materials; reception by collectors and copyists; catalogue raisonne. Included in this last section are works known only through copies (marked *K*) as well as works that survive only in literary descriptions (*V*); works presumably lost but implied by the existence of drawings (*Z*), and workshop productions (*W*). Additions to the oeuvre include a copy of a possible lost self portrait at the age of thirteen, formerly in the Stettin Museum (now Szceczin); and Lotte Brand Philip's identification of the Germanisches Nationalmuseum's portrait of a woman as Dürer's mother, reproduced with the combined arms of the Dürer and Holper families from the back of the panel. Alfred Stange's attribution of the votive *Miracle of the Drowned Boy of Bregenz* (Kreuzlingen) is still accepted as a work from the bachelor's journey. A convenient handlist of works, arranged according to location, is found on pages 308–312.

17. ————. "Der Jabach Altar." *Dürer-Studien. Untersuchungen zu das ikonographischen und geistesgeschichtlichen Grundlagen seiner Werke zwschen den beiden Italienreisen*, 142–261. Berlin: Deutscher Verlag für Kunstwissenschaft, 1983.

Suggests Canon Lorenz Beheim as the author of the iconographic programme of the so-called Jabach Altar. Also reproduces a drawing from the Cranach circle, copied from the Job scene before its separation from the two musicians (fig. 17).

18. ————. "Dürer." *Artdossier* (1988): 28ff.

Reports the sulphuric acid attack in Munich's Alte Pinakothek on the Paumgartner Altarpiece (noon, April 21, 1988), the standing Mater Dolorosa and the Glimm *Lamentation* by a deranged man. (For restoration reports see Munich, Neue Pinakothek, 1998).

19. ————. *Dürer–His Art and Life*, New York: Alpine, 1981.

The English translation, by Heidi Grieve, of the monograph copyrighted by Office du Livre, Fribourg, Switzerland (1980). Beautifully produced, with many color plates of excellent quality, a generous bibliography, and a wealth of detailed information on Nuremberg; the artist's early life; his stylistic development and travels; relationships to Maximilian I, and the Reformation; publications and diary. Extended captions for each work illustrated give detailed information on technique or subject matter. The author, Emeritus Director of the Berlin Kupferstichkabinett, also is the author of the most recent catalogue raisonné of the artist's paintings (q.v.). An essential work for general use.

20. ———. *Dürer: Werk und Wirkung*, 275 pp. 240 illus. Stuttgart: Elekta/Klett-Cotta, 1980.

[Dürer: Work and Effect.] This was the original German edition of the book published in English as *Dürer: His Art and Life*. (New York, Alpine, 1981, q.v.).

21. ———. "Dürer zwischen Symbolik und Naturwissenschaft." *Jahrbuch der kunsthistorischen Sammlungen in Wien* (1982/1983, 1986/1987): 33–42.

Dürer's nature studies considered from the standpoint of iconographic possibiity (e.g., the *Large Piece of Turf* and its individual plants, which, in other circumstances, would be interpreted unqualifiedly as symbolic, or in some cases as medicinal.

22. ———. "Dürers "aesthetischer Exkurse" in seiner Proportionslehre." *Kaleidoskop: Eine Festschrift für Fritz Baumgart zum 75. Geburtstag*, Ed. Friedrich Mielke. Berlin: Gebr. Mann, 1977.

Dürer's "aesthetic digression" in the *Four Books of Human Proportion* deals specifically with the passage at the end of Book III (Panofsky, 1955 p. 122). Anzelewsky views the usual catch phrase "aesthetic digression" as misleading, because it gives the erroneous impression that this material was not an integral part of Dürer's theory. Also he notes, correctly, that the use of the term "aesthetic" is an anachronism. Dürer saw the need for dealing with a variety of human physical types on the basis of the information on the four "humors" or temperaments known from ancient medical literature. By 1507, during the time of his return to Italy, he had come to the conclusion that no ideal set of proportions exists in

nature, noting that Apollo and Hercules, for example, had different body types. His ideas on human proportion are grounded in observation of nature, and in late Occamist thought, as opposed to Italian principles. This permitted him to be interested in the odd (bearded child, for example) as well as in the beautiful.

23. ———. "Dürers Selbstbildnis aus dem Jahre 1500." *Ars Auro Prior. Studia Joanni Bialostocki Sexagenario Dicata*, 287–290. Warsaw: 1981.

In this festschrift volume presented to the late Polish authority on Dürer (and on much else), Jan Bialostocki, Anzelewsky notes that Justi had been the first to recognize the use of a proportion scheme in the famous 1500 *Self Portrait* (Munich)—an idea that earlier would have been viewed as somewhat blasphemous. Panofsky then enlarged upon the Christological iconography of the painting, which he cast in the spirit of the *Imitatio Christi*—an idea endorsed by the Reformation historian Roland Bainton, who connected it with Franciscan mysticism. This article offers a useful review of the literature up to 1980, and cites Nicholas of Cusa and Bonaventura on human creativity; Pico della Mirandola on human stature in comparison to divinity; Pico's thoughts on free will; and Bialostocki's own article on the eye as "window of the soul" (q.v.). The author's thesis is that Dürer no longer regarded himself as a private person here, but rather as Man created by God in His own image—a thesis that would resonate with the use of the unusual verb *effingebat* to call attention to the fact that the image had been painted with "undying" (permanent) colors. Quotes Dürer's own 1513 remark: "Den wir werden durch kunst der gottlichen gepildnus destmer vergleicht."

24. ———. *Dürer-Studien. Untersuchungen zu den ikonographischen und geistesgeschichtlichen Grundlagen seiner Werke zwischen de beiden Italienreisen, Berlin: 1983,*

A series of speculative and detailed essays on the background and iconography of eleven selected works (eight prints, two paintings, one drawing) done between the artist's two trips to Italy (1494/1495 and 1505–1507.) Discusses the intellectual circle that influenced the artist during those years, and the relevant contents of Nuremberg libraries that he would have known. Among the author's most intriguing assertions is the idea that Dürer, aware of the

discovery of a Roman statue in a plowed field in Carinthia (Kärnten), may have routed his second trip via Klagenfurt rather than the Brenner Pass, and drawn the portrait of the *Windish (Slovenian) Peasant Woman* on his way, rather than having seen her in Venice. Also reviews the iconography of the *Sea Monster (Meerwunder)*, recalling the story of Glaucus and Scylla, from Ovid's *Metamorphoses*, and noting that the woman in the engraving wears a Milanese headdress, which might be taken for a reference to the story of the Lombard queen Theudelinde, who was abducted by a sea monster (46).

25. ———. "Eine Gruppe von Malern und Zeichnern aus Dürers Jugendjahren." *Jahrbuch der Berliner Museen* 27 (1985): 35–39.

Developed from the conference, *Engraving Before Dürer,* held at the Goethe Institute in Paris in 1982. Discusses the work of Wolfgang Beurer (whom some equate with the Housebook Master and/or the Master WB); Anton Beurer; Lorenz Katzheimer (who may or may not have been the engraver LCz); Master WB; and the Master of the Herpin Manuscript.

26. ———. "Eine unbekannte Zeichnung Dürers." *Jahrbuch der Berliner Museen* 28 (1986): 67–73.

Discusses a privately owned and previously unpublished drawing by Dürer. Done in brown ink, it depicts a warrior in fantastic armor (recto), and a sketch of two figures (verso). A date of approximately 1515–1516 is suggested.

27. Anzelewsky, Fedya. "Pflanzen und Tiere im Werke Dürers. Naturstudien und Symbolik." *Jahrbuch der Kunsthistorischen Sammlungen in Wien* 82/83 (n.s. vol. XLVI/XLVII) (1986): 33–42.

The author's paper for the 1985 symposium. Deals with Dürer's depictions of butterflies, stag beetles, *Männertreu* (Eryngium), Barbary apes, and various flowering plants.

28. ———. "Tafelbilder Albrecht Dürers 1490–1500." *Kunstchronik* 25, no. 7 (1972) [Paper presented at the 1972 Nuremberg symposium, "Problemen der Kunst Dürers zwischen 1490–1500].

Anzelewsky discussed problematic cases from his catalogue of Dürer's paintings (q.v.), including the supposed lost first self portrait. known from a seventeenth-century Augsburg copy formerly

in Stettin (now Szceczin), which also is now lost; and the *Rescue of a Drowning Boy* (Kisters collection, done on the way to Basel?). He traced the artist's route on his bachelor's journey via Colmar, Freiburg, Breisach, to the Bodensee, and from there via Konstanz to Basel. He rejected the Munich *Young Man* (1500) and the Paris *Young Woman of the Fürleger Family.*

29. Anzelewsky, Fedja, and Hans Mielke. *Albrecht Dürer. Kritischer Katalog der Zeichnungen*, Berlin: Staatliche Museen Preussischer Kulturbesitz, 1984.

Scholarly catalogue of the 122 drawings and watercolors by the artist that are in the Berlin print room. Notable watercolors include one of the views of *Kalkreuth* and the *Wire-Drawing Mill at Nuremberg*. Chiaroscuro drawings include the *Portrait of an Architect* (1506: study for the *Feast of the Rose Garlands*, a *Standing Apostle* (study for the *Heller Altarpiece*). Many portraits, including those of *Willibald Pirckheimer* (1503), *The Artist's Mother* (1514), and *Agnes Dürer in Netherlandish Headdress* (1521). The Appendix provides a catalogue of drawings formerly attributed to Dürer.

30. Appuhn, Horst. *Albrecht Dürer: Die Drei grossen Bücher*, Die bibliophilen Taschenbücher, 95. Dortmund: Harenberg, 1979.

Companion to the volume on the *Small Woodcut Passion* by the same author, an authority on late medieval German art and iconography, this reproduces and discusses the three large woodcut books—the *Apocalypse*, *Large Passion,* and *Life of Mary.* They were published in book form in 1511 as devotional manuals with Latin text, and the artist often sold them or made presents of all three as a group, as he did in 1513 with the presentation copy for Provost Georg Behaim (still in Nuremberg). It was the Behaim copy that was reproduced for this reduced edition, which offers complete translatons of the Latin texts as well as commentary.

31. ———. *Der Bordesholmer Altar und die andere Werke von Hans Brüggemann*, Königstein im Taunus: Langewiesche, 1983.

Discusses the influence of Dürer's *Small Passion* (published 1511) on the style and iconography of the great oak altarpiece carved by Hans Brüggemann in 1521 for the Augustinian abbey church in Bordesholm (now located, since 1666, in the apse of St. Peter's, Schleswig).

32. ———. *Der Triumphzug Kaiser Maximilians I*, 2nd ed. Dortmund: 1986.

The woodcut Triumphal Procession designed for Maximilian.

33. ———. *Die Kleine Passion von Albrecht Dürer*, Die bibliophilen Taschenbücher, 461. Dortmund: Harenberg Kommunication, 1985.

Includes a facsimile of the *Small Woodcut Passion* with its original Latin text, a translation of the Latin into modern German by Maria Kisser, and a discussion of the prints and their themes in the context of traditional Passion series.

34. Arend, Heinrich Conrad. *Das Gedächtnis der Ehren Albrecht Dürers*, Goslar: Johann Christian König, 1728.

[Remembrance of the Character of Albrecht Dürer.] The commemorative volume, dedicated to Duke Ludwig Rudolph of Braunschweig Luneburg (1671–1735), brought out in honor of the two hundredth anniversary of the artist's death is now available in a photomechanically reproduced facsimile edition with a colophon by the Nuremberg scholar Matthias Mende (Unterschneidheim, Alphonse Uhl, 1978), brought out in honor of the 450th anniversary of the same event. This was the first monograph on the artist, written by a Protestant minister, thirty-six-year-old Heinrich Conrad Arend (1692–1738), who served a tiny parish in the Harz mountains, Grund bei Clausthal. An avid student of Dürer's graphic art (but a man of insufficient social rank to have had admission to the princely collections of the artist's paintings and watercolors), however, he had traveled to both Nuremberg and Wolfenbüttel, and was familiar with both the Family Chronicle and the artist's scientific publications.

35. ———. *Das Gedächtnis der Ehren Albrecht Dürers*, Ed. Matthias Mende. Goslar 1728 ed. Unterschneidheim: Verlag Dr. Alfons Uhl, 1978.

This facsimile edition of Arend's biography honoring the two hundredth death anniversary of the artist was produced in honor of the 450th anniversary of the event, using the example in the collection of the Albrecht-Dürer-Haus-Stiftung in Nuremberg. The text is reproduced in its entirety, with a short Afterword by Matthias Mende. The original work of Baroque Dürer-reception by Arend (1692–1738) is quite rare, and was never previously reprinted, as it

had been eclipsed by the work of Joseph Heller a century later. Arend, a Protestant pastor in the tiny mountain village of Grund bei Clausthal, although essentially without funds or social connections, had traveled far and wide to see Dürer's works. As the princely collections of paintings and drawings were not available to him, he was often dependent upon copies—particularly in Nuremberg, where copies were displayed to replace the works that had been sold to such collectors as Rudolph II. Of Dürer's personal manuscripts he knew only the Family Chronicle, which had been published by Joachim von Sandrart in his 1675 Teutsche Akademie, although he knew the artist's own theoretical publications, as well as the graphic art, and proclaimed the "Adam and Eve" to be the artist's most perfect engraving.

36. Athens (OH), Ohio University, Trisolini Gallery. *Albrecht Dürer, Printmaker*, Michael B. Harper. 1976.

 Catalogue of an exhibition shown at Ohio University and also at the Gallery of Fine Arts in Columbus (OH), February 13–March 21, 1976.

37. Auburn, Walter. "Rembrandt: *Christ Driving the Money Changers from the Temple.*" *Auckland City Art Gallery Quarterly* 62–63, December (1976): 2–3.

 Publishes a first-state impression of Rembrandt's etching of *Christ Driving the Money Changers from the Temple* (B.69) from the collection of the Auckland (New Zealand) City Art Gallery, pointing out that Rembrandt, who owned a large number of prints by Dürer, borrowed the central figure of Christ from Dürer's corresponding woodcut from the *Small Passion*. Discusses Rembrandt's technique and iconography.

38. Auld, Alisdair A. "The Miracle of St. Eustace." *Scottish Art Review* 14, no. 1 (1975): 30–31.

 A general article on Dürer as master of the essential branches of renaissance art theory, as seen in the *St. Eustace* and *Agony in the Garden* engravings. [RILA 1233].

39. Austin (TX, USA). University of Texas, Archer M. Huntington Art gallery. *Nuremberg: A Renaissance City, 1500–1618*, Jeffrey Chipps Smith. Austin, TX: University of Texas Press, 1983.

Catalogue of an exhibition held at the Archer M. Huntington Art Gallery at the Unversity of Texas, produced in a permanent hardcover edition, this is a most useful reference work on Nuremberg from Dürer's prime until the Thirty Years' War. Engravings and pre-World War II photographs give an idea of the city's lost splendors. An essay on the Renaissance and Reformation in the city by Guy Fitch Little introduces the work, and Smith, the arranger of the exhibition, discusses pre-Reformation and Reformation art; the effects of Humanism on the arts; Dürer as teacher; and artistic developments up to the time of the Swedish invasion.

An illustrated catalogue of the works exhibited follows, and an appendix giving biographical sketches of about thirty important Nuremberg artists of the period who could not be represented in the exhibition (e.g., Veit Stoss, Peter Vischer the Elder, Adam Kraft, et al.) Lenders to the exhibition included thirty major American institutions in addition to the National Gallery of Canada and the Germanisches Nationalmuseum in Nuremberg. [Reviewed by John Nash, *Times Literary Supplement* (May 11, 1984) 528; Larry Silver, *Art Journal* 43, no. 4 (Winter 1983) 393–396].

40. Avila Padron, Ana. "El Pintor Juan Soreda. Estudio de su Obra." *Goya* 153, no. (November-December) (1979): 136–145.

Catalogues the complete work of the late sixteenth-century Spanish painter Juan Soreda, noting his dependence on prints by Dürer, Schongauer, and Lucas van Leyden, as well as on Italian prints and paintings.

41. Azevedo Cruz, Maria do Rosário de Sampaio Themudo de Barata. "Um portugués na Alemanha no temp de Dürer: Rui Fernandes de Almada." *Revista da Faculdade de Letras de Lisboa* 15, no. III, ser. (1973): 85–123.

Discovery that Dürer's friend the Portuguese merchant/diplomat Rodrigo d'Almada, who figures so prominently in Dürer's travel diary of his journey to the Netherlands (1520/1521), had traveled in Germany from autumn 1519 to January 1520, stopping in Nuremberg, and probably made the artist's acquaintance at that time.

42. Bach, Friedrich Teja. *Struktur und Erscheinung: Untersuchung zu Dürers graphische Kunst*, Berlin: 1996.

Extensively treats the marginal drawings in Maximilian's *Prayer-book*, particularly with regard to the arabesque marginal drawings and their significance for understanding the artist's creative process.

43. Bachter, Falk. *Balthasar Augustin Albrecht 1637–1765. Ein bayerischer Hofmaler des Barock.* Ph.D. dissertation, Munich, Ludwig-Maximilian-Universität, 1981.

Balthasar Albrecht was gallery inspector and restorer at the court of the Elector Max Emanuel, as well as his court painter (1727–1730), *Kammerdiener* (1751). The painter of the high altar at the Wieskirche, he was called upon to fresco the Munich Residenz after the 1729 fire that destroyed Dürer's Heller altarpiece. Not particularly important for Dürer studies, although influenced by his art to a certain extent.

44. Bailey, Martin. "Dürer's Comet." *Apollo* 141 (1995): 19-32.

The comet depicted in *Melencolia I* as a depiction of Halley's Comet.

45. Bainton, Roland. "The Man of Sorrows in Dürer and Luther." *Studies on the Reformation*, 51–61. Roland Bainton. Boston/London: Beacon Press/Hoddard & Stoughton, 1963.

(Originally published as an article in *The Art Bulletin* [vol. 29 (1947): 269-272.] Bainton was not an art historian, but was the most highly respected American scholar of Reformation history of his day, and the author of the standard English language biography of Luther [1950]. He was professor of ecclesiastical history at the Yale Divinity School.) Here the author discusses Dürer's penchant for depicting himself in the guise of Christ (1500 and 1522), and gives a history of visual and literary depictions of figures in imitation of Christ—both Catholic and Protestant.

46. Baldass, Ludwig. *Der Künstlerkreis Kaiser Maximilians*, Vienna: Anton Schroll, 1923.

Still a useful work despite its age, this brief (152 pp.) book remains one of few works offering an integrated picture of Maximilian's circle of sculptors, medallists, armorers, artists and historians. It situates Dürer, his journeymen and his brother Hans within the group of artists—including Cranach, Altdorfer, Hans Burgkmair, Peter Vischer, Stefan Godl, Wolf Traut, Leonhard Beck, Jörg Kölderer, Daniel Hopfer, Bernhard Strigel, Hans Baldung, Gregor

Erhardt, and a dozen others employed by the Emperor. The author's introductory essay includes a brief biography of Maximilian and historical overview of his changing reputation, pointing out that it was Goethe (*Faust II*) who first called attention to the Emperor's importance as a figure of great cultural importance, overtrumping the earlier view of his reign as a problematic one from the political standpoint. Catalogue notes (pp. 33–50) accompany the one hundred black-and-white illustrations. Dürer's works included are the portraits, selected drawings from the *Prayerbook*, the Triumphal Arch and Car and parts of the Procession; his contributions to the *Freydal* illustrations; and one of the drawings from the *Fechtbuch* manuscript of 1512.

47. Ballarin, Alessandro. "Tiziano prima del Fondaco dei Tedeschi." *Tiziano e Venezia. Convegno Internazionale di Studi, Venezia, 1976*, 493–499. Vicenza: Neri Pozza, 1980.

From the papers of the international conference on Titian held in Venice in 1976, honoring the four hundredth anniversary of the artist's death. Ballarin's paper deals with the style and chronology of Titian's work in Venice before the decoration of the new Fondaco dei Tedeschi—that is, between 1506, when Dürer was in residence in the city, until 1511. He examines the succesive influences of Giovanni Bellini, Dürer and Giorgione, and also provides a chronology for Giorgione's work between 1506–1508.

48. Ballschmiter, Thea, Renate Klingmann, and Barbara Haase. "Zum Problem des Humanismus und Realismus in der Kunst Albrecht Dürers." *Wissenschaftliche Zeitschrift der Ernst-Moritz-Arndt-Universität Greifswald* 20, Gesellschafts- und Sprachwissenschaftliche Reihe (1971): 201–208.

An East German essay from Dürer Year 1971 examining the artist's work in terms of the changing relationship between the individual and society. Humanism is seen as the source of realism, working together with anti-Papal sentiments to convey the new consciousness of the reformation era to the people. The *Four Horsemen of the Apocalypse* woodcut and the so-called *Four Apostles* panels are stressed.

49. Balus, W. "Dürer's Melencolia I: Melancholy and the undecidable." *Artibus et Historiae* 15 (1994): 9-21.

50. Barañano Letamendía, Kosme Maria de. "Disco de Sebaldo Schreier, por Alberto Durero." *Goya* 173 (March 1983): pp. 294–295.

 Study of a medal with the portrait of the Nuremberg humanist Sebald Schreyer (Madrid, Museo Lázaro Galdiano), designed by Albrecht Dürer in 1512.

51. Barrio Moya, José Luis. "Sobre un Retrato de Erasmo, por Durero, en Espana." *Archivo Espanol de Arte* 51, no. 1 (January-March) (1978): 99-100.

 Publishes a passage from the inventory of Charles II (1701–1703), mentioning a portrait of Erasmus by Dürer in the Alcázar of Madrid, probably lost when the Alcázar burned in 1734.

52. Bartsch, Adam. *Le peintre-graveur*, Vienna: J.V. Degen, 1808.

 Catalogue raisonné prepared in the early nineteenth century by the curator of the Imperial print collection, Vienna, who had access not only to the prints in the Hofbibliothek but also to major collections in France and Holland, and elsewhere in Germany (using the work of Carl Heinrich von Heinecken for the Saxon court in Dresden as an archetype). Prints are arranged first by artist, and then according to an iconographic scheme beginning with Biblical themes in chronological order (i.e., *Adam and Eve*); then the lives of Christ, the Virgin, and saints, and ending with secular subjects (alphabetized) and pure ornament. The text is in French (although Bartsch was Austrian), in order to make it more useful for an international readership. Premetric measurements (in *pouces* and *lignes*). *States described. Includes sixty-two doubtful and thirty-two rejected prints. (See also modern English edition edited by Walter L. Strauss,* The Illustrated Bartsch, *Commentary volume 10.)*

53. *Basel, Kunstmuseum. Lucas Cranach: Gemälde, Zeichnungen, Druckgraphik*, passim. Dieter Koepplin, and Tilman Falk. 2 vols. Stuttgart and Basel: Birkhäuser Verlag, 1974.

 Also contains articles by Kristin Buhler-Oppenheim, Helmut Borsch-Supan and Werner Schade. The catalogue of the large (660 works) Cranach five hundredth anniversary exhibition held in Basel June 15-September 8, 1974, featuring works by the entire Cranach workshop and comparative items by Dürer and others.

[Vol. 1 appeared in 1974; Vol. 2 not until 1976]. A magisterial, copiously documented work, indispensable for the study of Cranach's variations on ideas by Dürer, from classical mythology and allegory to portrait work and biblical illustrations. The attitude of both toward the Reformation is clearly delineated. Also contains an excursus on the handwriting of Cranach compared to that of Dürer (2: pp. 725–734). Selected bibliography, concordance, detailed index in vol. 2. [Reviewed by Gisela Goldberg in *Pantheon* 32 (Oct. 1974), 430–432; John Rowlands in *Burlington Magazine* 116 (Aug. 1974), 491–495; Peter Strieder in *Kunstchronik* 28, no. 5 (May 1975), 165–171].

54. Bashir-Hecht, Herma. *Der Mensch als Pilger. Albrecht Dürer und die Esoterik der Akademien seiner Zeit*, Stuttgart: Urachhaus, [1985].

Deals primarily with Dürer's woodcut *Gerson as Pilgrim* (1494), used as the title page for Wimpfeling's edition (Strassburg, 1502) of the works of Jean Gerson (1363–1429), the former Chancellor of the University of Paris. Explicates the astrological and astronomical symbols on Gerson's coat-of-arms and gives biographical material on Gerson. There also are chapters on esoteric Christianity; the Florentine, Roman, and Venetian academies; Conrad Celtis's sodalities in Germany; Dürer's esoterica (e.g., the *Philosophy* woodcut of 1502); his understanding of the temperaments; astrology; alchemy; and discussion of the *Meisterstiche* in light of these last. Sees the *Melencolia I* in terms of Agrippa von Nettesheim and Marsilio Ficino.

55. ———. "Gerson als Pilger." *Festschrift für Lottlisa Behling zum 75. Geburtstag*, 159-171. Munich: 1984.

The Festschrift for Behling, a very distinguished supervisor of dissertations, is a very rare item that appears to have been privately printed from camera-ready copy. (An example of it is to be found in the Zentralinstitut für Kunstgeschichte, Munich.) Bashir-Hecht notes that Dürer's woodcut of Jean Gerson as a pilgrim (used as title page for Wimpfeling's 1502 edition of Gerson's writings) is dated 1494. Depicting the Chancellor accompanied by a poodle, it is similar to *Jean Charlier de Gerson as Pilgrim*, printed by Georg Stucks, a Nuremberg woodcut that Dürer probably knew.

56. Baumeister, Annette. "Ein illuminiertes Missale des 16. Jahrhunderts im Landesmuseum zu Münster." *Zeitschrift für Kunstgeschichte* 42, no. 2–3 (1979): 92–116.

 Discusses the miniatures of the life of Christ in MS. 522, dated 1560 in the Landesmuseum, Münster. The author finds iconographical similarities with the Liège Gospels (St. Jean l'Evangeliste, Liège), and suggests that the models for both illuminated manuscripts were dependent on prints by Dürer and Hieronymus Cock.

57. Bazarov, Konstantin. *Landscape Painting*, London: Octopus Books, 1981.

 Traces the development of landscape painting from Dürer, Leonardo, Altdorfer, Patinir, attributing its late emergence in Europe (as opposed to Asia) to the attitudes of Christianity as opposed to those of Taoism. Relates European landscape painting to the new interest in nature that also produced the scientific revolution of the seventeenth century.

58. Bänsch, Dieter. "Zum Dürerkult der literarischen Romantik." *Marburger Jahrbuch für Kunstwissenschaft* 19 (1974): 259-274.

 A particularly important article disclosing the circumstances of the supposed "rediscovery" of Albrecht Dürer by Wilhelm Heinrich Wackenroder (1773–1798) and his friend Ludwig Tieck (1773–1853), who were primarily reponsible for the formation of the Romantic image of Dürer as a saintly and humble medieval craftsman—the image adopted shortly afterward by the Nazarenes. Shows the connection between this image and the economic situation in Nuremberg in the late eighteenth century: It was the best-preserved medieval German city, for the excellent reason that there had been virtually no money available for new construction since the end of the Thirty–Years' War.

59. Beck, Herbert, and Bernhard Decker. *Dürers Verwandlung in der Skulptur zwischen Renaissance und Barock*, Frankfurt am Main: Liebighaus Museum alter Plastik, 1981.

 An international loan exhibition of the greatest importance, devoted to the "Dürer-Renaissance" in sculpture, with loans from the Netherlands, Belgium, England, Switzerland, Austria, France, Sweden, Liechtenstein, and the United States, as well as from thirty-two German museums. In addition to the scholarly entries

on the 202 objects exhibited, there are essays by Decker on the problem of the forgeries, as opposed to the products of the Dürer-Renaissance. Artists exhibited include Hans Daucher, Georg Schweigger, Hans Schwarz, Adriaen de Vries, Master HL, and Antonio Abbondio. Many accomplished but anonymous works.

60. Begheyn, A. "Joachim bij Albrecht Dürer." *Antiek* 13, no. 7 (1979): 490–494. [Has English summary.]

Discusses Dürer's characterization of Joachim, the husband of St. Anne, in the first three scenes of his *Life of the Virgin* woodcut series [*Joachim's Offering,* the *Angel Appearing to Joachim,* and the *Meeting at the Golden Gate* , M.189-191], all of which are events related in the *Protoevangelium of James.* In depicting the meeting of Joachim and St. Anne at the Golden Gate, after being informed individually by Gabriel that Anne, heretofore barren, would bear a child, Dürer had tradition to guide him, because this had been the most popular of the three subjects in medieval art, where it was interpreted as a symbol of the Immaculate Conception of Mary—a doctrine dating from the twelfth century and associated with the cult of the Virgin. Dürer's understanding of the Immaculist nature of the subject is borne out by the bricked-up gateway and Joachim's closed purse, both symbolic of virginity. The author speculates that the unusually dominant position of Joachim in this work was due to the artist's wish not to have St. Anne's importance overshadow that of the Virgin Mary in the series—a not entirely convincing argument.

61. Behling, Lottlisa. "Eine "ampel"-artige Planze von Albrecht Dürer: *Curcurbita lagenaria L.* auf dem Hieronymus-Stich von 1514." *Pantheon* 30, no. 5 (1970): 396–400.

Identifies the gourd hanging in the top foreground of Dürer's *St. Jerome in His Study* and suggests symbolic meaning. (See also Parshall 1971.)

62. ———. "Zur Ikonographie einiger Pflanzendarstellungen von Dürer." *Jahrbuch der Kunsthistorischen Sammlungen in Wien* 82/83 (n.s. vol. XLVI/XLVII) (1986): pp. 43–56.

The author's paper for the 1985 Albertina symposium accompanying the international exhibition of nature studies by Dürer and his followers. Addresses the possible traditional symbolism of the

plants in the *Great Piece of Turf*: for example, dandelions also are found in Meister Francke's altarpieces and elsewhere as symbols of the Resurrection. Also deals with Dürer's use of flowers such as iris, columbine, lilies of the valley, and Maybells that have more familiar Christian symbolism. [Behling is the author of a standard reference work on the symbolism of plants in late medieval art, *Die Pflanzen der Mittelalterlichen Tafelmalerei*, Weimar, 1957.]

63. Benecke, Gerhard. *Maximilian I (1459-1519). An Analytical Biography*, London: 1982.

An excellent modern biography of Dürer's Imperial patron. But see also the definitive five–volume *Kaiser Maximilian I* by H. Wiesflecker (Munich, 1971–1986).

64. Benesch, Otto. *German Painting from Dürer to Holbein*, Geneva: Editions d'Albert Skira, 1966, passim.

A beautifully illustrated book (selected paintings only) for the general reader, by the former director of the Albertina Museum, Vienna. Organized into chapters on such topics as *Chiliasm 1490–1500*, *The Search for Form and the New Microcosm*, *The Age of the Great Altarpieces*, *The Spell of Nature*, *Doctrine*, *The Formation of the Character Portrait*, and *Cosmic Perspectives*. Select bibliography.

65. Benzing, Josef. "Humanismus in Nürnberg 1500–1540." *Albrecht Dürers Umwelt. Festschrift zum 500. Geburtstag*, 255–296. Eds. Gerhard Hirschmann and Fritz Schnelbögl. Nürnberger Forschungen, 15. Nürnberg: Verein für Geschichte der Stadt Nürnberg,

An annotated bibliography of some 341 items published in Nuremberg during the years in question. Essential.

66. Berbig, H. J. "Sammelbericht über die Literatur zum Dürer-Jahr 1971." *Archiv für Kulturgeschichte* 55 (1973): 35–55.

Review of the publications of 1971, produced in honor of the five hundredth anniversary of the artist's birth.

67. Berlin, Staatliche Museen Preussischer Kulturbesitz. *Das Berliner Kupferstichkabinett. Ein Handbuch zur Sammlung*, compiled by Alexander Dückers. Berlin: Staatliche Museen, [1994].

An essential work. Reflects the state of affairs in newly reunified Berlin, and in new quarters at the Kulturforum in the Tiergarten

area of the city. The collection now numbers approximately eighty thousand 80,000 works on paper, dating from the fourteenth century to the present, as well as manuscripts and incunabula. Berlin owns woodblocks as well as a large collection of prints and drawings by Dürer. The quality of the Berlin prints is unequalled anywhere in the world. This catalogue contains an introductory essay by Dückers (Anzelewsky's successor as Director from 1984), as well as a generous and detailed history of the collection prepared by Eugene Blum, Dückers, Renate Kroll, the late Hans Mielke, and Gottfried Reemann (pp. 17–42). Beginning in 1642 with the collections of the Brandenburg Elector Friedrich Wilhelm, it later incorporated the important collection of the Prussian Postmaster General, Karl Ferdinand Friedrich von Nagler (1830) with important Dürer drawings of high quality. Thirty-five more Dürer drawings were added in 1877 from the Posonyi-Hulot collection (Paris), while the drawing of the artist's *Mother at Age 63* was acquired from the Paris auction house of Firmin-Didot. Six more Dürer drawings came in 1890 (Mitchell and Klinkosch collections). Friedrich Winkler, who became Director in 1933 and was the author of the standard catalogue of the artist's drawings (four vols., q.v.), acquired still more in 1935 and 1938. The catalogue also relates the measures taken to secure the collection during World War II—part of it in the Zoo flak tower ("liberated" and taken to the Soviet Union in May 1945) and part in the salt mine at Grasleben (returned to Berlin by way of Wiesbaden by British and American troops). The separate histories of the collections in East and West Berlin are told. This is not a complete catalogue of the entire collection, but an overview of major holdings. The featured Dürers (Section III nos. 27–39) include the *Wire-Drawing Mill*; the *Holy Family* (ca. 1493); the *Valley at Kalkreuth*; two proportion studies; the chiaroscuro *Portrait of an Architect*; *Portrait of the Artist's Mother*; two silverpoint drawings of lions; the *Rest on the Flight to Egypt* (W.513); the woodblock for the *Arms of the Reich and the City of Nuremberg*; and several of the prints. Entries for all but the woodblock are by Hans Mielke, who until his death was curator of German prints and drawings before 1800.

68. Berlin (DDR), Akademie der Wissenschaft der Deutschen Demokratischen Republik, Zentralinstitut für Literaturgeschichte. *Deutsche Kunst und Literatur in der frühbürgerliche Revolution:*

Aspekte, Probleme, Positionen, Sibylle Badstubner et al. Berlin: Henschelverlag, 1975.

[German Art and Literature in the Early Bourgeois Revolution: Aspects, Problems, Positions. N.B.: The *frühbürgerliche Revolution* was the term used in the former East Germany to describe the complex of activities associated with the Reformation, including what is known elsewhere as the Peasants' War.] This volume of studies, written by an "authors' collective" (also an East German custom), treats Dürer, as well as Cranach, Grünewald, and the unfortunate Jörg Ratgeb, in respect to these events and in the company of Ulrich von Hutten, Martin Luther, Sebastian Lotzer, and Thomas Münzer.

69. Berlin (DDR), Staatliche Museen zu Berlin. *Kunst der Reformationszeit,* Berlin (DDR): Henschelverlag Kunst und Gesellschaft, 1983, passim.

Catalogue of the exhibition held in the Altes Museum, East Berlin, August 26–November 13, 1983, honoring the five hundredth anniversary of Martin Luther's birth, and distributed in the West through the Elephanten Press, West Berlin. Contributions by thirty-four authors, the majority from East Germany but also including several essays and museum loans from Russia, Czechoslovakia, Denmark, and Hungary; and loans of objects from Sweden, Spain, Austria, and the Netherlands. Introductory remarks by Hans-Joachim Hoffmann (DDR Minister of Culture) and Günter Schade (General Director of East Berlin's museums). Includes an essay by Sigrid Loos on the historical context ("Zeit des Aufbruchs und der Revolution," with obligatory emphasis on class struggle); Ernst Ullmann on the art of the Reformation period ("Kunst der Reformationszeit," pp. 17–23, and "Des Schwertes und des Zornes Zeit," pp.25–26). Works by Dürer exhibited included the *Large Passion,* the *Prodigal Son,* the engravings of peasants (B.86, 89, 90, 91); the *Knight, Death, and Devil*; the woodcuts of *Samson and the Lion* (B.2) and *Martyrdom of the 10,000 Christians* (B.117), *Crucifixion with Three Angels* (B.58I); the *Man of Sorrows* from the *Engraved Passion* (B.3); the Albertina's drawing of the *Adoration of the Magi* (Inv. 4837 D 158); the half-length miniature of the *Holy Family* (Leipzig); the *Large* (B.103) and *Small* (B.102) *Cardinals* (portrait engravings of Albrecht von Brandenburg) and the Vienna life drawing of the Cardinal made in Augsburg in 1518; the

Triumphal Arch; Rotterdam's bust-length charcoal drawing of a middle-aged *Unknown Woman* (1505); the nude *Self Portrait* from Weimar; the *Apollo and Diana* and *Adam and Eve* engravings; *Melencolia I*; *St. Jerome in his Study*; the *Penitent St. Jerome* (B.6); the drypoint *St. Jerome* (B.59); the *Penitence of St. John Chrysostom*; the portrait engravings of *Frederick the Wise, Willibald Pirckheimer*, and *Philipp Melanchthon*; and several unsigned watercolor studies of plants. The majority of the exhibition, however, was devoted to the Cranach workshop and to the younger followers of Dürer who took up the Protestant cause. Has a full bibliography but no index.

70. Berlin, Staatliche Museen Preussischer Kulturbeitz. *Bilder im Blickpunkt: Jacob van Utrecht: der Altar von 1513*, Rainald Groshans: 1982.

 The author assembles documentation concerning the activity of the painter Jacob van Utrecht (Jacobus Trajectensis Claessens) in Antwerp, Cologne, and Lübeck, using dendrochronological and infrared data to date a sixteenth-century triptych by his hand to the year 1513, and identifies influence from Dürer, as well as from Bernt Notke and Flemish artists.

71. Berlin, Technische Universität. *Ausstellungsdidaktik in Dürer-Jahr 1971*, Berlin: 1972.

 A 52-page monograph by an East Berlin student group analyzing techniques, sponsors and ideological aims of six of the exhibitions held in Nuremberg and Berlin in Dürer Year 1971.

72. *Martin Schongauer und sein Kreis: Druckgraphik, Handzeichnungen*, Ed. Marianne Bernhard. Munich: Südwest, 1980.

 Primarily illustrations, but briefly discusses Dürer, as well as Jörg Schweiger, Master ES, and Israhel van Meckenem.

73. Betz, Gerhard. "Wolgemut." In *Kindlers Lexikon der Malerei*, Munich: 1976.

 A convenient reference on the master to whom Dürer was apprenticed.

74. Béla, H. "Dürer *Meerwunder*—jenek tárgya és irondalmi forrása." *Müveszttörténeti Ertesitö* 20 (1971): 292–296.

Suggests that the iconographic source for *The Sea Monster (Meer-wunder)* may have been Ovid's *Fasti*, wherein Anna Perenna, the sister of Dido, escapes the attentions of Aeneas by fleeing with a horned water-god.

75. Bialostocki, Jan. "Dürer." *Encyclopedia of World Art*, cols. 512–531. Ed.-in-Chief Massimo Pallottino. New York/Toronto/London: McGraw Hill, 1958.

A detailed presentation of the facts of the artist's life, and a discussion of his major works, by the major East European Dürer expert of his generation (1921–1989). Agrees with Panofsky's interpretation of the *Melencolia I* as a *Melancholia artificialis*, or "artist's melancholy," with resonance in Dürer's own experience. Presents a good capsule statement on the artist's position vis-à-vis the onset of the Reformation. An excellent working bibliography extending to 1959, which includes a section on individual works and groups of works. Highly recommended.

76. ———. *Dürer and His Critics 1500–1971. Chapters in the History of Ideas Including a Collection of Texts*, Saecula Spiritalia, Dieter Wuttke, 7. Baden-Baden: Valentin Koerner, 1986.

An essential work for the study of Dürer reception, by the most highly respected and prolific of Poland's art historians who before his early death was Director of the Institute for the History of Art at the University of Warsaw, curator of the Gallery of European Painting in the National Museum in Warsaw, and a member of many academic and scientific societies throughout Europe and the United States. The book was written largely during two of his many visits to the Institute for Advanced Study at Princeton. Includes extensive quotations from German, French, Italian, and Latin texts (these last in translations made by William S. Heckscher). Topics include Dürer's image as a new Apelles; Dürer and Raphael as twin cultural idols; the progress of connoisseurship; the *Melencolia I* and the *Knight, Death, and Devil* in the Romantic vision; "Dürer in the agony of German ideologies;" criticism from Ruskin to Fry; Dürer and the Reformation—the *Apocalypse* series and *Four Apostles* (or Holy Men); Italy and the Antique; progress and stasis in scholarship. Originals of the translated poetical texts are included in the Addenda.

77. ———. "The Eye and the Window. Realism and Symbolism of Light Reflection in the Art of Albrecht Dürer and His Predecessors." *The Message of Images. Studies in the History of Art*, 77–92. Jan Bialostocki. Bibliotheca Artibus et Historiae, Józef Grabski, Vienna: IRSA, 1988.

Using the 1500 *Self Portrait*, the portraits of *Albrecht Dürer the Elder* (1490), *Conrad Verkell* (drawing, 1508), *Michael Wolgemut* (1519), the Infant Jesus from the *Virgin and Child with the Pink* and *Portrait of a Clergyman* (both 1516), *Willibald Pirckheimer* (1524), and the *Four Holy Men* (1526), the author discusses Dürer's method of indicating luster—the highlighting of the convex surface of the human eye by using reflections of windows of various shapes. This was a technique never used before, and one that immmediately became popular in the painting of his German contemporaries, and also in that of some painters in the Netherlands—where the motif had only been used previously to highlight such objects as Christ's morse (the Master of Flemalle, Philadelphia) or the crystal orb of the *Salvator Mundi*. Intrigued by Carla Gottlieb's observation ("The Mystical Window in Paintings of the Salvator Mundi," *Gazette des Beaux-Arts* 1960, 313–332) that window reflections must have been intended to operate as references to Salvation, Bialostocki notes that Dürer's consistent use of the device in secular portraiture casts doubt on an exclusively "mystical" meaning for the motif, pointing out that Dürer's reflected window came from the observation of nature, but that, as he used them in both indoor and outdoor settings, they probably retained a symbolic significance as a reference to light, or *claritas* itself—which, of course, had its own religious symbolism. He concludes that the artist may have meant to refer to the classical *topos* (Cicero, Lucretius, et al. that the eyes are windows of the soul.

78. ———. "Myth and Allegory in Dürer's Etchings and Engravings." *The Message of Images: Studies in the History of Art*, 132–138. Jan Bialostocki. Bibliotheca Artibus et Historiae, Józef Grabski, Vienna: IRSA, 1988.

An earlier version of this article from the Bialostocki omnibus previously appeared in the special issue of *Print Review* (1976), titled *Tribute to Wolfgang Stechow* (24–34), and is here dedicated to

Stechow's memory. The author both calls attention to the vast intellectual difference between Dürer's usage of classical myth and allegory and the late medieval secular allegories that previous Northern graphic artists had depicted, and points out that his own mythological and allegorical themes were both extremely abstruse and remarkably short-lived, being confined to the years between 1495 and 1505. Surprisingly, there are none after the second journey to Italy, although his interest in Humanistic themes (e.g., *Melencolia I*) remained undiminished. His conclusion was that the artist's basic interest in classical mythology accompanied his search for classical *pathos formulae*, and that when he felt that he had assimilated these sufficiently he returned to religious subject matter and to allegories under the guise of realism, such as *The Landscape with Cannon* or the *Knight, Death, and Devil.*

79. ———. "Vernunft und Ingenium." *Zeitschrift für Kunstgeschichte* (1971): 107–114.

[Reason and Inspiration]. An excellent discussion of Dürer's relativist concept of beauty, noting that in approximately 1512 his relativism turned to skepticism. Demonstrates that Dürer penetrated realms of thought unexplored by contemporary Italian theorists in undertaking an analysis of beauty, as well as in questioning the very possibility of knowing what beauty is. Dürer came to the conclusion that there are a number of different kinds of Beauty, but that none of them is attainable without Harmony. He made the important and sophisticated distinction between beauty of a work of art, and the aesthetic value of the figures depicted there, and was the first to recognize and describe artistic genius. He also acknowledged, however, that genius cannot be expressed without technical skill and theoretical knowledge. The author sees Dürer, convincingly, as the intellectual ancestor of the Enlightenment in Germany, and of Lessing in particular.

80. Biddle, Martin, Ed. *Albrecht Dürer. Etliche Underricht zu befestigung der Stett, Schlosz,vnd flecken*, Nuremberg, Weigel, 1527 ed. Richmond, Surrey (UK): Gregg, 1972.

A modern edition of Dürer's treatise on fortification.

81. Birke, Veronika, and Friedrich Pels, Eds. *Die Sammlung Ian Woodner*, Vienna: Albertina, 1986.

The catalogue of the Albertina's exhibition of the master drawings collected by Ian Woodner, a prominent real estate developer in New York and Washington. (A selection of 143 drawings from the collection, including Dürer's earliest known drawing for the Renaissance proportions of the male nude—not exhibited here—were donated to the National Gallery in 1991, after their owner's unexpected death in November 1990. Another 118 drawings, including further Dürers, were placed on deposit at the National Gallery with the expressed consent of the Woodner heirs to donate them over future years.) The collection also contains a miniature with Willibald Pirckheimer's coat-of-arms and that of his wife, an illuminated page from the Aldus Manutius edition of the *Idyllia* of Theocritus (cat. 48); a chiaroscuro drawing of the head of a young boy, on blue-gray prepared paper, attributed to the workshop by Wölfflin, the Tietzes, and Panofsky, but accepted by Winkler and Strauss as an autograph work; and a watercolor of the *Left Wing of a Blue Roller*, declared by Thausing (1884) and by Koreny (1985: No. 25) to be the work of Hans Hoffmann, while Oberhuber (1983) saw it as a work of Dürer's from the 1520s.

82. Bjurström, Per. *Dürer to Delacroix: Great Master Drawings from Stockholm*, Fort Worth, TX: Kimbell Art Museum,

 Catalogue of a loan exhibition of drawings from the Nationalmuseum, Stockholm, shown in Washington (National Gallery, October 27, 1985–January 5, 1986) and Fort Worth (Kimbell Art Museum, February 1-April 13, 1986). Included is Dürer's black chalk *Portrait of a Girl* [*sic*], dated 1515, considered to represent either a relative of the artist or, following Reuterswärd (1971, q.v.), possibly Felicitas Pirckheimer, the daughter of his good friend. It is related, in any event to a drawing of a similar young woman (W.561), thought to be a sister of the sitter.

83. Boberg, Jochen. "Der deutsche Dürer im bürgerlichen und faschistischen Geschichtsbild." *tendenzen* 12, (June/July) (1971): 128–131.

 Article in a left-leaning West German periodical published in Munich during the summer of Dürer Year 1971, discussing Dürer's role as "Führer der deutschen Maler" during the Third Reich, beginning with the *Dürerbund* of 1904, and somewhat later with what might be called the ethnic cleansing of his father's Hungarian

origins by Pinder and W. Waetzoldt and the dechristianizing of the
Knight, Death, and Devil. Includes quotations in praise of the artist
by such well-known racists as Paul Schultze-Naumburg, Hans F.
K. Günther, Theodor Hetzer, Karl Grosshans, and Irma Fiebig.

84. Boehm, Gottfried. "Die opaken Tiefen des Innern: Anmerkungen
 zur Interpretation der frühen Selbstporträts." *Studien zu Renaissance
 und Barock: Manfred Wundram zum 60. Geburtstag; eine
 Festschrift*, 21–33. Eds. Michael Hesse and Max Imdahl. Bochumer
 Schriften zur Kunstgeschichte, Frankfurt/Bern/New York: Lang,
 1986.

 Examines the painted self-portrait as it represents a visible form of
 the relationship to the self, using examples by Dürer, Giorgione,
 and Parmigianino.

85. Boesten-Stengel, Albert. "Albrecht Dürers *Zwölfjähriger Jesus
 unter den Schriftgelehrten* der Sammlung Thyssen-Bornemisza.
 Bilderfindung und *prestezza.*" *Idea. Jahrbuch der Hamburger Kun-
 sthalle* 9 (1990): pp. 43–66.

 An addition to the literature on the *Christ Among the Doctors*
 (Thyssen collection (A.98) since 1935; formerly Palazzo Bar-
 berini, Rome), which appeared too late for inclusion in
 Anzelewsky's revised catalogue of the paintings (1991, g.v.). Re-
 views the literature placing the painting in the context of previous
 half-length compositions by Mantegna and Bosch, and of carica-
 tures by Leonardo da Vinci. Identifies the inscription on the hat of
 the Jewish doctor at left as a reference to Matthew 23:5 ("But all
 their works they do for to be seen of men; they make broad their
 phylacteries, and enlarge the borders of their garments . . ."). Phy-
 lacteries (*tephillin*) are four excerpts from the Torah, to be bound
 on the forehead on certain ceremonial days, "between the eyes," as
 specified in Deuteronomy 6:8. These came to be regarded by
 Christians as a sign of Jewish intransigence and insistence upon
 the letter of the law, and appear in Hartmann Schedel's *Weltchronik*
 as referring specifically to Pharisees. [On this painting. See also
 Margaret Carroll (1995).]

86. Bologna. Palazzo Pepoli Campogrande. *I grandi maestri dell'inci-
 sione: Dürer, Rembrandt, Castiglione Genovese*, Ed. Marzia Fai-
 etti. Bologna: Alfa, 1983.

Prints from the Gabinetto delle Stampe, Pinacotheca Nazionale, Bologna, by "the great masters of print: Dürer, Rembrandt and Castiglione of Genoa." Catalogue entries and reproductions of selected prints [RILA 1231].

87. Bongard, Willi, and Matthias Mende. *Dürer heute*, Munich: Prestel, 1971.

 See Mende, "Dürer—der zweite Apelles" (p. 23ff.).

88. Bonicatti, Maurizio. "Dürer nella storia delle idee umanistiche fra Quattrocento e Cinquecento." *The Journal of Medieval and Renaissance Studies* 1 (1971): pp. 131ff.

 As in his other article on this same topic (in *Kunst im Aufbruch*, Ernst Ullmann, ed., Leipzig 1971, q.v.), this gives a somewhat unfocused picture of Venetian humanism and Dürer's relationship to it. It also contains serious errors of fact regarding Dürer's development (he dates the *Apocalypse* series, for example, to 1511 (presumably on the basis of the new title page made for it in that year), and expresses surprise at Mantegna's influence in "so late" a work. He also mistranslates the inscription on Dürer's woodcut with the *Owl between Four Birds* (Panofsky 404). Accuses the artist of "moral ambiguity." (See the review by W. Stechow, *The Art Bulletin* 56 (1974, no.2, pp. 268–269.)

89. Bonicatti, Mauricio. "Dürers Verhältnis zum Venezianischen Humanismus." *Albrecht Dürer. Kunst im Aufbruch*, Ed. Ernst Ullmann. Leipzig: 1972.

 Bonicatti's contribution on Dürer's relationship to Venetian Humanism, given as a conference paper at the University of Leipzig symposium—one of two held in East Germany to honor the artist's five hundredth birth year.

90. Bonnet, Anne-Marie. "Der Akt bei Albrecht Dürer." 1991.

 The author's *Habilitationsschrift* on Dürer's nudes.

91. Bonsanti, Giorgio. "Gli Artisti Stranieri nelle *Vite* del Vasari." *Vasari Storiografo e Artista. Atti del Congresso Internazionale nel IV Centenario della Morte, Arezzo-Firenze, 2–8 Settembre 1974*, 717–734. Florence: Istituto Nazionale di Studi sul Renascimento, 1976.

[The Foreign Artists in Vasari's *Lives*.] Paper delivered at the international Vasari congress marking the four hundredth anniversary of the artist/art historian's death, held at the Sala Maggiore of the Accademia Petrarca in Arezzo and at the Palazzo Vecchio in Florence (September 2–4, 1974). Examines a subject rarely studied before, noting how considerations arising from this study fit into our knowledge of Vasari as an art historian and as a source. Focuses on isolating Vasari's own sources. Artists dealt with include Dürer, Jan van der Straet (Stradano), Marten van Heemskerck, Bosch, and Bruegel [Author-RILA].

92. Bora, Giulio. "La prospettiva della figura umana—gli "scurti"—nela teoria e nella practica pittorica lombarda del Cinquecento." *Prospettiva rinascimentale: codificazioni e trasgressioni*, 295–317. Compiled by Marisa Dalai Emiliani. Florence: Centro di Firenze, 1980.

This paper on the perspective of the human figure in northern Italian art, presented at the Convegno Internazionale di Studi sulla Prospettiva held at the Castello Sforzesco in Milan in 1977, focuses on the method used by Mantegna and other Lombard artists, codified in a series of lost treatises (Bramantino, et al.), comparing it to analogous solutions adopted by Northern European authors of treatises, including Dürer.

93. Borries, Johann Eckart von. *Albrecht Dürer. Christus als Schmerzensmann*, Karlsruhe: Staatliche Kunsthalle, 1972.

This is a forty-one page pamphlet, but an important scholarly study of the Karlsruhe *Man of Sorrows*, now accepted by most scholars as an early Dürer. It contains full bibliographic apparatus, two quite good color plates—one a detail of Christ's face in actual size, emphasizing the very small scale of the painting and relating it to the traditions of Man of Sorrows and Job in Distress imagery in Germany. Von Borries, an emeritus curator of the museum, calls attention to the thistle motif in the punchwork on the gold background, relating it both to the Crown of Thorns and to Genesis 3:18 ("Thorns also and thistles shall it [i.e., the earth] bring forth to thee . . . ," part of God's curse after the fall of Adam). This new type of Man of Sorrows imagery is traced to Alsace, where Dürer spent the last year of his bachelor's journey, and to the influence of the Colmar Domini-

cans. The Karlsruhe painting came from the collection of the painter Philip Röth (b. 1841, Darmstadt, d. 1921, Munich), and was purchased by the museum in 1941 from his descendants. A physical report on the panel is included.

94. ———. "Die Tier-und Pflanzenstudien Hans Baldung Griens." *Albrecht Dürer und die Tier-und Pflantzenstudien der Renaissance–Symposium. Die Beiträge der von der Graphischen Sammlung Albertina von 7. bis 10. Juni 1985 veranstalteten Tagung,* 70–78. Ed. Fritz Koreny. Vienna: Jahrbuch der Kunsthistorischen Sammlungen in Wien, 1986.

Centers on the Baldung sketchbook in the Karlsruhe Kunsthalle, with depictions of parrots, horses, a cow, wild strawberries, columbine.

95. Boselli, Camillo. "Asterischi Bresciani: Due Ritratti Tizianeschi, un Monochromo del Mantegna, ed una Madonna del Dürer." *Arte Veneta* 33 (1979): 159-160.

[Brescian Notes: Two Titianesque Portraits, a Monochrome by Mantegna and a Madonna by Dürer.] Speculates that one of the works of art listed in the will of Conte Alfonso Martinengo Villagana (October 25, 1575) may be a Madonna by Dürer.

96. Böhme, Hartmut. *Albrecht Dürer. Melencolia I. Im Labyrinth der Deutung,* kunststück, Frankfurt am Main: Fischer Taschenbuch Verlag, 1989.

The author of this excellent contribution to the *kunststück* series of scholarly yet readable paperbacks on single art works is Professor of Literature at the University of Hamburg. Adapting his own earlier article for the *Festschrift für Karl Robert Mandelkow* (1988), he gives an excellent survey of the previous interpretations of Dürer's most enigmatic print, coming to the conclusion that its uniqueness resides in the artist's having loosened the relationship between sign and philosophical/theological meaning. He sees it as a meditation on the limits of knowledge—a gathering of references to all the crafts and technical skills and sciences of Dürer's time within "a landscape of thought," open to both light and shadow, truth and error, and very different indeed from the certitude of the Knight and the St. Jerome. This is essential reading, not least be-

cause it points to serious errors in Panofsky's interpretation of Marsilio Ficino that formed the basis for his (EP's) explanation of the engraving's meaning.

97. ———. "Zur literarischen Wirkungsgeschichte von Albrecht Dürers Kupferstich Melencolia I." *Zur Theorie, Geschichte und Wirkung der Literatur. Festschrift Karl Robert Mandelkow zum 60. Geburtstag*, 84–123. Eds. J. Schönert and H. Segeberg. Frankfurt am Main/Bern/New York: 1988.

See above commentary under Böhme's 1989 volume on "Melencolia I" for the *kunststück* series.

98. Böttger, Peter. *Die Alte Pinakothek in München. Architektur, Ausstattung und museales Programm*, Munich: Prestel, 1972.

Includes a brief but valuable "prehistory" of the Alte Pinakothek from the time of the Archduke Wilhelm V (reigned 1579-1597) to that of Ludwig I, the actual founder of the museum in the early nineteenth century. Of particular interest here are the set of sketches by Ludwig Schwanthaler for the artists' "portrait" statues to be placed on the balustrade, and the appended facsimile of the original collection catalogue compiled by Georg von Dillis, the museum's first Director, listing the contents of each gallery. Dürer's works were on view in Gallery I: the Paumgärtner altarpiece (its wings displayed separately); a *Bearing of the Cross* (now known to be by an imitator, Johann Georg Fischer); the *Portrait of Jakob Fugger* (now in Augsburg); the Glimm *Lamentation*. Gallery II had the *Suicide of Lucretia*. Displayed in "Cabinet" VII were the *Portrait of Oswolt Krel*; the wings of the Jabach altar; a copy of the 1497 *Portrait of Albrecht Dürer the Elder*; the *Portrait of Michael Wolgemut*; the *Portrait of a Young Man* dated 1500— tentatively identified as "Johannes Dürer" (the artist's younger brother—an identification no longer accepted); and the 1500 *Self Portrait*. In Cabinet VIII was a *Death of the Virgin* (no longer ascribed to Dürer—a copy after his woodcut from the *Marienleben*).

99. Brachert, Thomas. "Miszellen um eine Proportionsstudie Dürers." *Festschrift für Georg Scheja zum 70. Geburtstag*, Eds. Albrecht Leuteritz, et al. Sigmaringen: Thorbecke, 1975.

Concerns a sheet of proportion studies of a horse (Nuremberg, Stadtbibliothek).

100. ————. "Neues zu Dürers Madrider Selbstbildnis." *Restauro* 96, no. 3 (1990): 175f.

Since 1989 the Germanisches Nationalmuseum in Nuremberg has collaborated with the Bayerische Kriminalamt (Munich) in the study of Dürer's painting technique (see *Restauro* 1 (1981), pp. 22ff.: "Neues zu Dürers Kaiserbilder"), a process which has yielded clear impressions of the artist's fingerprints. Madrid police were informed of the technique and, under the direction of Francisco Diaz, Chief of the Criminal Technique Division, the artist's fingerprints also have been discovered in an earlier work, the Madrid *Self Portrait* of 1498. The fingerprints are especially visible in the glaze over areas of shadow, as in the dark part of the cloak over his shoulder. This is the earliest known example of Dürer's "finger painting," a technique that he may perhaps have learned from the Bellini workshop in Venice on his first trip to Italy. It also is found on the *Feast of the Rose Garlands* (Prague), painted in Venice in 1506.

101. Brachert, Thomas, and Adelheid Brachert. "Neues zu Dürers *Kaiserbildern.*" *Restauro* 95, no. 1 (1989): 22–39.

Reproduces (in color) two bust-length portraits of the Emperors Charlemagne and Sigismund, now in a private collection in Zürich, which were originally discovered by Max Friedländer in British collections. They correspond closely to Dürer's knee-length portraits of the two emperors (Nuremberg, Germanisches Nationalmuseum), which are unsigned and undated but securely documented on the basis of City Counci payments to Dürer (February 15, 1513). A succinct history of the Nuremberg relic collection and coronation regalia is given, including the elevation of the imperial regalia to the status of religious articles by Kaiser Karl IV in the fourteenth century. The authenticity of the Zürich paintings has been contested—they are dated, but the date is 1514. (Was the payment to Dürer in 1513 only an advance? Or are these copies?) The Bracherts present laboratory evidence, including the artist's fingerprints in areas of dark glazing, in support of an attribution to Dürer himself. An X-ray of the Charlemagne panel shows an original inscription referring to Kaiser Karl IV, not Charlemagne.

102. Brand, Erna. "Untersuchungen zu Albrecht Dürers Bildnis eines jungen Mannes." *Jahrbuch Staatliche Kunstsammlungen Dresden* 1970–1971 (1974): 59-83.

Identifies the portrait of a young man (Dresden), long known first as Bernard van Orley and more recently as Bernhard van Resten, as Bernhard van Reesen.

103. Brandl, Rainer. "Art or Craft?: Art and the Artist in Medieval Nuremberg." *Gothic and Renaissance Art in Nuremberg 1300–1500*, 51–60. New York: Metropolitan Museum of Art. Munich: Prestel, 1986.

 Discusses the organization of crafts in Nuremberg, where there were no guilds. Trades controlled by the City Council ("sworn crafts") reported to a ruling body (*Rugamt*) composed of delegates from the Lesser Council, which appointed the inspectors of the city's most important trades. Practitioners of the "free arts" (painters and sculptors) reported directly to the City Council. Also discussed are the normal organization of the artist's workshop (in Nuremberg, for example, a painter was permitted to make sculpture if he were so inclined, or a sculptor—like Veit Stoss—to paint. It was always a locksmith, however, who installed a finished altarpiece upon its altar). Nuremberg patronage is discussed in terms of types of objects commissioned and sample contracts. The role of artist as entrepreneur, and individual and collaborative projects are discussed, including the *Silver Altarpiece* made by Hans Dürer, Peter Flötner, Pankraz Lebenwolf, and Melchior Baier for King Sigismund of Poland's donation to the Cracow Cathedral.

104. Braunfels, Wolfgang. "Die reformatorische Bewegung im Spiegel von Dürers Spätwerk." *Albrecht Dürer, Kunst einer Zeitenwende*, 123–143. Ed. Herbert Schade. Regensburg: Pustet, 1971.

 One of the major papers from the symposium of the Bavarian Academy held in Nuremberg in Dürer Year 1971. Addresses the problem of the *Four Holy Men* (p. 134), and drawings for an unfinished Passion cycle (1521), among other works. Literary evidence is used as a basis for the development of Dürer's response to the Reformation.

105. Braunstein, Philippe. "La gravure avant Dürer: table ronde à l'Institut Goethe: exposé introductif." *Nouvelles de l'Estampe* 64–65 (July 1982): pp. 6–12.

 Report of papers given at the conference, "Engraving Before Dürer" (Paris, Goethe Institute, April 27, 1982) by Braunstein, on

commerce in the Germanic countries in the late fifteenth century; by Fritz Koreny of the Albertina on the origins of engraving on copper (reproductions, playing cards, pattern books); and by Fedja Anzelewsky of Berlin on prices and formats of prints in Dürer's time.

106. Bräutigam, Günther, and Matthias Mende. " 'Mähen mit Dürer.' Literatur und Ereignisse im Umkreis des Dürer-Jahres 1971." *Mitteilungen des Vereins für Geschichte der Stadt Nürnberg* 61 (1974): 204–282.

An extremely useful key to the exhibitions, scholarly papers, bibliographies, book reviews, *Festschriften*, colloquia, et al. of Dürer Year 1971: doubly important since all of these events had taken place after the publication of Mende's magisterial *Dürer-Bibliographie* in 1971. (See also Wolfgang Stechow's review of some of the same publications in *Art Bulletin, 1974*). The title ("Mowing with Dürer") comes from a cartoon by Jules Stauber (pen and collage, 1970), showing a farmer mowing a meadow with a matching team of three of Dürer's *Wild Hares*. The authors' intention here has been to cut a swath through the newest literature and special events. Of special interest are the reports on colloquia and exhibitions in central and eastern Europe (Vienna; Stift Gottweig; Dresden; Budapest; Prague; Rumania; Leningrad), as well as conferences and smaller exhibitions in the West (Basel, Nice, Florence, Arco, Bassano del Grappa, Copenhagen, Nantes, Bayonne, Caen, Nancy, Strasbourg, Amsterdam, Rotterdam, Manchester), and in Asia (Kyoto and Tokyo, 1972, where a loan exhibition from the DDR was displayed.) The authors object to Anzelewsky's calling his own catalogue (1st ed.) the "first to treat Dürer's paintings on a scientific basis." They further note Dresden's rejection of Anzelewsky's belief in the autograph quality of the Leipzig *Portrait of a Young Woman of the Fürleger Family.* (H. Marx, in *Dresdner Kunstblätter* 15 (1971) 3, 78–84; K.-H. Weber, ibid., (1971) 5, 140–144.) Dresden displayed the restored *Marienaltar,* now accepted as autograph, but the center of the "Dresden triptych" is still on the doubtful list. They express mixed feelings about the Rogner and Bernhard press edition of Dürer's drawings, noting that with Winkler's standard catalogue now unobtainable this is better than nothing, but that the text is not scholarly and the color reproduction of poor quality. The authors note (p. 239) that the great Dürer

monographs are very few, and have little to do with the anniversary
dates of the artists's birth or death (although some have been reis-
sued to coincide with those anniversaries).

107. Bremen. Kunsthalle. *Albrecht Dürer: Trintperg*, D. Rolf Speckmann,
 Günther Busch, and Jürgen Schultze. Bremen: Kunsthalle, 1979.

The catalogue of an exhibition (June 24-August 19, 1979) of
thirty-three works, organized around the museum's recent acquisi-
tion of Dürer's watercolor of the castle of Trento, inscribed "Trint-
perg," from the sale of the collection of Baron Robert von Hirsch.
The other items displayed, all from the Kunsthalle's own collec-
tion, include one painting, five watercolors, and twenty-seven of
Dürer's prints. The *Trintperg* is fully described, documented, and
discussed in the context of the artist's other landscape watercolors.
Of special interest is an essay on the group of watercolors and
drawings lost from the Kunsthalle during World War II, with illus-
trations of the most important ones. [For the fate of these works,
which were taken to Soviet Russia, see Akinsha and Koslov, *Beau-
tiful Loot.*]

108. ———. *Der nackte Mensch: Aspekte der Aktdarstellung in der
 Kunst*, Text by Gerhard Gerkens. Eine didaktische Ausstellung, 4.
 Bremen: Kunthalle,

[The naked human being : aspect of the representation of nudity in
art]. An exhibition of works in all media, beginning with Dürer and
including artists from the sixteenth to the twentieth centuries, all
from the Kunsthalle's own collections.

109. Bremen, Kunsthalle. *Zurück zur Natur, die Künstlerkolonie von
 Barbizon: ihre Vorgeschichte und ihre Auswirkung*, Günther
 Busch, et al. 1977.

The catalogue of a chronologically organized exhibition devoted to
the antecedents and the influence of the nineteenth-century artists'
colony in the Barbizon forest, featuring paintings, graphic art and
illustrated books by two hundred artists, beginning with the fif-
teenth century, and featuring Bremen's own landscape studies by
Dürer (minus the ones taken to Russia at the end of World War II,
of course). Dürer is rightly acknowledged as one of the major an-
cestors of landscape painting. In a section of the catalogue by G.
Busch amusingly titled *Vom Baum der Erkenntnis zur Erkenntnis*

von den Bäumen (From the Tree of Knowledge to the Knowledge of Trees), explores tree-painting from Dürer to Macke.

110. Brooklyn (NY), Brooklyn Museum. *Curator's Choice: Dürer to Dubuffet*, Jo Miller. 1975.

An exhibition (May 21-August 31, 1975) of sixty-nine prints and drawings from the permanent collection, acquired between 1969 and 1975 during the curatorship of the catalogue's author.

111. Brown, David Alan. "Correggio's *Mystic Marriage of St. Catherine* and its Sources." *Bulletin of the Detroit Institute of Arts* 60, no. 3–4 (Winter) (1982): 101–107.

Argues that the influence of Leonardo on Correggio's *Mystic Marriage of St. Catherine* (Detroit Institute of Arts) is not direct but transmitted through works of Mantegna and Dürer [Author: RILA].

112. ———. "A Print Source for Parmigianino at Fontanellato." Introduction by *Per A.E. Popham*, 43–53. Igino Consigli and Adrianna Consigli. Parma: Consigli Arte, 1981.

In this article for the Popham Festschrift, the author argues that Actaeon's hounds in Parmigianino's fresco cycle at Fontanellato are based on those in Dürer's *St. Eustace* engraving. He concludes that, because of the importance of the dogs in these frescoes, Parmigianino used Ovid's account of the story of Actaeon and Diana (*Metamorphoses*), where there is a similar emphasis [Author: RILA].

113. Brown, Margaret L. "The Subject Matter of Duerer's *Jabach Altar*." *Marsyas* 1 (1941): 55–68.

A graduate student paper originally written for Erwin Panofsky, which appeared in the first issue of New York University's graduate student publication. Dated but still useful for its succint review of the various interpretations of Job, from Early Christian times to the Renaissance, with reference to Gothic depictions (Rheims; Chartres; *Biblia Pauperum*). Notes Job's contradictory roles: as prophet of Resurrection ("I know that my Redeemer lives . . ."); as nonprophet (because comforted by the thought that he will die and his misery be forgotten); as Christian patience; as typological parallel to the Crowning with Thorns (*Biblia Pauperum*) or to the

Flagellation (*Speculum humanae salvationis.*) Also discusses mystery plays, which include Job/Satan episodes (Job is beaten by Satan; his wife argues with him).

114. Bruck, Robert. *Friedrich der Weise als Förderer der Kunst*, 153ff., 156ff., 160, 161. Strasbourg: Heitz, 1903.

An older, and patently Protestant, but still indispensable work for the study of Dürer's first patron, Frederick the Wise (1463–1525), later the protector of Martin Luther; for the altarpieces done for the Castle Church at Wittenberg (none of which is any longer in situ) and for documentation on the approximately seventy-five artists and craftsmen, in addition to Dürer, who were employed by the Elector. (These include Michael Wolgemut, as well as the early court painters Master Kunz and Master Ludwig of Leipzig, and of course Jacopo de'Barbari and Lucas Cranach the Elder.) Individual works by Hans Burgkmair (1506) and Master Jan (or Hans) from the Netherlands appear among the works in Frederick's inventories (reproduced here), as well as Dürer's *Hercules and the Stymphalian Birds*; the *Sorrows of the Virgin*; *Martyrdom of the 10,000*; *Adoration of the Magi*, and the engraved portrait of 1525. His earliest payments to Dürer date from 1494/1495 (prior to the sitting in 1496 for the Berlin portrait). Mention is made of meals for one week for "the painter Meister Albrecht and his wife" (Dürer and Agnes?) who were entertained in Wittenberg briefly from August 10–17, 1504.

115. Brussels. Palais des Beaux-Arts. *Albrecht Dürer aux Pays-Bas, son voyage 1520–21, son influence*, Text Fedja Anzelewsky, Matthias Mende, and Paul Eeckhout. Brussels: Palais des Beaux-Arts, 1977.

Catalogue of an exhibition featuring paintings, drawings, and sketchbook sheets created by Dürer during his year-long visit to the Netherlands in 1520–1521. Also includes examples of things mentioned in his diary of the trip, and works by local artists showing Dürer's influence [RILA 1236]. (Reviewed by André Jocou, *Connoisseur* 196/789 (November 1977) 238; Dirk Kocks, *Pantheon* 36 (January-March 1978) 62–64; Keith Roberts, *The Burlington Magazine* 119/896 (November 1977) 797.

116. Buchanan, Iain. "Dürer and Abraham Ortelius." *The Burlington Magazine* 124, no. December (1982): 734–741.

The Antwerp geographer and patron of the elder Bruegel, Abraham Ortelius owned an important art collection, including a number of woodcuts and engravings by Albrecht Dürer. Documentation is given from letters and archival sources on the Dürer revival in the later sixteenth-century Netherlands and Ortelius's role within it as an art dealer. His Dürer collection now survives in albums in the print rooms of the Rijksmuseum, Amsterdam and the Rothschild collection in the Louvre. Original inscriptions found in the albums are discussed, and the role of Ortelius's collection within the Kunstkammer tradition is considered, as well as its memorial aspect and importance as one of the first print collections devoted to a single artist's work.

117. Buck, August. "Enea Silvio Piccolomini und Nürnberg." *Albrecht Dürers Umwelt. Festschrift zum 500. Geburtstag*, 20–28. Eds. Gerhard Hirschmann and Fritz Schnelbögl. Nürnberger Forschungen, 15. Nürnberg: Verein für Geschichte der Stadt Nürnberg, 1871.

Recounts the 1432 visit of the future Pope Pius II, Enea Silvio Piccolomini, "the Apostle of Humanism," to the city in his capacity as secretary to the Bishop of Fermo, and later as papal legate in Frankfurt. Contrasts Piccolomini's enlightened view of Germany to the unflattering one held by Poggio Bracciolini, and discusses his selection by Kaiser Friedrich III to be the Imperial poet laureate; his works published in Nürnberg by Anton Koberger; his relation to Conrad Celtis, Johannes Cochlaeus, and Willibald Pirckheimer. Enea's treatise on education in the liberal arts, with heavy emphasis on classical literature is cited, as well as his pronouncement that too much time spent on arithmetic and geometry can be damaging, but that a humanistic education can "elevate those of humble birth to the level of nobility."

118. Budde, Hendrik. "Das "Kunstbuch" des Nürnberger Patrizier Willibald Imhoff und die Tier-und Pflanzenstudien Albrecht Dürers und Hans Hoffmanns." *Jahrbuch der Kunsthistorischen Sammlungen in Wien* 83/83 (1986): 213–241.

Willibald Imhoff, who probably had obtained part of his collection of Dürer's work from Ursula Dürer, the widow of the artist's goldsmith brother Endres, wished to move from Nuremberg to Bohemia after the failure of his business in the saffron trade. Consequently he accepted title to a large tract of land in Bohemia

including the mining town of Petschau from Rudolph II in exchange for his Dürers in 1588. Included in the deal, in addition to paintings and prints, was the "Kunstbuch," which held thirty-one drawings and watercolors, many of which are now in the Albertina. Documents indicate clearly that Imhoff had "shown" the album to his friend the painter Hans Hoffmann, author of a large number of copies and variations on the watercolors and one of the key figures in the so-called Dürer Renaissance. This is of particular interest, because it shows beyond a doubt that the Dürer Renaissance was already well underway before Rudolph II became involved. Willibald was an importer specializing in saffron. He had bought the Muffel house near St. Egidius's church in Nuremberg (formerly owned in Dürer's day by Anton Koberger, the artist's godfather). The house had a gallery of forty-seven paintings, and Dürer's *Glimm Lamentation* hung in the private chapel. (This was the house in which Dürer's letters to Pirckheimer from Venice were found in the eighteenth century, hidden behind paneling.) The author cites Augustus von Eye as the first scholar to make use of the Imhoff documents, which prove that Imhoff cannot have inherited his Dürers from his grandfather, Willibald Pirckheimer, as there is no mention of it in Imhoff's estate inventory. Imhoff's "Kunstpuch" (album of works on paper) is first mentioned in 1573—he says he acquired it from the estate of "Paulus Koler."

119. Burckhardt, Daniel. *Albrecht Dürers Aufenthalt in Basel 1492–1494*, Munich/Leipzig: G. Hirth, 1892.

 Of historic interest. Burckhardt (the Basel scholar whose careful archival research revealed the identity of Konrad Witz) was one of the most important early researchers to concern himself with Dürer's activity on his bachelor's journey. He reproduces the Paris self portrait (1493) when it was still owned by Eugen Felix in Leipzig; reviews the nineteenth-century scholarship on the first trip to Venice (Fiorillo; Rettberg; Hermann Grimm; Thausing); reproduces the back of the early *St. Jerome* woodcut bearing Dürer's signature as designer of the block; discusses Anton Koberger's connections with Hans Amerbach of Basel (both attended the Strassburg book fairs on a regular basis); reproduces Dürer's *Terence* drawings in full, with plot summaries.

120. Burmester, Andreas, and Johann Koller. "Säureanschlag auf drei Dürer-Werke in der Alten Pinakothek, München." *Restauro.*

Zeitschrift für Kunsttechniken, Restaurierung und Museumsfragen 96, no. 2 (1990): 89-95.

A continuation and more detailed report on the damage assessment and scientific conclusions on conservation methods for the *Glimm Lamentation, Paumgartner Altar,* and *Mater Dolorosa*, attacked with sulphuric acid by a vandal in the gallery of the Alte Pinkothek in 1988. (See Hubertus von Sonnenburg and Bruno Heimburg in *Restauro* 96 (1990), 1, 13–21.) Within twenty minutes after the attack the surfaces had begun to degenerate into a dark, syruplike fluid, smelling strongly of acid and not doing uniform damage. Because of its thick consistency, the acid could be cordoned off to prevent further horizontal spread; however, it was not possible to dilute this fluid with a wet substance without causing further damage to the panels, and the dark color of the fluid prevented visual assessment of the actual damage beneath. Dürer's painting materials were already well known: a ground containing chalk, white lead, ultramarine, azurite, smalti, malachite, cinnabar, red lac, red lead, lead-tin yellow, carbon black, and a few other pigments in smaller amounts. Much less had been known about his medium, however, which turned out to be linseed oil. But acid had now altered the pigments so that they themselves were acidic. In order to restore the pH balance, it was decided to use a commercial ion-exchanger from Bayer AG, Leverkusen (offered free of charge). This was applied as paste, and after performing its neutralizing effect could be brushed off as powder without causing further damage to the paint surface. In places, the acid had eaten into the wood, and Professor Dr. Fengel of the Institut für Holzforschung of Munich University was called on for advice.

121. Busch, Werner. "Lucas van Leyden's *Grosse Hagar* und die augustinische Typologieauffassung der Vorreformation." *Zeitschrift für Kunstgeschichte* 45, no. 2 (1982): 97–129.

 Interprets Lucas van Leyden's early engraving of Abraham bidding farewll to Hagar (ca. 1508) as a *paysage moralisé*, and points to its reliance on Dürer's *Large Hercules (Hercules Between Vice and Virtue)*.

122. Bushart, Bruno. "Der *Lebensbrunnen* von Hans Holbein d.A." *Festschrift Wolfgang Braunfels*, 45–70. Eds. Friedrich Piel and Jörg Traeger. Tübingen: Wasmuth, 1977.

Discovery of the coat-of-arms of the Augsburg merchant Georg Königsberger—Jakob Fugger's brother-in-law—on the elder Holbein's 1519 painting of the Virgin now in Lisbon (Museu Nacional de Arte Antigua) has made it possible to locate the painting in the circle around the Emperor Maximilian, and enhances the possibility that the Holbein painting influenced Dürer's 1521 design for an unexecuted painting of the Virgin, and to propose Jakob Fugger the Elder as its patron.

123. ———. *Die Fuggerkapelle bei St. Anna in Augsburg*, Munich: Deutscher Verlag, 1994.

A report on the chapel for which Dürer designed two epitaphs (W.484 and W.485). (Reviewed by Peter Strieder in *Zeitschrift für Kunstgeschichte*, 1994, no. 4, 699-704.)

124. Butts, Barbara R. "Albrecht Dürer and the Stained Glass for the All Saints Chapel of the House of the Twelve Brethren. The Boston Cartoon Reconsidered." *Journal of the Museum of Fine Arts Boston* 2 (1990): 65–79.

Reattributes the Boston study for the St. Michael window of the Landauer-endowed chapel of Nuremberg's retirement home for twelve old men to Dürer himself. (Jeffrey Chipps Smith had shown it in the Austin, TX, exhibition of 1983 as a Hans von Kulmbach, on the basis of comparison with other designs for stained glass by that artist.)

125. ———. *"Dürerschüler" Hans Süss von Kulmbach*. Ph.D. dissertation, Harvard, 1985.

Focuses on connoisseurship of Hans von Kulmbach's paintings.

126. ———. "A forgotten Drawing by Dürer." *Master Drawings* 26, no. 1 (Spring) (1988): 41–44.

Discusses Dürer's technique of hatching and crosshatching in connection with an uncatalogued and privately owned drawing from around 1511–1515, *Bust of a Woman*.

127. Büchsel, Martin. "Die gescheiterte *Melancolia generosa*: *Melencolia I*." *Städel-Jahrbuch* 9 (1983): 89-114.

Argues against the interpretation of *Melencolia I* as an illustration of *Melancolia generosa*, pointing to inconsistencies in Panofsky's

argument, which had followed Karl Giehlow (1903). Useful review of the symbolism of bats, from the Old Testament to Ovid, Thomas Aquinas, et al. Reads sphere in foreground as reference to Fortuna (opponent of Wisdom), and millstone as biblical reference to God's judgment.

128. Bühler, Wilhelm. "Dürers Melancholie und die Reformation." *Mitteilungen der Gesellschaft für vervielfältigende Kunst* 49 (1926): 10–11.

Of historical curiosity only. Regards the architectural elements and measuring instruments in the *Melencolie I* as signifying the end of Gothic church construction, and therefore a harbinger of the Reformation. The author supposes Dürer to have been familiar with Albrecht von Scharfenburg's Grail Temple, in the *[Jungerer] Titurel*, and to have been influenced by it.

129. Caesar, Elizabeth. "Sebald Schreyer." *Mitteilungen des Vereins für die Geschichte der Stadt Nürnberg* 56 (1969): 1–213.

The definitive work on the Nuremberg humanist Sebald Schreyer, whose interest in Renaissance classicism and friendship with the elder Dürer are thought to have been crucial early influences on the artist, perhaps leading him to undertake the first of his two journeys to Italy.

130. Cambridge University. Fitzwilliam Museum. *Dürer's Contemporaries in Germany from Schongauer to Cranach*, Cambridge (UK): Fitzwilliam Museum, 1980.

The handlist of an exhibition of sixty-two works held at the Fitzwilliam from April 22 until June 28, 1980. Cambridge owns a major collection of German graphic art by these artists.

131. Campbell, Lorne. *Renaissance Portraits*, New Haven/London: Yale University Press, 1990.

Campbell, who in addition to being one of the most important art historians in the British Isles is also the son and brother of portrait painters, touches on Dürer and his art throughout this valuable book. It is not, however, a simple catalogue of Renaissance portraits, but a wide-ranging and highly original study of types, poses, pigments, media, frames, covers, settings, clothing, attributes, functions, and uses of portraits during the period under discussion.

Particular attention is paid to Dürer's use of a viewing-apparatus, as illustrated in the *Underweysung der Messung* (here pp. 160–161); his lost portrait of King Christian II of Denmark (164); the use of Dürer's woodcut portrait of Maximilian as model for Vasari's portrait of Alessandro de' Medici (130); the engraved portrait of Erasmus and Dürer's view of the commemorative function of portraiture (193); the *Triumphal Arch* (201); the Madrid Self Portrait (14) and drawing of Maximilian (16); his portrait drawings from the Netherlandish journey (217).

132. Carroll, Margaret. "Dürer's *Christ Among the Doctors* Re-examined." *Shop-Talk: Studies in Honor of Seymour Slive.* Eds. Cynthia P. Schneider, William W. Robinson, and Alice I. Davies, 49–54. Cambridge (MA): Harvard University Press, 1995.

Sheds new light on the intensification of antisemitic imagery in the late fifteenth century, citing Nuremberg's decrees (1490) barring Jews from engaging in gold- and silversmith trade—measures that may have benefitted Dürer's father. Quotes Pirckheimer's allegation that Jews had poisoned the city's wells. Notes the differentiation of facial types among the Jewish doctors as in keeping with Reuchlin's two categories of Jews—those who can, versus those who will not be swayed by Christian argument. Also calls attention to the implications of imbalance of the four humors among these heads, suggesting possibility of homosexual lust in one case. Affirms Panofsky's *Albrecht Dürer* as a reclamation of German humanistic culture, taking exception to Moxey's interpretation of Panofsky's *Melencolia* analysis as the "emblem of the destruction of [his] ideal of German culture."

133. Carstensen, Jens. *Über das Nachleben antiker Kunst bei Albrecht Dürer.* Ph.D. dissertation, Freiburg im Breisgau, Albert-Ludwigs-Universität, 1982.

The author (b. 1938) is a lawyer from Lübeck, who had studied art history at Tübingen in the early 1960's with Hubert Schade. Returning to the subject twenty years later, after a legal career, he wrote this dissertation under the direction of Erik Forssman. His topic is the survival of antique *ekphrasis* in both Dürer's art and his writing. Works treated include the *Meerwunder*; *St. John's Vision of the Seven Candlesticks* and *Sol Justitiae*; the *Apocalyptic Woman*; *Witch Riding a Goat*; *Conrat Verkell*; *"Endres Dürer"*

(W.557); *Europa and the Bull*; *Hercules and the Stymphalian Birds*; *The Suicide of Lucretia*. Antique sources discussed, which the artist would have known via his friend Pirckheimer, include Aristotle's *Poetics*; Aulus Gellius, *Noctes Atticae*; the Elder Pliny; Lucian; Pausanias; Philostratus; Plato's *Symposium*; Theocritus; and Vitruvius. The author concludes that Dürer knew antique art works through Renaissance copyists. He sees Vitruvius as the basic source for the *Befestigungslehre*, and recognizes the early years (up to the time of the second Italian journey) as most fruitful for the artist's use of the Antique.

134. Carty, Carolyn M. "Albrecht Dürer's *Adoration of the Trinity*: A Reinterpretation." *The Art Bulletin* 67, (March) (1985): 146–153.

 Essential reading. The reworked version of a paper delivered at the Art Institute of Chicago's annual symposium in April of 1983, when the author was a graduate student at the University of Michigan. Summarizes Panofsky's interpretation, based on St. Augustine's *City of God*, Book 22, which maintains that the painting represents the elevation of the Christian community to eternal bliss, and offers a well-argued counterproposal that takes into account the doctrine of the Particular Judgment and its consequences for the individual soul. (Pope Benedict XII, *Benedictus Deus*, 1336; Pope Eugenius IV, *Laetentur Coeli*, 1439.) This doctrine holds that at the time of death, each person who dies without sin— or who has been cleansed by Purgatorial fire—enjoys a beatific vision of God, but each according to his merits, "one more perfectly than another." This argument successfully explains the hierarchichal arrangement of the picture, as well as the inclusion of the artist himself as a small figure standing on Earth. The central element of the Throne of Grace is identified as a eucharistic reference to transsubstantiation, and the elaborate frame is read as a "portal" to the painting.

135. Cashion, Debra Taylor. *The Rowland Prayerbook of Nikolaus Glockendon: Manuscript Painting in the Golden Age of Nuremberg*. Ph.D. dissertation, University of California-Berkeley, 1996.

 This dissertation was prepared in 1994 at Berkeley under the direction of James Marrow and Loren Partridge, and is a study of a vernacular prayerbook of over seven hundred pages (377 leaves), illustrated by Nikolas Glockendon (d. 1534) in Nuremberg, approx-

imately 1515–1518. The manuscript is replete with copies after prints by other artists, among which those of Albrecht Dürer are prominent. The author's findings discredit the anachronistic modern prejudice against copying, and call for additional ways of dealing with sixteenth-century artistic property in modern scholarship.

136. Cast, David. *The Calumny of Apelles: A Study in the Humanist Tradition*, Yale Publications in the History of Art, 28. New York: Yale University Press, 1981.

The book deals with the allegory of Calumny by Apelles, known to the Renaissance from Lucian's description. Cast points out that the theme was important for two reasons, both as a contribution to the representation of Virtue, and as a record of the action of one supreme Greek painter. He traces both the literary record, beginning with the first Humanists, and also the tradition of art works recreating the lost painting that begins with Botticelli, Raphael, and Mantegna in Italy and includes Dürer's design for the Nuremberg City Hall, commissioned on August 11, 1521 and surviving in the artist's sketch (W.922).

137. Celtis, Conrad. *De origine, situ, moribus et institutis Norimbergae (1502)*, Ed. A. Werminghoff. Freiburg im Breisgau: 1921.

A useful modern edition of Celtis's original 1502 treatise on Nuremberg, praising it as the central city of Europe.

138. Cetto, Anna Maria. "Der Dritte Apokalyptische Reiter." *Metropolitan Museum Journal* 9 (1974): 203–210.

A fascinating article, pointing out the discrepancy between Dürer's characterization of the Third Horseman of the Apocalypse and that used in earlier illustrations. Since 1498, when Dürer's great book first appeared, the four horsemen have been identified, respectively, as allegorical representations of War, Pestilence, Famine and Death. In earlier Apocalypse cycles, however, following the writings of Berengaudus, all four of the horsemen were interpreted as different aspects of Christ—the third one being the Lord as Law-Giver carrying the scales of Justice. For this reason, the Third Horseman customarily had a noble appearance. One of the reasons for this interpretation was the cry of the Voice: "Bilibris tritici denario, et tres bilibres hordei denario, et vinum et oleum ne laeseris" [Revelation. 6:6: "A measure of wheat for a penny, and three

measures of barley for a penny; and see thou hurt not the oil and the wine"]. The denarius, which in biblical times was the payment for a day's work, had deteriorated by Carolingian times to the denier, the smallest coin in circulation. The author speculates that therefore the price of one denarius for a measure [two pounds] of wheat must have seemed a blessing of good government—a Golden Age—to the medieval miniaturists and tapestry designers who preceded Dürer. According to Cetto, Dürer, who perceived all four of the horsemen as threatening, but still regarded the biblical denarius as the value of a day's wages, represented the Third Horseman as a usurer with the scales of inflation, and thus shaped our own image of the horsemen.

139. Chadraba, Rudolf. *Dürers Apokalypse. Eine ikonologische Deutung*, Prague: Verlag der Tschechoslowakischen Akademie der Wissenschaften, 1964.

A The author interprets the *Apocalypse* woodcut series as a harbinger of the Reformation, prophesying the catastrophes and social changes that were to follow. This is a work usually cited for purposes of refutation only. Although the "prophetic" qualities of the visual arts were once taken seriously, this is obviously a concept that cannot be justified.

140. ———. "Politische Sinngehalte in Dürers Apokalypse." *Wissenschaftliche Zeitschrift der Humboldt-Universität zu Berlin, Gesellschaftliche und Sprachwissenschaftliche Reihe* 12 (1963): 79-106.

[Historic interest only.] Argues that the *Apocalypse* series reflects the struggle of the German bourgeoisie against feudalism and the Papacy, specifically prefiguring utopian aspirations of Luther (which he later betrayed in accepting the hegemony of the German princes). [Parshall & Parshall] [The Reformation was always referred to as the *frühburgerliche Revolution* by Marxist writers in East Germany and Czechoslovakia at this time.].

141. Chapeaurouge, Donat de. "Der Christ als Christus. Darstellungen der Angleichung an Gott in der Kunst des Mittelalters." *Wallraf-Richartz Jahrbuch* 48/49 (1987): 77–96.

A useful article having bearing on Dürer's 1500 *Self Portrait*. The author calls attention to the ancient tradition by which princes and

political figures presented themselves as gods/goddesses—or as persons having direct access to the gods. The Bible leaves the door open for this practice: man is "made in God's image" (Genesis 1:27. See further St. Paul in Romans 8:29 and 6:1–11; 2 Corinthians 4:10). The imagery of Christ crowning Otto III and Henry II and establishing a direct connection with Archbishop Friedrich of Cologne are but a few of the manuscript illuminations and tomb brasses of the early Middle Ages cited here, as is Taddeo de Bartolo's depiction of St. Francis of Assisi as "the new Christ" (1403, Perugia), and the long tradition of Franciscan pictures of "the Christian" following Christ with a cross over his shoulder (source: the thirteenth century *Bible moralisée*, which expands on the directives issued by Sts. Matthew and Mark, to "take up the cross and follow" Christ, and culminates in Thomas à Kempis' *Imitation of Christ*). The concluding example (unless you count Joseph Beuys' washing his disciples' feet, February 5, 1971, also cited here), is Dürer's Munich *Self Portrait*, commemorating the artist as creator—a concept no more presumptuous than that of the Venetian Doge (Pietro Mocenigo), who twenty years earlier had caused himelf to be portrayed as an earthly hero overcoming the enemies of the Church as a parallel to Christ's overcoming Death. Further argues that painting of the so-called *Four Apostles* was the artist's own idea from start to finish (as opposed to Hans Kauffmann, 1973, q.v.).

142. Chastel, André. "Dürer à Venise en 1506." *Giorgione e l'humanesimo veneziano*, 459-463. Civiltà veneziana. Saggi, 27. Florence: L.S. Olschki, 1981.

Chastel's paper (in French) for the Corso Internazionale di Alta Cultura held at the Fondazione Giorgio Cini, Venice, August 26–September 16, 1978. Examines the impact of Venetian painting on Dürer, with particular attention to the *Feast of the Rose Garlands* (Prague, Národní Galerie) and the *Christ Among the Doctors* (Thyssen collection), both painted in Italy in 1506.

143. ———. "Zu vier Selbstbildnissen Albrecht Dürers aus den Jahren 1506–11." *Albrecht Dürer, Kunst im Aufbruch*, 37–45. Ed. Ernst Ullmann. Leipzig: Karl-Marx-Universität, 1972.

Deals with the four "assistant" self portraits tucked into the great altarpieces of 1506 (the *Feast of the Rose Garlands*), 1508 (*Mar-*

tyrdom of the 10,000), 1509 (the Heller Altarpiece), and 1511 (the Landauer Altarpiece). Little new information, as Stechow noted (*Art Bulletin* 1974), except for his reference to a predella by Lorenzo Lotto (not illustrated), which he sees as a possible source for the landscape in the Landauer Altar and its preparatory drawing of 1508 (Chantilly). Stechow found the association unconvincing, particularly in light of the fact that the predella is both undated and not universally accepted as a Lotto.

144. Châtelet, Albert. "Dürer und die nördlichen Niederlande." *Anzeiger des Germanischen Nationalmuseums* (1975): 52–64.

Professor Châtelet (Université des Sciences Humaines de Strasbourg) begins with the assumption that Dürer saw no Dutch art works other than those of Lucas van Leyden, whom he met in Antwerp in 1521 (despite the fact that Dürer had traveled through the eastern Netherlands on his return trip from the coronation of Charles V in the autumn of 1520, stopping in Nijmegen (November18) and passing through Tiel and Heerwarden and staying overnight in 's-Hertogenbosch, where he was feted by the local goldsmiths and admired the church of St. John, and departing by way of Tilburg—not to mention his later trips to Bergen op Zoom and the islands of Zeeland.) Châtelet does, however, assume a visit to the north Netherlands during the "lost" months of the bachelor's journey, as postulated by Oskar Schürer ("Wo ging Dürers 'ledige Wanderfahrt'?," *Zeits. f. Kunstgeschichte* 6 (1937) 171–199, and accepted by Panofsky). Châtelet sees a trace of such an earlier journey in a drawing of the *Holy Family* (Berlin KK., W.30), which he compares to Geertgen's *John the Baptist* (Berlin). He also sees a relationship between the *Adoration of the Shepherds* by the Master of the Virgin Among Virgins (Vienna, Kunsthistorisches Museum) and Dürer's *Adoration of the Child* (Dresden, now no longer accepted as by Dürer but attributed to a Netherlandish painter called "Meister Jhan"—see Anzelewsky' catalogue of the paintings). He also draws parallels between scenes in the *Large Passion* and works by Geertgen, and finds Dürer's *Christ Among the Doctors* (Thyssen coll.) to have been influenced by Hieronymus Bosch's *Crowning with Thorns* (London). He postulates that young Dürer may have made such a journey in order to meet Dutch woodblock cutters, and may have been reassured by the presence of Albert, Duke of Saxony and the Imperial army sent to restore order in the

Netherlands in 1492. Finally, he notes (correctly) that Dutch art was known in Nuremberg at the time of Dürer's first apprenticeship.

145. *Christensen, Carl C. Art and the Reformation in Germany*, Athens (OH): Ohio University Press, 1979.

A most useful general introduction to issues concerning the theological background of the role of art objects in the Reformed churches of Germany, written by an excellent Reformation historian. Chapter I describes the origin of iconoclasm in the Reformation, with emphasis on Karlstadt—author of the first major iconoclastic treatise—and includes an account of the destruction in Wittenberg. Chapter II deals with the development of Luther's thought on images and the uses of religious art. Subsequent chapters deal with iconoclasm in Basel, Nuremberg and Strassburg; and with early Lutheran art, centered on the Cranach studio. Chapter V deals with the Reformation as a cause of decline of art production in Germany. Of particular interest is the Excursus, an extended essay on Dürer's so-called *Four Apostles* and its relationship to the German Reformation.

146. ———. "Dürer's *Four Apostles* and the Dedication as a Form of Renaissance Art Patronage." *Renaissance Quarterly* 20 (1970): 325–334.

Christensen sees dedications of works of art of this sort as an outgrowth of literary practice by which authors dedicate their work to rulers or other important personages, and believes Dürer to have been the first visual artist to adopt the practice (as does Donat de Chapeaurouge, in *Schülerfest für Herbert von Einem*, Bonn, 1965, pp. 55–62). Practical problems for the Reformed parties caused by the depiction of the saints and scenes from their lives also are discussed. Nuremberg's Reformers and City Council adopted and supported a careful reaffirmation of the value of religious art of this sort. The author also calls attention to the unexpectedly large number of local artists who became adherents of the Radical Reformation.

147. ———. "Iconoclasm and Preservation of Ecclesiastical Art in Reformation Nuremberg." *Archiv für Reformationsgeschichte* 61 (1970): 205–221.

Discusses Nuremberg's orderly transition to the Reformed rite made possible by the prudent City Council, which took a firm stand against iconoclasm. Relates the fate of objects no longer needed for the new rite—many monasteries sold their gold and silver objects, as well as property, to the city by the end of 1525, and the Council resold the sacramental objects to such Catholic patrons as the Archbishop of Mainz, or had them melted down to finance other projects.

148. ———. *The Nuremberg City Council as a Patron of the Fine Arts, 1500–1550*. Ph.D. dissertation, Ohio State University, 1965.

Includes Dürer's works for the Council, commissioned in his last years.

149. ———. *Princes and Propaganda: Electoral Saxon Art of the Reformation*, Sixteenth Century Essays & Studies, Gen. Ed. Charles G. Nauert Jr., 20. Kirksville, MO: Sixteenth Century Journal Publishers, 1992.

Direct mention of Dürer is minimal, and confined to the engraved portrait (1524) done for the Saxon Elector Friedrich the Wise, whose court painter was Lucas Cranach. However, this is a useful work in giving a picture of the political world of Friedrich, who was one of Dürer's earliest and most important patrons, and of the beginning of Reformation iconography.

150. Clark, Anthony M., and Edward A Foster. *The Jones Collection. The Bequest of Herschel V. and Tessie Jones*, Nos. 62–82; plates 51–58. Minneapolis, MN: Minneapolis Institute of Arts, 1969.

The exhibition catalogue highlighting a major bequest of master prints, written by the late Director of the Minneapolis museum. (Exhibited December 12, 1968–February 9, 1969.)

151. Clark, T. H. "Das Northumberland-Service aus Meissener Porzellan." *Keramos* 70, no. October (1975): 9-92.

Dürer's *Rhinoceros* woodcut appears among the motifs from the graphic arts used in the decoration of a service of Meissen porcelain at Alnwick Castle, made about 1745, and probably part of the large dinner and dessert service presented by August III of Saxony to the British envoy, Sir Charles Hanbury Williams in 1747. Other

prints copied include designs by Eleazar Albin of London and Johann Elias Ridinger of Augsburg.

152. Clarke, T. H. *The Rhinoceros from Dürer to Stubbs. 1515–1799*, London, 1986.

Dürer's woodcut (B.136), based on hearsay evidence regarding the creature sent to King Manuel I of Portugal as a gift from King Muzafar of Cambodia in 1515.

153. Coburg. Kunstsammlungen der Veste Coburg. *Albrecht Dürer 1471–1528. Holzschnitte, Kupferstiche, Eisenradierungen aus dem Kupferstichkabinett der Veste Coburg*, Heino Maedebach. Coburg: 1971.

Created in connection with the Dürer five hundredth anniversary exhibition held in Coburg, a major repository of the artist's works on paper, this also serves as one of the Coburg collection catalogues. The original gift of 185 woodcuts, 111 engravings and six etchings came from the Erbprinz (later Herzog) Franz Friedrich Anton von Sachsen-Coburg-Saalfeld (1750–1806), who had acquired them in Nuremberg from the Imhoff collection (q.v.), as the 1800 inventory shows. They came bound in velvet and taffeta-covered albums, direct from Dürer's estate via Pirckheimer's heirs. Franz Friedrich Anton also bought (1797) the entire *Triumphal Procession* in 1797 from the Nuremberg dealer Frauenholz, for sixty gulden. This, too, came in a red velvet album. In addition to the many Dürer impressions of superb quality, specialty items include an impression of the *St. Hubert* printed on satin, not mentioned in Meder. The catalogue includes information on watermarks and papers. (N.B.: The Coburg print room also possesses a rare set of the Frauenholz auction catalogues that are invaluable for research.)

154. Coburg, Kunstsammlungen der Veste Coburg. *Meisterwerke europäischer Grafik 15.–18. Jahrhundert aus dem Besitz des Kupferstichkabinettes Coburg; Ausstellung zur 200. Jahrhundertfeier des Coburger Kupferstichkabinettes 1775–1975*, Heino Maedebach. Kataloge der Kunstsammlungen der Veste Coburg, 5. Coburg: 1975.

The two hundredth-anniversary exhibition of choice items from the vast (three hundred thousand items) print collection of the

fortress of Coburg, including a history of the collection and pho-
tographs of the facilities. The thirty-six Dürers exhibited represent
only a fraction of the Veste's holdings (111 impressions of the en-
gravings, six etchings, 185 woodcuts). This is one of the most im-
portant collections in the world: most of it comes directly from the
Imhoff collection (Willibald Pirckheimer's heirs) in Nuremberg, a
part of which was assembled during the artist's lifetime, and pre-
sumably with his knowledge and advice. The catalogue includes
notes on condition and watermarks, as well as references to the
major oeuvre catalogues. The Coburg collection was assembled by
Duke Franz Friedrich Anton von Sachsen-Coburg-Saalfeld
(1750–1806), whose priced set of auction catalogues containing
his handwritten notes also is housed in the print room. He began to
collect "old German" prints around 1775, long before the Bois-
serée brothers "discovered" medieval German painting in Cologne.
Many of his purchases were made in Nuremberg at the Frauenholz
auctions. A unique Dürer item is the impression of the *St. Eustace*
printed on silk. [On the Coburg collection of Dürers, see the col-
lection catalogue published in 1971, *Albrecht Dürer 1471–1528.*]

155. Collins, Patricia. "Prints and the Development of *istoria* Painting
on Italian Renaissance Maiolica." *Print Quarterly* 4, no. 3 (Sep-
tember 1987), 223–235.

Includes a montage by the Tuscan ceramic decorator known as the
Vulcan Painter on a plate now in the British Museum. It features a
satyr family, based on Dürer's engraving (*The Satyr Famnily*,
B.59), seated in a landscape that incorporates a portion of the
background of Dürer's *Large Hercules* (B.73, also known as *The
Choice of Hercules*, or *Hercules between Vice and Virtue*).

156. Colloque International Albrecht Dürer, Nice, 1974. *La Gloire de
Dürer*, Ed. Jean Richer. Actes et Colloques, 13. Paris: Klincksieck,
1974.

These are the papers presented at the international colloquium titled
Albrecht Dürer dans l'art et la pensée européens held in Nice (Feb-
ruary 7–9, 1972), under the auspices of the Faculty of Letters and
Sciences at the University of Nice. Contents include: Part I: *Aspects
de Dürer et de son art*, by Georg Kauffmann; *Venise à l'époque de
Dürer d'après le plan de Barbari*, by Giuseppe Mazzariol; *Albert
Dürer à Venise*, by Teresio Pignatti; *Les auto-portraits d'Albert*

Dürer, by André Chastel; *La signification du portrait chez Albert Dürer*, by Peter Strieder; *Dürer dans le courant réaliste de son Temps*, by Léon de Groer; *Les aquarelles de Dürer*, by Maurice Serullaz; *Albert Dürer et les artistes*, by Kurt Bauch; *Autour de l'exposition de Dresde, recherches sur Dürer*, by Werner Schmidt; *A propos de la* Crucifixion *vue de biais*, by Pierre Vaisse; *Dürer ou le classicisme impossible*, by Germain Bazin; *Dürer et le démon de la Connaissance*, by Jean Mouraille; Part II: *Albert Dürer et les écrivains son rayonnement intellectuel: Dürer et les Romantiques allemands*, by Jean Philippon; *Victor Hugo et Albert Dürer*, by Jean-Bertrand Barrere; *Jules Michelet et Albert Dürer*, by Jean Richer; *Marges pour l'Apocalypse*, by Michel Butor; *Note sur l'Apocalypse de Dirck Vellert*, by Maurice Serullaz; *Allocution de clôture*, by André Chastel; *Thomas Mann et Dürer*, by Walter Rehm. [Reviewed by Michael Greenhalgh in *Apollo* 101, no. 156 (February 1975), 145–146.]

157. Cologne. Archiepiscopal Museum. *500 Jahre Rosenkranz. 1475 Köln 1975*. Cologne: 1975.

Five hundredth anniversary exhibition celebrating the official recognition of rosary devotion, initiated by the Dominican order in Cologne in Dürer's childhood. Offers useful background information for interpretation of the *Feast of the Rose Garlands* (Prague).

158. Conway, William Martin. *The Writings of Albrecht Dürer*, Ed. Alfred Werner. New York: Philosophical Library, 1958.

With an introduction by Alfred Werner and a change of title (the original British edition was called *Literary Remains of Albrecht Dürer*), this reproduces Sir Martin Conway's original translation of Dürer into plummiest nineteenth-century Cantabrigian prose—an unfortunate bowdlerization, in some spots, of the true effect of the artist's quite direct and clear writing style. Still useful, however, for those who do not yet read German well enough to use the definitive edition of Dürer's written work by Hans Rupprich (*Dürers schriftlicher Nachlass*, 3 vols., Berlin 1956–1969, vol. 1, q.v.) A convenient feature is the Appendix listing miscellaneous material from the British Museum's important collection of Dürer manuscripts. For the general flavor of Dürer's writing, however, a far better impression is given by Wolfgang Stechow in his selection of key documents for Prentice Hall's *Sources and Documents* series,

as well as by Walter Strauss (*Complete Drawings*, 1974, passim.) and Hutchison (*Albrecht Dürer: A Biography*, 1990).

159. Copenhagen. Statens Museum for Kunst. *Albrecht Dürer. Kobberstik og Raderinger*, Erik Fischer. 1971.

Copenhagen owns a fine and nearly complete collection of Dürer's prints. This slender catalogue is of particular interest for Fischer's introductory essay, pointing out Dürer's personal dealings with King Christian II, to whom he sold "the best" of his graphic work for five gulden during their mutual sojourns in the Netherlands after the coronation of Charles V. Although much of this original collection was destroyed in a palace fire, care has been taken to reconstruct it. Fischer also gives a useful list of literature relating to the royal Danish collection in general, including Carl Friedrich von Rumohr and J. M. Thiele's *Geschichte der königlichen Kupferstichsammlung zu Copenhagen* (1835), and Bernhard Hausmann, *Albrecht Dürers Geschenke an den König Christian II von Dänemark* (I. Archiv für die zeichnenden Künste 5, 1859, pp. 165–167).

160. ———. *Ensomhedens billede*, Tue Gad. Lommebog, 24. 1983.

A brief exhibition catalog (sixteen pages), in Danish, devoted to "Pictures of Solitude." Includes Dürer's prints of St. Jerome, together with works by Lucas Cranach, Rembrandt, and the hermit series by Jan and Raphael Sadeler after Marten de Vos *Oraculum Anachoreticum*).

161. Cornell, Alan. "The Dürers gone! Good heavens, a monk's caper?" *The New York Times*, A, (September 21, 1995): 4.

Feature article detailing the investigation by Benedict Weingartner of the theft of twenty-six Dürer prints from the Benedictine monastery of Lambach (Austria).

162. Cremer, Erika. "Dürers verwandschäftliche Beziehungen zu Innsbruck." *Festschrift Nikolaus Grass*, vol. 2, 125–130. 2 vols. Innsbruck/Munich: 1975.

Documents the presence in Innsbruck of members of the Rummel family, relatives of the artist's wife Agnes, providing an added incentive for his visit to the city during the first Italian journey and perhaps also an explanation for the fact that he made an unprece-

dented three watercolor views of the city (all three in the Albertina today).

163. Cuttler, Charles D. "Undercurrents in Dürer's 1500 *Self Portrait.*" *Pantheon* 50 (1992): pp. 24–27.

The author, an American emeritus professor (University of Iowa) who has published widely on the art of northern Europe, relates the Munich *Self Portrait* (1500) to the tradition of autonomous northern self portraiture beginning with the enamel medallion of Jean Fouquet (Louvre: ca. 1450). Citing Wuttke's observation of the similarity to Byzantine Christological imagery (q.v., 1980), he suggests the possibility of further influence from portrait medals close to Dürer's time and region, such as that of *Maximilian I as Archduke* (1479); the medals of Pisanello, which were probably known to Nuremberg humanists of the day; and the mosaics of San Marco, as recalled from his first trip to Venice. He also gives a useful review of recent literature on the self portrait, and introduces new evidence showing the image in the portrait to be in violation of Nuremberg's sumptuary laws regulating the style of hair and dress for members of the artisan class.

164. Dal Canton, Giuseppina. "Redon e la melancolia." *Artibus et Historiae* 7, no. 14 (1986): 125–142.

[In Italian, with English summary.] Summarizes Redon's notes on Dürer, particularly *Melencolia I*, and examines Redon's various treatments of the theme of melancholy.

165. De Grummond, Nancy. "VV and Related Inscriptions in Giorgione, Titian and Dürer." *The Art Bulletin* 57, no. 3 (September) (1975): 346–356.

The letters 'VV' appear on the parapet of Giorgione's Giustiniani portrait (Berlin), datable at about 1504–1506—about contemporary with Dürer's second trip to Italy, most of which he spent in Venice. The author has found similar inscriptions on a number of sixteenth-century Venetian portraits from the Giorgione circle. She suggests that VV stands for *vivus* (living)—a term found on certain Roman tombstones—and was intended to imply that the painting made both the sitter and the artist immortal, noting that Dürer used either the adjective *vivus* or its cognate verb *vivere* on several of his portraits—notably the engraving of Friedrich the Wise

(B.M.F.V.V.), with variants on those of Pirckheimer (*vivitur inge-nio*); Erasmus (*ad vivam effigiem*; and Melanchthon (*Viventis*).

166. Decker, Bernhard. "Böcklins Seitenblick auf Dürer." *Georges-Bloch-Jahrbuch. Des kunstgeschichtlichen Seminars der Univer-sität Zürich* (1995): 108–126.

The *pièce de résistance* here is Arnold Böcklin's *Der Abenteurer* (The Adventurer, Bremen Kunsthalle) and its relationship to Dürer's *Knight, Death, and Devil*. Böcklin has committed a *Ritter-Denkmal faux pas* here in pose and composition. Is this Ariosto's Astolf and his horse Rabican? Decker says no. The horse with drooping head comes from Death's mount in Dürer's engraving. Dürer's knight is idealized, and won't go further than the edge of the composition. Decker recounts, and finds implausible, Perrig's recent theory (1987) that Dürer's rider is a satirical reference to the late, and militant, Pope Julius II (d. 1513), thus a papal Anti-Christ. Decker sees the Dürer instead as an ingenious variation on the theme of the Three Living and Three Dead, and the Böcklin as a mockery of the heroic ideal.

167. ———. "Der Heller-Altar von Dürer und Grünewald—ein Kult-bild der Renaissance Malerei?" *Albrecht Dürer. Über den sicht-baren Beginn der Neuzeit*, 118–139. Detlef Hoffmann. Rehburg-Loccum: Evangelische Academie Loccum, 1986.

The written version of a lecture preliminary to the publication of the same author's excellent volume on the Heller Altar for the *kunst-stück* series (q.v.). Exposes the role of art historians in "seculariz-ing" the Heller altarpiece as a piece of the Dürer cult, by glossing over the importance of Grünewald's contribution, which must have been planned by Heller from the beginning.

168. ———. "Die *Betende Hände*–ein deutsches Schicksal." *Albrecht Dürer. Über den sichtbaren Beginn der Neuzeit*, 144–151. Re-hburg-Loccum: Evangelische Academie Loccum, 1986.

An interesting commentary on the fluctuating popularity of Dürer's chiaroscuro drawing of *Praying Hands*, one of the life studies made in preparation for the lost Heller Altar. This work re-placed the *Knight, Death, and Devil* after World War I as Dürer's most frequently reproduced work in Germany. From 1930–1950 it was a symbol of religious resistence to totalitarian government and

Cold War. After World War II, however it gradually fell to the level of kitsch, seen at flea markets in various forms: on wall plaques on Catholic pilgrimage routes, tombstones, sofa cushions, and so on, and pilloried in the agitprop of the Heidelberg artist Klaus Staeck, who commented on organized religion by showing the hands bolted together by a wing-nut.

169. ———. "Dürer-Nachahmungen und Kunstgeschichte—ein Problem am Rande." *Dürers Verwandlung in der Skulptur zwischen Renaissance und Barock*, Frankfurt am Main: Liebighaus, Museum alter Plastik, 1981.

Decker's seminal article in the catalogue of the 1981 exhibition of sculpture influenced by Dürer's work, which establishes his importance as a transitional figure in the creation of Baroque style.

170. ———. "Notizen zum Heller-Altar." *Städel-Jahrbuch* 10 (1985): 179-192.

Noting that the dismembered and partially destroyed Heller Altarpiece was Dürer's largest, most famous, and best documented but least known work, the author discusses the scholarly controversy over the original arrangement of Dürer's *Assumption of the Virgin* and the grisaille panels from the wings: three surviving panels from Dürer's studio, delivered in August 1509 with the main panel (Frankfurt am Main, Historisches Museum, where Jobst Harrich's copy of the destroyed central panel also is located), and four by Matthias Grünewald (1511–1512: Frankfurt, Städelsches Kunstinstitut, *St. Lawrence* and *St. Cyriacus*; and Karlsruhe, Kunsthalle, *St. Elizabeth*, and an unknown female martyr saint). Decker concludes that the Grunewald grisailles, long considered by some to have been ordered by Heller several years after the dedication of the altarpiece, were actually part of the orginal commission. He speculates further that the altarpiece may have been topped by a lunette, similar to the one on the frame of the Landauer Altar, and was probably provided with carved pilasters that separated the fixed wings from the moveable ones.

171. Dellwing, Herbert. "Der Rahmen als Weltgerichtsportal und Himmelspforte." *Kunsthandel. Zeitschrift für Bild und Rahmen* 87, no. 3 (1995): 26–28.

This article on the frame as Last Judgment portal and entrance to Heaven concerns the Landauer altarpiece (Vienna). Unlike Raphael's contemporary *Sistine Madonna*, to which Panofsky had compared it, Dürer's altarpiece is incomplete without the subject matter contained in its original frame. A brief history of the Landauer chapel at the *Zwölfbruderhaus* is given (founded 1501, operated as an old men's home until 1808, bombed 1945). The altarpiece had already been removed by 1585—to Rudolph II's collection in Prague, later to be moved to the Belvedere (1780) in Vienna, and finally to the Kunsthistorisches Museum (1875). The original lindenwood frame (now attributed to Ludwig Krug) was left behind in Nuremberg at the time of Rudolph's purchase, to grace the copy that he provided, and a copy of the frame was made for the original altarpiece by the sculptor Ludwig Geiger (1880). No contract between Dürer and Matthäus Landauer has survived —only the modello drawing now in Chantilly—and so it is not known what the artist and original owner called it. The title "All Saints picture" was first applied in the late nineteenth century— long after the painting and its frame had been separated. The painting appears to depict a scene from St. Augustine's *City of God*, with Landauer and his son-in-law, Wilhelm Haller, among the Blessed. The columns on either side of the frame create a portal, with the picture appearing behind it. With its lunette of Christ in Judgment and its lintel showing the Blessed and Damned between the sun and a hell-mouth, the frame recalls the Last Judgment portals of great cathedrals. (See also K. Schaeffer,"Albrecht Dürer und der Rahmen des Allerheiligenbildes," *Mitteilungen des Germanischen Nationalmuseum* 1986.)

172. Disertori, Benevento. "The First Century of Etching." *The Print Collector (Il cognoscitore di stampi)* 12, (March–April) (1975): 6–13.

 Refers mainly to prints from the Calcografia Nazionale in Rome. (Reprint of an article from the March 1922 issue of *Emporium.*)

173. Dittmann, Lorenz. "Über das Verhältnis von Zeitstruktur und Farbgestaltung in Werken der Malerei." *Festschrift Wolfgang Braunfels*, 93–109. Eds. Friedrich Piel and Jörg Traeger. Tübingen: Wasmuth, 1977.

[On the relationship of temporal structure and coloring in painting.] Explores the idea of a dimension of time in Dürer's use of color in the Landauer altarpiece (*Adoration of the Trinity*, 1511, Vienna) and in the earlier Paumgärtner Altarpiece (Munich), as well as in works by Altdorfer, Titian, Rembrandt, and Manet.

174. Dodgson, Campbell. *Albrecht Dürer*, Reprint ed. New York: Plenum,

Originally published in London and Boston (1926) as part of the series Masters of Engraving and Etching. Contains illustrations of all of Dürer's intaglio prints (no woodcuts). The author was the most important Dürer scholar in England, Keeper at the British Museum, fluent in German and highly respected internationally.

175. *Essays on Dürer*, Ed. Charles Reginald Dodwell. Manchester Studies in the History of Art, 2. Manchester/Toronto/Buffalo: University of Manchester Press, 1973.

Essays by Michael Levey, Peter Skrine, James Byam Shaw, Alistair Smith, Keith Andrews, Henry Ley, and Ulrich Finke. These essays are of a very general nature. Levey ("Dürer and the Renaissance," pp. 1–23) presents a case for the artist as a Renaissance man *prior to* his contact with Italy. Discusses Nuremberg humanism (drawing on Lewis Spitz), pointing up Dürer's influence *on* Italian art. Skrine ("Dürer and the Temper of His Age," 24–42) takes up the artist's image as seen through Tieck's *Franz Sternbalds Wanderungen*, and moves on to his status as humanist vis-à-vis Hutten, Luther, and Celtis. Byam Shaw ("Dürer the Engraver," 43–64) gives a straightforward description of the engraving process, followed by examples of the reciprocal influences between Dürer and Italy. (Carpaccio's *St. Jerome*; Dürer's adaptation of the Colleoni monument in *Knight, Death, and Devil*). Smith ("Dürer as Portraitist," 65–81) recounts the Apelles/Protogenes, Dürer/Bellini *topoi* of manual skill, noting that in portraiture Dürer does not follow classical precedent (i.e., full profile), and discusses self portraiture, and autobiography. Andrews ("Dürer's Posthumous Fame," 82–103) contains fresher material, discussing early posthumous criticisms by Italians (Malvasia, Ludovico Dolce); influence on Terbrugghen, Adriaen de Vries, and Rubens; the opinions of Hogarth and Reynolds; Goethe, von Arnim, and Brentano;

influence of the "gothic" Dürer; Peter Cornelius; Matthias Prechtl's *Sgt.-Major Ritter, Miss Todt, and Fritz Teufel*. Ley ("Dürer and the seventeenth Century," 104–120) discusses Van Mander, Lomazzo, Quadt von Kinkelbach, and Sandrart, noting that Sandrart—himself the first German painter to be knighted, was acutely aware as well as envious of Dürer's Imperial associations, and was the first to publish information on fakes, copies, and pastiches. Other topics include aspects of collecting (Thomas Howard Earl of Arundel; Maximilian I; the *Fürlegerin* paintings as copies; the collection of Franz Gerhaerdt and Bernhardt Albert von Instenraedt (Cologne), who acquired the Arundel works. Finke ("Dürer and Thomas Mann," 121–146) deals with Mann's 1928 essay on Dürer, as well as with *Joseph and His Brothers*, and *Dr. Faustus*; Mann's choice of Philip Melanchthon's portrait as the model for Jonathan Leverkuhn. Mann's views on Dürer are colored by his having read Ernst Bertram's *Nietzsche*. [Reviewed by Peter Strieder in *Pantheon* 34.]

176. Dornberg, John. "Deliberate Malice." *Art News* 87, (October) (1988): 63ff.

A feature article on the vandalism of Dürer's *Lamentation* painted for the goldsmith Albrecht Glimm, the *Mater Dolorosa* and the three panels of the Paumgartner altarpiece in the Alte Pinakothek, Munich on April 21, 1988 by Hans Joachim Bohlmann, using sulphuric acid. Estimated worth of the paintings given as $55 million. [For full report on restoration, see Munich, Neue Pinakothek, 1998.]

177. Dornik-Eger, Hanna. *Albrecht Dürer und die Graphik der Reformationszeit*, Schriften der Bibliothek des Österreichischen Museums für angewandte Kunst, 2. Vienna: Österreichisches Museum für angewandte Kunst, 1969.

A publication written to accompany an exhibition, rather than a true catalogue. The introduction offers a concise summary of Dürer's involvement in the issues of the Reformation, as well as a useful summary of the scholarly literature. A distinction is made between Dürer's approach to Reformation art and that of Lucas Cranach and his studio. The author sees criticism of the Church in the early *Mass of the Angels* (Rennes, Musée des Beaux-Arts).

178. ———. *Albrecht Dürer und die Druckgraphik für Kaiser Maximilian I*, Vienna: Österreichisches Museum für angewandte Kunst, 1971.

Excellent catalogue of the exhibition of prints made for Maximilian by Dürer and his circle, including the *Triumphal Arch* and *Triumphal Procession*. Essays on Dürer and the Museum für Kunst und Industrie in Vienna (its opening coincided with Dürer-Fest 1871: Thausing gave a series of lectures, and the Festival publication featured Dürer's costume studies). Also included are essays on Dürer and Maximilian; and Hans Herkheimer's *Neue Zeitung* account of the emperor's death. Individual catalogue entries and bibliography.

179. ———. "Albrecht Dürers Stellung zu Humanismus und Reformation." *Mitteilungen der Gesellschaft für vergleichende Kunstforschung in Wien* 25 (1972): 1–6.

Identifies criticism of the established Church in several early works, especially the so-called *Mass of the Angels* (Rennes, Musée des Beaux-Arts), a theme developed from the earlier exhibition catalogue for the Österreichisches Museum für angewandte Kunst (1969). Interprets this work as an allegory directed against abuses —specifically the sale of indulgences. This is an interesting hypothesis, but it should be borne in mind that Dürer was not above turning out prints of indulgenced subjects himself—for example, the 1513 engraving of the Vernicle (B.25).

180. Dresden, Kunstverein. *Spruch-und Liederkranz zum Albrecht Dürer-Feste in Dresden am 7ten April, 1828 von einem Mitstifter des Dürerschen Kunstvereins gesammelt und in den Druck gegeben*, Dresden: Gärtner, [1828?].

Festival poetry from the Dresden celebration of the artist's three hundredth death anniversary in 1828.

181. Dresden, Albertinum. *Deutsche Kunst der Dürerzeit*, Dresden: Albertinum, 1971.

The chief exhibition held in the German Democratic Republic in honor of Dürer's five hundredth birth anniversary, it drew primarily on works in all media from the state collections of Dresden, Leipzig, Weimar, and Budapest. Doubts the authenticity of the Leipzig *Fürlegerin* (Woman of the Fürleger Family, accepted by

Anzelewsky); presents the Dresden *Crucifixion* (1500) as original. (Reviewed by Wolfgang Stechow in *The Art Bulletin* 56 (1974), 260 and 263.)

182. Dresden, Kupferstich-Kabinett. *Vermisste Zeichnungen des Kupferstich-Kabinettes Dresden*, Christian Dittrich. Dresden: Staatliche Kunstsammlungen, 1987.

Of special interest is the introduction by Werner Schmidt, who at the time was Director of the Dresden print room. Dresden's collection was one of the hardest hit by losses during World War II— about eight percent of its single drawings and 19% of its albums of drawings, almost its entire "first garniture" (some two hundred works by the most famous European artists acquired since 1882) have disappeared. The loss of these 4,816 items—most of them unpublished and unphotographed—is probably permanent. In 1939 the most valuable graphic works were placed in storage in the cellar under the Kupferstich-Kabinett. They were safe as late as April 7, 1942, after which they were gradually moved to Schloss Weesenstein (Pirna) and placed in the castle's dungeon. Further works were taken to Schloss Wurschau (near Bautzen). In 1945 a military action of Russian troops pitted against S.S. *Werwolf* commandos took place near Weesenstein; after September 1950, when the museum staff regained access to Schloss Weesenstein, the thefts were discovered. Six Dürer drawings were taken; luckily, however, another carton containing Dürer drawings was overlooked. Still missing are Winkler III no. 706 (Bookplate for Pirckheimer, ca. 1513); W.III no. 641 (*Sleeping Woman on a Stool*, ca. 1515); W.III no. 560 (*Head of a Beardless Young Man*, possibly Hans Dürer, ca. 1520); W.IV no. 909 (*Head of a Young Man Wearing a Cap*); and two copies after Dürer (B. 74 and W. 452.) [For a Russian account of the removal of the graphic art from Weesenstein Castle, see Akinsha and Kozlov, *Beautiful Loot*, esp. pp. 119-124.]

183. Dreyer, Peter. "Sulle Silografie di Tiziano." *Tiziano e Venezia. Convegno Internazionale di Studi, Venezia*, 503–511. Vicenza: Neri Pozza, 1980.

A paper read at the conference on Titian and Venice, sponsored by the Università degli Studi di Venezia (September 27-October 1, 1976). Dreyer examines the procedures used by Northern artists,

including Dürer and Altdorfer, in making woodcuts, using prepara-
tory studies and partially cut blocks, as background for the study of
Titian's actual role in the production of woodcuts [RILA].

184. Dube, Wolf Dieter. "Anmerkungen zum Triptychon *Versuchung*
 von Max Beckmann." *Pantheon* 38, no. 4 (1980): 393–397.

In the course of his discussion of Beckmann's *Temptation* triptych
(Munich), the author discusses Dürer's influence on the painting
Woman Meditating by the Sea (1937: Bremen, Kunsthalle) with re-
gard to the attitude and gestures of the figure as well as its *facies*
nigra. Dube speculates that, like Dürer, Beckmann was creating a
mental self portrait as an expression of self-justification at the mo-
ment of severest threat to his artistic career.

185. Dürer, Albrecht. "Beischüfter auf Bildnissen und Zeichnungen."
 Dürers schriftlicher Nachlass, 210–211. Ed. Hans Rupprich. 3
 vols. Berlin: Deutscher Verein für Kunstwissenschaft, 1956.

This section of Rupprich's definitive edition of Dürer's written
legacy deals with his inscriptions on his own and other works of art
(e.g., Document 76: his inscription on the famous woodcut by
Michael Ostendorfer depicting the fanatic rites of the Cult of the
Beautiful Virgin at Regensburg—"What is this specter that has
arisen on the banks of the Danube? . . ."—deploring the dishonor
done to the Virgin Mary by the behavior of this radical religious
group led by the renegade monk Balthasar Hübmaier. Implicit in
Dürer's remark is his fear for the cause of religious reform. Docu-
ment 83 transcribes the Biblical quotations from the painting of the
so-called *Four Apostles* (Munich), dated 1526, which refer to the
dangers of following false prophets.

186. ———. *Beschryvinghe van Albrecht Dürer, van de Menschelijke*
 Proportion, Amsterdam: 1978.

A small edition (five hundred copies) of the modern, full-size fac-
simile of the 1622 Dutch quarto edition of the *Four Books of*
Human Proportion, originally published in Arnhem.

187. ———. *Das Ring- und Fechtbuch*, 1512.

A handwritten manuscript on wrestling and hand-to-hand combat
with sword and dagger (Vienna, Albertina, Inv. No. 26232).

Thirty-five pages, with 200 hand-colored pen drawings. Watermarks; Bull's Head with Cross and Serpent (similar to Briquet 15366–81). Probably begun for Maximilian, it was discovered in the Steiermark in 1823 by the theologian Vincenz Weintridt and presented to Emperor Franz I (1833). The date 1512 does not appear in the original manuscript, but is inscribed on the late sixteenth-century endpaper and title page. The drawings are of lesser quality than the autograph drawings of swordplay in the British Museum (Cod. Add. 5229), which are securely dated 1512. The Vienna written text, as Rupprich has shown, is certainly by Dürer and Pirckheimer, although left unfinished and completed by another hand. [See Rupprich III, pp. 427–432; and Koschatzky/Strobl *Dürerzeichnungen der Albertina* no. 84.]

188. ———. *Die Kunst aus der Natur zu 'reyssenn'. Welt, Natur und Raum in der Druckgraphik, Holzschnitte, Kupferstiche uns Radierungen aus der Sammlung-Otto-Schäfer-II.*, Eds. Erich Schneider and Anna Spell. Schweinfurt: Ludwig & Höhne Verlag, 1997.

Introduction by Otto Schäfer. A catalogue of the Schäfer Dürers—a fine and nearly complete collection, displayed publicly in the Bibliothek Otto Schäfer, Schweinfurt (Judithstrasse 16.) September 28, 1997–January 25, 1998; and at the Stadtmuseum in Amberg from February 15–April 26, 1998. In addition to the title essay by Schneider, contains articles by Peter Krüger ("Nachahmung, Erfindung und Konstruktion der Natur im graphischen Oeuvre Albrecht Dürers"); Matthias Mende ("Natur und Kunst. Anmerkungen zu Dürers Wirklichkeitssinn"); and Kristina Herrmann-Fiore ("Zur Verwandlung der Naturstudien in Dürers graphischen Drucken"). Catalogue entries on the individual prints were written by Schneider and Spell.

189. ———. *Etliche Underricht zu Befestigung der Stett Schloss und Flecken*, Comm. Alvin E. Jaeggli. Zürich: Dietikon, 1971.

Facsimile edition with commentary in modern German. Jaeggli directs his text toward the problem of the Turkish menace on the eastern borders of the empire, and on Dürer's interest in firearms. Printed on excellent paper, this has a much lengthier commentary than the English facsimile by Biddle (q.v.). Reviews the various editions, giving information on papers and watermarks; excellent bibliography. A limited edition.

190. ——. *Etliche Underricht zu Befestigung der Stett Schloss und Flecken*, Intro. Martin Biddle. Richmond (UK): Gregg, 1972.

Facsimile of the 1527 Nuremberg edition (Weigel) of Dürer's treatise on fortification, dedicated to Ferdinand I, King of Hungary and Bohemia (the future Holy Roman Emperor). The printer is thought to have been Hieronymus Andreae, Dürer's *Formschneider*. Biddle's introduction is excellent, noting that this is the artist's least-known publication, and is the *earliest* printed book on artillery fortifications. It also contains an ideal plan for a royal town—possibly also the first such plan to be published in northern Europe. Biddle notes its influence on Henry VIII's great scheme of coastal fortifications (1539-1543) from Berwick south to Kent, west to Cornwall, and also at Calais. The treatise was a compendium of ideas already current in Germany, quite uninfluenced by the Italian development of the angle-bastion, as Biddle notes, a fact that, unfortunately, made Henry VIII's fortifications obsolete already by 1545. The various posthumous editions are cited.

191. ——. *Unterweysung der Messung mit dem Zirkel und Richtscheit*, Ed. Alvin Jaeggli. Zürich: Dietikon, 1966.

Facsimile edition of the *Manual of Measurement*, made from the original Nuremberg edition of 1525. Has bilingual commentary section in German and English by Christoph Papesch.

192. ——. *Von Menschlicher Proportion*, Nördlingen: 1980.

A modern facsimile (in quarto) of the original 1528 Nuremberg edition of the *Four Books of Human Proportion*.

193. Dürer. Albrecht. *Hierin sind begriffen vier bücher von menschlicher Proportion durch Albrechten Dürer von Nürenberg erfunden und beschriben zu nutz allen denen so zu dieser Kunst lieb tragen*, Zürich: Dietikon, 1961.

An excellent facsimile of the original 1528 edition of Dürer's *Four Books of Human Proportion*.

194. "Dürer-Sammlung nach Schweden verkauft." *Die Kunstauktion* 4, no. 6 (1930): 12.

Notice of the sale of the collection of Dürer prints from Schloss Wildenfels (near Zwickau, in Saxony), to Baron Harald Raab of Stockholm.

195. Düsseldorf, Universität. Kunstmuseum. *Mensch und Tod: Totentanzsammlung der Universität Düsseldorf aus fünf Jahrhunderten,* Margarete Bartels and Dieter Graf. 1978.

The catalogue of a selection of 111 works from the collection of prints and drawings dealing with the theme of death, assembled by a Hanover physician (Prof. Dr. med. Werner Block) and donated to the University of Düsseldorf in 1976 and circulated to various galleries in Germany in 1978 and 1979, accompanied by this catalogue, created for the tour. Artists represented range from Dürer to the nineteenth-century reviver of wood engraving, Alfred Rethel, as well as to Käthe Kollwitz and Georges Rouault.

196. Dvořák, Max. "Dürers Apokalypse." *Kunstgeschichte als Geistesgeschichte. Studien zur abendländischen Kunstentwicklung,* 191–202. Munich: R. Piper, 1928.

A period piece, but one by a reputable art historian of the "Vienna School" of art history, successor to Wickhoff at the University, and later head of the Austrian Monuments Commission after World War I, when the preservation of the Austrian patrimony was an extremely serious matter. Dvořák (1874–1921) saw the *Apocalypse* series as a pictorial sermon reflecting pre-Reformation unrest, with antipapal elements prefiguring Luther's own. This essay was published posthumously. An English translation, by John Hardy, of the entire book has been published as *The History of Art as the History of Ideas* (Munich, R. Piper, 1984).

197. Dwyer, Eugene. "The Subject of Dürer's *Four Witches.*" *The Art Quarterly* 34, no. 4 (Winter) (1971): 456–473.

Interprets the 1497 engraving (B.75), often thought to represent four witches and/or a scene of abortion, as a depiction of Discord and the Three Fates, but allows for many layers of meaning, including witchcraft.

198. Eberlein, Johann Konrad. "Dürers Melancholie-Stich—Analyse eines Beispiels." *Kunstgeschichte. Eine Einführung,* Eds. Hans Belting, Heinrich Dilly, et al. Berlin: 1986.

A general "state of the question" article.

199. Eckert, Willehad Paul. "Erasmus und Willibald Pirckheimer." *Willibald Pirckheimer 1470–1970. Dokumente, Studien,*

Perspektiven, Kuratorium Willibald Pirckheimer. Nuremberg:
Glock & Lutz, 1970.

Treats Pirckheimer's relationship to and correspondence with
Erasmus, beginning with Pirckheimer's first recorded letter to Bea-
tus Rhenanus about Erasmus (late 1513) and his follow-up letter,
also to Beatus Rhenanus (December 5, 1514) asking for an intro-
duction. Contains the exchange of correspondence with Erasmus
concerning Dürer's portrait engraving; Erasmus's reaction to the
news of Dürer's death.

200. Eckert, Willehad Paul, and Christoph von Imhoff. *Willibald Pirck-
heimer. Dürers Freund im Spiegel seines Lebens, seiner Werke und
seiner Umwelt,* Cologne: Wienand, 1982.

First published in Dürer Year 1971, which began with an "Advent"
ceremony at Willibald Pirckheimer's tomb in Nuremberg's Ceme-
tery of St. John, this is a more recent and accessible work than the
earlier and more specialized studies of Hans Rupprich, and in-
cludes a wealth of documentary material. Christoph von Imhoff is
a modern-day member of the important Nuremberg family into
which Willibald Pirckheimer's favorite daughter married, and that
fell heir to his prime collection of Dürer's work. He wrote the sec-
tion on Pirckheimer, "Bürger, Ratsherr, Kriegsmann und Hu-
morist" (pp. 7–68), which contains much valuable background
material on the Pirckheimer family, their investments, and
Willibald's first biography, the "Tugendbüchlein." Also included is
an essay on Caritas Pirckheimer, by Adam Wienand. Eckert exam-
ines the friendship of Dürer and Pirckheimer, including the artist's
horoscope, his works for Pirckheimer and letters to him; the
"Ring-und Fechtbuch" on which they collaborated; the *Triumphal
Arch* and *Car*; Pirckheimer's elegy on the artist's death; the Swiss
War; Pirckheimer's translations; his autobiography; the bibliogra-
phy of his publications (pp. 391–395.) Monographs on Pirck-
heimer are cited, beginning with that of his descendant Hans VII
Imhoff (1606) and the Jesuit Konrad Rittershausen (1610). In the
nineteenth and twentieth centuries there have been at leat 20 (not
counting this one.) In an appendix the controversy between Miklas
Holzberg and Christoff von Imhoff over Pirckheimer, the quality
of his translations, and the possibiity of homoerotic feelings to-
ward Dürer is reproduced.

201. Egg, Erich. *Die Hofkirche zu Innsbruck*, Innsbruck/Vienna/Munich: Tyrolia, 1974.

This is essentially an excellent photo album of the Maximilian cenotaph, which is shown to be not primarily a grave monument (Maximilian died in Wels, anyway, and was interred there), but "a political testament," stressing the Emperor's pan-European connections and (supposed) classical descent. The over-life-sized bronze statues are not pleurants, like the figures on the Burgundian tombs of Maximilian's in-laws. He must have been thinking also of the grand Italian monuments for *condottiere*, and perhaps of Leonardo's plans (ca. 1490) for Ludovico Sforza's monument. Egg sees the *Triumphal Procession* woodcut commission, designed under Dürer's supervision, as a preliminary stage. Dürer's sketch (Berlin) of the Emperor's ancestor, Graf Albrecht von Hapsburg follows, further developed in a drawing by Jörg Kolderer (Braunschweig) modelled in wood by Hans Leinberger and cast by Stefan Godl (1518). Dürer was commissioned in 1513–14 to design more figures, to be modelled and cast by Peter Vischer and Leinberger.

202. Eichberger, Dagmar. "*Naturalia* and *artefacta*: Dürer's nature drawings and early collecting." *Dürer and his Culture*, 13–37. Eds. Dagmar Eichberger, and Charles Zika. Cambridge/New York/Melbourne: Cambridge University Press, 1998.

A general overview of *Kunst und Wunder* collecting as stimulated by world exploration, and of drawings and watercolors as appealing substitutes for middle-class collectors who could not aspire to own live animals or the most exotic shells, and so on. Treats Dürer's own role as collector late in life, as reflected in his Netherlandish diary; his preference for *naturalia* as subjects of study (he didn't draw the objects from Mexico). Margaret of Austria's collection is more fully described by the author, who is at work on a monograph on the subject. Notes Dürer's rise in status, from purchasing agent for Pirckheimer during the second trip to Venice (1506) to independent collector (1520–1521).

203. *Dürer and His Culture*, Eds. Dagmer Eichberger and Charles Zika. Cambridge/New York/Melbourne: Cambridge University Press, 1998.

Eichberger, who is Senior Research Fellow with the Deutsche Forschungsgemeinschaft and teaches at the University of Saarbrücken, and Zika, a specialist in German history who is Senior Lecturer at the University of Melbourne, were both editors and contributors to this interesting volume of essays. These represent a selection from among the papers presented at an international conference held in 1994 in Melbourne in connection with the exhibition of Dürer's prints exhibited at the National Gallery of Victoria. In their brief Introduction they state their view that "contemporary cultural practices and discourses, rather than Dürer's evolutionary development as an artist, offer the key to the understanding of much of Dürer's artistic work." (p. 1) Thus, they have followed the direction taken in both of the then two Germanies in Dürer Year 1971. The volume includes "Naturalia and artefacta: Dürer's nature drawings and early collecting" (Eichberger, pp. 13–37); "Germanic patriotism in the age of Dürer" (Larry Silver, pp. 38–68); "The Michelfeldt Tapestry and contemporary European literature" (Wim Hüsken, 69-90); "Ways of seeing in the age of Dürer," by the late historian Bob Scribner, to whom the book is dedicated (pp. 93–117); "Dürer's witch, riding women and moral order" (Zika, pp. 118–140); "Tokens of affection: the meanings of love in sixteenth-century Germany" (Lyndal Roper, pp. 143–163); "The censorship of images in Nuremberg, 1521–1527" (Christiane Andersson, pp. 164–178); "Changing German perceptions of the historical role of Albrecht Dürer" (Paul Münch, pp. 181–199); and "The making of Dürer in the collection of the National Gallery of Victoria" (Irena Zdanowicz, pp. 200–210). Generous footnotes, a general bibliography and index are included. (Notes on individual essays are listed by author elsewhere in this volume.)

204. Eichler, Hermann. *Recht und Reich bei Dürer*, Forschungen zur Rechts-und Kulturgeschichte, 8. Innsbruck: Universitätsverlag, 1976.

The published, extensively documented version of a lecture given to mark the opening of a Dürer exhibition in Steyr. The artist's position as citizen of an Imperial free city is discussed. Dürer is also situated vis-à-vis the introduction of the new, Italian-inspired legal system, citing *Codex juris civilis*, published by Frisner and Sensenschmidt, 1975. Dürer's use of legalistic imagery is touched upon (Last Judgment, *Sol justitiae*, the Apocalyptic riders, the so-

called *Four Apostles*) as well as the the idealized portraits of the Holy Roman emperors Charlemagne and Sigismund made for Nuremberg's *Heiltumskammer*, and the works commissioned by Maximilian—particularly the *Triumphal Arch*.

205. Einem, Herbert von. "Dürers *Vier Apostel.*" *Stil und Überlieferung*, 124–138. Düsseldorf: Schwann, 1971.

[First published in *Anzeiger des Germanischen Nationalmuseums* (Nuremberg) 1969, 89-103. Still an essential item.] Points out that the title "Four Apostles" is incorrect: St. Mark was not an Apostle but an Evangelist. Long recognized as one of the artist's masterpieces, the work was placed in the upper Regiments-chamber (or *Losunger-Stube*) in the autumn of 1526. As this was a gift to the City Council, Dürer is presumed to have chosen the subject himself, as well as the Bible verses inscribed beneath the four figures (which were cut off and returned to Nuremberg when Maximilian I of Bavaria acquired the panels, not to be reunited with the figures until 1922). Von Einem noted Dürer's rejection of Italian influence in late works such as this, and takes issue with (Panofsky's) theory of a never-completed Mary altar in Netherlandish style, cut short by the Reformation, pointing out that there is no evidence whatever that this was the case. He cites Pirckheimer's letter to Tscherte (1530), saying that Pirckheimer himself, "like our Albrecht," had been "*gut lutherisch*" in hopes that corruption in the [Catholic] church would cease, but now was disillusioned to find the "evangelical scoundrels make the others look pious." Notes Dürer's companions in the Netherlands included south German, Nuremberg, and Augsburg merchants, as well as the Portuguese factor (likely a Marrano; they were well-disposed toward Luther at this time); his standing as Nuremberg humanist; and his correspondence with Spalatin. Discusses the position of the City Council in 1525 in closing the convents and monasteries but opposing Thomas Müntzer and the Peasant revolt, and citing the trial and expulsion from the city of the schoolmaster Hans Denck and the three "godless" young artists (Jörg Pencz and the Beham brothers), as well as the arrest of Dürer's *Formschneider*. Relates the artist's emphasis on Sts. John and Paul (the two full figures) to the fact that John was Luther's favorite of the four Evangelists, while Paul's attribute is his traditional sword—here interpreted as a weapon to be used against civic unrest. Von Einem sums up the literature on the

four holy men as representing the four temperaments, first men-
tioned by Johann Neudörfer (1497–1563), the Nuremberg writing-
master who had done the lettering of the text on the panels. The
author also cites G. Pfeiffer's hypothesis that the four may be por-
trait heads: St. John closely resembles Melanchthon. Possibly the
other three might be modeled on Camerarius, Michael Roting, and
Hieronymus Baumgartner. Attention is called to Karlstadt's policy
of iconoclasm (as well as of his dedication of a pamphlet to Dürer),
and Dürer's documented regret for the destruction of art works and
art treatises in ancient times. Includes a useful bibliography of the
earlier literature, including Panosky's 1931 article, "Zwei Dür-
erprobleme," in *Munchner Jahrbuch* (1–48).

206. ———. *Goethe-Studien*, Collectanea Artis Historiae, Munich: W.
 Fink, 1972.

Contains the author's essay on Goethe's writings on Dürer [*Goethe
und Dürer*. Goethe, who stopped in Munich on his way to Italy,
was particularly taken with Dürer's so-called *Four Apostles*, re-
marking on its *"unglaublichen Grossheit"* (October 18, 1786: see
also the Hamburg edition of Goethe's complete works, vol. 2, p.
103).

207. ———. "Notes on Dürer's *Melencolia I.*" *Print Review* 5, Spring,
 1976. A Tribute to Wolfgang Stechow (1976): 35–39.

Expanding on the research of Saxl, Panofsky, and Klibansky, dis-
cusses in particular the iconography of "Night"—one important re-
spect in which Dürer's *Melencolia* differs from calendar
illustrations of the four temperaments, as well as from representa-
tions of Saturn, the planet of melancholy. Von Einem points out that
Saturn also is the planet of Night, as well as of Melancholy, and that
in south Italian medieval scrolls "Caligo" (Night) is personified as a
woman covered by a mantle, her head resting in her hand. Cites an
anonymous Venetian engraving of the early sixteenth century as a
possible source, and reproduces the 1552 woodcut by Antonio
Francesco Doni (*I marmi* that is dependent on it. Reaffirms Panof-
sky's interpretation of the print as a "spiritual self portrait" of Dürer.

208. Eisler, Colin. *Dürer's Animals*, Washington/London: Smithsonian
 Institution Press, 1991.

Well produced and liberally illustrated, this is basically a book for the general reader, but also can be of use to the specialist. Although undocumented it is thoroughly indexed and has a bibliography. Beginning with the artist's training and early years, it includes subsequent chapters on the various Madonnas with animals; the bird, animal, and insect studies; St. Jerome and the lion; dogs; farm animals; equestrian motifs; exotic animals; mythical creatures; animals associated with sin; and a short, unillustrated section on "poached hares and copy cats," which touches very briefly on the use of Dürer's animals—particularly the ones from the prints—as models for such younger artists as Lucas van Leyden.

209. Eisler, William Lawrence. *The Impact of the Emperor Charles V Upon the Visual Arts*. Ph.D. dissertation, Pennsylvania State University, 1983.

See especially Chapter 2—"State Art and Maximilian I" (27–94). Discusses Maximilian's aims as set forth in the *Weisskunig* (1514), in which the good ruler goes to great lengths to acquire knowledge of his forefathers, as well as to immortalize his own deeds in words and images. The systematic collection of historic coins was part of this effort, as was the study of painting—in what proves to be a strictly utilitarian way. Also of interest is Maximilian's establishment of regular postal service, centered at Innsbruck and reaching Milan (1500), Mantua (1507), and Ravenna. The author addresses the question why Maximilian was so focused on the past, since the office of Holy Roman Emperor was not hereditary. See also Chapter 4 on Charles V in the Low Countries, 1520–1540.

210. Eksardjian, David. "A Dürer Drawing and a Classical Torso." *Master Drawings* 32 (1994), 273–274.

Suggests the the drawing of a female nude seen from the back (Paris, Louvre) may have begun as a drawing after the Apollo Saurocthonos (Rome: Casa Sassi), and dates it to 1494–1495 during the first trip to Italy.

211. Emmer, Michele. "Art and Mathematics: The Platonic Solids." *Leonardo* 15, no. 4 (1982): 277–282.

Notes the special interest shown by Renaissance artists in geometric plane shapes and solid forms, particularly regular or Platonic

solids. Mentions Uccello, and examines Dürer's *Melencolia I* in this connection.

212. Endres, Rudolf. "Zur Einwohnerzahl und Bevölkerungsstruktur Nürnbergs im 15. und 16. Jahrhundert." *Mitteilungen des Vereins für die Geschichte der Stadt Nürnberg* 57 (1970): 242–271.

The demographics of Nuremberg in Dürer's time.

213. Ephrussi, Charles. *Albrecht Dürer et ses Dessins*, Paris: 1882.

Of historic interest as the first monograph on the artist's drawings. Ephrussi, who had come from Odessa by way of Austria, was an early collaborator on the *Gazette des Beaux-Arts*.

214. Ernstberger, Anton. "Kurfürst Maximilian I. und Albrecht Dürer. Zur Geschichte einer grossen Sammlerleidenschaft." *Anzeiger des Germanisches National-Museums 1940–1953* (1954): 143–196.

Basic reading, developed from primary documents in the Nuremberg Stadtarchiv. Discusses the major early collections of Dürer's work, beginning with Dürer's commissions from the City Council of Nuremberg and the collections of Pirckheimer and his Imhoff heirs, and the later collections of the goldsmith Wenzel Jamnitzer, the physician Melchior Ayrer, the merchants Paul Praun and Martin Peller, and others; the royal collections of emperors Maximilian and Rudolf II; Charles I of England, Christina of Sweden, and Philip IV of Spain, before concentrating on those of the House of Wittelsbach, and in particular of the Elector Maximilian I (1597–1651), who prized Dürer's work above that of all other artists. Relates in detail the negotiations for the acquisition of the *Paumgärtner Altar* (from St. Catherine's Church, Nuremberg), and the doubts about the authenticity of the wings; the *Heller Altar* from Frankfurt, Dominican Church in 1612–1614; the marching orders given to general Tilly to retrieve the *St. Jerome* altarpiece from Stendal; the carrot-and-stick treatment of the Nuremberg Council in order to obtain the so-called *Four Apostles* (Four Holy Men). Reproduces the Imhoff inventory of April 1630 (twenty-eight works, with asking prices, which the Elector Maximilian thought were too high); the question of a Dürer signature forged by Hans Imhoff, and of the presence of copies in the Imhoff collection (which had once been sent on approval to Rudolph II in Prague, who subsequently returned it for unknown reasons.) Also lists the

Imhoff pictures sent on approval to Amsterdam in 1633 by Hans Hieronymus Imhoff, as recorded in his *Geheimbuchlein*, and records the sale of the Pirckheimer library to Thomas Howard, Lord Arundel during the latter's visit to Regensburg in 1636.

215. Ettlinger, Helen S. "The Virgin Snail." *Journal of the Warburg and Courtauld Institutes* 41 (1978): 316.

A brief but fascinating note regarding the symbolism of the snail, as manifested in the marginal drawings for Maximilian's Prayer Book, as well as on an altarpiece of the Annunciation by Cossa (Dresden, Gemäldegalerie). The snail became a symbol of perpetual virginity in the early Renaissance. Franz von Retz in his *Defensorium inviolatae virginitatis beatae Mariae* postulates that, as the snail became pregnant from the dew of heaven, so did the Mother of God become pregnant through the Holy Spirit.

216. Evans, Mark. *Northern Painters and Italian Art from the Mid-Fifteenth to the Early Sixteenth Centuries.* Ph.D. dissertation, University of East Anglia, 1983.

Discusses distinguished Northern painters who visited northern Italy during this period, including Rogier van der Weyden, Michael Pacher, Joos van Wassenhove, and Dürer. The author finds that in terms of influence, fifteenth-century Florentines were virtually ignored by northern artists—exceptions being Fra Angelico, Andrea del Castagno, and Donatello. The most influential Italian artist in this respect was Mantegna, and after him Piero della Francesca and the Bellini family. Direct copying was rare until Jan Gossaert's day, although compositional motifs and narrative devices were adapted.

217. ———. "Pollaiuolo, Dürer and the Master IAM van Zwolle." *Print Quarterly* 3, no. 2 (1986): 109-116.

Examines the influence of Antonio Pollaiuolo's engraving, *Battle of the Nudes,* on Northern artists of the fifteenth and sixteenth centuries, including Dürer and the Zwolle Master.

218. Evers, Hans Gerhard. *Dürer bei Memling*, Munich: Fink, 1972.

Highly speculative. The author, better known for his publications on Flemish painting, maintains that Dürer visited the Netherlands on his bachelor's journey, as had been fashionable for young German

journeymen of the previous generation, and that, moreover, he was accepted into the workshop of the German-born Hans Memling in Bruges at the time when Memling would have been at work on his Crucifixion altarpiece for export to Lübeck (1491). His case rests heavily on the supposed identificaton of the blond boy to the left of St. Dismas's cross in the Lübeck altarpiece as a portrait of young Albrecht Dürer—slender evidence indeed. [See also the review by Josua Bruyn, *Oud-Holland* 90/2 (1976), 132.]

219. ———. "Zur Zeichnung *1514 die grosz kirch zu Antorff* in der Albertina." *Pantheon* 32, no. 3 (1974): 247–248.

This concerns the drawing of the Church of Our Lady (now the Antwerp Cathedral) in the Albertina inscribed "*1514 die grosz kirch zu Antorff*," in Dürer's hand. Formerly it was assumed that the drawing had been made and dated by Dürer and that the date was contemporary with the drawing. Unfortunately, however, it is now known beyond a doubt that Dürer was never in Antwerp in 1514, and that the drawing itself is late Gothic in style, and thus suspiciously old-fashioned in comparison to Dürer's known works from that year (which would include two of the *Meisterstiche*, among other things). To complicate the issue still further, the drawing shows the completed tower of Antwerp Cathedral erected in 1508. The upshot has been that the drawing has generally been rejected as an autograph work by Dürer. This article, which is highly speculative, finds certain similarities to Dürer's early watercolor landscapes, however, and argues that he could have made the body of the drawing during a hypothetical visit to Antwerp (undocumented) while on his bachelor's journey in approximately 1490–1491, and calls for new enquiry into the building history of the cathedral in the hope that new evidence regarding the construction of the octagonal storey of the north tower might enable the drawing to be dated during the bachelor's journey. This article should be read guardedly, bearing in mind that Evers (in *Dürer bei Memling*, q.v.), has argued on the basis of the portrait of an unidentified blond youth in Memling's Lübeck altarpiece that Dürer must have been a journeyman in the Memling studio in Bruges while the altarpiece was in progress, and that Memling, a fellow German, used the handsome youth as a model. A simpler solution might be that the drawing was made by an older artist still working in the Gothic style—and that it came into Dürer's possession because of

his interest in architecture, amply demonstrated in his travel diary of 1520–1521. In any event, Dürer's supposed presence in Antwerp in 1490–1491 is entirely undocumented, and seems highly unlikely.

220. Eye, August von. *Leben und Wirken Albrecht Dürer's*, 2 (revised; 1st ed. 1860) ed. Nördlingen: G. H. Beck, 1869.

Sets the agenda for all future "Life and Art . . ." books. Discusses the artist's apprenticeship and *Wanderjahre*, and the state of the visual arts in late medieval Germany in the fifteenth century. Divides Dürer's activity into periods, beginning with 1491–1506, including discussions of his marriage to Agnes Frey and his relationship to Konrad Celtis and Hartmann Schedel. Gives extended discussions of early portraits, and such prints as the Small Courier; the Four Witches (pp. 115ff., opining that no happily married man would have made such a print); the Apocalypse series; the Madonna with the Monkey; the *Meerwunder* (here identified a the Rape of Amymone); Hercules Killing the Stymphalian Birds; and the small genre engravings, culminating in the Fall of Man and the Green Passion. The 1505–1507 trip to Italy is given a separate chapter (Cahpter 4), while the high point of the artist's career is seen to be the years 1507–1513 (Chapter 5). Subsequent chapters deal with the years 1514–1519 (Chapter 6), including the works for Maximiian and the trip to the Augsburg Reichstag; the Netherlandish journey (Chapter 7); and the last years, 1521–1528 (Chapter 8). Special features are the notes, which contain interesting information regarding portrait sitters, provenances and documents; a handlist of works, and—quite a unique feature—a fold-out comparative table detailing the Imhoff inventories of 1573, 1574, 1580, 1588, 1628, and 1633–1658.

221. Falk, Tilman. "Naturstudien der Renaissance in Augsburg." *Albrecht Dürer und die Tier- und Pflanzenstudien der Renaissance–Symposium. Die Beiträge der von der Graphischen Sammlung Albertina von 7. bis 10. Juni 1985 veranstalteten Tagung*, 79-89. Ed. Fritz Koreny. Vienna: Jahrbuch der Kunsthistorischen Sammlungen in Wien, 1986.

Discusses plant and animal studies by Hans Burgkmair, the elder Holbein, and the Monogrammist CA with the Acorn in relation to those by Dürer.

222. Fehl, Philipp. "Iconography or *Ekphrasis*: The Case of the Neglected Cows in Titian's *Rape of Europa*." *Acta del XXIII Congreso Internacional de Historia del Arte*, 260–277. 3 vols. Granada: Universidad de Granada, 1973.

On the basis of cows in the background, Fehl argues that Ovid, rather than Achilles Tatius is the source for Titian's *Rape of Europa* (Boston, Gardner). In an appendix, he discusses Dürer's drawing of the same subject (Albertina).

223. Ficker, Friedbert. "Dürers Pflanzenaquarellen." *Deutsche Apotheke-Zeitung* 27 (1971): 1008–1011.

Identifies the healing properties of some of the plants appearing in Dürer's watercolors: *Marzell*, recommended by Albertus Magnus for controlling bleeding and by Hildegard of Bingen for treating broken bones, as well as an antidote for love-spells; dandelions for gall bladder ailments; *Pauseblümchen* for festering ("hot") wounds; *Bock* for "cold nature."

224. Field, Richard S. *Albrecht Dürer, 1471–1528, A Study Exhibition of Print Connoisseurship*, Philadelphia: Philadelphia Museum of Art, 1970.

One of the most innovative and useful of the 1971 exhibitions was this selection of early and late impressions and copies arranged and catalogued by Richard Field for Philadelphia, and held over in Washington.

225. Fink, Otto. "Zur Frage der Identifizierung von Dürers Rheinburg-skizzen." *Burgen und Schlosser* 18 (1977), 61–64.

Identifies one of the middle-Rhenish castles sketched during the Netherlandish journey (1520–1521) as Burg Lahneck, and another as either Burg Rheinfels or Burg Katz.

226. Finke, Ulrich. "Dürers *Melencolie* in der französischen und englischen Literatur und Kunst des 19. Jahrhunderts." *Zeitschrift des deutschen Vereins für Kunstwissenschaft* 30 (1976): 67–85.

The author, a member of the Art History faculty of the University of Manchester (UK) published this and the related general study of Dürer-reception in France and England (q.v.) after having been invited to lecture on the subject at Nuremberg's Stadtmuseum Fembohaus in 1975. His work is absolutely essential reading.

227. ————. *Französische und englische Dürer-Rezeption im 19. Jahrhundert*, Renaissance Vorträge, 4/5. Nuremberg: Stadtgeschichtliche Museen, n.d.

This booklet was developed from a lecture given by the author at Nuremberg's Stadtmuseum Fembohaus on May 29, 1975. This or the pamphlet should be required reading for anyone interested in Dürer's reception, particularly in the nineteenth and twentieth centuries. Discusses Alfred Michiel, Delacroix, Victor Hugo, Théophile Gauthier, Gérard de Nerval, Baudelaire, and Sartre; William Blake, Fuseli, Charles Lamb, Lord Eastlake, Ruskin, Prince Albert, Burne-Jones, James Thomson, and William Bell Scott among others.

228. Fiore-Hermann, Kristina. "Das Problem der Datierung bei Dürers Landschaftsaquarellen." *Anzeiger des Germanischen Mationalmuseum* 89 (1971): 122–142.

The Nuremberg exhibition of 1971 provided the opportunity to view Dürer's landscape watercolors together as a group (except, of course, for those still missing from the Bremen museum since World War II). The differences in technique were striking. These works had been dated in wildly different ways until the publication of Winkler's work, which was so authoritative as to discourage further investigation. He placed them all between 1495–1500. But Winkler's chronology rests on an outmoded art-historical concept—that of the supposed opposition of color and line. Fiore-Hermann gives a brief overview of the literature, and compares the landscape watercolors with the landscape backgrounds of the artist's dated panel paintings, such as the *Portrait of Oswolt Krel*; the *Adoration of the Magi* (Uffizi); and with the watercolor *Dream of the Deluge*, which is securely dated 1525. She makes a case for dating the *Weidenmühle* (Mills on a River Bank: Paris) after 1506, and the *Kalkreuth* landscape (Berlin) as late as 1516–1520.

229. Firmenich-Richartz, Eduard. *Sulpiz und Melchior Boisserée als Kunstsammler. Ein Beitrage zur Geschichte der Romantik*, Jena: 1916.

The classic monograph on the Boisserée brothers' collection, developed from the 1827 inventory, taken immediately prior to its sale to Ludwig I of Bavaria for 240,000 gulden. (The collection was to be incorporated into the Alte Pinakothek upon its foundation in 1836.) The collection included the *Lamentation* made for

Hieronymus Holzschuher (No. 193); the wings of the so-called Jabach Altar (*Joachim and Joseph*, and *Simeon and Lazarus*, nos. 194 and 195), as well as five paintings by followers of Dürer (Nos. 196–200).

230. Fischer, Erik. *Albrecht Dürer, Kobberstik og Raderinger*, Copenhagen: Statens Museum for Kunst, 1971.

King Christian of Denmark, who knew Dürer personally and had entertained him at dinner when both were sojourning in the Netherlands, once owned what must have been a spectacular set of the artist's prints. While most of those perished subsequently in a palace fire, there has been a special effort in the Copenhagen print room to assemble a comparable collection with impressions of fine quality. This catalogue of the Dürer Year exhibition is by the Director of Copenhagen's Print Room (now retired).

231. Flechsig, Eduard. *Albrecht Dürer, sein Leben und seine künstlerische Entwicklung*, 2 vols. Berlin: Grote, 1928.

This is one of the standard older biographies of Dürer, written by a cleric whose forte was the reliable use of archival material. He later wrote what became the standard monograph on the life of Martin Schongauer.

232. Fleischmann, Peter. "Anmerkungen zum Patriziat und zu Kunstsammlungen des 16. Jahrhunderts in Nürnberg." *Kunst des Sammelns. Das Praunsche Kabinett. Meisterwerke von Dürer bis Carracci*, 13–24. Ed. Katrin Achilles-Syndram. Nuremberg: Verlag des Germanischen Nationalmuseums, 1994.

Fleischmann's essay deals with the status of the Praun family within Nuremberg's patriciate, from 1363 until the late eighteenth century, discussing the changing character of the city's ruling class from the small group of ministers appointed by the Imperial court (1319-1332) to their replacement by the upper bourgeoisie. The distinctions between *Wohledelgeboren*, *Edel*, *Ehrsam*, and *Patrizier* are made clear, as are the means by which new families could be elevated to eligibility for membership in the city council as older families died out. Of particular interest is the brief history of the Imhoffs as heirs to the Pirckheimer collection of Dürers.

233. Franke, Ilse O'Dell. "Die Nachwirkung von Dürers Tierdarstellungen auf Arbeiten Jost Ammans." *Albrecht Dürer und die Tier- und*

Pflanzenstudien der Renaissance—Symposium. Die Beiträge der von der Graphischen Sammlung Albertina von 7. bis 10. Juni 1985 veranstalteten Tagung, 91–99. Ed. Fritz Koreny. Vienna: Jahrbuch der Kunsthistorischen Sammlungen in Wien, 1986.

Discusses Amman's nature studies for Conrad Gessner as influenced by Dürer's animal studies.

234. Frank, Volker. "Die herausgerissene Wahrheit." *Bildende Kunst* 4 (1978), 165–168.

Deals with the realism of Dürer's charcoal drawing of his dying mother (Berlin: 1514). The title is a play on the artist's own statement from the *Unterweysung der Messung*, that "art" (i.e., knowledge) is embedded in Nature, and that he who can extract it has it [*wer sie heraus kann reissen, der hat sie,*].

235. Frankfurt am Main. Liebighaus Museum alter Plastik. *Dürers Verwandlung in der Skulptur zwischen Renaissance und Barock*, Herbert Beck and Bernhard Decker. Frankfurt am Druckerei Hugo Hassmüller,

[Dürer's Transformation in Sculpture from Renaissance to Baroque.] The catalogue of an international loan exhibition held at the Liebighaus from November 1, 1981 until January 17, 1982. Inspired by the exhibitions in Munich and Nuremberg devoted to the paintings and graphics of the "Dürer-Renaissance" around 1600, this interesting exhibition assembled fine examples of the sculpture of the same movement from the collections of major European and American museums. An introductory essay identifies several of the most important themes initiated or popularized by Dürer's designs, and offers general remarks on the stylistic characteristics of German Mannerism, and the character of the *Kunst und Wunderkammern* in which many such works were originally displayed. Concluding essays by Bernhard Decker address the problems of Dürer forgeries, historicism, and Dürer's image among his own contemporaries. Artists represented in the exhibition include Hans Wydyz (1457–1510); Hans Schwarz (1520) and David Degler (1600/1605–1682) of Augsburg; Matthias Gebel (1527–1528); Hans Daucher; Willem van den Broeck of Antwerp (1549); Albert von Soest (d. Lüneburg ca. 1587–1590) Hans Petzolt (1628); Antonio Abondio (1538–1591); Master JH of Passau (workshop); Master IEG of Vienna (1691); Peter Wiber of Nuremberg (1603);

Caspar zur Lahn of Tübingen (1628); Georg Pfründt (1603–1663); Christoph Angermair (d. Munich 1623–1633); Caspar Gras (of Innsbruck? ca. 1620); Georg Schweigger (mid-seventeenth c.); Leonhard Sattler (1676–1744); Pierre Legros (ca. 1700); Bernhard Kern (circle); and a large number of anonymous works of high quality by Austrian, Bavarian, Swabian, and Netherlandish sculptors and goldsmiths. Several works by Dürer's older contemporary Veit Stoss also are included. Secular as well as sacred works in all three-dimensional media are included, each with full catalogue entry and illustration. [Reviewed by Malcolm Baker in *Burlington Magazine*, 124 (July 1982), 471–472; Jörg Rasmussen in *Kunstchronik* 35 (July 1982), 240–248; Christian Theuerkauff in *Pantheon* 40 (January–March 1982) 54–56.]

236. Fredel, Jürgen, and Franz-Joachim Verspohl. "Zur Kritik der Künstlerideologie in der ersten Hälfte des 19. Jahrhunderts–Die frühen Dürerfeiern." *Marburger Jahrbuch für Kunstwissenschaft* 19 (1974): 275–287.

Argues that the image of Dürer held by German artists in the early nineteenth century was shaped in accordance with their own middle class ideals in such way that he appeared to have been half medieval patriarch, half independent producer of merchandise. By the middle of the nineteenth century, this image had been adopted by the lower middle-class, producing a wave of Dürer kitsch; by the establishment of the Second Reich, after 1870, Dürer became the poster boy for the whole middle-class notion of upward mobility. The article is a well-researched example of pioneering *Rezeptionsgeschichte* applied to Dürer, and also is representative of what might be called the Marburg approach to art history.

237. Fried, Joseph P. "U.S. Judge Orders Return to East Germany of 2 Dürers Stolen in '45." *The New York Times*, A, B, (June 16, 1981): A1, B19.

Dürer's early portrait diptych of the Nuremberg patricians Hans Tucher and his wife Felicitas, née Rieter (1499), were stolen from the air raid shelter at Schloss Schwarzburg, housing the painting collection of the Weimar Museum during World War II. They found their way onto the art market and had been purchased in 1946 for $500 by the New York attorney, Edward J. Elisophon. The East German government successfully sued for the return of the paintings,

by now worth millions of dollars, which had come to the possession of the Weimar Museum in 1918 from the Archducal collection.

238. Friedmann, Herbert. *A Bestiary for Saint Jerome: Animal Symbolism in European Religious Art*, Washington, D.C.: Smithsonian Institution Press, 1980.

A study of St. Jerome and his animal associates, seen both in the saint's study and in the wilderness. Includes Dürer's *St. Jerome in his Study* (engraving, 1514; pp. 101–114); and handlist of the ten St. Jerome compositions by the artist. Extensive bibliography of animal lore.

239. Fucíková, Eliska. "Historisierendes Tendenzen in der Rudolfinischen Kunst. Beziehungen zur älteren deutschen und niederländischen Malerei." *Albrecht Dürer und die Tier- und Pflanzenstudien der Renaissance–Symposium. Die Beiträge der von der Graphischen Sammlung Albertina von 7. bis 10. Juni 1985 veranstalteten Tagung*, Ed. Fritz Koreny. Vienna: Jahrbuch der Kunsthistorischen Sammlungen in Wien, 1986.

Dürer's influence on nature studies by various artists of the late sixteenth century at the court of Rudolf II. Includes works by Hans Hoffmann and Adriaen de Vries.

240. Fucíková, E. "Umelcí Na Dvore Rudolfa II. A Jejich Vztah K Tvorbe Albrechta Dürera." *Umení* 20, 149ff. (1972):

[The Dürer style and its representatives at the court of Rudolph II.] Has a summary in German.

241. Fuhse, Franz. "Zur Dürerforschung im 17. Jahrhundert." *Mitteilungen aus den germanischen Nationalmuseums* (1895): 66–73.

A review of the seventeenth-century Dürer studies of Joachim von Sandrart, Hans Hauer, and Matthias Quadt von Kinckelbach, by one of the most reliable and important scholars of the late nineteenth century.

242. Gage, John. "A *Locus Classicus* of Colour Theory: The Fortunes of Apelles." *Journal of the Warburg and Courtauld Institutes* 64 (1981): 1–26.

Discusses Pliny's account (*Naturalis historia*) of Apelles' four-color system of painting, noting the ca. 1507–1515 engraving of

Nicoletto da Modena depicting Apelles contemplating a tablet with four geometric shapes, possibly corresponding to the primary colors. The author examines comparisons of Dürer and Titian with Apelles, based on their mastery of color, concluding that until the nineteenth century the four-color theory was associated with the aesthetic ideal of simplicity, which simply adopted identifications of the basic colors that were popular in each period until approximately 1600, when the modern theory of primary colors began to evolve.

243. Galichon, Émile. "Albert Dürer, sa vie et ses oeuvres IV: son oeuvre gravé." *Gazette des Beaux-Arts* 1st ser. 7 (1860): 74–96.

Galichon, editor of the *Gazette des Beaux-Arts*, who also was an excellent connoisseur and collector of old master prints, published this chronologically arranged catalogue of ninety-three engravings, ten etchings and drypoints, together with doubtful and rejected prints. In the following year (1861: Paris) he published a monograph based on his articles for the journal.

244. ———. "Albert Dürer. Sa vie et ses oeuvres. 6. Influence d'Albert Dürer sur les arts en Europe." *Gazette des Beaux-Arts* 8 (1860): 17–24.

An assessment of the artist's importance for European art written by the nineteenth-century French connoisseur and who amassed one of the most important collections of Dürer's prints. Of historical interest.

245. Gall, Günter. "Albrecht Dürer: "also sol der schuch ausgeschnitten werden." Anmerkungen zu einer Zeichnung." *Festschrift für Peter Wilhelm Meister, zum 65. Geburtstag am 16. Mai 1974*, Eds. Anneliese Ohm and Horst Reber. Hamburg: E. Hauswedell, 1975.

Comments on Dürer's two drawings (British Museum, W.938, Collection Sloane 5218–200) for the construction of a shoe, inscribed "the shoe should be cut this way," made for a Nuremberg shoemaker. The article explores the development of shoe styles after 1500, and especially the extent to which Dürer tried to express his own social standing by his choice of shoe style—that is, the upper-class "cow-muzzle" shape (*Kuhmaulschuh*) and vamp decoration. The author, who is on the staff of the Deutsche Ledermuseum in Offenbach am Main, also takes up some problems of

dating that can be resolved more precisely by reference to costume details.

246. Galland, Georg. *Eine Dürer-Erinnerung aus dem romantischem Berlin.*, 1912 ed. Studien zur deutschen Kunstgeschichte, 151. Baden-Baden: Valentin Koerner,

Reconstructs the events of the festival commemorating the three hundredth anniversary of Dürer's death, organized by Gottfried Schadow, Director of the Berlin Academy and held in the Concert Hall of the *Singakademie* on the evening of April 18, 1828 (Dürer's death date according to the newly revised calendar). The eight hundred guests, who were treated to an oratorio written specially for the occasion by the nineteen-year-old Felix Mendelssohn, included the Prussian Crown Prince and his family, as well as the ancient war hero Field Marshall August Graf Neidhardt von Gneisenau—the reformer of the Prussian officer corps. [Berlin now had not only an eighteen-year-old University, and Academies of Art and Music, but also a Superior Military Academy whose young officer candidates were given instruction calculated to produce their "spiritual advancement" and love of country, as well as in the usual military tactics. See Gordon A Craig, *The Politics of the Prussian Army 1645–1945*, Oxford University Press, 1955, Chapter 2, "Reform and Reaction 1807–40," and Hutchison, "Der vielgefeierte Dürer," *Deutsche Feiern*, Wiesbaden, Athenaion, 1977, 25–44.]

247. Garlick, Kenneth. "The Chambers Hall Gift." *Apollo* 117, no. 254 (April 1983): 296–301.

Brief account of the life and activity of the nineteenth-century British collector, Chambers Hall, a major benefactor of both Oxford University's Ashmolean Museum and the British Museum, London. His collection included important drawings by Dürer, as well as by Leonardo, Rembrandt, Claude Lorrain and Watteau. [RILA no. #7473]. Among the Dürer items given to Oxford in 1855 is the famous unfinished watercolor inscribed "Welsch Pirg" (i.e., foreign—Italian—mountain, Lugt 551).

248. Garrett, Albert. *A History of British Wood-Engraving and its International Roots*, Tunbridge Wells: Midas, 1978. [U.S. publisher Humanities Press; Atlantic Highlands, NJ, 1978.]

Discusses Dürer, among others, as formative influence on Edward
Gordon Craig, Eric Ravilious, and Lucien Pissarro.

249. Gatti Perrer, Maria Luisa. "Precisazioni su Palazzo Besta." *Arte
Lombarda* 67 (1983): 7–69.

Studies the fresco decoration of the Palazzo Besta (Teglio: ca.
1540–ca. 1630), executed in part under the patronage of Azzo IV
Besta. Discusses literary and visual sources of the frescoes, citing,
among others, the influence of Dürer and the elder Bruegel.

250. Geissler, Heinrich. "Ad vivum pinxit. Überlegungen zu Tierdar-
stellungen der zweiten Hälfte des 16. Jahrhunderts." *Albrecht
Dürer und die Tier- und Pflantzenstudien der Renaissance–Sympo-
sium. Die Beiträge der von der Graphischen Sammlung Albertina
von 7. bis 10. Juni 1985 veranstalteten Tagung*, 101–114. Ed. Fritz
Koreny. Vienna: Jahrbuch der Kunsthistorischen Sammlungen in
Wien, 1986.

Dürer's influence on nature studies by various artists of the late
sixteenth century.

251. Gelbcke, Friedrich August. *Albrecht Dürers Tod: Drama in Zwei
Auflagen*, 112 pages. Leipzig: C.F. Dörffling, 1836.

One of the nineteenth-century plays "starring" Albrecht Dürer as a
pious Christian (and basically medieval) hero.

252. Ghiescu, Gheorghe. "Proportiile Corpului in Arta Anticâ si Mod-
erna." *Arta* 25, no. 11 (1978): 26–29.

A very sweeping survey, in Romanian, of the problems of human
proportion in an artistic, philosophical, aesthetic, pedagogical, and
anthropological context. Discusses the ancient canon, Byzantine
proportion theory, Cennini, Alberti, Leonardo, and Dürer, as well
as more modern proportion theories, including that of Le Cor-
busier, and makes a plea for the study of proportion in light of
modern knowledge.

253. Gibson, Walter S. "Jan Gossaert de Mabuse; *Madonna in a Land-
scape*." *Bulletin of the Cleveland Museum of Art* 61, (November)
(1974): 286–299.

In connection with the discussion of Cleveland's Gossaert
Madonna dating from 1531, the author, a well-known authority on

Netherlandish art, traces Gossaert's development and the roots of his style, including specific comparisons with Dürer's works.

254. Giehlow, Karl. "Dürers Stich, *Melencolia I* und der maximilianische Humanistenkreis." *Die graphischen Künste* no. 26 and 27, *Mitteilungen der Gesellschaft für vervielfältigende Künste* (1903): 29–41 (1903); 6–18 and 57–78 (1904).

An influential early study of the *Melencolia I*, relied upon by later writers, including Panofsky. Identifies the Neoplatonic philosophy of Marsilio Ficino as the general context of the iconography, in particular the *De vita triplici* of 1489 which examines the influence of Saturn on the melancholy temperament.

255. ———. "Poliziano und Dürer." *Die graphischen Künste* no. 25, *Mitteilungen der Gesellschaft für vervielfältigende Künste* (1902): 22–26.

Identifies Poliziano's *Manto* as the source of the iconography of the *Nemesis* (often called *The Large Fortune.*) The Florentine Humanist describes the Roman goddess Fortuna and the Greek goddess Nemesis as the same divinity, and locates her as hovering in the air. Influential for Panofsky.

256. Gilman, Sander. *Seeing the Insane*, New York: Wiley, Brunner/Mazel, 1982.

Detailed history of the imagery of the insane from the early Middle Ages to the present, with emphasis on the interaction between social history, intellectual history and the history of the fine arts. Treats, among others, images by Bosch and Dürer [RILA] [The only references to Dürer are the *Melencolia I* and *Ship of Fools*. *Melencolia I* is analyzed as expresing grief. The Ship of Fools noted as having later become an emblem of insanity.]

257. Giosefi, Decio. "Grandezza e singolarità di Alberto Dürer." *Festschrift Richard Milesi: Beiträge aus den Geisteswissenschaft*, 79–92. Foreword by Friedrich Wilhelm Leitner. Klagenfurt: Verlag des Geschichtvereines für Kärnten, 1982.

Briefly surveys Dürer's work and examines the German and Italian aspects that make his art unique and great. Proposes that the artist's 'Bolognese teacher' can be identified as Giovanni Agostino da Lodi [Author: RILA].

258. Giuliano, Antonio. "Germania capta." *Xenia* 16 (1988): 101–114.

Discusses the 1st century Roman relief of a *Weeping Dacia*, or "Germania capta," formerly in the Cesi collection and now in the courtyard of the Palazzo dei Conservatori, Rome, and its reputation and influence in sixteenth century art, illustrating examples of the Renaissance iconography of the seated woman holding her bowed head in grief, including Dürer's *Melencolia I*.

259. Gmelin, Hans Georg. "Illuminierte Druckgraphik um 1600: ein Phänomen der 'Dürer-Renaissance'?" *Städel-Jahrbuch* 9 (1983): 183–209.

Examines the practice in Germany (ca. 1600–1620) of hand-coloring prints made in the fifteenth through seventeenth centuries, especially those by Albrecht Dürer and his contemporaries. This practice, which today would be considered criminal behavior, was not unusual, as fifteenth-century woodcuts were not highly valued in their own day and in the following two centuries, when it was quite common to hire a *Briefmaler* to color such cuts when they were to be used for book illustrations. Everard Jabach's [1567–1636] *Stammbuch*, assembled in Cologne and now in the library at Wolfenbüttel, has many such hand-colored cuts. The Nuremberg illuminator Georg Mack ("Master GM" of 1588) mounted small engraved plates on book leaves that he provided with hand-drawn marginal illumination. Other such colorists include Dominikus Rottenhammer (active 1626), who colored an impression of Dürer's *St. Jerome in His Study*, and Johann Wiericx, who illuminated the *Melencolia I*—both examples now in the Veste Coburg, which has the best collection of such works. Others can be found in the Graphische Sammlung in the former East Berlin (uninventoried, but mostly from Nagler's collection).

260. ———. "Vorbild und Rezeption: Motive aus Dürers Graphik in Kunstwerken der Niedersächsischen Landesgalerie." *Weltkunst* 54, no. 6 (March 15, 1984): 699–702.

[Model and influence: motifs from Dürer prints in art objects in the Niedersächsische Landesgalerie, Hanover.] Identifies pictorial and figural quotations from Dürer prints in paintings and sculpture (mostly sixteenth century German) in the collections of the Hanover gallery.

261. Goddard, Stephen. "Ernst Förster's Drawing *Dürer at His Mother's Deathbed* and Its Role in the 1828 Dürer Festival." *Pantheon* 46 (1988): 117–120.

The Curator of Prints and Drawings at the University of Kansas' Spencer Museum of Art (Lawrence, KS) reports on the acquisition (1976) of a preparatory drawing by Ernst Förster for one of the transparencies purporting to illustrate scenes from the life of Dürer that were made for the gala 1828 celebration of the artist's three hundredth death anniversary in Nuremberg. [For the attribution to Förster see Mende, "Die Transparente" . . . (1969).]

262. Gohr, Siegfried. "Anna Selbdritt." *Die Gottesmutter; Marienbild in Rheinland und in Westfalen*, 243–254. Recklinghausen: A. Bongers, 1974.

[One from a collection of seventy-six articles on Marian imagery in the Rhine valley and Westphalia.] There is no convenient English translation for the German *Anna Selbdritt*—a "maternal Trinity" consisting of overlapping images of St. Anne with her daughter the Virgin Mary, and her grandson the Infant Jesus. Gohr traces the history of the veneration of St. Anne from its origins in the proto-Gospel of St. James (ca. 150 A.D.) and in sixth-century Byzantium, to the introduction of the cult in Europe through the importation of relics during the crusades, touching on various shrines—including Düren, which figures in Dürer's travel diary—and deals with the basic types of the image. He divides them into the Italian *Sapientiae* and the Northern horizontal arrangement popularized by Dürer [example: New York, Metropolitan Museum]. Also deals with the transformaton of Anne into a matriarch after 1500 (Cranach).

263. Goldberg, Gisela. "Dürer-Renaissance am Münchner Hof." *Um Glauben und Reich. Kürfurst Maximilian I: Beiträge zur Bayerischen Geschichte und Kunst 1573–1657*, 318–322. Ed. Hubert Glaser. Munich: Hirmer, 1980.

An essay presented in conjunction with the exhibition held at the Munich Residenz, June 12 to October 5, 1980. Discusses the enthusiasm for Dürer at the Munich court as reflected in the original paintings and copies in the collections of Wilhelm V and Maximilian I. Summarizes Goldberg's lengthier article in *Münchner Jahrbuch* (1980).

264. ———. "Münchner Aspekte der Dürer-Renaissance unter beson-
derer Berücksichtigung von Dürers Tier-und Pflanzenstudien."
Jahrbuch der Kunsthistorischen Sammlungen in Wien 82/83
(1986): 179–188.

Discusses the religious pastiches by Georg Vischer (*Christ and the
Adulteress, Bearing of the Cross*), and also the sometimes hilarious
operations performed on genuine Dürers in order to bring them
into line with current tastes—most notably the landcape and
horses once added to the portraits of the Paumgartner brothers; a
flying stag beetle à la Dürer added to the sky over Hans Burgk-
mair's *St. John on Patmos*, and more.

265. ———. "Veränderungen von Bildern der ersten Hälfte des 16.
Jahrhunderts: Versuch einer Interpretation." *Städel-Jahrbuch* 9
(1983): 151–182.

Discusses paintings from the first half of the sixteenth century in
the Bavarian State Collections, once owned by the Archduke Max-
imilian I, which were altered during the seventeenth century. In ad-
dition to works by Hans Burgkmair, Lukas Cranach (whose
Lucretia was modestly provided with a minidress), the elder Hol-
bein, and others, several major works by Dürer were "modern-
ized." The tiny portraits and arms of the family of the Nuremberg
goldsmith, Albrecht Glimm were overpainted with a pattern of
grasses and other plants in both lower corners of the *Lamentation*
(ca. 1500), and came to light again only in the cleaning of
1923–1924, which also revealed that Christ's left foot had been
completely repainted as well, and that many smaller changes had
been made in the landscape background. The *Paumgartner Altar-
piece* had been dismembered in order to display the *Nativity* sepa-
rately from the wings. In the *Nativity* panel, the small portraits of
the Paumgartner family had been overpainted with cut stones
(lower left) and with a hatchet or adze (lower right). The plain
black backgrounds of the wing paintings featuring the full-length
portraits of two Paumgartner brothers as Sts. George and Eustace
had been covered over with elaborate landscape work based on the
background of the *Knight, Death, and Devil*, and each saint had
been provided with a horse and tournament helmet. Archival pho-
tographs of both altarpieces are reproduced, showing them before
and after cleaning.

266. ———. "Zur Ausprägung der Dürer-Renaissance in München." *Münchner Jahrbuch der bildenden Kunst* 31 (3rd series) (1980): 129–175.

Required reading; a wealth of useful documentation regarding the previous scholarship on Dürer reception, including sixteenth and seventeenth-century works painted in imitation of Dürer's style. Discusses the use of the term "Dürer-Renaissance" for art produced in the late sixteenth-early seventeenth centuries with a retrospective character oriented primarily around Dürer, but also around his contemporaries, and establishes the chronology of the movement, which coincides with the rule of Maximilian I, Duke of Bavaria (1597–1651), and Bavarian Elector after 1623. Discusses the rivalry between Maximilian I and the Emperor Rudolph II, each of whom tried to outdo the other in acquiring original works by the artist, thus setting off a wave of forgeries as well as of reproductive copies and new compositions in which individual figures and other motifs from Dürer are recycled—among them several works by Georg Vischer. Lists the Dürers in Maximilian I's collection and their provenance: principally the Imhoff and Tucher collections, Church of St. Catherine and City Hall (Nuremberg), and the Dominican Church (Frankfurt: the Heller Altar). Also lists the paintings by Cranach, Altdorfer, and other German artists in Maximilian I's possession, including those inherited from his father, Wilhelm V. Illustrates a wonderful, anonymous seventeenth-century pastiche, *The Twelve Apostles* (Bayerische Staatsgemälde-sammlungen), which combines the *Four Holy Men* with the Apostles from the Heller Altar. Also illustrated are Georg Vischer's *Christ and the Adultress* (1637), featuring the 1500 face of Dürer as Christ; and the same artist's *Bearing of the Cross*. Includes a valuable handlist of other "creative copies" of this nature by French, Italian, and Dutch artists.

267. Goldberg, Gisela, Bruno Heimberg, and Martin Schawe. *Albrecht Dürer. Die Gemälde der Alten Pinakothek*, Munich: Bayerische Staatsgemäldesammlungen, 1998.

Foreword by Georg, Prince von Hohenzollern. This very substantial volume serves as both a collection catalogue and the catalogue of the exhibition celebrating the completion of ten years' restoration work on the paintings damaged in 1988 by an acid attack: the

Paumgartner Altarpiece, and the Glimm *Lamentation*. (It has not been possible to restore the third painting—the *Mater Dolorosa* that once formed the center of an altarpiece with the *Seven Sorrows* panels now in the Dresden museum.) The full conservation history is documented. Infrared reflectography was performed on all of the Munich Dürers, as well as on the Augsburg Staatsgalerie's *Portrait of Jacob Fugger* and Nuremberg's *Hercules and the Stymphalian Birds* (or *Harpies?*). All photography and pigment analyses were placed on display with the paintings, which also included Munich's undamaged Dürers—the 1500 *Self Portrait*, the *Four Holy Men* (or *Apostles*), the *Lucretia*, the *Holzschuher Lamentation*, the *Portrait of Wolgemut*, the *Madonna with the Carnation*. The catalogue contains six essays: two by Martin Schawe on aspects of the Munich collection; Bruno Heimberg's on Dürer's painting technique; Andreas Burmeister and Christophe Kalkel on Dürer's pigments; Ursula Baumer, Irene Ficaler, and Johann Koller on his binding medium; Andreas Burmeister on retouching the damaged areas. A catalogue section follows, with full scholarly apparatus for each of the fourteen paintings. Other useful features include a catalogue of copies after Dürer, and concordances to the catalogue and the inventories. The full bibliography is particularly useful for its references to exhibition catalogues.

268. Goldberg, Gisela, and B. Heine. *Dürer-Renaissance*, Munich: 1971.

In 1971 it had been agreed that other German museums would lend great works by Dürer to Nuremberg's Germanisches Nationalmuseum for the most important of the many exhibitions mounted in honor of the artist's five hundredth birthday. Following the lead of Hans Kauffmann, who had pioneered research in the field of Dürer reception in the seventeenth century, Munich arranged this interesting show around its own collection of works inspired by Dürer.

269. Gombrich, Ernst H. *Aby Warburg, An Intellectual Biography. With a Memoir on the History of the Library by F. Saxl*, 2nd ed. Chicago: University of Chicago Press, 1986.

Discusses Warburg's 1905 paper on Dürer's response to classical "pathos formulae" (p. 181: "Dürer und die Italienische Antike," in A. Warburg, *Gesammelte Schriften*, vol. 2, 2 vols., Leipzig/Berlin, 1932, pp. 443–449); the *Melencolia I* (211–215: *Ges. Schr.* 530–531).

270. ———. "The Evidence of Images." *Interpretation: Theory and Practice*, 97–103. Ed. C. S. Singleton. Baltimore: 1969.

 Interprets the *Knight, Death, and Devil* in terms of a dialogue between Death and the Knight, in which Death warns of life's unpredictabilities, the perils of overconfidence and pride, and the threat of Hell.

271. ———. *The Sense of Order*, passim, esp. pp. 251–254. Ithaca (NY): Cornell University Press, 1979.

 Discusses Dürer's predilection for bilateral symmetry in the marginalia of the *Prayerbook* as a function of his contact with the classical tradition and Renaissance engraved ornamental designs.

272. Goris, J. A., and Georges Marlier, Eds. *Albrecht Dürer: Diary of his Journey to the Netherlands. 1520–1521.*, Translator Martin Conway. English trans. ed. London: Lund Humphries, 1971.

 An edition of Martin Conway's 1889 translation into Victorian English of Dürer's travel diary, with an introductory essay discussing the religious turmoil of the period and the Protestant sympathies of Dürer's Antwerp contacts.

273. Gottlieb, Carla. "The Window in the Eye and the Globe." *The Art Bulletin* 57, no. 4 (December) (1975): 559–560.

 In a brief article the author discusses Jan Bialostocki's recent contribution to the *Festschrift für Gert von der Osten* (Cologne, 1971, q.v.), titled "The Eye and the Window: Realism and Symbolism of Light-Reflections in the Art of Albrecht Dürer and His Predecessors," in which the eye is treated as "the window of the soul"; and that by Hans-Jürgen Horn, "Respiciens per fenestras, Prospiciens per cancellos," in *Jahrbuch für Antike und Christentum* 10 (1967) 51–56, which speaks of the eye as the *reflection* of the soul (or heart, or mind). Gottlieb herself had been the author of a previous study of similar Netherlandish light effects ("The Mystical Window in Paintings of the Salvator Mundi," *Gazette des Beaux-Arts* 66 [1960] 313–332), which was criticized by Bialostocki in his 1971 essay. Gottlieb in the present article takes exception to Bialostocki's naturalistic interpretation of the reflected windows on the Netherlandish *Salvator Mundi*'s globes that the Polish scholar had identified as predecessors of Dürer's use of the window motif in the eyes of certain portrait sitters. Citing biblical and patristic liter-

ature, she contests Bialostocki's denial of an iconographic connection between Christ and the window motif. The article is an interesting one from the point of view of Netherlandish religious imagery, but does not deal directly with Dürer's use of the motif. [In any event, none of the above literature offers a satisfactory explanation, other than the obvious one, for the use of the reflected window in the eye of the *Wild Hare* (watercolor, Albertina).]

274. Götz, Wolfgang. "Historismus. Ein Versuch zur Definition des Begriffes." *Zeitschrift des Deutschen Vereins für Kunstwissenschaft* 24 (1970): 211.

A useful essay on historicism, published on the eve of Nuremberg's exhibition honoring Dürer's five hundredth birth annniversary.

275. Greenfield, K. R. *Sumptuary Laws in Nürnberg. A Study in Paternal Government*, Johns Hopkins University Studies in Historical and Political Science, 36, no. 2. Baltimore: Johns Hopkins University, 1918.

An older but still extremely valuable study of Nuremberg's city statutes regulating dress. For example, gold trimmings for "male persons" were banned except for doctors of law and for knights. The City Council also frowned on fancy shirts, embroidered borders, useless ornamentations, and other "needless and senseless contrivances," and banned the wearing of short jackets revealing too much of the male anatomy.

276. Gregory, Sharon Lynne. "Vasari's Early Interest in Dürer. "Un nordico ritratto" in *Christ Carried to the Sepulchre*." *Apollo* 141, no. 397 (1995): 33–35.

An article developed from the author's doctoral dissertation for Queen's University (Kingston, Ont., q.v.), identifying a figure in Vasari's early painting (Arezzo, 1532) as a portrait of Dürer.

277. ———. *Vasari and Northern Prints: An Examination of Giorgio Vasari's Comments on, and Use of, Woodcuts and Engravings by Martin Schongauer, Albrecht Dürer and Lucas van Leyden*. Ph.D. dissertation, Queen's University, Kingston (Canada), 1996.

This study was prepared under the direction of David McTavish (Queen's University, Kingston, Canada). It examines—in the con-

text of sixteenth-century Italian art criticism—Vasari's qualified praise, in the 1568 edition, of printmakers from north of the Alps as they affected the art of Marcanonio Raimondi, Andrea del Sarto, Jacopo Pontormo, Giovanni Bellini, and others. More innovatively, the author then goes on to examine Vasari's own artistic reliance on such prints, and in particular his interest in Dürer's art from the very beginning of his career (as in the 1532 Arezzo *Christ Carried to the Sepulchre*, in which the author recognizes a portrait of the German artist. This interest continues to the very end of Vasari's working life (e.g., the drawings for the vault of the Florentine Cathedral). The use by Vasari and his pupils of Dürer's *Treatise on Fortifications* (1527) also is discussed, as are Vasari's use of motifs from prints by Schongauer, Cranach, and Lucas van Leyden.

278. Grimm, Harold J. *Lazarus Spengler: A Lay Leader of the Reformation*, Columbus (OH): Ohio State University Press, 1978.

Required reading for anyone interested in Dürer's relationship to the Reformation, and to Nuremberg politics. A full-length biography of Dürer's close friend and neighbor in the Zisselgasse, Nuremberg's Municipal Secretary—the single man most responsible for seeing that the city's transition to the new reforms instituted by Luther went smoothly, without the rioting or iconoclasm that went on in some less fortunate cities. Impeccably researched and documented, gives a full account of Spengler's association with Dürer, which began to supplant the artist's relationship to Pirckheimer in the later years of the artist's life. The author (now deceased) was considered "the Nestor of German Reformation historians in America."

279. Gronau, Georg. "Venezianische Kunstsammlungen des 16. Jahrhunderts." *Jahrbuch für Kunstsammler* 4/5 (1924): 9–34.

Deals with items by Dürer in the collections of Cardinal Grimani (p. 24) and Gabriele Vendramin (pp. 29–30 and 34).

280. Grosch, Gerhard. "Medizinhistorische Bibliographie zum Leben und Werk Albrecht Dürers." *Münchner Medizin. Wochenschrift*, 113 (1971): 810–814.

A bibliographical update of the medical literature concerning Dürer's life and work.

281. Grossmann, Maria. *Humanism in Wittenberg 1485–1517*, Nieuwkoop: B. de Graaf, 1975.

Places Friedrich the Wise's patronage of Dürer in the context of his entire patronage of artists and craftsmen, as well as in that of the pioneering study of the *humaniora* [*sic*] at the newly-founded Wittenberg university, and of Wittenberg as an early center of printing.

282. Grote, Ludwig. *Albrecht Dürer*, The Taste of Our Time, Geneva: Albert Skira, 1965.

Ludwig Grote became Director of the Germanisches National-musem Nuremberg immediately after World War II. His book, in the English translation by Helga Harrison and the attractive but somewhat exaggerated color printing common to the Skira books of the 1950s and 1960s, gives a balanced treatment of the life and paintings (no graphic art) for the general reader.

283. ———. "Albrecht Dürers *Anna Selbdritt*. Ein Auftrag von Linhart Tucher." *Anzeiger des Germanischen Nationalmuseums* (1969): 75–88.

Grote had already published a monograph on the Tucher family (*Die Tucher. Bildnis einer Patrizierfamilie*, Munich, 1961). This article deals with the painting of the Virgin and Child with St. Anne owned by the Metropolitan Museum. After the publication of the Tucher book, he discovered correspondence from 1628 and 1630 proving that the painting had been in the estate of eighty-one-year-old Linhart Tucher in 1568, and stating that Linhart had inherited it from his father, Anton II Tucher. It was further listed in the inventory of Paul IV Tucher in the family archive in Simmelsdorf as a picture "from Dürer's hand," worth twenty-four gulden. Also discussed in the article are the cult of St. Anne in Nuremberg, and the Tucher family's attitude toward the Reformation. The devotion to St. Anne may have been introduced to the city by Conrad Celtis, who had become a friend of Johannes Trithemius—the author of a scholarly treatise on St. Anne—in Heidelberg. Dürer's numerous prints and drawings of the Anna Selbdritt theme also are included.

284. ———, Ed. *Albrecht Dürer, die Apokalypse, Faksimile der deutschen Urausgabe von 1498*, Munich: Prestel, 1970.

A facsimile edition of unusual beauty, with an exemplary introduction by an emeritus Director of the Germanisches Nationalmuseum. Dürer originally published the Apocalypse (1498) in separate Latin and German editions. In later years he reprinted only the Latin one, which makes this facsimile of the German edition doubly useful.

285. ———. "Das Männerbildnis Albrecht Dürers in Boston." *Zeitschrift des Deutschen Vereins für Kunstwissenschaft* 25 (1971): 115–122.

Establishes the identity of the sitter in the poorly preserved painted *Portrait of a Man* (Boston, Isabella Stewart Gardner Museum) as the Portuguese diplomat, Rodrigo de Almada, who also is portrayed in the portrait drawing in Berlin (W.813): KdZ 40)

Berlin accession number, necessary for identifying this particular drawing of ordering a photo.

286. ———. "Der Dessauer Christophorus und der junge Dürer." *Festschrift Klaus Lankheit*, 139–150. Ed. Wolfgang Hartmann. Cologne: M. DuMont Schauberg, 1973.

Discusses the small panel painting of St. Christopher formerly in the Anhaltische Gemäldegalerie, Dessau (present whereabouts unknown—lost, destroyed, or perhaps taken to the Soviet Union at the end of World War II). First documented in the eighteenth-century collection of Princess Amalie von Anhalt (d. 1793). Reviews the literature, and discusses the copy found in Graz in 1921.

287. ———. *Die romantische Entdeckung Nürnbergs*, Munich: 1967.

An early work on the "discovery " of Nuremberg by the Romantic generation, a topic explored more fully during and after the exhibitions of 1971.

288. ———. *Die Tucher. Bildnis einer Patrizierfamilie*, Bibliothek des Germanischen Nationalmuseums Nürnberg zur deustschen Kunst- und Kulturgeschichte, 15/16. Munich: Prestel, 1961.

See especially the section "Veit Stoss, Albrecht Dürer und die Tucher," (pp. 69–85). Two married couples of the Tucher family were among Dürer's earliest portrait clients when he opened his Nuremberg workshop in the late 1490s: Niklaus and Hans XI

Tucher and their wives. Hans XI (nicknamed "der Schnupfer" be-
cause of his allergies) held office in Nuremberg's Treasury Depart-
ment, and was married to Felicitas Rieter (both portraits are now in
Weimar). Nikolaus, whose portrait is lost, was the husband of El-
speth (née Busch), the beautiful woman in the Kassel portrait, who
was the daughter of the man who had charge of Nuremberg's ar-
tillery. Other commissions from the Dürer workshop include Dr.
Sixtus Tucher's two glass paintings in trefoil form (on this, see also
Corine Schleif, 1987 and 1990). The family was one of the most
important in the city, active in city government since the beginning
of the fourteenth century as members of the elite "Small" City
Council and representatives of Nuremberg in the affairs of the Em-
pire. Owners of imposing stone houses, moated castles, and large
tracts of land outside the city, they had made their fortune—as had
all of Nuremberg's patricians—in foreign trade (Venice, Geneva,
Lyon, Antwerp), dealing in silver (a German monopoly), imported
spices, and indigo. Their unusually copious family papers provide
an enormous amount of valuable information about imperial do-
ings, as well as about life in Nuremberg in general (Endres II's
Baumeisterbuch of 1461 is particularly notable). Hans Tucher's
description of his trip to the Holy Land went through twelve
printed editions and became a popular guidebook to Palestine. The
most important member of the family was Anton II, a client of both
Dürer and Veit Stoss, as well as a personal friend of Friedrich the
Wise and Luther, who played an important role in preventing civil
disturbance in Nuremberg during the transition to the Reformed
liturgy. His *Hausbuchlein* is in Dresden. His son Linhart—the last
of the old patriciate—insisted that his own sons keep on in trade,
even after others were taking measures to join the nobility. Lorenz
II gave up the gothic town house in favor of a little *Schloss*. The
Tuchers were pious, and made many gifts and bequests to the
Church: Lorenz I and Sixtus I both studied law and became canons
(St. Lorenz); Sixtus, like Dürer, was a friend of Conrad Celtis.
Tuchers patronized Wolgemut, Stoss, Dürer, Vischer, Flötner, Jam-
nitzer, and were related by marriage to Christoph Scheurl, the Be-
haims, Holzschuhers, Imhoffs and other prominent families.
Tucher papers record the intimate details of Nuremberg's sumptu-
ary laws: for example, the ban on girdles with silver tips over a cer-
tain weight; "fine pearls"; silver purses; slit shoes; coats with
slashed sleeves "so that the undergarment can be pulled through";

rosaries worth more than 12 heller. The differing regulations for each social class, and for each type of occasion are recorded (dance, church, "at home," street wear). On the street, a female patrician must always be accompanied by a servant. Expensive furs (ermine) and gold ornaments were forbidden to all males except nobility. Wives of patricians, however, could wear imported velvet, damask, and so on, if their husbands could afford it. A special suit featuring a high hat was reserved for members of the City Council. There is a full description of the annual (spring) *Schembartlaufen* (p. 17), a raucous ritual phased out after the Reformation, which was originally the special privilege awarded to the city's butchers as a reward for not having rebelled against the city government. The high point was the "Hell," pulled on a sled. Zoning regulations and building codes for *Weiherhäuser* (pond houses) are given (p. 21: compare Dürer's watercolor, London). Other matters discussed include education (Tuchers attended St. Lorenz parish school, and afterward acquired accounting skills and training in prices, weights, and measures from a local *Rechenmeister)*; formation of the first trading company (1471); attendance at trade fairs (Frankfurt am Main, Leipzig, Nördlingen); membership in the Fondaco dei Tedeschi (Venice) and endowment of an altar in S. Bartolommeo. The introduction of rosary devotion into Nuremberg by the Dominican nuns of St. Katherine's (1490) and foundation of a Rosary Brotherhood in the early sixteenth century, and publication of Ulrich Pinder's *Beschlossener Gart des Rosenkranz Marias*, with woodcuts by Dürer and others (1505) also is discussed. The book is well illustrated in black and white and has a bibliography, but lacks an index.

289. ———. "Die 'Vorderstube' des Sebald Schreyer. Ein Beitrag zur Rezeption der Renaissance in Nürnberg." *Anzeiger des Germanischen Nationalmuseums* (1954): 43–67.

Schreyer's *Vorderstube* (front room), decorated in 1494 in Renaissance style by a painter whose name, unfortunately, has not come down to us would have constituted young Dürer's first exposure to Renaissance painting. Schreyer lived in the Burgstrasse one block away from the Dürer family.

290. ———. "Vom Handwerker zum Künstler. Das gesellschaftliche Ansehen Albrecht Dürers." *Festschrift für Hans Liermann zum 70.*

Geburtstag, 26–47. Erlanger Forschungen–Reihe A: Geisteswissenschaften, 16. 1964.

Discusses Dürer's relationship to the *Sodalitas Staupitziana*, gathered around Luther's own Augustinian confessor Johann von Staupitz during the latter's visit to Nuremberg, and the theological issues that were of interest to this circle of Humanists. Also considered briefly is the artist's friendship with Melanchthon.

291. Grunewald, Erika Singsen. "Works by Master MZ in the Oberlin Collection." *Allen Memorial Art Museum Bulletin* 31, no. 2 (1974): 66–77.

Discusses three phases of the stylistic development of the south German monogrammist MZ, who is presumed to have worked in the vicinity of Nuremberg as well as at the Bavarian court in Munich. Describes his indebtedness to Dürer and establishes a relative chronology for his twenty-two engravings.

292. Guarino, Sergio. "La Formazione Veneziana di Jacopo de' Barbari." *Giorgione e la Cultura Veneta tra '400 e '500: Mito, Allegoria, Analisi Iconologica*, 186–198. Ed. Maurizio Calvesi. Rome: De Luca, 1981.

[In a volume of papers delivered at a conference held in November, 1978 at the Istituto di Storia dell'Arte dell'Università di Roma]. The author cites references to Jacopo de' Barbari in Dürer's treatise on human proportion and in his correspondence in order to show that Jacopo (whose real name remains unknown) was actually a native of Venice, born about 1470–1475 (and thus approximately Dürer's own age), and argues that his activity began in Venice in the early 1490s. Accepts the attribution of the portrait of Luca Pacioli to Jacopo, but denies the artist's previously supposed connection with Caterina Cornaro's court at Asola. Also discusses Jacopo's relationship to Leonardo da Vinci, whose drawings of geometric solids are reflected in the Pacioli portrait.

293. Gurlitt, Cornelius. *Die Kunst unter Friedrich dem Weisen*, Dresden: Gilbers, 1897.

The first comprehensive study of Friedrich the Wise as patron of the arts.

294. Gümbel, Albert. "Die englische Mission des Grafen von Arundel in Nürnberg, Mai und November 1636." *Archivalische Zeitschrift* N.S. 11, no. Beilage 1 (1904): 100–117.

Hanns Hieronymus Imhoff's account of the sale of the Pirckheimer library to Thomas Howard, Earl of Arundel (the "Father of Vertue in England"), pp. 115–116.

295. Haase, Gunther. *Kunstraub und Kunstschutz. Eine Dokumentation*, esp. 231–242. Hamburg: Published by the author, 1991.

The author, a Hamburg attorney, has studied the handling and mishandling of art works in World War II as a hobby for many years. This is a thorough study, with an enormous number of references to primary documents and personal interviews. Of particular interest here are the papers dealing with the negotiations surrounding the shipping of a group of 202 old master paintings from Berlin's Kaiser- Friedrich-Museum, including Dürer's *Madonna with the Goldfinch, Virgin in Prayer,* and portraits of *Hieronymus Holzschuher* and *A Young Woman* to the United States, and plans for a touring exhibition in 1948. The paintings had been discovered by advancing American troops in wartime storage in the salt mine at Merkers in 1945, had been shipped to the United States aboard the Army transport *James Parker* in December of that year and stored in the vaults of the National Gallery in Washington. When in the spring of 1948 General Lucius Clay, U.S. Military Governor of Germany, reported that safe storage in the American zone of occupation had been made available, fourteen of the oldest and most fragile of the paintings were returned to Germany, while the rest were sent on tour to Detroit, Cleveland, Toledo, St. Louis, Minneapolis, San Francisco, Los Angeles, and Pittsburgh.

296. Haendcke, Berthold. "Die Stellung der deutschen Maler vom Beginn des 16. Jahrhunderts am Schlusse dieses Zeitraums." *Kunstchronik* new ser. 23 (1912): 579.

Discusses Dürer's reception in the sixteenth century.

297. Hagen, Ernst August. *Norica: das sind Nürnbergische Novellen aus alter Zeit. Nach einer Handschrift des sechszenten Jahrhunderts*, Breslau: J. Max, 1829.

The author (b. 1797) claims to have edited a manuscript written by Dürer's patron Jacob Heller of Frankfurt. No such manuscript exists. (English edition: *Norica, or Tales of Nürnberg: From the Olden Time*, London, Chapman, 1851.)

298. Hahn, Cynthia. "Joseph as Ambrose's 'Artisan of the Soul' on the *Holy Family in Egypt* by Albrecht Dürer." *Zeitschrift für Kunstgeschichte* 47, no. 4 (1984): 515–522.

Argues for the influence of the theology of St. Ambrose on the meaning of Dürer's characterization of Joseph in the *Sojourn of the Holy Family in Egypt*, one of the wooduts from the *Life of Mary* series (1511).

299. Halbe-Bauer, Ulrike. *Mein Agnes. Die Frau des Malers Albrecht Dürer. Biographisches Roman.* Mühlacker (Germany)/Irdning (Steiermark, Austria): Stieglitz, 1996.

Although this is a historical novel, the background material is reasonably accurate, and the plot is more plausible than those of many of the works of fiction dealing with Dürer himself. Agnes has generally been portrayed more or less in terms of Willibald Pirckheimer's assessment of her as a shrew, but this novel is written from the point of view of women's history, and contains a chronology of Agnes's life (pp. 311–313). Slight deviations from the known facts include a honeymoon in Venice, however, and a somewhat overweening emphasis on Dürer's supposed melancholia that ill accords with the personality revealed in his written work. But the development of Agnes Frey's personality, from naive bride to harried daughter-in-law to workshop supervisor in her husband's absence, and her embarrassment at her childlessness, rings true.The author, a Freiburg teacher, was the translator of Colin Eisler's *Dürer's Animals* (q.v.) into German, and has previously published historical novels on the Münster Anabaptists (*Propheten im Dunkel*, 1984), and on Paracelsus (1992).

300. Hall, Edwin, and Horst Uhr. "*Aureola* and *Fructus*: Distinctions of Beatitude in Scholastic Thought and the Meaning of Some Crowns in Early Flemish Painting." *The Art Bulletin* 60, no. 2 (June) (1978): 249–270 (esp. 254–255).

In the course of their discussion on the *aureola* of Scholastic thought, which signified a state of beatitude—the essential reward

of the blessed, namely joy in their work perfected—and *fructus*, the laborer's joy in determining to lead a spiritual life, the authors briefly discuss (254–255) the significance of their findings for the iconography of the Dresden Altarpiece. In the wing panels, which are by Dürer, Sts. Anthony and Sebastian are shown with angels hovering over their heads, holding narrow circlets of gold—the *aureola* of martyrs for St. Sebastian, and that of doctors of the church for St. Anthony, who was said to have surpassed all others in the study of sacred scripture. In the central panel—rejected by Anzelewsky as an autograph Dürer (see *Das malerische Werke*, 1971, 134–137) and attributed to a Netherlandish painter called Master Jhan (Jan Joest of Kalkar?)—a similar pair of angels hold a crown over the head of the Virgin, the *aureola* of virginity. (For a dissenting view of Anzelewsky's attribution see Axel Janeck, "Dürer Colloquium Nürnberg," *Kunstchronik* 25, no. 7 (1972): 155–213.

301. Hallyn, Fernand. "Holbein: La Mort en Abyme." *Gentse Bijdragen tot de Kunstgeschiedenis* 25 (1978): 1–13.

In process of studying the iconography of Holbein's so-called *Ambassadors* (London, National Gallery) with its anamorphic death's head, compares Dürer's *Melencolia I* and Domenico Fetti's *Melancholy* (Paris, Louvre).

302. Hamann, Günther. "Albrecht Dürers Erd-und Himmelskarten." *Albrecht Dürers Umwelt. Festschrift zum 500. Geburtstag,* 152–177. Eds. Gerhard Hirschmann, and Fritz Schnelbögl. Nürnberger Forschungen, 15. Nürnberg: Verein für Geschichte der Stadt Nürnberg, 1971.

Dürer's involvement in the development of both astronomical and topographical cartography is a subject less frequently dealt with in the literature. This article deals with his three maps of earth and the northern and southern skies which were dedicated to the Archbishop of Salzburg, Cardinal Matthäus Lang von Wellenburg, patron of Stabius.

303. Hamburg, Kunsthalle. *Köpfe der Lutherzeit,* Eds. Werner Hofmann, and Peter-Claus Schuster. Munich: Prestel, 1983.

An exhibition of portrait prints, drawings, and medallions from the age of the Reformation, shown in Hamburg in honor of Martin Luther's five hundredth birth anniversary. Portraits by Dürer of fig-

ures connected with the Reformation, as well as of lesser and even
unknown people are included, along with works by about forty
other artists. Hofmann's catalogue essay deals philosophically
with the themes of likeness and equality in sixteenth century art
and thought, while Schuster's essay deals with the humanistic por-
trait. Full catalogue entries for all exhibited works, together with
iconographic index and chronological tables prepared by Friedrich
Gross [RILA].

304. Hampe, Theodor. "Nürnberger Ratsverlässe über Kunst und Kün-
stler im Zeitalter der Spätgotik und Renaissance (1449)
1474–1618 (1633)." Quellenschriften für Kunstgeschichte und
Kunstkritik des Mittelalters und der Neuzeit, Rudolf Eitelberger
von Edelberg, and Camillo List, 11 (new series). Vienna/Leipzig:
Karl Graeser & Co./B.G.Teubner, 1904.

Published proceedings of the Nuremberg City Council that have to
do with art and artists, including Albrecht Dürer the Elder and the
Younger, Hans Dürer, Dürer's father-in-law Hans Frey, as well as
Veit Stoss, Peter Vischer, Adam Kraft, and others. The documents
are arranged chronologically, and are thoroughly indexed. The
original spelling is preserved ("Albrechten Thurer"). The docu-
ments included refer to such craftsmen as buchsenmeisters and
brass workers, as well as goldsmiths, painters, sculptors, and mak-
ers of scientific instruments.

305. Hamsik, Mojmir. "Dürers *Rosenkranzfest*: Zustand und Technik."
Bulletin of the National Gallery in Prague (1992), 128–131.

Results of scientific analysis and observations on the painting tech-
nique of Dürer's "German picture," the Rosary altarpiece painted
for the German church in Venice, which has been in Prague since
its acquisition by Rudolph II.

306. Hand, John Oliver. "Saint Jerome in His Study by Joos van Cleve
[Joos van der Beke]." *A Tribute to Robert A. Koch. Studies in the
Northern Renaissance*, 53–61. Princeton University: Department
of Art and Archaeology, 1994.

Dürer's engraving of *St. Jerome in His Study* (1514) and his 1521
painting of St. Jerome (Lisbon) are noted as sources for the paint-
ing of the same subject by Joos van Cleve (dated 1528: Princeton

University Museum, gift of Joseph F. McCrindle). Joos was Co-deacon of the Antwerp painters' guild when Dürer arrived there in 1520.

307. Hannig, Peter. "Ein spätgotischer Hausaltar in der Albrechtsburg Meissen." *Dresdner Kunstblätter* 22, no. 2 (1978): 42–47.

A sixteenth-century carved and polychromed altarpiece showing the Virgin and Child with Sts. Eberhard of Salzburg and Ursula is based on Dürer's *Madonna with the Monkey.*

308. Hanover (NH), Dartmouth College Museum and Galleries. *Prints and Drawings of the Northern Renaissance 1470–1600*, Introduction by Jan Van der Marck. 1976.

The catalogue of an exhibition of Dartmouth's holdings, which include prints by Dürer and Schongauer. The text was written by art history undergraduate students.

309. Harbison, Craig. "Dürer and the Reformation: The Problem of the Re-dating of the *St. Philip* Engraving." *The Art Bulletin* 58, no. 3 (September) (1976): 368–373.

The author offers the interesting hypothesis that the change of date on Dürer's engraving of the apostle Philip (from 1523 to 1526, as can be seen from the palimpsest on the tablet with his signature) was the result of the artist's having withheld publication of the print for three years while he pondered the use and abuse of religious art. (Panofsky had argued that the engraving was somehow related to the panels now in Munich (*Four Holy Men* or Apostles), which he took to be wings of a supposed *sacra conversazione* triptych—an idea since disproved by laboratory results. See Anzelewsky, *Das malerische Werk* (p. 275), and Kurt Martin, *Albrecht Dürer, Die vier Apostel*, (Stuttgart, 1963, 21–23.) The artist had begun an Apostle series in 1514; Harbison argues that he returned to it in 1523, publishing two additional plates (Sts. Simon and Bartholomew), and engraved but withheld the St. Philip, issuing it with its new date in 1526, the year after Luther's treatise *Against the Heavenly Prophets in the Matter of Images and Sacraments*, in which the reformer railed against the destruction of religious images, and the year in which he presented his *Four Holy Men* to the Nuremberg City Council.

310. Harnest, Joseph. *Das Problem der konstruierten Perspektive in der altdeutschen Malerei*. Ph.D. dissertation, Munich, 1974.

 The author's dissertation for the Technische Universität, Munich. For the essentials of his work, see his essay in Peter Strieder, *Dürer* (both the New York, 1981 and Augsburg, 1996 editions have it. q.v.).

311. ———. "Theorie und Ausführung in der perspektivistischen Raumdarstellung Albrecht Dürers." *Festschrift Luitpold Dussler*, 189–204. 1972.

 Dürer's perspective theory and his actual use of perspective in constructed space.

312. Hartlaub, Gustav Friedrich. *Dürer und die Nachwelt*, Mannheim: Städtische Kunsthalle, 1928.

 The catalogue of an exhibition centering on Dürer's influence, held in Mannheim from May 20–July 28 in the anniversary year 1928. Contains essays by Hanna Kronberger-Frentzen and E. Strubing. Reviewed by Erich Dürr in *Der Cicerone* 20 (1928), 412; and by E. Strubing in *Kunstchronik und Kunstliteratur*, supplement to *Zeitschrift für bildende Kunst*, 62 (1928/1929) 5, 64.

313. Hartmann-Wülker, Dürten. *Die Beurteilung Dürers in der deutschen Literatur des 18. Jahrhunderts*. Ph.D. dissertation, Bonn University, 1969.

 Eighteenth century reception of Dürer as reflected in German literature.

314. ———. "Eine Schrift von J.C. Lavater über Dürers "Vier Apostle" und das Dürer-Urteil des 18. Jahrhunderts." *Zeitschrift des Vereins für Kunstwissenschaft* 25 (1971): 17–35.

 Developed from the author's unpublished Master's thesis for Bonn University (1969), discusses the eighteenth-century judgment of Dürer as reflected in the essay of the father of phrenology, the Swiss scientist J. C. Lavater, on the heads of Dürer's *Four Holy Men* (Munich, Alte Pinakothek).

315. Hartmann, Wolfgang. *Der historische Festzug, Seine Entstehung und Entwicklung im 19. und 20. Jahrhundert*, Studien zur Kunst des 19.Jahrhunderts, 35. Munich: 1976.

An important study of the cultural significance of German historical pageantry of the nineteenth and twentieth centuries, which often was dependent on the art of Albrecht Dürer for inspiration and/or costume design.

316. ———. *Kaiser Maximilian und Albrecht Dürer in Nürnberg. Ein Künstlerfest der Spätromantik und sein Anspruch*, Renaissance Vorträge, 6. Nuremberg: Albrecht-Dürer-Haus-Stiftung, 1977.

The published version of lecture given in Nuremberg at the Stadtmuseum Fembohaus on February 25, 1976. Dr. Hartmann, Dozent at the University of Karlsruhe and the author of an important study of historical pageantry (q.v.), spoke on the Carnival pageant produced at the Bavarian court in Munich in 1840, which is considered the first German festival with historic costumes. Its aims and its progressive and reactionary tendencies are evaluated in relation to German art and society of the 1840s. The 600 participants paraded from the Hoftheater through the Residenz and Hofgarten arcade to the Odeon, all in sixteenth-century costume. The cast included characters dressed as Maximilian I (played by the painter Wilhelm Lichtenfeld), Dürer (the painter Eduard Gerhardt), Pirckheimer, Wolgemut, Anton Koberger, Adam Kraft, Veit Stoss, Peter Vischer and his sons, Hans Springinklee, Hans Sachs, and a host of councilmen, noblemen, knights, mercenaries, falconers, musicians, representatives of the various professions (including Carl Spitzweg playing Lazarus Spengler, the municipal secretary of Nuremberg), and mummers in mythological costume. The author gives an excellent discussion of nineteenth-century historical pageantry in general, and of the post-Wackenroder image of Dürer as affected by the scholarship of Joseph Heller (1828), the current vogue for Moritz von Schwind, and the wish to glorify the house of Wittelsbach as patron of the arts, in the tradition of Maximilian of Hapsburg. The festivities are immortalized in Wilhelm von Kaulbach's design for the mural in Munich's Neue Pinakothek (1850) and the etching and drawings of Eugen Napoleon Neureuther (Munich, Staatliche Graphische Sammlung).

317. Hase, Oskar. *Die Koberger*, Leipzig: 1885.

The definitive biography of Dürer's godfather, the Nuremberg publisher and sometime goldsmith. Although his papers for the years of Dürer's boyhood and apprenticeship unfortunately are not

among those that have survived, it is nevertheless essential to read this book in order to visualize the publisher's influence on his godson's business dealings in later years.

318. Hauptman, William. "*La melancholie* in French Romantic sculpture." *La scultura nel XIX secolo*, 111–117. Ed. Horst Janson. International Congress of the History of Art (24th, 1979, Bologna), Bologna: CLUEB, 1984.

Notes the pervasive influence of melancholy in nineteenth century France, suggesting Dürer's *Melencolia I* as the main source, together with funerary sculptures of mourners. Presents a number of allegorical sculptures of Melancholy exhibited at the Salons of the 1840s.

319. ———. "Manet's Portrait of Baudelaire: An Emblem of Melancholy." *Art Quarterly* 1/3 (1978): 214–228.

Examines Manet's series of etched portraits of Baudelaire, suggesting that the second state, approximately 1867 (eliminated from the final state published in 1869) of one with an emblematic device at the bottom reflects influences from Dürer and Goya.

320. ———. *The Persistence of Melancholy in Nineteenth-Century Art: The Iconography of a Motif.* Ph.D. dissertation, Pennsylvania State University, 1975.

"Preliminary investigation of the pictorial language of melancholic imagery reflected in critical and philosophic writings in the nineteenth century, as well as in art. Begins with the impact [of Dürer's engraving] felt in the nineteenth century, particularly in the works of Gautier, de Nerval, Baudelaire, and Hugo. . . ." [Author: in RILA].

321. ———. "An Unusual Binding after Dürer's *Melencolia I.*" *Journal of the Warburg and Courtauld Institutes* 38 (1975): 341–342.

Discusses a gold binding design for Ignaz von Born's satire, *Monachologia* (Edinburgh, 1852), which depicts a bat dressed in monk's habit carrying a banderole.

322. Hausmann, Bernhard. *Albrecht Dürers Kupferstiche, Radierungen, Holzschnitte, und Zeichnungen unter besonderer Berücksichtigung*

der dazu verwandten Papiere und deren Wasserzeichen, Hanover: Hahn'sche Hof-Buchhandlung, 1861.

Based on Bartsch, but providing additional information, including a discussion of watermarks and papers used by Dürer.

323. Haussherr, Reiner. "Eine verspätete Apokalypsen-Handschrift und ihre Vorlage." *Studies in Late Medieval and Renaissance Painting in Honor of Millard Meiss*, vol. 1, 219–240. Eds. Irving Lavin and John Plummer. 2 vols. New York: New York University Press, 1977.

A long unknown illustrated manuscript of the Apocalypse (Ms. A.B. 143, Staatliche Kunstakademie, Düsseldorf), produced for the Monnier de Savignat family (Franche Comté) after 1530 and containing excerpts from the Commentary of Berengaudus, was influenced both by Dürer's *Apocalypse* and by MS. Salis.38, Bibliothèque municipale, Metz 9a mid-thirteenth century English manuscript).

324. Hayum, Andree. "Dürer's portrait of Erasmus and the *ars typographorum*." *Renaissance Quarterly* 38, no. Winter (1985): 650–657.

Examines the engraving (B.214) and its inscription in light of Dürer's publication on Roman lettering.

325. Heaton, Mary Margaret Keymer [Mrs. Charles]. *The Life of Albrecht Dürer of Nürnberg. With a Translation of His Letters and Journal and an Account of His Works*, Portland ME: Longwood, 1977.

A modern reprint of the second, revised, and enlarged edition [London: Seeley, Jackson & Halliday, 1888]. The first edition, published in London in 1870 a year in advance of Dürer's four hundredth birth anniversary, was the second major monograph on Dürer ever printed in English, and was reviewed by Moriz Thausing in *Zeitschrift für bildende Kunst* 5 (1870), 157–158. [The first was by William Bell Scott, published in London in 1869 and also reviewed by Thausing in the same pages.] There had been no scholarly monograph published in Germany at that time due to the events of the Franco-Prussian War and the excitement of the establishment of the Second Reich. After the publication of Thausing's own monograph in 1874 (q.v.), Mrs. Heaton revised her earlier

work, acknowledging her indebtedness to Thausing's work and following his detailed and positivistic method. Her book presents the facts as then known so clearly and accurately that the book was still considered viable nearly a century later, when the present reprint was brought out, and six years after the flurry of studies published in German honoring the artist's five hundredth birthday in 1971.

326. Heffels, Monika. *Albrecht Dürer. Sämtliche Holzschnitte*, Ramerding: Berghaus Verlag, 1981.

A quarto volume, basically a picture book with full-page illustrations of excellent quality. The woodcuts are divided as follows: Series, Single Sheets, Book Illustrations. No locations are given for each print, but general acknowledgments are given to the best German, Austrian, and Swiss print rooms (Basel, Berlin, Dresden, Munich, Nuremberg, Vienna) as well as to London and Photo Marburg. Front matter (by André Deguer) begins with eight pages of biography and three pages of very general text on the woodcuts.

327. ———. *Meister um Dürer: Nürnberger Holzschnitte aus der Zeit um 1500–1540*, Kirchdorf: Berghaus, 1981.

Sixteenth-century woodcuts (1500–1540) by Nuremberg masters influenced by Dürer. Has full-page reproductions of good quality, and twenty-three pages of text, including an essay for each master. Artists are divided into three groups: 1) those who are documented as having worked for Dürer and were influenced by him; 2) a younger generation, born approximately 1500 who were influenced but not actually documented as having worked for him; and 3) a few contemporaries of his who had no immediate connection to his workshop. Artists discussed include Baldung, Hans von Kulmbach, Schäufelein, Springinklee, Wolf Traut, Erhard Schön, the Beham brothers, Georg Pencz, Ludwig Krug, Niklas Stör (Springinklee's assistant), and Peter Flötner.

328. Heffner, David. "A memento diaboli in Dürer's *The Virgin with the Dragonfly*." *Print Collector's Newsletter* 18, no. 2 (May–June) (1987): 55–56.

The insect in the lower right corner of Dürer's early engraving (B.44) has been identified variously as a butterfly, a dragonfly, a grasshopper, and a praying mantis (see also Sebastian Killermann,

Albrecht Dürers Pflanzen- und Tierzeichnungen (Studien zur deutschen Kunstgeschichte, 119), Strasbourg 1910, pp. 44–45; Rudolf Wustmann, "Von einigen Tieren und Pflanzen bei Albrecht Dürer," *Zeitschrift für bildenden Künste*, new ser. 22, 1911, p. 109; Campbell Dodgson, *Albrecht Dürer, Engravings and Etchings*, London, 1926, no. 4; Erwin Panofsky, *Life and Art of Albrecht Dürer* vol. 2, p. 4; Charles Talbot et al., *Dürer in America: His Graphic Work*, Washington, 1971, pp. 112–133, no. 2). Heffner argues that the insect is a damselfly, and that it is an emblem for the devil.

329. Heitzer, Elizabeth. *Das Bild des Kometen in der Kunst*. Ph.D. dissertation, Aachen, 1993.

(Studien zu profanen Ikonographie, 4.) Discusses the identity of the comet in Dürer's *Melencolia I*.

330. Held, Julius. *Dürers Wirkung auf die niederländsiche Kunst seiner Zeit*, The Hague: 1931.

The author's doctoral dissertation. Examines Dürer's Netherlandish diary in detail, listing the works of art which he recorded as having sold or traded during his sojourn in 1520–1521. Held, much better known today as a leading authority on the work of Rubens and Rembrandt, was the youngest of the German art historians who emigrated to the United States shortly before World War II. He taught at Columbia University before his retirement.

331. Heller, Joseph. *Das Leben und die Werke Albrecht Dürers*, 2 vols. Bamberg: E.F. Kunz, 1827.

This was the most thorough and reliable oeuvre catalogue of the early nineteenth century. Volume 1 is biographical. Volume II, part 1 deals with the paintings and drawings, and attributes sculpture to the artist. Volume II, part 2 catalogues the portraits, engravings (104: two doubtful; one rejected) and woodcuts (174: 199 doubtful, 52 rejected); and prints (301 prints after Dürer; seven prints in his style; nine prints with false Dürer monograms. Particularly valuable for its extensive list of copies. A projected Volume III, which would have dealt with Dürer's theoretical publications, never appeared, but a second edition of Volume II was printed in Leipzig in 1831, with the addition of a section on medals designed by and after Dürer.

332. Hermann-Fiore, Kristina. "Caravaggio's *Taking of Christ* and Dürer's Woodcut of 1509." *Burlington Magazine* 137, no. January (1995): 24–27.

The rediscovery of Caravaggio's long-lost *Taking of Christ* (Dublin, National Gallery of Ireland), commissioned in 1603 by the Marchese Ciriaco Matthei, inspired the author to seek Caravaggio's sources. She suggests the comparable scene from the Small Woodcut Passion as the prototype for the choice of the moment *before* the kiss of Judas, citing the post-Reformation view of Dürer as *pictor christianissimus*, and Francisco Pacheco's praise of the artist (in *Arte de la Pintura*).

333. ———. *Dürers Landschaftsaquarelle; ihre kunstgeschichtliche Stellung und Eigenart als farbige Landschaftsbilder*, Bern and Frankfurt am Main: Herbert Lang, 1972.

The published version of the author's dissertation. Discusses Dürer's landscape watercolors in the context of their originality and position in the history of landscape painting from nature. Makes the questionable claim that Dürer's watercolors are "the only authentic paintings" by the artist that retain their original colors. Assumes that they are factual, accurate representations. Gives dates for many which are much later than the "canonical" ones. [Review by Ernst Strauss in *Pantheon* 32, no. 1 (Jan.-Mar. 1974), 111–112; and Rudolf Zeitler in *Konsthistorisk Tidskrift* 43, no. 3–4 (1974) 146–148. See also Bräutigam/Mende, 268–269].

334. ———. "Rubens und Dürer." *Rubens: Kunstgeschichtliche Beiträge*, 101–128. Ed. Erich Hubala. Konstanz: Leo Leonhardt, 1979.

A thorough study of the neglected topic of Rubens's reliance on Dürer's prints as sources of inspiration. The author correctly notes that while studies of "Rubens and Italy" abound, there has been scant attention to Rubens's roots in northern tradition. Cites Aubertus Miraeus's life of the Archduke Albert (Antwerp, 1622) on northern paintings in the collection of Albert and Isabella, and Sandrart's evaluation of collections of Dürer prints in Antwerp and Amsterdam as well as more recent sources, including Hans Kauffmann (in *Anzeiger des Germanischen Nationalmuseums* 1940–1953.) Recounts the legend that Maximilian I had given Dürer a coat-of-arms with three shields "for all painters" (the arms used by Antwerp's Guild of St. Luke). Discusses Rubens's use of the *Pro-*

portionslehre; his *Flagellation* for the Church of St. Paul in Antwerp, based on Dürer's engraving (B.8); the *Supper at Emmaus* (Paris, St. Eustache) based on Dürer's small woodcut Passion (B.48); the *Holy Family with the Apple Tree* (Vienna) and Dürer's *Holy Family* (B.96); the influence of the *Assumption of the Virgin* woodcut, and many other examples, including landscapes.

335. ———. "Zur Datierung von Dürers Aquarellen." *Anzeiger des Germanischen Nationalmuseums* (1971): 122ff.

Based on the author's doctoral dissertation, it advances the entirely plausible theory that Dürer's landscape watercolors were not done, as has previously been supposed, in one brief campaign clustered around the first trip to Italy (1494–1495), but actually extended over a much longer period, with the two views of Kalchreuth having been done perhaps as late as 1516–1520. She also envisions the earliest views of the area around Nuremberg as predating the bachelor's journey, basing her opinion on the preexisting tradition of landscape painting in Franconia. (See also the report of her paper at the 1972 Nuremberg Colloquium, in *Kunstchronik* 25 (1972), pp. 203–206, with comments by Martin Gosebruch, Bernhard Degenhart, Willibald Sauerländer, Hans Christoph von Tavel, Peter Strieder, and Franz Winzinger.)

336. Hess, Daniel. "Dürers Selbstbildnis von 1500—'Alter Deus' oder Neuer Apelles?" *Mitteilungen des Vereins für Geschichte der Stadt Nürnberg* 77 (1990): 63–90.

A shortened version of the author's *Lizentiatsarbeit* (Zürich, 1988), prepared in consultation with Rudiger Becksmann and Martin Warnke. Discusses the theory of Anzelewsky, Wuttke and others that *Dürer's Self Portrait in Für* reflects the *alter Deus*— man's creation in God's image and with creative power as a divine gift. The author makes a strong case for the painting as representing the apogee of Dürer's artistic activity and recognition of his individuality in the Renaissance sense—directed NOT toward medieval piety but toward fame and worldly recognition. This is a depiction of the artist as the New Apelles. Hess cites Justi (Leipzig, 1902), who already had recognized Vitruvian theory as the basis for the construction, and faults those who deny Italian influence (Winzinger, 1954, who saw in it a construction scheme based on an equilateral triangle superimposed over a circle) or see a Mount

Athos-like scheme here (Panofsky). Infrared examination shows no geometric diagram in the underdrawing—nothing is visible but extra-fine pen lines, a more elaborate underdrawing than usual for this artist. Perusal of the sketchbooks also fails to support the constructions of Winzinger, Panofsky, et al., for Dürer customarily used a circle, not an equilateral triangle as his basis for the construction of faces, drawing the radius from the root of the nose, as Leonardo da Vinci did. Also discussed is the *Orpheus* drawing (Hamburg): Hess agrees with Schuster (q.v.): that the *Hercules* engraving has a similar message—man is at once godly and sinful, and can only attain the highest goals through mastery of the senses—and cites the *Lehrbuch der Malerei* (1512) as to the role of portraiture in preserving the likeness of a man after his death (Rupprich II, pp. 109, 112.) As to the use of the verb *effingere* in the inscription, Hess cites Christoph Scheurl's letter to Lukas Cranach, noting that Pirckheimer had advised Dürer to use the imperfect tense (according to Pliny, Apelles also had signed his work that way. See Rupprich, *Willibald Pirckheimer und die erste Reise Dürers nach Italien*, Vienna, 1930, p. 73f.). For the sake of "staying power" Dürer gave his age as twenty-eight (he wasn't, but that was the age cited by Isidore of Seville as the beginning of manhood, the age of greatest beauty and strength). Wimpfeling and Scheurl both used the Apelles *topos* in connection with Dürer's four-color scheme. Cites the "wish-fulfillment" function of the artist's self portraits—both 1498 and 1500—in elevating the social standing of the "new" artist, no longer a mere handworker. In 1500 Conrad Celtis was viewed as "the new Horace, Ovid and Martial"; Dürer was the new Apelles.

337. Hetzer, Theodor. *Die Bildkunst Dürers*, Ed. Gertrude Berthold. Schriften Theodor Hetzers, 2. Mittenwald/Stuttgart: Mäander/-Urachhaus, 1982.

A series of Dürer studies originally written 1935–1943 by Hetzer (1890–1946), a formalist who had studied with Wölfflin and who taught at the University of Leipzig from 1934 until illness forced his retirement in 1941. Two of the studies included appear here for the first time—one on Dürer' objectivity, the other on the *Small Passion*. The first and most extensive essay is devoted to Dürer's art between 1510–1528. In it, Hetzer compares Dürer with Giotto (he had also studied with Rintelen, a major Giotto scholar, in Basel

in 1914/1915, and Rintelen had been his major professor). In the same work he discusses the transformation in Dürer's graphic techniques during these years, as well as his position in the Renaissance and his idea of the classical. In other essays he discusses the notion of a specifically "German" concept of form; portraits; and the marginal drawings in Maximilian's prayerbook, which he believed to have been executed in sequence (pp. 273–314, "Über Dürers Randzeichnungen im Gebetbuch Kaiser Maximilians"). As Hetzer said in the Introduction to "Dürers Hoheit" (1939), "I have discovered no drawings, have not altered the chronology, not offered a new interpretation of *Melencolia*." He claimed instead to have undertaken his study of Dürer's art simply for the joy of looking at the works.

338. Hetzer, Theodore. "Über Dürers Randzeichnungen im Gebetbuch Kaiser Maximilians." *Zeitschrift für deutsche Geisteswissenschaft* 3 (1941): 178–200.

An essential study of the iconography of the marginal decorations for Maximilian's *Prayerbook*.

339. Heusinger, Christian von. "Ein neuentdecktes Exempla der Dürer-Tapete auf schwarzen Grund." *Jahrbuch der Berliner Museen, new ser.* 25 (1983), 143–159.

A previously undescribed example of the woodcut "Tapestry of Michelfeld" on a black ground is in New York (Metropolitan Museum). The same print on a white ground was already known.

340. Hinz, Berthold. *Dürers Gloria: Kunst, Kult, Konsum*, Berlin: Gebr. Mann, 1971.

Witty and engagé catalogue of an exhibition held at the Staatliche Kunstbibliothek in Berlin, inspired by Nuremberg's exhibition (*Nürnberger Dürerfeier 1828–1928*, q.v.), also held in the Dürer Year 1971. Explores the image of Dürer as it was exploited in the nineteenth and early twentieth centuries in keeping with bourgeois tastes and aspirations. Essays on Dürer's reception in the Goethe circle (pp. 14–15); the Romantic "cult" of Dürer, his "ideal" pairing with Raphael, and the Dürerfests of 1828 in Nuremberg and Berlin (pp. 16–25); the Dürer monument (pp. 25–28); his reception by the bourgeoisie compared to his image in Munich's 1840 carnival sponsored by Ludwig I of Bavaria (pp.28–36); Dürer and

Reichskultur in 1871–1918 (pp. 37–41); the post-World War I Dürer 1918–1928 (pp. 43–44). Of special interest are the table of founding dates of German art museums and art associations 1810–1890 (p. 47) and the convenient comparative table of political, cultural, and social history (pp. 50–76) for the years 1800–1929. Exhibited are works by Franz Pforr, Friedrich Overbeck, Friedrich Schinkel, Adolph Menzel, Heinrich Olivier, Christian Daniel Rauch, Carl Jäger, Wilhelm Kaulbach, Franz von Stuck, Hans Makart, and others.

341. Hirschmann, Gerhard. "Albrecht Dürers Abstammung und Familienkreis." *Albrecht Dürers Umwelt. Festschrift zum 500. Geburtstag*, 35–55. Eds. Gerhard Hirschmann and Fritz Schnelbögl. Nürnberger Forschungen, 15. Nürnberg: Verein für Geschichte der Stadt Nürnberg, 1971.

Provides a useful summary and critical review of Lukinich's 1928 study of the Hungarian branch of the artist's family (originally presented in 1928 as an address to the Budapest Academy of Sciences), accepting the Hungarian scholar's finding that the senior Dürer's family can only have been of pure Hungarian stock, but disproving his contention—made in agreement with the earlier suggestion of the Hungarian scholar L. Haan—that the family had at any time belonged to the nobility. Accepts Erwin Kisch's suggestion that the godfather of Dürer's goldsmith cousin Niclas "Unger" was most likely the Hungarian court jeweler known as Nicolas Aurifaber who was active in Gyula. He cautions against Kisch's more wide-ranging speculations about earlier generations of the Dürer/Ajtosi family, however, while accepting the possibility that the elder Dürer's brother Johannes, known to have been a priest living in Grosswardein, may have been the Father Johannes who was tutor to Nikolaus von Doboka. Also reviews the documents concerning the artist's mother's family, the Holpers of Nürnberg and the Ellingers of Weissenburg; and those of the family of the artist's godfather, Anton Koberger, and of Bernhard Walther, from whose estate Dürer purchased the house by the Tiergartnertor, as well as those concerning his Frey and Rummel in-laws. He also examines the artist's relationships to his surviving brothers, his sisters-in-law, and to the children for whom he himself was godfather (including the nephew of Christoph II Scheurl). He concludes by quoting from the will left by the artist's wife Agnes. Useful genealogical charts are included in an appendix.

342. *Albrecht Dürers Umwelt, Festschrift zum 500. Geburtstag Albrecht Dürers am 21 Mai 1971. Herausgegeben vom Verein für Geschichte der Stadt Nürnberg und von der Senatskommission für Humanismus-Forschung der Deutschen Forschungsgemeinschaft,* Eds. Gerhard Hirschmann and Fritz Schnelbögl. Nürnberger Forschungen, 15. Nuremberg: Verein für Geschichte der Stadt Nürnberg, 1971.

Dürer's position in his time is the theme of this volume of excellent papers given by West German academics and archivists, plus one museum director and a theologian, from a symposium given by the Arbeitskreis für Humanismus-Forschung der Deutschen Forschungsgemeinschaft in Nuremberg on May 21, 1971. Contributions include Hanns Hubert Hofmann's essay on the political and social situation in Dürer's day (pp. 1–8); Wolfgang von Stromer's on Nuremberg's economic life at the time (9–19); August Buck's on Enea Sylvio Piccolomini (the future Pope Pius II) and Nuremberg (20–28); Klaus Leder's on elementary education in the city (29–34); Gerhard Hirschmann's on Dürer's ancestors and family circle (35–55); Fritz Schnelbögl on Nuremberg (56–77); Hans Rupprich on Dürer and Pirckheimer (78–100); Gottfried Seebass on Dürer's stand in regard to the Reformation (101–131); Joseph E. Hofmann on Dürer's mathematics (132–151); Günther Hamann on the terrestrial and celestial maps (152–177); Alexander von Reitzenstein's on the *Theory of Fortification* (178–192); Ottfried Neubecker's on heraldry in Dürer's time (193–219); Werner Schultheiss's on Dürer and the law (220–254); and Josef Benzing's excellent annotated bibliography on humanism in Nuremberg 1500–1540 (255–300). [For commentary on individual articles, see author listings.]

343. Hlaváček, Lubos. *Albrecht Dürer: Kresby,* Prague: Odeon, 1982. [Albrecht Dürer: Drawings.].

344. Hoenig, Alan. "A Constructed Dürer Alphabet." *TUGboat* 11, no. 3 (1990): 435–438.

The author, a specialist in computer typesetting and typefounding at John Jay College of the City University of New York, used a software system called METAFONT in order to reproduce Dürer's Roman titling alphabet as it appears in *Of the Just Shaping of Letters* (Nuremberg, 1525), which was one among many attempts by artists to generate recipes for the construction of beautiful Roman lettering

by means of circular arcs and straight lines only. Dürer's alphabet, in which each letter is imagined to inhabit the inside of a square, is by far the most successful such system in approaching the grace of antique monument lettering. Among Hoenig's conclusions, however, is the interesting fact that Dürer must have fudged his data, for there seemed no way to construct the shapes in Dürer's illustrations simply by using the artist's written rules. Hoenig's computerized alphabet is called Computer Dürer Roman (CDR), and was designed with the aid of a grant from the Research Foundation of CUNY.

345. *Albrecht Dürer: über den sichtbaren Beginn der Neuzeit*, Ed. Detlev Karl Ermert Hoffmann. Rehberg-Loccum: Evangelische Akademie Loccum, 1986.

Papers of a conference held at the Evangelische Akademie, Loccum, April 18–20, 1986. Includes articles by Fritz Koreny (on plant and animal studies); Stephan Müller-Doohm (on the origin of modern subjectivity); Bernard Decker (on 1) the Heller Altarpiece, and 2) the *Praying Hands*); and Rudolf zur Lippe (on perspective).

346. Hoffman, Joseph. "Lelio Orsi si è dato ai tedeschi." *Acta historiae artium* 31, no. 1–4 (1985): 31–41.

[In English.] Considers realism in the work of Lelio Orsi as a product of the influence of sixteenth-century German art in general, and of Dürer in particular.

347. Hoffmann, Konrad. "Dürers *Melencolia*." *Kunst als Bedeutungsträger: Gedenkschrift für Günther Bandmann*, 251–277. Eds. Werner Busch, Reiner Haussherr, and Eduard Trier. Berlin: Gebr. Mann, 1977.

In contrast to Panofsky's interpretation of the print Hoffmann maintains that the inscription *Melencolia I* applies only to the bat and is not the title of the engraving itself. In his view the print represents the contrast between *acedia* and the genius of *Melencolia* (the personification is implied as "Melencolia II"). With the rainbow motif as an allusion to the biblical promise made to Noah (Genesis 9) that there would be no new deluge, Dürer counters contemporary astrological mass hysteria concerning Johannes Stöffler's prediction for February 1525. The author interprets the tower in terms of the biblical Tower of Babel after the deluge (Genesis 1).

348. ———. "Dürers *Melencolia*." *Print Collector's Newsletter* 9, no. 2 (1978): 33–35.

[See also the German version in the *Gedenkschrift für Günther Bandmann*.] A convincing revision of the standard interpretation by Panofsky. The author maintains that Dürer intended the bat—which proverbially shuns light—and not the human figure, to represent Melencolia I (this is why the creature holds the banner inscribed with the title). The allegorical human figure represents *Melencolia generosa*. The appearance of the rainbow over the watery landscape recalls God's covenant with Noah after the Deluge. Hoffmann sees the tower, "apparently meant to reach the sky," as a reference by Dürer meant to counteract the contemporary fear of a second deluge, provoked by Johannes Stoeffler's prediction (in the *Almanach* of 1499) of a fatal planetary conjunction in the watery sign of Pisces (scheduled for 1524). The author is a member of the Kunsthistorisches Institut at the University of Tübingen.

349. Hofmann, Hanns Hubert. "Albrecht Dürers politische und soziale Umwelt." *Albrecht Dürers Umwelt—Festschrift zum 500. Geburtstag*, 1–8. Eds. Gerhard Hirschmann and Fritz Schnelbögl. Nürnberger Forschungen, 15. Nuremberg: Verein für Geschichte der Stadt Nürnberg, 1971.

The author, who is a professor at the University of Würzburg, discusses the political and social history of Dürer's time, from the *Reichsreform* promulgated at Worms in 1495, which regularized the status of Imperial cities, including Nuremberg, and the institution of the common penny, to the War of the Landshut Succession (1503–1504) and the Peasants' War of 1525, during which three hundred castles and manors were destroyed. Other topics touched upon are Götz von Berlichingen; the robber barons of 1512–1523; the Sodalitas Staupitziana in Nuremberg (the pre-Lutheran study group led by Luther's own confessor, Johann von Staupitz, to which Dürer and Pirckheimer belonged); the population (fifty-thousand—second only to Cologne); epidemics; civic order; and sumptuary laws.

350. Hofmann, Joseph E. "Dürers Verhältnis zur Mathematik." *Albrecht Dürers Umwelt. Festschrift zum 500. Geburtstag*, 132–151. Eds. Gerhard Hirschmann and Fritz Schnelbögl. Nürnberger Forschungen, 15. Nürnberg: Verein für Geschichte der Stadt Nürnberg.

Discusses the artist's publications dealing with mathematics, with emphasis on the *Unterweysung der Messung*, and his contributions to the field. Also includes a useful section on the teaching of mathematics in Nuremberg schools in the artist's youth.

351. Hofmann, Walter Jürgen. *Über Dürers Farbe*, Erlanger Beiträge zur Sprach-und Kunstwissenschaft, 42. Nuremberg: Hans Carl, 1971.

See Stechow (1974; p. 263), who found this extremely disappointing. The author attempts to discuss Dürer's actual use of color in terms of his theoretical writing on the subject, but eschews any attempt to deal with stylistic changes over time. Unfortunately he uses only two illustrations, one of which is surely not by Dürer (W. 614; one of the many *Blue Roller* wing variations). The other is the Landauer Altar. The author's writing is complex to the point of illegibility; even Stechow found it "extremely involved and difficult language." The topic itself is one of great interest, but this work leaves the field wide open for further research.

352. Hollstein, Friedrich Wilhelm Heinrich, et al. *German Engravings, Etchings and Woodcuts ca. 1400–1700, 8 vols.,* 1–259. Amsterdam: Menno Hertzberger, 1954.

Edited by K. G. Boon, then director of the Rijksprentenkabinet, and R. W. Scheller of Amsterdam University. Two hundred ninety-five prints by Dürer and more than twenty-eight books illustrated by him. The Hollstein volumes are illustrated virtually completely, albeit with reproductions of poor quality, and contain a minimum of information beyond bibliographic references and sample provenance.

353. Holst, Karen. "En Fortolkning af Albrecht Dürers Ungdomstegning *Yngling for Tronende Olding.*" *En Bog om Kunt til Else Kai Sass,* 115–135. Copenhagen: Forum, 1978.

[An Interpretation of Albrecht Dürer's drawing, *A Man Kneeling before a Potentate.* Published in the Festschrift for E. K. Sass.] This essay concerns a drawing in the Ashmolean Museum, Oxford (Parker 283), which depicts a young shepherd kneeling before an old man of high rank who is enthroned on a bench. The author interprets the subject as that of David and Samuel, tracing the history of the theme in art beginning with the Dura-Europas Synagogue, and concluding that the example in the St. Nicholas Chapel of the

Freiburg Minster is the one most closely resembling Dürer's. She explains Dürer's choice of subject psychologically in terms of the young artist's wish to meet Martin Schongauer.

354. Holzinger, Ernst. "Von Körper und Raum bei Dürer und Grünewald." *De Artibus Opuscula. Essays in Honor of Erwin Panofsky,* 238–253. Ed. Millard Meiss. New York: New York University Press, 1961.

Holzinger, of the Städelsches Kunstinstitut, Frankfurt, had been the author of a 1928 article on the Basel *St. Jerome* woodcut, assessing the quality (or lack of it) of the block as opposed to Dürer's original drawing. In this article for the Panofsky *Festschrift,* he characterizes Dürer as the master of three-dimensionality, as opposed to Grünewald, the master of space. It is a connoisseur's argument, based on acute observation buttressed with detailed knowledge of Dürer's written work. The author notes, correctly, that already at the age of thirteen, Dürer manifested an innate sensitivity to corporeal reality that he cannot have derived from any preexisting German paintings or graphics that were known to him, and that this quality—which he nurtured throughout his career— distinguishes his own work from that of his contemporaries as well as of his followers. Works discussed include the *Anti-Christ* and *Voyage of Fools* illustrations for Sebastian Brant's *Ship of Fools* (Basel, 1494), the standing saints from the *Jabach Altar* wings, and the Budapest *Portrait of a Young Man*, none of which he accepts as autograph work; and the *Portrait of Oswolt Krel* and the Berlin *Portrait of a Young Girl* (1507), which are genuine.

355. Hoos, Hildegard. "'Neugotik' in der Nürnberger Goldschmiedekunst um 1600?" *Städel-Jahrbuch* 9 (1983): 115–130.

Analyzes the use of late Gothic motifs in the goblets produced by Nuremberg goldsmiths approximately 1550–1600 and explains the phenomenon as a politically motivated reference to the period in which Dürer lived. Rejects the notion of a "Gothic revival," showing that Gothic motifs were integrated into a continuously evolving, forward-looking style.

356. Hoppe-Sailer, Richard. "Das *Grosse Rasenstück*: zum Verhältnis von Natur und Kunst bei Albrecht Dürer." *Studien zu Renaissance und Barock: Manfred Wundram zum 60. Geburtstag; eine*

Festschrift, 35–64. Eds. Michael Hesse and Max Imdahl. Bochumer Schriften zur Kunstgeschichte, Frankfurt/Bern/New York: Lang, 1986.

Analyzes the compositional construction of Dürer's watercolor, the *Great Piece of Turf* (Albertina) to illustrate the underlying sense of order imposed by the artist in his depictions of nature.

357. Horváth, B. D. " 'Meerwunder'—jének táryya és irodalmi forrása." *Müvészetörténeti értesitó* 20 (1971): 292–296.

The author suggests Anna Perenna (from Ovid's *Fasti*) fleeing the house of Aeneas as the subject of the engraving that Dürer always referred to simply as the "Meerwunder." (N.B.: Previous identifications of the subject have included Amymone and Nessus; and the abduction of Queen Theudelinda; Achelous and Perimele; and the abduction of Deijaniera.)

358. Howarth, David. *Lord Arundel and His Circle*, New Haven and London: Yale University Press, 1985.

[David Howarth is a Lecturer at the University of Edinburgh.] This excellent monograph deals with the life and collections of the seventeenth-century Earl Marshall of England, Thomas Howard, fourteenth Earl of Arundel (1585–1646), whom Horace Walpole would later characterize as the "father of vertue in England." The owner of the finest collection of drawings ever to be assembled, as well as of one of the world's most important collections of paintings, he was the friend and patron of Rubens, Van Dyck, and Inigo Jones, and due to his policy of using culture in order to maintain a place in the Privy Council was arguably the man most responsible for guiding the taste of Charles I, the Duke of Buckingham, and other members of the Stuart court. Through his inheritance from a childless relative—John, Lord Lumley—he had acquired Dürer's portrait of Henry Parker, Lord Morley (who had posed for the artist while serving as ambassador to the Archduke Ferdinand). During Italian travels he acquired an excellent set of the *Life of Mary* that had once belonged to a Venetian painter. In 1636, as ambassador to the Imperial court in Vienna, he passed through Nuremberg and was the recipient of a Dürer Madonna—a gift from its owner, the Bishop of Würzburg, which Arundel valued so highly that he "ever carried in my own coach since I had it" (139). In May of that year while in Nuremberg he bought the entire library and art collection that had formerly be-

longed to Dürer's best friend Willibald Pirckheimer, whom Arundel had long admired as the ultimate scholar-collector, counsellor and correspondent of learned men. The collection, then owned by Pirckheimer's descendant Hans Imhoff included Dürer's letters to Pirckheimer from Venice, his Netherlandish diary, and books written or illuminated by Dürer. Also in imitation of Pirckheimer Arundel retained a great engraver, Wenceslas Hollar, and on his way back to England he stopped in Antwerp to have his portrait painted by Rubens in the format that Dürer had used for his engraved portrait of Pirckheimer in 1524. It was Hollar who etched a copy of Dürer's 1498 *Self Portrait* (Madrid), using Richard Greenbury's painted copy of the Dürer as his model (illus. no. 124), while Arundel presented the original Dürer to Charles I, along with the *Portrait of Albrecht Dürer the Elder* now in the National Gallery, London.

359. Höss, Irmgard. "Das religiös-geistige Leben in Nürnberg am Ende des 15. Jahrhundert und Ausgang des 16. Jahrhundert." *Miscellanea Historiae Ecclesiasticae*, 17–36. Louvain: 1967.

Religious life in Nuremberg in Dürer's day.

360. Hugelshofer, Walter. "Überlegungen zu Hans Baldung." *Zeitschrift für Schweizerische Archäologie und Kunstgeschichte* 35, no. 4 (1978): 263–275.

[Thoughts on Hans Baldung.] Among the topics discussed is that of the relationship of Baldung to Dürer.

361. Hults, Linda C. "Dürer's *Lucretia*: Speaking the Silence of Women." *Signs: Journal of Women in Culture and Society* 16, no. 2 (1991): 205–237.

Bringing the tools of feminist criticism to bear on Dürer's 1518 painting (Munich) and his chiaroscuro drawing of 1508 (Albertina), the author's purpose has been to demonstrate ways in which the patriarchal agenda of the Renaissance worked at cross purposes with the idea of female heroism, producing images that carried an ambivalent social message. Noting that Dürer's works more nearly approach the heroic than do the Lucretias of Lucas Cranach or Hans Baldung, Hults suggests the interesting possibility that the Munich painting may have been done as a gift for Susanna of Bavaria, Maximilian's niece, who was married in 1518 during the Imperial Diet at Augsburg, which Dürer attended.

362. ———. *The Print in the Western World: An Introductory History*, esp. 75–95. Madison (WI): University of Wisconsin Press, 1996.

A good basic introduction to Dürer's activity as printmaker up to 1514, within the context of a general history of western printmaking.

363. Humphrey, Peter. "La festa del Rosario di Albrecht Dürer." *Eidos. Rivista di Cultura* 20, no. 2 (1988): 4–15.

Discusses Dürer's Rosary Altarpiece (Prague) in light of the fact that a Rosary Brotherhood had newly been founded in Venice in 1504 in the church of St. Bartolommeo, for which the altarpiece was painted. (See also Antonio Niero, 1974 on this point).

364. Hutchison, Jane Campbell. *Albrecht Dürer: A Biography*, Princeton: Princeton University Press, 1990.

A biography of the artist, drawn from the documents as compiled by Rupprich and from recent scholarship on the works and on the artist's relationship to the Reformation in light of the publications centered on the Luther anniversary (1983). Includes modern English translations of the Family Chronicle, letters from Venice, letters to Jacob Heller, and Netherlandish diary, and concludes with the artist's reception from the sixteenth century through the Third Reich and the five hundredth anniversary exhibitions of 1971.

365. ———. "Albrecht Dürer: *Praeceptor Mundi*." *Renaissance, Reform, Reflections in the Age of Dürer, Bruegel and Rembrandt. Master Prints from the Albion College Collection*, 47–56. Ed. Shelley K. Perlove. Dearborn: University of Michigan-Dearborn, 1994.

Discusses Dürer's intimate involvement with the still novel trade of book publishing, which led him to issue organized sets of large woodcuts suitable for classroom use, and the didacticism of his imagery. Suggests a source for the *Lamentation* from the *Large Passion* in Israhel van Meckenem's engraving of the same theme, rather than in Geertgen tot Sint Jans's painting as is commonly supposed by those who would direct the missing years of the bachelor's journey to the northern Netherlands. Both the Meckenem and the Dürer show the influence of two popular Passion plays, the *Planctus ante nescia* (Lament of Mary) and the *Magdalene Play*,

which either or both artists could have seen in Frankfurt. Briefly discusses Passion prints as derived from the traditional manuscript imagery of the Divine Office of Hours of the Cross.

366. ———. *Albrecht Dürer. Eine Biographie*, Trans. Eva Gärtner. Frankfurt am Main: Campus Verlag, 1994.

The German translation of *Albrecht Dürer: A Biography* (Princeton, 1990) by the same author. Reviewed by Thomas Kliemann, in *Nürnberger Zeitung* (December 3, 1994), Literatur, p. 94; Johann Konrad Eberlein, in *Frankfurter Allgemeine*, October 8, 1994; "dpa" in *Mittelbayerische Zeitung*, November 20, 1994; "pe" in *Südwest Presse*, December 3, 1994; "P.E." in *Bayernkurier,* December 17, 1994; Rolf Dorner, in *Limmattaler Tagblatt,* November 26, 1994.

367. ———. "Albrecht Dürer: "Ehrlich gehalten nah und feren'." *Responsibility and Commitment. Ethische Postulate der Kulturvermittlung. Festschrift für Jost Hermand*, 71–82. Eds. Klaus L. Berghahn, Robert C. Holub, and Klaus R. Scherpe. Frankfurt am Main/Berlin/Bern/New York/Paris/Vienna: Peter Lang, 1996.

Discusses Dürer's uniquely long-lived fame and honor in Germany and elsewhere as in part a function of his intellectual generosity and dedication to teaching—traits not shared by Grünewald, Cranach, Holbein, nor even Rembrandt. His unusually great productivity seems deliberately calculated in order to counteract the popular impression of Germans as barbaric and lazy that had colored European opinion since at least the time of John of Salisbury, and was reinforced by remarks made by Tacitus in the *Germania*, newly available in a printed edition edited by Konrad Celtis.

368. ———. "Der vielgefeierte Dürer." *Deutsche Feiern*, 25–45. Eds. Reinhold Grimm and Jost Hermand. Athenaion Literaturwissenschaft, 5. Wiesbaden: Akademische Verlagsgesellschaft Athenaion, 1977.

Examines the "celebrated" Albrecht Dürer, from the annual rites of the Nazarenes initiated in Rome in 1815 to the events of the Dürer Year 1971, with particular attention to Dürer's image during the Third Reich, and his role in the de-Nazification of post-World War II Nuremberg.

369. ———. "Forum: Dürer's Praxitelean *Aphrodite.*" *Drawing. The International Review published by the Drawing Society* 13, no. 3 (September–October) (1991): 55–56.

Argues that Dürer's drawing of a nude woman with a wand (Sacramento, Crocker Art Gallery), the first of the artist's drawings to enter an American collection, derives its slight awkwardness from an attempt to combine the head and arms of a life model with the posture and proportions of the lost *Aphrodite of Knidos* by Praxiteles, known in Renaissance Europe through many Roman copies and variants, all of them armless. Suggests further that the object she holds, usually identified as a herald's wand, may have been the artist's misinterpretation of the thyrsus carried by maenads at bacchanalian revels in Antiquity.

370. Hüsgen, Heinrich Sebastian. *Raisonnierendes Verzeichnis aller Kupfer- und Eisenstiche, so durch die geschickte Hand Albrecht Dürers selbsten verfertigt worden; ans Licht gestellt, und in eine systematische Ordnung gebracht, von einem Freund der schönen Wissenschaften,* Frankfurt am Main/Leipzig: Ioh.Georg Fleischers Buchhandlung, 1778.

An important early catalogue raisonné of one hundred of Dürer's intaglio prints (no woodcuts), with measurements in premetric units and a list of copies, compiled in the eighteenth century by Goethe's friend. Hüsgen (1746–1807) was not only the owner of an important collection of Dürer's prints, but was also the current possessor of the famous lock of Dürer's hair, cut off after the artist's death and sent to his former pupil Hans Baldung Grien. The existence of this scholarly catalogue, as well as the same author's note on the copy of the Heller Altar (Frankfurt, Johannes Byrhoffer, 1790) are evidence enough that the allegations of Tieck and Wackenroder, that Dürer had been "forgotten" by the late eighteenth century, were Romantic nonsense. Hüsgen's print collection had passed intact to Edward Steinle by 1865, and was acquired in 1873 by the Vienna Academy. (See Moriz Thausing, "Hüsgen's Dürer-Sammlung und das Schicksal von Dürers sterblichen Überresten," in *Zeitschrift für bildende Kunst*, 9 (1874), 321–333; and the same author's review of the Hüsgen collection in *Kunstchronik*, supplement to vol. 10 (1874) of *Zeitschrift f. bild. Kunst*, p. 14.)

371. Hüsken, Wim. "The Michelfeldt Tapestry and contemporary European literature. Moral lessons on the rule of deceit." *Dürer and His*

Culture, 69–90. Eds. Dagmer Eichberger and Charles Zika. Cambridge/New York/Melbourne: Cambridge University Press, 1998.

One of the conference papers from the 1994 Melbourne symposium. The author is Lecturer in late medieval and early Renaissance Dutch literature at the University of Nijmegen. He deals here with the long-disputed three-woodcut frieze said to have been inspired by "einem alten Tebich" seen at Schloss Michelfeldt am Rhein in mid-Lent 1524. Subjects represented are Time turning the Wheel of Life; Justice and Deceit (or The Corrupt Judge); Truth and Reason. Hüsken reviews the basic literature, both pro and con, dealing with the attribution to Dürer, and relates the iconography to Sebastian Brant, Hans Sachs, and the imagery of Carneval, or "the world upside down," noting that Dürer is said to have seen the original tapestry during Carnival in 1524.

372. Hütt, Wolfgang. *Albrecht Dürer 1471 bis 1528, Das gesamte graphische Werk*, Munich: 1970.

Complete edition of the artist's graphic art, including drawings as well as prints.

373. ———. "Verhältnis und Beitrag Albrecht Dürers zur Kunst der Reformationszeit." *Bildende Kunst* (1971): 235–239.

Dürer was highly regarded in the Deutsche Demokratische Republik, where by Dürer Year 1971 there was strong sentiment in favor of emphasis on the German "heritage." *Bildende Kunst*, an East German periodical, was not widely subscribed to in the United States, where it was regarded by many with suspicion as too politically motivated to be entirely reliable. This article identifies Humanist and Reformation elements in several of Dürer's works.

374. Imhoff, Christoph von. *Berühmte Nürnberger aus neun Jahrhunderten*, Nuremberg: Verlag Albert Hofmann, 1984.

This extremely useful reference work written by a modern member of one of the most important Nuremberg families having connections with Albrecht Dürer and his friend Pirckheimer comprises a set of biographies of prominent Nurembergers from the mid-eleventh century until the mid-twentieth. Albrecht Dürer's biography is found on pages 84–86. Other entries of special interest include Anton Koberger, Michael Wolgemut, Peter Vischer the Elder, Sebald Schreyer, Bernhard Walther, Willibald Pirckheimer, Caritas Pirckheimer, Matthäus Landauer, Veit Stoss, Kaspar

Nützel, Johannes Werner, Conrad Celtis, Martin Behaim, Lazarus Spengler, Sixtus Oelhafen, Hans Süss von Kulmbach, Wolf Traut, the Beham brothers, Georg Pencz, Christoph Scheurl, Johannes Cochlaeus, Anton II and Sixtus Tucher, Willibald Imhoff, Paulus II Praun. Biographies are arranged chronologically, while documentation is found in a separate list at the end, under the names of the biographees arranged alphabetically. Other useful features include a complete index of persons, and lists of the families eligible for membership in the City Council, from 1300–1729, giving the date when each family was first mentioned.

375. ———. "Die Imhoff-Handelsherren und Kunstliebhaber. Überblick über 750 Jahre alte Nürnberger Ratsfamilie." *Mitteilungen des Vereins für Geschichte der Stadt Nürnberg* 62 (1975): 1–42.

This article on the Imhoff family, with whom Dürer had many important business dealings, was developed from the author's keynote lecture for the exhibition *Die Imhoff* ("The Imhoff Family"), held in Nürnberg's Pellerhaus (June 18, 1971), and for the entry on the family in *Neue Deutsche Biographie*, vol. 10 (1974). The primary material on the family is the Imhoff album in the Germanisches Nationalmuseum's archive. Whereas the family, who belonged to the parish of St. Lorenz, are noted for their patronage of Michael Wolgemut and Adam Kraft rather than of Dürer, they were long related by marriage to the Pirckheimer family, and a younger member of the family, Willibald, was the owner of the most important collection of Dürer's work before the Holy Roman Emperor Rudolph II, who acquired much of it.

376. Indra, Bohumir. "K pobytu Hanse Dürera v Olomouci." *Casopis Slezského Muzea, series B* 28 (1979) 2: 183–184.

Reveals the possibility that Dürer's younger brother Hans may have been in Olmütz after his departure from Nuremberg (1510) and before his arrival in Cracow, where he was employed as court painter from 1527 until his death in 1534. The evidence presented in support of this hypothesis consists of two paintings by his hand mentioned in a 1581 will.

377. Iowa City (IA). University of Iowa Museum of Art. *The Owen N. Elliott Collection of Prints*, 1983.

Exhibition catalogue of prints in the Museum's permanent collection, featuring works by seventy-four artists, among them Dürer.

378. Ithaca (NY). Cornell University, Herbert F. Johnson Museum of Art. *German Renaissance Prints*, Ed. Kathleen W. Carr. Ithaca, NY: Cornell University,

Introduction by Caroline F. Malseed. The catalogue of an exhibition of sixty-five German Renaissance prints. Cornell University's Herbert F. Johnson Museum of Art owns a large number of such prints dating from 1500–1550—mainly works by Dürer.

379. Ivins, William M. Jr. "Notes on Three Dürer Woodblocks." *Metropolitan Museum Studies* 2 (1929): 102–111.

It was the contention of Ivins, who as Director of the print room had acquired the block of Dürer's early *Samson and the Lion* for the Metropolitan, that the young artist, dissatisfied with the butchery of his woodblock designs by the professional *Formschneider* in Basel, had resolved to cut his own when he opened his own workshop in Nuremberg. He based his opinion on the carving quality of three early blocks, which resemble relief sculpture more than the abrupt linework of the blocks known to have been done, later, by professional cutters such as Hieronymus Andreae. (Ivins's theory has since been challenged by Matthias Mende [q.v., 1971], who points out that such activity on the part of a painter and designer would have been not only unprecedented but unique in the history of Nuremberg, although a few local sculptors are known to have cut blocks from time to time.)

380. Jacobowitz, Ellen. "*The Virgin and Child with the Pear*, 1511, by Albrecht Dürer." *Philadelphia Museum of Art Bulletin* 80, no. Summer–Fall (1984): 343–344.

Announces a newly acquired impression in the Philadelphia Museum.

381. Jaffe, Michael. "Ripeness is All: Rubens and Hélène Fourment." *Apollo* 107, no. April (1978): 290–293.

Suggests that Rubens's *Self Portrait with Hélène and a Child on a String* (New York, Metropolitan Museum, Wrightsman Collection) is related to Dürer's engraving *The Promenade*.

382. Jahn, Johannes. "Albrecht Dürer. Sendung und Personlichkeit." *Albrecht Dürer. Die künstlerische Entwicklung eines grossen Meisters*, 8–45. Berlin (DDR): Deutsche Akademie der Kunst, 1954.

This is an item from a volume of historical interest—a soft-cover Dürer book assembled to accompany a traveling exhibition of *reproductions* of works by Dürer, circulated in East Germany under the auspices of the German Academy of Arts. The keynote biographical essay is by Johannes Jahn (b. 1892), then the leading art historian in both the museum and the University of Leipzig. The next item in the catalogue is the obligatory quotation from Friedrich Engels, *Der Deutsche Bauernkrieg*. Then follow an essay by Wilhelm Fraenger on the *Bauernsäule* (pp. 84–99), and finally a section of quotations from Dürer's theoretical writing, and an essay by the catalogue's editor, Gerhard Pommeranz-Liedtke, on the most important dates in the artist's life.

383. ———. "Entwicklungsstufen der Dürerforschung." Leipzig, Berlin: Akademie Verlag, 1971.

A "state of the question" review of Dürer studies by the leading art historian in Leipzig in the years after World War II. Jahn, born in 1892, had studied under both August Schmarsow (d. 1936) and Wilhelm Pinder (1878–1947: his dissertation adviser), and stresses Leipzig scholarship, for Leipzig was the leading East German university.

384. ———. *Kunstwerk, Künstler, Kunstgeschichte: ausgewählte Schriften von Johannes Jahn*, Ed. Ernst Ullmann. Seemann-Beiträge zur Kunstwissenschaft, Leipzig: E.A. Seemann, 1982.

A collection of essays by the Leipzig art historian, Johannes Jahn (1892–1976), including his small monographs on Dürer, Leonardo and Michelangelo; a study of compositional problems of landscape; and an investigation of Goethe's relationship to pictorial art [RILA].

385. Janeck, Axel. "Dürer Colloquium Nürnberg." *Kunstchronik* 25, no. 7 (1972): 185–213.

Reportage, by Nuremberg's Curator of Prints and Drawings, of the papers presented at the colloquium on the artist's early work (1490–1500), and of the individual responses to each paper. Presenters included Franz Winzinger (on Dürer's relationship to the

art of Martin Schongauer); Volker Michael Strocka (on the influ-
ence of the Housebook Master); Albert Châtelet (on the influence
of the northern Netherlands, especially of Geertgen tot Sint Jans);
Gisela Goldberg (on the Alte Pinakothek's portrait of an unknown
young man dated 1500); Wilhelm H. Köhler (on the problem of the
authorship of the Dominican altarpiece in the Colmar Museum);
Fedja Anzelewsky (on Dürer's panel paintings 1490–1500, both
extant and lost); Teresio Pignatti (on Dürer and Jacopo de'Bar-
bari); John Rowlands (on the British Museum's drawing of two fe-
male mourners (W.192) and Sir Edmund Bacon's painting of *St.
Jerome in Penitence*); Kristina Herrmann-Fiore (on dating the
landscape watercolors); Lisa Oehler (the drawings of the female
nude, W.85 (Paris) and W.947 (Sacramento); Dieter Kuhrmann (on
the *Flagellation* from the *Large Passion*); Erika Simon (on Dürer
and Mantegna); Peter Strieder (on antique prototypes for the *Meer-
wunder* [Sea Monster] engraving). Respondents, in addition to the
presenters, included Bernhard Degenhart, Martin Gosebruch, Di-
eter Koepplin, Willibald Sauerländer, and Wolfgang Wegner.

386. Jante, Peter Rudolf. *Willibald Imhoff. Kunstfreund und Sammler.*
Ph.D. dissertation, Georg-August-Universität, Göttingen, 1985.

The author's inaugural dissertation, offset from typescript. First
publication of Willibald Imhoff's "ander Kostpuch"—an Imhoff
household book covering accounts from the years 1564–1578.
Works consulted also include Willibald's "Memory a puch" (in-
ventory, 1533–1576: Stadtbibliothek Nürnberg StB Amb. 65.4),
which also includes family history and information on the forma-
tion of his collections; the *Inventory of the Art Collection 1573/74*
(Hs. Stadtbibliothek Nürnberg StB Amb. 66.4); and the *Haushalt-
buch* ("ander Kostpuch") from 1564–1578 (Pap. Hs. 191 B11,
Stadtbibliothek Nürnberg StB. Amb. 64.4). Contains introductory
biographical information on Willibald Imhoff's granduncle,
Dürer's best friend Willibald Pirckheimer, as humanist and collec-
tor (Imhoff was the son of Pirckheimer's daughter Felicitas and
Hans IV Imhoff). Pirckheimer is characterized as, above all, a col-
lector of books (his library was acquired in the seventeenth century
by Thomas Howard, Earl of Arundel). He also, however, owned
valuable silver hollowware; medals; books illustrated by Dürer;
the original manuscripts for Dürer's *Four Books of Human Propor-
tion*; the artist's letters from Venice and Netherlandish diary;

Dürer's gifts (a big sea-turtle shell, stag antlers, four pieces of Chinese porcelain, coral, ivory). Willibald Imhoff, who was eleven years old when Pirckheimer died, was given an education in art appreciation by his paternal grandmother, Katherine Imhoff (née Muffel), the widow of Hans VI Imhoff. Over the years he lived for extended periods in Lyon, Antwerp and Nuremberg, with frequent travels to Frankfurt, and tours in Spain and Geneva. His "Memoryapuch" lists his purchases of Dürer prints, but the "ander Kostpuch" is by far the most interesting and detailed, giving prices for his many purchases of major engravings and paintings—including Dürer's *Glimm Lamentation*, the *Portrait of Kleeberger*, the watercolor *Portrait of Maximilian*, and a Dürer *Madonna*, in addition to various Italian and other German works. Comparative prices of clothing and household goods can be drawn from the inventories of these items, also included.

387. Jászai, Géza. "Die Sündenfall-Darstellung Johann Brabenders in Münster: ein frühes Beispiel der Dürerrezeption in der norddeutschen Skulptur des 16. Jahrhunderts." *Städel-Jahrbuch* 9 (1983): 55–68.

Analyzes the extent to which Dürer's engraving of the *Fall of Man* may be said to have influenced Johann Brabender's sculptural group of the same subject in the Westfälisches Landesmuseum, Münster, concluding that the relationship between the works is more complex than has been supposed.

388. Jelinek, Hans. "Dürer's Etching *The Desperate Man*: Discovery of a Date and Some Thoughts About an Old Controversy." *Print Review* 4 (1975): 4–13.

The author discerns a previously unnoticed date, 1514, on the right foot of the *Desperate Man*, which may mean that it was the first of the artist's etchings. This reinforces the theories of Panofsky and Friedländer that it was a trial plate, with a pastiche of images rather than a narrative image. The date seen by Jelinek also is the same one suggested by Panofsky.

389. Jenny, Ulrike. "Vorstufen zu Dürers Tier-und Pflanzenstudien." *Jahrbuch der Kunsthistorischen Sammlungen in Wien* 82/83 (n.s. vol. XLVI/XLVII) (1986): 23–31.

Contests Hans Hoffmann's statement (see 1971 Nuremberg exhibition catalogue) that "hardly any other great artist . . . since Giotto . . . was less rooted in the art of the past [than Dürer.]" Discusses fifteenth century sources utilized by Dürer, including Pisanello, Mantegna, Schongauer, and others.

390. Jones, Mark, and Mario Spagnol. *Sembrare e non Essere. I Falsi nell'Arte e nella Civiltá*, esp. 114–123. Milan: Longanesi, [1993].

First published in English as *Fake? The Art of Deception*. Translated into Italian by Mary Archer, with entries on Dürer fakes by Giulia Bartrum and Anthony Griffiths, both of the British Museum. The section cited here ("I falsi in Europa del Renascimento al XVIII secolo") deals with the "cult" of Dürer, reproducing Hieronymus Wiericx's *Madonna with the Monkey*; Hans Hoffmann's *Dead Blue Roller*; the anonymous sixteenth-century copy of the *Nativity* engraving ("Weihnachten," 1504: Brit. Mus. PD E 44–35); Raimondi's engraved copy of the *Annunciation* from the Marienleben; Hans von Kulmbach's charcoal drawing of *Sts. Katherine and Barbara* with a false AD monogram (Brit. Mus.); Georg Schweigger's *Naming of John the Baptist* (1642, London—a stone relief carving based on Dürer's *Death of the Virgin* woodcut); Luca Giordano's *Christ Before Pilate*, in the manner of Dürer's composition from the Small Passion.

391. Jones, Rebecca K., and Margaret A. Hagen. "The Perceptual Constraints on Choosing a Pictorial Station Point." *Leonardo* 11, no. 3 (Summer) (1978): 191–196.

Discusses artists' choices of pictorial station points, and the constraints under which they were made, in art historical context and in terms of modern perceptual psychology. Alberti, Dürer, and Leonardo da Vinci are compared with current speculations of Gibson and Pirenne [RILA].

392. Junghans, Helmar. *Wittenberg als Lutherstadt*, figs. 23, 25, 26, 35. Göttingen: Vandenhoeck & Ruprecht, 1979.

The Castle Church and the altarpieces by Dürer and others that have been linked with it.

393. Jurascheck, Franz. *Das Rätsel in Dürer's Gottesschau. Die Holzschnittapokalypse und Nicolaus von Cues*, Salzburg: 1955.

Juraschek, who had written several interesting articles on individual woodcuts from the Apocalypse series, tried here to view it whole as an organic development from the theology of Nicholas of Cusa (1401–1464). While it cannot be doubted that Dürer, like nearly everyone else, had heard of the late Cardinal Bishop of Brixen, one of the foremost European theologians after the Council of Basel and before Luther, the attempt to tie the Apocalypse illustrations so closely to his thought in more than a general way is highly speculative, and has been accepted by almost no one except Walter Strauss and Peter Strieder. Reviewed in *Bulletin Monumentale* 113 (1955), 297 (Marcel Aubert?); *Salzburger Hochschulwochen* (1955), 138–139 (Franz Fuhrmann); *Heilige Kunst. Mitgliedsgabe des Kunstvereins der Diözese Rottenburg* (1956), 98; *Theologische Literaturzeitung* 85 (1960), no. 7, 542–544. [For more on Nicholas of Cusa see Anton Lübke, *Nikolaus von Kues*, Munich, Verlag Georg W. Callwey, 1968.]

394. Juraschek, Franz von. "Der Todsündendrache in Dürers Apokalypse." *Jahrbuch der preussischen Kunstsammlungen* 58 (1937): 189–194.

Argues that the seven-headed dragon in Dürer's woodcut B.71 fom the Apocalypse series symbolizes the seven deadly sins, a not unreasonable idea.

395. Jürgens, Klaus H. "Neue Forschungen zu dem Münchener Selbstbildnis des Jahres 1500 von Albrecht Dürer." *Kunsthistorisches Jahrbuch Graz* (1983): 167–190; 143–164.

Analyzes the *Self Portrait in a Fur Coat* as addressing a humanist public, Dürer portraying himself as the universal artist whose creativity has its origin in divine grace. By the superimposition of a hexagram onto the outlines of the portrait, argues that the figure six played an important role in Dürer's theoretical thought absorbed through contacts with humanists and philosophers, including Celtis, Pirckheimer, and the Italian artist Jacopo de'Barbari.

396. Kahsnitz, Rainer. "Sculpture in Stone, Terra Cotta and Wood." *Gothic and Renaissance Art in Nuremberg 1300–1500*, 61–74. New York. Metropolitan Museum of Art. Munich: Prestel, 1986.

Largely concerns predecessors and contemporaries of Dürer (e.g., the fourteenth-century *Schöne Brunnen* and the Parler style; the

Schlüsselfelder tomb; Adam Kraft; Veit Stoss), but concludes with a brief discussion of Dürer's designs for sculpture.

397. ———. "Stained Glass in Nuremberg." *Gothic and Renaissance Art in Nuremberg 1300–1550*, 87–92. Metropolitan Museum New York. Munich: Prestel, 1986.

The author, who is Chief Curator of the Germanisches National-museum, discusses Nuremberg as a center of stained glass produc-tion in the Parler style, calling attention to original glass remaining in the city's principal churches, St. Sebaldus (the Behaim window, 1379–86; the Pfinzing window, ca. 1515) and St. Lorenz (the Coronation of the Virgin, ca. 1390–1400; and Emperor's window, ca. 1477, carried out in the workshop of Michael Wolgemut). The activity of Wolgemut's deceased partner, Hans Pleydenwurff as a glazier is documented, as are Wolgemut's own further activities in the Lorenzkirche and in the Church of St. Michael in nearby Fürth. The activity of Dürer and his pupils at the beginning of the six-teenth century constitute a last flowering of the art, just before the Reformation. [Exhibited items were the trefoils for Dr. Sixtus Tucher, made after drawings from the Dürer circle.]

398. Kaplan, Alice M. "Dürer's 'Raphael' Drawing Reconsidered." *The Art Bulletin* 56, no. 1 (1974): 50–58.

[A reduction of the author's Master's thesis]. Concerns the draw-ing in the Albertina, dated 1515 in Dürer's hand and inscribed with a note indicating that "Raphahill" had sent it to him, "sein Hand zu weisen" [Albertina cat. no. 7, a life drawing depicting a standing male nude in two different poses]. Although the status of the draw-ing as an autograph Raphael remains uncertain, it unquestionably comes from Raphael's studio and has traditionally been associated with the *Battle of Ostia* fresco in the Vatican's Stanza dell'Incen-dio. The author argues that, while the drawing does duplicate the pose of the centurion at the far left of the fresco, fresh examination of the documentation for both fresco and drawing points to the conclusion that the drawing is an original study for the figure of St. Paul in Raphael's tapestry cartoon of the *Blinding of Elymas*. Her argument, that Raphael would scarcely have sent to Germany a working drawing that was still in use for the painting of the *Battle of Ostia,* is a convincing one. (The status of the attribution to Raphael was beyond the scope of this article, but the author lists

the pertinent literature in a note on p. 57. Konrad Oberhuber [1962], who has since become the Albertina's director, returned the attribution to Raphael in an article for the *Jahrbuch der kunsthistorischen Sammlungen in Wien*, 58, pp. 46–47.)

399. Karling, Sten. "Riddaren, döden och djävulen." *Konsthistorik Tidskrift* 39 (1970): 1–13.

See "Ritter, Tod und Teufel," in *Actes 22e Congrès International de l'Histoire d'Art* (1972).

400. ———. *"Ritter, Tod und Teufel:* Ein Beitrag zur Deutung von Dürers Stich." *Actes 22e Congrès International de l'Histoire d'Art*, (1972) 733. Budapest:

The Swedish art historian, in his paper for the Budapest meeting of the International Congress (1969), maintained that Dürer's *Knight, Death, and Devil* represents, not the Erasmian Christian soldier envisioned by Paul Weber (1900), Erwin Panofsky (1943), and others, but the more controversial German robber baron (a theory first put forward in 1879 by Heinrich Merz). He saw the dog, not as the symbol of the Christian virtue of Fidelity, but—in light of the creature's "fearful, laid-back ears"—a reminder of Melanchthon's tale of the Devil who followed Faust in the form of a dog. [See Ursula Meyer in *Print Collector's Newsletter*, 9 (1978) 2 , 35–39.]

401. Kassel, Staatliche Kunstammlungen. *Die Altdeutsche Malerei*, Anja Schneckenburger-Broscheck. Kassel,: Staatliche Kunstsammlungen, 1982.

The collection catalogue of the fifteenth- and sixteenth-century German paintings in the picture gallery at Schloss Wilhelmshöhe, including Dürer's *Portrait of Elspeth Tucher* (1499), as well as works by his teacher Michael Wolgemut and his follower Hans Baldung Grien. Although the eighteenth-century inventory of the Kassel collection listed three paintings attributed to Dürer, the Tucher portrait, which first appears in the inventory of 1830, is the only one remaining that is still attributed to Dürer.

402. Kastner, Joseph. "Extracting Art from Nature." *Natural History* (September 1989): 76ff.

Dürer's approach to nature study in the *Large Piece of Turf* compared to work of Leonardo da Vinci.

403. Kauffmann, C. M. "An Early Sixteenth-Century Genealogy of Anglo-Saxon Kings." *Journal of the Warburg and Courtauld Institutes* 47 (1984): 209–216.

 Deals with MS Arundel 53 (London, College of Arms), written in England approximately 1510 but illustrated by a Netherlandish artist attached to the Tudor court at Richmond, who modernized the manuscript with drawings influenced by Dürer's prints and other printed images.

404. Kauffmann, Hans. "Albrecht Dürers Dreikönigsaltar." *Wallraf-Richartz Jahrbuch* 10 (1938): 166–178.

 Proposes that Dürer's *Adoration of the Magi* (Uffizi) may be the missing central panel of the *Jabach Altarpiece* (left wing, *Job*, Frankfurt, Städelsches Kunstinstitut; right wing, *Two Musicians*, Cologne, Wallraf-Richartzmuseum), painted by Dürer for the Castle Church in Wittenberg and installed there by the artist around 1503. (The theory has since been contested by Anzelewsky, who proposes a different reconstruction with an *Anna Selbdritt* as center. See his *Dürer-Studien*, 142–161).

405. Kauffmann, Hans. *Albrecht Dürer Die Vier Apostel. Vortrag gehalten den 18. April 1972 im Kunsthistorischen Institut in Utrecht*, Utrecht: 1973.

 The published text of an address given at the Kunsthistorisch Institut of the Rijksuniversiteit Utrecht, Kauffmann demonstrates that there was already some preconceived plan afoot in the Nuremberg City Council for such a work as the so-called *Four Apostles* before Dürer painted the work now in Munich. (Contrast Chapeaurouge, et al., who have assumed that the artist conceived of the project entirely by himself.)

406. ———. "Albrecht Dürer um 1500." *Studies in Late Medieval and Renaissance Painting in Honor of Millard Meiss*, 261–274. Eds. Irving Lavin and John Plummer. 2 vols. New York: New York University Press, 1977.

 Discusses the astonishing formal development seen in Dürer's works during the critical period between the *Apocalypse* (1498) and *Fall of Man* (1504), including architectural and landscape settings of the *Marienleben*, *Large Passion*, *Green Passion*, *Meerwunder*, and *Weihnachten*.

407. ———. "Dürer in der Kunst und im Kunsturteil um 1600." *An-*
 zeiger des Germanischen Nationalmuseums 1940–53 (1954):
 18–60.

 Published a year before Lüdecke and Heiland (q.v.), this was the
 first extensive examination of Dürer's "afterlife" in art and art crit-
 icism, shown to have been much longer lived than Mannerism. The
 author, better known today for his Rubens studies, was the most
 important German academic art historian specializing in Northern
 art during the years of World War II and for at least a decade after-
 ward. Artists discussed include Lambert Lombard, A. van den
 Heuvel, Hans Hoffmann, Aegidius Sadelaer, Tobias Stimmer,
 Georg Hoefnagel, Wenzel Hollar, Jacques Bellange, Adriaen de
 Vries, Cornelis Cornelisz, Hendrik Goltzius, Peter Paul Rubens,
 Francisco Zurbaran, and Alonso Cano. Collectors discussed in-
 clude Rudolph II; Thomas Howard, Lord Arundel; and Charles I.

408. Kaufmann, Leopold. "Die Nachwirkung Albrecht Dürers auf die
 spätere Zeit." *Zeitschrift für deutsche Kulturgeschichte* n.s. 2, no. 7
 (1873): 470–481.

 Of historical interest: A pioneering work on Dürer's influence.

409. Kaufmann, Lynn Frier. *The Noble Savage: Satyrs and Satyr Fami-*
 lies in Renaissance Art. Ph.D. dissertation, University of Pennsyl-
 vania, 1979.

 Discusses Dürer's role in popularizing the subject with his *Satyr*
 Family of 1505, and in domesticating into a harmless *paterfamilias*
 a figure who in Antiquity was invariably depicted as a lusty and
 bestial libertine. Notes that while the print had a wide following
 among Italian engravers (Jacopo de'Barbari, Benedetto Montagna,
 Giovanni Battista Palumba, the Master of 1515), it appeared in
 panel painting only by artists north of the Alps (Altdorfer,
 Cranach)—a fact "not unrelated to its origins and meaning."

410. Kaufmann, Thomas Da Costa. "Hermeneutics in the History of
 Art: Remarks on the Reception of Dürer in the Sixteenth and Early
 Seventeenth Centuries." *New Perspectives on the Art of Renais-*
 sance Nuremberg, 22–39. Ed. Jeffrey Chipps Smith. Austin, TX:
 University of Texas—Archer M. Huntington Art Gallery, 1985.

 The author, a professor at Princeton who is the leading authority
 on the patronage of Rudolph II, discusses conflicting interpreta-

tions of Dürer as seen in the response to "Melencolia I," and most particularly in various copies of the artist's other works in which Dürer's original images have been deliberately transformed either in scale, medium, or other visual aspects, making it clear that the copyist has considered questions of design, function or meaning. Images include Daniel Fröschl's *Virgin and Child* (Vienna, Kunsthistorisches Museum); the canonization of Dürer's art around 1600; Hans Baldung's *Adam and Eve* woodcut (1511) and variations on Dürer's *Small Horse*; Lucas Cranach the Elder's *Melancholy*, and Bartholomaus Spranger's panel paintings of standing Sts. Wenzel, Veit, Sigismund, and Adalbert (Prague, National Gallery). Demonstrates that Baldung and the elder Cranach questioned and rejected many of the values embodied in Dürer's art, and suggests that contemporary hermeneutic theory may reveal a less rational side to Dürer and to German Renaisance culture.

411. Kaufmann, Thomas Da Costa. "The Perspective of Shadows: The History of the Theory of Shadow Projection." *Journal of the Warburg and Courtauld Institutes* 38 (1975): 258–287.

Kaufmann published this outstanding article while on a graduate fellowship at the National Gallery of Art in Washington. It is an excellent study of the practical artistic problems involved in the representation of cast shadows, and of how they came to be treated in art theory according to the rules of perspective. Leonardo da Vinci was the first to write on the perspectival projection of shadows, since shadow formation had previously been considered more a concern of astronomy than of optics and had generally been omitted from early Renaissance studies of linear perspective. Leonardo, however, who was concerned mainly with aesthetic effects, never published his findings, and his theory was imperfect in any case. Kaufmann shows that it was Albrecht Dürer who first published a demonstration of shadow projection, and goes on to discuss the sixteenth century dissemination of Dürer's ideas, as well as of Leonardo's. Appendices reproduce quotations from Dürer's writings (1525), as well as of Franiciscus Aguilonius (1613) and Pietro Accolti (1625).

412. Keil, Robert. "Zu Dürers frühen Proportionszeichnungen des menschlichen Körpers." *Pantheon* 43 (1985): 54–61.

[On Dürer's early drawings of human proportions.] Analyzes and chronologically groups Dürer's studies of male and female bodies

executed approximately 1500–1505, immediately before his second trip to Italy. Discusses the influence of Vitruvian canons of proportion and of Jacopo de' Barbari on this early phase of Dürer's work. Has summaries in English and French [RILA].

413. Kircher, A. *Deutsche Kaiser in Nürnberg. Eine Studie zur Geschichte der Stadt Nürnberg von 1500–1612*, Freie Schriftenfolge der Gesellschaft für Familienforschung in Franken, 7. Nuremberg: 1955.

Covers the activities of Maximilian I in Nuremberg at the time of his patronage of Dürer.

414. Klauner, Friderike. "Gedanken zu Dürers Allerheiligenbildern." *Jahrbuch der Kunsthistorischen Sammlungen in Wien* 75, (n.s. 39) (1979): 57–92.

Sees the influence of Luca Signorelli's Orvieto Cathedral frescoes on Dürer's *Martyrdom of the Ten Thousand*, suggesting that he may have seen them in 1506. Identifies Matthäus Landauer's nephew, Wilhelm Schlüsselfelder, as one of the figures represented in the Landauer Altarpiece (*Adoration of the Trinity*, Vienna). Schlüsselfelder, the administrator and guardian of the Landauer *Zwölfbrüderhaus*, stands behind the peasant with the flail, placing a kindly hand on the poor man's shoulder in reference to the charitable work of the Landauer family. Also discusses the derivation of the type of self portrait, and the original frame.

415. Knappe, Karl Adolf. *Dürer: Complete Engravings, Etchings and Woodcuts*, New York: Abrams, 1965.

One of several popular editions of the complete prints; well produced with full-page illustrations of good quality. Has a concordance with Bartsch numbers; a handlist giving locations of the impressions reproduced. Has an introductory essay (thirty-four pages) with background material on the artist's life and on the Nuremberg context. The prints are arranged chronologically. This is the best noniconographically arranged catalogue, and is the one favored by Peter Strieder. There are a few concepts, however, that are dated: for example, Knappe interprets the Apocalypse series entirely in terms of late fifteenth-century chiliasm and a supposed sense of tragedy that infects "the German soul," in terms of Thomas Mann's *Dr. Faustus*.

416. Koch, Ebba. "The Baluster Column–a European Motif in Mughal Architecture and its Meaning." *Journal of the Warburg and Courtauld Institutes* 45 (1982): 251–262.

Discusses the use of a foliate pilaster in palace architecture during the reign of Shah Jahan (1628–1658) and the adoption of the motif in Mughal and Hindu architecture and decoration. Finds parallels with European architecture, and discusses the influence of prints by Dürer and his followers and of the columnar device of Charles V as symbolic of absolute sovereignty and dynasty [RILA 1108].

417. Koehler, Sylvester Rosa. *A Chronological Catalogue of the Engravings, Drypoints and Etchings of Albrecht Dürer*, New York: Grolier Club, 1897.

Of historical interest as a pioneering work by an American (though German-born) connoisseur, the first curator of the Boston Museum's print collection, whose impressive sensitivity to print quality set an important precedent for future additions to the collection.

418. Koerner, Joseph Leo. "Albrecht Dürer's *Pleasures of the World* and the Limits of Festival." *Das Fest*, 180–216. Eds. Rainer Warning and Walter Haug. Poetik und Hermeneutic, 14. Munich: 1989.

[A shorter version appeared in German as "Der letzte Gast des Festes. Eine Interpretation von Albrecht Dürers Federzeichnung *Die Freuden der Welt*," in *Frankfurter Allgemeine Zeitung* (October 14, 1987, 35).] The published version of a paper delivered at the Arbeitsgruppe Poetik und Hermeneutik in Bad Homburg (October 1987), deals with the author's perception of the relationship between Dürer's general aesthetic and the legal status of his monogram.

419. ———. "The Fortune of Dürer's *Nemesis*." Fortuna, Eds. Walter Haug and Burghardt Wachinger, 239–294. Regensburg, Tübingen: 1995.

[Papers of the tenth Regensburg conference on the meaning of the Fortuna theme in the transition from the Middle Ages to the Renaissance.]

420. ———. *The Moment of Self-Portraiture in German Renaissance Art*, Chicago: The University of Chicago, 1993.

The author, a professor of fine arts at Harvard and winner of the Mitchell Prize for the History of Art (1992), has published widely

on German artists, including Hans Baldung and Caspar David Friedrich, and is well-versed in German philosophy and modern reception theory—particularly the reception theory of Hans-Georg Gadamer and Hans Robert Jauss. The present work was developed and revised from his 1988 Berkeley dissertation, *Self Portraiture and the Crisis of Interpretation in German Renaissance Art: Albrecht Dürer, Hans Baldung Grien, Lucas Cranach the Elder.* In it he examines Dürer's path-breaking self portraits—particularly the Munich painting of the half-millenium year 1500—in terms of their motivating circumstances, their character as models for German Renaissance art, and their establishment of the principle that the value and meaning of an image "derives from its being *by* someone." The "aesthetic aftermath" of Dürer's art production, including both religious and mythological works, is seen in the deliberate deformation of his vision by Baldung's debasement of the viewer, in which reception itself becomes the work of art, and which he associates with the new hermeneutic method of Luther (reviewed by Patricia Emison in *The Burlington Magazine*, 136 (1994), 765; Bruce Krajewski in *Renaissance Quarterly* 49, 1 (Spring 1996) 180–181; Susan Forster in *Art History*, vol. 17 (December 1994), 664–668).

421. Kohler, Wilhelm H. "Albrecht Dürers *Bildnis einer Fürlegerin*; eine Neuerwerbung der Gemäldegalerie." *Jahrbuch der preussischer Kulturbesitz* 14 (1977): 175–197.

Discusses Berlin's acquisition of the portrait of a young girl in a red dress with her hair pinned up in braids, seated by a parapet near a window. An inscripton gives the date as 1497 and her age as seventeen ("in her eighteenth year"). The coat-of-arms of the Fürleger family of Nuremberg also appears on the work. The author discusses the iconography of the flowers in her hands, concluding that it is a bridal portrait [RILA]. [On this painting and its pendant (Frankfurt, Stadel) See also Anzelewsky (1991) nos. 45 and 46.]

422. Kohlhaussen, Heinrich. "Ein Drachenleuchter von Veit Stoss nach dem Entwurf Albrecht Dürers." *Anzeiger des Germanischen Nationalmuseums* (1936): 135–141.

Late overpaint removed from the chandelier in the shape of a dragon, made by Veit Stoss from a design by Dürer, reveals the original light gilding in good condition. Pauli had published

Dürer's drawing (*Münchner Jahrbuch*, 1937) with its inscription by Johannes Neudorffer's grandson stating that the piece had originally hung in the *Regimentstube* of Nuremberg's city hall. The first known fixture of this type was made in 1370 for the Erfurt city hall; Riemenschneider made two (Sterzing; Ochsenfurt), also both for city halls. Dürer had also designed a similar fixture for Pirckheimer (1513), but utilizing elk antlers and a mermaid's torso.

423. ————. *Nürnberger Goldschmiedekunst des Mittelalters und der Dürerzeit 1240 bis 1540*, Berlin: 1968.

Kohlhaussen had been a National Socialist during the Third Reich and sometimes wrote in the spirit of ultrapatriotism, but his work on Nuremberg goldsmiths is still a major resource in this underrepresented field.

424. Konecny, Lubomir. "Albrechta Dürera *Laus Bombardae*." *Uméni* 19 (1972): 326–344.

Interprets Dürer's *Landscape with Cannon* etching as a *laus bombardae* (praise of the cannon), a symbol of progress, and sees the onlookers as representatives of various groups in society. This was an interesting attempt—the first to allegorize the print—but, as Bialostocki points out (1988), the emblem books he cited that depict weapons as symbolic of progress were all published later than the print, which dates from 1518 (Jacob Bornitz, *Emblemata ethico politica*, Mainz, 1669; Diego de Saaredra Fajardo, *Idea d'un Principe Politico Christiana*, Amsterdam, 1659).

425. Konowitz, Ellen. "Drawings as Intermediary Stages: Some Working Methods of Dirk Vellert and Albrecht Dürer Re-examined." *Simiolus* 20, no. 2/3 (1990): 143–153.

Compares Vellert's use of tracings with Dürer's preliminary outline drawings in pen on white paper (e.g., the *Bearing of the Cross*, Berlin; *Ecce Homo,* Schilling Collection, Edgeware; the Washington *Entombment*), which he subsequently traced into compositions for the *Green Passion*. Since the two artists did not meet until fifteen years after the completion of Dürer's series, the author concludes that the practice must at one time have been more widespread, and may have had to do with the relationship between workshop stock and presentation pieces for clients.

426. Koreny, Fritz. *Albrecht Dürer und die Tier- und Pflanzenstudien der Renaissance*, Munich: Prestel, 1985.

An essential work. The catalogue of an exhibition of nature studies in watercolor and various drawing media by Dürer, his contemporaries and his followers, Hans Hoffmann, Georg Hoefnagel, and others. The author, through careful stylistic comparison, unmasks several watercolors previously attributed to Dürer as the work of the Dürer "Renaissance" of the late sixteenth century. Generally it is Dürer's decisive sense of form and acute observation of nature that distinguishes his work from the more mindlessly rhythmic work of his copyists, as in the case of the many wings of blue rollers that exist. (A startlng feature of the Vienna exhibition was an actual, stuffed blue roller, whose brilliant plumage was, if anything, even brighter than Dürer's depiction of it.) [Reviewed by Detleff Hoffmann, *Kritische Berichte* 14, no. 2 (1986) 83–87.]

427. Albrecht Dürer und die Tier-und Pflanzenstudien der Renaissance–Symposium. Die Beiträge der von der Graphischen Sammlung Albertina vom 7. bis 10. Juni 1985 veranstalteten Tagung, Ed. Fritz Koreny, Vienna, Albertina, June 7, 1985. Vienna: Jahrbuch der Kunsthistorischen Sammlungen in Wien, 1986.

Papers of the symposium held at the Albertina in connection with the international loan exhibition of nature studies on paper by Dürer and his followers, including Hans Hoffmann. Individual presenters include Koreny, Konrad Oberhuber, Katrin Achilles, Fedya Anzelewsky, Lottlisa Behling, Johann Eckart von Borries, Hendrik Budde, Tilman Falk, Ilse O'Dell Franke, Eliska Fucikova, Heinrich Geissler, Gisela Goldberger, Ulrike Jenny, Gunther Pass, and Sam Segal. (See under individual authors.)

428. Koreny, Fritz. "Albrecht Dürers Studien eines Rehbocks in Bayonne und Kansas City." *Jahrbuch der Kunsthistorischen Sammlungen in Wien* 82/83 (1986): 11–17.

Koreny's conference presentation at the symposium accompanying the Albertina's exhibition of nature studies by Dürer and his followers (q.v., 1985). He uses the watermark (Crown with Cross and Triangle) divided between the two drawings of a roebuck (Bayonne, France and Kansas City, MO) to demonstrate that the two were drawn on the same sheet of paper. This article also is of interest for its account of the provenance of the Kansas City draw-

ing, from the collection of Prince Heinrich Lubomirski (1777–1850), who bequeathed it to the Lemberg (now Lwow Poland) Ossolineum. [On this collection, see also H. Reitlinger in *The Burlington Magazine* 50 (1927), pp. 153–158.] The Lemberg drawings were stored in the salt mine at Alt Aussee during Word War II and were taken to the collecting point in Munich at the war's end. They were returned to the Lubomirski heir, and later appeared on the market. Most were acquired by American public and private collections, among them the Nelson-Atkins Museum in Kansas City (MO) and the Art Institute of Chicago.

429. ———. "Tier-und Pflanzenstudien von Albrecht Dürer." Albrecht Dürer. Über den sichtbaren Beginn der Neuzeit, Ed. Detlef Hoffmann, Loccum, 1986. Loccum: Evangelische Akademie Loccum, 1986.

A general lecture, undocumented, summing up many of the observations made in the Vienna exhibition catalogue (Albertina, 1985, q.v.). Works discussed include the *Madonna with the Many Animals*; the *Stag Beetle*; various *Blue Roller* studies (Bamberg, Bayonne, Vienna, Berlin, Woodner [New York]); the *Great Piece of Turf*; and the *Wild Hare*.

430. Koreny, Fritz, and Konrad Oberhuber. "Albrecht Dürer und Hans Hoffmann." *Jahrbuch der Kunsthistorischen Sammlungen in Wien* (1982–1983/1986–1987): 17–21.

Discusses the *Blue Roller* wing studies in Vienna, Bamberg, Bayonne, and in the Woodner Collection (New York.) Bamberg's roller comes from the important early nineteenth-century collection of Joseph Heller. Oberhuber concludes that the Woodner watercolor is by Hans Hoffmann. [This is a summary of Oberhuber's informal discussion of the originals at the exhibition, given in the galleries for members of the Symposium.].

431. Koreny, Fritz, and Sam Segal. "Hans Hoffmann–Entdeckungen und Zuschreibungen." *Jahrbuch der Kunsthistorisch Sammlungen in Wien* 85/86 (1989): 57–65.

A Düreresque hare ensconced in an elaborate woodland setting (oil on panel) on the market at Sotheby's; an oil of the *Expulsion from Paradise* acquired by the Kunsthistorisches Museum in Vienna (featuring an Adam and Eve after Girolamo Siciolante); depictions

of peonies by Dürer, Schongauer, and Hans Hoffmann; many stud-
ies of wild animals by Hoffmann (including a painted *Rhinoceros*).

432. Koschatzky, Walter. *Albrecht Dürer. The Landscape Water-Colours*,
New York: St. Martin's Press, 1973.

A beautifully produced book in horizontal format, treating the
landscape watercolours as a group (not merely the ones in Vienna).
The author, then Director of the Albertina, gives a detailed essay
on the history and problems of the watercolors; the methods used
by the artist and the place of the watercolors in his oeuvre; an
overview of the controversies and vendettas among art historians
(Ephrussi vs. Grimm; Burckhardt vs. Wickhoff; Meder vs. Burck-
hardt; Lippmann vs. Meder; Luise Klebs vs. Haendke; Winkler vs.
Beenken and the Tietzes). Koschatzky gives valuable insights into
painting from nature; the grouping of the landscapes according to
subject and style in chronological sequence; the route and proba-
ble travel time of the first Italian journey; problems concerning the
route, and the return to Nuremberg. There is a concordance table
giving museum collections and Thausing (1876), Ephrussi (1882),
Lippmann (1883–1929), Tietze (1928–1937), Winkler (1936–
1939), Panofsky (1943), and Ottino (1968) numbers; a map show-
ing the route to and from Italy. The pièce de resistance, however, is
the body of the catalogue, with full page illustrations in excellent
color, and on facing pages the information on provenance and dis-
cussion of technique and sites.

433. ———. *Old Master Drawings from the Albertina*, Washington,
D.C.: International Exhibitions Foundation, 1984.

The catalogue of the exhibition of a selection of drawings from Vi-
enna's Albertina Museum which was circulated to the National
Gallery, Washington, and to the Pierpont Morgan Library in New
York. Beautifully produced with full page illustrations in excellent
color. The introduction by the Albertina's then director Walter Kor-
chatzky (pp. 12–20) gives a history of the museum and its collec-
tions from the time of its founding by Duke Albert Casimir of
Saxe-Teschen (1738–1822). Individual entries by Koschatzky and
by Alice Strobl give full provenance and bibliographic references
for each of the exhibited drawings, which include Dürer's *Studies
of Three Hands* (No. 3, 1493: recto, *Studies of Heads and Feet*,
verso); *Knight on Horseback* (No. 4, 1498, inscribed "This was the

armor in Germany at that time"); three studies for the Heller altar: *Head of an Apostle* (No. 5, 1508, *Drapery Study* (No. 6, 1508), and *Praying Hands* (No. 7, 1508); *The Virgin and Child with Saints* (No. 8, 1511); *The Virgin Nursing the Child* (No. 9, 1512); *Head of a Black Man* (No. 10, 1508); *The Italian Trophies* (No. 11, 1518, study for the *Triumphal Procession*); *View of Antwerp Harbor* (No. 12, 1520). When exhibited in New York, the Morgan Library added its own Austrian medieval manuscripts and drawings by Dürer and his followers, with a checklist.

434. Koschatzky, Walter, and Alice Strobl. *Die Dürerzeichnungen der Albertina. Zum 500 Geburtstag*, Salzburg: Residenz Verlag, 1971.

Notable for its excellent introduction to the history of the Dürer collection in the Albertina. The literature on the silverpoint *Portrait of Albrecht Dürer the Elder*, thought by many to be a self portrait of Dürer's goldsmith father, is reviewed briefly. The view of Nuremberg's *Trockensteeg* (Covered Bridge) is declared to be of autograph quality. The perspective *Ceiling Design*, long attributed to Dürer's presumed student Jörg Pencz (Winkler, vol. I, plate XXII) is shown to be related to the *Unterweysung der Messung*, and therefore is by Dürer himself. Other changes of attribution also are made. A unique feature of this catalogue is the thorough investigation of the sources from which Rudolf II obtained his Dürer drawings: abundant correspondence between the Emperor, his agents, and some of the owners (e.g., Willibald Imhoff, Hans Hofmann) is reproduced, and biographical data on the *dramatis personae* is reproduced. The history of the collection after being housed in the Albertina also is taken up—the rumors of impending sale after World War I, and the removal for safe-keeping to various locations in 1942, during World War II.

435. ———. *Dürer Drawings in the Albertina*, Greenwich, CT.: New York Graphic Society, 1972.

An *abridged* English version of *Die Dürerzeichnungen der Albertina* (q.v.). Serious scholars will need to consult the original German edition (see above entry).

436. Kotrborá, M. A. "Obraz Ruzencové slavnosti Abrechta Dürera." *Umení* 19 (1971): 588–599.

According to Brautigam/Mende, this is the definitive work on the *Feast of the Rose Garlands* (Dürer's Rosary altarpiece, now in Prague). Text in Czech.

437. Kratzsch, Gerhard. *Kunstwart und Dürerbund. Ein Beitrag zur Geschichte der Gebildeten im Zeitalter des Imperialismus*, Göttingen: Vandenhoeck & Ruprecht, 1969.

Based on the author's 1966 dissertation for the University of Münster. This interesting and thoroughly researched work does not deal directly with Dürer, but rather with the ways in which his name was exploited by Ferdinand Avenarius and his followers through the medium of the conservative periodical Kunstwart, and the Dürerbund with its call to arms against smut and bad taste. Although the Bund laid the groundwork for the aesthetics of later National Socialism, it was an organization to which many German pastors, schoolteachers, artists, and art historians belonged (including Wilhelm von Bode, Max Lehrs, Max Liebermann, Hans Thoma and Heinrich Wölfflin).

438. Kredel, F. "Die Zeichnungen Albrecht Dürers zu dem Lustspiel *Andria* von Terenz." *Philobiblon* 15 (1971): 262–276.

Dürer's drawings for the *Andria* woodcut illustrations intended for Johann Amerbach's unpublished Basel edition of the comedies of Terence (195–159 B.C.), which was to have been edited by Sebastian Brant.

439. Krohm, Hartmut, and Eike Oellermann, Eds. Flügelaltäre des späten Mittelalters, Berlin: 1992, D. Reimer,

A general study of late medieval triptychs, including those by Dürer.

440. Krödel, Gottfried. "Nürnberger Humanisten am Anfang des Abendmahlsstreites. Eine Untersuchung zum Verhältnis Pirckheimers and Dürers zu Erasmus von Rotterdam besonders in den Jahren 1524–1526." *Zeitschrift für bayerische Kirchengeschichte* 25 (1956): 40–50.

Argues that, in spite of such differences as those over the proper interpretation of the Last Supper, and thereby of the Christian communion service, both Pirckheimer and Dürer came to share Erasmus' disapproval of extremes in the Reformation movement.

Discusses the so-called *Four Apostles* panel as a powerful statement against fanaticism.

441. Kruft, Hanno Walter. "Die Cappella del Crucifisso im Dom von Palermo: eine Rekonstruktion." *Pantheon* 37, no. 1 (March) (1979): 37–45.

 The Crucifixion Chapel of the Cathedral of Palermo was destroyed during eighteenth-century renovations, except for fragments of the original late-sixteenth century sculptured decoration executed by Fazio and Vincenzo Gaggini (1557–1565 and 1582–1584). The author attempts a reconstruction based on documentation and on the reliefs, giving proof of the translation into sculpture of works by Dürer, among others, including Raphael.

442. Krüger, Peter. *Dürers "Apokalypse." Zur poetischen Struktur einer Bilderzählung der Renaissance*, Gratia. Bamberger Schriften zur Renaissanceforschung, Dieter Wuttke, 28. Wiesbaden: Harrassowitz, 1996.

 This excellent study of the narrative structure of Dürer's *Apocalypse* series grew from a series of interdisciplinary lectures given at the University of Bamberg in the summer semester of 1993. The author gives an extremely useful overview of the professional literature on the art-historical study of narrative, beginning with Aby Warburg's 1892 dissertation on Botticelli, and including Panofsky, Wolfgang Kemp, Felix Thürlemann, Oskar Bätschmann, the Marburg School, the New Munich (anti-Sedlmayr) School, et al. Discusses the relationship of pictures to text, using Dr. Otto Schäfer's (Schweinfurt) excellent example of the first German language edition—demonstrating in passing that Panofsky had not consulted a complete set of the Apocalypse prints, and therefore misinterpreted the relationship of pictures to the relevant textual passages from the Book of Revelation (they are not on the verso of each picture, giving the illustration precedence over the written word, but pictures and text are on facing pages). The author also discusses the series in the tradition of preexisting Apocalypse pictures, including the recycled set from Koberger's 1483 Bible (originally made for the Cologne Bible), and points out Italian influences as well, including that of the manuscript copy of Alberti's *De Pictura* that is known to have been in Nuremberg as early as 1471. Of particular interest is Chapter VII (pp. 109–126), on the reception of

the new Latin translation of Aristotle's *Poetics* (prepared in Venice 1492–1494 by Giorgio Valla), which the author rightly sees as critical for the structure of Dürer's series, as well as an influence on his choice of theme—the Apocalypse being the one portion of the Bible most ideally suited to treatment in keeping with Aristotle's concept of "Mythos".

443. Kubin, Ernst. *Sonderauftrag Linz. Die Kunstsammlung Adolf Hitler. Aufbau, Vernichtungsplan, Rettung*, esp. 25, 64, 83, 96, 136. Vienna: ORAC, 1989.

Documents Hans Posse's trip to Poland after the 1939 invasion to select paintings for inclusion in Hitler's projected museum for Linz, which was to have been built in his own honor. Posse reported on "a series of beautiful drawings by Albrecht Dürer and other German masters" that had fallen into Russian hands with the capture of the Lemberg Ossolineum. He also noted that by the end of July the Poles had packed everything for storage (p. 25). Also discusses storage of the works from the Albertina, including Dürer's *Great Piece of Turf* and *Melencolia I* in the salt mine at Ischl-Lauffen. The trucks left the Albertina on March 8, 1945, and on March 12 the building was bombed. On May 3, by order of Baldur von Schirach, the Dürers and other valuable works were removed from Ischl-Lauffen for transport to "an unknown location," over the protests of the curators and conservators, after which the Ischl storage place was sealed. On May 7, Germany surrendered to General Eisenhower in Reims.

444. Kuhn, A., Ed. *Goethe's Faust*, xv. Eltville: 1976,

Quotes a letter from the Nazarene painter Peter Cornelius to Goethe (1811) stating that he had Dürer's *Randzeichnungen* in his studio (i.e., the lithographic reproductions by Alois Senefelder of Dürer's drawings for the Prayerbook of Maximilian).

445. Kuhrmann, Dieter. *Über das Verhältnis von Vorzeichnung und ausgeführtem Werk bei Albrecht Dürer*. Ph.D. dissertation, Berlin, 1964.

A study of the artist's use of preliminary drawings, seen in relation to such finished works as the *Visitation* from the *Life of Mary*, B.84; the *Adoration of the Trinity* (*Landauer Altarpiece*), Vienna;

and the idealized portraits of the Holy Roman emperors Charlemagne and Sigismund (Nuremberg). For many of his most important religious works no general sketch of the entire composiition is preserved—only individual sketches. A useful feature of this publication also is its overview of previous oeuvre catalogues.

446. Kuhrmann, Dieter, and Bernhard Degenhardt. *Dürer und seine Zeit. Zeichnungen und Aquarelle aus den Sammlungen Biblioteca Ambrosiana, Mailand*, Munich: 1967.

Dürer drawings and watercolors from the Ambrosiana, Milan, exhibited with works from the Bayerische Staatsbibliothek and the Staatliche Graphische Sammlung, Munich, held in the Graphische Sammlung. Featured are Winkler nos. 53, 80, 81, 102, 107, 112, 193, 204, 228, 231, 244, 298, 379, 488, 565, 590, 610, 617–618, 751, 847, 942; Tietze 549, and marginal drawings for the Maximilian Prayerbook. (Reviewed in *Weltkunst* 37 (1967), 23, 1221; and by Christopher White in *Master Drawings* 6 (1968), 1, 55.

447. Kuretsky, Susan Donohue. "Rembrandt's Tree Stump: An Iconographic Attribute of St. Jerome." *The Art Bulletin* 56, no. December (1974): 571–580.

Discusses the significance of the dead tree with a living branch in Rembrandt's etching (1648) and its association with the Crucifixion and Redemption in northern art from Dürer to the late seventeenth century, refering to the prominence given to St. Jerome by the humanists of the Renaissance.

448. Kurth, Willi. *The Complete Woodcuts of Albrecht Dürer*, Magnolia: Peter Smith, 1963.

This serviceable and succint catalogue, translated from the German edition of 1927 (Munich: reprinted 1935) by S. M. Welsh, has gone through many editions. Useful when a "portable" catalogue is needed for purposes of comparison, but the English editions are cheaply printed. Contains a minimum of text. A previous English language reprint was issued by Crown (New York, 1946).

449. Kurz, Otto. Preface by *The Decorative Arts of Europe and the Islamic East: Selected Studies*, Ernst Gombrich. Studies in the History of European Art, London: Dorian Press, 1977.

Among the twenty-one essays by Kurz is the one on Dürer, Leonardo da Vinci and the invention of the Ellipsograph, and on a pseudoclassical inscription and a drawing by Dürer.

450. Kuspit, Donald B. *Dürer and the Northern Critics 1502–1572.* Ph.D. dissertation, University of Michigan, 1971.

[Dissertation Abstracts International 32, no. 3 (1971): 1414 A.] In part concerned with Dürer's art in relation to Protestantism, and with Melanchthon's view of Dürer's work as the perfect rhetoric for religion, and vehicle for Protestant introspection in particular [Parshall & Parshall].

451. ———. "Dürer and the Lutheran Image." *Art in America* 63, no. 1 (1975): 56–61.

Discusses Dürer's late portraits in short format, both paintings and graphics, concluding that "the best" ones depict friends who shared the artist's commitment to Luther (i.e., *Frederick the Wise, Willibald Pirckheimer, Philip Melanchthon*, and the painted portraits of *Hieronymus Holzschuher* and *Jakob Muffel* are said to reflect the experience of religious conversion through the novelty of their technique).

452. ———. "Melanchthon and Dürer: The Search for the Simple Style." *The Journal of Medieval and Renaissance Studies* 3 (1973): 177–202.

Developed from the author's dissertation (Ann Arbor, 1971). Analyzes Melanchthon's literary references to Dürer, in particular an illustration of a principle of rhetoric where the artist's "simple" style is praised and is found ideally suited for the expression of Protestantism. Kuspit finds this notion of style to be essentially subjective and revelatory [Parshall & Parshall].

453. Kutschbach, Doris. *Albrecht Dürer. Die Altäre*, Stuttgart/Zürich: Belser Verlag, 1995.

Developed from the author's doctoral dissertation (Munich, Ludwig-Maximilians-Universität, 1993), prepared with the advice of curators in Munich, Vienna and Prague. An excellent general book, well produced and thoroughly documented, dealing with both the triptychs and the single-panel altarpieces by Dürer. In her Introduction, the author discusses Dürer as a transitional figure, the *Dür-*

erzeit as a period of transition, not only in the arts but in politics, science, and religion, and the decision to abandon the medieval triptych form in favor of the single-panel format as due to Italian influence. The *Paumgärtner Altar* is discussed in the context of the question whether it is an altarpiece or a memorial (Martin Paumgärtner, d. 1478; his wife Barbara, née Volckamer, d. 1494—however, these dates are not inscribed on the painting as would have been customary. On the other hand, its use of tiny portrait figures is in keeping with previous Nuremberg epitaph paintings, such as that for Clara Imhoff [1438], Germanisches Nationalmuseum.) It was commissioned in connection with Stefan Paumgärtner's trip to Palestine (1498), and its original placement is given (east wall of the south transept of Nuremberg's former Dominican convent church of St. Katherine). Its provenance is traced through its acquisition in 1613 by Maximilian I (who donated a copy by Jobst Harrich to St. Katherine's). The two fixed wings, *St. Barbara* and *St. Katherine* by Hans Baldung (both now in Schwabach, in the—now Lutheran—church of St. Martin), also are reproduced, as is the standing Madonna from the exterior of the left wing—also by a member of Dürer's workshop, approximately 1500–1502. A unique feature of Dürer's central composition is the placement of Joseph as though he were in process of climbing up into the painting—the first use of such a transitional figure in German art. The guises of the brothers Stefan and Lukas in armor as Sts. George and Hubert is explained as a reference to the noble background of the family, which entitles its males to participate in tournaments. Oddly, no mention is made of the acid attack or of the restoration then in progress (see Munich 1998 exhibition catalogue for this material). The complex provenance of the various parts of the so-called *Jabach Altar* are discussed, and the most important literature. Kutschbach sides with Anzelewsky in accepting Friedrich the Wise as the original patron, and suggests the possibility that the missing central panel may have been a reliquary shrine, and theorizes that it may have been created , not for the Saxon court, which has no record of it, but for Wittenberg. (Friedrich the Wise's reliquaries were melted down by Johann Friedrich in order to finance the League of Schmalkalden.) Dürer's drawings for the so-called Ober-St.Veit Altar, and the final painting by Schäufelein are discussed as probably having been originally commissioned for a Nuremberg church, although bearing the arms of both Friedrich the

Wise and Johann the Magnanimous. The lost *Heller Altar*, Dürer's last triptych, is presented with the letters pertaining to it, and is seen in the context of Rasmussen's observation that it is the first altarpiece to combine the German transforming-altar format with a basically Italianate style. Gives a useful brief review of earlier German depictions of the Assumption of the Virgin (Master of the St. Wolfgang altar (Warsaw); Wolgemut (1499: Straubing), and Dürer's own previous "heaven-and-earth" compositions of visionary material, suggesting—correctly, we think—that the supposed Italian influence on Dürer has been overestimated. Discusses the reconstruction of the *Seven Sorrows of the Virgin* altarpiece, here accepted as the artist's first major work after the first trip to Italy, and notes the provenance of the Madonna (Munich) from Kloster Benedictbeuren (1803/1804), while the Dresden portions can be traced to 1588 in the Saxon court. The Rosary Brotherhood at St. Bartolommeo is suggested as possible patron of the Altar (Prague), and the observation made that the only securely identifiable portraits in it are those of Dürer himself and Maximilian. (The Pope could be any of three possibles, as Anzelewsky has noted.) Speculates that the man in black might be Domenico Grimani, and that the architect might be Augsburg's Meister Hieronymus. Notes that the painting combines features of a Marriage of the Virgin and a Coronation of the Emperor (Maximilian had not yet been crowned in 1506). The *Landauer Altar* is seen in its original setting (the windows of the chapel also were designed by Dürer).

454. Lanckoronska, Maria. "Doppelsinn einer Ovid-Illustration Albrecht Dürers." *Gutenberg-Jahrbuch* (1972): 317–327.

Sees the *Death of Orpheus* drawing (Hamburg) as a satiric reference to Florentine Neoplatonists, and Orpheus as a representation of Cardinal Giuliano della Rovere, the future Pope Julius II.

455. ———. "Dürers Antonius-Stich als Sterbebild für Kaiser Maximilian I." *Gutenberg-Jahrbuch* (1973): 369–374.

Makes an interesting case for the interpretation of the artist's 1519 engraving of *St. Anthony in a Landscape* as a *pleurant* mourning the death in January of that year of the Emperor Maximilian I.

456. Landau, David, and Peter W. Parshall. *The Renaissance Print 1470–1550*, New Haven: Yale University Press, 1994.

Rather than a chapter devoted to him, there are many references to Dürer sprinkled throughout this monumental work, which gives a good idea of the means of production and distribution of prints in the late fifteenth and early sixteenth centuries and of Dürer's general influence in the refinement of Northern engraving, as well as his standing in comparison to Italian engravers of the same era.

457. Landolt, Hanspeter. "Zur Geschichte von Dürers Zeichnerischer Form." *Anzeiger des Germanischen Nationalmuseum* (1971): 143–156.

Landolt attempts to discover the method or system by which Dürer developed his ability as draftsman to its full potential. Central to his argument are "finished" and shaded pure pen drawings with clearly defined illumination (e.g., *Madonna and Child with Musical Angel*, Windsor, dated 1519: W.536). Discusses sources of his drawing style (the Housebook Master; Schongauer and his group), and the influence of Dürer's style on his followers, suggesting the probability that the spread of Dürer's style inhibited the spread of "Danube School" sketchiness.

458. Langston, D. E. A Linguistic Analysis of Albrecht Dürer's *Ein vnder richt alle mas zw endern*. Ph.D. diss., Tulane, Ann Arbor microfilm, 1980.

459. Laveissière, Sylvain. "Nancy, Musée des Beaux-Arts: Un volet de retable du XVIe siècle retrouvé." *Revue du Louvre et des Musées de France* 29, no. 5–6 (1979): 362–364.

A *Presentation of Christ in the Temple* with a grisaille *Visitation with Donor* on the verso has been reunited with its pendant, the other wing of a dismembered altarpiece of unknwn provenance. In this article it is assigned to eastern France and dated to the early sixteenth century, noting the influence of Albrecht Dürer.

460. Lawrence, Kansas. University of Kansas, Spencer Museum of Art. *The Engravings of Marcantonio Raimondi*, Essays by Innes H. Shoemaker and Elizabeth Broun. Lawrence, KS.: University of Kansas, 1981.

The catalogue of an exhibition originating at the Helen Foresman Spencer Museum of Art, University of Kansas (November 16, 1981–January 3, 1982) and subsequently shown at the William Hayes Ackland Museum of the University of North Carolina,

Chapel Hill, and at the Wellesley College Museum. Valuable for its full page reproductions of the seventy works exhibited, and especially for Shoemaker's essay, *Marcantonio and His Sources*, which includes an account of the Italian engraver's stay in Venice and his influence from Albrecht Dürer, particularly from the *Life of Mary* woodcuts, which he copied faithfully in engraving. Broun's essay explores the uses of reproductive prints.

461. Leder, Klaus. "Nürnberg's Schulwesen an der Wende vom Mittelalter zur Neuzeit." *Albrecht Dürers Umwelt. Festschrift zum 500. Geburtstag*, 29–34. Eds. Gerhard Hirschmann and Fritz Schnelbögl. Nürnberger Forschungen, 15. Nürnberg: Verein für Geschichte der Stadt Nürnberg,

Discusses the question of the elementary school attended by Dürer, whose family lived in the parish of St. Sebald. He would have been eligible to attend St. Sebald's excellent Latin school, but his minimal knowledge of Latin and both his excellent written German and his proficiency in mathematics and geometry suggest that he may have attended one of the city's Rechenschule instead. The curricula and staffing of the city's Latin schools (St. Sebald, St. Lorenz, the Spitalschule, St. Egidius), and Nürnberg as locus of school reform well before the Reformation.

462. Leidinger, Georg. *Albrecht Dürers und Lukas Cranachs Randzeichnungen zum Gebetbuch Kaiser Maximilians I in der Bayerischen Staatsbibliothek zu München*, Munich: 1922.

An older but still definitive work on the example of Maximilian's Prayerbook that is housed in the Bavarian State Library in Munich, with its marginal illustrations by Dürer and Cranach.

463. Leitschuh, Franz Friedrich. "Dürers Ruhm in vier Jahrhunderten." *Jahresberichte des Vereins für Geschichte der Stadt Nürnberg* 11 (1888): 17–19.

Of historical interest as an early study of Dürer-reception.

464. ———. "Zu Albrecht Dürer. Albrecht Dürer im Urteil der Jahrhunderte." *Studien und Quellen zur deutschen Kunstgeschichte*, 101–123. Leitschuh. Collectanea Friburgensia, N.S.14. Freiburg (Switz.): Universität Freiburg, 1912.

Not seen.

465. Lepel, Wilhelm Heinrich Friedrich, Graf von. *Catalogue de l'oeuvre d'Albert Dürer par un amateur*, Dessau: Jean Chretien Mence, 1805.

Anonymously published catalogue of Dürer's prints, including states; copies after his work (pp. 114–124). Premetric measurements.

466. Levenson, Jay Alan. *Jacopo de'Barbari and the Northern Art of the Early Sixteenth Century*. Ph.D. dissertation, New York University, 1978.

"Jacob of the Barbarians," as he was known in Italy from his seemingly unfathomable decision to go and live in northern Europe, worked both at the court of Friedrich the Wise and later at that of Maximilian's daughter, Margaret of Austria, in Malines. Albrecht Dürer claimed to have received his earliest inspiration from "a man named Jacobus, born in Venice and a charming painter," but noted sadly that his role model had refused to part with professional secrets critical for the construction of the beautiful figure. By the late nineteenth century this artist had been identified as Jacopo de'Barbari, the creator of half a dozen paintings, a monumental woodcut panorama of Venice and about thirty engravings that had previously been assigned to the "Master of the Caduceus." Levenson sought to reconstruct Jacopo's authentic oeuvre and assess his importance for the development of the German renaissance. The first chapter is a biography. Documents and early sources are reproduced in an Appendix. A section on historiography traces the artist's rediscovery and the subsequent inflation of his oeuvre. Attributions, chronology, and development are discussed next, and the final chapter is concerned with his influence on six important German and Netherlandish contemporaries. A catalogue raisonné follows.

467. Levey, Michael. *The Burlington Magazine* 113 (1971): 484–8. Review of the Nuremberg exhibition.

468. ———. "To Honour Albrecht Dürer: Some 1971 Manifestations." *The Burlington Magazine* 114 (1980), 63–68.

Reviews a selection of the 1971 events, including the exhibitions at the British Museum, Copenhagen's National Gallery, Manchester's Whitworth Art Gallery as well as the colloquium held at the

Warburg Institute (London), where papers were given on "Dürer and Humour," the treatise on fortification, and Dürer's economic circumstances. Notes with a certain British *sangfroid* that outside Germany Dürer is viewed "with admiration—at best—rather than with affection," and questions the practice of making such a production of anniversary years, "as if it mattered to the artist," a point well taken (and one also expressed by Matthias Mende in *Durer Heute* (1971), q.v.). Also comments on the exhibitions in Nuremberg and Munich; the catalogue by Keith Andrews of Dürer prints in Scottish collections; the show at Colnaghi's; Bremen's quixotic "Dürer und Picasso" show at the Kunsthalle; Anzelewsky's catalogue of the paintings (q.v.); the colloquium in Leipzig (q.v., under Ullmann, Ernst); and takes a parting shot at Panofsky's connoisseurship (he still accepted the London *Madonna with the Iris*, a work long removed from the artist's oeuvre).

469. ———. "Dürer and England." *Anzeiger des Germanischen Nationalmuseums* (1970): 157–164.

Dürer's first connection with England occured in 1521 when he drew the portrait of *ein englischer edelmann* at Antwerp (Rupprich I, 172), probably a charcoal drawing, no longer identifiable. The same man paid him to paint his coat of arms. E. Schilling identifies the verso of a drawing in Frankfurt (W.287) as the set of studies for the coat-of-arms—which are those of the Abarrow family of North Charford, Hampshire. Dürer's next English patron was Lord Morley, Henry VIII's ambassador to Nuremberg, sent to present the Order of the Garter to the Archduke Ferdinand (portrait now lost, but preliminary drawings on green paper survive: British Museum, W.912). Niklas Kratzer's correspondence with the artist began shortly after the ambassador's return home. (Kratzer had met Dürer in Antwerp, but was now asking the price of a full set of prints—October 1524.) Levey also deals with criticisms by the future Archbishop of York, Dr. Edward Lear; John Donne (*Satyricon*); Richard Burton (*Anatomy of Melancholy*); Peacham's *Compleat Gentleman* (1622). He also discusses the collection of Thomas Howard, Earl of Arundel; Sir Hans Sloane (1660–1753), whose Dürer manuscripts and many drawings are in the British Museum; criticisms by Hogarth, Horace Walpole, William Gilpin, Joshua Reynolds, as well as appreciations by other British artists—Nicholas Hilliard, Sir Peter Lely, Paul Sandby, William

Blake, Sir Thomas Lawrence, Charles Lamb, William Bell Scott. Levey suggests that criticism of Dürer as "gothick" was due to overweening reverence for Italy, but also partly to the fact that the name "Dürer" was used as a catch-all for anything slightly odd on the art market.

470. Levinger, Matthew. "No Old Man's Sorrow: A New Ruskin Letter." *The Burlington Magazine* 960, no. March (1983): 158–159.

The author presents a previously unpublished holograph letter by John Ruskin, written to Clarence Hoag on December 22, 1894 and now in the Charles Roberts Collection of the Haverford College Library (Haverford, PA). The letter contains a description of Dürer's engraving *Knight, Death, and Devil*, an impression of which Ruskin was sending to Hoag as a gift. The letter is both lengthy (six hundred words) and more clearly written than scholars had previously supposed possible with Ruskin after 1889 [RILA]. On Ruskin and Dürer, see also Ulrich Finke (1976).

471. Libman, Mikhail Iakovlevic (Michael J. Liebmann). *Djurer i Ego Epoha; Zivopis' i Grafika Germanii Konca XV i Pervoj Poloviny XVI Veka*, Moscow: Iskusstvo, 1972.

[Dürer and His Epoch; German Painting and Graphics at the End of the Fifteenth and First Half of the Sixteenth Centuries]. Summary in German. [Reviewed by C. Nesselstrauss in *Iskusstvo*, 38, no. 5 (1975), 70–71.]

472. Liebmann, Michael J. (Mikhail Iakovlevic Libman). *Aus Spätmittelalter und Renaissance*, Weinheim (DDR): Acta Humaniora, 1987.

A group of essays by the leading Dürer specialist in the former Soviet Union (Leningrad). Dürer appears in references throughout this general book on the late Middle Ages and early Renaissance, and is featured in the article "Die Londoner Zeichnung *Kopf eines alter Weibes*" (the London drawing of the head of an old woman, pp. 103–104). This drawing was first attributed to Dürer by Ephrussi, but was later given to Grunewald by Campbell Dodgson and others. Winkler returned it to Dürer; Flechsig took it away. Liebmann returns the attribution to Dürer on the basis of style and technique.

473. Liess, Reinhard. *Die Kunst des Rubens*, Braunschweig: Waisenhaus, 1977.

Published to coincide with the four hundredth aniversary of Rubens's birth, this book explores the Flemish artist's sources—among them Dürer's prints—from his apprenticeship to Otto van Veen until the end of his career in 1640.

474. Lippmann, Friedrich. *Zeichnungen von Albrecht Dürer in Nachbildungen*, 7 vols. Berlin: Grote, 1883.

These seven volumes of excellent reproductions are arranged according to the collections in which the drawings are—or were—found: 1) Berlin print room (then the Königliche Kupferstichkabinett); the William Mitchell collection and the collections of John Malcolm of Poltalloch and Frederick Locker (all three in London), 1883; 2) Public museums in Germany and the Austro-Hungarian Empire (Bamberg, Bremen, Budapest, Coburg, Darmstadt, Dresden, Frankfurt a.M., Hamburg, Munich, Weimar [but not Vienna]; and the private collections of Beckerath, Bendemann, Blasius, Franck, Lanna, Vieweg, and in England the Heseltine and Poynter collections, 1888; 3) The British Museum, London, and in Paris the Louvre and Bibliothèque Nationale, 1894, 4) Other public and private collections in France (Chantilly, Bonnat, Edmond von Rothschild, Robert-Dumesnil, Schickler, École des Beaux-Arts, Valton); in England (Windsor Castle, Oxford, Chatsworth, Warwick Castle, and the Malcolm, Ch. Robinson, and Seymour collections; in Italy, the Royal Library in Turin; in Austria the public collections in Vienna other than the Albertina; additions to the public and private collections in Germany and Austria-Hungary (Lanna, von Feder, Weisbach; Erlangen University Library; Berlin Kupferstichkabinett, 1896; 5) The Albertina (prepared with the assistance of Joseph Meder. 1905); 6) [1927]; and 7) [1929] Supplements, published by Friedrich Winkler.

475. London. Heim Gallery Ltd., Institution. *100 of the Finest Drawings from Polish Collections: A Loan Exhibition under the Patronage of Prof. Dr. Stanislaw Lorentz, Director of the National Museum of Warsaw and the Rt. Hon. Kenneth Robinson, Chairman of the Arts Council of Great Britain*, Heim Exhibition Catalogues, 82. London: 1980.

The catalogue of an exhibition circulated in London, Cambridge, Dublin, and Cardiff. Essays by Jan Bialostocki ("Introduction: The Importance of Drawings"); and Maria Mrozinska ("Preface: The Collecting of Drawings in Poland"). One Dürer exhibited (No. 24: formerly in the Lubomirski Museum, Lemberg [Lwow], now in Wroclaw in the Ossolineum: *Head of a Bearded Man Seen from the Front*, black-and-white chalk against a red background; catalogue entry by Mieczyslaw Radojewski). Rejected by the Tietzes as an autograph work, but rehabilitated by Winkler on the basis of another drawing formerly in the Lubomirski Museum (*Man in a Hood*).

476. London. British Museum, Institution. *Animals in Art*, Jessica Rawson. London: British Museum, December 1977.

Not, strictly speaking, an exhibition catalogue but a book published to accompany the British Museum's exhibition of animals from its own collections in all media, by artists ranging from Pisanello to Dürer, Rembrandt, and George Stubbs. (Reviewed in *The Times Literary Supplement*, December 9, 1977.)

477. London, British Museum. *Mantegna to Cezanne: Master Drawings from the Courtauld*, Text by William Bradford and Helen Braham. London: British Museum, 1983.

The catalogue of an exhibition of 126 drawings from the collection of the Courtauld Institute of Art, University of London, celebrating the fiftieth anniversary of the Courtauld. Dürer is among the sixty-eight artists represented.

478. Longhi, Roberto. *Arte Italiana e Arte Tedesca con altre Congiunture fra Italia ed Europa: 1930–1969*, Opera Complete di Roberto Longhi, 9. Florence: Sansoni, 1979.

Twenty previously published essays by Longhi, including ones on Dürer, Hugo van der Goes, Jan van Scorel, and Rubens.

479. [Los Angeles, CA], University of California, Grunewald Center for the Graphic Arts, *Twenty Years of Acquisition: Evolution of a Study Collection. The Grunewald Center for the Graphic Arts*, Introduction by E. Maurice Bloch. Los Angeles, CA, University of California: Frederick S. Wright Art Gallery, 1974.

An illustrated catalogue of some five hundred prints and drawings and *livres deluxe* from UCLA's permanent collection. They range from the fifteenth century to the present, but include works by both Dürer and Schongauer.

480. Löcher, Kurt. "Albrecht Dürer: The Emperors Charlemagne and Sigismund." *Gothic and Renaissance Art in Nuremberg 1300–1550*, 305–306. Ed. Rainer Kahsnitz. Munich and New York: Prestel, 1986.

Brief history of the Imperial portraits made for Nuremberg's Heiltumskammer, including discussion of their reevaluation as autograph Dürers (upgraded from shopwork) after the cleaning performed in preparation for the 1971 exhibition in Nuremberg, Reproduces the preparatory drawing (London, Courtauld Institute, Count Seilern Collection; Winkler 503), as well as backs of the panels with their arms and rhymed inscriptions.

481. ———. "Die Michael Wolgemut zugeschriebene *Himmelfahrt Mariae* aus der Pellerschen Gemäldesammlung in Nürnberg." *Mitteilungen des Vereins für Geschichte der Stadt Nürnberg* 81 (1994): 1–12.

Unlike Christ, who ascended to Heaven under his own power, the Virgin Mary was thought to have been lifted bodily. Late medieval German artists preferred to illustrate her reception in Heaven in terms of her coronation by Christ and God the Father. A painting of the *Assumption of the Virgin* first mentioned in the 1641 inventory of the Peller mansion in Nuremberg, and by 1828 attributed to Michael Wolgemut, was sold in 1984 to a private collector in New York through Bob Haboldt, Inc. Löcher challenges the attribution to Wolgemut, and gives the painting (which was influenced *by*, rather than *on* Dürer) to an anonymous "Master of the Dominican Cycle."

482. ———. "Dürers Italienische Bilder." *Museen und Ausstellungen in Nürnberg. Monats-Anzeiger* 24 (1983), 189–190.

Deals with the *Madonna dell' Alpe*, considered to be a painting from the artist's first Italian journey.

483. ———. "Dürers Kaiserbilder." *Das Schatzhaus der deutschen Geschichte*, 305–330. Ed. Rudolf Pörtner. Düsseldorf and Vienna: 1982.

Dürer's idealized portraits of Charlemagne and Sigismund, commissioned for the Nuremberg *Heiltumskammer.*

484. ————. "Panel Painting in Nuremberg 1350–1550." *Gothic and Renaissance Art in Nuremberg 1300–1500,* 81–86. Ed. Rainer Kahsnitz. Munich: Prestel, 1986.

Discusses the development of panel painting in Nuremberg from its introduction with the *Hirzlach Epitaph* (1350); the Imhoff Altarpiece (1420); the Tucher Altarpiece (1450); the work of Hans Pleydenwurff and his partner Michael Wolgemut, the apprenticeship and teaching career of Dürer. The important distinction is made between Wolgemut's documented Peringstorffer Altarpiece and the 1487 Altarpiece of St. Vitus from the Augustinian church (Germanisches Nationalmuseum), once attributed to him but now known to have been painted by Rueland Fruehauf the Younger of Passau and an unidentified master.

485. Luber, Katherine Crawford. "Albrecht Dürer's Maximilian Portraits: An Investigation of Versions." *Master Drawings* 29, no. Spring (1991): 30–47.

Developed from the author's Bryn Mawr dissertation. As a Fulbright grantee in Austria in 1988–1989, Luber had the opportunity to make a close comparison of all of the Dürer portraits of Maximilian, including the Nuremberg version, which she was permitted to trace. Comparison of the tracing with an infrared reflectogram of the Vienna painting, the original drawing that had been made during the Emperor's life sitting with the artist during the 1518 Augsburg Diet, and the posthumously published woodcut of 1519 showed all of the facial contours to be exactly congruent, disproving Silver's contention that the Vienna painting is the larger. This suggests the use of a single transfer cartoon developed from the life drawing. (Incised lines can still be seen in raking light on the drawing itself.) This method was contrasted to that of Bernhard Strigel in his portraits of the Emperor, each of which was developed from a different image. Luber noted further that the Nuremberg Dürer, which, painted on linen, is in poor condition, seems to represent a more youthful, dark-haired version of the Emperor, while the Vienna painting, which was probably a commission from Maximilian himself, renders the more accurate likeness of the sitter. The author comes to the entirely credible conclusion that the

Nuremberg painting may have been a processional banner done for use during the coronation of Charles V, Maximilian's grandson and successor.

486. Lucie-Smith, Edward. *The Waking Dream: Fantasy and the Surreal in Graphic Art 1450–1900*, Trans. Nicholas Fry. New York/London: Knopf/Thames & Hudson, 1975.

[Translation of *Quatre siècles de surrealisme.*] A popular survey of drawings, engravings, etchings, and woodcuts having fantastic, surreal, or presurrealist subject matter. Include works by Dürer, Bosch, and Holbein, among others.

487. Ludolphy, Ingetraut. *Friedrich der Weise, Kurfürst von Sachsen 1463–1525*. 110–112. Göttingen: Vandenhoeck & Ruprecht, 1984.

A recent biography of Friedrich the Wise, containing a short section on his activity as patron of the arts.

488. Lukinich, Emerich. "Albrecht Dürers Abstammung." *Ungarische Jahrbücher* 9 (1929): 104–110.

An early study of Dürer's Hungarian ancestry. Surmises, however, on the slender evidence of Albrecht the Elder's excellent written German in the letter which he wrote to his wife from Linz in 1492 (for which see Rupprich I, p. 252), that his mother Elisabeth must have been a native speaker of German. See Hirschmann's critical commentary in *Albrecht Dürers Umwelt* (Nuremberg, 1971) 36–37.

489. Lurie, Ann Tzeutschler. "The *Weeping Heraclitus* by Hendrick Terbrugghen in the Cleveland Museum of Art." *Burlington Magazine* 121, no. 914 (May) (1979): 279–287.

Discusses the influence of Dürer's *St. Jerome*, among others, on the Cleveland *Heraclitus*, which was formerly thought to represent St. Jerome until identified by Benedict Nicholson as Heraclitus.

490. Lutz, Heinrich. "Albrecht Dürer und die Reformation, offene Fragen." *Miscellanea Bibliothecae Hertzianae. Zu ehren von Leo Bruhns, Franz Graf Metternich, Ludwig Schudt*, 175–183. Römische Forschungen der Bibliotheca Hertziana, 16. Munich: Verlag Anton Schroll, 1961.

Based on documentary evidence, this is still one of the most important sources for the study of Dürer's relationship to and connec-

tions with Luther, Ulrich Zwingli, Karlstadt, and the Nuremberg schoolmaster Hans Denck, whom the City Council exiled for his association with the radical Thomas Münzer (1490–1525), who advocated the slaughter of everyone not a "born again" member of the Kingdom of God on earth, and was executed as one of the leaders of the Peasants' War. Comments on Dürer's silence at the time of the trial of Denck, and of the Beham brothers and Jörg Pencz (the so-called three godless painters). Also investigates Pirckheimer's loss of enthusiasm for the Reformation after the Peasants' War in 1525, and Dürer's similar reaction at about the same time.

491. ———. "Albrecht Dürer in der Geschichte der Reformation." *Historische Zeitschrift* 206 (1968): 22–44.

A careful review of the documents concerning Dürer's involvement in the events of the early Reformation, also discussing the complexities of his religious beliefs as they developed in his last years [Parshall & Parshall].

492. Lüdecke, Heinz, and Susanne Heiland. *Dürer und die Nachwelt*, Berlin: Rütten & Loening, 1955.

Published in the former East Germany, for the Deutsche Akademie der Künste, this was a pioneering work in the comparative reception of Dürer. Like many East German publications it came out in a small edition and was printed on paper of poor quality that is now quite fragile. It is still an essential work, however, and was done with meticulous scholarship, and with full bibliography. There are chapters on German Humanists and the Reformation; Italian and Netherlandish artists and theoreticians; Dürer's image in the Baroque period; the Enlightenment; "Sturm und Drang" and Neoclassicism; the Romantic period; the Dürer anniversary celebrations; writings from Adolph Menzel to Thomas Mann. In the first section of the book each author is quoted in a brief selection. The latter half gives a short biographical sketch of each author. There are thirty-two black-and-white illustrations, many of which are of items influenced by Dürer or made in his honor.

493. Lynch, Terence. "The Geometric Body in Dürer's Engraving *Melencolia I.*" *Journal of the Warburg and Courtauld Institutes* 45 (1982): 226–232.

The author demonstrates that the polyhedron in the foreground of Dürer's engraving can be constructed in perspective, as shown, by means of only a straight-edge, compasses, and the magic square set in the wall.

494. Maas, Herbert. *Nürnberg. Geschichte und Geschichten*, Nuremberg: Albert Hofmann, 1985.

A useful account for the general reader covering Nuremberg history, landmarks, specialties, historic figures, and customs. Bibliography.

495. Maedebach, Heino. *Albrecht Dürer, 1471–1528, Holzschnitte, Kupferstiche und Eisenradierungen*, Coburg: Kunstsammlungen der Veste, 1971.

The medieval fortress at Coburg in Saxon Franconia (Martin Luther's "mighty fortress"), today a museum, houses one of Germany's most extensive and important collections of early German prints and drawings. Included in the collection are 185 impressions of Dürer's woodcuts, 111 engravings and six etchings—a collection that can be traced to Dürer's contemporaries, the patrician Imhoff family of Nuremberg. The Dürer prints passed through two subsequent collections before being acquired in 1792 by Duke Franz Friedrich Anton of Saxe-Coburg-Saalfeld. Highlights of the collection are the excellent editions of all four of the woodcut picturebooks, the *Engraved Passion*, the "Master Engravings" and the *St. Eustace*, including an impression of the latter on silk.

496. Magnabosco, Ornella. "Per gli Esordi del Savoldo e i suoi Rapporti con la Cultura Lombarda tra Quattro e Cinquecento." *Paragone* 35, no. 417 (1984): 23–43.

[On Savoldo's early period and his relationship to Lombard culture of the late fifteenth and early sixteenth centuries.] Notes the influence of Dürer and northern painting on the young Savoldo, as well as his debt to Lombard painters.

497. Manchester (UK), City Art Gallery. *From Dürer to Boucher. Old Master Prints and Drawings from the Collection of the City of Manchester*, Manchester: City Art Gallery, 1982.

Introduction by Martin Royalton-Kisch; preface by Timothy Clifford. One hundred sixty works shown. (Reviewed by David

Scrase in *The Burlington Magazine* 124 (December 1982) 957 pp. 784–787).

498. Mander, Karel van. *Ter Liefde der Const: Uit het Schilderboeck van Karel van Mander*, Ed. W. Waterschoot. Nijhoffs Nederlandse Klassieken, Leiden: Martinus Nijhoff, 1983.

Annotated edition (in Dutch), with introductions, of the lives of Jan van Eyck, Dürer, Bosch, Holbein, Pieter Bruegel, Frans Floris, Lucas de Heere, and Hendrick Goltzius from van Mander's *Schilderboeck* (Haarlem, 1604).

499. Mardersteig, Giovanni. "Albrecht Dürer in Basel und die illustrierten Terenz-Ausgaben seiner Zeit." *Philobiblion* 16 (1972): 21–33.

The relationship of Dürer's drawings for Johann Amerbach's unpublished Terence edition to contemporary illustrated editions of the same Roman author's comedies. These plays, which had been staples of Latin education all through the Middle Ages, were now attracting the attention of mature humanists interested in the fine points of ancient theater.

500. Marrow, James Henry. *From Sacred Allegory to Descriptive Narrative: Transformations of Passion Iconography in the Late Middle Ages*. Ph.D. dissertation, Columbia University, 1975.

The author's dissertation. Studies narrative Passion imagery in the literature and art of the late Middle Ages, particularly that of the Netherlands and Germany, dealing with questions of interrelationships between the visual arts and such popular literature as the so-called Secret Passion of Christ, as well as of invention of motifs grounded in the wording of the Penitential Psalms. Discusses works by Dürer, as well as those by Bosch, Grünewald, and others.

501. Massing, Jean Michel, and Christian Meyer. "Autour de quelques essais musicaux inédits de Dürer." *Zeitschrift für Kunstgeschichte* 45, no. 3 (1982): 248–255.

("On some unpublished musical attempts by Dürer.") Identifies three sheets from notebooks by Dürer as musical manuscripts (Nuremberg, Germanisches Nationalmuseum, Merkelsche Dürer-Handschrift fol. 7 verso; and London, British Library, Sloane 5229 fol. 38 recto and verso.) Gives modern transcription, and relates Dürer to music and musicians. [RILA no #6751].

502. Matthews, Wendell Glen. "Albrecht Dürer as a Reformation Figure." Ph.D. dissertation, University of Iowa, 1968.

Centers on the nineteenth-century scholarship, and argues that the artist's involvement with the Reformation can best be seen in his concept of 'the Word of God," from 1520 on [Dissertation Abstracts 29 (1968): 669].

503. Maué, Hermann. "The Development of Renaissance Portrait Medals in Germany." *Gothic and Renaissance Art in Nuremberg 1300–1500*, 105–107. New York. Metropolitan Museum of Art. Munich: Prestel, 1986.

Traces beginning of the art of portrait medals to Pisanello (1432), and its importation to Germany at a surprisingly late date—only after 1500 and under the influence of Maximilian. Briefly discusses the technique and documents the commissions for Dr. Christoph Scheurl's medals from Matthes Gebel.

504. ———. "Nuremberg's Cityscape and Architecture." *Gothic and Renaissance Art in Nuremberg 1300–1500*, 27–50. New York. Metropolitan Museum of Art. Munich: Prestel, 1986.

Discusses the architectural history of the city, reproducing valuable pre-World War II photographs which show the Old City before its near-total destruction by the R.A.F. Includes views and information on the the Dürer house and Tucher Schloss; the Great Hall of the Old City Hall; the Imperial fortress; the principal churches; Caritas Pirckheimer's convent of St. Clara; the Heilig-Geist-Spital and its church, which was the repository for the Imperial regalia; the Twelve-Brothers Houses founded by Matthäus Landauer; the city defenses. Also includes a panoramic photograph of the bomb damage as it appeared in 1946. Excellent bibliography.

505. Mauquoy-Hendrickx, Marie. *Les estampes des Wiericx conservées au Cabinet des Estampes de la Bibliothèque Royale Albert Ier*, Brussels: 1978.

The basic source work on Hieronymus Wiericx, whose oeuvre includes forgeries of Dürer's work, including the *Man of Sorrows* (Dürer B.20; Wiericx no. 527) he *Sudarium Held by Two Angels* (Dürer B.25; Wiericx 573); *The Virgin on the Crescent* (Dürer, B.33, B.31, and B.30; W.714, 715, and 716); the *Madonna Nursing* (Dürer B.34 and B.36; Wiericx 728 and 729); the *Madonna by a*

Wall (Dürer B.40; Wiericx 750); *The Virgin Seated Embracing Jesus* (Dürer B.35, Wiericx 748); the *Madonna with the Monkey* (Dürer B.42, Wiericx 751); the *Virgin and Child Crowned by an Angel* (Dürer B.37, Wiericx 767); the *Virgin and Child Crowned by Two Angels* (Dürer B.39, Wiericx 769). All are signed with Dürer's monogram.

506. Maurer, Wilhelm. "Humanismus und Reformation im Nürnberg Pirckheimers und Dürers." *Jahrbuch für fränkische Landesforschung* 31 (1971): 19–34.

Analyzes the effects of Humanism and of the Evangelical movement on both Pirckheimer and Dürer, concluding that Dürer, drawn more to Luther than to Erasmus and less deeply influenced by Humanism than was Pirckheimer, remained true to the Lutheran approach, even though he recognized the problems created by the onset of the Reformation [Parshall & Parshall].

507. Maykawa, Seira. *Zwei Dürerprobleme*, Konstanz: Leo Leonhardt, [1984].

The author is Director of the National Museum of Western Art in Tokyo, and Ordinarius in Art History at Tokyo University. Reprinted here are two essays: one on the so-called *Four Apostles* (1957), and the other on Giorgione's use of Dürer sources in *The Tempest*. Also included is a brief history of Dürer reception in Japan, where his nature studies and elegant line work have been highly admired, beginning in 1910 with the introduction of Wölfflin's monograph and reinforced in 1940 with the first loan exhibition of his graphic art—sent from Germany in honor of the 2600th anniversary of the Japanese Empire—and a second, from the DDR, in 1972. In the *Four Apostles,* it is noted that St. Mark is not an Apostle but an Evangelist, appearing as a witness, and the author of the biblical passage describing Christ's having sent the Apostles out, two by two, to become missionaries—Mark and Paul both went to Cyprus (Acts 13:5–13). St. John holds his book open to the first chapter of Mark's Gospel; feels the prominence given to St. John may be related to the fact that the Nuremberg City Council paid the artist 112 Rhenish gulden in the name of Hans [i.e., John] Volckamer, the old Burgermeister and his young successor, Lazarus Holzschuher. The essay on Giorgione's *Tempest* notes its resemblance to Dürer's *Family of Satyrs*, and speculates that the

artist's documented departure from Venice in mid-winter (February) of 1507 may have been occasioned by the offer from the Venetian Senate of two hundred ducats per year to become the official painter to the city which the artist cites in a letter of 1524 as having been made to him "nineteen years ago."

508. Mayor, A. Hyatt. *Artists and Anatomists*, Limited edition New York: Metropolitan Museum of Art, 1984.

A survey of the study of anatomy from ancient times to the present, including Dürer's contributions.

509. McIntosh, Christopher. "Birthplace of Bankers and Brecht: Augsburg and Its Environs." *Country Life* 167, no. 4308 (Jan.) (1980): 306–307.

Gives a brief history of Augsburg mentioning notable citizens including Jacob Fugger and his portrait by Dürer (Augsburg, Staatsgalerie). (But on the portrait, see also the discouraging laboratory report on its infrared examination in the Munich exhibition catalogue of 1998.)

510. McKittrick, Bruce. "Dürer in Frankreich—ein unbekannter Holzschnitt der *Geburt Christi*." *Bücher-Markt* 4, no. 7 (1995): 22–23.

The previously unpublished woodcut after Dürer's *Nativity* is by an anonymous French copyist active approximately 1540–50.

511. Meder, Josef. *Die grüne Passion Albrecht Dürers*, Monographien zur deutschen Kunst, 4. Munich: 1923.

The standard work on the twelve drawings known collectively as the "Green Passion" (Winkler nos. 298–314), so called because they are drawn on green primed paper (pen and brush heightened with white; Vienna, Albertina).

512. Meder, Josef. *Dürer-Katalog. Ein Handbuch über Albrecht Dürers Stiche, Radierungen, Holzschnitte, deren Zustände, Ausgaben und Wasserzeichen*, New York: Da Capo Press, 1971.

Although there are many catalogues of Dürer's prints, when the value of a particular impression is to be calculated, there is no substitute for Joseph Meder's definitive reference guide to the artist's prints in all media, in which the characteristics of the various edi-

tions of each plate and block are analyzed by means of the meticulous observation of the accumulated bits of damage to the linework and background caused by successive printings. Note is also made of the watermarks characteristic of each edition. First published in 1932 (Vienna: Gilhofer). The Da Capo edition is a simple reprint, brought out in time for the anniversary year 1971.

513. Meder, Josef. "Zur ersten Reise nach Venedig (1494–95)." *Jahrbuch der Kunsthistorischen Sammlungen des allerhöchsten Kaiserhauses (Vienna)* 30 (December 1911): 183–227.

An early study of the artist's first trip to Italy, which is largely undocumented except for the series of landscape watercolors, costume and animal studies.

514. Melbourne, (Victoria Australia). National Gallery of Victoria. *Albrecht Dürer in the Collection of the National Gallery of Victoria,* Ed. Irena Zdanowicz. 226 pages. The Robert Raynor Publications in Prints and Drawings, 5. Melbourne: The Gallery, 1994.

Collection catalogue, with six essays and bibliography. Melbourne has one of the world's most comprehensive collections of Dürer's prints. Holdings include the three *Meisterstiche*, acquired 1891, which formerly belonged to the important nineteenth-century British etcher, Seymour Hayden, as well as works from the collection of the American metallurgist Robert Carl Sticht, and from that of the Australian artist Lionel Lindsay, as well as twenty strong impressions from the London gallery of the Goya expert Tomás Harris (ex-colls. Mariette and Friedrich August of Saxony); and three hundred prints from the collection of Sir Thomas Barlow (purchased 1956)—a total of some 450 impressions. There is also a preparatory pen and ink drawing for the engraving *The Madonna Crowned by an Angel* (1520). Essays, intended for a general audience, are: Angela Hass, "A Double Honour. Albrecht Dürer"; Charles Zika, "Nuremberg: The City and its Culture in the Early sixteenth Century"; Larry Silver, "The Power of the Press: Dürer's Arch of Honour"; Dagmar Eichberger, "Dürer and the Printed Book"; Ursula Hoff, "Thomas Barlow, Dürer Collector."

515. Melion, Walter S. *Shaping the Netherlandish Canon: Carel van Mander's* Schilder-Boeck, Chicago and London: University of Chicago Press, 1991.

This fresh and important study investigates the ingredients that formed Carel van Mander's aesthetic judgments as expressed in the *Schilder-Boeck* (Haarlem, 1604) in some detail, and finds Dürer's art—the prints especially—to have been quite important. Designating Dürer "the honor of the Germans," he declares engraving to be the prime medium for Northern artists, and particularly recommends Dürer's handling of drapery as worthy of emulation (102). Melion also discusses the views of Domenicus Lampsonius, Lambert Lombard, and Giorgio Vasari on Dürer and his influence in Italy (Chapter 10), as well as those of the Hungarian humanist Johannes Sambucus, whose flattering poem compared Dürer to the Ancients (162–163: Apelles, Lysippus, Praxiteles), and comments on Goltzius' prints in imitation of Dürer and Lucas van Leyden. [The author is professor of art history at The Johns Hopkins University, Baltimore.]

516. Mende, Matthias. *Albrecht Dürer. Zum Leben, zum Holzschnittwerk. Chronologisches Verzeichnis der Holzschnitte. Hinweise zum aktuellen Schrifttum. Zeittafel. Konkordanz*, Munich: Edition Tomus, 1976.

A luxury facsimile edition of the woodcuts, accompanied by essays on the artist's life; his activity as a designer of woodcuts viewed in the context of what is actually known about woodcut production in contemporary Nuremberg; a chronological catalogue raisonné of the woodcuts; a chronology of the artist's life; a concordance table giving Bartsch, Passavant, Kurth, Meder, Panofsky, Hollstein, and Knappe numbers. This work was produced in a small and expensive edition because of its plates, but its essays are absolutely essential reading. The author concludes that—contrary to popular belief—it would have been highly unlikely that Dürer cut his own blocks. The author's familiarity with Nuremberg archives (he has directed the city's historical museums, including the Dürerhaus) enables him to give fresh insight into many of the events of the artist's life, as well as into his workshop practices. Mende is by far the most prolific Dürer scholar working today, and one of the most important.

517. ———. *Albrecht Dürer; sämtliche Holzschnitte*, Munich: Tomus, 1976.

A revision of the 1927 edition by Willi Kurth (Munich, Holbein Verlag, many times reprinted). Twenty-nine of Kurth's reproductions have been omitted and thirty-nine added, including the *Martyrdom of St. Sebastian of the Wandering Years*, recently rediscovered in Basel (1974). Excellent plates in folio form, and an accompanying text volume with essays, a chronology of the woodcuts, references, and concordance. The author offers convincing arguments suggesting that Dürer did not cut his own blocks for the great picturebooks and the *Samson and the Lion* as Ivins had thought.

518. ———. *Albrecht Dürer. Das Frühwerk bis 1500.* Hamburg: Olde Hansen, 1976.

This is an undocumented but very useful study of Dürer's first decades of activity, including the recent discovery of Sir Edmund Bacon's painting of the penitent *St. Jerome*. Mende deals with some very important issues here. He notes that it comes as a surprise to "some Germans" that not all of Dürer's work was of top quality, and criticizes the former irresponsible practice of assigning some of the artist's less attractive early works to his "workshop"—without pausing to consider that he did not yet have one. Works under discussion include the awkward *Bagnacavallo Madonna* and the Karlsruhe *Man of Sorrows* as well as the universally accepted early watercolors, the *Hercules and the Stymphalian Birds*; the two *Lamentations*, the *Haller Madonna*, and the early portraits, including the self portraits of 1493, 1498, and 1500. On the watercolors, he notes that the *View of Innsbruck* is "the first city view in the modern sense," and that the artist's use of the watercolor medium on the trip to Italy had nothing to do with lack of time on the journey. Mende also recounts one version of the trickery by which the 1500 *Self Portrait* was taken to Munich in 1805: the Nuremberg painter Abraham Wolfgang Küfner (1760–1817) borrowed the painting from the Nuremberg City Hall, split the panel, and painted a copy on the newly exposed side of the back panel, returning the copy to the City Hall and offering the original for sale to the director of the Munich gallery, Christian von Mannlich. (On this forgery see also Georg Caspar Nagler, *Albrecht Dürer und seine Kunst*, Munich, 1837; Hans Vollmer's biography of Küfner in Thieme-Becker, *Allgemeines Lexikon der bildenden*

Künstler, vol. 22, Leipzig, 1928; as well as the recent exhibition catalogue by Goldberg, Heimberg and Schawe, *Albrecht Dürer. Die Gemälde der Alten Pinakothek*, Munich, Bayerische Staats-gemäldesammlungen, 1998, pp. 342–343 and Note 346.)

519. ———. *Das alte Nürnberger Rathaus. Baugeschichte und Ausstattung des grossen Saales und der Ratsstube*, 2 vols. Ausstel-lungskataloge der Stadtgeschichtlichen Museen Nürnberg, 15. Nuremberg: Stadtgeschichtliche Museen, 1979.

Foreword by Karl Heinz Schreyl. The definitive work on Nurem-berg's old City Hall, with its grand salon for dancing decorated by Albrecht Dürer after his return from the Netherlands in 1521. Chronological overview of the building history from 1332, to its almost total destruction in the bombing raids of 1944/1945 and postwar reconstruction. Reproduces early seventeenth-century in-terior views, and details the condition reports of the eighteenth, and restorations of the nineteenth and early twentieth centuries. Particularly valuable for its black-and-white photographic details made during the restoration of 1902. Volume II is the catalogue section containing plans, models, exterior and interior views, and all the known paintings, including Dürer's *Calumny of Apelles* and *Triumphal Procession of Maximilian*. The first major publication on the old City Hall since 1891, it appeared as a result of the exhi-bition of 1978.

520. ———. "Das Dürer-Denkmal." *Denkmäler im 19. Jahrhundert*, Eds. Volker Plagemann and Hans-Ernst Mittig. Munich: 1971.

The history of the public monument (1828–1840) honoring Dürer—the first monument erected in honor of an artist—which features a life-sized bronze "portrait" statue by the Berlin sculptor Christian Daniel Rauch. It was commissioned by order of King Ludwig I of Bavaria who provided a "matching funds" grant to be supplemented by donations from the public, including the school-children of Nuremberg. Originally intended for dedication at the festivities honoring the artist's three hundredth death anniversary in 1828, it was not finished until 1840, when a separate celebration was held (on a date totally unconnected with Dürer, but one of high significance for the burgeoning economic life of contemporary Bavaria).

521. ———. "Die Transparente der Nürnberger Dürer-Feier von 1828. Ein Beitrag zur Dürerverehrung der Romantik." *Anzeiger des Germanischen Nationalmuseums Nürnberg* (1969): 177–209.

The basic study of the transparencies made by Munich artists under the auspices of the Nazarene painter Peter Cornelius, that were contributed to the Nuremberg celebration of Dürer's three hundredth death anniversary in 1828. The finished works were intended to be lit from the back, in order to resemble stained-glass windows. Mende suggests that the iconographic program may have been the work of Cornelius's eldest pupil, Ernst Förster, who is better known for his art-historical writings. The original transparencies, two meters high, have been lost, but the general effect is preserved in the small stained-glass copies by Joseph Sauterleute (Nuremberg, Germanisches Nationalmuseum.) In keeping with the imitation of stained glass, the attempt was made to emphasize the Christlike qualities of Dürer—even to calming the storm on the River Scheldt, which recalls all too strongly Christ's similar success on the Sea of Galilee. Other memorable moments included the marriage of Dürer to Agnes Frey (by Wilhelm Kaulbach); Dürer's reception into Antwerp (by Herman Stilke); Dürer at his mother's deathbed (Ernst Förster); and Dürer and Raphael at the throne of Art (Adam Eberle—included at Cornelius's insistence).

522. ———. *Dürer A-Z. Sechzig druckgraphische Dürer-Variationen zeitgenössischer Künstler von Anderle bis Zimmermann. Herausgegeben von den Stadtgeschichtlichen Museen Nürnberg und der Albrecht-Dürer-Haus-Stiftung,* Nuremberg: Verlag Hans Carl, 1980.

Catalogue of sixty modern prints acquired by the Dürerhaus, assembled for the European Weeks in Passau, which are "paraphrases" of works by Dürer, from the Czech artist Jiri Anderle to Warrington Colescott, Salvador Dali, HAP Grieshaber, Andre Masson, Michael Matthias Prechtl, Klaus Staeck, Paul Wunderlich, Mac Zimmermann. Beautifully produced on coated stock; many color plates; scholarly entries. Many prints by artists from eastern Europe. Contains an introduction on the recent modern phenomenon of "art works about art" with special reference to the interest in Dürer in recent years.

523. ———. "Dürer- der zweite Apelles." *Dürer heute*, Willi Bongard, and Matthias Mende. Munich: 1971.

524. Mende, Matthias. "Dürer–der zweite Apelles. " *Dürer heute*. Eds. Willy Bongard, and Matthias Mende, 23–42. Bonn, Bad Godesberg, Inter Nationes, c1970.

[English edition: *Dürer Today*.] Essential reading. A pioneering essay on Dürer's identity as "the new Apelles," a term of praise used by Konrad Celtis (who contrasted the "old Apelles" with the new one in a manuscript) and by Wimpheling (1502). The term resonated as far afield as Bologna (1506), according to Scheurl, who was there at the time. Sbrulius (1507) transformed it to "the German Apelles," and Eobanus Hesse, in his eulogy on the artist's death in 1528 declared that he had surpassed Apelles. Also deals with the Christomorphic portrait (Munich:1500) and its progeny by J. K. Fischer; as well as with early editions of his books; and his influence on Lovis Corinth, Ernst Ludwig Kirchner, and Egon Schiele.

525. ———. "Dürer's so-called *Portrait of Damião de Góis*: Toward a Reconstruction of a Lost Painting of 1521." *Tribute to Lotte Brand Philip, Art Historian and Detective*, 103–111. Eds. William W. Clark, Colin Eisler, William S. Heckscher, and Barbara G. Lane. New York: Abaris, 1985.

Concludes that while the painted *Portrait of a Man* dated 1551 (Fig. 1: private collection) and the Netherlandish drawing, *Portrait of a Man* (Vienna, Albertina, inv. no. 3166: Fig. 2) do reflect lost portraits by Dürer, the sitter cannot have been the Portuguese humanist Damiao de Góis, who arrived in Antwerp only in 1523—two years after Dürer's return to Nuremberg—and was only twenty-six years old when the artist died (thus too young to have been the sitter, who is shown as a more mature man).

526. ———, Ed. *Dürer-Bibliographie. Zur fünfhundertsten Wiederkehr des Geburtstages von Albrecht Dürer*, Wiesbaden: Otto Harrassowitz, 1971.

An essential work for serious scholarship. Complete and meticulously cross-indexed listing of more than ten thousand entries ref-

erencing the entire professional literature from the sixteenth century to 1970, published by the Germanisches Nationalmuseum in connection with the events of Dürer Year 1971. For this reason it does not include the numerous publications that appeared during that year, many of which were major exhibition catalogues featuring new scholarship. It also is lacking some important references to earlier scholarly works produced in the United States. [Reviewed by Dieter Kuhrmann in *Pantheon* 32 no. 2 (April-June 1974), 203–204; and by Walter L. Strauss in *Print Review* 6 (1976), 100–101].

527. ———. *Düreriana. Neuerwerbungen der Albrecht-Dürer-Haus-Stiftung*, Nuremberg: Verlag Hans Carl, 1990.

A large, well produced, and scholarly volume detailing the most recent acquisitions of works of art for the Dürerhaus. These include two of the artist's own prints (a nineteenth-century impression of the woodcut of a Roman theater designed for the unpublished Basel edition of the comedies of Terence, and an impression of the *Prodigal Son*) and several woodcuts produced in his workshop or in collaboration with others (the *Triumph of Maximilian*); the seventeenth-century chiaroscuro restrike of the *Portrait of Ulrich Varnbühler*; a number of early copies after works by Dürer; nineteenth-century memorabilia from the Dürer-Verein; and many modern works, from Walter Crane to Astrid Feuser (b. 1951) and the Danish Erik Skjoldborg (b. 1940). A substantial essay on the history of the Albrecht-Dürer-Haus-Stiftung (1976 to date) preceeds the fully illustrated catalogue, which has many color plates.

528. ———. *Dürer-Medaillen. Münzen, Medaillen, Plaketten von Dürer, auf Dürer, nach Dürer. Herausgegeben von den Stadtgeschichtlichen Museen Nürnberg und der Albrecht-Dürerhaus*, Nuremberg: Verlag Hans Carl, 1983.

Book published in connection with an exhibition at the Dürerhaus. Discusses and reproduces all of the coins and medals known to, utilized by, and designed by Dürer, as well as those struck in his honor, showing his impact on later centuries from the sixteenth to the present. Three hundred four catalogue entries by more than 120 various artists, modellers, die-casters, and engravers, including the

artist's contemporaries Hans and Luwig Krug, Hans Schwarz, Peter Vischer the Younger, Mathes Gebel, and Hans Suess von Kulmbach, as well as Doris Waschk-Balz (b. 1942) and Heidimarie Unterschütz (b. 1951).

529. ———. "Dürers Traumbilder." *Kurz und Gut* 10, no. 1 (1976): 40–44.

Comments on Dürer's anxiety and daydreams and his attempt to overcome them through his art. Discusses some uninterpreted works from around 1515, and then pays attention to the watercolor *Dream Vision of a Deluge* of 1525 (Vienna, Kunsthistorisches Museum] [Author; RILA].

530. ———. "Dürers Bildnis des Kaspar Nützel." *Mitteilungen des Vereins für Geschichte der Stadt Nürnberg* 69 (1982): 130–142.

Discusses Dürer's lost portrait, apparently dating from approximately 1517–1518, here identified as that of the influential Nuremberg city councillor Kaspar Nützel, known today through a painted copy in Jagdschloss Grunewald (Berlin: Verwaltung der Staatlichen Schlösser und Gärten, Inv. no. 1899; Anzelewsky No. 135), and through two preparatory drawings by Dürer (Munich and Paris [Louvre, Rothschild Collection, dated 1517], W. 565 and 566.) The identification of Nützel, who was the unauthorized translater of Luther's ninety-five theses into German, is made on the basis of a 1669 engraving by Johann Friedrich Leonart. Nützel was approximately the same age as Dürer, and was a fellow member of the "Sodalitas Staupitziana." An avid follower of the Reformation and advocate of the closing of convents, he therefore became the enemy of Pirckheimer, whose sister was a Franciscan abbess. The former identity of the sitter as the Augsburg attorney and classicist Konrad Peutinger is disproved.

531. ———. *Im Namen Dürers. Druckgraphische Jahresblätter des Albrecht-Dürer-Vereins in Nürnberg 1833–1874*, Nürnberg: Verlag Hans Carl, 1991.

More than simply an exhibition catalogue, this is a valuable resource for the study of both Dürer-reception in nineteenth-century Nuremberg and for the early history of artists' associations as dem-

ocratic institutions. Arranged in honor of the two hundredth an-
niversary of the founding of Nuremberg's Albrecht-Dürer-
Gesellschaft, Mende, with the assistance of Margit Kern and Heinz
Glaser, assembled a collection of the reproductive engravings
(Jahresblätter) that were commissioned as annual gifts to members
of the Albrecht-Dürer-Verein in Nuremberg between 1833–1874
(the years during which the organization was housed in the Dür-
erhaus), together with a selection of the original paintings upon
which they were based. Some of the Jahresblätter actually depict
scenes fromn Dürer's life and/or legend (e.g., Eugen Napoleon
Neureuther's etching depicting the Emperor Maximilian I award-
ing Dürer a coat-of-arms), while a few others depict Nuremberg
views and monuments or works associated with Dürer's contem-
poraries. Each object is fully catalogued, with provenance, bibli-
ography and illustration. The most valuable part of the book for
our purposes, however, is Mende's detailed chronicle of the first
one hundred years of Nuremberg's Kunstverein, from its foun-
dation in the late eighteenth century by the young Nurem-
berg physician Johann Benjamin Erhard and the well-known art
dealer and publisher Johann Friedrich Frauenholz. Erhard, whose
circle of friends included Kant, Schiller, Herder, Goethe, Novalis,
Fichte, Klopstock, and Pestalozzi, was a prominent Jacobin
who served for a time as Nuremberg's secret agent in revolution-
ary Paris, and it was his conviction that works of artistic
genius could best be nurtured, not in solitude but through contact
between artists, who would stimulate one another. Mende relates
concisely, year by year, the growth and amalgamation of Nurem-
berg's organizations of artists and dilettantes, against the back-
ground of the Napoleonic wars and the changing fortunes of
Nuremberg after the Congress of Vienna and the annexation of the
city by the Kingdom of Bavaria. Included are discussions of the
role of the Verein in drawing instruction and reform of the Nurem-
berg Academy; the dates of establishment of artists' organizations
in other German and Swiss cities; the particular role of engraving,
which was a Nuremberg specialty; the contemporary artists who
were buried in Dürer's tomb; the full texts of anthems sung over
his grave. Many text illustrations are of interest—among them Carl
Friedrich Echtermeier's marble group of Deutschland (a heroic
woman in a diadem and quasimedieval gown) placing a laurel

wreath on the brow of a small bust of Dürer. (Kassel, Staatliche Museen, 1882).

532. ———. *Mit Dürer unterwegs*, Nuremberg: Germanisches Nationalmuseum, 1971.

Exhibition of the drawings and watercolors produced by six German artists who were funded by the Faber-Castell Foundation to travel to places where Dürer had gone and to create original works of art. Some are straightforward modern landscapes, others wonderfully witty commentaries on what modern commerce has wrought. Artists represented are Peter Ackermann, Manfred Bluth, Siegbert Jatzko, Carl-Heinz Kliemann, Anton Lehmden, and Michael Matthias Prechtl. Prechtl's Netherlandish sketchbook is particularly notable for its traffic jam in the Domplatz at Aachen; Groote Kerk at Bergen with adjacent TV aerials; Our Lady's church in Antwerp with smog and traffic signs; the Kermis at Mechelen with carnival rides.

533. ———. *Wirkung und Nachleben Dürers. Neuerwerbungen und Leihgaben der letzten Jahre*, Ausstellungskataloge der Stadtgeschichtlichen Museen Nürnberg, 9. Nuremberg: Grossdruckerei Erich Spandel, 1976.

Festschrift for the one hundredth anniversary of the Dürer-Haus-Stiftung in Nuremberg. Catalogue of acquisitions and important loans made to the Dürerhaus from 1971 to 1976. Includes original prints by Dürer, as well as prints, drawings, woodblocks, medals, a few paintings, and other memorabilia by members of the artist's own workshop, as well as by nineteenth-century followers. Many portraits of the artist. Artists exhibited include Baldung, Schäufelein, Hans von Kulmbach, Springinklee, the Beham brothers, and the elder Cranach. Copies after Dürer by Hieronymus Greff, Wenzel von Olmütz, Raimondi, Hieronymus Hopfer, Ludovico Cigoli, Hans Hoffmann, and others.

534. Mende, Matthias, and Inge Hebecker. *Das Dürer-Stammbuch von 1828*, Nuremberg: Dürer-Haus, 1973.

Details the elaborate planning for the Dürer anniversary celebration of 1828, which began as early as 1826 when Albert Christoph Reindel, the Director of Nuremberg's *Kunstschule*, issued an invitation to all artist of German ancestry, whether living in Germany

or abroad, to send representative works of their own to Nuremberg for a permanent collection. He naturally had assumed that these would be prints and drawings, which could have been stored in albums, but was astounded to receive paintings, sculpture and works in all media from fifty-seven artists, ranging in age from twenty-three to seventy-three, and working in diverse styles from Rococo to Biedermeier. Among the entries were works by Caspar David Friedrich, Matthias Christoph Hartmann, Carl Heinrich Rahl, Ernst Mayer, and Joseph Wintergerst.

535. Menz, Cäsar. *Das Frühwerk Jörg Breus des Ältern*, Schwäbische Geschichtsquellen und Forschungen, 13. Augsburg: Kommissionsverlag Bücher Seitz, 1982.

Explores the artist's background and his relation to Jan Polack, focusing on three of his most important early works, all executed before 1502. In his study of the third of these, an altarpiece for the Benedictine abbey church of Melk, he stresses the influence on Breu of Dürer's woodcuts and engravings.

536. Merlo, Johann Jakob. "Die Familie Jabach zu Köln und ihre Kunstliebe." *Annalen des historischen Vereins für den Niederrhein* 9/10 (1861): 1–80.

See especially pages 22–23 for discussion of the so-called Jabach Altarpiece.

537. ———. "Jabach, Everhard." *Allgemeine deutsche Biographie*, 518–522. Leipzig: 1881.

The definitive work on the celebrated seventeenth-century banker of Cologne, who acted as agent for Cardinal Mazarin at the sale of the collection of Charles I of England, and whose own collection of 5600 master drawings was acquired in the 1670s by Colbert, forming the nucleus of the Cabinet des dessins of the Louvre.

538. ———. *Kölnische Künstler in alter und neuer Zeit*, 195–196. Düsseldorf: L. Schwann, 1895.

"Dürer, Nikolaus, genannt Unger." The entry in this standard older reference work, based on Cologne guild records, that treats Dürer's goldsmith cousin from Hungary. Nikolaus had trained with Albrecht Dürer the Elder, and it was he whom Dürer and Agnes visited on their journey to the Netherlands. Nikolaus had apparently

married a Nuremberg woman, and had owned a house in the Bergamentergasse (Nürnberg Stadtarchiv, Litterae 10 fol. 23). By 1501 he was living in Cologne.

539. Mesentseva, Charmian Aleksandrovna. *Dürer, 1471–1528. Graphische Werke in der Sammlung der Eremitage*, Leningrad: The Hermitage, 1971.

Catalogue (in Russian and German) of the important exhibition of prime impressions by Dürer from the collection of the Hermitage (not including, of course, the works secretly held since World War II). Beautifully produced, with text by one of the two best Dürer scholars in the former Soviet Union, whose connoisseurship and iconographic expertise are comparable to that found in Germany.

540. ———. "O syushetye xilografi Albrechta Dürera, *Gerkules*." Konferentsya posvyashtshennaya 500–letyou so dnya roshdshenya Albrechta Dürera, Tezisy dokladov, 5–7. Leningrad, Leningrad: 1971.

Identifies the subject of Dürer's woodcut B.127 (1496), inscribed simply "Erkules," as *Hercules Slaying the Molionides* (who were Siamese twins). The same discovery had been made simultaneously by the German classicist Erika Simon, who published it in the catalogue of the 1971 Nuremberg exhibition (q.v.). A later version of Mesentseva's article was published in *Trudy Gosudarstvennogo Ermitazha* 14 (1973), 5–13.

541. Mesentseva (Mezentseva), Charmian Aleksandrovna. *The Renaissance Engravers. Fifteenth– and Sixteenth–Century Engravings, Etchings and Woodcuts*. Translated from the Russian by Lenina Sorokina. Bournemouth (UK) and St. Petersburg: Aurora, 1996.

This is the English edition of a work devoted to the fifteenth- and sixteenth-century prints in the collection of the Hermitage, St. Petersburg, written by the curator who specializes in German prints of this period. It is beautifully produced, with a number of color plates, but is a selection of the cream of the collection chosen with an eye toward giving an idea of its scope. Nineteen of the Hermitage's superb Dürers are included. Although this book was obviously intended for a more or less general readership, it is valuable for Mesenteva's many original iconographical insights.

542. Mesentseva (Mesenceva), Charmian Aleksandrovna. "Zum Problem: Dürer und die Antike. Albrecht Dürers Kupferstich 'Die Hexe'." *Zeitschrift für Kunstgeschichte* 46, no. 2 (1983): 187–202.

New interpretation, by the curator of Northern prints at the Hermitage, of Albrecht Dürer's engraving, *The Witch* (ca. 1502–1505). Suggests that the witch is connected with representations of Aphrodite Pandemos as seen in antique gems and cameos. Also examines the motif of the witch in the work of Hans Baldung, Pieter van der Heyden (1565), and Jacob de Gheyn (*Kitchen of the Witches*, 1600), and in relation to Nicholas Poussin's painting *Venus and Bacchus*, (ca. 1635, St. Petersburg).

543. Meyer, Ursula. "Dürer's *Victoria* and his Apocalyptic symbols." *Kritische Berichte* 11, no. 4 (1983): 13–36.

Study of the iconography and political significance of the design for a monument, featuring a dead peasant, commemorating the victory of the princes over the rebels in the German *Peasants' War* (1525).

544. ———. "Political Implications of Dürer's *Knight, Death, and Devil.*" *Print Collector's Newsletter* 9, no. 2 (1978): 35–39.

The author is a professor in the Art Department of Herbert H. Lehman College, City University of New York. The article was developed from a paper read in the session, Art and Ideology, sponsored by the Caucus for Marxism and Art, at a meeting of the College Art Association (January 1978). It gives a useful and well documented review of the changing perceptions of Dürer's *Knight* that, the author maintains, is an image whose political content has been consistently denied since the nineteenth century, when Christian chivalric and Germanic mythological interpretations began to obscure the original social significance of the print. Admitting that the virtuous and Christian interpretation began with Joachim von Sandrart (1675), Meyer points out that he was, however, the only writer to attribute these qualities to the Knight, and cites Hans Schwerte's discovery (1962: q.v.) that the artist's contemporaries perceived a Phantom-Rider [*Gespenster-Reiter* who was in league with Death and the Devil—not their adversary. Quoting Dürer himself, who referred to knights as *Tiraisbulis milites* (ruffian soldiers) in his letter to Pirckheimer of August 15, 1506, she also

notes the attack on the artist's own dealer by one of their number, Kunz Schott, who absconded with a portfolio of the artist's graphics, as well as the futile attempt made at the Gelnhausen Reichstag (1502) to suppress such activity. She further cites Heinrich A. Cornill d'Orville's study of old German manuscripts (1865), which confirm this interpretation as the prevailing one. (See H. A. Cornill d'Orville, "Mittheilungen über einige Kupferstiche und Holzschnitte von Albrecht Dürer nach alten Katalogen," in *Archiv für die zeichnenden Künste*, ed. Robert Naumann, 11 (1865), 62). The modern Swedish critic Sten Karling (q.v.) reinforces the interpretation of the Knight as in league with the Devil. Also noted is W. Waetzoldt's substitution of the idealized Germanic for the Christian knight (". . . the *Rider* is a descendant of the warriors of Nordic heroic legends, an ancestor of Prussian officers" (*Dürer und seine Zeit*, 1935 edition, 233) and his still more ominous statement a year later that "Heroic souls have loved this engraving—as Nietzsche did and Adolf Hitler does. They love it because it is an image of victory." (W. Waetzoldt, *Ritter, Tod und Teufel*, Berlin, Georg Stilke, 1936, 36). Also reviews the Christian interpretation from Sandrart to Wölfflin and Panofsky, which became the canonical one. [Appeared as "Politische Bezüge in Dürers 'Ritter, Tod und Teufel'," in *Kritische Berichte* 6, no. 6 (1978), 27–41.]

545. Meyers, Jeffrey. "Dürer and Mann's *Faustus*." *Art International* 17 (1973): 56–60; 63–64.

Thomas Mann's indebtedness to Dürer motifs is well known, but this is one of rather few studies in English.

546. Mészáros, László. *Italien sieht Dürer. Zur Wirkung des deutschen Druckgraphik auf die italienische Kunst des 16. Jahrhunderts*, Erlangen: Palm & Enke, 1983.

An offset typescript, poorly produced but useful for its handlist of 358 items of Italian art influenced by Dürer's prints, including the copies by Raimondi, Giovanni Antonio da Brescia, Zoan Andrea, Benedetto Montagna, Giulio Campagnola, Master IB with the Bird, as well as paintings by Giorgione, Carpaccio, Titiam, Andrea del Sarto, Pontormo, and many others. Also deals with pre-Dürer graphics having influence in Italy (especially Schongauer's influence on Robetta, Nicoletto da Modena, Andrea Previtali, Raphael, Michelangelo, and Veronese). Cites Vasari, Lomazzo, Giovanni

Paolo, Ludovico Dolce, as well as modern authors (Oskar Hagen, Arpad Weixlgärtner, and Theodore Hetzer).

547. Mielke, Hans. *Albrecht Dürer. 50 Meisterzeichnungen aus dem Berliner Kupferstichkabinett*, Berlin: Staatliche Museen Preussicher Kulturbesitz, 1991.

The catalogue of an exhibition of fifty of Dürer's drawings and watercolors from the Berlin print room, on loan to Düsseldorf in 1991, written by the late curator of the Berlin collection. Dürer passed through Düsseldorf on his return to Antwerp from Cologne (November 14, 1520) after the coronation of Charles V. The exhibition was sponsored by Dr. Johannes Rau, Minister-President of Nordrhein-Westfalen, and the catalogue is both scholarly and beautifully produced with full page illustrations of each drawing in excellent color (even such hard-to-reproduce ones as *Rodrigo de Almada* [W.813] and *Agnes in Netherlandish Costume* [W.814]), plus comparative material. The sixteen page introductory essay treats the artist's development as a draftsman, integrating the drawings into his life and production of works in other media. There also is a useful brief section on provenance (five of the drawings exhibited are traceable to the collection of Willibald Pirckheimer's heir, Willibald Imhoff the Elder—one being the 1503 portrait of Pirckheimer. The Imhoff collection had been acquired by Rudolf II, and 371 Dürers, including Rudolf's, had passed to the Albertina by 1783. About 220 disappeared, however, during the Napoleonic occupation of Vienna (1809), some sold by a dishonest curator to General Andreossy and to the Vienna dealer Josef Grünling (d. 1845). Among Grünling's buyers was the Director of the Vienna Coin-Engraving Academy, Josef Damiel Böhm (d. 1865). After Böhm's death, the Vienna dealer Alexander Posonyi sold his collection in lots to a number of buyers, among them the Berlin print room, and Oberbaurat David Bernhard Haussmann (Hanover), from whose Braunschweig heirs, Dr. Rudolf Blasius and family, the museum acquired still more of the former Albertina drwings, while another forty of them came by way of the Hulot collection.

548. Minott, Charles I., Robert Koch, and Barbara T. Ross. *Albrecht Dürer, the Early Graphic Works*, Record of the Art Museum, Princeton, University, 30 no. 2. Princeton NJ: Princeton University, 1971.

Princeton University's 1971 exhibition honoring Dürer featured his early prints only, and was published as a regular issue of the Record.

549. Mittig, Hans-Ernst. *Dürers Bauernsäule. Ein Monument des Widerspruchs*, kunststück, Klaus Herding, Frankfurt: Fischer Taschenbuch Verlag, 1984.

An essential volume in this series of scholarly paperbacks. Discusses Dürer's woodcut design for a 1525 book illustration depicting a "victoria" monument culminating in a dead peasant run through with a sword, in the context of the Peasants' War, as well as in the conflicting views of modern scholarship. A reliable guide to what is actually known of Dürer's views on the cause of the peasants, and to his interest in modern armaments and portraits of aristocracy who opposed the peasants.

550. Moffitt, John F. " 'Le Roi à la ciasse?' Kings, Christian Knights, and Van Dyck's Singular Dismounted Portrait of Charles I." *Artibus et Historiae* 4, no. 7 (1983): pp. 79–99.

Argues that Van Dyck's equestrian portraits of Charles I are all representations of the Christian Knight theme drawing on such literary sources as Erasmus' *Enchiridion militis christiani* (1503) and Olivier de la Marche's *Le chevalier délibéré* (1488), as well as on such visual sources as Dürer's *Knight, Death, and Devil* and Titian's *Charles V at the Battle of Mühlberg*.

551. Mojzer, Miklós. "Két puttó Nagyszebenböl és a magyarországi reneszánsz néhány kevéssé ismert emléke." *Müvészettörténeti értesitö* 31, no. 2 (1982): pp. 105–119.

[Two Putti from Nagyszeben (Sibiu) and a Few Little Known Renaissance Relics of Hungary.] In Hungarian, with English summary. Discusses the use of the nude in northern European art of the fifteenth and sixteenth centuries, showing the influence of both Italian art and of Dürer on sixteenth-century art in Hungary. Focuses on two wooden putti from Nagyszebeni in the Magyar Nemzeti Galéria, Budapest [RILA 1545].

552. ———. "La datation de la *Deposition de Croix* du Maître MS." *Bulletin du Musée Hongrois des Beaux-Arts* 43 (1974): 53–74, 153–162.

Uses motifs from Dürer, among other criteria, in a discussion of the inscribed but disputed date 1495 on a panel painting by the monogrammist MS in the Warsaw Museum. Also discusses the possibility that Master MS and the engraver known as Master MZ may have been one and the same artist.

553. ———. "Les panneaux du Maître MS conservées à Budapest, Hontszentantal (Antol) et Lille." *Magyar Nemzeti Galéria evkönyve* 3 (1980): 5–40; 149–163.

The author attributes a group of panel paintings in Budapest, Hontszentantal, and Lille by the painter known as Master MS to the hand of the south German engraver who signed his plates with the monogram MZ, noting that both painter and printmaker relied on the same sources of inspiration—Schongauer, Dürer among them.

554. ———. "Um Meister MZ." *Acta Historiae Artium* 21, no. 3–4 (1975): 371–428.

Reports on the state of research on the Bavarian engraver Master MZ, expanding on the dissertation of Angelika Lenz (University of Giessen, 1972), especially with regard to the later works of this monogrammist that show the influence of Dürer's early engravings, including the *Madonna with the Monkey*, the *Madonna with the Dragonfly*, *The Promenade*, *Five Lanquenets and an Oriental on Horseback*, the *Small Courier*, the *Ill-Assorted Couple*, and more.

555. Morley, Brian. "The Plant Illustrations of Leonardo da Vinci." *Burlington Magazine* 121, no. 918 (September) (1979): 533–560.

The author, an Australian botanist, discusses Leonardo's contribution to the development of botanical illustration, making brief comparison to the botanical illustrations of Dürer.

556. Morvay, Andreas Johann. *Ein unbekanntes Dürerwerk*, Basel: Morvay Verlag, 1992.

(Translated from the Hungarian by Paul Georg Morvay: original title *Egy Ismeretlen Dürermü.*) A very brief essay (fourteen pages of text, twenty-nine illustrations) dealing with the well-known silver pax from the Amerbach Cabinet in the Basel Historisch Museum, which is engraved on both sides with scenes from Martin Schongauer's Passion of Christ. The author attributes the pax to the workshop of Schongauer's goldsmith brother Georg (Jörg). In

the past the pax often has been attributed to Martin himself. Morvay notes differences in the engraving technique of the harder contour lines, giving the work a "woodcut-like" quality unlike the autograph work of Martin Schongauer, and suggests that the young Dürer may have been the engraver. Dürer lived in Georg Schongauer's house during his time in Basel (1492). This is a highly speculative theory, since the pax is undated, but an interesting one.

557. Moxey, Keith P. F. "Panofsky's Melancolia." *The Practice of Theory: Poststructuralism, Cultural Politics, and Art History*, 65–78. Ithaca, NY/London: Cornell University Press, 1994.

Discusses Panofsky's monograph on Dürer in terms of its author's cultural and social values—in particular his commitment to Kantian reason—which is characterized as typical of his generation, and of his status as a member of an upper-class family of acculturated German Jews at a time when the destruction of German culture at the hands of the forces of unreason seemed immanent. He sees Panofsky's choice of Dürer as an outstanding representative of the German "national" temperament, and the choice of the *Melencolia I* as emblematic of the artist's struggle against unreason as reflecting Panofsky's own state of mind as German emigré.

558. ———. "The Social Function of Secular Woodcuts in Sixteenth Century Nuremberg." *New Perspectives on the Art of Renaissance Nuremberg: Five Essays*, 63–81. Ed. Jeffrey Chipps Smith. Austin, TX: University of Texas—Archer M. Huntington Art Gallery, 1985.

Discusses the rise of secular imagery in early sixteenth-century German woodcut production. Prints discussed include Sebald Beham's *Large Peasant Holiday, Siege of Vienna,* and *Standard Bearer*; Barthel Beham's *Peasants of Mögeldorf* (1528); Erhard Schoen's *Company of Mercenaries*; woodcuts of mercenaries by Hans Vogtherr and Niklas Stör; and Hans Weiditz's *Farmer Ulin and His Wife* (1531).

559. Möseneder, Karl. "Blickende Dinge: Anthropomorphes bei Albrecht Dürer." *Pantheon* 44 (1986): 15–23.

["Things that look": Anthropomorphic imagery in the work of Albrecht Dürer.] Summaries in English and French.

560. Mössner, Wolfgang. "Der rechte Tritt im Schritt." *Diversarum artium studia: Beiträge zu Kunstwissenschaft, Kunsttechnologie und*

ihren Randgebieten; Festschrift für Heinz Roosen-Runge zum 70. Geburtstag am 5. Oktober 1982, 117–125. Eds. Helmut Engelhardt and Gerda Kempter. Wiesbaden: Reichert, 1982.

Surveys the depiction of horses and their gaits—especially the walk and the trot—from Antiquity to the late nineteenth century. Focuses on the motif of the false step in Dürer's *Knight, Death, and Devil* and the gait of the bronze horse of San Marco, Venice.

561. Mulazzani, Germano. "Raphael and Venice: Giovanni Bellini, Dürer, and Bosch." *Studies in the History of Art. Raphael before Rome* 17 (1986): 149–153.

In a special issue of the journal published by the National Gallery of Art, Washington, D.C., devoted to the proceedings of the symposium sponsored by the Center for Advanced Study in the Visual Arts (January 6–8, 1983). The author suggests that in 1505 Raphael traveled to northern Italy, and in particular to Venice, to complete his training. In support of this hypothesis he cites motifs from the work of Dürer, Giovanni Bellini, and Hieronymus Bosch in early paintings by Raphael datable between 1505 and 1506, when Dürer was in residence there.

562. Munich, Haus der Kunst. *Pablo Picasso: eine Ausstellung zum hundertsten Geburtstag; Werke aus der Sammlung Marina Picasso*, Ed. Werner Spies, et al. Munich: Prestel Verlag, 1981.

The catalogue of an exhibition of 277 works spanning the years from 1892–1972 from the collection of Picasso's daughter Marina, shown in honor of the centennial of his birth (Munich: February 14-April 20, 1981; also shown in Cologne, Frankfurt am Main, and Zurich). Essays by eight authors. In his introductory essay Werner Spies discusses, among other things, the influence of Dürer, Velasquez, and Hans Baldung Grien on Picasso's work.

563. Munich. Staatliche Graphische Sammlung. *Albrecht Dürer. Druckgraphik*, Exhibition and Text Herbert Wilhelm Rott. Munich: Staatliche Graphische Sammlung, 1998.

Catalogue of the exhibition of a selection of fifty of Dürer's graphics from the Munich print room's own holdings, on view in the Neue Pinakothek from April 3–June 7, 1998 to accompany the exhibition of the artist's paintings from the Bavarian State Collections (q.v.) celebrating the restoration of the Paumgartner Altar and Glimm epitaph. A slender (forty-seven page) paperbound volume

with approximately a dozen illustrations, including a few detailed photographs, its text consists of a general essay characterizing the artist's contributions to the development of engraving, etching, and woodcut, and the role played by the graphic arts in the development of his own career. A brief (eleven page) annotated handlist of the prints follows, giving inventory numbers, collectors' mark, and watermark designations, provenance, and brief paragraphs of text. The prints are arranged in eight categories—Early Engravings (six), Early Woodcuts (three), The Large Passion (four), Proportion and Perspective (three), the Life of Mary (all twenty), the Master Engravings (all three), Etchings (two, plus the plate for the *Agony in the Garden*, on loan from the Staatsbibliothek Bamberg, ex coll. Joseph Heller, q.v.), and Late Works (eight). The most interesting items are the Marienleben, each sheet in proof state and all but one from the same collection, and the iron etching plate, which was discovered in the eighteenth century by the Innsbruck painter/etcher Joseph Schöpf (1745–1822) in the possession of a local blacksmith. It was subsequently owned by the painter Johann Georg Schedler (1777–1866), from whom the Dürer scholar Heller acquired it, published it in his catalogue (vol. 2, part 2, p. 390), before willing it to the Bamberg State Library.

564. Murr, Christophe Gottlieb von. *Description du Cabinet de Monsieur Praun à Nuremberg*, Nuremberg: 1797.

The 512–page collection catalogue, published in French—the language of the Enlightenment—that Murr began compiling in 1778 for Sigmund Christoph Ferdinand Praun. It brought a flood of visitors to the Nuremberg collection, some of whom, like Goethe, were interested in bidding on various items. Not entirely reliable in the modern sense, it does however offer valuable information that the works by the Dürer copyist Hans Hoffmann were acquired directly from the artist. Murr also set the pattern for future collection catalogues to be prepared as sales catalogues. The sale itself was handled by the Nuremberg dealer Johann Friedrich Frauenholz (Vienna, February 1802). (Five of the Dürers were remaindered until the early nineteenth century.)

565. Musper, H. T. "Das Original der *Windischen Bäuerin* von Albrecht Dürer." *Pantheon* 29 (1971): 474ff.

The author claims to have discovered the "original" of Dürer's drawing of a laughing Slovenian woman (1505), declaring the British Museum's famous drawing to be a copy. The argument is unconvincing (see Stechow in *The Art Bulletin* 1974, p. 265, no. 16).

566. Musper, Heinrich Theodor. *Dürers Kaiserbildnisse*, Cologne: M. DuMont Schauberg, 1969.

A brief (sixty-four page) monograph dealing with the relationship between Dürer's two idealized "portraits" in ¾ length of the Holy Roman Emperors Charlemagne and Sigismund (undated; both Nuremberg, Germanisches Nationalmuseum, Anzelewsky, nos. 123–124), and a pair of bust-length paintings of the same two emperors, signed in Dürer's name and dated 1514, then in a private collection in Zurich, which Max Friedländer had discovered at a London dealer's in 1938 and attributed to the artist himself. The author, who dedicated his book to Friedländer's memory, accepts the attribution and reproduces both paintings in good color, together with a photocopy of Friedländer's 1939 letter of attribution and the text of an unpublished article written by Friedländer on his find. The book is of historic interest only, since it was written before the Nuremberg panels were cleaned (1971), and before the publication of Anzelewsky's catalogue of the paintings (two editions, q.v.). It also should be noted that the attribution was made at a time when advancing age and a need for funds in exile are known frequently to have clouded Friedländer's judgment. These, together with a nearly identical pair in the Vienna Museum, now are believed to be posthumous sixteenth-century copies after the heads of the Nuremberg portraits.

567. Münch, Paul. "Changing German perceptions of the historical role of Albrecht Dürer." *Dürer and His Culture*, 181–210. Eds. Dagmer Eichberger and Charles Zika. Cambridge/New York/Melbourne: Cambridge University Press, 1998.

The author is professor of modern European history at the university in Essen. He gives a useful overview of Dürer-reception, from the cult of relics practiced at the time of the artist's own death, to the art politics of the Third Reich and the two Germanies of Dürer Year 1971, concluding with the interesting question, "What will happen now?" Illustrations include rare photographs of Alexander

Kips' tile decoration, *German Industry* (Chicago World's Fair, 1893), which centers around Dürer's 1500 Self Portrait; Hubert Lanzinger's enormous portrait of Adolf Hitler as Dürer's Knight; and, from 1970–1971 Klaus Staeck's parody of the *Praying Hands* secured by a wing-nut, and Walter Schreiber's *Rabbit Hutch*. Draws on secondary literature (q.v.) by Bialostocki; Lüdecke and Heiland; Matthias Mende; Ernst Ullmann; and Hutchison.

568. Nagler, Georg Kaspar. *Albrecht Dürer und seine Kunst*, Munich: Ernst August Fleischmann, 1837.

An early monograph, illustrated with lithographs. The section on the prints is based on Heller's catalogue, with some additional information. 104 engravings: seventeen rejected; 174 woodcuts: 199 rejected; sixty-four additional doubtful and rejected prints. Nagler, better known for his catalogue of artists' monograms, was himself a collector of German graphic art, whose excellent collection went to the Berlin print room.

569. Naples. Museo e Gallerie Nazionali di Capodimonte. *Albrecht Dürer e la grafica Tedesca del '500*, Ed. Alba Castamagna. Mostre e Musei, 4. Naples: 1976.

German prints of the 1500s. (Reviewed by L. Bapi, in *Print Collector/Il conoscitore di stampe* 8/35 (January–February 1977), 52.

570. Neave, Dorinda. "The Witch in Early Sixteenth-century German Art." *Woman's Art Journal* 9, no. 1 (1988): 3–9.

Examines depiction of witches as exclusively female and sinister, using examples by Dürer, Hans Baldung, and Lucas Cranach, arguing that such depictions reinforced the stereotype of woman as evil, popularized by those who hunted and prosecuted witches.

571. Nesselrath, Arnold. "La progettazione della Incoronazione di Carlomagno." *Raffaello a Roma: il convegne del 1983*, 173–181. Rome: Edizioni dell'Elefante, 1986.

[The Planning of *The Coronation of Charlemagne*. From the proceedings of the conference sponsored by the Vatican Museum and the Biblioteca Hertziana, March 21–28, 1983.] Suggests that the general schema of the composition of Raphael's fresco in the Stanza dell'Incendio was based on two prints by Dürer: *Christ before Pilate* and *Christ before Ananias*.

572. Neubecker, Ottfried. "Heraldik zwischen Waffenpraxis und Wappengraphik. Wappenkunst bei Dürer und zu Dürers Zeit." *Albrecht Dürers Umwelt. Festschrift zum 500. Geburtstag*, 193–219. Eds. Gerhard Hirschmann and Fritz Schnelbögl. Nürnberger Forschungen, 15. Nürnberg: Verein für Geschichte der Stadt Nürnberg,

Coats-of-arms in Dürer's day as they related to contemporary armor and armaments. Distinguishes the concept of heraldry in the Dürerzeit from its origins in the earlier medieval period. Discusses such contemporary patrician coats-of-arms as those done for Johannes Tscherte, the Behaim family, Lorenz Staiber, Johann Stabius and Dürer's own escutcheon; the Pirckheimer arms in Italian fashion; and various engravings and woodcuts incorporating arms, such as *The Coat of Arms of Death*.

573. Neudörffer, Johann. *Nachrichten von dem vornehmsten Künstlern und Werkleuten, so innerhalb hundert Jahren in Nürnberg gelebt haben. 1546, nebst Fortsetzung von Andreas Gulden 1660. Abgedruckt nach einer alten Hs. in d. Campeschen Slg. Nürnberg*, Nuremberg: Friedrich Campe, 1828.

The Nuremberg writing-master's "who's who" of artists and craftsmen active in the city during the previous century (ca. 1446–1546.) Dürer is found on pages 36–38; his father-in-law Hans Frey on pages 29–30.

574. New York. Metropolitan Museum of Art. *Gothic and Renaissance Art in Nuremberg 1300–1550*, Rainer Kahsnitz, et al. Munich: Prestel, 1986.

The catalogue of an exhibition shown in Nuremberg at the Germanisches Nationalmuseum and in New York. Included were objects in all media, the majority from West German museums, churches and private collections, but also loans from Austria, Canada, France, Ireland, Poland, Switzerland, the United Kingdom, and the United States. Beautifully produced, it contains scholarly essays by Alfred Wenderhorst (on Nuremberg's history as an Imperial city); Hermann Maué (on Nuremberg's cityscape and architecture, and on German portrait medals); Rainer Brandl (on the status of artists and/or craftsmen in medieval Nuremberg); Rainer Kahsnitz (on sculpture in all media, and on stained glass); William D. Wixom (on brass work); Kurt Löcher (on Nuremberg panel painting); Rainer Schoch (on printmaking); and Johann

Willers (on Nuremberg armor). [See individual entries as indexed by author.]

575. New York: Metropolitan Museum of Art. *XV-XVI Century Northern Drawings from the Robert Lehman Collection*, George Szabó. New York: Metropolitan Museum of Art, 1978.

 A collection catalogue of the entire holdings (thirty-five) of the Lehman collection in this area, including five Dürers, and the self portrait drawing with pillows on the verso (W.27, 32, 154, 521, 850).

576. Nicholas, Lynn H. *The Rape of Europa. The Fate of Europe's Treasures in the Third Reich and the Second World War*, New York: Alfred A. Knopf, 1994.

 The definitive work on the fate of artworks taken as plunder by German agents during the Third Reich. Discusses, among others, the fate of the *Dresden Altarpiece* (365); *Four Apostles* (Holy Men), (123); *Head of Christ* (366); *Irises* (366); the Lubomirski Collection (429–431); *St. Onophrius* (366); *Saints* (392); *Self Portrait* (1493, Paris, p. 121); (1498, Madrid, p. 52). Thoroughly researched and well documented.

577. Niero, Antonio. "Ancora sull' origine del Rosario a Venezia e sulla sua iconographia." *Rivista di storia della chiesa in Italia* 28 (1974): 474ff.

 First publication of the fact that a Rosary Brotherhood had been founded in Venice in 1504 in the church of St. Bartolommeo— shortly prior to the commission for Dürer's Rosary Altarpiece. This opens the question whether the altarpiece might have been commissioned by this brotherhood "della Madonna della zoia restata"—a fact that would certainly explain why the artist never mentioned his client by name, but always referred to this altarpiece as "the German picture."

578. Notre Dame (IN): University of Notre Dame, Medieval Institute. *Renaissance Drawings from the Ambrosiana*, Ed. Robert Randolph Coleman. South Bend, IN: University of Notre Dame, 1984.

 Exhibition of drawings from the Biblioteca Ambrosiana, Milan, including eleven Dürers. Contributions by Giulio Bora, Diane DeGrazia, Bert W. Meijer, and Alessandro Nova. Sponsored by the Kress Foundation.

579. Nuremberg: Museen der Stadt Nürnberg. Dürerhaus. *Das Dürer Stammbuch von 1828,* Matthias Mende. Nuremberg: Hans Carl, 1973.

A reconstruction of the collection of art works assembled in Nuremberg in the Imperial fortress in 1828 to honor the three hundredth anniversary of the artist's death. Albert Reindel, Director of the Nuremberg *Kunstschul* at the time, conceived the idea and issued a printed invitation in the November 20, 1828 issue of *Kunstblatt,* urging all German artists who "wished to honor the German people" to send examples of their work to Nuremberg for the occasion. A printmaker himself, he had naturally expected to receive prints and drawings that could be stored in an album, but also received oil paintings, silver medals, and a plaster bust of Dürer. (The choice of the Kaiserburg was politically motivated, as the old Imperial fortress was useless after the city lost its independence as an imperial "free city" with its annexation to the Kingdom of Bavaria in 1806.) The collection was later displayed in the Landauer Chapel (1840–1853). Other than the three or four reproductive prints after paintings by Dürer, the works submitted bore little relation to his art, but are of historic interest. Artists participating included Caspar David Friedrich, Johann Christian Clausen Dahl, Johann Gottfried Schadow, Karl Friedrich Schinkel, Schnorr von Carolsfeld, and others.

580. Nuremberg: Germanisches Nationalmuseum. *Die Gemälde des 16. Jahrhunderts,* Kurt Löcher, and Carola Griess. Stuttgart: Gerd Hatje, 1997.

The huge, beautifully produced new collection catalogue of the sixteenth century paintings, including works by Dürer, Baldung, Schäufelein, Pencz, Wolgemut, Jacopo de'Barbari, and others in Dürer's circle of friends, rivals, acquaintances, and imitators. Excellent color; scholarly apparatus and bibliography. The Dürer paintings featured include the *Charlemagne* and *Sigismund*; the 1519 portraits of Wolgemut and Maximilian; a 1613 copy after the portraits of the Paumgärtner brothers with a two-panel Annunciation; a painted copy of the *Madonna with the Monkey,* approximately 1580; a Holy Family (variation on B.99), also approximately 1580.

581. Nuremberg: Albrecht Dürer Gesellschaft. *Albrecht Dürer zu ehren,* Nuremberg: Albrecht Dürer Gesellschaft, 1971.

Catalogue of an invitational exhibition in Nuremberg in Dürer Year 1971, assembled by the oldest German art association and held in the Germanisches Nationalmuseum, beginning on May 23. Fifty-nine artists submitted work, including Josef Albers, Fernando Botero, Salvador Dali, Otto Dix, HAP Grieshaber, Marino Marini, André Masson, Pablo Picasso, Graham Sutherland, Paul Wunder-lich, and many others. Many submitted work based on themes cre-ated by Dürer (e.g., Adolph Frohner's *Four Witches*, now wearing bras and garter belts). Other work submitted included Botero's chubby versions of three portraits by Dürer; Picasso's *Man with Long Hair*; Walter Schreiber's *Hasenstall* (a high-rise rabbit hutch); and Dieter Kramer's *Melancholie*, who sits on a littered beach beside an R.V. Most of the artists submitted brief written statements about their work and their relationship or first exposure to Dürer's art (many claiming to have discovered it at age thirteen). The exhibition was sponsored, appropriately, by Roland Graf Faber-Castell.

582. Nuremberg. Germanisches Nationalmuseum. *Albrecht Dürer 1471–1971*, Ed. Leonie von Wilckens. Nuremberg: Germanisches Nationalmuseum, 1971.

An essential work. The most important of the many exhibitions arranged in honor of the artist's five hundredth birth anniversary, it includes the most important works in all media, and excellent es-says by major scholars: Hans Kauffmann, on Dürer and his times; Fritz Zink, on his travels; Ludwig Veit, on the family and docu-ments; Peter Strieder on the family portraits, and on the contempo-rary discovery of individuality; Leonie von Wilckens on Nuremberg, Basel, and Strassburg; Wulf Schadendorf on the influ-ence of Schongauer and the Housebook Master; Teresio Pignatti on the Italian experience; Ludwig Veit on Maximiliam and Nurem-berg as an Imperial city; Georg Kauffmann on Humanism; Erika Simon on Dürer and the Antique; and Karl-Adolf Knappe on the Christian subject matter. Other essays deal with the nature studies; the publications; the scientific projects; and the designs for stained glass, metalwork, and other arts.

583. ———. *Aus der Frühzeit der Germanistik. Quellen und Forschun-gen*, Intro. Walther Matthey. 1954.

A small but useful pamphlet with a handlist of books displayed at the Germanisches Nationalmuseum during the 1954 *Deutsche*

Germanistik-Tagung (conference on German literature). The books, all from the museum's own collection of approximately 250,000 volumes, included thirteenth-, fourteenth- and early fifteenth-century manuscripts, as well as incunabula from Dürer's own day—for example, both the Basel and Strassburg editions of the *Narrenschiff*, which Dürer is usually credited with having illustrated, at least in part; and a number of the publications of his humanist friends and/or promoters (Wimpfeling, Celtis, Beatus Rhenanus). There also was a copy of *Die vier Königsreich* by Caspar Sturm, whose portrait Dürer drew in 1521.

584. ———. *Focus Behaim Globus*, Eds. Wolfgang Pühlhorn and Peter Laub. 2 vols. Nuremberg: Verlag des Germanischen Nationalmuseums, December 2, 1992.

The huge, very scholarly catalogue of the exhibition, arranged by Johannes Karl Wilhelm Willers, with essays by various authors, on different aspects of sixteenth-century cartography, geography, and astronomy, as well as a set of essays on Martin Behaim, his globe—made on contract from the Nuremberg City Council—and its relation to contemporary travel and exploration. Of greatest interest here is Willers's essay on the life and work of Dürer's older contemporary Martin Behaim I (pp. 173–188), which offers interesting precedents for Dürer—such as his trips to the fairs in Antwerp and Bergen op Zoom (1484 and 1489), where he bought gall nuts (for making ink). He married a Portuguese woman, the daughter of the governor of the Azores islands of Fayal and Pico, and made several trips to Portugal. The Behaims had been neighbors of Albrecht Dürer the Elder and his family in the neighborhood near the Imperial fortress until 1491. Volume I contains the essays; Volume II the catalogue entries and photographs of the items exhibited, which include armillary spheres, planetaria, navigation instruments, clocks, globes, curiosities, and travel souvenirs. Dürer's map of the heavens is treated at nos. 1.20 and 1.21; his world map in globe form is at no. 2.28. A late sixteenth-century/early seventeenth-century rhinceros in the form of a collage made of shells, after Dürer's woodcut, is cat. no. 5,31.

585. Nuremberg. Germanisches Nationalmuseum. *Kunst des Sammelns. Das Praunsche Kabinett. Meisterwerke von Dürer bis Carracci*, Ed. Katrin Achilles-Syndram. Nuremberg: Verlag des Germanischen Nationalmuseums, 1994.

This important exhibition and scholarly catalogue recreates, insofar as possible, the famous Nuremberg collection of the Praun family, begun by Hans I Praun (1432–1492) as it existed in the days of his great-grandson Paul II Praun (d. 1616), when it was a famous tourist attraction in his home on the Weinmarkt. Hans I was the contemporary of Albrecht Dürer the Elder; his nephew Stephan II (1513–1578), the father of Paul II, continued the collection. The family were important merchants on the international scene, with opportunities to collect in Bologna, where Paul II spent most of his life, and in the Netherlands as well as in Germany. The collection contained a full set of Dürer's graphic art as well as his portrait of Michael Wolgemut and a number of his drawings, including the portrait sketch of Kaspar Nützel (1517: Munich, previously identified as both Jacob Fugger [Murr] and Konrad Peutinger [Winkler]. The identification as Nützel was made by Mende [1982, q.v.]). Important essays on collecting in Nuremberg by Peter Fleischmann, Rainer Schoch, Katrin Achilles-Syndram and Teresz Gerszi (q.v.).

586. Nuremberg, Germanisches Nationalmuseum. *Meister um Albrecht Dürer*, Peter Strieder, et al. Anzeiger des Germanischen National-Museum, 1961.

The catalogue of an exhibition devoted to works of art in all media produced under the immediate influence of Dürer. Introductory essays on the Dürer workshop and "school" (Ludwig Grote); Masters "around" Dürer—Hans von Kulmbach, Hans Baldung, Hans Schäufelein, Hans Dürer, Wolf Traut, Hans Leu, the Beham brothers, Jörg Pencz, Hans Springinklee, et al. Entries on painting and book illumination by Strieder; on glass painting, Gottfried Frenzel; on drawing, Herwarth Röttgen; on single-heet woodcut, Fritz Zink; on woodcut book illustration, Stephan Waetzoldt. Herwarth Röttgen was the bibliographer, and Leonie von Wilckens the copy editor.

587. Nuremberg. Germanisches Nationalmuseum. *Vorbild Dürer: Kupferstiche und Holzschnitte Albrecht Dürers im Spiegel der Europäischen Druckgraphik des 16. Jahrhunderts*, Nuremberg: Germanisches Nationalmuseum, 1978.

An exhibition of 223 works detailing the influence of Dürer's engravings and woodcuts on the work of other European printmakers of the sixteenth century. (Reviewed by Peter-Klaus Schuster in *Kunstchronik* 31/12 [Dec. 1978] 465.

588. Nuremberg. Norishalle. *Gold und Silber. Schmuck und Gerät von Albrecht Dürer bis zur Gegenwart,* unpaginated. Ed. Curt Heigl. Nuremberg: Stadt Nürnberg /Landesgewerbeanstalt Bayern, 19 March 1922.

 An international loan exhibition of gold and silver jewelry, tableware, and other work from German, Swiss, Czech, Austrian, Scandinavian, French and British collections. Included were objects made from designs by Dürer by goldsmiths (e.g., Ludwig Krug), together with Dürer's own silverpoint portrait at the age of thirteen (Albertina) and a set of his drawings for six double-pokals (Dresden, Landesbibliothek). The catalogue contains a number of essays by various authors, the most important of which for Dürer studies is that by Judith Koós, "Dürer und Ungarn," which reviews the theories of Lajos Haán and Zoltan Takács Felvinczi regarding the origins of the Dürer family name and crest, and calling attention to Edith Hoffmann's bibliography of 1928 (*Dürer Literatur in Ungarn 1800 bis 1922,* published by the Royal Hungarian Ministry for Culture and Education, Budapest, 1928).

589. Nuremberg. Stadtarchiv, Ed. *Nürnberger Urkundenbuch,* Quellen und Forschungen der Stadt Nürnberg, 1. Nuremberg: Stadtrat, 1959.

 Transcriptions of the documentary record of Nuremberg deeds, court, and council proceedings.

590. Nuremberg, Stadtgeschichtliche Museen. *Werke Dürers auf Briefmarken der Welt,* Karl Heinz Schreyl, and Helmut Thiel. Nuremberg: Stadtgeschichtliche Museen, 1979.

 An exhibition of postage stamps from around the world that feature Dürer's works.

591. Oberhuber, Konrad. "Charles Loeser as a Collector of Drawings." *Apollo* 107, no. June (1978): 464–469.

 Brief biography of Charles Loeser (1864–1928), one of the benefactors of Harvard's Fogg Museum, a connoisseur in the tradition of Morelli who lived and collected in Florence. Most of the drawings in his collection, which he viewed as his "libro di disegni," were Italian; however, his collection also included Dürer's *Nude Man in Front and Side Elevations,* (ca. 1523; Panofsky 1624a), a study copied from the Dresden Sketchbook in preparation for its use as Figure "A" on folio Avi of the *Four Books of Human Proportion.*

592. ———. "The Drawings of Dürer and Raphael." *Drawing* 7, no. 2 (July-August) (1985): 25–29.

An essay excerpted from a lecture given at the Pierpont Morgan Library, New York, on May 1, 1985, making detailed comparisons between drawings by the two artists showing how differently they drew, how differently they conceived of drawing, and how essentially different were their outlooks as artists.

593. ———. "Sur quelques dessins germaniques." *Connaissance des Arts* 376 (1983): 76.

Accepts the watercolor study of the *Left Wing of a Blue Roller* (Woodner Collection) as a genuine Dürer from the 1520s. (But see also Koreny, 1985, no. 25, who accepts Thausing's attribution to the Dürer copyist, Hans Hoffmann)

594. ———. *The Works of Marcantonio Raimondi and of His School*, 2 vols. The Illustrated Bartsch, Gen. Ed. Walter L. Strauss, 26–27. New York: Abaris, 1978.

These are the two plate volumes illustrating Volume 14 of the original Bartsch catalogue, *Le peintre-graveur* (Vienna, 1808–1828). There is no commentary beyond the Ed.'s Note in each volume. The selection of Raimondi prints, arranged in Bartsch's original icono- graphic order—biblical subjects first, beginning with Adam—was based on the collections of the British Museum, the Albertina, and the print rooms of the Metropolitan Museum, New York; the Boston Museum of Fine Arts; Berlin, Dresden and Amsterdam. The many copies after Dürer, by both Marcantonio himself and his Venetian follower Agostino Veneziano are found in Volume 27.

595. Oechslin, Werner. "Albrecht Dürer tra storia dell'arte e ideologia (in occasione del cinquecentesimo anniversione dell'artista)." *Paragone* 22, no. 261 (1971): 56–69.

Sharp and amusing criticism of German chauvinism as reflected in Dürer centennials and publications. Pages 63ff. review the history of scholarly and nonscholarly argument about Dürer's relationship to and significance for German Protestantism [Parshall & Par- shall].

596. Oehler, Lisa. "Das Dürermonogramm auf Werken der Dürerzeit." *Städel-Jahrbuch,* n.s. 3 (1971): 79ff.

[Continued in the 1973 issue.] Questions the authenticity of the Dürer monogram on the portrait drawing of *Endres Dürer* (New York, now in the Pierpont Morgan Library), attributing both monogram and drawing to Wolf Huber. The drawing, first published by Panofsky (1963) is not in good condition, but the attribution to Huber was rejected by Talbot, et al. (1971) and Stechow (1974). Her 1973 article discusses the use of Dürer's monogram by some of his former students, as a mark of respect after they had left his workshop (Hans von Kulmbach; Hans Springinklee; Sebald Beham; Hans Baldung). The 1973 article continues to examine Dürer monograms on works of the artist's era. The author, whose 1959 dissertation had dealt only with the early form of the monogram in which the letters are separated rather than superimposed, suggested that this form of the monogram should not be explained as a collector's mark, but instead was probably used by two of the artist's students on their own drawings. This view was criticised by those who found such a practice inconceivable. In the present essay Oehler defends her original position.

597. Olds, Clifton C., Egon Verheyen, and Wayne Tressider. *Dürer's Cities: Nuremberg and Venice*, Ann Arbor: University of Michigan Museum of Art, 1971.

Essays by Olds on Dürer and Nuremberg; by Verheyen on Dürer and Venice; and by Tresidder on Dürer's influence on Venetian art in the early sixteenth century. Graphic art by Dürer, Georg Pencz, Hans Schäufelein, Hans Springinklee, Jacopo de' Barbari, Domenico and Giulio Campagnola, Mantegna, Benedetto Montagna, Antonio Pollaiuolo, Marcantonio Raimondi, and bronzes by Alessandro Leopardi and Andrea Riccio.

598. Olson, Roberta Jean. "Giotto's Portrait of Halley's Comet." *Scientific American* 240, no. 5 (1979): 160–170.

Cites Dürer's *Melencolia I* as reliable depiction of Halley's Comet, in support of theory that Giotto's Star of Bethlehem in the Arena Chapel frescoes depicts a previous appearance of the same comet.

599. Orth, Myra D. "Geofroy Tory et l'enluminure. Deux livres d'heures de la collection Doheny." *Revue de l'Art* 50 (1980): 40–47.

Notes the influence of Dürer on woodcut book illustrations by Geofroy Tory in five books published between 1524/1525 and

1531, and miniatures in a book of hours also in the Doheny collection, concluding that it is highly probable that the miniatures served as the models for Tory's woodcuts.

600. Osten, Gert von der. *Hans Baldung Grien. Gemälde und Dokumente*, Berlin: Deutscher Verlag für Kunstwissenschaft, 1983.

The definitive work on the life, paintings and related drawings of Hans Baldung. Contains a biography, individual catalogue entries on each of the paintings, and drawings, and most valuably of all, an appendix in which each of the documents from the archives of Strassburg and Freiburg is reproduced in full and in chronological order, beginning with his acquisition of Strassburg citizenship in 1509.

601. Oxford: Oxford University, Christ Church. *Catalogue of Drawings by Old Masters at Christ Church, Oxford*, James Byam Shaw. 2 vols. Oxford: Oxford University Press, 1976.

A complete catalogue of one of the collections of 1903 drawings, including those by Dürer, assembled by General John Guise, an old member of the College, in 1765. One of very few early collections of old master drawings that have remained intact in England. (Reviewed by Anthony Blunt in *Apollo*, 104 (Nov. 1976), 417–418; and Christopher White in the *Times Literary Supplement* 3914, March 18, 1977, 320.)

602. Palm, E. W. "Tenochtitlan y la Ciudad ideal de Dürer." *Journal de la Société des Americanistes* new ser. 50 (1951): 59–66.

The influence of Montezuma's capital on Dürer's concept of the ideal (fortified) city with a royal palace at its center as published in the *Befestigungslehre*. The city plan of Tenochtitlan became known in Europe through the woodcut illustration in the 1524 German translation of Hernando Cortés's correspondence regarding the discovery and conquest of Mexico.

603. Panofsky, Erwin. *Dürers Kunsttheorie, vornehmlich in ihrem Verhältnis zur Kunsttheorie der Italiener*, Berlin: 1915.

[Dürer's art theories compared to those current in Italy.] For Panofsky's final thoughts on this, see his *Life and Art of Albrecht Dürer*.

604. ———. *Albrecht Dürer*, 1st ed. 2 vols. Princeton: Princeton University Press, 1943.

From the 3rd edition (1948) on, this indispensable work was published in what the author called a "portable" one-volume edition, minus the handlist of works that the original edition features. This was the first major monograph on the artist in English (although there had been earlier biographies, based on the research of Moriz Thausing, that did not go deeply into the subject matter of the artist's works). Panofsky, the product of a Kantian education in Germany and a long association with the Warburg Institute in Hamburg, brought new erudition to bear on such matters as the artist's use of mythological themes and of classical proportions— issues that had been rather pointedly ignored by his more *volkisch* predecessors in Germany.

605. ———. "Dürers Stellung zur Antike." *Wiener Jahrbuch für Kunstgeschichte* 1 (XV) (1922): 43–92, 126.

An early article on the works from the late 1490s based on classical themes, a topic which would form a major part of the author's 1943 monograph (q.v.), and one in which he had become immersed at the Warburg Institute.

606. ———. "Perspektiv als symbolische Form." *Vorträge der Bibliothek Warburg*, 258–330. Leipzig/Berlin: 1927.

Reprinted in *Aufsätze zu Grundfragen der Kunstwissenschaft*, Berlin, 1964, 99–167.

607. ———. "An Unpublished Portrait Drawing by Albrecht Dürer." *Master Drawings* 1 (1963): 35–41.

Accepts the charcoal portrait drawing (now Pierpont Morgan Library, 324 × 262 mm.), which has a false Dürer monogram, as the work of Albrecht Dürer, and the sitter as his brother Endres, although an annotation on the mat calls the drawing a portrait of the younger of the artist's two surviving brothers, Hans. The identification (previously made by Felice Stampfle [1955, p. 11]) is based on a comparison with the silverpoint drawing dated 1514 (Vienna, Albertina, W.558), which bears an inscription in Dürer's hand explaining that he had made the drawing of Endres on the sitter's thirtieth birthday.

608. ———. "*Virgo et Victrix*: A Note on Dürer's *Nemesis*." *Prints* 1 (1962): 13–38.

Points out that the theme of *The Large Fortune* comes from Poliziano's *Manto* and Pomponius Laetus's *Handbook of Roman History*, information that was not included in the original edition of the Dürer monograph (1943).

609. Paris: Bibliothèque Nationale. *Albrecht Dürer*, Paris: Bibliothèque Nationale, 1971.

This exhibition mounted for Dürer Year 1971 included the Bibliothèque Nationale's own print holdings plus a small loan of drawings.

610. Paris: Centre Culturel du Marais. *Albrecht Dürer 1471–1528: gravures, dessins*, Jacqueline Guillaud, Maurice Guillaud, and Hans Mielke. 2 vols. Paris: Centre Culturel du Marais, 1978.

Catalogue of an exhibition of 150 works (136 prints; fourteen drawings), organized in honor of the 450th anniversary of Dürer's death. A separate portfolio contains fifteen sheets of reproductions of all the drawings and one of the prints.

611. Parma: Fondazione Magnani Rocca, Mamiano de Traversetolo. *Albrecht Dürer. Temi e Techniche*. Simona Tosini Pizzetti, and Giovanna Dellana. Trento: Improvvisazione Prima, 1996.

Dürer's themes and techniques, 216 page exhibition catalogue.

612. Parshall, Linda, and Peter Parshall, Eds. *Art and the Reformation: An Annotated Bibliography*, Reference Publications in Art History, Craig Harbison, Art of Northern Europe. Boston: G. K. Hall, 1986.

A most useful source for readings on artists involved in the Reformation, including Dürer, compiled after the major publications of the Martin Luther anniversary year (1983) had appeared. Indexes standard reference sources, literature on individual Reformers, both Protestant and Catholic; contemporary accounts of the Iconoclasm; art of the period in western Europe; text illustrations and printed propaganda; religious iconography; individual artists; architecture and furnishing; decorative and minor arts. The majority of references to Dürer are found on pages 179–197. Also indexed are his students Hans Baldung, the Beham brothers, Hans Leu, and many contemporaries including the Cranachs and Grunewald.

613. Parshall, Peter W. "Albrecht Dürer's *St. Jerome in His Study*: A Philological Reference." *The Art Bulletin* 53 (September 1971): 303–305.

Offers a convincing explanation of the gourd hanging from the ceiling in Dürer's master engraving of 1514, which he identifies as a variety of the Latin genus *Cucurbita*, depicted in a woodcut illustration for Johannes de Cuba's *Hortus Sanitatis* (1485: Mainz, Peter Schöffer.) The author sees it, not simply as a symbol of transience as Reuterswärd had done (1967)—although transience is of importance in the biblical tale of Jonah, who reclined under such a vine—but as a veiled allusion to St. Jerome's activity as a text critic in his translation of the Hebrew story of Jonah into the Latin of the Vulgate. Rejecting the older Latin translation of the Hebrew word *ciceion* (castor-oil plant) as "cucurbita," and not knowing a Latin or Greek word for this plant, he substituted "hedera" (a type of ivy), which provoked an exchange of letters between Sts. Augustine and Jerome. Erasmus, who was then editing a complete edition of St. Jerome's works, and who was in correspondence with Dürer's friend Willibald Pirckheimer, would have been well aware of this refinement.

614. ———. "Albrecht Dürer and the Axis of Meaning." *Allen Memorial Art Museum Bulletin. Oberlin College* 50, no. 1 (1997): 4–31.

Explores what the author calls "the phenomenon of pictorial ambidextrousness " in Dürer's graphic art—that is, the artist's ability to compensate for the reversal of images in the printmaking process. Prints touched on include the *Fall of Man*; the three *Meisterstiche*; the *Witches' Sabbath*; and the *Prodigal Son* with its preparatory drawing. Also treats a few drawings—marginalia from the *Prayerbook of Maximilian*; the study sheet with *Nine St. Christophers*; the Bremen *Naked Couple with a Demon* (lost World War II); the Rennes *Angels' Mass*, and the Weimar *Nude Self Portrait*.

615. ———. "Camerarius on Dürer: Renaissance Biography as Art Criticism." *Joachim Camerarius (1500–1574)*, 11–29. Ed. Frank Baron. Beiträge zur Geschichte des Humanismus im Zeitalter der Reformation, Munich: 1978.

An analysis of Camerarius's brief biography of the artist, published in the Introduction to his Latin translation of the *Four Books of Human Proportion* (1532), in which he comments on the artist's own elegantly proportioned body, Grecian nose, and high moral character, as well as his interest in science and mathematics; royal patrons; sojourn in Venice and contact with Giovanni Bellini and

Mantegna; and superior ability to recreate the effects of Nature—particularly in portraiture; and, very importantly, his superiority to other contemporary and more "colorful" German painters (prominent among whom must have been Lucas Cranach). Camerarius (1500–1574: Joachim Kammermeister of Bamberg), Dürer's much younger contemporary, was one of the most important philologists of the Reformation era who became, on the recommendation of Melanchton, the new Director of Nuremberg's reformed Gymnasium in 1526.

616. ———. "The Print Collection of Ferdinand, Archduke of Tyrol." *Jahrbuch der Kunsthistorischen Sammlungen in Wien* 78 (1982): 139–184.

The collection of the Archduke Ferdinand (d. 1595: Vienna, Kunsthistorisches Museum) is one of only two substantial sixteenth-century collections that have survived more or less intact (the other was assembled by Philip II of Spain.) Parshall surveys early practices in print collecting, noting (pp. 140–141) that Nuremberg remained a center of print collecting throughout the sixteenth century—one of the most notable collections being that of Willibald Imhoff the Elder (d. 1580), the grandson of Pirckheimer, who had inherited not only through his mother (Felicitas Pirckheimer) but had made purchases from Endres Dürer's widow of some 130 works, received as late as the year before his own death. Imhoff owned twenty-nine albums of prints, most of them by Dürer—probably almost a complete set, as well as a number of drawings. Records suggest that he attached importance to autograph status (original as opposed to copy), as well as to impression quality and financial value, and seems at one time to have envisioned using the collection as the nucleus of an art dealership—attempting to corner the market on Dürers at a time when the artist's work was fast becoming increasingly rare and expensive. Another Nuremberg collector discussed here is Dr. Melchior Ayrer (d. 1570). The Basel collector Johannes Amerbach and his son Bonifacius; the Elector of Saxony in Dresden (who acquired many of his Dürers from Endres Cranach); and Wilhelm V of Bavaria (who purchased prints from Philipp Fugger) also are discussed, as are the Nuremberg collectors Paul Praun and Paul Beheim. Compared to the most avid patrician collectors, Ferdinand of Tyrol was a second-rater who received his

album of Dürers as a gift from Count Reinhard Solms (who may have gotten it from Dürer's former student Hans Döring).

617. Passamani, Bruno. *Albrecht Dürer e l'incisione tedesca dei Secoli XV e XVI*, Bassano del Grappa: Museo Civico, 1971.

 One of Italy's most important collections of Northern prints in general, and of Dürers in particular, is that in the municipal museum of Bassano del Grappa. This was Bassano's catalogue of the Dürer Year exhibition, which featured the museum's Dürers in a setting of other German fifteenth- and sixteenth-century prints.

618. Passavant, Günter. "Reflexe nordischer Graphik bei Raffael, Leonardo, Giulio Romano und Michelangelo." *Mitteilungen des Kunsthistorischen Institutes in Florenz* 22, no. 2 (1983): 193–222.

 Discusses Raphael's preparatory drawings (Oxford, Ashmolean) for the *Madonna and Child with a Book* (Pasadena, Norton Simon Museum), and his preparatory drawing (Stockholm) for the *Coronation of the Virgin* (Vatican) in relation to early prints by Dürer, and traces the dragon and monster in Raphael's *St. Michael and the Dragon* (Louvre) to similar motifs in Dürer's *Apocalypse* woodcuts [Author: RILA].

619. Passavant, Johann David. *Le Peintre-Graveur contenant l'histoire de la gravure sur bois, sur métal et au burin jusque vers la fin du 16. siècle. . . .* , 144–227. Reprint ed. Burt Franklin Bibliography Reference Series: Art History and Art, 12. New York: Burt Franklin, [1st edition 1862].

 Passavant, who had been a member of the Nazarenes, left his personal print collection—which is of excellent quality—to the Städelsches Kunstinstitut, Frankfurt. His Dürer catalogue is based on those of Bartsch and Heller, with additional observations (pp. 158–end). He adds two engravings and more than forty-eight woodcuts; 128 rejected prints; one doubtful print. States are described, and measurements given in premetric pouces and lignes.

620. Patty, James. S. "Baudelaire and Dürer: Avatars of Melancholia." *Symposium* 38, no. Fall (1984): 244–257.

 Deals with the influence of Dürer's *Melencolia I* on Baudelaire's *Fleurs du mal*.

621. ——— *Dürer in French Letters*, Paris/Geneva: Champion-Slatkine, 1989.

Treats Dürer's reputation in French literature ("French letters" was certainly an unfortunate choice of title in light of its risqué meaning in British English!) Essentially, this is a large collection of quotations arranged in chronological order. In a brief first chapter the author deals with the three centuries of so-called obscure fame, from the first mention of Dürer's name by Jean Pèlerin (*De artificiali perspectiva*, Toul, 1521) and Geofrey Tory (*Champ fleury*, Paris, 1529) through the early years of the nineteenth century, when the artist's reputation as theoretician outdistanced his fame as painter or printmaker, until his rediscovery as the returning Napoleonic armies arrived with loot from Prussia, Italy, and Austria. Chapters 2 and 3 deal with the rediscovery and reevaluation of his art, both in Romantic Germany and in France's Musée Napoleon. Subsequent chapters deal with Dürer's image as man and writer (Jules Janin, Charles Blanc, Duchaine ainé, Dumesnil); various nineteenth-century attempts to label, classify, or categorize the artist (Mme. de Stael, Alfred Michiels, Renouvier et al.); art critics 1800–1830 and their judgments of Dürer's work in comparison to Italian or Dutch art of the same period; Dürer and the poets (Victor Hugo, Theophile Gautier, Gérard de Nerval, Alfred de Musset are stressed). A final and useful summary places the manipulation of Dürer in the context of traditional French preference for Greek sculpture and Italian painting, and his "afterlife" among the Symbolists, Decadents, and Naturalists. Admirably documented, and with a generous bibliography (pp. 304–336).

622. Pechstein, Klaus. "Bemerkungen zu Erasmus Hornick in Nürnberg." *Anzeiger des Germanischen Nationalmuseums* (1979): 116–120.

The article deals with Erasmus Hornick's purchase in 1559 of the copy of Francesco Colonna's *Hypnorotomachia Poliphili* (Venice, Aldus Manutius, 1499) previously owned by Dürer, which the artist presumably purchased on his second trip to Italy (1505–1507). While in Nuremberg, Hornick also made three sets of ornamental engravings, which are discussed here.

623. Peltzer, Alfred. *Albrecht Dürer und Friedrich II. von der Pfalz*, Studien zu deutschen Kunstgeschichte, 61. Strassburg: Heitz & Mundel, 1905.

Explores Dürer's patronage from Friedrich II of the Palatinate (1482–1556). The artist is known to have provided the silverpoint profile portrait of Friedrich (London, British Museum; Winkler 903) used to strike the silver gulden issued in 1523 that are represented in the state coin collections of Munich and Vienna. Dürer apparently drew Friedrich's likeness when the latter presided over the 1522–1523 meetings of the Imperial Tribunal in Nuremberg. Peltzer also called attention to an entry in the 1685 inventory of Heidelberg Castle listing a youthful portrait of Friedrich, on panel, attributed to Dürer, and sought to identify this lost work with a portrait of a young man in the collection of the Archduke of Hesse-Darmstadt.

624. Perrig, Alexander. *Albrecht Dürer oder die Heimlichkeit der deutschen Ketzerei. Die Apokalypse Dürers und andere Werke von 1495 bis 1513.*, Weinheim: VCH Verlagsgesellschaft, 1987.

Reviews Dürer's position vis-à-vis Luther, Melanchthon, and Erasmus, and the historicopolitical context of the writings of Thausing (1876), Dvořák (1923), Waetzoldt (1935), Heydenreich (1939), Chadabra (1969), and Grote (1970) on the artist's religious beliefs, siding more or less with Waetzoldt. Perrig sees the word "heimlich" (secret) in the title of the Apocalypse series as key, and finds hidden criticisms of the fifteenth-century papacy, and the *Apocalypse* series—which he considers the artist's most important—as a true harbinger of the Reformation. Also contains essays on the *Monstrous Sow of Landser* (pp. 36–38); *Hercules and the Molionides* (pp. 38–43); the *Martyrdom of the Ten Thousand* (pp. 48–54); the *Mass of St. Gregory* woodcut (pp. 54–59); and the *Fugger Epitaph* designs (pp. 59–71). Abundant and useful footnotes and bibliography.

625. Perrot, Françoise. "Les verriers et l'estampe." *Le stampe e la diffusione delle immagini e degli stili*, 31–37. Ed. Henri Zerner. International Congress of the History of Art, 24. Bologna: CLUEB, 1983.

Discusses prints as sources for stained glass, analyzing the way in which the designer of the cartoon—often the glass painter himself—uses the print, what he retains or rejects, and why; the contribution of prints to the renewal of iconographic schemes, and prints as vehicles of style. In particular dscusses the *Assumption of the Virgin* commissioned approximately 1520 by Margaret of Austria

from an unknown glazier for the church of Brou (Bourg-en-Bresse) and inspired by Dürer's woodcut, and the Trinity window, approximately1520, at Saint-Saulge in the Nievre, based on Dürer's woodcut of the same subject.

626. Perusini, Teresa. "Il flügelaltar della Pieve di Santa Maria a Pontebba e la Donauschule." *Arte in Friuli–Arte a Trieste* 5–6 (1981): 105–115.

Study of an altarpiece with moveable wings and a carved center in the church of S. Maria Maggiore at Pontebba. The center is a *Coronation of the Virgin* by the early sixteenth-century woodcarvers of the Villach workshop that produced many altarpieces in Styria and Kärnten in the style of the fifteenth-century Pacher studio. As in many such altars of this period, there is no stylistic relationship between the carved and the painted portions, for the wings, which depict scenes from the life of the Virgin, are painted in a more modern style showing direct knowledge of contemporary German art by Dürer, the elder Cranach, and Altdorfer.

627. Pfaff, Annette. *Studien zu Albrecht Dürers Heller Altar*, Nürnberger Werkstücke zur Stadt- und Landesgeschichte, 7. Nuremberg: Schriftenreihe des Stadtarchivs, 1971.

The published version of the author's dissertation on the altarpiece (destroyed) that the artist painted for Jacob Heller of Frankfurt, who presented it to the local Dominican church where he intended to be buried. All documents relating to both the genuine altarpiece—including the artist's famous letters to Heller describing the technique used—and (a unique feature) the documents relating to Jobst Harrich's copy (1613–1614) are reproduced and discussed. Dürer's preparatory drawings (one, in London, hitherto unpublished.) Rejects the idea (accepted by Anzelewsky) of Dürer's participation in the designs for the wings with the martyrdoms of Sts. Catherine and James and the portraits of Heller and his wife; proposes Hans Döring. Also rejects the female saints of the grisaille wings as by Grunewald, giving them to Martin Caldenbach, after designs by Grunewald. (Reviewed by Wolfgang Stechow, *The Art Bulletin* 56 (1974) 263).

628. Pfeiffer, Gerhard. "Albrecht Dürer und Lazarus Spengler." *Festschrift für Max Spindler zum 75. Geburtstag*, 379–400. Eds.

Dieter Albrecht, et al. Munich: C.H. Beck'sche Verlagsbuchhand-
lung, 1969.

Discusses Dürer's attitude toward the Reformation in light of Pirck-
heimer's and Spengler's evolving responses, concluding that Dürer
and Spengler were first attracted to Luther's teachings for Human-
ist reasons, later parting company over the institutionalization of
the reforms in Nuremberg.

629. ———. "Albrecht Dürer's *Four Apostles*: A Memorial Picture
from the Reformation." *The Social History of the Reformation. In
Honor of Harold J. Grimm*, 271–296. Eds. L. P. Buck and J. W.
Zophy. Columbus (OH): Ohio State University Press, 1972.

Pfeiffer had already theorized in 1960 that the painting is a memo-
rial with "portrait character." (G. Pfeiffer; he restates the idea here,
nominating the founders of the Nuremberg Gymnasium as the men
portrayed [Melanchthon, Roting, Camerarius, and H. Baumgart-
ner].) Peter Strieder rejected the theory, publishing the Nuremberg
City Council's account book entry on the painting, together with
the artist's own letter, in the *Festschrift Klaus Lankheit* (Cologne,
M. DuMont, 1973: "Albrecht Dürers *Vier Apostle* om Nürnberger
Rathaus," pp. 151–158). Dürer does term the painting a *Gedächt-
nis*, but clearly means it in the sense of a memento or memorial to
himself and his own art.

630. Pfeiffer, Gerhard et al. *Nürnberg–Geschichte einer europäischen
Stadt*, Munich: 1971.

The standard modern history of Nuremberg.

631. Pfeiffer, Gerhard. "Zur Deutung einer Dürerzeichnung." *Idea.
Jahrbuch der Hamburger Kunsthalle* 3 (1884): 43–47.

The work under discussion is the Kunsthalle's 1519 pen drawing
of a peasant, holding his hat and a whip in one hand, the other hand
held out as if greeting someone of higher status (his knees are bent
slightly). The drawing is inscribed "Daz ust der pawer der dy priff
gert." Pfeiffer explains this in terms of Nuremberg peasant status in
relation to that of landlord, citing a local statute concerning the
Heiliggeistspital.

632. Pfötsch, K. *Die Farbe beim jungen Dürer*. Ph.D. dissertation,
Braunschweig, 1973.

[Color in Dürer's early work.]

633. Philip, Lotte Brand. *Das neu entdeckte Bildnis von Dürers Mutter,* Renaissance Vorträge, 7. Nuremberg: Albrecht-Dürer-Haus-Stiftung, 1981.

The German translation of the author's original 1978/1979 publication in *Simiolus* (q.v.), brought out after her lecture in May 1981 at the Stadtmuseum Fembohaus.

634. ———. "The Portrait Diptych of Dürer's Parents. With research and comment by Fedja Anzelewsky." *Simiolus* 10 (1979): 5–18.

The author makes a case for the identification of a late fifteenth-century panel painting portraying a middle-aged matron in a white headdress (Nuremberg, Germanisches Nationalmuseum since 1925) as the missing half of a portrait diptych representing Dürer's parents, painted about 1490, and therefore a pendant to the early portrait of his father holding a rosary (Florence, Uffizi), which is signed and dated 1490 and bears the combined Dürer-Holper arms on the verso. She theorizes that the portraits were separated at some time between 1588 and 1628, probably in order to sell the father's portrait to Rudolph II. Anzelewsky pointed out that both paintings bear the inventory number "19," which is the number that appears in the inventory of Willibald Imhoff (1573), assigned to a portrait diptych representing Albrecht Dürer the Elder and his wife. The inventories of his heir, Hans Imhoff, show only the portrait of the mother (now no. 13). Philip relates the style of the painting to the methods of the Wolgemut workshop, assigning it to an anonymous older pupil of Wolgemut than Dürer himself.

635. Piccard, Gerhard. *Die Kronenwasserzeichen. Findbuch I,* Stuttgart: Staatliche Archivverwaltung Baden-Württemberg, 1961.

The first of Piccard's volumes treating the watermark of the Crown, one frequently used by Dürer. Piccard's works on German watermarks are critical for the study of Dürer's prints and drawings, since his information is based on the thorough study of dated legal documents in municipal archives, unlike the earlier and more general work of Briquet.

636. ———. *Die Ochsenkopfwasserzeichen. Teil 1–3, Findbuch II, 1–3,* Stuttgart: Staatlichen Archivverwaltung Baden-Würtemberg, 1966.

Piccard's volumes dealing with the various forms of the Bull's Head watermark, a late fifteenth-century paper used by both Dürer and many of his predecessors. Through thorough cataloguing of examples occurring on dated legal documents in municipal archives, he has been able to localize these papers in time and region to an extent never before possible.

637. Piel, Friedrich. *Albrecht Dürer: Aquarelle und Zeichnungen*, Köln: Dumont, 1983.

Basically a picture book reproducing eighty-seven of the watercolors and drawings, many in color. Has a bibliography.

638. Pignatti. Terisio. "The Relationship Between German and Venetian Painting in the late Quattrocento and Early Cinquecento." *Renaissance Venice*, 244–273. Ed. J. R. Hale. London: 1973.

General background covering the period of Dürer's two trips to Italy.

639. Pignatti, Terisio. "Dürer e Lotto." *Lorenzo Lotto: Atti del Convegno Internazionale di studi per il V Centenario della Nascita [Lorenzo Lotto: Proceeding of the International Conference of Studies for the Fifth Centenary of His Birth]*, 93–97. Venice: Stamperia di Venezia, 1981.

Argues that Lotto's early style (1503–1508) was influenced by Dürer, as well as by other German, Flemish, and Ferrarese artists [RILA].

640. ———. "Giorgione e Tiziano." *Tiziano e il Manierismo europeo*, 29–41. Ed. Rudolfo Palluchini. Civiltà Veneziana. Saggi, 24. Florence: Olschki, 1978.

Traces influences on Titian from approximately 1507 (when Dürer was still in Venice), focusing on Giovanni Bellini, Giorgione and Dürer in combination, as seen in the *Flight into Egypt* (St. Petersburg, Hermitage); and compares Giorgione and Titian at the Fondaco dei Tedeschi, 1508.

641. Pilz, Kurt. "Willibald Pirckheimers Kunstsammlung und Bibliothek." *Willibald Pirckheimer 1470–1970. Dokumente, Studien, Perspektiven*, 93–110. Willibald Kuratorium Pirckheimer. Nuremberg: Glock & Lutz, 1970.

Pirckheimer's art collection and library are reconstructed by means of Dürer's letters from Venice; the seventeenth-century inventory of Thomas Howard, Earl of Arundel, who purchased the library; Hans Imhoff's inventory (Pirckheimer's grandson); Pirckheimer's own inventory of 1531 listing the silver objects, Venetian glass, porcelain, majolica, and arms; and the Imhoff family archive.

642. Pilz, Wolfgang. *Das Triptychon als Kompositions- und Erzählform in der deutschen Tafelmalerei von der Anfangen bis zur Dürerzeit.* Ph.D. dissertation, Munich, 1970.

An unpublished dissertation on composition and narrative form in German triptychs, culminating in those of Dürer and his contemporaries.

643. Pingree, David. "A New Look at Melencolia I." *Journal of the Warburg and Courtauld Institutes* 43 (1980): 257–258.

Suggests an interpretation of *Melencolia I* based on astral magic—specifically that of the *Picatrix*, and sees the print as representing three states of being: terrestrial, celestial, and the intermediate in which the material and psychological elements of this world are formed. Accepts W. Heckscher's explanation of the ladder—representing faith—as the means by which the soul ascends to the supercelestial, and the building as the tower of Wisdom.

644. Pirckheimer, Willibald Kuratorium. *Willibald Pirckheimer 1470–1970. Dokumente, Studien, Perspectiven. Anlässlich des 500. Geburtsjahres herausgegeben vom Willibald Pirckheimer-Kuratorium*, Eds. Karl Borromeus Glock and Ingeborg Meidinger-Geise. Nuremberg: Glock & Lutz, 1970.

Part I contains essays on Pirckheimer's life and world: Willehad Paul Eckert ("Erasmus and Willibald Pirckheimer," 11–22); Dietmar Pfister, Hans Max von Aufsess, Hubert von Welser, Christoph von Imhoff, Wolfgang von Stromer, Kurt Pilz ("Willibald Pirckheimer's Kunstsammlung und Bibliothek," 93–110); Pirckheimer's bibliography (edited by Glock). Part II is devoted to selected letters, for example, to his sister Caritas, to Hieronymus Emser; his elegy on Dürer's death (137). Two further sections deal with Pirckheimer's impact on Nuremberg humanism today, and modern essays in his praise. (This is politically a "Green"-oriented publication.)

645. Pirsich, Volker. "Die Dürer—Rezeption in der Literatur des beginnenden 19. Jahrhunderts." *Mitteilungen des Vereins für Geschichte der Stadt Nürnberg* 70 (1983), 304–333.

Dürer's image in Romantic literature.

646. Poensgen, Georg. "Die Begegnung Goethes mit der Sammlung Boisserée in Heidelberg." *Ruperto-Carola. Mitteilungen der Vereinigung der Freunde der Studentenschaft der Universität Heidelberg* 12, no. 27 (1960): 82–110.

Goethe's impression of the Boisserée brothers' collection of early German and Netherlandish religious works rescued from the secularization of Cologne's churches and convents. (For the inventory of this collection, which now forms an important part of the Alte Pinakothek in Munich, see Firmenich-Richartz, 1948.)

647. Poesch, Jesse. "Sources for Two Dürer Engravings." *The Art Bulletin* 46, no. 1 (March) (1964): 78–86.

Interprets Dürer's so-called *Four Witches (Four Naked Women)* as a depiction of the Choice of Paris, utilizing imagery of Venus (wearing a myrtle wreath) and the Three Graces, citing Virgil's *Eclogues* (7, 62) as authority for the association of myrtle with Venus. Also illustrated is Nicoletto da Modena's copy inscribed DETVR PVLCHRIOR 1500 on the fruit overhead, implying that the Italian understood it to be a Judgment of Paris. The author illustrates as precedent for four naked woman a woodcut illustration from Colard Mansion's edition of the *Ovid Moralisé* (Bruges, 1484) and the text by Petrus Berchorius (d. 1362) that accompanies it. In this account, Venus represents the voluptuous life—and is compared to the harlot of Isaiah 23:16—while the three graces, described as nude maidens, are to represent avarice, carnal desire, and infidelity, all of which can be expected to accompany the voluptuous life. The print thus illustrates not the Judgment of Paris, but the result of his choice. Author also discusses the etching, *Abduction on a Unicorn* (1516) as a possible variant of the story of the abduction of the Witch of Berkeley, depicted in the Nuremberg Chronicle.

648. Polak-Trajdos, Ewa. "Ze studiów nad twórczoscig Mistrza Krucyfiksów Siedmiogrodzkich." *Biuletyn Historii Sztuki* 39, no. 1 (1977): 3–18.

[From Studies of the Oeuvre of the Master of Transylvanian Cruci-fixes. Summary in French.] A group of four crucifixes is connected with the style of Veit Stoss, especially that of his stone crucifix for the church of St. Mary, Krakow (1491, and with reminiscences of Dürer's *Crucifixion* woodcut from the *Large Passion* (before 1500). Stoss's sons Johann or Veit the Younger, both born in Krakow, are suggested as identities for the Master, and the works are dated in the first years of the sixteenth century.

649. Polzer, Joseph. "Dürer et Raphaël." *Nouvelles de l'Estampe* 17, no. (September-October) (1974): 15–22.

Deals with the influence of Dürer's woodcut on Raphael's *Way to Calvary* (Madrid, Prado), and on the *Entombment* in the Borghese Gallery, Rome.

650. Préaud, M. "La sorcière de Noël." *L'esoterisme d'Albrecht Dürer*, 47–50. 1977.

The author views Dürer's *Witch Riding Backward on a Goat* in as-trological terms—Saturnalia, the turning of the year, the world up-side down (noting the artist's monogram turned aside), and remarks on the Power of Women topos and the pun on the word *anus* (old woman), and *annus* (year).

651. Price, David. "Albrecht Dürer's Representations of Faith: The Church, Lay Devotion and Veneration in the *Apocalypse*." *Zeit-schrift für Kunstgeschichte* 57, no. 4 (1994): 688–696.

The author is a member of the Department of Germanic Languages at the University of Texas, Austin. He views Dürer's *Apocalypse* series in terms of popular piety ("the lay devotional movement of its age"), although not excluding clerical and monastic piety. He gives a useful overview of the literature, from Thausing and Dvořák, who both saw revolutionary sensibility at work ("a revolu-tionary hymn, directed at Rome," Dvořák, *Kunstgeschichte als Geistesgeschichte*, note 2), to Chadabra (q.v., 1971), who carries it further, seeing an expression of sympathy for Hans Böheim, the tragic "Pfeiffer of Niklashausen," as well as innuendo against Rudolf von Scherenberg, the Bishop of Würzburg, who suppressed the Niklashausen riots in 1476. Gombrich's critical response is cited ("The Evidence of Images," in *Interpretation: Theory and Practice*, Charles Singleton, ed., Baltimore, 1969, p. 92). Alexan-

der Perrig (q.v.) revived the revolutionary notion, but alleged that Dürer was concealing his revolutionary sympathies from the Church, and that he identified the Anti-Christ with the Pope. Price remarks on Dürer's depiction of the common perople in the series as "compassionate," balancing scenes of destruction with "positive portrayals of the . . . dignity of the poor," and on the hierarchy (there are no precedents in earlier woodcute for the "four-and-twenty elders" in Dürer's series). He notes the Angel "signing" the saved, like a priest on Ash Wednesday, and interprets the incident in which St. John devours the Book as his receiving grace conveyed by scripture. He further remarks on the depiction of false veneration (the Whore of Babylon). He also makes sound suggestions for background reading: Bernd Moeller's "Frommigkeit in Deutschland um 1500," in *Archiv für Reformationsgechichte* 56 (1965), 5–31, and Heiko Oberman's "Die Gelehrten die Verkehrten," in *Religion and Culture in the Renaissance and Reformation*, Steven Ozment, ed. Kirksville (MO), 1989.

652. Providence (RI): Rhode Island School of Design. *Europe in Torment 1450–1550. An Exhibition by the Department of Art, Brown University, at the Museum of Art, Rhode Island School of Design*, Preface Stephen E. Ostrow and Stephen K. Scher. 1974.

An exhibition of works in all media dating from 1450–1550 and dealing with the themes of death, apocalypse, Last Judgment, witchcraft, and the occult, in works of art by Dürer, Holbein, Bruegel, and others. Treats the period as one of transition from Medieval to Renaisance and Reformation.

653. Pröll, Franz Xaver. *Die Scheurl von Defersdorf. Aus d. Geschichte einer Nürnberger Patrizierfamilie*, Ausstellungskataloge der Stadtbibliothek Nürnberg, 62. Nuremberg: Stadtbibliothek, 1969.

With a Foreword by Siegfried Freiherr Scheurl von Defersdorf. The catalogue of an exhibition devoted to the history of the family and descendants of Dürer's friend the Nuremberg humanist and jurist, Christoph Scheurl, who included a brief biography of the artist in his *Libellus de laudibus Germaniae et ducum Saxonie* (Leipzig, June 1508; see Rupprich I, pp. 290–92).

654. Publius Terentius Afer. *Andria, oder das Mädchen von Andros*, Translator Felix Mendelssohn-Bartholdy. Verona: 1971.

A modern edition of Felix Mendelssohn's German translation of Terence's *Andria*, with twenty-five illustrations by Dürer and an afterword by Giovanni Mardersteig.

655. Puss, Gunther. "Dürer und die wissenschaftliche Tierdarstellung der Renaissance." *Jahrbuch der Kunsthistorischen Sammlungen in Wien* 82/83 (n.s. vol. XLVI/XLVII) (1986): 57–67.

The author's paper for the Albertina symposium on the nature studies of Dürer and his followers (1985, q.v.). In his discussion of the scientific aspects of Dürer's nature studies, Pass contrasts Leonardo da Vinci's still more scientific approach. He also treats the only one of Dürer's animals—the *Rhinoceros*—which is consistently cited in scientific literature (although it is nearly unique among his works in *not* having been done from nature).

656. Quednau, Rolf. "Raphael und 'alcune stampe di maniera tedesca'." *Zeitschrift für Kunstgeschichte* 46, no. 2 (1983): 129–175.

Focuses on Raphael's use of German prints of the late fifteenth and early sixteenth centuries. Dürer and Raphael exchanged drawings and prints between 1513 and 1515. In this context, discusses Raphael's study of two nude men (Vienna: Albertina) bearing a Dürer autograph from 1515 and adapted from Dürer's woodcut of the *Martyrdom of St. John the Baptist*. Argues that the background of Raphael's *Madonna and Child with a Book* (Pasadena: Norton Simon Museum) derives from Dürer's engraving *The Penitence of St. John Chrysostom*, and also that the backgrounds of the Canigliani *Holy Family* (Munich) and the Colonna Altarpiece (New York, Metropolitan) are based on prints by Dürer. Also examines the role of Dürer's prints as models for Perugino and for North Italian and Florentine artists around 1500.

657. Rasmussen, Jörg. *Die Nürnberger Altarbaukunst der Dürerzeit.* Ph.D. dissertation, Munich, 1970.

This dissertation remains unpublished, but has been very influential in the literature on Dürer's religious commissions (e.g., D. Kutschbach, q.v.). The author discusses the "mass production" of altarpieces in Nuremberg 1488–1491 (twenty-three were made locally). Disproves Panofsky's allegation that German altarpieces having full-standing figures in the wings had carved centers before Dürer. This was certainly not the case in Nuremberg. Chapter 2 per-

tains to Dürer (pp. 13–44), and Chapter 3 to his followers (Hans von Kulmbach's altars for Nuremberg and environs and for Krakow; Wolf Traut's Artelshofen altar). Assumes the Dresden *Sorrows of the Virgin* altarpiece to have been done for Wittenberg's castle church. Notes that the *Paumgartner Altarpiece* was done for the south transept of the Dominican church of St. Katherine (east end), and that the so-called Ober St. Veit altarpiece was made for the same Nuremberg church. Of Dürer's northern clients, only Jakob Landauer gave him the opportunity to do a "taffel," Italian-style: all the rest ordered triptychs. The Rosary Altar for the German church in Venice had been his first full-fledged "taffel," or *pala*, but was wider than the normal Venetian altarpiece. Jakob Heller was not prepared to give the artist a free hand for a total *opus novum*, but Jakob Landauer did, and the artist designed both the picture and its Renaissance frame, complete with "column-hose" (perhaps thinking of the Venetian ones actually upholstered in brocade). The Landauer was his last altarpiece: Caritas Pirckheimer wanted to modernize the altar at St. Clara's convent, and wrote to her brother Willibald about Dürer, but there is no evidence that the commission actually went forward.

658. ———. "Kleinplastik unter Dürers Namen: das New Yorker Rückenakt-Relief." *Städel-Jahrbuch* 9 (1983): 131–144.

Suggests that the relief depicting a female nude seen from the back (Metropolitan Museum), signed "A.D." and dated 1509, was executed by Ludwig Krug after a design by Dürer, and that it may be identical with the "frawenbild" sent by Dürer to Friedrich the Wise in April of that year. (Ludwig Krug, the son of the elder Dürer's collaborator, Hans Krug, was the carver of the Last Judgment relief on the frame of the Landauer Altar two years later.) Discusses Sandrart's contention that Dürer also practiced sculpture (which would have put the artist on a plane with Leonardo and Michelangelo in this respect). Denies any connection between the New York relief and the antique Venus Callipygos in the Farnese collection, which had not yet been discovered.

659. ———. "Zu Dürers unvollendetem Kupferstich *Die grosse Kreuzigung*." *Anzeiger des Germanischen Nationalmuseums* (1981): 56–79.

Deals with the unfinished engraving—one of the artist's largest—executed only in outline (Amsterdam, Rijksmuseum: trial proof).

The author terms the print a *confessio Lutherana*, on the basis of unusual features of the iconography. He notes that it is a "four-nail" Crucifixion, not in accord with the vision of St. Bridgit of Sweden, sees an idealized portrait of Martin Luther in the guise of St. John, and argues that the plate was left unfinished due to Dürer's growing disillusionment with the increasing sectarianism of the Reformation around 1525. Finds it significant that Philipp Melanchthon, rather than Luther, was his model for one of the so-called *Four Apostles*, painted in 1526.

660. Raupp, Hans-Joachim. *Bauernsatiren. Entstehung und Entwicklung des bäuerlichen Genres in der deutschen und niederländischen Kunst ca. 1470–1570*, esp. Ch. 3 (pp. 165–194). Niederzier: Lukassen, 1986.

Gives a brief overview of the development of the imagery of peasants as analyzed by Berthold Haendke (1912: a progress toward realism with Dürer a major turning point); Waetzoldt (1948: a deep gulf between Dürer's peasant imagery and that of his predecessors); Franzsepp Würtenberger (1957: Dürer as the first to introduce peasants as objects of "special observation"); Renate Radbruch (Dürer's graphic art as historic turning point toward realism); Gert von der Osten and Horst Vey (1969: Dürer's peasants as the first "completely objective expression of life and customs"). Also notes the Marxist view of Dürer as a revolutionary. Quotes Dürer himself (*Proportionslehre*, Rupprich III, p. 192) as saying that a talented artist can show more of his power and art in a "rough" picture of a peasant than many others can in their "great" works. Raupp sees the engraving of *The Cook and His Wife* (B.84) as descendants of the lower classes in traditional depictions of the Dance of Death (p. 61); the *Gypsy Family* (B.85) inspired by the Housebook Master. In Chapter 3, Raupp develops the theme of dancing peasants, citing the late medieval disapproval of dancing as "heathen" (cf. the Children of Israel and the golden calf), and quotes Geiler von Kaysersberg's condemnation of throwing one's partner into the air, so that one can see everything "hinden und voren . . . bis in de weich." In this section he treats Dürer's *Dancing Couple* and their *Bagpiper* (1514), as well as the rather decorous marginal drawings of dancing peasants for Maximilian's Prayerbook. Bases his arguments on H. P. Clive, *The Calvinists and the Question of Dancing in the 16th Century* (Bibliothèque

d'Humanisme et de Renaissance, Travaux et Documents, 23), 1961, 296–323.

661. Rearick, W. R. "Lorenzo Lotto: The Drawings, 1500–1525." *Lorenzo Lotto: Atti del Convegno Internazionale di studi per il V Centenario della Nascita* [*Lorenzo Lotto: Proceeding of the International Conference of Studies for the Fifth Centenary of His Birth*], 23–36. Venice: Stamperia di Venezia, 1981.

The author identifies the stylistic origin of the Venetian artist Lorenzo Lotto's early drawings in the conventional chiaroscuro style of Venice, and points to the strong influence of Dürer, who was in residence 1505–1507.

662. Rebel, Ernst. *Albrecht Dürer. Maler und Humanist*, Munich: C. Bertelsmann, 1996.

An excellent new biography, based on Rupprich's publication of the documents and in part on Hutchison (1990). Basically a psychological reading of the artist's life and work, it includes brief discussions of ninety-eight of the works in all media as they occur in chronological order. Has a chronological table, generous and scrupulous documentation, and selected bibliography. Accepts L. Brand Phillip's identification of Nuremberg's early portrait of a woman as the artist's mother, and accepts as authentic both the Nuremberg and London portraits of Albrecht the Elder. Excellent section on Wolgemut and early Nuremberg painting and history of "sworn" versus "free" crafts in Nuremberg (Ch. 4). Accepts Hutchison's hypotheses that the bachelor's journey probably included stops in Bamberg, Mainz, Frankfurt, and perhaps Cologne —but not the Netherlands—prior to the artist's arrival in Colmar, and that Dürer's failure to make a portrait of Martin Luther cannot be taken to mean that the two had never met. Makes the interesting suggestions that the eryngium sprig in the Paris self portrait had primarily a religious significance; and that Koberger may well have been the one who inspired the young artist to make his first trip to Venice. A final section on "Dürer today" includes a brief mention of the Bauhaus and a comparison with Joseph Beuys (1921–1986). Has ninety-eight black-and-white illustrations.

663. ———. *Die Modellierung der Person. Studien zu Dürers Bildnis des Hans Kleeberger*. Stuttgart: Franz Steiner, 1990.

A study of the enigmatic Kleeberger portrait (1526), developed from the author's *Habilitationsschrift (Personenmetaphorik und Personenbegriff im Porträt der Dürerzeit*, Munich, 1988), with a wealth of interesting comparative material. Notes that the unusual Roman Imperial format, highly atypical for German merchants, has caused art historians to treat the painting in "stepmotherly" fashion, if at all. Gives a brief biography of Kleeberger (born Hans Scheuhenpflug, son of a harnessmaker who left town under a cloud of dishonesty). The family had been neighbors of Albrecht Dürer the Elder (1486) in the neighborhood "unter der Vesten." Hans was a self-made man, becoming a financier and taking Bern citizenship, who had financial dealings with the French court. Recounts his marriage to and abandonment of Pirckheimer's daughter,the widowed Felicitas Pirckheimer Imhoff, who died soon afterward (1530), and Pirckheimer's contempt for him ("meer ein Jud da ein Christ . . ."), both as a son-in-law and as a usurer. Dürer's portrait was done before the marriage, when Kleeberger appeared to be a wealthy, up-and-coming young man, and Rebel notes that he commissioned three actual medals in 1526, probably designed by Dürer. Pliny conveys the information that portraits of prominent ancient Romans were done on round shields (the *imago clipeata*), which were displayed on the wall during the sitters' lifetimes.

664. Regina, Saskatoon (CND): University of Regina, Norman McKenzie Art Gallery. *Prints by Rodolphe Bresdin. Gravures de Rodolphe Bresdin*, Michael Parke-Taylor. Regina, Sask.: University of Regina, 1981.

The catalogue of a loan exhibition of Bresdin's prints, shown in Regina October 16–November 22, 1981 and in the Museum of Fine Art, Montreal January 15–February 28, 1982 notes Dürer's influence, as well as Rembrandt's, in the nineteenth-century French artist's technique and presentation.

665. Reinhardt, Hans. "Baldung, Dürer und Holbein." *Zeitschrift für Schweizerische Archäologie und Kunstgeschichte* 35, no. 4 (1978): 206–216.

Basel's Baldung paintings (from both his Freiburg and Strassburg periods); Baldung's influence on the younger Holbein (1517–1519); Dürer's influence on Holbein, especially the architecture of the *Presentation in the Temple*, from the *Marienleben*, on Baldung's *Holy Family* chiaroscuros.

666. Reitzenstein, Alexander von. "Etliche Vnderricht/zu Befestigung der Stett/Schlosz/vnd Flecken." *Albrecht Dürers Umwelt. Festschrift zum 500. Geburtstag*, 178–192. Eds. Gerhard Hirschmann and Fritz Schnelbögl. Nürnberger Forschungen, 15. Nürnberg: Verein für Geschichte der Stadt Nürnberg, 1971.

A discussion of Dürer's *Befestigungslehre* (Treatise on Fortification) and its preliminary drawings and sources, including the artist's 1519 drawing (W.626) of the seige of the fortress of Hohenasperg (Württ.), made during his journey to Switzerland with Pirckheimer in April and May of that year. Treats the previous development of fifteenth-century fortification in response to artillery fire.

667. Retberg, Ralf Leopold von. *Dürers Kupferstiche und Holzschnitte; ein kritisches Verzeichnis*, Munich: Theodor Ackermann, 1871.

Retberg was a retired army officer, who also had written on the Wolfegg Hausbuch. His Dürer volume came out in the year of the victory at Sedan, which also marked the artist's four hundredth birth anniversary. Catalogues 270 prints by the artist, plus seventy-three doubtful and rejected ones. Uses modern measurements (millimeters)—he was apparently the first to do so; describes watermarks and additional states. A supplement was published in [Zahn's] *Jahrbuch für Kunstwissenschaft* 5 (1873), 192.

668. Reuterswärd, Patrik. "The Dog in the Humanist's Study." *Konsthistorisk Tidskrift* 50, no. 2 (1981): 53–69.

Discusses compositions, beginning in the fourteenth century with a depiction of Petrarch at his desk, in which various humanists, including St. Augustine and Tycho Brahe, are shown in their studies accompanied by a dog. Among others, discusses Dürer's St. Jerome. Concludes that the most widely accepted symbolic meaning of the dog seems to have been fidelity and sagacity, although in the case of Carpaccio's St. Augustine (Venice, Scuola di S. Giorgio degli Schiavoni), it symbolized prophecy, in accordance with the hieroglyphics of Horapollo.

669. ———. "Felicitas." *Svenska Dagbladet*, (August 16, 1971): 5.

Suggests that the Stockholm print room's black chalk portrait of a young woman wearing an elaborate headband and a braid may be Felicitas, the daughter of Willibald Pirckheimer, who was eighteen or nineteen years old when she was engaged to be married (which would explain the headdress).

670. ———. "Sinn und Nebensinn bei Dürer. Randbemerkungen zur *Melencolia I.*" *Gestalt und Wirklichkeit, Festgabe für Ferdinand Weinhandl*, 424–429. Ed. R. Muhlher. Berlin: 1967.

In the course of his discussion of *Melencolia I* as a *vanitas* picture, the author identifies the gourd hanging from the ceiling in the *St. Jerome in His Study* as a symbol of transience. He sees a phantom skull on the surface of one prominent facet of the polyhedron. This item has been invisible to most other viewers, including the present writer.

671. Ribeiro, Mário de Sampayo (see Sampayo-Ribeiro).

672. Riccomini, Eugenio. "La Collezione Magnani." *Paragone* 36, no. January–March–May (1985): 320–330.

Comments on the collecting interests of Gino Magnani and on the major paintings in Parma's Fondazione Magnani Rocca, Corte di Mamiano. The collection includes the *Madonna and Child in Front of an Archway* found in a convent near Ravenna that Anzelewsky identified as an early Dürer done in 1494.

673. Riedl, Peter Anselm. *Die Fresken der Gewölbezone des Oratorio della Santissima Trinità in Siena*, Abhandlungen der Heidelberger Akademie der Wissenschaften, Philosophisch-Historische Klasse, Jahrgang 1978, 2. Heidelberg: C. Winter, 1978.

An examination of the Tuscan vault frescoes dating from approximately 1600 depicting the Apocalypse (a new date proposed on the basis of careful analyis of primary documents). Stylistically the sources are Dürer's *Apocalypse* woodcuts, and Bernard Salomon's illustrations (which are themselves based on Dürer).

674. Rix, Martyn. *The Art of the Botanist*, London: Lutterworth Press, 1981.

[Published in the United States as *The Art of the Plant World: The Work of the Great Botanical Illustrators*. Woodstock, Overlook Press, 1980]. Traces the development of botanical knowledge from the sixth century A.D. to the present, including Dürer's contribution.

675. Roberts, Jane. *Master Drawings in the Royal Collection from Leonardo to the Present Day*, London: Collins Harvill.

A collection catalogue for visitors to the Queen's Gallery at Windsor Castle. One Dürer drawing is featured: a gray brush drawing of a greyhound seen in profile, a study for one of the dogs in the *St. Eustace* engraving (B.57) and formerly owned by the British painters, Paul Sandby (Lugt 2112) and Sir Thomas Lawrence (Lugt 2445).

676. Ronen, Avraham. "Il Vasari e gli Incisori del suo Tempo." *Commentari* 28, no. (January–September) (1977): 92–104.

[Vasari and the Engravers of His Time.] Examines, among much else, Vasari's debt to Dürer's *Apocalypse* in his own frescoes of the same subject (commissioned 1539) in the refectory of St. Michele in Bosco, Bologna.

677. Roper, Lyndal. "Tokens of affection: the meanings of love in sixteenth-century Germany." *Dürer and His Culture*, 143–163. Eds. Dagmer Eichberger and Charles Zika. Cambridge/New York/Melbourne: Cambridge University Press, 1998.

The author is Reader in history at Royal Holloway and Bedford New College of the University of London, and has published widely on German social history of the Reformation era, with a specialty in Augsburg. Noting the frequency with which Dürer and his contemporaries depicted themes of "the couple," this essay develops the general context of courtship as a societally controlled institution in the area ecompassing Nuremberg, Augsburg, and Ulm in the artist's time. Included are courtship rituals and gifts; women's rituals; "love magic" as substitute for actual power; love sickness (curable by intercourse); the need of both sexes to acquire the social prestige of marriage. The author adds an important caveat, the "it is not enough to interpret Dürer's couples as conforming to an understanding of men as active and women as passive," but that their individual complexity (both attraction and fear) must be recognized.

678. Rosand, David. "Titian and the Woodcut *alla Veneziana*." *Art News* 75, no. 7 (September) (1976): 56–59.

Published in connection with the exhibition held at the National Gallery, Washington (October 30, 1976–January 2, 1977) by Rosand, who coauthored the exhibition's catalogue with Michelan-

gelo Muraro. Discusses Titian's role in the creation of "a new kind of graphic language, a bold and pictorial Venetian equivalent to the xylographic art of Dürer."

679. Rosasco, Betsy. "Albrecht Dürer's *Death of Orpheus*: Its Critical Fortunes and a New Interpretation of Its Meaning." *IDEA. Jahrbuch der Hamburger Kunsthalle* 3 (1984): 19–42.

Panofsky saw this drawing as a pivotal one—Dürer no longer repeating Mantegna line for line, but now able to compose in Renaissance style. Sandrart, an early owner of the drawing (by 1669), called it "Dürers Kunst Probe." Subsequent literature by Ephrussi, Thausing, Wölfflin, and Pauli all analyzed the drawing in relation to the anonymous North Italian engraving of the same subject. Edgar Wind ("Hercules and Orpheus: Two Mock-Heroic Designs by Dürer," *Journal of the Warburg and Courtauld Institutes*, 1939) saw satiric references to Poliziano's *Festa d'Orfeo*, which ends with this scene, and to the Orphic movement in Florence. Panofsky blanked out on this, failing to apply his iconographic method and falling back on stylistic analysis—and his was the prevailing approach until at least 1972 (Lankoronska). Peter-Klaus Schuster (1978, q.v.) read the Orpheus as a self portrait—a meditation on the fate of the artist. Anzelewsky saw a lost Mantegna as prototype for both the Italian engraving and Dürer's drawing. Rosasco briefly notes the provenance of the drawing, from the collection of Melchior Ayrer (1520–1570) to the present, and cites Ovid (*Metamorphoses*. X, 83–85; XI, 1ff.) on Orpheus as a homosexual poet; and a reference in Landricci to measures to be taken in Florence against homosexuals (December 1494)—all recommended by Savonarola. First-time offenders were to be made to stand in public wearing a sign announcing their crime, second offenders were to be tied to a column, and third-time offenders burned at the stake. Earlier Florentine law (1432) had been more lenient—only after the fifth offense would the homosexual be executed. Rosasco accepts Rupprich's (1930) hypothesis that Dürer and Pirckheimer were together in Venice in 1494/1495.

680. Rosenberg, Charles M. "The Influence of Northern Graphics on Painting in Renaissance Ferrara: Matteo da Milano." *Musei Ferraresi: Bolletino Annuale* 15 (1985): 61–74.

Discusses visual quotations, especially from Dürer, in the Breviary of Ercole d'Este (Modena, Biblioteca Estense, V.G. 11, lat. 424; four illuminations in the Strossmayer Gallery, Zagreb).

681. Rosenfeld, Hellmut. "Sebastian Brant and Albrecht Dürer. Zum Verhältnis von Bild und Text im *Narrenschiff*." *Gutenberg Jahrbuch* (1972): 328–336.

Karl Friedrich von Rumohr (1837) was the first to suggest young Dürer's involvement in the designing of the woodcut illustrations for Sebastian Brant's *Ship of Fools* (Basel, 1494). Weisbach (1896) proposed an anonymous "Meister der Bergmannschen Offizin." Since Winkler (1951), majority opinion has given the illustrations back to Dürer.

682. Rosenfeld, Myra Nan. "Sebastiano Serlio's Drawings in the Nationalbibliothek in Vienna for His *Seventh Book on Architecture*." *The Art Bulletin* 56, no. 3 (September) (1974): 400–409.

[First presented as a lecture at the National Gallery of Canada (Ottawa) on March 2, 1973, it was based on research funded by the Canada Council and the Graduate Faculties of McGill University.] The body of this article concerns Serlio's *Book Seven* (Frankfurt, Jacopo Strada, 1575). Of interest here, however, is her discovery that Dürer's *Befestigung der Stett, Schloss und Flecken* (Nuremberg, 1527) was the inspiration for the first of Serlio's volumes (*Book IV: On the Five Roman Orders*, Venice, 1537) published ten years later. Serlio adapted the organization of Dürer's fortified city in his illustrated version of Polybius' *Book on Military Camps* (Munich, Bayerische Staatsbibliothek, Codex Icon 190). Dürer's was the first treatise on architecture to be published with illustrations.

683. Rotterdam: Museum Boymans-van Beuningen. Text by *Duitse Tekeningen 1400–1700: Catalogus van de Verzameling in het Museum Boymans-van Beuningen*, A. W. F. M. Meij. 1974.

The catalogue of seventy-seven German drawings, including ten by Dürer, from the permanent collection of the Boymans-van Beuningen Mueum in Rotterdam. Fully illustrated; includes watermarks.

684. ———. *From Pisanello to Cezanne: Master Drawings from the Museum Boymans-Van Beuningen, Rotterdam*, Ger Luijten, and A. W. F. M. Meij. Rotterdam: Museum Boymans-van Beuningen,

The catalogue of an exhibition organized and circulated by Art Services International, Alexandria (VA), which was shown at the Pierpont Morgan Library, New York, the Cleveland Museum, and the Kimbell Museum in Fort Worth. Foreword by Wim Crouwel, Director, and a history of the collection by Ger Luijten (6–16). The exhibition contained seven Dürer drawings: No. 2: a *Coat of Arms* showing a man leaning on a tiled stove, formerly in the important Paul von Praun collection (Nuremberg, 1802) and Koenigs collection (Haarlem), and "acquired" in 1941 for the proposed Hitler Museum in Linz, returned to The Netherlands by east Germany in 1987. No. 3: *The Holy Family* (gouache), also once earmarked for the Hitler Museum and returned in 1987. No. 4: *Portrait of a Young Woman* (1505, black chalk). No. 5: *The Pirckheimer Coat of Arms*, on a decorated page from Aristophanes' comedy *Ploutos*, formerly owned by Rubens's patron Thomas Howard, Earl of Arundel. No. 6: *Study of Two Feet* (chiaroscuro drawing, study for the Heller Altar). No. 7: *Study Sheet with a Seated Woman and a Man's Head* (pen and brown ink, two construction drawings for an octagon on the verso. Formerly in the Lubomirski Museum in Lemberg [Lwow]). No. 8: *The Three Fates* (1515, pen, ink, and watercolor. Also from the Koenigs Collection, returned by East Germany in 1987).

685. ———. *Het Dier in de Prentkunst: Grafiek uit de 15de tot de 17de Eeuw*, B. D. Ihle. Catalogi van Tentoonstellingen Prenten uit Eigen Bezit, 55. 1974.

[The Animal in Graphic Art from the fifteenth to the seventeenth Centuries.] Catalogue of 126 prints from the museum's own collection, emphasizing the use of animals, some by Dürer, in allegory and symbol, as well as their use as forms from nature.

686. Rowlands, John. *The Age of Dürer and Holbein: German Drawings 1400–1550*, Cambridge (UK)/New York/New Rochelle/Sydney: Cambridge University Press, 1988.

The handsomely produced, permanent edition of an exhibition catalogue done for the British Museum by Rowlands, assisted by Giulia Bartrum. Rowlands is the current Keeper of the Museum's Department of Prints and Drawings. The exhibition, which included drawings from the Museum's own collection supplemented as needed by a smaller number from other British sources, featured Dürer and Holbein in a setting of works by their predecessors and

contemporaries. In addition to full catalogue entries and illustrations for each drawing, includes a useful section on the history of the British Museum's collection, which began with the Dürers assembled by Sir Hans Sloane, and commentary on its chief curators, including Campbell Dodgson and Sir Karl Parker. Dürer's drawings are featured in Chapter 8 (58–114: Nos. 34–84). In addition to line drawings, there are three important landscape watercolors: a view of the *Castle of Trent*; a *Larch Tree*; the *Pond House* (*Weiherhaus*); an unfinished study of water, sky, and pine trees; a large number of important portrait drawings in all media; several preparatory sketches for important prints, including the *Prodigal Son* and the *Rhinoceros*.

687. Rowlands, John. *The Graphic Work of Albrecht Dürer. An Exhibition of Drawings and Prints in Commemoration of the Quincentenary of his Birth*. London, The British Museum, 1971.

London's contribution to the events of Dürer Year 1971 was this major exhibition and its scholarly catalogue, which revealed the discovery of five unpublished drawings on the reverse sides of works by Dürer in the museum's collection, among them a sky study on the reverse of the *Pond in the Woods* that changes the probable time of day for the main watercolor from sunrise, as formerly assumed, to sunset. Three hundred seventy items were exhibited, in chronological order. A lone painting was included—the *St. Jerome* from the collection of Sir Edmund Bacon (now at the Fitzwilliam Museum in Cambridge), a work not universally accepted at the time. For more recent scholarship on the Dürer drawings and watercolors in England see Rowlands (1988).

688. Rupprich, Hans. "Die kunsttheoretischen Schriften L. B. Albertis und ihre Nachwirkungen bei Albrecht Dürer." *Schweizer Beiträge zur allgemeinen Geschichte* 18–19 (1960): 219–239.

Alberti's works on art and architecture were not available in print during Dürer's lifetime, but it is clear that he was aware to some extent of Alberti's ideas, which were circulated among humanists in handwritten copies. Rupprich, the final authority on Dürer's written legacy, examines Alberti's influence.

689. ———. *Dürer–Schriftlicher Nachlass*, 3 vols. Berlin: Deutscher Verein für Kunstwissenschaft, 1956.

An absolute necessity for serious scholarship on the artist, his writings, his clients, and his contemporaries. Reproduces the original language of the artist's published and unpublished work, with extensive footnotes in modern German explaining obscure terms and identifying obscure people. Also included (Volume 2) are all of the letters written by humanists who mention Dürer or his work. These are in the original languages—whether Latin or German. Dürer's theoretical publications are treated in Volume 3.

690. ———. "Dürer und Pirckheimer. Geschichte einer Freundschaft." In *Albrecht Dürers Umwelt. Festschrift zum 500. Geburtstag*, 78–100. Eds. Gerhard Hirschmann and Fritz Schnelbögl. Nürnberger Forschungen, 15. Nürnberg: Verein für Geschichte der Stadt Nürnberg, 1971.

An essential and convenient summary of the various aspects of the friendship between the artist and his best friend, the Nuremberg humanist and patrician Willibald Pirckheimer (b. 1470). Summarizes and critiques Winkler's (1957) view of Pirckheimer as rather self-absorbed and unable completely to appreciate the full extent of Dürer's talent ("Er war Liebhaber von Klassikerausgaben und Geweihen, nicht Kunstsammler"). Briefly discusses the importance of Pirckheimer's literary "portraits" of the artist, as well as the social entree he gave Dürer to two generations of important humanists—Nuremberg's Lazarus Spengler, Johannes Werner, Benedictus Chelidonius, and Christoph Scheurl, as well as the younger group of Johannes Cochläus, Eoban Hesse, Thomas Venatorius, Joachim Camerarius, et al., and also his contacts and correspondents elsewhere, such as Konrad Celtis, Lorenz Beheim, Erasmus, Johannes Reuchlin, Ulrich von Hutten, Philipp Melanchthon, Konrad Peutinger, and his connections at the courts of Maximilian, Friedrich the Wise, and the Sforza in Milan. More fully, discusses Dürer's manuscript illustrations and other works commissioned by Pirckheimer; the contents of Pirckheimer's library, and his role as editor of Dürer's publications and participant in the artist's quest for art theory.

691. ———. "Dürers Schriftlicher Nachlass und seine Veröffentlichung." *Anzeiger des Germanischen Nationalmuseums 1940–1953* (1954): 7–17.

This brief article introduced the initial post-World War II issue of the Nuremberg Museum's bulletin, a special issue devoted to the Dürer "Renaissance" of the late sixteenth-early seventeenth century. It served as a state-of-the-question report on the author's forthcoming three-volume publication (Berlin, 1656–1669, q.v.), and was valuable especially for its convenient listing of the autograph manuscripts and early collectors.

692. ———. *Dürers Stellung zu den agnoëtischen und kunstfeindlichen Strömungen seiner Zeit. Mit einem neuen Dürer-Brief*, Sitzungsberichte, Bayerische Akademie der Wissenschaften, Philosophisch-Historische Klasse, 1959, 1. Munich: Bayerische Akademie, 1959.

This pamphlet discusses Dürer's refusal to join the radical artists who became iconoclasts, despite his sympathy for the Reformation. Rupprich cites pre-Reformation statements by Dürer as to the divine origin of art; regret for the lost work of the Ancients; relationship to the Lutheran iconoclast Karlstadt, as well as to Luther and Ulrich Zwingli; the arrest of Dürer's *Formschneider*, Hieronymus Andreae. The newly-discovered letter published in full here is one written by the artist to Pirckheimer, in late 1527 or early 1528 (Vienna, Österreichische Nationalbibliothek, Hs 12643 [Suppl. 589]).

693. ———. *Willibald Pirckheimer und die erste Reise Dürers nach Italien*, Vienna: Anton Schroll, 1930.

Rupprich is the definitive authority on documents relating to both Dürer and the Pirckheimer family. This early work, however, has been largely discredited because it presumes a trip to Rome on the first trip to Italy. (N.B.: Anzelewsky has since argued that the artist did go to Rome on the second Italian trip.) Pirckheimer was a primary source of Dürer's own education in the classics, and of his motivation to visit Italy in order to absorb the principles of Renaissance art. A wealthy young man from the ruling class in Nuremberg, he was at university in Italy during the artist's first, year-long visit, and is thought to have traveled home to Nuremberg with him in the late spring of 1495 in order to attend the wedding of his only noncloistered sister. Chapter 1 deals with Pirckheimer's biography—he studied in Padua, where Averroism was a specialty, for approximately three years before moving to Pavia after a disagreement with Padua's Rector. He remained in Pavia from the summer

of 1491 until summer 1495. Chapter 2 is a discussion of a note-book (Brit. Mus. Hs. cat. 1854–1875, vol. II, p. 912ff: twenty-one pages on late fifteenth century paper) presumed to be from his own sojourn in Italy. (HOWEVER: See Alice Wolf, "Notiz zu Hans Rupprichs Buch *Willibald Pirckheimer und die erst Reise Dürers nach Italien,* in *Die Graphische Kunst,* new ser. 1 (1936), 138–139, demonstrating that this supposed travel notebook contains copies of another Nuremberg humanist's sketches.) In Chapter 3 the au-thor attempts to coordinate the activities of Dürer and Pirckheimer in Italy in 1494/1495.

694. Rückert, Günther. "Mit der Zeit ein Feuer." *Portrait einer dicken Frau,* Günther Rückert. Berlin: 1974,

Günther Künert's radio play, *Mit der Zeit ein Feuer,* published as part of a collection, paints an image of Albrecht Dürer as sympa-thetic to the most radical element of the Peasant cause—the fol-lowers of the executed Anabaptist leader Thomas Münzer. [This is quite the opposite of the capitalist "fellow traveler" Dürer of Mar-tin Walser's *Sauspiel,* q.v., published in the following year in Frankfurt.]

695. Saffrey, Henri D. "Albrecht Dürer, Jean Cuno O.P. et la Confrerie du Rosaire à Venise." *Philophronema: Festschrift für Martin Sicherl.* Ed. Dieter Harlfinger, 263–291. Paderborn/Munich/Vi-enna, 1990.

Argues, on the basis of a drawing in the Albertina, that the head of St. Dominic in Dürer's *Feast of the Rose Garlands* (Prague) may be a portrait of the artist's friend, the Dominican friar, Jean Cuno.

696. Salas, Xavier de. *Museo del Prado,* vol. 6. 7 vols. Madrid: Edi-tiones Orgaz, 1978.

The definitive collection catalogue of the Prado, which possesses Dürer's 1498 *Self Portrait*; the *Adam* and *Eve* panels (1507); and the famous portrait of a man in a fur collar holding a rolled parch-ment in his hand (1521 or 1524), who has been variously identified as Lorenz Sterck or Hans Imhoff.

697. Salvini, Roberto. *Albrecht Dürer. Disegni,* Florence: La Nova Italia, 1973.

Albrecht Dürer drawings [reviewed by Kristina Herrmann-Fiore in *Kunstchronik* 29, no. 4 (April 1976), 125–128.

698. ———. "*Il Compianto* di Albrecht Dürer." *Antichità viva* 18, no. 3 (May–June) (1979): 21–27.

[The *Lamentation* of Albrecht Dürer.] The author considers the various versions of this theme treated by the artist between 1495–1500: the unique woodcut (British Museum: ca. 1495); the small panel from the *Mater Dolorosa* polyptych (Dresden: ca. 1496); the woodcut from the *Large Passion* (B.12: ca. 1498); in the drawing (Munich, Graphische Sammlung no. 37933); in the Holzschuher panel (Nuremberg, Germanisches Nationalmuseum). With the exception of the Munich sketch, all were created independently of one another, but yet are strictly connected in iconography and composition, and may be regarded as steps toward the *Lamentation* painted for the Nuremberg goldsmith Albrecht Glimm (Munich, Alte Pinakothek).

699. ———. "Leonardo, i Fiamminghi e la Cronologia di Giorgione." *Arte Veneta* 32 (1978): 92–99.

In attempting to establish "objective" principles for a chronology for Giorgione's small number of works, the author makes some observations on the relationship of Leonardo's work to Giorgione and Dürer in Venice, 1506.

700. ———. "Paralipomena su Leonardo e Dürer." *Studies in Late Medieval and Early Renaissance Painting in Honor of Millard Meiss,* 377–391. Eds. Irving Lavin and Christopher Plummer. New York: New York University Press, 1977.

Not simply a comparison of similar motifs treated by the two artists, as was the case with much of the previous literature, but an explanation of the basic approaches of Dürer and Leonardo as similarly founded in respect for science—and therefore according a fundamental role to drawings. Discusses Winzinger's suggestion that the visit of Giovanni Galeazzo di Sanseverini to Nuremberg (1502) was an important means of transfer of ideas. Works discussed include the *Madonna with the Many Animals* and *Wild Hare*; the Uffizi *Adoration of Magi*; the *Paumgartner Altarpiece*; the *Vilana windisch* (drawing of a Slovenian woman smiling:

British Museum); and *Christ Among the Doctors* (Thyssen Collection).

701. Sampayo-Ribeiro, Mário de. *Processo e história de uma atoarda: O retrato de Damião de Goes por Alberto Dürer*, Publicaçoes do Instituto Alemåo da Universidade de Coimbra, Coimbra: Universidade de Coimbra, 1943.

 Discusses Dürer's drawing W.317 in connection with a lost painting. A refutation of Joaquim de Vasconcellos' theory of identity (in "Albrecht Dürer e a sua influencia na peninsula," *Renascença portugueza. Estudos sobre as relaçöes artisticas de Portugal nos seculos 15 e 16*, Porto, 1877).

702. Sarab'janov, A., Compiler. *Hudozestvennyi Kalendar': Sto pamjatnyh dat 1978*, Moscow: Sovetskij Hudoznik, 1977.

 [One hundred dates to remember.] A calendar with artists' biographies, celebrating important birth and death anniversaries. The majority of artists are Russian, but Dürer's 450th birth anniversary is noted.

703. Saran, Bernhard. "Eobanus Hesse, Melanchthon und Dürer. Unbefangene Fragen zu den *Vier Aposteln*." *Oberbayerisches Archiv* 105 (1980), 183–210.

 Sees Peter and Mark as later additions to the so-called *Four Apostles* (Munich), arguing that Mark is a portrait of Helius Eobanus Hessus (1488–1540), who came to Nuremberg in 1526 to teach poetry and rhetoric at the new gymnasium founded by Melanchthon, who has long been recognized as the model for St. John in the same work.

704. Sass, E. Kai. "A la recherche d'un portrait disparu de Christian II, Roi de Danemark, peint par Albrecht Dürer en 1521." *Hafnia, Copenhagen Papers in the History of Art* (1976): 163–184.

 It is well known from Dürer's travel diary of his stay in the Netherlands that he made a drawing and painted a portrait of Christian II, King of Denmark, in July of 1521 when Christian had traveled incognito to meet his brother-in-law, the newly crowned Emperor Charles V. Dürer's drawing is in the British Museum, while the painting seems to have disappeared. The author attempts to reconstruct the appearance of the lost painting by collating the drawing

with the description of the King by Gasparo Contarini, the Venetian ambassador to the Imperial court, and from accounts of Christian's clothing purchases made in the Netherlands. (But see also Mende, in *A Tribute to Lotte Brand Philip.*)

705. Saxl, Fritz. "Dürer and the Reformation." *Lectures*, vol. 1, 267–276 (Plates vol. 2, 182–194). Ed. Hugh Honor. 2 vols. London: Warburg Institute, 1957.

Reprinted in F. Saxl, *A Heritage of Images* (Harmondsworth, Penguin, 1970), 105–117. Traces the early influence of Giovanni Bellini and of Italianate ideals of beauty in Dürer's work, attributing their disappearance from the artist's style around 1520 to his growing preoccupation with Lutheran ideas. Discusses the *Apocalypse* as antipapal. Also discusses the *Lament for Luther* from the diary of the Netherlandish journey, and the so-called *Four Apostles.*

706. Sayre, Eleanor, et al. *Albrecht Dürer, Master Printmaker*, Boston: Museum of Fine Arts, 1971.

The Boston Museum's exhibition honoring Dürer's five hundredth birthday anniversary. featuring the Museum's own fine collection of his prints, and showing multiple impressions and comparisons between prints of prime quality and those of lesser value. This print room has deliberately retained its duplicates for educational purposes, following the policy of its first curator, Sylvester Rosa Koehler. The exhibition contained 221 objects, and the catalogue gives a brief history of the collection; a discussion of printmaking techniques, and of stylistic development in Dürer's intaglios, in addition to the individual catalogue entries of each work, directed toward technique and print condition. A convenient handlist of the Museum's Dürer holdings, with accession numbers, appears at the end.

707. Scalini, Mario. "Il *Reuther* di Albrecht Dürer, tipologia e simbologia di un armamento." *Antichità viva* 23 (January 1984): 15–18.

(Has English summary.) Supports the argument that Dürer's *Knight, Death, and Devil* was inspired by Erasmus of Rotterdam's *Enchiridion militis christiani* (Handbook of the Christian Soldier). But argues, however, that the armor worn by the knight identifies him as dressed for hunting rather than for war. Suggests that he can be identified as Chronos.

708. Schade, Herbert, Ed. *Albrecht Dürer, Kunst einer Zeitenwende*, Regensburg: Pustet, 1971.

 These are the six papers presented at the Bavarian Catholic Academy's Dürer symposium, held in Nuremberg. Contains articles by Wolfgang Braunfels on the *Four Holy Men* (or Apostles; Munich); Hermann Bauer on the meaning of the painted image in Dürer's art; by the Munich historian Karl Bosl on Church, world, and individuality in the age of the Reformation; by K. A. Knappe on tradition and originality in Dürer's work; by B. Rupprecht on the relationship between painting and reality in the pre-Dürer era (1460–1500); and by Peter Strieder on the meaning of the self portraits.

709. Schade, Sigrid. *Schadenzauber und die Magie des Körpers*, pp. 73–79; 67–69; 124–125. Worms: Werner'sche Verlagsgesellschaft, 1983.

 This is essentially a book about Hans Baldung Grien and witchcraft, but contains references to Dürer. The author cites Preaud's article ("Sorcière de Noël," q.v.) in connection with Dürer's early engraving of *A Witch Riding Backward on a Goat*, and citing the identical references to Saturn and Saturnalia, the world upside down, the power of women, and the old pun on *anus* (old woman) and *annus* (year).

710. Schadow, Johann Gottfried. *Wittenbergs Denkmäler der Bildnerei, Baukunst, und Malerei*, Wittenberg: 1825.

 An important nineteenth-century study treating Friedrich the Wise as art patron, by the author of the souvenir program for the ceremony held in Berlin in 1828 to commemorate the three hundredth anniversary of Dürer's death.

711. Schandorf, Wulf. "Ludwig Grote. 8 August 1893 Halle/Saale–3 März 1974 Gauting bei München." *Anzeiger des Germanischen Nationalmuseums* (1974): 6–7.

 Obituary for one of the leading Dürer experts of the twentieth century, Grote had been a member of the *Wandervögel* movement as a youth, and had studied Dürer's art and life with Eduard Flechsig (q.v.). Director of the Germanisches Nationalmuseum from 1951 until his retirement in 1962 at the age sixty-nine, he had been driven out of his pre-World War II post as director of the Dessau Museum. At the time when he came to Nuremberg shortly after the war, the very existence of the Germanisches Nationalmuseum was

threatened because of the unsavory association of early German art and of Nuremberg itself with the taste of the Hitler era. Grote put the museum back on the map, and back on its feet financially, opening it to modern German art as well as the art of the Middle Ages and Dürerzeit.

712. Schädler, Alfred. "Die 'Dürer'-Madonna der ehemaligen Sammlung Rothschild in Wien und Nicolaus Gerhaert." *Städel-Jahrbuch* 9 (1983): 41–54.

Reaffirms the attribution to Gerhaert of the boxwood standing *Madonna and Child* (34.3 cm.) formerly in the collection of Anselm Salomon von Rothschild. The work appeared in New York in 1948 and was acquired by Julius Bohler of Munich. (Privately owned: on loan to the Bayerisches Nationalmuseum, Munich since 1981.) The base is inscribed with a seventeenth- or perhaps nineteenth-century Dürer monogram. Also publishes a contemporary replica of the statuette (private collection).

713. Schefer, Leopold. *The artist's married life; being that of Albrecht Dürer. Trans. from the German by Mrs. J[ohn] R[iddle] Stodart*, Rev. ed. New York: Miller, 1872.

First published in English in London (1848), and 1853 (Chapman's Library for the People, vol. 10), and in New York (1862). Point of departure is Pirekheimer's view of the artist's marriage to Agnes Frey as an unhappy one. Historic interest only.

714. Scheicher, Elisabeth. *Die Kunst- und Wunderkammern der Habsburger*, Vienna/Munich/Zurich: 1978.

This is a large and beautiful book, obviously intended for a popular audience; however, it is responsibly documented. Discusses what remains of the objects sent by Cortez to honor Charles V—the exhibition of pre-Columbian art so admired by Dürer during his visit to the court in Brussels (pp. 26–30). Also treated is the collection of Kaiser Friedrich III, for whom Dürer's father performed certain commissions (47–50); and those of Maximilian I, Dürer's own patron (52–59) and of his daughter, Margaret of Austria (who refused to buy from Dürer, 59–62). A selection of works from the vast collections of Rudolph II is given (142–156).

715. Schellemann, Carlo. "Albrecht Dürer in der geschichtlichen Realität." *tendenzen* 12, no. June/July (1971): 99–120.

The leading article in a left-leaning West German periodical published during the summer of Dürer Year 1971. Discusses the Netherlandish diary entries regarding the Assumption Day procession and the lament for Luther; the background of class warfare, including the *Bundschuh* peasant rebellion of 1493 in Alsace; the *Monument to a Dead Peasant* and its text. Sees the wicked judge in the *Apocalypse* series as a reference to the tyrannical Bishop of Würzburg, Rudolf von Scherenberg, who ordered the execution of one of the peasant leaders. Puts in a good word for Germany's much-maligned merchant class, however, as harbingers of progress (as well as usurers). Discusses the artist's youth against background of craft control by Nuremberg's City Council, and his supposed involvement in the illustrations for the *Ship of Fools*; the *Self Portraits* as "standpoints" reflecting the maxim "Know thyself;" the nature studies and theoretical works. Interprets the *Large Fortune* and *Melencolia I* as expressive of bourgeois values.

716. Scherer, Valentin. *Dürer; des Meisters Gemälde, Kupferstiche und Holzschnitte*, Klassiker der Kunst, Stuttgart: Deutsche Verlags-Anstalt, 1908.

The American edition of this once-popular album was published by Brentano's, New York in 1921, and is still found in many U.S. libraries. IT IS NOT RELIABLE.

717. Schewe, Josef. "Zur Deutung einer bisher ungedeuteten Dürer-Zeichnung." *Das Münster* 25 (1972): 164.

Explains the iconography of the enigmatic early drawing (W.42: Oxford, Ashmolean Museum) depicting a youth kneeling before an enthroned old man, which had been exhibited in the Nuremberg exhibition and illustrated in the catalogue (1971: no. 67.) Schewe identifies the subject as that of the young pilgrim and the unjust judge, from the legend of St. James. As Stechow (*The Art Bulletin*, 1974) noted, however, the elderly man and young woman looking in at the window are surely not the parents of the youth, but the wicked innkeeper and his treacherous daughter who had falsely accused the young pilgrim of theft.

718. Schindler, Herbert. *Die fränkischen Aquarelle Albrecht Dürers. Ursprung und frühe Vollendung der realistischen Landschafts-*

malerei, 2nd ed. Munich: Bayerische Vereinsbank, Zentralsteilung ÖAV, 1983.

A brief survey of Dürer's "local" Franconian landscape watercolors seen in relation to previous Franconian landscapes in all media, including the well-known views of Nuremberg from the Krell altarpiece (Nuremberg, St. Lorenz), the woodcut from the Wolgemut workshop in Hartman Schedel's *Weltchronik*, and, more particularly, the Katzheimer watercolor views of Bamberg architecture (Berlin, Kupferstichkabinett).

719. Schlegel, Ursula. "Mars, Venus und Amor. Ein Relief von Antonio Lombardo." *Mitteilungen des Kunsthistorischen Institutes in Florenz* 28 (1984): 65–76.

Argues that a bronze relief with *Mars, Venus, and Amor* (Berlin, Staatliche Museen, Skulpturengalerie), which thermoluminescence analysis shows to have been made in Venice in the latter half of the sixteenth century, is based on a little-known marble relief in the Munich Residenz. The author attributes the Munich relief to Antonio Lombardo, dating it approximately 1504–1506, and relates it to Dürer's *Adam and Eve* (B1) of 1504, suggesting that it was purchased with the collection of Andrea Loredan by Albert V of Bavaria in 1568, and that Loredan commissioned the bronze copy at that time [Author: RILA].

720. Schleif, Corine. *Donatio et Memoria: Stifter, Stiftungen und Motivationen an Beispielen aud der Lorenzkirche in Nürnberg*, Kunstwissenschaftliche Studien, 58. Munich: Deutscher Kunstverlag, 1990.

This excellent study by a young American professor (Arizona State University, Tempe, AZ) deals in depth with the donors and donations of art works made to the Nuremberg church of St. Lorenz by leading patricians and clerics and their families in Dürer's day. Contains a wealth of information concerning Dürer's patrons the Imhoffs, Sixtus Tucher, Anton Kress, and others, as well as works by Dürer's teacher and associates. Includes discussion of the drawings for stained glass commissioned by Probst Sixtus Tucher that are attributed to Dürer (pp. 179–188), and the Rayl epitaph, once thought to be by Dürer but now considered a work from the Wolgemut circle. (See also Schleif, *Art Bulletin* 1987).

721. ———. "The Proper Attitude Toward Death: Windowpanes Designed for the House of Canon Sixtus Tucher." *The Art Bulletin* 69, no. December (1987): 587–603.

A pair of stained glass trefoils from the Hirschvogel workshop (Nuremberg, Germanisches Nationalmuseum) commissioned in 1502 by Canon Sixtus Tucher for the Tucher House in Nuremberg are placed in the context of the canon's reaction against the popular iconography of the Dance of Death, as well as against the almost equally popular modern Humanist view dismissing death as a motivating force for life. The preparatory drawings for the trefoils (Hanover, Niedersächsisches Landesmuseum, *Death on Horseback* and Frankfurt am Main, Städelsches Kunstinstitut, *Cleric Before an Open Grave*) traditionally have been attributed to Dürer (Lippmann, Winkler), and/or his workshop (Flechsig, Panofsky, Strauss).

722. ———. [In progress.] A monographic study of Agnes Dürer.

723. Schnelbögl, Fritz. "Das Nürnberg Albrecht Dürers." *Albrecht Dürers Umwelt. Festschrift zum 500. Geburtstag*, 56–77. Eds. Gerhard Hirschmann and Fritz Schnelbögl. Nürnberger Forschungen, 15. Nürnberg: Verein für Geschichte der Stadt Nürnberg, 1971.

Deals with contemporary topographical depictions of Nürnberg, including the oldest (that in the background of the Krell Altar in St. Lorenz, ca. 1480); the woodcut view from the south from the Nürnberg *Chronicle*; the artist's own watercolor *View of Nürnberg from the West*, and the later drawing by Hans Wurm (1515–1520) and watercolor by Erhard Etzlaub (1516). Also discusses Dürer's landscape watercolors made in and around Nürnberg, such as the *Wiredrawing Mill*, the *Cemetery of St. John*, and the *Covered Bridge*, as well as houses owned by the artist's family members and associates. Includes a labeled neighborhood map of the Burgstrasse.

724. Schoch, Rainer. "A Century of Nuremberg Printmaking." *Gothic and Renaissance Art in Nuremberg 1300–1500*, 93–99. New York. Metropolitan Museum of Art. Munich: Prestel, 1986.

Discussion of the documentary evidence for printmaking and playing card manufacture in Nuremberg as early as 1397; of the division of labor involved in making woodcuts; the Stromer paper mill; iconographic types of early single-sheets—some of them perhaps

emanating from the Dominican convent of Sankt Katharina. Cites Geiler von Kaisersberg's recommendation for the use of penny prints as religious images; Wolgemut's designs for Koberger book illustrations; Veit Stoss's brief involvement in engraving; Dürer's background and beginnings as *peintre-graveur*; his pupils.

725. ———, "Die kostbarste unter allen nürnbergischen Kunstkammern." Glanz und Ende des Praunschen Kabinetts. *Kunst des Sammelns. Das Praunsche Kabinett. Meisterwerke von Dürer bis Carracci*, 25–34. Ed. Katrin Achilles-Syndram. Nuremberg: Verlag des Germanischen Nationalmuseums, 1994.

The Praun collection as it was displayed at the time of Goethe's visit to Nuremberg (November 6–15, 1797), on the second floor of the house in the Weinmarkt. Described by Christoph von Murr (q.v.) as the "most precious of all Nuremberg collections"; its Dürers were but a part of its 250 paintings, around six hundred drawings (one of the oldest drawing collections north of the Alps), 6,000 engravings in addition to medals, gems, ivories, statues, and natural curiosities in an installation virtually unchanged since the late sixteenth century. The guest book containing alphabetized names of the seventy visitors to the collection from 1768–1801 still survives (Nuremberg Archives: Von Praun Rep. E 28 II, No. 1479) and also includes the names of Dresden's curator C. H. von Heinecken; George III of England's curator Richard Dalton. According to a letter from Wilhelm Heinrich Wackenroder, however, the Erlangen student who was to contribute so materially to the early Romantic "cult" of Dürer, the current Von Praun (a lawyer) was willing to admit visitors only when someone really important came to town, and was "no connoisseur." This article also contains an interesting discussion of the portfolio by Gottlieb and Maria Katharina Prestel (1775) of engraved facsimiles of selected drawings from the collection, including Dürer's *Anna Selbdritt* (The Virgin with St. Anne and the Christ Child; now in Budapest), and of the sale of the collection by the Nuremberg dealer Johann Friedrich Frauenholz over the years 1798–1820. First choice of the graphic art went to Moritz Graf Fries. Five of Dürer's paintings, however, remained unsold until well into the new century (1809–1832). King Ludwig I of Bavaria acquired the portrait of Wolgemut and the 1500 portrait of a young man (then thought to be Hans Dürer).

726. Schöber, David Gottfried. *Albrecht Dürer, eines der grössesten Meister und Künstler seiner Zeit; Leben, Schriften und Kunstwerke, aufs neue und viel verständiger, als von ehemals geschehen, beschrieben, von D. G. Schöber,* 164 pages. Leipzig/Schleiz: J.G. Mauke, 1769.

The first scholarly monograph on the artist that attempts to deal with Dürer in the context of his time. Like Arend's monograph of 1708 (q.v.), written by a dilettante. Schöber owned a private collection of the prints, and also made use of the travel literature of the day. (Reviewed in *Lexikon deutsche Dichter und Prosaisten,* Karl Heinrich Jördens, ed., Leipzig, 1906, p. 404.)

727. Schröder, Eberhard. *Dürer. Kunst und Geometrie. Dürers kunsthistorisches Schaffen aus der sicht seiner* Underweysung, Basel/Boston/Stuttgart: Birkhauser, 1980.

The author (b. 1920), who holds a doctorate in natural science with a *Habilitationsschrift* on differential geometry, was formerly *Dozent* in mathematics at the Technical University in Dresden. Although as the title suggests, this technical study deals mainly with Dürer's *Unterweysung der Messung* (Manual of Measurement), and more specifically with perspective construction, it also contains interesting chapters on the engravings *St. Jerome in His Study* (pp. 53–64) and *Melencolia I* (pp. 64–76). Here he demonstrates that the complex perspective, derived from Piero della Francesca's *De prospectiva pingendi* used in the two engravings, is nowhere explained in Dürer's book, which was intended for "the younger generation."

728. Schubert, Dietrich. "Die Elternbildnisse von Otto Dix aus den Jahren 1921–14–Beispiel einer Realismus-Wandlung." *Städel-Jahrbuch* 4 (1973): 271–298.

Otto Dix actually called himself a "student" of Dürer, Cranach and Grunewald, as is well known, and had selected drawings of his own to lend to the exhibition of modern artists honoring Dürer's five hundredth birthday (Nuremberg, 1971) before his own death, shortly before the exhibition opened. Schubert examines the dissimilar results achieved by Dix while working within the bounds of a type of Realism (*Neue Sachlichkeit*).

729. Schultheiss, Werner. "Albrecht Dürers Beziehungen zum Recht." *Albrecht Dürers Umwelt. Festschrift zum 500. Geburtstag,*

220–254. Eds. Gerhard Hirschmann and Fritz Schnelbögl. Nürnberger Forschungen, 15. Nürnberg: Verein für Geschichte der Stadt Nürnberg,

The law played a more prominent role in the late-medieval Imperial city of Nüremberg than in many other places. Schultheiss gives a most essential and concise summary of major points of civil and criminal law applicable within the city itself, as well as that having jurisdiction over intercity commerce and warfare. Refers to extant contracts between clients and major Nüremberg craftsmen; remarks on the fact that most of Dürer's were contracts apparently settled either orally or in brief business letters. Discusses Dürer's contracts with sales agents; his involvement on behalf of his brother Hans in the prosecution of another apprentice who had injured Hans with a knife; the negotiation of his pension; his dealings with the City Council; his duties as a citizen; the limitations imposed by his social standing; the legal implications of his use of his monogram, coat-of-arms, and seal; the limitations of sixteenth-century copyright.

730. ———. "Ein Vertrag Albrecht Dürers über den Vertrieb seiner graphischen Kunstwerke." *Scripta Mercaturae* 1, no. 2 (1969): 77–81.

Discovery of Dürer's contract with his agent, Georg Coler (July 26, 1497).

731. Schulz, Barbara. "Bemerkungen zu dem Dürerholzschnitt des heiligen Christophorus mit dem Gegendruck von Abels Tod." *Kunst in Hessen und am Mittelrhein* 11 (1971): 81ff.

Announces the discovery of a counterproof of Dürer's "Cain and Abel" on the verso of an impression of the *St. Christopher* woodcut (B.103, dated 1511). This is of particular interest, because the authenticity of the St. Christopher as an autograph Dürer has been doubted in the past (Panofsky no. 323, and Nuremberg 1971, no. 356).

732. Schuster, Peter-Klaus. "Bild gegen Wort: Dürer und Luther." *Anzeiger des Germanischen Nationalmuseums* (1986): 35–50.

Centers on the conflicting views of Dürer and Martin Luther as to which of the senses—vision or hearing—is dominant, and thus whether visual imagery or the written word is the more effective

means of communication. Reproduces the 1867 etching by Friedrich Wilhelm Eichens, *The Age of the Reformation*, after the cartoon by Wilhelm von Kaulbach for the mural on the staircase of the Neues Museum, Berlin (1862), which shows Luther in the center holding the Bible over his head, with Dürer in an adjacent alcove painting *The Four Apostles* on the wall, with a huge crowd below. Schuster, who is the reigning authority on the *Melencolia I*, (1991, q.v.), also examines the 1500 *Self Portrait* and the *Four Apostles*, both having lengthy inscriptions, for signs of any turning away from Nuremberg humanism toward Lutheranism. He finds none: Dürer was a Christian humanist throughout his life, and is accurately characterized by Schuster as more liberal than Luther. The author relates the inscription on the self portrait to Pico della Mirandola's memorable essay placing humankind "a little lower than the angels." He also discusses the theme of *free will* as recurrent in the "Master Engravings," and interprets the *Monument for the Peasants' War* as running counter to Luther's eulogizing the fallen soldiers in terms of Christ as the Man of Sorrows. Other works discussed include the late *Last Supper* woodcut (1523) and the painted *Adam and Eve* (Madrid: 1507).

733. ———. "Das Bild der Bilder. Zur Wirkungsgeschichte von Dürers *Melancholie*-Kupferstich." *Idea, Jahrbuch der Hamburger Kunsthalle* 1 (1982): 72–134.

Essential reading before the publication of the author's 1991 two-volume monograph (q.v.). The most complete study to date of Dürer's *Melencolia* and its literature, from 1514 to the twentieth century. Explains the print as an allegory of supreme wisdom, as expressed by the transcendancy of the science of mathematics. The Roman numeral I is interpreted as a measure of all numbers, and thus a symbol of God.

734. ———. *Melencolia I. Dürers Denkbild.* 2 vols. Berlin: Gebr. Mann, 1991.

Essential reading. Volume I is the text; Volume II the footnotes and plates. The text consists of seven chapters: 1) Various interpretations of the print from the sixteenth century to the present; 2) The iconography of Melancholy and the medical tradition; 3) The iconography of Mathematics; 4) The Virtues: including sections on Astronomy and Vanitas, the *Docta ignorantia*, and *Christus sapi-*

entia Dei; 5) Dürer's humanism; 6) The *four Meisterstiche* (the usual three Master Engravings plus the *Adam and Eve*; and 7) "the picture of pictures," including the spiritual self-portrait theory popularized by Panofsky. Schuster, who from 1989 has been chief curator at the Neue Nationalgalerie, Berlin, places the Melencolia in the context of Dürer's humanistic thought, and sees it as an apologia for free will and for the pursuit of scientific knowledge as a virtue. Discarding older notions of the print as a "spiritual self portrait" of the artist, or as the personification of Geometry, he identifies the winged figure as Astronomy, the most sophisticated branch of mathematics—and the most important by virtue of its proximity to the Divine, giving its practitioners the hope of "reawakening" the perfection in themselves that had been present in Eden before the Fall. He sees the "I" of the title both as the elementary mathematical unit and a reference to Christian unity. He sees the print thus as a summa of the artist's humanistic beliefs, and accepts its close relationship to the other two Meisterstiche: *Knight, Death, and Devil*, and *St. Jerome in His Cell*.

735. ———. "Zu Dürers Zeichnung *Der Tod des Orpheus* und verwandten Darstellungen." *Jahrbuch der Hamburger Kunstsammlungen* 23 (1978): 7–24.

Developed from a lecture given in January 1978 for the Friends of the Hamburg *Kunsthalle*, this supplements and corrects the work of Warburg and Panofsky. The author gives a nonhomoerotic and Christian interpretation of Hamburg's early *Death of Orpheus* drawing, following the *Ovid Moralisée*. The singer Orpheus, characterized by Dürer in the inscription as a homosexual, falls victim to the blows of the Maenads of unbridled sensuality. Sensuality paired with intellect, represented in the drawing by the book of Orphic songs fastened to the tree, is undying. Dürer's drawing is therefore one of the earliest representations of the problematic character of the artist, of his role as an outcast as well as of the claim of art to immortality. The maxim of the Orpheus drawing recurs also in Dürer's *Hercules at the Crossroads*. In contrast to Panofsky, the author stresses the mediating role of Hercules, who parries the punishing blows of Virtue and thus unites intellect and sensuality as a virtuous, humanistic athlete. He concludes by interpreting Thomas Mann's *Death in Venice* as a new version of the death of Orpheus and stresses the relationship between Dürer's humanistic ideal of

virtue and the apology for culture made by Aby Warburg and Thomas Mann [Author: RILA].

736. Schweikhart, G. "Novità e bellezza. Zur frühen Dürer-Rezeption in Italien." *Festschrift Herbert Siebenhüner zum 70. Geburtstag*, 111–136. Eds. E. Hubala, and G. Schweikhart. Würzburg: F. Schöningh, 1978.

[On the early influence of Dürer in Italy.] On the basis of some drawings and prints, discusses Dürer's early influence in Italy. These make it clear that in the first phase it was not the spiritual character of his art, but rather his use of antique figures and his technical bravura that interested Italian artists. Gives particular attention to the changes made by Italian draftsmen to Dürer's designs—for example, to the drawing after *Adam* (Princeton Art Museum). Only in the second decade did the image of Dürer in the sense described by Vasari begin to change in favor of expressive elements, for example drapery studies, and, increasingly, religious themes. [Author: RILA].

737. Schweinfurt. Bibliothek Otto Schäfer. *Dürer als Erzähler*, Erich Schneider, and Anna Spall. Schweinfurt: 12 October 1995.

An exhibition of eighty of the narrative prints of Dürer from the important collection of Dr. Otto Schäfer. ("Narrative" is defined rather loosely to include such prints as the *Rhinoceros* and the *Small Horse*.) Full page reproductions, rather general text, with essential bibliography. The importance of this work is the glimpse that it gives of the very high quality and impressive depth of the collection.

738. Schwemmer, Wilhelm. "Albrecht Dürers Grab auf dem Johannisfriedhof." *Mitteilungen des Vereins für Geschichte der Stadt Nürnberg* 62 (1975): 279–284.

The significance of Dürer's grave in Nuremberg's Cemetery of St. John. It had been "cleared" in 1550 when there were no longer any surviving relatives of either the artist or his wife and was purchased for the use of the Nuremberg Academy by Joachim von Sandrart, who renovated it in 1681 and provided the fulsome inscription ("Rest here in peace, prince of artists! You more than great man! There is nowhere your equal in the many fields of art. The earth was painted out; now the heavens have you. . . . Because

no one is his equal he must lie here alone. . . ."). Ironically, of course, Dürer's remains no longer lay there at all, and his grave was destined to be recycled many times, finally becoming one of the focal points of the nineteenth-century "cult" of Dürer.

739. Schwerte, Hans. *Faust und das Faustische. Ein Kapitel deutscher Ideologie*, Stuttgart: 1972.

A thorough and fascinating study of images that the author deems "Faustian" in German literature and art, including a section devoted to Dürer's *Knight, Death, and Devil*. (It is worth bearing in mind that the author, who attained a highly respected position in academia after World War II, was unmasked in the 1990s as a former S.S. officer; however, this does not invalidate his findings, and in fact gives him a unique kind of expertise in this particular case.)

740. Scribner, Bob. "Ways of seeing in the age of Dürer." *Dürer and His Culture*, Eds. Dagmar Eichberger, and Charles Zika. Cambridge/ New York/Melbourne: Cambridge University Press, 1998.

Cites William Ivins (1938) on pre-Renaissance lack of a logical system of representing objects in space, and inability to duplicate any picture exactly—problems solved in part by the introduction of one-point perspective and printmaking. Discusses Nicolas of Cusa's fascination with the power of the lens to magnify, and the moral assumption that he drew in relation to the "all-seeing eye" of Christ; Alberti's "window"—the world seen through a pane of glass; St. Augustine's assessment of the sense of hearing as dominant over seeing; the visionary contemplation of Suso, Tauler, and St. Bridgit of Sweden; the Mass of St. Gregory and "perception" of the supernatural (and its corollary, the "real presence" of the Devil); the role of the artist as manipulator of visual perception— "all-seeing" portraits, erotic images with the power of sexual arousal; visual perception used to demean or belittle "the other" (Jews, women, religious opponents). The author stresses the fact that "the age of Dürer remained one in which many different ways of seeing were possible"—a dilemma not unlike our own in the twentieth century.

741. Seebass, Gottfried. "Dürers Stellung in der Reformatorischen Bewegung." *Albrecht Dürers Umwelt. Festschrift zum 500. Geburtstag*, 101–131. Eds. Gerhard Hirschmann and Fritz Schnelbögl.

Nürnberger Forschungen, 15. Nürnberg: Verein für Geschichte der Stadt Nürnberg, 1971.

Essential reading. Takes note of the enduring difference of opinion as to Dürer's religious beliefs (e.g., Anzelewsky sees him as Lutheran; Braunfels as Catholic to the end). Discusses the documentary evidence, and the history of the artist's discovery of and interest in Luther's writings during the period leading up to the Diet at Worms and the famous Lament for Luther in the Netherlandish Diary. Sets realistic parameters for the artist's view of Luther as interpreter of "the Holy Gospel." Also discusses the artist's later correspondence with Niklas Kratzer; his friendship with Melanchthon, and his association/disassociation with the three "godless" young artists—Jörg Pencz and the Beham brothers.

742. Segal, Sam. "Die Entstehung der Still-Leben-Tradition in der Rudolfinischen Kunst im Hinblick auf Dürer." *Jahrbuch der Kunsthistorischen Sammlungen in Wien* 82/83 (n.s. vol. XLVI/XLVII) (1986): 273–286.

The author's presentation at the 1985 Albertina symposium on the nature studies of Dürer and his followers. A very general survey of the origins of autonomous still life from its beginnings as appended to religious pictures. The author is better known for his works on Dutch still life painting of the seventeenth century.

743. Seibold, Gerhard. "Die Pellersche Gemäldesammlung." *Anzeiger des Germanischen Nationalmuseums* (1982): 70–82.

Deals with the collection assembled in Nuremberg, largely between 1610 and 1620, by the wealthy local merchant Martin Peller. It contained a number of Venetian paintings by such masters as Palma Giovane and Leandro Bassano, in addition to the *Lamentation* attributed to Dürer's shop (Nuremberg, Germanisches Nationalmuseum), and probably the portrait of Jacob Muffel (Berlin-Dahlem). The collection was sold gradually between 1816 and 1833. Reproduces the inventories of 1641 and 1801 and the list of paintings sold to Baron Egon Franz von Fürstenberg in 1833. The Peller House (1602–1607), by the architect Jakob Wolff the Elder, extensively restored after World War II, now serves as exhibition space for the *Stadtarchiv*.

744. Sickel, Lothar. "Der "ungläubige" Petrus. Zur Bedeutung eines Schlüsselmotivs in den *Vier Aposteln* von Albrecht Dürer." *Niederdeutsche Beiträge zur Kunstgeschichte* 34 (1995): 41–56.

Calls attention to the action of St. Peter in the so-called *Four Apostles*, who seems to be reading and reacting to something called to his attention by John (Paul and Mark, on the adjacent panel, are not involved with each other in this way). Sickel seeks a prototype in Giovanni Bellini's *Coronation of the Virgin* (Pesaro, Museo Civico), in the bust-length painting of Peter and John by Giovanni Antonio da Lodi (Milan, Brera), Fra Angelico's Linaiuoli Tabernacle (Florence, St. Marco) and Luca Signorelli's Peter-and-John fresco in St. Maria di Loreto—not insisting that Dürer had seen these particular examples, but calling attention to the existence in Italy of a tradition of portraying Peter and John together. His point is that the Dürer scholarship has fallen under the spell of a "psychosomatic obsession" with the apostles as depictions of the Four Temperaments while losing sight of the theological implications. In the Signorelli, for example, John points to an open book, while Peter looks like an *illiterato*. Sickel argues that the viewer identifies with Dürer's St. Peter, about to be enlightened.

745. Siebenhühner, Herbert. "Tizians *Dornenkrönung Christi* für S. Maria delle Grazie in Mailand." *Arte Veneta* 32 (1978): 123–126.

Establishes a date for the Louvre's version of Titian's *Christ Crowned with Thorns* (commissioned 1540 by the Confraternity of the Holy Crown for the Corona chapel in St. Maria delle Grazie, Milan, final payment 1542). Also examines sources for the painting, including Dürer's woodcut from the so-called *Albertina Passion*.

746. *Das Gebetbuch Kaiser Maximilians. Mit den Randzeichnungen von A. Dürer und L. Cranach.*, Heinrich Sieveking. Munich: 1987.

The Bavarian State Library's copy of the *Prayerbook*, with an introduction by Heinrich Sieveking.

747. Silver, Larry. "Christ-Bearer: Dürer, Luther, and St. Christopher." *Essays in Northern European Art Presented to Egbert Haverkamp-Begemann on His Sixtieth Birthday*, 239–244. Ed. Anne-Marie Logan. Doornspijk: Davaco, 1983.

Citing quotations from one of Luther's sermons (April 16, 1530) and from the *Tischreden*, in which the story of St. Christopher is explained as a Christian allegory rather than as fact, Silver argues that the two prints and the sheet of "four small [drawings] on gray paper" depicting St. Christopher carrying the Infant Jesus constitute a reflection of his conversion to Lutheranism. The sheet of

four drawings was presented to the Antwerp landscape painter
Joachim Patinir, and is presumed lost or misidentified; however,
the Berlin Print Room owns a sheet with nine such drawings,
monogrammed and dated 1521 (W.800), and related to his two en-
gravings of the saint (B.51, B.52) made in the same year. They are
here contrasted to the artist's two earlier woodcuts (B.104, ca.
1500–1505; B.103). He fails, however, to find a satisfactory expla-
nation for the fact that Luther's references postdate not only the
prints and drawings but also the artist's death (1528). [The author,
who formerly taught at Northwestern University, is now Farquhar
Professor of Art History at the University of Pennsylvania.]

748. ———. "Germanic patriotism in the age of Dürer." *Dürer and his
Culture*, 38–68. Eds. Dagmar Eichberger, and Charles Zika. Cam-
bridge/New York/Melbourne: Cambridge University Press, 1998.

A convenient review of the basic literature by Joachimsen, Spitz,
and Wuttke. Includes the recovery of Tacitus' *Germania*; Celtis in
Nuremberg, and Dürer's woodcut designes for his publications;
extensive quotations from Heinrich Bebel; Maximilian as "the new
Apollo."

749. ———. "Prints for a Prince: Maximilian, Nuremberg, and the
Woodcut." *New Perspectives on the Art of Renaissance Nurem-
berg: Five Essays*, 7–21. Ed. Jeffrey Chipps Smith. Austin, TX:
University of Texas—Archer M. Huntington Art Gallery, 1985.

A discussion of Maximilian's patronage and his ties to Nuremberg.
The author briefly discusses Nuremberg's position as an Imperial
city, its role as repository for the Imperial regalia and relic collec-
tion, and Dürer's portraits of Charlemagne and Sigismund as back-
ground for the Emperor Maximilian I's commissions for the
Triumphal Arch, the *Triumphal Procession*, the *Prayerbook* draw-
ings, and the painted and woodcut portraits of Maximilian. The
programs and the various collaborators on the Procession and the
Arch, and the Emperor's own role in their iconographic content,
are discussed, including the influence of Willibald Pirckheimer's
Latin translation of the *Hieroglyphica*.

750. Silver, Larry, and Susan Smith. "Carnal Knowledge: The Late En-
gravings of Lucas van Leyden." *Nederlands Kunsthistorisch Jaar-
boek* 29 (1978): 239–298.

An extensive iconological study of Lucas van Leyden's late engravings of nudes, discussing the influence of Italian engraving as well as of Dürer's *Adam and Eve* (B.1) and *Large Fortune (Nemesis*: B.77). [For more extensive discussion of Dürer's influence on Lucas van Leyden, including his religious subjects, see the exhibition catalogue by Ellen Jacobowitz and Stephanie Loeb, *The Prints of Lucas van Leyden and His Contemporaries*, Washington, D.C., National Gallery of Art, 1983.]

751. Simon, Erika. "Die Rezeption der Antike." *Albrecht Dürer 1471– 1971*, 263–278. Nuremberg. Germanisches Nationalmuseum. Nuremberg: Germanisches NAtionalmuseum, 1971.

Dürer's role as "the second Apelles;" his prints and drawings on sometimes abstruse classical themes, mostly in the late 1490s, and his ability to assimilate the classicizing styles of Mantegna and Antonio Pollaiuolo; his dependence on Pirckheimer for knowledge of Pliny, Ovid, and other ancient authors. It was Simon who first correctly identified the *Hercules Slaying the Molionides*. Catalogue entries also include the *Meerwunder*; *Four Witches ("Discordia")*; *Pupilla Augusta; Battle of Sea Gods; The Large Hercules; Hercules and the Stymphalian Birds; The Satyr Family; Arion;* and others.

752. ———. "Dürer und Mantegna 1494." *Anzeiger des Germanischen Nationalmuseums* (1971): 21–40.

Dürer's drawings, dated 1494, after Mantegna's *Battle of Sea Centaurs* (apparently based on an antique sarcophagus in the Villa Medici, Rome) and *Bacchanale* (based on Diodoros 3:58). Simon identifies the battle of sea centaurs as derived by Mantegna from a scene in the *Aeneid* (1:28), in which the Furies, personifying Juno's wrath, invoke a storm at sea to prevent Aeneas, son of Venus, from reaching Italy.

753. Simonsfeld, H. *Der Fondaco dei Tedeschi in Venedig und die deutsch-venetianischen Handelsbeziehungen*, 2 vols. Stuttgart: 1887.

A venerable but reliable study of the Fondaco dei Tedeschi, which was the headquarters of the German merchants trading in Venice, and of German trade in Venice generally, covering the period during which Dürer was active in the city.

754. Singer, Hans Wolfgang. *Versuch einer Dürer-Bibliographie*, Studien zur Kunstgeschichte, 41. Strassburg: Heitz, 1903.

Singer's initial compilation of the literature, which formed a base for his updated version done for Dürer Year 1928 (q.v.). Reviewed by Max Friedländer in *Deutsche Litteraturzeitung* 24 (1903), cols. 1803–1805.

755. *Versuch einer Dürer-Bibliographie, 2.*, Ed. Hans Wolfgang Singer. Studien zur deutschen Kunstgeschichte, 41. Strassburg: Heitz, 1928.

Singer's second bibliography, twice as large as the first, brought out in time for the events of the year-long celebration honoring the artist's four hundredth death anniversary in 1928. Reviewed by Erich Römer in *Der Cicerone*, 21 (1929) Sonderheft 3, Kunstliteratur, 3 and 11.

756. Skrine, Peter. "Dürer and the Temper of his Age." *Essays on Dürer*, 24–42. Ed. C. R. Dodwell. Manchester Studies in the History of Art, 2. Manchester/Toronto: Manchester and Toronto University Presses, 1973.

An assessment of Dürer's career in light of his relation to Humanist and Reformation patterns of thought and patronge [Parshall & Parshall].

757. Sladeczek, Leonhard. *Albrecht Dürer und die Illustrationen zur Schedelchronik. Neue Fragen um den jungen Dürer*, Studien zur deutschen Kunstgeschichte, 342. Baden-Baden: Valentin Koerner, 1965.

An examination of the facts known about the operation of Michael Wolgemut's workshop at the time of Dürer's apprenticeship, and the publication (1493) by Dürer's godfather, Anton Koberger, of Hartmann Schedel's *Weltchronik* (*World Chronicle*), with its 645 woodcuts, during the artist's absence on his bachelor's journey. Points out that the woodcut blocks were being designed beginning in 1488, when Dürer as an apprentice would almost certainly have been involved. Calls attention to the unusual series of illustrated books published by Koberger between 1488 and 1493, concluding that the same team of form-cutters must have been employed for them all. Cites compositional resemblance of *The Creation of Eve* from the Chronicle to Dürer's *Angel with the Key to the Bottomless*

Pit from the *Apocalypse* series as evidence of Dürer's participation in Schedel's commission.

758. Slee, Jacquelynn Baas. "A Literary Source for Rudolphe Bresdin's *La Comédie de la Mort.*" *Arts Magazine* 54, no. 6 (1980): 70–75.

The author suggests the Cave of Despair passage from Spenser's *Fairie Queene* as a literary source for Bresdin' 1854 lithograph, otherwise "a pychological self portrait modeled on Dürer's *Melencolia*.".

759. Sleptzoff, Lola. "Le motif de la main dans la peinture allemande." *Norms and Variations in Art: Essays in Honor of Moshe Barasch*, 63–80. Jerusalem: Magnes Press, Hebrew University, 1983.

Discusses the treatment of hands in fifteenth- and sixteenth-century German religious painting, including their use as focal points of the composition; relationships between the character of a figure and the form of the hands; and the use of twisted or distorted hands to express emotion. In addition to Dürer's work, includes Gothic paintings in the International Style and works by Konrad Witz, Friedrich Pacher, Grünewald, and Cranach.

760. Smith, Alastair, and Angela Ottino della Chiesa, Eds. *The Complete Paintings of Dürer*, Classics of World Art, London: Weidenfeld & Nicholson, 1971.

A convenient book of reproductions for student use.

761. Smith, Alistair. "Dürer and Bellini." *The Burlington Magazine* (May 1972): 326–329.

Examines Camerarius's tale (1532): published in his Latin translation of the *Four Books of Human Proportion* of Giovanni Bellini's supposedly asking Dürer for "one of the brushes that you draw hair with," maintaining that it is a recasting of Pliny's story of the rivalry between Apelles and Protogenes of Rhodes, who drew lines of ever-decreasing thickness on top of one another.

762. ———. "*Germania* and *Italia*: Albrecht Dürer and Venetian Art." *Royal Society of Arts Journal* 127, no. (April) (1979): 273–290.

[The Fred Cook Memorial Lecture.] An interesting but unconvincing attempt to prove that Dürer made only one trip to Italy—the one documented by his letters to Pirckheimer from Venice

(1505–1507). This involves redating all of the landscape watercolors, and maintaining that the dated (1495) drawing of a woman in Venetian costume was made in Nürnberg by utilizing a gown made in Venice and shipped north for Agnes. (The author does not explain how the fittings for the gown were accomplished, still less how the woman in the drawing, whom he presumes to be Agnes, managed to find a Venetian hairdresser in Nuremberg.) Smith purports to believe the *Death of Orpheus* drawing a private joke, its meaning no longer accessible, but thinks the Orpheus a portrait of Pirckheimer.

763. Smith, David R., and Liz Guenther. *Realism and Invention in the Prints of Albrecht Dürer*, Durham (NH)/Hanover/London: University Press of New England, 1995.

The catalogue of an exhibition featuring a selection of Dürer's prints from the Boston Museum of Fine Arts and from the museums of several New England colleges and universities. Smith, a member of the Department of Art and Art History at the University of New Hampshire, is responsible for essays titled "A Sketch of Albrecht Dürer" (vi), and "Dürer's Wit" (1–7), based on the literary theories of the early Soviet critic Mikhail Bakhtin; Guenther, a doctoral candidate at Princeton whose approach follows that of Hayden White, contributed a lengthier essay on "Dürer's Narrative Style" (8–14). Smith and two New Hampshire alumnae were responsible for individual catalogue entries on the single-sheet prints included in the exhibition (there are no individual entries for any of the prints from the narrative cycles—selections from the *Large* and *Small Woodcut Passions*, the entire *Marienleben* (from the Bowdoin College collection) and the *Engraved Passion*. No information on provenance beyond current ownership is offered, and no assessment of print quality.

764. Smith, Elise Lawton. *The Paintings of Lucas van Leyden*. Ph.D. dissertation, University of North Carolina, 1981.

In presenting a comprehensive stylistic and iconographic analysis of seventeen paintings attributed to Lucas, and numerous copies after lost paintings, finds Dürer's influence to be a critical factor in the development of the Dutch artist's handling of space and the human figure.

765. Smith, Graham. "Bronzino's Use of Prints: Some Suggestions." *Print Collector's Newsletter* 9, no. 4 (September–October) (1978): 110–113.

The author notes that in his early works Bronzino was influenced by Albrecht Dürer's graphic art, while in his later period he tended to utilize only Italian sources.

766. *New Perspectives on the Art of Renaissance Nuremberg: Five Essays*, Ed. Jeffrey Chipps Smith. Austin, TX: University of Texas—Archer M. Huntington Art Gallery, 1985.

The five papers in this volume were presented at a symposium held at the Archer M. Huntington Art Gallery as an accompaniment to the exhibition titled "Nuremberg, a Renaissance City," catalogued (q.v.) and arranged by the editor. Included are an introduction to sixteenth-century Nuremberg by the editor; Larry Silver, "Prints for a Prince" (on the woodcuts for Maximilian); Thomas Da Costa Kauffmann, "Hermeneutics in the History of Art: Remarks on the Reception of Dürer in the sixteenth and early seventeenth centuries;" Christiane Andersson, "Polemical Prints in Reformation Nuremberg;" Keith Moxey, "The Social Function of Secular Woodcuts in Sixteenth Century Nuremberg;" and "The Transformations of Patrician Tastes in Renaissance Nuremberg," by the editor. A sixth paper by Richard Field was not included, due to its author's prior commitments. [See commentary on individual entries.]

767. Smith, Jeffrey Chipps. "The Transformation of Patrician Tastes in Renaissance Nuremberg." *New Perspectives on the Art of Renaissance Nuremberg: Five Essays*, 82–100. Ed. Jeffrey Chipps Smith. Austin, TX: University of Texas—Archer M. Huntington Art Gallery, 1985.

Discusses changing patronage of the arts by the wealthy merchant families of Nuremberg, from the pre-Reformation activities of Sebald Schreyer and Mattheus Landauer to Leonhard Hirschvogel, Willibald Imhoff, Paulus Praun, and Martin Peller. Includes works by Adam Kraft, Peter Vischer the Elder, Peter Flötner, and Georg Pencz, Erhard Schön, Johann Gregor von Schardt. Stylistic changes in architecture, sculpture, and goldwork from late Gothic to Renaissance taste. Of particular interest is the unique collection

of Dürer's work in the possession of Willibald Imhoff, the grandson of Dürer's friend Pirckheimer, whose 1573 inventory is of critical importance for the documentation of Dürer's work.

768. Smith, Molly. "On the Significance of Albrecht Dürer's *St. Anthony Before a City.*" *Kresge Art Center Bulletin* 9, no. 2 (December 1975): 5–10.

Relates the print to Matthew 5:14: "Ye are the light of the world. A city that is set on a hill cannot be hid." Proposes that the city view is a composite of several cities Dürer knew, and that the artist's purpose in making the print grew from his understanding of the role of St. Anthony in religious history.

769. Smith, Robert. "Dürer as Christ?" *Sixteenth Century Journal* 6, no. 2 (1975): 26–36.

The author, from Flinders University of South Australia uses internal evidence to suggest that the *Self Portrait* drawing [formerly] in Bremen is a mirror image precluding the melancholic significance that Panofsky thought to see in Dürer's gesture toward a spot at one side of his torso where the spleen would have been located had a mirror not been used. Smith suggests instead that it may be part of the artist's self-identification with Christ of the Passion.

770. Sohm, Philip L. "Dürer's *Melencolia I*: The Limits of Knowledge." *Studies in the History of Art: National Gallery of Art* 9 (1980): 13–32.

A well-documented study by a younger scholar now a professor in Toronto. He reviews the previous literature, accepting the pairing of the print with the *St. Jerome in His Study*, and reads it as a temporal sequence, with an implied past and a depicted present. He joins K. Rossmann (in the Festschrift for Karl Jaspers (Munich, 1953) and Konrad Hoffmann (q.v.) in rejecting Panofsky's theory of the influence of Agrippa von Nettesheim, who characterized the melancholic state as a "frenzy." Noting that the distance between the points of the commpass held by Melancholy is precisely equal to the radius of the sphere at her feet, as well as to one third of the rainbow's radius, he maintains that Melancholy, having already measured earthly quantities with the tools and instruments of geometry, has failed to recognize the clues to God's existence until

the arrival of the comet and the rainbow, at which time the saturnine bat is frightenend away by divine light.

771. Sonnenburg, Hubertus von, and Bruno Heimberg. "Säureanschlag auf drei Dürer-Werke in der Alten Pinakothek in München." *Restauro. Zeitschrift für Kunsttechniken, Restaurierung und Museumsfragen* 96, no. 1 (1990): 13–21.

Gives the details of the vandalism of three of Dürer's paintings by fifty-one-year-old Hans Joachim Bohlmann, a retired chemical plant worker who arrived in Munich from Hamburg by train on April 21, 1988 and went directly to the Alte Pinakothek, carrying two bottles of concentrated sulfuric acid concealed in his suit pockets. The three paintings—the *Glimm Lamentation*, the *Paumgartner Altar,* and the standing *Mater Dolorosa*, all of them unglazed, were hanging side by side in the southwest corner of the gallery. There have been *twenty-three* such attacks in different north German museums, but Munich's was the most damaging; within seconds Bohlmann had splashed the paintings in twelve places before two boys, Niklas Schäfer (sixteen) and Michael Wiese (fifteen) grabbed his arms. He warned them quietly to be careful of the acid, and allowed himself to be led away. Fortunately, scientists from the Dörner Institute were then in the Alte Pinakothek's depot and were on the scene in minutes, laying the injured paintings flat and removing their frames in order to minimize the spread of the acid, which was then neutralized by ion-exchange. Keeping the paintings at thirty-five percent humidity, a complete photographic record, infrared examination and chemical analysis were made, and the irreparably damaged areas of pigment were removed and the ground covered with beeswax. The paintings were allowed to dry thoroughly before restoration could begin in the fall of 1989. In a second article in the same issue, Von Sonnenburg recommends the use of nonreflective glass, both as protection against vandalism and because of its ability to double the life of the varnish layer ("Die Verglazung von Gemälden," pp. 22ff.). On the Munich acid attack see also Burmester and Koller in *Restauro* 1990. And the 1998 exhibition catalogue, *Albrecht Dürer: Die Gemälde der Alten Pinakothek*, esp. chapter 7, "Die Retusche des Verlustes," by Bruno Heimberg and Andreas Burmester (pp. 126–135)

772. Spohrhahn-Krempel, Lore, and Wolfgang von Stromer. "Das Handelshaus der Stromer von Nürnberg und die Geschichte der ersten deutschen Papiermühle." *Vierteljahrschrift für Sozial- und Wirtschaftsgeschichte* 47 (1960): 81–104.

A history of Germany's first paper mill, founded in Nuremberg in 1390 by Ulmann Stromer—more than a half century before the invention of the printing press. A ready supply of relatively inexpensive paper was a necessary prelude to the development of the graphic arts in Nuremberg.

773. Sprigath, Gabriele. "Man wirt euch fortan mit einer newen logiken bescheichen." *tendenzen* 12, no. June/July (1971): 121–127.

Article in a left-leaning West German periodical published in Munich during the summer of Dürer Year 1971, discussing the excessive expense of the Nuremberg festivities and the exploitation of the artist's image ("Dürer statt Führer") to further the hidden agendas of such sinister institutions as the Dresdner Bank and the Dorland Agency.

774. Springer, Anton. "Inventare der Imhoff'schen Kunstkammer zu Nürnberg." *Mittheilungen der kaiserliche u. königliche Central-Commission zur Erforschung und Erhältung der Baudenkmale* 5 (1860): 352–357.

The inventory of the collection of Willibald Imhoff the Elder (1519–1580). Willibald Pirckheimer's grandson, who also was the patron of the Dürer copyist Hans Hoffmann.

775. Springer, Jaro. *Albrecht Dürers Kupferstiche in getreuen Nachbildungen*, Munich: Holbein-Verlag, 1914.

One of the earliest catalogues of the prints with excellent reproductions. Treats only the intaglio prints (102); appendix with seven rejected prints.

776. Stafski, Heinz. "Zur Rezeption der Renaissance in der Altarbaukunst Süddeutschlands." *Zeitschrift für Kunstgeschichte* 41 (1978): 134–147.

Does not deal directly with Dürer, but offers valuable insights into the reception of Renaissance style in Nuremberg and Augsburg by Hans Daucher, Hans Burgkmair, Loy Hering, Daniel Hopfer, and Hans Degler.

777. Städtische Galerie Altes Theater Ravensburg, Fürstlich zu Wald-
burg Wolfegg'sche Kunstsammlungen, Wolfegg. *Von Schongauer
zu Rembrandt. Meisterwerke der Druckgraphik aus der Sammlung
der Fürsten zu Waldburg-Wolfegg*, 46–55. Bernd M. Mayer, Peter
Eitel, Michael Schauder, and Peter Schmidt. Ostfildern (Ruit) bei
Stuttgart: Gerd Hatje, 1996.

The scholarly catalogue of an exhibition of master prints from the
collection of the Princes of Waldburg-Wolfegg, held at the Städtis-
che Galerie Altes Theater in Ravensburg (November10–January
12, 1997). Includes fully documented entries for all prints, among
them Dürer's *Madonna with the Grasshopper* (B.44); *Hercules
and the Molionides* (B.127); the *Large Hercules* (B.73); the *Coat
of Arms of Death* (B.101); the *Desperate Man* (B.70); and the *Rhi-
noceros* (B.136). This important collection, begun approximately
1640 by Truchsess Max Willibald von Waldburg (1604–1667), and
one of the oldest and most important remaining in the possession
of the same noble family, is not normally open to the public.

778. Stechow, Wolfgang. "Alberti Dureri Praecepta." *Studies in the His-
tory of Art* [1] (1971): 81–92.

The English edition of the author's lecture, given in German at the
opening of the Nuremberg exhibition (May 21, 1971) and pub-
lished in German in the *Anzeiger des Germanischen Nationalmu-
seums* (1971–1972), 11ff. In a welcome relief from the xenophobic
publications of the previous generation, Professor Stechow, one of
the German art historians who emigrated to the United States dur-
ing the Third Reich, stressed the international aspects of Dürer's
art and life, as not only the Praeceptor Germaniae, but his address
to Europe and the future in the inscriptions on his engraved por-
traits of the last years; his awareness of his audience as consisting
of the simple as well as the educated; his awareness of the gift of
artistic genius and its attendant responsibilities. Includes his rela-
tionships to his actual pupils as well as his reception in future cen-
turies.

779. ———. "Die Chronologie von Dürers Apokalypse und die En-
twicklung von Dürers Holzschnittwerk bis 1498." *Jahrbuch der
philosophischen Fakultät der Georg August-Universität zu Göttin-
gen* 2, no. Historisch-Philologisches Abteilung No. 27 (1922):
165–169.

An excerpt from the author's doctoral dissertation (Göttingen 1921: typescript. U 22.3560). Stechow, who became better known later for his publications on Dutch seventeenth-century painting, used stylistic analysis in an attempt to determine the chronological sequence in which the various blocks of the Apocalypse series had been designed, envisioning those with a lingering medieval *horror vacui* as earlier than those in which the images were larger and more clear-cut.

780. ———. *Dürer and America*. Washington, D.C.: National Gallery of Art, 1971.

Distributed as a separately bound essay with the catalogue of the National Gallery's 1971 exhibition of the same name, and bound into the hardback Macmillan edition (also 1971). Reviews Dürer's own fascination with the exhibition of pre-Columbian art sent by Cortez, which he saw in Brussels in 1520, and publishes for the first time the history of American collecting and commentary on Dürer, including an essay by the nineteen-year-old Oliver Wendell Holmes.

781. ———. *Northern Renaissance Art 1400–1600*, 86–125. Sources and Documents in the History of Art, Gen. Ed. H. W. Janson, Englewood Cliffs/London/Sydney/Toronto/New Delhi/Tokyo: Prentice-Hall International,

The section on Dürer contains fresh translations into modern English of selected documents including the *Family Chronicle*; portions of the letters from Venice to Pirckheimer; the letters to Jacob Heller of Frankfurt regarding the painting of his altarpiece, now lost; selected entries from the *Netherlandish Diary*; brief portions of the theoretical writings; two letters to the unknown "ghost writer" (Hans Ebner?) who was working with him on the Dedication for the *Unterweysung der Messung*. In addition, there are a citation each from publications by Erasmus of Rotterdam and Joachim Camerarius concerning Dürer.

782. ———. "Recent Dürer Studies." *The Art Bulletin* 56 (1974): 259–270.

Essential reading. Reviews the forty-two publications generated by the Dürer Year 1971–1972, including exhibition catalogues, published in both eastern and western Europe and in America.

These works had appeared too late for inclusion in Matthias Mende's comprehensive Dürer bibliography (q.v.), which had gone to press in 1970 and is itself reviewed here. The most extensive review is that of Anzelewsky's catalogue raisonné of the paintings (*Das malerische Werk*). Also included are reviews of various items of research on the prints and drawings, the artist's life and interests, and the colloquium papers presented in East and West Germany.

783. Steck, Max. *Albrecht Dürer als Kunsttheoretiker. Die geistes- und problemgeschichtliche Stellung seiner Proportionslehre im Kunstraum der Renaissance,* Zürich: Dietikon, 1961.

Commentary by the leading authority on Dürer as mathematician and scientist, which accompanies the Dietikon facsimile edition of the *Four Books of Human Proportion* (1961, q.v.).

784. ———. *Dürers Gestaltlehre der Mathematik und der bildenden Künste,* Halle/Saale: 1948.

Still the best introduction to Dürer's geometry.

785. Steinbock, Wilhelm. " 'Dz hab ich gfisyrt"; Bemerkungen zu Dürers *Liegendem weiblichen Akt* von 1501 in Wien." *Jahrbuch des Kunsthistorischen Institutes der Universität Graz* 9/10 (1974): 185–193.

"This I constructed": notes on the artist's *Reclining Female Nude* of 1501 in Vienna.

786. Steinmann, Martin. "Regiomontanus und Dürer—eine Handschrift mit berühmten Vorbesitzern." *Baseler Zeitschrift* 79 (1979), 81–89.

Concerns a copy of Witelo's (Vitellius's) *De perspectiva* (Basel, University Library) once owned by Regiomontanus, and later by Erasmus Flock and Dürer.

787. Steinraths, F. J. E. "Der Paumgärtner—Altar der Alten Pinakothek in München und andere Memorialetafeln Albrecht Dürers aus der Zeit um 1500." *Kunstchronik,* 1998.

Deals with state of research and open questions regarding the Glimm *Lamentation* and Holzschuher Epitaph.

788. Stejskal, Karel. "Novy Vyklad Dürerovy Apokalypsy." *Uméni* 14 (1966): 1–64.

("A New Interpretation of Dürer's *Apocalypse*," in Czech.) Supports interpretations by Max Dvorák (1928) and Rudolf Chadabra (1964, q.v.)—specifically Chadabra's arguments maintaining that the *Apocalypse* was a harbinger of the Reformation [Parshall & Parshall]. (For a refutation of this idea, which the present writer finds untenable, see also R. F. Timken-Zinkann, 1972.)

789. Sternath, Hermann. "Die grosse Schau der kleine Unterschiede." *Weltkunst*, no. 11 (June) (1985): 1598–1601.

Review of the Albertina's exhibition of Dürer's plant and animal studies, arranged by Fritz Koreny, who also wrote the catalogue (q.v.). The reviewer stresses the importance of the exhibition, and the fact that—*mirabile dictu*—no anniversary is being commemorated. The show and its catalogue are the culmination of decades of scholarly research, undertaken after it became clear at the time of the 1971 anniversary year that surprisingly little genuine research had ever been done on the plant and animal watercolors. The reason for this lack was perfectly clear: big problems of attribution stood in the way. These works had been so treasured since the sixteenth century that many copies and imitations had been made. Exhibited were ninety-three items—seventy-seven on loan. Thirteen studies of the *Wild Hare*—some copies, some free variations by Hans Hoffmann, Georg Hoefnagel; four *Blue Rollers* and one variant by Hoffmann. The provenance of the Albertina's collection is given (ex coll. Willibald Imhoff, who owned them by 1545 and permitted his friend Hofmann to see them and, perhaps, to begin already making copies even before going to the court of Rudolf II in Prague where, with Hoefnagel, he made more.) From Rudolf's collection the Dürers and their progeny passed to Duke Albert of Sachsen-Teschen, the founder of the Albertina.

790. Strasbourg: Cabinet des estampes. Catalogue by *Les choix d'un amateur d'estampes: gravures sur cuivre de la collection Robert Stehelin*, Nadine Lehni. Strasbourg: Cabinet des estampes and Bibliothèque des musées, 1977.

Catalogue of 113 objects from the print collection of Robert Stehelin, containing work by Dürer among others.

791. Strauss, Gerald. *Nuremberg in the Sixteenth Century: City Politics and Life between Middle Ages and Modern Times*, 2nd ed. Bloomington (IN)/London: Indiana University, 1976.

A reliable political history of Nuremberg in Dürer's day, by one of the most eminent American historians in the field of early modern German studies.

792. Strauss, Walter L. *Albrecht Dürer: Intaglio Prints, Engravings, Etchings & Drypoints*, New York: Kennedy Galleries, 1975.

Reprints plates and other material used in the Dover volume (1972) by the same author. Includes catalogue text, bibliography, and index. Strauss, who held a doctorate in mathematics, was an award-winning designer of children's toys who published widely on Dürer in later life. He was both publisher and general editor of *The Illustrated Bartsch* series (New York: Abaris Books).

793. *Albrecht Dürer—The Painter's Manual 1525*, Ed. Walter L. Strauss. New York: Abaris Books, 1977.

A useful publication reproducing in facsimile the artist's *Unterweysung der Messung* (The Manual of Measurement), with a translation in modern typeface on each facing page. A well-documented Introduction explains the background of the artist's research and writing, his concern for the classics, and his several preliminary drafts, one of which is the manuscript titled *Speiss für Malerknaben* (Food for Young Painters, 1512). The author also calls attention to Dürer's letter dated December 5, 1524, to the mathematician-astronomer Nikolas Kratzer at the court of Henry VIII, enquiring as to the status of his projected Euclid translation. [Reviewed by Marco Magnifico in *Print Collector (Il Conoscitore di Stampe)* 45 (1980), 41–43.]

794. *The Book of Hours of the Emperor Maximilian the First Decorated by Albrecht Dürer, Hans Baldung Grien, Hans Burgkmair the Elder, Jörg Breu, Albrecht Altdorfer, and Other Artists*, Ed. Walter L. Strauss. New York: Abaris Books, 1974.

Complete facsimile edition in full color of the prayerbook commissioned by the emperor—a limited edition printed with moveable type, adorned with hand drawn marginal illustrations in colored inks, by a "consortium" of artists. Includes both the Besançon and Munich portions combined in one volume, as well as translations of the Latin text; detailed commentary; biography of Maximilian, and history of the Prayerbook. [Reviewed by Michael Greenhalgh in *Apollo* 101, no. 156 (February 1975), 145–146;

Michael Levey in *Burlington Magazine* 118, no. 876 (March 1976), 162–163].

795. Strauss, Walter L. *The Complete Etchings, Engravings and Drypoints of Albrecht Dürer*, New York: Dover, 1972.

A convenient and inexpensive general introduction to Dürer's intaglio prints.

796. ———. *The Complete Drawings of Albrecht Dürer*, 6 vols. New York: Abaris Books, 1974.

Unlike the classic four-volume catalogue of Friedrich Winkler (q.v.), whose numbers are the ones generally in use for identification of Dürer's autograph drawings, the Strauss catalogue includes not only the universally accepted drawings but all those attributed to the artist over time. It divides the works into "File," or study drawings; "Preparatory" drawings made prior to the execution of a particular project; and "Autonomous" drawings, of a relatively finished nature, which are seemingly unrelated to any known work. This feature has been criticized as both arbitrary and confusing, as it is not always entirely evident to which category a particular drawing originally may have belonged, for in at least a few cases a drawing may have served more than one of these functions. A more useful feature is the generous selection of documents, translated into modern English, that form the armature of the catalogue, placing the drawings in chronological order. Strauss also reproduces some genuine Dürer drawings that Winkler did not have access to (e.g., the beautiful portrait of *A Carmelite Nun, "Mechtild,"* done in Antwerp in November of 1520), and also reproduces the versos of some drawings not illustrated by Winkler. [Reviewed by John Rowlands in *Apollo* 102 (December 1975), 482–483; Donald Kuspit in *Art in America* 63 (September 1975), 125; Charles Talbot in *Master Drawings* 14, no. 3 (Autumn 1965), 287–299; George Szabo in *Art News* 74 no. 9 (November 1975), 42–43; Christopher Brown, *Times Literary Supplement* 3891 (October 8, 1976) 1275. See also Bräutigam and Mende, "Mähen mit Dürer," 1991.]

797. *The Human Figure by Albrecht Dürer. The Complete Dresden Sketchbook*, Ed. and trans. Walter L. Strauss. New York: Dover, 1972.

A convenient and inexpensive edition reproducing the set of measured drawings of human proportion that the artist made in 1507, and corrected in 1509 after his return from the second trip to Italy (Dresden, Sächsische Landesbibliothek). All previous studies of this sketchbook, which contained basic research for his posthumously published *Four Books of Human Proportion* (Nuremberg, 1528), were in German, the most important being that of Robert Bruck (1905). This useful English translation is by Strauss, who had been born in Nuremberg and was still fluent in German after more than thirty years' residence in New York.

798. Strauss, Walter L. "The Passion of Christ in the Printed Image: Random Thoughts about its Meaning and Standardization." *A Tribute to Lotte Brand Philip*, 193–204. New York: Abaris, 1985.

On the basis especially of prints by Dürer, Schongauer, and Rembrandt, examines the extent to which artists were able to illustrate and convey the meaning of the Passion of Christ. Prints discussed are the *Last Supper* woodcuts (1510 and 1523); the *Crucifixion*s from the Large Passion and Engraved Passion; *Ecce Homo* from the Engraved Passion; *Bearing of the Cross* from the Small Passion and the Engraved Passion; *Resurrection* from the Engraved Passion.

799. *Sixteenth Century German Artists: Albrecht Dürer*, Ed. Walter L. Strauss. The Illustrated Bartsch, 10. New York: Abaris, 1980.

The illustrations pertaining to Volume 7 of Adam Bartsch's original *Le peintre-graveur.*

800. Strauss, Walter L. *Sixteenth Century German Artists: Albrecht Dürer*, The Illustrated Bartsch, Commentary Volume 10. New York: Abaris, 1981.

This volume, by the general editor of the Illustrated Bartsch series, who was also its publisher, provides commentary on each of the prints by Dürer that were listed in Adam Bartsch's *Le peintre-graveur*, all of which were illustrated in the Plate Volume 10 of the present series, and also discusses and illustrates all known copies and forgeries, as well as genuine prints by Dürer that were not known to Bartsch. A table of repositories and a generous bibliography are included.

801. ———. "St. Catherine and St. Barbara." *Master Drawings* 10, no. 1 (1972): 19–20.

The author uses a sundered watermark to prove conclusively that these two drawings (W.90 and W.194) were drawn on the same sheet of paper.

802. ———. "The Wherewithal of Witches." *Source* 2, (Winter) (1983): 16–22.

Discusses the hallucinogenic "flying ointments" and incense purportedly used by witches in regard to Hans Baldung's *Study for the Bewitched Groom* (1544: Basel, Kupferstichkabinett) in the context of the so-called *Four Witches* and the *Witch Riding Backwards* by Dürer, as well as depictions of witches by Urs Graf, Hans Franck, and Albrecht Altdorfer. Cites an entry in the record of the Nuremberg City Council (February 15, 1515) reporting the exorcism held at a deserted house in the Judengasse in order to bring a stop to the "demoniac" activities causing disorder and fear among the populace.

803. ———. *The Woodcuts and Woodblocks of Albrecht Dürer*, New York: Abaris Books, 1980.

One of the earlier books on the graphic arts of Dürer brought out by this author at his own publishing company, this volume was produced in haste and with many typographical errors, and neglected to mention repositories for the woodcuts (although they are given for the blocks, which are illustrated in a section separate from the impressions to which they pertain). Does not address the question whether or not the artist cut his own early blocks. Attempts to arrange the woodcuts in chronological order, even when it means the deconstruction of a narrative series. Of interest are the bibliography and facsimile watermarks of Dürer's papers, and of the watermarks of posthumous impressions. Each woodcut is illustrated, discussed, and provided with its own bibliographical references, and there is a concordance to the catalogue numbers of Bartsch, Kurth, Tietze, Panofsky, and Hind. [Reviewed by Peter Strieder in *Burlington Magazine* 124 (October 1982) 638–639; and by Jane Campbell Hutchison in *The Art Bulletin*, 64 (1982), 2, 332–336). Strauss's volume of commentary for *The Illustrated Bartsch* is a much superior reference work.]

804. Strickland, Diane Claire. *Maximilian as Patron: The Prayerbook.* Ph.D. dissertation, University of Michigan, 1980.

Discusses each of the examples of the prayerbook, which was printed with movable type but provided with differing hand-drawn marginalia by several artists in addition to Dürer.

805. Strieder, Peter. *"Albrecht Dürers Vier Apostel* im Nürnberger Rathaus." *Festschrift Klaus Lankheit,* 151–157. Ed. Wolfgang Hartmann. Cologne: M. DuMont Schauberg, 1973.

A documentary history of the painting, its place of installation in Nuremberg's City Hall, its acquisition by Maximilian of Bavaria in the early seventeenth century, and the replacement commissioned for it in 1627 from the painter Georg Gärtner. Cites in full Dürer's undated letter to the Nuremberg City Council offering the painting, one that he had done with unusual care, as a *"Gedächtnus"* (remembrance), and the actions of the Council dated October 5, 1526 acknowledging his gift, and October 6 asking him to name his price, or failing that, to accept an honorarium. A further entry in the city's account book for the year 1627 dealing with the acquisition of the painting by Maximilian of Bavaria states that the work had been a memorial honoring the Burgermasters Hans Volckamer and Lazarus Holzschuher and noting the amount of the honorarium given to the artist and his wife. Strieder discusses Josef Baader's unfounded suspicions of this last document (1862), and makes a convincing argument that Dürer had intended the work as a remembrance, not of particular individuals nor of the Reformation, but of his own ability and public spirit.

806. ———. *Albrecht Dürer: Paintings–Prints– Drawings*, New York: Abaris Books, 1982.

The author (b. 1913) was for many years Director of the Germanisches Nationalmuseum in Nuremberg, retiring in 1978. This is the first English edition of his general book on Dürer, and is a large, well produced volume containing commentary on eighty paintings, twenty-six of the watercolors, 162 of the prints, and 120 of the drawings in all media. The artist's life and personality; the city of Nuremberg, his stylistic development, and publications are discussed, and some of the documents are reproduced. Although the color work is less impressive than Alpine's production of the

Anzelewsky monograph (q.v.) it is important for its well-focused writing and its judicious selection and sensitive discussion of works, virtually all of which are universally accepted as the artist's own. [Reviewed by Graham Hughes, *Arts Review* 39, no. 24 (November 19, 1982), 616; John Rowlands, *Apollo* 118, no. 12 (July 1983), 112; Jean Michel Massing, *Burlington Magazine* 126, no. 981 (December 1984), 788–789.]

807. ———. "Communio Sanctorum. Albrecht Dürers *Anbetung der Heiligen Dreifaltigkeit* für die Kapelle im Zwölfbruderhaus des Matthäus Landauer." *Brückenschlagen 1902–1992 Bridgebuilding. Festschrift für Ferdinand Eckhardt*, 83–104. Nuremberg: Hans Carl, [1992].

(Has a brief English summary.) After his petulant letter to Jakob Heller renouncing the art of painting in favor of printmaking (August 26, 1509), Dürer accepted the commission for the *Landauer Altarpiece*, perhaps because Matthäus Landauer came from a family of painters—or, perhaps, because he was simply a more sympathetic client than Heller—but certainly because the chapel at the retirement home for twelve old gentlemen (designed by Hans Behaim the Elder) was small and new, and the altar would be the focal point of its square plan. Landauer purchased the land (November 18, 1501) along the old city wall near the Laufer Tor, and Behaim had erected the chapel in 1506/1507. Destroyed in World War II, it has been reconstructed. (The windows, which had been removed in the nineteenth century and sold to the Kunstgewerbe Museum in Berlin, were destroyed in World War II.) Dürer's altarpiece (Vienna, Kunsthistorisches Museum) was sold to Rudolf II in 1585 for seventy gulden—without its original frame, which remained behind and is now in the Germanisches Nationalmuseum. Strieder accepts Rasmussen's theory (dissertation, q.v.) that Ludwig Krug, not Peter Vischer, was the carver of the frame. He notes that the theme of the *Gnadenstuhl* (Throne of Grace, a Trinity image featuring the Crucified Christ) is without precedent in Nuremberg painting (most surviving fifteenth-century examples are Austrian rather than German), but finds a possible precedent in a 1449 triptych by an unknown painter from Wiener Neustadt, donated by Kaiser Friedrich III to the Spitalkirche zum Heiligen Geist in Bad Aussee, which was founded to care for old and disabled salt miners. He points out that the Holy Roman Emperor depicted is not Maximilian, whom Dürer always portrays wearing the Order of

the Golden Fleece. This figure wears the older collar of the Aragonese Order of the Jar, making reference to the marriage of Maximilian's son Philip to Joanna, the heiress to Castile and Aragon, and to their son, the future Charles V (Duke of Burgundy since 1506 and nominal King of Castile). The man in golden armor wears the Brandenburg Order of the Swan-Knight and a small enamel wreathed Madonna on his collar with the arms of the Haller family (Landauer's son-in-law, Wilhelm Haller, owned one like it). The veiled woman in red with expensive jewelry is probably Haller's wife—who shortly afterward left their stormy marriage and had it annulled by the Bishop of Bamberg (1514). The altarpiece depicts the *Communio Sanctorum*—the fellowship of living Christians with the company of saints—a concept well known in the West since the fourth century, and not exclusive to St. Augustine's *City of God* as Panofsky and others have assumed. This permitted the artist to abandon Nuremberg's awkward tradition of shrunken donor families in favor of large figures portrayed from life. A fragment of one of the cartoons for the windows has survived (a *Fall of the Rebel Angels*: Boston Museum of Fine Arts), sometimes attributed to Dürer or to Hans van Kulmbach.

808. ———. "Die Bedeutung des Porträts bei Albrecht Dürer." *Albrecht Dürer. Kunst einer Zeitenwende*, 84–100. Ed. Herbert Schade. Regensburg: Pustet, 1971.

The author's paper for the symposium sponsored by the Bavarian Catholic Academy held in Nuremberg in Dürer Year 1971.

809. ———. "Dürer, Albrecht." *Dictionary of Art*, 427–447. London: Macmillan & Co., 1996.

The most recent major encyclopedia entry on the artist. Discusses life and work; working methods and techniques; theoretical writings; character and personality; critical reception and posthumous reputation. Separate sections on Hans Dürer (445); and on the so-called Dürer Renaissance (by Matthias Mende: 445–447). Selective bibliography, divided by subject: Dürer's own writings; monographs and catalogues raisonnés; exhibition catalogues; facsimile editions; reproductions; bibliographies.

810. ———. *Dürer. Mit Beitragen von Gisela Goldberg, Joseph Harnest, und Matthias Mende*, Königstein im Taunus: Verlag Langewiesche, 1981.

A monograph on the artist's life and work, well illustrated. In-cludes contributions on the technical examination of the so-called *Four Apostles* (Munich, Alte Pinakothek); Dürer and perspective; and writings by and about Dürer. Later translated into English and published by Abaris Books, New York (q.v.) and in London by Muller (1982). [Review of the English edition by Michael Baxan-dall, *London Review of Books*, 5 (March 17–31, 1983), 16–17.].

811. ———. *Dürer. Mit Beiträgen von Gisela Goldberg, Joseph Harnest, Matthias Mende*, Augsburg: Bechtermünz, 1996.

This is an update of the Königstein/New York editions, and is the best all-around "life and work" volume available, despite the somewhat uneven color reproduction. The layout and text are iden-tical to the New York edition in all but very minor respects: some small changes in the notations accompanying the reproductions, and in the Bibliography. No mention is made of the sulfuric acid damage to the Paumgartner Altar, the Glimm *Lamentation,* and the *Mater Dolorosa* in Munich in 1988, however, or of the fact that several of the watercolors missing from Bremen since World War II are now known to be in Russia. Strieder does not accept Lotte Brand Philip's attribution of the *Portrait of Barbara Dürer* (Nuremberg) to Albrecht Dürer (Willibald Imhoff, who once owned it, also had grave doubts about it).

812. ———. *The Hidden Dürer*, Oxford: Oxford University Press, 1978.

A generously illustrated book for the general reader.

813. Strieder, Peter, et al. *Meister um Albrecht Dürer*, Nuremberg: Ger-manisches Nationalmuseum, 1961.

An essential work. The final exhibition in a series that began in 1928 with works of Nuremberg artists who were active in Dürer's youth; followed in 1931 by an exhibition of Nuremberg painting from 1350–1450. This exhibition was a major one, with many in-ternational loans, presenting the work of Dürer's workshop and his followers, including Hans Baldung Grien, the Beham brothers, Hans Dürer, Nikolaus Glockendon, Hans Suess von Kulmbach, Hans Leu, Georg Pencz, Hans Plattner, Hans Schäufelein, Hans Springinklee, Wolf Traut, and such anonymous artists as the Mas-ter of the Ansbach *Christ in the Winepress*, and the Master of the

altar made for the Humanist Sebald Schreyer (Heilig-Kreuz-Kirche, Schwäbisch-Gmünd.) The contents include an important introductory essay by Peter Strieder, and an extensive bibliography for each painter, in addition to the more than four hundred works exhibited—paintings, drawings, prints, and stained glass.

814. Strieder, Peter. "Noch einmal zu Albrecht Dürers Kaiserbildern." *Anzeiger des Germanischen Nationalmuseums* (1979): 111–115.

A critique of Franz Winzinger's article, "Umstrittene Werke Albrecht Dürers: die Kaiserbilder" in *Zeitschrift für Kunstwissenschaft* 31, 1–4 (1977), 17–50. Concludes that the half-length portraits in private ownership and the life-size kneeling figures of the Emperors Charlemagne and Sigismund in the Germanisches Nationalmuseum Nuremberg cannot have been painted by the same artist. Dürer was paid for the pictures in large format by the city of Nuremberg in 1511.

815. ———. "*Schri.kunst.schri.und.klag.dich.ser*–Kunst und Künstler an der Wende vom Mittelalter zur Renaissance." *Anzeiger des Germanischen Nationalmuseums* (1983): 9–26.

(The lament for art, "Schri.kunst . . ." is from the inscription on the Tiefenbronn *Altarpiece of Mary Magdalene*, signed by Lukas Moser and dating from the fifteenth century.) Essay on the changing social and political role of the German artist in the period of transition marking the arrival of the Renaissance and beginning of the Reformation. Argues that seventy-five years after Moser, Dürer expressed much the same complaint in simpler terms in one of his letters to Jakob Heller (Rupprich I, p. 72). The word *Kunst* has a new meaning for Dürer: not just manual dexterity (that is *Brauch*), but a combination of *ars* and *scientia* that gives new standing to artistic ability In addition to Dürer, treats Lucas Cranach, Tilmann Riemenschneider, Matthias Grunewald, and Jerg Ratgeb.

816. ———. *Tafelmalerei in Nürnberg 1350–1550*, Königstein: Langewiesche, 1993.

The definitive work on two centuries of Nuremberg painting, including Dürer, his forebears and his followers. Introductory essays on the political and economic situation; individual painters and workshops; a catalogue section with complete documentation on each painting; a valuable set of indices, including one arranged by

location. Completely and splendidly illustrated, with liberal use of excellent color.

817. ———. *Vorbild Dürer: Kupferstiche und Holzschnitte Albrecht Dürers im Spiegel der Europäischen Druckgraphik des 16. Jahrhunderts*, Nuremberg: Germanisches Nationalmuseum, 1978.

Catalogue of an exhibition of 223 works illustrating Dürer's example: the influence of his woodcuts and engravings on the graphic arts in sixteenth-century Europe. The suggestion is made (158) that the *Madonna by the Wall* (B.40) was developed as a counterpoint to the *Melencolia I*. Reviewed by Peter-Klaus Schuster in *Kunstchronik* 31 no. 12 (December 1978), 465.

818. ———. "Wolgemut, Michael." *Dictionary of Art*, London: Macmillan & Co., 1996.

A welcome addition to the sparse literature in English on Dürer's teacher.

819. ———. "Zur Nürnberger Bildniskunst des 16. Jahrhunderts." *Münchner Jahrbuch* 7 (1956): 120–168.

Situates Dürer's activity as portraitist in the context of earlier and later Nuremberg work. It was he who introduced the profane portrait-diptych format, and who trained important painters of the next generation. Included are fine portraits by anonymous artists (those of Hans and Barbara Straub; Johann and Magdalena Neudörfer; Volker Coiter) as well as those by known artists (Hans Plattner, Nicholas Neufchatel and Hans Hoffmann).

820. Strocka, Volker Michael. "Die Persönlichkeit des Hausbuchmeisters und sein Einfluss auf das Werk Dürers." *Kunstchronik* 25, no. 7 (1972): 186–188

[A paper presented at the 1972 Nuremberg symposium, "Problemen der Kunst Dürers zwischen 1490–1500."] Strocka, who proposed an identification between the Housebook Master, the Master WB, and Wolfgang Peurer, or Beurer (see *Argo. Festschrift für Kurt Badt*, Cologne, 1970, 249–260), discussed Dürer's early drawings W.17, 38, 41, 44, and 56 in terms of the influence of Wolfgang Beurer's 1484 *Rider*, and several of the Housebook Master's drypoints (esp. L.69, *The Stag Hunt*), offering the interesting suggestion that Beurer may have been Dürer's unknown "Strassburg Master" whose portrait, now lost, is listed in Willibald

Imhoff's inventory. The paper was well received, but Anzelewsky and Winzinger questioned whether it would have been possible for the young Dürer to have seen the drypoints, and cautioned against too great reliance on the "Wolfgang Peurer" *Rider*.

821. Stromer, Wolfgang von. "Innovation und Wachstum im späten Mittelalter: Die Erfindung der Drahtmühle als Stimulator." *Technikgeschichte* 44 (1977): 89–120.

The technical history of the development of wire-drawing mills, such as the one on the Pegnitz in the outskirts of Nuremberg portrayed in one of Dürer's watercolors (Berlin).

822. ———. "Nuremberg in the International Economics of the Middle Ages." *The Business History Review* (Cambridge MA) 44 (1970): 210–225.

Nuremberg's ranking internationally on the eve of Dürer's birth.

823. ———. "Nürnbergs wirtschaftliche Lage im Zeitalter der Fugger." *Albrecht Dürers Umwelt. Festschrift zum 500. Geburtstag*, 9–19. Eds. Gerhard Hirschmann and Fritz Schnelbögl. Nürnberger Forschungen, 15. Nürnberg: Verein für Geschichte der Stadt Nürnberg, 1971.

Discusses Nuremberg's economy in comparison to the greater and more cosmopolitan wealth of Augsburg in the age of the Fugger and Welser families. Gives comparative net worth of Dürer's friend Dr. Christoph Scheurl, and of other prominent Nuremberg families including Tucher, Holzschuher, Koberger, Imhof, Tetzel, and Hirschvogel; background of the city's toll-free status; the Fondaco dei Tedeschi and trade with Milan, Genoa and Venice; the copper trade with Bohemia; commerce with Poland, Hungary, the Steiermark, Portugal, and the East Indies; importation of metals and Nuremberg manufacturing; the fame of the city's goldsmiths (including Dürer's grandfather, Heinz Holper, as well as his father and brother—citing Kohlhaussen's 1968 monograph [q.v.].

824. Strzygowski, Josef. *Dürer und der nordische Schicksalshain. Eine Einführung in vergessene Bedeutungsvorstellungen*, Heidelberg: Carl Winter's Universitätsbuchhandlung, 1937.

The date of publication of this volume, well into the Third Reich, as well as its rather florid title (literally, "Dürer and the Nordic Grove of Fate") should warn the reader that this is a work of histor-

ical interest only. The author, who as a younger man had done some highly respected work on early Christian and Byzantine art, fell under the spell of the *völkisch* movement in later years, writing a number of books on the supposed character and beliefs of the "Indogerman," or Aryan race. Most of them were published by this very press. Fortunately only the first two chapters have anything remotely to do with Dürer; in Chapter 1 the author discusses the Last Judgment section of the frame of the Landauer Altar, and in the following chapter the "holy area" of such compositions as the Madonna in a meadow or garden setting. The book concludes with a ringing endorsement of six landscape paintings by a female relative, Frau Herta Strzygowski.

825. Stuhr, Michael. "Zu den künstlerischen Vorstufen von Dürers *Vier Aposteln.*" *Kunst und Reformation*, 133–149. Ed. Ernst Ullmann. Seemann Beiträge zur Kunstwissenschaft, Leipzig: E.A. Seemann, 1983.

 [On the artistic preliminary stages of Dürer's *Four Apostles.*] Speculates particularly on the relationship between Dürer's so-called *Four Apostles* (Four Holy Men) of 1526 and Hans Baldung Grien's *Twelve Apostles* of 1512–1516 in Freiburg im Breisgau (Cathedral; formerly Minster).

826. Stuttgart, Staatsgalerie, Graphische Sammlung. *Meisterwerke alter Druckgraphik aus der Staatsgalerie Stuttgart; zum 100. Geburtstag des Stifters Max Kade*, Heinrich Geissler, Monika Kopplin, August Rave, and Thorsten Rodiek. Stuttgart: Staatsgalerei, 1983.

 Stuttgart's print collection is an important one, and this well-printed catalogue (consisting largely of full-page illustrations, each of which is accompanied by a paragraph of text) gives an idea of its quality. Twenty-four of Dürer's most famous engravings and woodcuts are exhibited (Cat. nos. 38–61) in fine impressions, with entries written by Geissler. Notable among the Max Kade collection's holdings is its superb early edition of the *Life of Mary* series, which appears to have belonged to the same set (although watermarks differ, all are early papers, and they are of equal print quality and are identically trimmed). Great rarities are the three broadsheets cut from the same block (*Death and the Landsknecht*, cat. 51) with their accompanying poetry, still uncut, and in impeccable

condition. The *Melencolia I* bears among others, the collector's mark of Pierre Mariette (1707).

827. Suckale, Robert. "Haben die Physiognomischen Theorien für das Schaffen von Dürer und Baldung eine Bedeutung?" *Festschrift Wolfgang Braunfels*, 357–369. Eds. Friedrich Piel and Jörg Traeger. Tübingen: Wasmuth, 1977.

Examines the question of meaning in the physiognomic studies of Dürer and Baldung, such as the profile heads. The first "Physiognomikon," from the school of Aristotle, and the second from Theophrastus of Eresos allege that the outward appearance is an index to man's moral, intellectual and physical qualities *and weaknesses*. Body and soul communicate interchangeably, and human beings partake of certain qualities of animals (wolfish, leonine, doglike, etc.). The theory was applied only to adult men, and was not judged useful for either women or children. Its practical application for the artist, especially for the portraitist, gave guidance on the size of eyes, color and type of iris, and general expression, and becomes intermixed with Galen's observations on the humors and their typical complexions. Discusses the printed literaure in German prior to Dürer, and his few written references to the temperaments ("feurig, luftig, wesserig, irdish": Rupprich III, 282) and to animal qualities of men (". . . als ein beer, wolf, fux oder ein hundt. . .") and his constructed heads with proportions departing from the ideal. Hans Baldung is the only other German artist who made such rows of heads.

828. Sutton, Denys. "Aspects of British Collecting, Part I: Early Patrons and Collectors." *Apollo* 114, no. 237 (November) (1981): 282–297.

Part I covers British collecting from medieval times to the execution of Charles I, who received Dürer's 1498 *Self Portrait* (now Madrid, Prado) and the portrait of *Albrecht Dürer the Elder* (now London, National Gallery) as presents from Thomas Howard, Lord Arundel. [For further commentary on Lord Arundel's Dürers, which included numerous drawings and prints, see David Howarth, *Lord Arundel and His Circle*, Yale, 1985.]

829. Swoboda, Karl M. *Das 16. Jahrhundert nördlich der Alpen*, Geschichte der bildenden Kunst, 6. Vienna: Schroll, 1980.

Discusses the fifteenth-century background for painting in Germany, Austria and the Netherlands in the first quarter of the sixteenth century, treats Dürer, Grünewald, the younger Holbein, and gives a survey of Netherlandish painting from Massys to Bruegel.

830. Szabó, George. "Dürer and Italian Majolica I: Four Plates with *The Prodigal Son amid the Swine.*" *American Ceramic Circle Bulletin* (1970): 5–28.

The author, now retired, at the time of publication was curator of ceramics in the Lehmann Collection at the Metropolitan Museum. This fascinating and well illustrated study deals with Italian Renaissance plates from the Lehmann collection (acquired by Lehmann from William Randolph Hearst), the Cleveland Museum, the Museo Civico in Bologna, and an example formerly in the Schloss Museum, Berlin, which was destroyed or lost during World War II. All are copied after Dürer's early engraving of the *Prodigal Son*—a piece that Vasari later singled out for particular praise on account of its "exotic" German architecture (now known to reflect the farmyard of the small manor house at Himpelshof, near Nuremberg). Dürer's engraving would have been available in the original, as well as—more probably—the reverse copies by Giovanni Antonio da Brescia (1500–1510) and Nicoletto da Modena (also before 1510). At least two of the plates are known to have been made in Faenza.

831. Tanner, Marie. *The Last Descendant of Aeneas. The Hapsburgs and the Mythic Image of the Emperor*, Chapters V and XII. New Haven: Yale University Press, 1993.

The only comprehensive scholarly study of the Imperial mythic image in the Christian West, from its origins in the fundamental myth of Rome as the new Troy set forth in the *Aeneid* to its consolidation in the sixteenth century under Charles V and the Spanish monarchy, setting Dürer's *Triumphal Arch* and *Triumphal Car* woodcut designs for Maximilian firmly in context, as well as his portrait of Maximilian (Vienna) and idealized portrait of Charlemagne. There are other studies offering more complete information about these works of Dürer's, but this book is valuable for its grasp of Maximilian's place in the manufactured history of the Hapsburgs as a whole. Written in Rome using the resources of the Vatican Library and the Herziana, it includes a full discussion of

Maximilian's ambition to succeed Julius II as Pope—a topic usually tactfully avoided.

832. Tanzi, Marco. "Novità e revisioni per Altobello Melone e Gianfrancesco Bembo." *Richerche di Storia dell'Arte,* 17 (1982): 49–56.

[New and Revised Notes on Altobello Melone and Gianfrancesco Bembo.] Also discusses the work of Marco Marziale, another artist active in the Cremona area at the beginning of the 1500s, who introduced the innovations of Dürer after Dürer's sojourn in Venice 1505–1507, and influenced the young anticlassic painters Melone and Bembo, who are the main subject of this article.

833. Tatar, Maria M. "The Art of Biography in Wackenroder's *Herzensergiessungen eines kunstliebenden Klosterbruders* and *Phantasien über die Kunst.*" *Studies in Romanticism* 19, no. 2 (1980): 233–248.

Discusses the significance for the Romantic era of Wackenroder's characterizations of artists —including Dürer and Raphael among others. He divides artists into two groups: those, including Dürer, Raphael and Leonardo, who created art, and those, like Francesco Francia, Piero di Cosimo, and Joseph Berglinger, whose lives were works of art.

834. Tavel, H. C. von. "Die Randzeichnungen Albrecht Dürers zum Gebetbuch Kaiser Maximilians." *Münchner Jahrbuch der bildenden Kunst* 16 (1965): 66ff.

One of the most important studies of Dürer's marginal drawings for the Emperor Maximilian I's *Prayerbook.* Updated in 1971 by Vetter and Brockhaus (in the Nuremberg *Anzeiger,* q.v.).

835. Taylor, Francis Henry. *The Taste of Angels: A History of Art Collecting from Rameses to Napoleon,* Boston: Little, Brown & Co., 1948.

After fifty years this pioneering work by a former Director of the Metropolitan Museum is still useful for its information on early collectors of Dürer's work such as Albert Casimir of Sachsen-Teschen (1738–1832) and his wife, the Archduchess Maria Christina, founders of the Albertina, who acquired the world's most important collection of the artist's drawings and watercolors

from Schloss Ambras. The works had originally come directly from the widowed Agnes Dürer by way of the grandson of Willibald Pirckheimer, who in turn had sold them to Rudolph II. Other Dürer drawings were obtained by the couple from the heirs of Cardinal Granvella.

836. Tedeschi, Martha. *Great Drawings from the Art Institute of Chicago: The Harold Joachim Years 1958–1983*, Chicago: Art Institute of Chicago/Hudson Hills Press, 1985.

Catalogue of an exhibition featuring the acquisitions made during the late Harold Joachim's tenure as Director of the Department of Prints and Drawings. One Dürer was purchased—*The Young Steer*, (W.239) datable to approximately 1493, formerly in the Lubomirski Museum, Lemberg [Lwow]. It was acquired in 1965 from the collection of Clarence Buckingham (cat. no. 26). The drawing in pen and black ink, is one of the artist's earliest animal studies.

837. Theissing, Heinrich. *Dürers* Ritter, Tod und Teufel. *Sinnbild und Bildsinn*, Berlin: Gebr. Mann Studio-Reihe, 1978.

An essential work on the interpretation and reception of the first of Dürer's three so-called *Meisterstiche*, the *Knight, Death, and Devil* (B.98: dated 1513). Reviews the history of the artist's involvement with the depiction of horses and riders, including possible prototypes in Italian equestrian sculpture. Counters traditional earlier German interpretations of the rider as a symbolic figure comparable to Siegfried, a nameless robber baron, Franz von Sickingen, Faust, or Nietzsche's "trostlos vereinsamter," recasting the image as one of harmony and order. Excellent bibliography. [On this engraving, see also Hans Schwerte (1972) and Jan Bialostocki (1986).]

838. Thürlemann, Felix. *Vom Bild zum Raum. Beiträge zu einer semiotischen Kunstwissenschaft*, 71–90. Cologne: DuMont, 1990.

The author (b. 1946), who is Professor of Art History at the University of Konstanz, has previously published on Paul Klee and Wassily Kandinsky. In Chapter 3 of the present group of studies in semiotic method, he discusses Dürer's *Landauer Altarpiece* and his theoretical notes *On Colors* (Rupprich II, 392–394). Subtitling this essay "Reconstruction of a historical color-syntax," he notes similarities with Gottfried von Strassburg's "color syntax" as ex-

pressed in *Tristan*, where Gilân's "wonder-dog" Petiterein has fur of all colors—white, green, red, yellow, and blue—each color being compared to other substances ("whiter than snow," etc.), but without any single color being dominant. He notes the use of the same hues in the Landauer Altar, where Dürer has overcome his earlier tendency to think in terms of colored "stuff." Dürer's color notes are cited, wherein the artist advocates creating light and dark shades of hues by changing pigments, rather than by simple admixture of black and white (e.g., yellow must be shaded with a darker yellow, etc.).

839. Tietze, Hans. "Dürer und Goethe." *Zeitwende. Monatsschrift* 4, no. April (1928): 308–323.

Discusses Goethe's admiration for Dürer's *"holzgeschnitzteste Gestalt"* (approximately, "wood-carved manliness") as opposed to the *"geschminkte Puppenmaler"* (powdered painters of dolls) who were his own late eighteenth-century contemporaries. Tietze calls attention to Goethe's knowledge of Dürer's prints, seen in the collection of Duke Karl August; his correspondence with Lavater (1780) and acquaintance with the important collector and connoisseur Sulpiz Boisserée; his comments on the 1493 *Self Portrait* (seen in the Beireis collection in Helmstädt); Goethe's own watercolors; and common personality traits of the two men.

840. Tietze, Hans, and Erika Tietze-Conrat. *Kritische Verzeichnis der Werke Albrecht Dürers*, 3 vols. Augsburg (vol. 1)/Basel/Leipzig (vol. 2–3): Filser, 1928.

Volume 1 of the Tietzes' critical catalogue of Dürer's oeuvre deals with his youthful work up to and including the second trip to Italy in 1505. Volume 2, published in two parts, concerns the mature years, and Volume 3, the works from the Netherlandish journey (1520) to the death of the artist in 1528. Hans Tietze, had been one of the earliest supporters of Oskar Kokoschka, and was portrayed with his wife Erika in a famous double portrait by that artist—the first to achieve the dubious distinction of being officially declared "decadent"—Tietze was anathema to the conservative art historians specializing in Dürer (Friedrich Winkler, in particular, called him "a journalist"). The first volume of the catalogue was reviewed by Curt Glaser *Kunst und Künstler*, 26 (1927–28), 486–487; Hermann Beenken, *Jahrbuch für Kunstwissenschaft* 5 (1928),

112–116; Friedrich Winkler, *Der Cicerone*, 20 (1928), 469–476; Campbell Dodgson, *The Burlington Magazine* 53 (1928), 201–202; Heinrich Wölfflin, *Deutsche Literaturzeitung* 50 (1929), 191, Sp. 901–903; and others. Only Campbell Dodgson remained on board to review volumes 2 and 3 (*The Burlington Magazine*, 71 [1937], 238–239; and 73 [1938], 89–90). The Tietzes were among the distinguished German art historians who emigrated to New York University's Institute of Fine Arts after the promulgation of the Nuremberg Laws.

841. Timann, Ursula. "Zum Lebenslauf Georg Pencz." *Anzeiger des Germanischen Nationalmuseums* (1990): 97–112.

The primary documents on Pencz had been published previously (Hans Georg Gmelin, "Georg Pencz der Maler," *Münchner Jahrbuch* 3rd ser., vol. 17 (1966) 49–120). This article contains some newly discovered material, however, and also reviews the known facts, shedding new light on the artist's relatives and family circumstances. The author corrects Gmelin's misidentification of Pencz's *Portrait of Antoine Perrenot*, the future Cardinal Granvella, as that of his father, Nicolas. Both father and son came to Nuremberg: Nicolas in February of 1543, his son earlier, in 1541. Also identifies Crispin Herrant as having been a pupil of Dürer's (p. 106). Pencz's place of death (October 1550) is disclosed as Breslau.

842. Timar, Arpad. "Dürer-Literatur in Ungarn in der ersten Hälfte des 19. Jahrhunderts." *Acta historiae artium* 24, no. 4 (1978): 391–396.

[Dürer literature in Hungary in the first half of the nineteenth century.].

843. Timken-Zinkann, R. F. *Ein Mensch namens Dürer. Des Kunstlers Leben, Ideen, Umwelt,* Berlin: Gebr. Mann, 1972.

Discusses various aspects of the artist's religious convictions, finding Dürer to have been loyal to the Reformation (57, 131–135), but questions arguments for the presence of pre-Reformation elements in the *Apocalypse* series as had been suggested by Chadabra and others. The author also rejects the political interpretation of the *Peasant Monument* [Parshall & Parshall].

844. Tofani, Anna Maria Petrioli. "Ludovico Cigoli: variazione su un tema di Dürer." *Scritti di storia dell'arte in onore di Roberto Salvini*, 85–92. Ed. Cristina De Benedicti. Florence: Sansoni, 1984.

Attributes a sixteenth-century drawing of the Trinity (Florence, Uffizi: Gabinetto dei disegni) to Cigoli, and points out that its composition was inspired by Dürer's 1511 woodcut of the same theme.

845. ———. *Omaggio a Dürer, Mostra di Stampe e Disegni*, Florence: Galleria degli Uffizi, 1971.

The Uffizi's print room is fortunate to possess not only prints by Dürer but a small number of drawings as well, and prepared this exhibition of his works on paper, titled "Homage to Dürer," for the anniversary year 1971.

846. Toronto: Art Gallery of Ontario. *Sir Edmund Walker, Print Collector*, 1974.

Catalogue of an exhibition held in Toronto November 22, 1974–January 12, 1975, and subsequently circulated to several other institutions in the province of Ontario, featuring a selection of seventy-four from the large collection of intaglio prints donated to the Gallery by Sir Edmund Walker (1848–1924), the Canadian banker-philanthropist who founded its Department of Prints and Drawings. The exhibition included works by Dürer, among other artists from the sixteenth through twentieth centuries. [RILA].

847. Toronto: Art Gallery of Toronto. *Terbrugghen: Melancholy*, Karen A. Finlay. 1984.

Argues that the painting by Hendrick Terbrugghen previously known as the *Repentant Magdalen* (ca. 1627: privately owned) should be retitled *Melancholy* on grounds that it cannot be securely identified as Mary Magdalene *per se*, but has many attributes of Melancolia. Cites Dürer's engraving as the most important example of the theme.

848. Tosini Pizzetti, Simona, and Giovanni Dellana. *Albrecht Dürer; Temi e Tecniche*. Trento: Improvvisazione Prima, 1996.

Catalogue of an exhibition held at the Fondazione Magnani Rocca, Mamiano di Traversetolo, Parma, illustrating Dürer's themes and techniques.

849. Troutman, Philip. *Albrecht Dürer, Sketchbook of His Journey to the Netherlands, 1520–21*, New York/Washington: Praeger, 1971.

Reproduces the drawings from the Netherlandish sketchbook together with pertinent quotations from the travel diary. The quality of reproduction is inferior to the edition by Edmund Schilling and Heinrich Wölfflin (Frankfurt am Main, 1928), but Troutman was the original translator of Schilling's text for the 1968 facsimile edition published in London.

850. Troyen, Carol L. *Dürer's* Life of the Virgin. Ph.D. dissertation, Yale University, 1979.

After the *Apocalypse*, the twenty woodcuts of the *Life of the Virgin* formed Dürer's most innovative woodcut series and his most ambitious effort at book illustration, becoming the canonical treatment of the theme in Northern Europe and inspiring many subsequent sixteenth-century cycles. The completed set was published in book form in 1511; however, most of the prints had actually been designed and executed in the years 1501–1504, a transitional period in the artist's career, and the period with which this dissertation deals. The author suggests that the cycle should be viewed as a whole, and investigates the context of the program for which it was made and the pictorial traditions that contributed to it, including Dürer's own previous Mariological works.

851. Trux, Elisabeth M. *Untersuchung zu den Tierstudien Albrecht Dürers*, Würzburg: Ergon, 1993.

Inexpensively printed but well documented, this unillustrated paperback was developed from the author's Master's thesis, written under the direction of Erich Hubala at the Julius-Maximilian-Universität, Würzburg during the preparation of the Vienna exhibition of the artist's plant and animal studies (1985, q.v.). Dürer's animal studies are referred to in the text by their Winkler numbers; a concordance to Strauss, Koschatzky-Strobl, Koreny, and other pertinant literature is appended. Trux consulted Koreny, Mende, and others, and was given access to the original works of art in Berlin, Coburg, Cologne, Düsseldorf, Frankfurt, Hamburg, London, Munich, Nuremberg, Paris, and Vienna. Noting the trend of previous scholarship to classify the "nature studies" in categories, in isolation from the total *oeuvre*, she has performed a service by approaching the animal studies in relation to the artist's works in

other media, and to similar works by other artists. Noting for example that the first animal studies were made during the first trip to Italy (1494/1495), reaching a peak of production around 1500–1505, she argues that they may have been inspired in part by knowledge of north Italian tradition dating back to the mid-fourteenth century (Giovanni de' Grassi, Michelino da Besozzo, Pisanello, the Bellini workshop), as well as by contemporary Italian "life" casts of crustaceans by Andrea Riccio. Trux, like Kauffmann distinguishes between the basic aims of Dürer and Leonardo da Vinci, finding a "portrait-like" quality in Dürer's animal studies—a tendency to see animals as individuals, rather than as types—unlike Leonardo's more clinical approach, which involved dissection. She argues that all of Dürer's studies, however, were made strictly for the artist's own studio use—even the *Wild Hare*, which Eisler (1990) viewed anachronistically as an end in itself. Such close readings of individual animals freed Dürer from the clichés of his predecessors.

852. Ullmann, Ernst, Ed. *Albrecht Dürer: Kunst im Aufbruch*, Leipzig: Karl-Marx-Universität, 1972.

The series of papers given at the international Dürer symposium held at the University of Leipzig honoring Dürer's five hundredth birthday. The editor was the senior East German academician dealing with German art, a widely-published generalist. Papers include one by the editor, on Albrecht Dürer and "early bourgeois" art in Germany (the term used in the DDR to describe what westerners call the Dürerzeit, or Renaissance). The most substantial essays are those by Erna Brand (pp. 99ff.) on the *Altarpiece of the Seven Sorrows* (Dresden), which attributes the distorting overpainting to the Cranach School, and by Lisa Oehler, who dated the same work after 1503 on the basis of the overpaint, but attributed the whole altarpiece to "a member of the Cranach workshop or the young Schäufelein or the very young H. S. Beham." A carefully documented study by the Bulgarian scholar Assen Tchilingirov (pp. 123ff.) traces the influence of Dürer's prints on the iconography of post-Byzantine art of the Orthodox church, and the Romanian, Eleonora Costescu, discusses the influence of the woodcuts in the late medieval art of southeastern Europe. Rudolf Zeitler discusses the position of Dürer's *Befestigungslehre* (Treatise on Fortifications) in scientific literature. An article by Andre Chastel (37ff.)

considers a predella by Lorenzo Lotto—not entirely convincingly—as the possible source of the landscape in which Dürer stands at the base of the *Landauer Altarpiece* (1511). There also are brief articles by M. Steinmetz on German humanism; G. Brendler on the image of man in the "early bourgois revolution"; P. H. Feist on Dürer's world view, human image, and "mastership"; M. J. Liebmann (Moscow) on Dürer's personality; M. S. Kagan on his aesthetic views; M. Kuhirt on the new quality of realism in Dürer's work; H. Olbrich on "aspects of the realistic form of representation in Dürer's work" (in which the author attributes the artist's realism entirely to "the laws of production" of his time); H. Meusche on the artist's use of one-point perspective; I. Emmerich on the relationship of scientific and artistic insight in Dürer's work; R. Chadabra on Dürer and the significance of "the vegetal element" in German art after 1500; S. Wollgast on the artist's relationship to the "left wing" of the Reformation; and M. Bonicatti on Dürer's relationship to Venetian humanism. The majority of these papers—particularly those by East German and Italian citizens— are of interest mainly as examples of Marxist doctrine, which tended to deny the artist his ability to make individual choices. Remarkably, it was often the Russian, Bulgarian, and Romanian scholars whose work was most free of politicizing jargon. The work of Mikhail Liebmann, for example, has been consistently of interest both here and elsewhere.

853. ———. *Albrecht Dürer*, 4th ed. Leipzig: VEB Verlag Bibliographisches Institut, 1977.

Dürer' life and artistic development are presented with reference to recent research in aesthetics in this ninety-six–page monograph. His personality is outlined on the basis of autobiographical materials, art works, and statements by his contemporaries. [RILA].

854. ———. *Albrecht Dürer*, 2nd ed. Leipzig: Seemann, 1979.

A reprint of the 1971 edition of this brief nineteen–page work, previously published by the Bibliographisches Institut, Leipzig.

855. ———. "Albrecht Dürer und die Wirkung der Grafik." *Le stampe e la diffusione delle immagini e degli stili*, Ed. Henri Zerner. International Congress of the History of Art, 24. Bologna: CLUEB, 1983.

Paper presented at the twenty-fourth International Congress of the History of Art, which took for its theme the idea of prints as agents of the transfer of images and styles. Ullmann, the senior East German academic (University of Leipzig) gave a general discussion of Dürer's prints, his beginnings with Martin Schongauer and the Housebook Master, and his interchange with Mantegna and Raphael. Mentions works based on Dürer's prints, by Lucas Cranach, Tilmann Riemenschneider, Jan Gossaert, and Rembrandt (the *Death of the Virgin* etching, 1639). Remarked on Dürer's sales organization for distribution of his prints.

856. ———. "Albrecht Dürer und die frühbürgerliche Kunst in Deutschland." *Kunst und Reformation*, 87–100. Ed. Ernst Ullmann. Seemann Beiträge zur Kunstwissenschaft, Leipzig: E.A. Seemann, 1983.

[Albrecht Dürer and Early Bourgeois Art in Germany.] Traces Dürer's artistic development in relation to the Reformation and the social upheavals of the era as reflected in the artist's own writings and selected works. "Early bourgeois" was the approved Marxist term for the art of the fifteenth and early sixteenth centuries.

857. ———, Ed. *Albrecht Dürer—Schriften und Briefe*, Leipzig: Philipp Reclam jr, 1989.

Published in the German Democratic Republic on the eve of reunification and on poor paper, this is nevertheless an extremely convenient and portable short version of Dürer's letters, Family Chronicle, Netherlandish diary, and theoretical publications. Convenient features are a chronological table and a biographical dictionary of persons mentioned in the documents, including nicknames and variant spellings. Ernst Ullmann, whose obligatory quotation from Friedrich Engels on the back cover signals his point of view, was the senior scholar from the University of Leipzig who was a participant at international conferences in the West for many years before the events of 1989. He was a member of the Communist Party in high standing.

858. ———. *Albrecht Dürer–Selbstbildnisse und autobiographische Schriften als Zeugnisse der Entwicklung seiner Persönlichkeit.* (Sitzungberichte der Sächsischen Akademie der Wissenschaften

zu Leipzig. Philologisch–historische Klasse 133.3) Berlin: Akademie Verlag, 1994.

Ullmann's paper for a 1992 Leipzig conference was dedicated to the one hundredth birth anniversary of Johannes Jahn, and begins with an interesting biographical sketch of Jahn, who as post-World War II director of the Leipzig Museum, as well as of the University's art history institute, played an essential role in East German cultural affairs and who, as Secretary of the Saxon Academy had reported on the state of Dürer research in Dürer Year 1971 (q.v.). Ullmann then goes on to quote from Dürer's Family Chronicle, contrasting it to the writings of Ghiberti and other contemporary Italian artists, and gives a review of Dürer's various self portraits. He concludes that the artist's striking assertion of his individuality is only partly due to his upbringing in the trading city of Nuremberg, owing a great deal also to his having made contacts with intellectuals both at home and abroad. This line of argument, coming three years after German reunification, is of particular interest in light of the fact that it might have been less well received if he had made it a few years earlier.

859. ————. "Bemerkungen zum künstlerischen Programm Albrecht Dürers." *Problemi di Metodo: Condizioni di Esistenza di una Storia dell'Arte*, 197–200. Ed. Lajos Vayer. Atti del XXIV Congresso di Storia dell'Arte, 10. Bologna: CLUEB, 1982.

The text of a paper delivered at the twenty-fourth International Congress of the History of Art. Ullmann (University of Leipzig, DDR) shows, with reference to Dürer's writings, that the artist's aim was the representation of reality as a means to the understanding of the world.

860. Ullmann, Ernst, Günther Grau, and Rainer Behrends, Eds. *Albrecht Dürer: Zeit und Werk*, Leipzig: Karl-Marx-Universität, 1971.

Contains an excellent paper by E. Chojecka on Dürer's influence on sixteenth-century art in Poland (161ff.); a general essay by Johannes Jahn on portrait and landscape paintings, drawings and watercolors; an interesting essay by R. Grosse (179ff.) on Dürer's position in the history of the German language. Less compelling are R. Zeitler's paper on "action and individuality" (153ff.), which centers around the so-called *Portrait of Hans Dürer* (a silverpoint

drawing of doubtful authenticity [W.284: British Museum]), and P. H. Feist's article on "the importance of Dürer's work for the Socialist Nationalkultur in the DDR." The general tenor of much of the volume is set by the statement of the editors (viii) that in West Germany the "humanistic heritage is abused in order to hide the profoundly inhumane character of Imperialism" (See the review by Wolfgang Stechow in *The Art Bulletin*, 1974, p. 268).

861. Ulrichs, Ludwig. "Beiträge zur Geschichte der Kunstbestrebungen und Sammlungen Kaiser Rudolf's II. 3. Die Sammlung Granvella." *Zeitschrift für bildende Kunst* 5 (1870): 136–141.

Reconstructs the estate of Cardinal Antoine de Granvelle, son of Charles Perrenot de Granvelle, who had been Chancellor of Burgundy under Charles V in the artist's lifetime. Cardinal Granvella himself became a member of the Netherlands Privy Council and principal adviser to Margaret of Parma. His estate included four paintings by Dürer: the *Martyrdom of 10,000*; two Madonnas; a St. Michael, and a large number ("over two hundred") of drawings and watercolors, many of which were acquired from his estate for Rudolph II.

862. Urbach, Zsuzsa. "Ein Burgkmairbildnis von Albrecht Dürer?: Probleme des Budapester Bildes." *Anzeiger des Germanischen Nationalmuseums* (1985): 73–90.

Urbach is one of the leading Hungarian scholars dealing with northern art of this period. She attributes the Budapest Szépmüvészeti Múzeum's portrait of Hans Burgkmair the Elder to Dürer. The painting was loaned to the 1971 exhibition in Nuremberg, but was disattributed by Anzelewsky. Urbach's article is of particular interest for its discussion of related works, complete with photographic details, X-rays, and extensive bibliography. This painting has at various times been thought to represent Christoph Scheurl (the Tietzes); or Endres Dürer (Zoltan Takács, Panofsky, Musper, Winkler, Fenyö). Urbach's identification of the sitter as Burgkmair is made on the basis of Burgkmair's self portrait in the Hamburg Kunsthalle and the 1519 Burgkmair medal, as well as on Dürer's 1518 drawing in Oxford. An added item of interest is Urbach's explanation of the *Netzhaube* (also known as a "schwäbisch hawb," or "gestrickte [knit] Haube"), which also appears on the portraits of Jacob Fugger and Jakob Muffel. This

turbanlike headdress, which was worn only during the early years of the sixteenth century, was favored almost exclusively by older men, mostly residents of Augsburg and Nuremberg, who continued to stuff their long hair into these mesh caps long after younger men had begun to wear short hair.

863. ————. "Notes on Breugel's Archaism: His Relation to Early Netherlandish Painting and Other Sources." *Acta Historiae Artium* 24, no. 1–4 (1978): 237–256.

Dürer's *Death of the Virgin* is cited as one of many sources of Bruegel's grisaille in Upton House (Banbury), and is seen as symptomatic of Humanist attitudes on the part of Bruegel and Ortelius.

864. Vagnetti, Luigi. "Il processo di maturazione di una scienza dell'arte: la teoria prospettica nel Cinquecento." *Prospettiva rinascimentale: codificazioni e trasgressioni*, 424–474. Florence: Centro di Firenze, 1980.

A paper presented at the international conference on the study of perspective, held at the Castello Sforzesco, Milan, in 1977. Discusses the character of sixteenth century perspective theory, the bridge between fifteenth-century theorizing practice and the scientific theory of the seventeenth century. Analyzes the principal sixteenth-century treatises, including those of Dürer, Guarico, Viator, Serlio and Commandino. Also briefly examines minor German, French, and Italian treatises (RILA).

865. van Gelder, Jan G. "*Sister Metzgen*: A Portrait by Albrecht Dürer." *Master Drawings* 9, no. 2 (June 1971): 154–159.

Dürer's charcoal drawing of a lovely young woman with downcast eyes (Paris, Fondation Custodia Inv. 4323; Tietze II no. 781; Winkler IV, 1939, p. 32) is here identified as that of the Carmelite nun, "Sister Metzgen," mentioned in the travel diary of the artist's Netherlandish journey. The drawing, dated 1520, which at the time of Van Gelder's writing had been exhibited publicly only twice (1836 and 1938), was one of the large number of Dürer drawings purloined from the Albertina by General Andreossi during the Napoleonic occupation of Vienna, and passed subsequently through the collections of the English painter Sir Thomas Lawrence and the opera singer Pauline Viardot before being eventually acquired by Frits Lugt. The Albertina drawings as a parcel had come from

Dürer's own collection through his heirs, Agnes and Endres Dürer, and Willibald Imhoff, who sold the collection to Rudolph II.

866. Vasconcellos, Joaquim de. *Renascença portugueza. Estudos sobre as relaçöes artisticas de Portugal nos seculos 15 e 16. 1. Albrecht Dürer e a sua influencia na peninsula*, Archeologia artistica, 1. Porto: 1877.

A general treatment of Dürer's influence in the Iberian peninsula. But consult also Mário de Sampayo Ribeiro (Coimbra, 1943), who has refuted the author's identification of the drawing supposedly portraying the Portuguese friend of Erasmus and collector of Northern art, Damiåo de Goes, the purchaser of Hieronymus Bosch's St. Anthony triptych (Lisbon).

867. Veit, Ludwig. "Das Archiv des Germanischen Nationalmuseums. Eine Übersicht über seine Bestände." *Anzeiger des Germanischen Nationalmuseums* (1954): 248–255.

A most useful introduction to the collection of records, autographs, and seals, giving a brief history and key to general arrangement of the Museum's archival section, which, in addition to Nuremberg files, contains papers from Eichstätt, Regensburg, Schweinfurt, Windsheim, and elsewhere. Of particular value for Dürer research are the family letters and papers of Nuremberg's patriciate—the Behaim, Imhoff, Kress, Löffelholz, Oelhafen, Praun, Reitzenstein, Volckamer, and others.

868. Venice. Gallerie dell' Accademia. *Giorgione a Venezia*, Introductions by Teresio Pignatti, and Rodolfo Pallucchini. Venice: Gallerie dell'Accademia, 1978.

Catalogue of the exhibition of the Venetian works of Giorgione, displaying work by Dürer as one of the formative influences on the younger Italian artist.

869. Vetter, Ewald M., and Christoph Brockhaus. "Das Verhältnis von Text und Bild in Dürers Randzeichnungen zum Gebetbuch Kaiser Maximilians." *Anzeiger des Germanischen Nationalmuseums* (1971): 70–121.

Ewald Vetter is a well-known and widely published authority on the religious iconography of fifteenth-century German art. This study considers the marginal drawings made by Dürer in their rela-

tionship to the adjacent passages of text in the printed *Prayerbook* commissioned by Maximilian—a logical extension of the early nineteenth-century studies of Oether and the Hofrath Meyer (1808/1809) for the Strixner facsimile edition of the Prayerbook drawings, as well as of studies that have been performed on illuminated manuscripts in recent years. The authors give a thorough overview of the various critical opinions to date (1971) (e.g., were the drawings pure fantasy? satire? incipient Lutheranism?). Nazis saw them as evidence of Dürer's "Germanness" (*Deutschtum*). Highly recommended is Hans Christian von Tavel (in *Münchner Jahrbuch*, 1965, q.v.), but additions and corrections are offered here. Authoritative and extensively documented. Essential reading.

870. Vey, Horst. "Nicholas Hilliard und Albrecht Dürer." *Museion. Studien aus Kunst und Geschichte für Otto H. Förster*, 155–68. Cologne: 1960.

An important early study of Dürer's influence in England on the Elizabethan miniaturist and author of *A Treatise on the Art of Limning*, in which Dürer's rules for painting and engraving are praised but declared tedious. Vey is better known as the author of a seminal work on Van Dyck drawings, and for the directorship of the Karlsruhe Kunsthalle. A former student of Hans Kauffmann, who was among the first to call attention to this aspect of Dürer's "afterlife" in art and theory (Nuremberg *Anzeiger*, 1954, q.v.), he also studied in England after World War II, soon after the first Hilliard exhibition (London, Victoria and Albert Museum, 1947).

871. Viasse, Pierre. *Albrecht Dürer*, Paris: Fayard, [1995].

This is an "art-and-life" monograph that is part of a series of scholarly biographies (Jonathan Brown's *Velasquez* has appeared as part of the same series). The author, Professor at the University of Geneva, is familiar with the essential German literature—Anzelewsky, Strieder, and the papers of the Nuremberg Dürer-Year conference (*Albrecht Dürers Umwelt*, q.v.). Well documented and with selected bibliography and twenty-three black-and-white illustrations, it is the most reliable Dürer book in French.

872. Vienna: Graphische Sammlung Albertina. *Europäische Meisterzeichnungen aus dem Zeitalter Albrecht Dürers*, Walter Koschatzky, Alice Strobl et al. 25 May 1926.

Introduction by Walter Koschatzky; text by Alice Strobl, Fritz Koreny, and others. A modestly produced catalogue of Vienna's exhibition for Dürer Year 1971. Since many of the Albertina's best Dürer drawings and watercolors were on loan to Nuremberg's Germanisches Nationalmuseum for the most important Dürer exhibition ever, Vienna assembled an interesting exhibition of his Italian, Dutch, Austrian, and German contemporaries.

873. Vienna: Kunsthistorisches Museum. *Albrecht Dürer im Kunsthistorischen Museum*, Karl Schütz and Rotraud Bauer. Vienna: Kunsthistorisches Museum, 1994.

This essential volume was produced to commemorate the return to public view of Dürer's *Landauer Altarpiece*, which had been under conservation for five years in order to stabilize the lindenwood panel (climatic conditions in the Museum had caused minor damage. During its absence in the laboratory a copy had been placed on display). Full details of the restoration are discussed. Rounding out the exhibition were the Museum's other Dürers (the *Portrait of Maximilian, Portrait of Johannes Kleeberger, Young Venetian Woman,* and Dürer's "Kunstbuch" opened to the watercolor *Dream of the Deluge).*

874. Vlnas, Vit. "Der Kampf um Dürers Rosenkranzfest im Jahr 1928." *Bulletin of the National Gallery in Prague* (1992), no. 2: 111–120.

Recounts the context of the acquisition by the state of Czechoslovakia of Dürer's *Feast of the Rose Garlands*, formerly the property of Rudolph II, and after him of the Strahov Monastery on the Hradschin. When western attention was called to this, arguably the artist's most important altarpiece, by the events of Dürer Year 1928, agents from both the United States and the Weimar Republic made attempts to acquire it (the U.S. by purchase, and Germany by trading the fourteenth-century Glatz Madonna).

875. Voltelini, Hans von. "Urkunden und Regesten aus dem kaiserliche und königliche Haus-, Hof- und Staats-Archiv in Wien." *Jahrbuch der kunsthistorischen Sammlungen des allerhöchsten Kaiserhauses* 13, no. 2 (1892): XXVI–CLXXIV.

Acquisitions from the estate of Cardinal Antoine de Granvelle (nos. 9465, 9485, 9504, 9509, 9514, and 9415. See also Vol. 15 (1894), no. 12526.

876. Waetzoldt, Wilhelm. "Der Begriff des 'Barbarischen'." *Kunstver-waltung in Frankreich und Deutschland*, 120–128. Ed. Otto Graut-off. Bern: Max Drechsel, 1915.

An early article by Waetzoldt, a Professor at the university in Halle, who later became the author of a major monograph on Dürer (q.v.). Gives a brief overview of the historical characteriza-tion of the Germans as barbaric. This generalization is shown to have been made most frequently by Italians (who themselves had once been labeled barbarians by the ancient Greeks). Sources quoted include Petrarch (in Prague, 1356); Gianantonio Compano (on failure to raise Regensburg to join a crusade against the Turks, 1471: calls "the whole land a den of thieves," and criticizes lack of interest in the arts); Filippo Villani, Lorenzo Ghiberti, and Filarete (all of whom equated Gothic with barbaric). Waetzoldt goes on to note that the defense of Germany and the Gothic begins in the mid-eighteenth century (Knorr's *Allgemeinen Künstlerhistorie*, 1759, one third of which is devoted to Dürer and his work). Ch. L. V.Hagedorn's defense of Dürer against Hogarth (1762); Marck (in *Merkur*, 1780); William Heinse's defense of the Gothic in *Ard-inghello* (1785), and the better known Romantic authors recogniz-ing the Gothic as both German and French (Wackenroder, Tieck, Schlegel, the Boisserée brothers, Victor Hugo). Waetzoldt ob-serves that an increase in the use of the term "barbaric" as a syn-onym for "German" generally accompanies *wars* (1813, 1870, 1914.) [Note the date of the article: 1915.]

877. ———. *Dürer and His Times*, London: Phaidon, 1950.

Translated by R. H. Boothroyd from the German, this had been the standard general biography in Germany during the Third Reich. The first edition was published in Vienna (1935), and the fifth Ger-man edition in Königsberg during World War II (1944). Although Waetzoldt was considered a reliable art historian at the time as re-gards his knowledge of Dürer, his writing now seems dated be-cause of its rather militaristic turns of phrase, as well as his evident belief in Aryan supremacy.

878. Walker, John A. "Art and the Peasantry. Parts I, II and III." *Art and Artists* 13, nos. 9, 10, 11 (1979): 26–35; 14–17; 24–29.

A very general discussion, by the former Director of the National Gallery (Washington), of peasant imagery, from Dürer and the

German Peasants' War of 1525 to Bruegel, Callot, the Pont-Aven school, Kollwitz, and the twentieth-century peasantry as portrayed in film and television. (On peasants, however, see Hans-Joachim Raupp.)

879. Walser, Martin. *Das Sauspiel. Szenen aus dem 16. Jahrhundert*, Frankfurt am Main: Suhrkamp, 1975.

Dürer is shown in a conservative light in this satirical play centered in sixteenth-century Nuremberg, in which the city's intellectuals legitimize the actions of the nobility in the brutal suppression of the peasant cause and the Anabaptist movement. Other characters include Pirckheimer, Melanchthon, Camerarius, Lazarus Spengler, Paracelsus, and Hans Sachs.

880. Walters, Margaret. *The Nude Male: A New Perspective*, London/ New York: Paddington Press (Grosset & Dunlap), 1978.

A feminist perspective on the history of the image of the male nude. Rather a sweeping survey, beginning with the Greek Apollo and continuing to female artists of the twentieth century, but touching on Dürer in passing. The author's point is that western art has traditionally been shown the male nude from the male viewpoint; she examines underlying social attitudes responsible for this.

881. Warburg, Aby. "Dürer und die italienische Antike." *Verhandlungen der 48. Versammlung deutscher Philologen und Schulmänner in Hamburg, Oktober 1905*, Leipzig: 1906,

Reprinted in Warburg's collected papers (*Gesammelte Schriften*, 2 vols., Leipzig and Berlin, 1932, pp. 443–449.) Discusses the artist's response to classical "pathos formulae," particularly in the Hamburg drawing of *The Death of Orpheus*, based on a work from the Mantegna circle—which in its turn was based on the revival of the pagan past as seen in Poliziano's play, *Orfeo*, performed at the Mantuan court. [On Warburg, see E. H. Gombrich, *Aby Warburg, an Intellectual Biography*, 2nd ed. Oxford, Phaidon, 1986.]

882. ———. "Heidnisch-antike Weissagung in Wort und Bild zu Luthers Zeiten." *Gesammelte Schriften*, 487–558. 2 vols. Leipzig and Berlin: 1932.

An unfinished piece, originally promised to the *Proceedings* of the Heidelberg Academy, but delayed by the onset of Warburg's men-

tal illness. Assembled in final form by Fritz Saxl's help. Analyzes three Dürer prints—the *Syphilitic*, which illustrates the baleful influence of the conjunction of Jupiter and Saturn in the sign of Scorpio; the *Monstrous Sow of Landser*, a "prodigy" used by Sebastian Brant as propaganda for Maximilian; and the *Melencolia I*, which Warburg saw as a reference to the genius of Maximilian, who considered himself a "child of Saturn."

883. Warnke, Martin. *Hofkünstler. Zur Vorgeschichte des modernen Künstlers*, esp. 94–180. Cologne: DuMont, [1985].

Warnke (b. 1937, Brazil) is a professor in Hamburg (formerly Marburg). A useful and original study, written in the wake of a series of court-oriented exhibitions held in Europe during the 1980s (the Wittelsbachs, the Medici, the Gonzaga, etc.), Warnke examines the development of court structure from the mid-thirteenth century, and the artist's place "at first between city and court," then as integral part of the court. Dürer's status between Maximilian and the Nuremberg City Council is treated, and the artist's remark that "only a good painter" is qualified to judge the work of another painter (115). Discusses the politics of the dedication of one's work to a sovereign in an attempt to gain attention, thereby making a return gift necessary (as Dürer attempted to do with Margaret of Austria, and succeeded in doing with the *Four Apostles* and the City Council, 128ff.). Warnke's chapter on *Tischordnungen* is of great interest for Dürer studies, as it records the household accounts from Wittenberg Castle for 1504, which reveal that among the many dinner guests allotted to the then-court painter Jacopo de'Barbari there appeared "der moler meister Albrecht mit dem weybe" for an entire week. Notice also is taken of Dr. Lorenz Behaim's amazement that Dürer was awarded the seat of honor at the Bishop of Bamberg's dinner table; and of the artist's own account of King Christian II of Denmark's egalitarian hospitality toward him. The matter of Dürer's pension is taken up in the chapter titled "Sparmassnahmen," (178–180). Other topics of interest include the division of labor on Maximilian's monument in Innsbruck; Dürer's use of a sketch by Ambrogio de Predis for one of his portraits of Maximilian (276); the mythological elevation of the artists' social status in the nineteenth century using Maximilian's imaginary visit to Dürer's workshop as a subject for history painting (and, slightly earlier, the imagined scene of Leonardo da Vinci dying in Francis I's arms).

884. ———. *Künstler, Kunsthistoriker, Museen. Beiträge zu einer kritischen Kunstgeschichte*, Bucher report, 6. Lucerne/Frankfurt am Main: Heinrich Klotz/C. J. Bucher, 1979.

[Artists, Art Historians, Museums. Contributions to a Critical Art History.] Artists discussed include Dürer, as well as Leonardo, Caravaggio, Rubens, Poussin, and Blake. The art historians include Vasari, Hans Sedlmayr, Arnold Hauser, and Panofsky. The museum treated is the Frankfurt Historisches Museum, which houses works of mainly regional and historical interest. Warnke himself is a prominent art historian of the Marburg school, which views art and artists in historical and economic context.

885. Washington, D.C. National Gallery of Art. *Dürer in America: His Graphic Work*, Ed. Charles W. Talbot. Washington, D.C.: National Gallery of Art, 1971.

Notes by Gaillard Ravenel and Jay A. Levenson. (A permanent hardback edition was published by Macmillan, New York and London, 1971.) Since there are so few paintings by or even attributed to Dürer to be found in the United States, the 1971 exhibitions in Washington and Boston (q.v.) were devoted to his graphic art. Washington's included both prints and drawings, and was notable for bringing to public view the drawings acquired during World War II from the former Lubomirski Museum in Lemberg (modern Lwow), which are divided among several American and Canadian museums including Boston, Chicago, Kansas City, New York, Cleveland and Ottawa. It also included Walter Strauss's observation (before his own publication) that the Metropolitan Museum's *St. Catherine* (W.90) and the *St. Barbara,* formerly in Rotterdam (W.194), were drawn on the same sheet of paper.(Reviewed by Wolfgang Stechow in *The Art Bulletin* 56 (1974), p. 264; and by Alan Shestack in *The Art Quarterly*, 1972, 302ff.).

886. Washington, D.C.: National Gallery of Art. *Hans Baldung Grien: Prints and Drawings*, Eds. James H. Marrow, and Alan Shestack. Washington, D.C.: National Gallery, 1981.

The catalogue of a loan exhibition held in Washington from January 25–April 5, 1981, and also shown at Yale University Art Gallery (April 23–June 14). Surveys Baldung's prints and drawings, investigating questions of style, technique, compositional sources, and subject matter. Essays by Charles Talbot ("Baldung and the Female Nude") and Linda C. Hults ("Baldung and the

Reformation"), as well as Shestack's Introduction, deal with
Dürer's influence on the artist, who is presumed to have been his
journeyman. Works discussed include the *Large Fortune, Adam
and Eve*, and a number of Dürer's religious woodcuts. [Reviewed
by Johann Eckart von Borries in *Kunstchronik* 35 (February 1982);
Colin Eisler, *Print Collector's Newsletter* 12 (July–August 1981);
Robert A. Koch, *Master Drawings* 19 (Summer 1981); John Row-
lands, *Burlington Magazine* (123 [April 1981]).]

887. ———. *Master Drawings from the Collection of the National
Gallery of Art and Promised Gifts*, Andrew Robison, et al. Wash-
ington, D.C.: National Gallery of Art, 1978.

Survey of the Gallery's collection, presented chronologically. In-
cludes the *Tuft of Cowslips* watercolor (1526: attributed to Dürer)
from the collection of Armand Hammer promised to the Gallery,
as well as the following gifts and purchases: *Young Woman in
Netherlandish Dress* (1521, brush with brown and white ink on
gray-violet prepared paper, Widener Collection); *An Oriental
Ruler Seated on His Throne* (ca. 1495, pen and black ink, Ailsa
Mellon Bruce Fund); *The Entombment* (1504, pen and gray ink,
Syma Busiel Fund). The *Cowslips* (German *Himmelschlüssel*)
has been reclassified as "Anonymous German, first quarter of
the sixteenth century" in F. Koreny's catalogue of the Alber-
tina exhibition *Albrecht Dürer und die Tier- und Pflanzenstudien
der Renaissance* (1985, no. 72, q.v.). Fully illustrated but without
text.

888. *Die Alpen in der Malerei*, Ed. Bruno Weber. Rosenheimer Rar-
itäten, Rosenheim: Rosenheimer Verlagshaus A. Förg, 1981.

Major scholars survey painted views of the Alps from the sixteenth
to the twentieth centuries, beginning with Leonardo, Dürer, and
Altdorfer, and including Turner, Klee, Hodler, and Kokoschka.
The book is arranged topographically, with chapters on the Swiss
Alps by the editor; Italian Alps by Nicolo Rasmo, known for his
work on Michael Pacher; Austrian and Yugoslavian Alps by
Alexander Wied, who has done excellent work on the elder
Bruegel; and the German Alps by Eberhard Ruhmer, who has pub-
lished widely on Dürer and Cranach. [Reviewed by Lucas
Wuthrich in *Zeitschrift für Schweizerische Archäologie und Kunst-
geschichte*, vol. 39 no. 1 (1982), 86–87.]

889. Weber, Ingrid S. "Venus Kallipygos, der *Weibliche Rückenacht* nach Dürer." *Städel-Jahrbuch* 9 (1983): 145–150.

Discusses a malachite cameo depicting a nude seen from the back (Kassel, Staatliche Kunstsammlungen, dating ca. 1677), made in a Kassel atelier and traceable as far back as a late seventeenth-century German collection and referred to in eighteenth- and nineteenth-century inventories as *Venus Callypigous*. Argues that this and related reliefs of the same subject, which the author considers to be early seventeenth-century carvings after Dürer's *Nude Seen from the Back* (1506, Berlin: W.402), were all thought to be representations of Venus, and suggests that Dürer also may have identified his drawing as such, despite his model's more meager endowment of adipose tissue. Related works include a relief in the Metropolitan Museum, New York, made of Solnhofen limestone and inscribed "A.D. 1509," and lead casts made from it.

890. Weckerle, J. "Neue Forschungen zur Herkunft Albrecht Dürers." *Süddeutsche Vierteljahresblätter* ser.3, 21 (1972): 176–180.

Reports on the most recent research regarding Dürer's family background (as of Dürer Year 1971). Recommended and utilized by Peter Strieder.

891. Weichardt, Wilhelm. *Albrecht Dürer Kupferstiche. Dreiundfünfzig der wertvollsten Kupferstiche in Originalgetreuer Wiedergabe*, Munich: Einhorn, [1936].

A historical curiosity, this quarto-size volume of fifty-three plates produced during the Third Reich has tipped-in illustrations in original size, mounted on heavy stock, but no commentary on the engravings themselves. Singled out for praise in the brief Introduction are, of course, the *Meisterstiche*, "vor allem wirklicher Volksbesitz geworden." Unsurprisingly the "manly" *Knight, Death, and Devil* is played off against *Melencolia* ("das Bild dumpfer Traurigkeit"). St. Jerome is said to illustrate "the restful end of life of a good man." The arrangement of plates is largely chronological.

892. Weidner, Karl-Heinz. *Richter und Dürer. Studien zur Rezeption des altdeutschen Stils im 19. Jahrhundert*, Europäische Hochschulschriften, ser. 28: Kunstgeschichte, 26. Frankfurt am Main/New York: Peter Lang, 1983.

A study of Dürer's influence on the nineteenth-century German painter Ludwig Richter (1803–1884), seen in the context of the politically charged "old-German" style of the nineteenth century.

893. Weis, Adolf. " '. . . diese lächerliche Kürbisfrage . . .': Christlicher Humanismus in Dürers Hieronymusbild." *Zeitschrift für Kunstgeschichte* 45, no. 2 (1982): 195–201.

Interprets the large vegetable hanging from St. Jerome's ceiling as a pumpkin, relating it to St. Jerome's controversial translation of the Hebrew text of Jonah, and arguing that Dürer, with the help of his friend Willibald Pirckheimer, must have been familiar with St. Jerome's Epistolae on this issue (RILA No. 6752). See also Peter Parshall's article (*The Art Bulletin,* 1971), properly identifying the item as a gourd, and making much the same point.

894. Weiser, Benjamin . "$10 Million in Looted Art is Recovered." *The New York Times*, (September 10, 1997):

Reports the seizure in a New York hotel from a Japanese collector, by agents of the United States Customs Service, of twelve old master drawings, including Dürer's *Women Bathing*, which alone is valued at $6 million, and another unnamed Dürer. The drawings had been looted from a storage facility used by the Bremen Kunsthalle at the end of World War II, had been shipped to the former Soviet Union, and were being exhibited in the National Museum of Baku in Azerbaijan when, in 1993, they were stolen a second time and were allegedly purchased by Masatsugu Koga, sixty, who was released on a personal recognizance bond of $250,000 pending a hearing. Mr. Koga claimed to have been attempting to return the drawings to the Bremen Museum. U.S. Customs agent Bonnie Goldblatt testified, however, that Mr. Koga had first approached the German Embassy in Tokyo in April (1997) offering to sell the drawings, which he said were owned by his family, to Germany for $12 million. He later lowered his price to $6 million, claiming to be working with an unnamed Russian business partner. He has since admitted that he knowingly purchased and had been attempting to sell stolen works, allegedly to pay for a kidney transplant.

895. Weismantel, Leo. *Albrecht Dürer. Der junge Meister*. Freiburg and Munich: Karl Alber. 1954.

Dürer has been a popular figure in German romantic fiction and drama since the early years of the nineteenth century (see Mende, *Bibliographie* pp. 587–591 for specific references). Weismantel is one who carried the genre forward during and after World War II. This is one of his several such novels, concentrating on the brief period of the first Italian journey (1494 through summer 1495). The plot revolves around Agnes Dürer's jealousy at her bridegroom's interest in drawing the nude female figure—for which Willibald Pirckheimer's voluptuous but fictitious maid had obligingly posed. The trip to Italy is undertaken when the maid, and Agnes, discover her pregnancy—the product, we are led to believe, of Dürer's first and only orgasm to date. The resourceful Pirckheimer bundles the maid off to his sister Charitas's convent, where she manages to contract the plague, miscarries Dürer's child, and obligingly dies, as all sinful young women did in the literature of the 1950s. The artist, meanwhile, meets everyone of consequence in Venice—the Bellini family, and Giorgione (portrayed, not without reason, as the ultimate partygoer dancing on top of the table). Dürer remains virtuous, garners a host of new impressions, and returns home to be reconciled with Agnes, thus curing her of a temporary lapse into insanity—and fulfilling another popular expectation of the 1950s reader.

896. Weiss, Josef. "Kurfürst Maximilian I von Bayern als Gemäldesammler. Neue archivalische Beiträge." *Historisch-politische Blätter f.d. kathol. Deutschland,* 142 (1908): 545–569.

Publishes documents dealing with the Elector Maximilian of Bavaria's acquisition of the Paumgärtner Altar (1612/1613); the central panel of the Heller Altar (1614); the so-called *Four Apostles* (Four Holy Men: 1627); and an unsuccessful effort to obtain a *St. Jerome*, dated 1511, then in Stendal.

897. Wenderhorst, Alfred. "Nuremberg, the Imperial City: From Its Beginnings to the End of Its Glory." *Gothic and Renaissance Art in Nuremberg 1300–1550,* 11–26. New York: Metropolitan Museum of Art, and Nuremberg: Germanisches Nationalmuseum. Munich: Prestel, 1986.

Discusses Nuremberg from its founding by the Emperor Henry III; its development as an important administrative center of the Empire under the Hohenstaufen and later under the Hohenzollern line;

membership in the Rhenish League; and alliance with the Hapsburg king Rudolf I; its history under Ludwig the Bavarian, and its defection to side with Charles IV. The transfer of the Imperial regalia to the Nuremberg fortress in 1424, the subsequent annual ritual of the display of the sacred treasure, and Dürer's idealized portraits of Charlemagne and Sigismund which were painted for the chamber behind the gallery of the *Heiltumsstuhl*. The city's official seals are illustrated, and the constitution and activities of the City Council discussed. Of particular interest is the section on the city's economy, based on its crafts—especially those associated with metalwork, and later with publishing and the manufacture of scientific instruments.

898. Werkner, Patrick. "Der Wappenturm Maximilians I in Innsbruck." *Wiener Jahrbuch für Kunstgeschichte* 34 (1981): 101–113.

Compares the painted decoration of Maximilian's tower for coats-of-arms (Innsbruck) with the program in Dürer's *Triumphal Arch* woodcuts, and discusses the architectural alterations up to 1768.

899. Wessely, Joseph Eduard. "Das Manuscript von Paul Behaim's Kupferstichkatalog im Berliner Museums." *Repertorium für Kunstwissenschaft* 6 (1883): 54–63.

Publication of the handwritten inventory of the collection of Paul III. Behaim (1592–1637): "Verzeichniss allerley Kunst von alten niederlendischen, teutschen, italienischen, französischen unnd anderen gueten Meistern, in Kupfer unnd holtz an tag gegeben, collegiert unnd zusammengebracht durch Paulus Behaim juniorem 1618, 9 Decembris." (Kupferstichkabinett Fol. 177.) See also the *Nachtrag* by Julius Janitsch published in *Repertorium* 7 (1884), pp. 128–129.

900. White, Christopher. *Dürer and His Drawings*, New York and London: Watson & Guptill and Phaidon, 1971.

[Phaidon: *Dürer, the Artist and His Drawings*.] A book for the general reader, produced in a beautiful edition by a venerable press specializing in the publication of works devoted to fine drawings. But does not list present owners of the drawings from the former Lubomirski collection now in Kansas City (the *Roebuck*) and Chicago (the *Bullock*). [Reviewed by Wolfgang Stechow in *The*

Art Bulletin 56 (1974) p. 264; and by Eric Young in *Apollo* 99 no. 146 (April 1974) 295.]

901. White, Lynda S. "A New Source for Dürer's *Knight, Death, and Devil.*" *Source* 2, no. 2 (1983): 5–9.

The author suggests that Dürer's engraving of 1513 draws upon elements of Lucas Cranach the Elder's woodcut of 1506, *Knight in Armor Riding Toward the Right.*

902. Wiederanders, Gerlinde. *Albrecht Dürers Theologische Anschauungen*, Berlin: Evangelische Verlagsanstalt, [1975].

[Albrecht Dürer's religious views.] Seeks to determine how closely Dürer's religious art can be considered to reflect his personal religious beliefs. Using the artist's writings, including inscriptions and prayers, as reported in Rupprich I, examines Dürer's view of Christ (Chap. 3), and his depictions of the Passion; the Trinity; the Virgin (Chap. 5); the Apocalypse, Saints, Apostles. Reports his contact, via Pirckheimer, with Luther, Staupitz and Capito; his reaction to the Peasant War. Makes the interesting obsevation that the artist's first trip to Italy coincided closely with the burning of Savonarola at the stake in Florence. Shows Dürer less plagued by scruples than Luther was, and backing off from the cutting edge of reform in later life.

903. Wiesflecker, H. *Kaiser Maximilian I*, 5 vols. Munich: 1971.

The definitive biography of Dürer's most illustrious client. (For a briefer treatment, see Gerhard Benecke (London, 1982).

904. Wiesner, Merry E. *Working Women in Renaissance Germany*, The Douglass Series on Women's Lives and the Meaning of Gender, New Brunswick (NJ): Rutgers University Press,

Contains a brief and not entirely accurate reference to Agnes Frey Dürer, but is otherwise a solidly researched and original study of the occupations of women in Renaissance Germany, including much on Nuremberg. Particularly enlightening is the explication of the work permitted to goldsmiths' and merchants' wives and daughters, and the civic regulation of such dangerous women as widows and bathhouse attendants, all of whom are of interest for Dürer studies.

905. Wilhelmy, Petra. *Studien zur Zeitgestaltung im Werk Albrecht Dürers*, Europäische Hochschulschriften, Reihe XXVIII, Kunstgeschichte, 238. Frankfurt am Main: Peter Lang, 1995.

(Dissertation: Universität des Saarlandes.) Written after consultation with Matthias Mende, Axel Janeck, Lorenz Dittmann, Wolfgang Götz, et al. Deals with Dürer's methods of depicting the passage of time (invoking Gadamer's essay, "Über leere und erfüllte Zeit," in *Sitzungsberichte der Heidelberg Akademie* 1969, 17–35). Reviews previous literature (Etienne Sourieau, Dagobert Frey, Pierre Francastel, Lorenz Dittmann, et al., and the article on "Space and Time," *Encyclopedia of World Art*). Notes that Hans Kauffmann was the first to link Dürer's rhythmic art with elements of time and physical motion (see Kauffmann, *Albrecht Dürers rhythmische Kunst*, Leipzig, 1924). Cites the artist's use of the cycle of illustrations; his compositions such as *The Angel of the Four Winds*, from the Apocalypse series; his use of architectural metaphors in the Life of Mary. The author also addresses such topics as the figure in motion; historical time; sacred versus profane time; and sees the *Landauer Altarpiece* as a culminating point.

906. Willens, Johannes. "Armor of Nuremberg." *Gothic and Renaissance Art in Nuremberg 1300–1500*, 100–104. New York: Metropolitan Museum of Art. Munich: Prestel, 1986.

Discusses Nuremberg as center of ironworking trades and defensive armor manufacture—particularly of helmsmithing—which began as early as the thirteenth century. Includes Dürer's watercolor, *Three Views of a Jousting Helmet* (Paris, Louvre), and discussion of ornamental etching on armor.

907. Williamstown (MA). Sterling and Francine Clark Art Institute. *Dürer Through Other Eyes: His Graphic Work Mirrored in Copies and Forgeries of Three Centuries. An Exhibition Prepared by Students in the Williams College-Clark Institute Graduate Program in Art History*, Ed. Amy Golahny. Williamstown (MA): Sterling and Francine Clark Art Institute, 1975.

Foreword by Julius Held. Forty-nine works shown: includes ten previously unpublished prints by Dürer copyists. Catalogue entries by Judith Adams, Elizabeth A. Cogswell, Anna Cohn, Jay Fisher, Amy Golahny, John Haletsky, Johanna Karelis, and Linda C. Ny-

vall. The papers included were written by students in a seminar on Dürer conducted in the spring of 1974: general essays on "The Documents and Literature on Printed Copies After Dürer," by Anna Cohn (pp. 9–12); "Techniques of Copying," by Judith Adams (13–16); "Hieronymus Hopfer," by Elizabeth A. Cogswell (five etchings: 18–24); "Jan Wierix," by John Haletsky (25–28); "Marcantonio Raimondi," by Amy Golahny (six engravings: 29–33); individual entries on Wenzel von Olmütz's *Dream of the Doctor* (34–35), "Master W.S. (Wolf Stuber)," (38–40); anonymous copies of the *Nemesis* (ca. 1600; 48–49), a late sixteenth-century *St. Jerome in His Study* (52), a late impression from the reworked plate of Dürer's drypoint *St. Jerome by a Pollard Willow* (53–54), the pastiche *Virgin by the Gate* (an engraving utilizing details from different Dürer woodcuts: 62–65), and an unreversed copy after the pastiche (66–67), by Jay Fisher; Johannes Ladenspelder's copies of *Adam and Eve* and the *Sea Monster* (36–37), three copies after *Melencolia I* (50–51), a reversed copy of the *Madonna and Child with the Pear* on late sixteenth-century Roman paper (55), an unrecorded reverse copy after the *Virgin on a Crescent with a Sceptre and a Starry Crown* (56) by Johanna Karelis; an unpublished reversed copy after the engraved portrait of Willibald Pirckheimer (56–57), an unreversed copy after the portrait of Erasmus, formerly attributed to Jan Wierix (57), a reversed copy after the *Lamentation* from the *Large Passion*, from the circle of Marcantonio Raimondi (59), an unreversed woodcut copy after *Joachim and the Angel,* and an eighteenth-century unreversed copy after *The Presentation of the Virgin* from the *Marienleben* (61), and the well-known pastiche with a false Dürer monogram based on Marcantonio's *Venus and Cupid* (67), by Amy Golahny; Johannes Crato's *Holy Trinity* (42–43), Johann Mommard's *Man of Sorrows Seated* from the Small Passion (44), anonymous unreversed etchings after *The Bath House* and the *Lamentation* from the *Large Passion* (58), anonymous unreversed copies after the *Annunciation, Entry into Jerusalem,* and *Last Supper* from the *Small Passion* (60–61), by Linda C. Nyvall. Forty-nine illustrations, and bibliography particularly useful for its listing of exhibition catalogues.

908. Wilson, Adrian. "The Early Drawings for the Nuremberg Chronicle." *Master Drawings* 13, Summer (1975): 115–130.

Five pages of detailed original drawings for woodcuts for the
Nuremberg Chronicle (1493) were discovered in 1972, used as
endpapers in a Koberger Bible. They had been coated with lime
and glue, and only the handwritten words *Archa Noe* (Noah's Ark)
and some ruled lines were visible. When the pages were soaked off
the binding boards, they were discovered to be manuscript-layouts
for Hartmann Schedel's famous Chronicle, and as such they are the
earliest known designs for a printed book. Included are sketches
for the family trees of Adam and Noah, which the author finds
strikingly similar to the early work of Dürer, who at that time
would have been an apprentice in the Wolgemut workshop where
the Chronicle's illustrations were made. The drawings, manuscript-
layouts, and corresponding printed pages are illustrated [RILA].

909. Wilson, Jean C. "Enframing Aspirations. Albrecht Dürer's Self
 Portrait of 1493 in the Musée du Louvre." *Gazette des Beaux-Arts*
 127 (1995): 149–158.

 Discusses Christianity's injunction against self-regard, and
 Thomas à Kempis's *Imitatio Christi* as suppressing self portrai-
 ture—self regard, requiring a mirror, had been symbolic of the
 deadly sin of Pride. (Earthly existence being considered futile, self
 regard was therefore pointless.) Autonomous portraiture only
 began in the mid-fourteenth century, while most self portraits by
 artists date from the sixteenth century or later—with a few notable
 exceptions, including three by Dürer. Wilson considers the Louvre
 portrait not to be "an exercise in self-expression" but as a "self-
 fashioning" image of the person that "he very much wanted to
 achieve." As Greenblatt noted in a well-known study on Renais-
 sance England, "self-fashioning" occurs when an individual is up-
 wardly mobile and subjects himself to models of dress and
 behavior. Dürer, the child of an immigrant father, was "marrying
 up" into the Frey family. He is dressed in courtly style, holding a
 sprig of eryngium (an aphrodisiac, advertising his manhood). Wil-
 son cites K.R. Greenfield's *Sumptuary Law in Nürnberg. A study in
 Paternal Government* (Johns Hopkins University Studies in His-
 torical and Political Science, ser. 36 no. 2, Baltimore, 1918) on the
 use of gold trim, illegal in Nuremberg for men of Dürer's class.
 The practice of sending a portrait to the prospective bride *at all*
 suggests familiarity with the customs of the nobility. (See also
 Lorne Campbell, *Renaissance Portraits,* on this point.)

910. Winterthur (Switzerland), Kunstmuseum. *Odilon Redon*, Rudolf Koella, Günter Busch, and Jürgen Schultze. 1983.

The catalogue of an exhibition of two hundred paintings, drawings, and prints, most of them from Swiss, Dutch, and German private collections. All three authors (Busch on drawings, Schultze on prints, and Koella on paintings) emphasize Redon's relationship to such Old Masters as Dürer, among other sources of influence. Also includes a German translation of Redon's *Confidences d'artiste*, first published 1909; reprinted in *A soi-même* (Paris, 1929.) [Redon confessed that he had "said nothing" that was not already grandly presented in Dürer's *Melencolia. A soi-même*, Paris, 1922, p.27.].

911. Winzinger, Franz. *Albrecht Dürer. Mit Selbstzeugnissen und Bilddokumenten*, Rowohlts Monographien, Beate Kusenberg, Reinbeck bei Hamburg: Rowohlt Taschenbuch Verlag, 1985.

A brief but extremely useful work by the Regensburg scholar, who had published widely on Dürer and the Altdorfers and was one of the few German authorities to attempt to discover a conduit by which Dürer might have known something of the art and thought of Leonardo da Vinci. (See also his article in *Pantheon* 1971.) It is chiefly concerned with the flow of events rather than with stylistic analysis, and brings out the visit of Galeazzo di Sanseverino, protege of Leonardo's employer the Duke of Milan, to Willibald Pirckheimer in Nuremberg in 1502. Well documented, with generous bibliography, chronological table, and brief quotations from Camerarius, Erasmus, and Melanchthon, as well as Wackenroder, Wölfflin, and Winkler.

912. ———. "Dürer und Leonardo." *Pantheon* 29 (1971): 3ff.

Centers around the Munich drawing of *Two Young Horsemen* (pen and brown ink), attributed to Dürer, and Leonardo's silverpoint and pen drawing on rose-tinted paper, *Two Horsemen* (Cambridge, Fitzwilliam Museum, ex coll. Sir Peter Lely). The attribution of the Munich drawing to Dürer was rejected by Lippmann and the Tietzes, while Lisa Oehler (*Marburger Jahrbuch* 17 (1959), 88, 90) suggested Hans von Kulmbach as the author. Winkler, however, embraced it as the "freest and happiest of all the horse-and-rider depictions by the young Dürer." (Winkler I, p. 39, no. 53.) It also had been previously accepted by Flechsig (1931) and by Munich's Peter

Halm (*Hundert Meisterzeichnungen*, 1958, p. 33f., no. 23) and Dieter Kuhrmann (*Zeichnungen der Dürerzeit*, 1967, no. 12). Winzinger establishes Galeazzo di Sanseverino as the link between Leonardo and Dürer, who never met. Leonardo's scientific and artistic observations were unpublished, but Dürer seems to have shared many of his interests, including human and animal proportion. Galeazzo, who was a member of the court at Milan, came to Nuremberg at least once, when he was the houseguest of Willibald Pirckheimer, who had known him since university days at Pavia. This material is incorporated in Winzinger's short monograph (Rowohlt, ca. 1971, q.v.).

913. ————. "Dürers Verhältnis zu Martin Schongauer." *Kunstchronik* 25, no. 7 (1972): 185–186.

One of the papers presented at the Nuremberg symposium, "Problemen der Kunst Dürers zwischen 1490–1500." Winzinger discussed the problem of the relationship to Schongauer in terms of Dürer's early drawings, harking back to his own 1968 article in *Jahrbuch der Berliner Museen* (pp. 151ff., q.v.) The younger artist adopted Schongauer's comma-shaped modeling strokes, and found in Schongauer models for both ideally beautiful heads (e.g., London's *Head of a High Priest*, 1470) and realism (Nuremberg's *Head of an Executioner*, also ca. 1470). Dürer was apparently given access to a number of Schongauer's drawings by the latter's brothers, and probably made copies. Winzinger saw evidence of this in the heads of figures in the two Nativity compositions (Berlin, Coburg), and drew a comparison to Schongauer in Rotterdam's *Madonna in a Courtyard* (attributed to Dürer) and in the Berlin *St. Dorothy*. Response to the paper was mixed: Lisa Oehler, Martin Gosebruch, and Doris Schmidt doubted the attribution of the Coburg *Nativity* to Dürer, and Kurt Bauch expressed his objection to the practice of making new attributions on the basis of photographs.

914. ————. "Eine unbekannte Zeichnung Albrecht Dürers aus seiner Wanderzeit." *Pantheon* 40, no. 2 (1982): 229–232.

Discusses a previously unpublished drawing attributed to Albrecht Dürer and dated to about 1493—thus presumably done on his bachelor's journey in the Rhine valley. The drawing, privately owned, depicts the head and hands of a meditating woman. The au-

thor bases his attribution on comparisons with Dürer's *Self Portrait with Hand and Cushion* (New York, Metropolitan Museum, Lehmann collection) and *Hand Studies* (Albertina).

915. ———. "Umstrittene Dürerzeichnungen II: die *Vilana windisch.*" *Zeitschrift des deutschen Vereins für Kunstwissenschaft* 29, no. 1–4 (1975): 28–43.

Demonstrates that the British Museum's drawing inscribed *Una Vilana windisch* is the autograph Dürer, while the drawing of the same laughing peasant woman (privately owned) that had been put forward by H. T. Musper as the original (*Pantheon* 1971, p. 474) is a slavishly exact copy, possibly done in Dürer's studio by one of his assistants at the request of a collector. In the second part of the essay, Winzinger argues that the drawing of Count Albrecht of Hapsburg (Berlin), recently attributed by Anzelewsky to Burgkmair, is an original by Dürer.

916. ———. "Umstrittene Werke Albrecht Dürers: die Kaiserbrustbilder." *Zeitschrift des Deutschen Vereins für Kunstwissenschaft* 31, no. 1–4 (1977): 17–50.

Detailed examinations of the disputed half-length idealized portraits of the Holy Roman Emperors Charlemagne and Sigismund (privately owned: Zurich), concluding that both are genuine. [But see Strieder, 1979, in *Anzeiger des Germanishen Nationalmuseums*, who rejects the privately owned paintings as autograph works by Dürer.]

917. ———. "Zu Dürers Kaiserbildnissen in Zürich." *Pantheon* 39, July-September (1981): 204–208.

Suggests that the idealized portraits of the emperors Charlemagne and Sigismund in a private Zurich collection antedate the more famous paintings known as the *Heiltumsbilder* (Nuremberg, Germanisches Nationalmuseum), which were commissioned by the City Council for the chamber in which the Imperial relic collection rested before being shown publicly. The author argues that the Zurich works are autograph paintings by Dürer, done in 1514. An X-ray of the portrait of Charlemagne led to the discovery of an earlier inscription indicating that the picture was originally intended to portray the fourteenth-century Emperor Charles IV.

918. Wirth, Jean. *La Jeune Fille et la Mort: Recherches sur les Thèmes Macabres dans l'Art Germanique de la Renaissance*, Publications du Centre de Recherches d'Histoire et de Philologie, 5: Hautes Etudes Médiévales et Modernes,36. Geneva: Droz, 1979.

[The Young Woman and Death: Research on Macabre Themes in Germanic Art of the Renaissance.] The author discusses medieval influences, with reference to the representations of cadavers prior to Dürer and by his followers. Also includes a discussion of legends about death; the work of Hans Baldung; changing concepts of death during the Reformation; the work of Urs Graf, Peter Flötner, and Niklaus Manuel Deutsch.

919. ———. "Le rêve de Dürer." *Symboles de la Renaissance*, Texts by Cristoforo Giarda, Ernst Gombrich, and Meyer Schapiro. Paris: Presses de l'École normale supérieure, 1976.

A short piece on Dürer's watercolor *Dream of a Deluge*, published with the papers of a course given at the École normale supérieure 1969–1971.

920. Wixom, William D. "The Art of Nuremberg: Brass Work." *Gothic and Renaissance Art in Nuremberg 1300–1500*, 75–80. New York. Metropolitan Museum of Art. Munich: Prestel, 1986.

Discussion of Nuremberg brass casting (the craft practiced by Dürer's father-in-law, Hans Frey), including the distinction between the alloys resulting in "red casts" (*Rotguss*) and "yellow casts" (*Gelbguss*)—an issue taken very seriously in the late Middle Ages and Renaissance. The Apollo Fountain and Sebaldus Tomb are discussed, as is the organization of the Vischer family foundry.

921. Wolfenbüttel: Herzog August Bibliothek. *Graecogermania*, Dieter Hurlfinger. 22 July 1909.

Catalogue of the exhibition of Greek incunabula published in Germany, including the editions of Vergil, by Dürer's godfather, Anton Koberger (1492), and the Hesiod published in Augsburg in 1486 by Erhard Ratdolt.

922. Wollgast, Siegfried. "Albrecht Dürer–sein Verhältnis zum "linken Flügel" der Reformation." *Albrecht Dürer. Kunst im Aufbruch*, 199–205. Ed. Ernst Ullmann. Leipzig: Karl-Marx-Universität, 1972.

[From the volume of conference papers presented at the former Karl-Marx-University, Leipzig, May 31-June 3, 1971, honoring Dürer's five hundredth birth anniversary.] Discusses the inscription on the so-called *Four Apostles* (Munich), evidencing the artist's skepticism about institutionalized religion, arguing that Dürer's experience with mysticism and his disillusionment over the events of the Peasants' War (1525) led him to sympathize with the radical elements of the Reformation. His association with the Beham brothers, Sebastian Franck and (perhaps) L. Hätzer are cited as evidence. [The reader, however, would do well to bear in mind the dangers of relying too heavily on the tactic of proclaiming guilt by association.]

923. Wölfflin, Heinrich. *Die Kunst Albrecht Dürers*, 1st ed. Munich: Bruckmann, 1905.

This durable work, written by the reigning Dürer scholar of the early twentieth century, has been reprinted in many editions (no. 6, brought out in a revision by Kurt Gerstenberg came out in 1943; another was published to coincide with the celebration of the artist's five hundredth birth anniversary in 1971.) Wölfflin was at heart a formalist, and his clear and accessible language has traveled well through the political turmoil of two world wars and the Cold War. Still useful for historic interest, as well as for the author's acute observations on the artist's personal style.

924. ———. *Die Kunst Albrecht Dürers*, 4th ed. Munich: S. Bruckmann, 1920.

The standard German monograph on Dürer's art, first published in 1905, has gone through many editions, including a new one in 1971, long after the author's death. It begins with a section on the biography, then devotes individual chapters to the artist's major works—the *Apocalypse*; *Large Passion*; *Life of Mary*; the early engravings; early paintings; Italy and the large altarpieces; the post-Italian graphic style, including the *Small Passion*; the "Master Prints" and related works; the works for Maximilian; the Netherlandish journey; and late works. The book concludes with chapters on the artist's choice of a linear style; his search for the secret of beauty; and an appendix in which newer literature could be discussed in order to update the book. Wölfflin was famously formalistic, but his keen eye for style has made this a useful resource for lecturers from that day to this.

925. Wuttke, Dieter. *Aby M. Warburgs Methode als Anregung und Aufgabe*, Gratia: Schriften der Arbeitsstelle für Renaissanceforschung am Seminar für deutsche Philologie der Universität Göttingen, 2. Göttingen: University, 1978.

An essay originally presented as a lecture in Hamburg (October 1974) on the fourteenth German Art Historians' Day. Demonstrates Warburg's method with an original study of Dürer and Konrad Celtis as Humanists, focusing on the *Self Portrait* of 1500.

926. ———. "Dürer und Celtis. Von der Bedeutung des Jahres 1500 für den deutschen Humanismus. Jahrhundertfeier als symbolische Form." *Journal of Medieval and Renaissance Studies* 10 (1980): 73–129.

A welcome antidote to the obsession with late fifteenth-century chiliasm that infects too many English-speaking art historians. Wuttke here, as in his 1985 article for *Artibus et Historiae* (q.v.), shows that, far from dwelling in fear of the imminent Last Judgment, the turn of the new century held almost Utopian promise for Germany's humanists.

927. ———. "Humanismus als integrative Kraft: die Philosophie des deutschen "Erzhumanisten" Conrad Celtis; eine ikonologische Studie zu programmatischer Graphik Dürers und Burgkmairs." *Artibus et Historiae* 6, no. 11 (1985): 65–99.

[The integrating power of humanism: the philosophy of Conrad Celtis, the German "arch-humanist." An iconological study of Dürer's and Burgkmair's engravings. Has English summary.] Interprets Dürer's woodcut of *Philosophy*, made for Celtis' *Amores* (1502), and Hans Burgkmair's print of the *Imperial Eagle*, devised by Celtis. Proposes solutions to some iconographic riddles, for example, the Greek letters in the *Philosophia* and the *Judgment of Paris* in the *Imperial Eagle*. Discusses sources with respect to form and content and attempts to show that they represent the essence of German humanism about 1500, which aimed at an encyclopedic education, as well as at the integration of Antiquity, the Middle Ages, and the Renaissance—that is, at the best of knowledge of all time, without separating the humanities from mathematics and science. Also makes an important point of the lack of humanist pessimism in the late 1490s with regard to the possible ending of the world, asking why, if the Last Judgment were at hand, would

Dürer have bothered to paint his 1500 *Self Portrait* in "undying" colors? And why would Celtis have written a literary self portrait? Wuttke also treats Celtis's abortive *Germania Illustrata*, and discusses parallels betwen Celtis and Vergil.

928. ———. "Unbekannte Celtis-Epigramme zum Lobe Dürers." *Zeitschrift für Kunstgeschichte* 30 (1967): 321–325.

The author discovered an unpublished epigram written by Celtis, the "arch Humanist" and Imperial poet laureate before 1500, addressed to Dürer. The script used closely resembles that of the inscription on the artist's famous 1500 *Self Portrait* (Munich).

929. Yates, Frances A. "Chapman and Dürer on Inspired Melancholy." *The University of Rochester Library Bulletin* 34 (1981): 25–34.

Citing Panofsky's dependence upon a handwritten manuscript, dated 1510, of Agrippa von Nettesheim's *De occulta philosophia* as the source of Dürer's iconography of *Melencolia I,* Yeats argues that his interpretation of the print is "a Romantic distortion." Alternatively, she sees the winged figure in the engraving as "the Agrippian combination of Magica and Cabbala, surrounded by Saturnine allusions." She interprets the figure as angelic; the ladder as an allusion to Jacob's ladder "on which the angels ascend and descend." Asking "Where, then, is *Melancholy II*?," she argues that a trace of this supposedly lost work can be found in a poem by the Elizabethan writer George Chapman—"Shadow of Night" (1594). Although Yates was a preeminent authority on Elizabethan imagery, her theory did not find wide acceptance.

930. Zahn, Peter. " 'Dornach will ich mit dem negsten potten kumen." Albrecht Dürers Reise-, Fract- und Botenkosten, aus seinen Briefen von Venedig und aus dem Tagebuch der Reise in die Niederlande." *Fränkische Postgeschichtsblätter* 29 (1971): 5–9.

A report on the practical aspects of Dürer's foreign travel, including costs of transportation, package delivery, and message service, based on his letters from Venice and the notations in his Netherlandish diary.

931. ———. *Neue Funde zur Entstehung der Schedelschen 'Weltchronik' 1493*, Renaissance Vorträge, 2/3. Nuremberg: Albrecht-Dürer-Haus-Stiftung, 1973.

The discovery by two student workers in Nuremberg's Stadtbiblio-
thek of a gathering of layout pages for Hartmann Schedel's
Weltchronik (often inaccurately called in English "The Nuremberg
Chronicle") bound into a volume of Anton Koberger's ninth Ger-
man Bible (1483) prompted this interesting publication, which
contains a useful review of the various theories regarding the pos-
sible participation of young Albrecht Dürer in the designs for por-
tions of the *Weltchronik*.

932. Zahn, W. Albert von. *Dürer's Kunstlehre und sein Verhältnis zur
 Renaissance. Mit Genehmigung der Philosophischen Facultät der
 Universität Leipzig*, Leipzig: Rudolph Weigel, 1866.

 The author's Habilitationsschrift. An interesting early study, di-
 vided into seven chapters: 1) an introductory discussion of the be-
 ginning of the Renaissance in Germany; 2) the central role played
 by art theory in the art of the Renaissance, including its relation-
 ship to mathematics and the sciences; 3) Dürer's role, and the rela-
 tionship of the Reformation to the Renaissance 4) Dürer's contact
 with Italian art, and with other northern artists; 5) the theoretical
 work of Dürer's Italian predecessors Alberti and Leonardo, as well
 as the influence of Euclid and Vitruvius; 6) Dürer's own theoretical
 publications, and 7) a concluding chapter comparing Dürer's theo-
 ries with those of the Italians, and characterizing German art theo-
 ries after Dürer's death.

933. Zdanowicz, Irena. "The making of Dürer in the collection of the
 National Gallery of Victoria." *Dürer and His Culture*, 200–210.
 Eds. Dagmer Eichberger and Charles Zika. Cambridge/New
 York/Melbourne: Cambridge University Press, 1998.

 Zdanowicz is Senior Curator of Prints and Drawings at the Na-
 tional Gallery of Victoria in Melbourne. This brief but interesting
 essay traces the Dürer acquisitions from the beginnings of the
 colony of Victoria (1853), when reproductions of his works were
 sought for the Public Library. The Australian gold rush of 1875
 made it possible eventually to acquire three fine original impres-
 sions (1891) from the estate of Whistler's brother-in-law (1818–
 1910) Seymour Haden, one of the creators of the nineteenth-cen-
 tury etching revival. A generous legacy from Arthur Felton (1904)
 made it possible to purchase further important prints, including the
 Robert Carl Sticht collection (1923) and a group of engravings,

among them the Engraved Passion, from the Goya expert Tomàs Harris (1949), and culminating in the visit of Sir Thomas Barlow (1950) who, impressed by the quality of the Haden impressions, offered his own collection of Dürers, intact, for 45,000 pounds sterling. This purchase (1956) completed the collection, which has now been catalogued and examined for repairs, watermarks, and collectors' marks. The fortunate decision has been made not to wash the prints. Interesting diversions are the interest of the Surrealists in Dürer (especially that of the poet Max Harris); and a cycle of 17 poems, an elaborate hoax titled "The Darkening Ecliptic" published in the avant garde journal *Angry Penguins* (June 1944) written under pen names by conservative poets James McAuley (1917–1976) and Harold Stewart (1916–1985) protesting the lack of modern craftsmanship.

934. Zika, Charles. "Dürer's witch, riding women and moral order." *Dürer and His Culture*, 118–140. Eds. Dagmar Eichberger and Charles Zika. Cambridge/New York/Melbourne: Cambridge University Press, 1998.

Zika, Senior Lecturer in history at the University of Melbourne, is a specialist in the lore of witchcraft. He points to the lack of agreement in approximately 1500 as to how witches should be depicted, and establishes Dürer's use of a number of sources in the creation of his *Witch Riding Backwards on a Goat* (1505). Discussed are the implications of riding backward; riding as a "highly gendered act"; the symbolism of goats; distaffs; and tumbling putti as images of disorder.

935. Zink, Fritz. "Albrecht Dürer in Nürnberg-Himpelshof." *Jahrbuch für fränkische Landesforschung* 29 (1969): 289–293.

Zink was chief curator of the Germanisches Nationalmuseum, and director of its print room, from 1948 until his retirement in 1978. He provides positive identification of the location of the farm depicted in the artist's engraving of *The Prodigal Son* as in the hamlet of Himpelshof, a short distance west of Nuremberg.

The Dürer House
Chronology (after Matthias Mende)

ca. 1420	Constructed. (Dendrochronology 1984: Roof timbers felled 1416–1418.)
1501	Purchase by the astronomer-mathematician Bernhard Walther (150 gulden).
1502	Astronomical observatory installed.
1504	Walther dies.
1509	Dürer purchases the house from Walther's estate (275 gulden). Uses it as residence and workshop.
1514	Death of Dürer's mother, who had lived with the artist and his wife.
1528	Death of Dürer in the house; it becomes property of his wife Agnes.
1539	Death of Agnes Dürer; her sister Katherina Zinner inherits the house.
1541	Katherina Zinner sells the house to Niclas Freyenhammer, a blackmith, who installs his forge on the ground floor. His son Heinrich, also a blacksmith, inherits it in 1549. Many changes of ownership over the following two hundred years.
1766	Placed at auction, the house is bought by Abraham Lallmann, a hatmaker, who deeds it to his son Heinrich (1770).
1825	Death of Heinrich Lallmann, a bachelor, the last private owner of the house. It becomes property of the city of Nuremberg.

1826 Restoration of the house by Alexander Heideloff. A memo-
 rial room with a marble bust of Dürer is installed, and the
 house is rented to a local art society, renamed the Albrecht
 Dürer Society (*Albrecht Dürer Verein*).

1828 Three hundredth anniversary of Dürer's death. The house is
 headquarters for receptions for out-of-town guests, includ-
 ing Sulpiz Boisserée, Leo von Klenze, Carl Blechen, Peter
 Cornelius, and others.

1840 Festivities in the house, honoring the unveiling of the
 bronze statue of Dürer by Christian Daniel Rauch and
 Jakob Daniel Burgschmiet in the nearby Milchmarkt—re-
 named Dürerplatz.

1860 Documents concerning the house are auctioned in Nurem-
 berg and taken first to Paris, then to Cologne, where they
 are sold again in 1864. Nineteen, which had ended up in
 Hanover, were destroyed in World War II. Three survive
 and are in Nuremberg's archive.

1871 Four hundredth anniversary of Dürer's birth. Establishment
 of the Albrecht Dürer House Foundation (*Albrecht Dürer-
 Haus-Stiftung Albrecht Dürer Verein*) for purposes of
 restoration and conversion into a museum.

1875 The house is now occupied by the Foundation, the Dürer
 Society having moved out. Attempts to purchase the prop-
 erty from the city are unsuccessful. The painter Carl Jäger
 suggests furnishing the house in the style of Dürer's time,
 and Friedrich Wanderer is commissioned to develop plans.

1877 The stained glass artist Christoph Philipp Böhmländer be-
 comes curator of the house, which is being refurnished
 with reproductions in the style of the Dürerzeit.

1891 The Foundation acquires three of the Dürerhaus docu-
 ments, including Dürer's original deed of purchase. (Now
 in the Nuremberg Municipal Archives.)

1893 Curator of the house is Carl Daumerlang, a painter and
 graphic artist.

1899 An attic dormer salvaged from a demolished house of the
 period is added to the roof of the house, to approximate its
 external appearance in Dürer's day. (Bernhard Walther's

observatory had been destroyed when the roof was repaired by a later owner.)

1915 Installation of electricity in the house.

1924 Extensive exterior renovation by Heinrich Bauer.

1927–1928 Interior restoration and complete refurnishing by Bauer and Heinrich Höhn. Commemoration of the four hundredth anniversary of Dürer's death. The painter August Falcke appointed Curator; his widow appointed after his death in 1931.

1942–1945 Extensive damage due to aerial bombardment of Nuremberg by the R.A.F. during World War II.

1949 Gala reopening of the house after restoration. (Reported in *Nürnberger Nachrichten* 5 (August 31, 1949). (Mende no. 606.)

1956–1971 The graphic artist Konrad Volkert is curator—the last to be granted living privileges in the house.

1969–1971 Construction of modern exhibition space in annex on west side of house, under direction of Harald Clauss.

1971 Extensive restoration in honor of Dürer's five hundredth birth anniversary. Reinstallation directed by Karl Heinz Schreyl, including a printing press built to resemble one illustrated in a drawing by the artist.

1984 Opening of the third floor of the house to the public, and installation of permanent exhibition of contemporary art works reflecting Dürer reception.

1990 Complete renovation of exterior with documentation of traces of earlier states of the building by the Nuremberg firm of Hermann Wiedl.

REFERENCES

Views

For early views of the Dürer house (1715–1895), see Matthias Mende, *Dürer-Bibliographie* (Wiesbaden: Harrassowitz, 1971), Chap. V, nos. 567–580. (Depictions of house by J. A. Delsenbach, Samuel Mikovinyi, Langhans, Friedrich Wagner, Lorenz Ritter, and others.)

History and Documentation

1. Joseph Heller, [Purchase of the Dürerhaus by the city of Nuremberg], in *Wochentliche Kunstnachrichten* 1 (1825 no. 50): 487–488, and (52), 502. (Mende no. 569.)

2. [Friedrich Campe]. *Zur Einzugsfeier in Dürers Haus den 30 November 1826.* Nuremberg: Campe, 1826. (Mende no. 570.) Unsigned two-page pamphlet announcing the gala opening of the house after its initial restoration.

3. Kress, Georg Freiherr von. "Das Dürerhaus und seine Geschichte," *Jahresberichte der Verein für Geschichte der Stadt Nürnberg*, 11 (1888) 15–17. (Mende no. 579) Text of lecture given on November 8, 1888.

4. Kress von Kressenstein, Georg Freiherr. "Albrecht Dürer's Wohnhaus und seine Geschichte," in *Wort und Bild dargestellt im Auftrag der Verwaltung der Albrecht Dürer-Haus-Stiftung.* Nuremberg: Dürerhaus, 1896. (Mende no. 581.)

 Includes report of acquisition of Dürer's deed of purchase (June 14, 1509) (Reproduced in facsimile in Hans Rupprich, *Dürers schriftlicher Nachlass* 1 (Berlin: 1956) No. 3.

 Reviews: *Jahresbericht für neuere deutsche Literaturgeschichte,* 8 (1897), I 12 (Cornelius Gurlitt). *La chronique des arts et de la curiosité* (1897 no. 9), 90–91 (Auguste Marguillier). *Mitteilungen der Verein für Geschichte der Stadt Nürnberg* 12 (1898), 343–344 (Edmund Wilhelm Braun).

5. Höhn, Heinrich. *Das Albrecht Dürer-Haus. Seine Geschichte und seine Sammlungen. Ein im Auftrag der Albrecht Dürer-Haus-Stiftung verfasster Führer.* Nuremberg: Dürerhaus, 1911. (Mende no. 585) The first official guidebook to the Dürer house and the collection of modern Franconian artworks it had acquired by 1911, written by one of the two men responsible for the recent restoration and refurnishing. An update by the same author appeared in *Der fränkische Bund* 1 (1924 no. 4/5) Umschau 1.

6. Schauwecker, Heinz. *The Dürer House in Nuremberg. Eight paintings in watercolours after originals by William Ritter, artist of Nuremberg.* Nuremberg: 1928. (Mende no. 596.) English edition of the souvenir album produced in honor of the Dürer Year 1928, which brought a record number of out-of-town visitors to the city to view the first comprehensive exhibition of Dürer's work.

7. Bauer, Heinrich, and Heinrich Höhn. *Das Albrecht-Dürer-Haus in Nürnberg und seine Wiederherstellung im Dürer-Gedächtnisjahr 1928* . Nuremberg: Albrecht-Dürer-Haus-Stiftung, 1928 (Mende no. 598.) Report by the two restorers of the house, also published by the Albrecht Dürer House Foundation in time for the year-long festivities honoring the artist's four hundredth death anniversary.

8. Höhn, Heinrich. *Das Dürer-Haus zu Nürnberg. Ein Führer durch seine Geschichte, seine Einrichtung und seine Sammlungen.* Nuremberg: Albrecht Dürer-Haus-Stiftung, 1930 (Mende no. 600.) A new sixty-four–page guidebook with twenty-two illustrations, reporting on both the restored house and its collections. An English translation, also published by the Dürer-Haus-Stiftung, came out in 1931 (Mende no. 601).

9. Schulz, Fritz Traugott. *Nürnbergs Bürgerhäuser und ihre Ausstattung. Herausgegeben mit Unterstützung des Stadtrats Nürnberg vom Verein für Geschichte der Stadt Nürnberg. Vol. 1: Das Milchmarkt Viertel. Part 1.*
Leipzig and Vienna, 1909–1933 (Mende no. 603.) The restoration of the Dürer House led to renewed respect for the historic buildings of central Nuremberg. This volume, sponsored by the City Council and published by the Nuremberg Historical Society deals with the area around the former Milk Market (renamed Albrecht-Dürer-Platz), site of the Dürer monument.

10. "Das Wohnhaus von Albrecht Dürers Vater," *Die Weltkunst* 9 (1935, no. 41) 1–2. (Mende no. 605). Report on the restoration of the house "unter der Vesten" (i.e., immediately downhill from the Imperial fortress) in Nuremberg's Burgstrasse, at the corner of Obere Schmiedgasse, which Albrecht Dürer the Elder purchased in 1475 for two hundred gulden, and in which the artist lived from the age of four until his departure for his bachelor's journey. The house, in Nuremberg's Latin Quarter—the most desirable section of the city—was destroyed in World War II.

11. Schwemmer, Wilhelm, and Harald Clauss. *Das Albrecht Dürer-Haus in Nürnberg.* Nuremberg: Albrecht-Dürer-Haus-Stiftung, 1959. Coauthored by the Museum Director, Wilhelm Schwemmer, and *Baudirektor* Harald Clauss, who later supervised the construction of the modern annex to the house. Includes building history, brief biography of the artist, and extracts from the Family Chronicle. An English translation (undated) appeared, also approximately 1959. (Mende no. 610).

12. Schwemmer, Wilhelm. *Die Bürgerhäuser der Nürnberger Altstadt aus reichstädtischer Zeit. Erhaltener Bestand der Sebalder Seite.* Nuremberg, 1961 (Nürnberger Forschungen. Einzelbearbeiten Nürnberger Geschichte, 6) (Mende no. 611). Condition report of the private houses in the area surrounding the Church of St. Sebald (Dürer's parish), dating from the time when Nuremberg was still an Imperial free city. Dürer House featured 24–26.

13. Mende, Matthias, ed. *Dürer Haus Nürnberg.* With essays by Harald Clauss and Karl Heinz Schreyl. (Nürnberg: Museen der Stadt Nürnberg, 1971). Unpaginated but useful pamphlet containing floor plans of the house, a brief, illustrated history of the building; topography of the Tiergärtnertor area; the 1971 restoration and construction of the annex; and a timetable of the artist's life and major works. Of particular interest is the brief illustrated essay on the "Wanderer-Zimmer," restored after Ferdinand Schmidt's pre-1900 photograph of the room decorated in 1875 by Friedrich Wanderer and Karl Jäger in their conception of "the spirit of Dürer." A list of current publications on Dürer, with their 1971 prices, is appended.

14. Mende, Matthias. *Das Dürerhaus in Nürnberg Geschichte und Gegenwart in Ansichten von 1714 bis 1990. The Dürer House in Nuremberg. Its Past and Present from 1714 to 1990.* Nuremberg: Verlag Hans Carl, 1991. A nicely produced exhibition catalogue presenting views of the house as interpreted by Johann Adam Delsenbach, Johann Christoph Erhard, W. R. Smith, Johann Georg Wolff, Friedrich Wagner, Georg Paul Buchner, Carl Ferdinand Langhans, Johann Leonhard Deifel, J. G. F. Poppel, Carl Friedrich Kaeppel, Alexander Marx, W. H. Harriot, Edward W. Cooke, Émile Rouargue, Lorenz Ritter, Friedrich Perlberg, Hans Blum, Johann Andreas Luckmeyer, Friedrich Trost, Sr., Carl Daumerlang, Stanley Anderson, Emil Stumpp, Klara Minnamier, Ewald Friedrich (showing the damage after the bombardment in World War II), Wolfgang Hertel, Friedrich Neubauer, Brigitta Heyduck, Toni Burghart, Gisela Habermalz, Siegbert Jatzko, Bernd Cibis, Peter Ackermann, Gisela Breitling, Egbert Herfurth, Wolfgang Lenz, Paul Mersmann, Kurt Muhlenhaupt, and Gerd Winner. Prefaced by a chronological table recording the building history, and an excellent essay by Mende on the role of the house in the "cult" of Albrecht Dürer between the Romantic period and *Neue Sachlichkeit.* The seven graphic works from 1990 were available for sale through Sandoz AG, Nuremberg.

Chronology

1471	May 21. Nuremberg. Birth of the artist, third of the eighteen children of the Hungarian-born goldsmith Albrecht Dürer the Elder (1427–1502) and his wife Barbara, née Holper (1451–1514). Dürer's godfather was the goldsmith Anton Koberger, soon to become Germany's most important publisher.
1475	The elder Dürer purchased and moved his family into the house "unter der Vesten" (destroyed in World War II), which stood near the Imperial fortress in Nuremberg's Latin Quarter.
ca.1477–1483	Formal education, either in the parish school of St. Sebaldus or, as seems more likely, in one of Nuremberg's privately run "German schools."
ca.1482–1485	Apprenticeship in father's goldsmith workshop.
1484	Age thirteen. Earliest dated work, (*Self Portrait,* silverpoint, Vienna, Albertina).
1486–1489	Age fifteen–eighteen. Apprenticeship (November 30, 1486) to the Nuremberg painter/woodcut designer Michael Wolgemut (1434/1437–1519).
1490–94	First painting: *Portrait of Albrecht Dürer the Elder* (Florence, Uffizi). Departure "after Easter" (1490) on bachelor's journey, principally in Rhine valley. Left Nuremberg April 11, 1490, perhaps traveling west with

Koberger's book freight pack train bound for Frankfurt. Possible stops in Cologne and/or Mainz before 1492.

1492 Visit to the Colmar workshop of the Alsatian painter-engraver Martin Schongauer, unaware that Schongauer had died on or before February 2, 1491, probably of the plague. Cordially received by Schongauer's brothers, the goldsmiths Paul, Caspar (?), and Georg, and the painter/engraver Ludwig.

1492–1493 Journeyman in Basel as designer of woodcut illustrations (*Epistolare beati Hieronymi*, Nikolaus Kessler, August 2, 1492; 147 drawings on woodblock for unpublished edition of the *Comedies* of Terence. Possible contributions to the woodcut illustrations for Sebastian Brant's *Narrenschiff* and Geoffrey de la Tour Landry's *Ritter vom Turn* (both Bergmann von Olpe, 1494 and 1493 respectively).

1493–1494 Strassburg. *Self Portrait* (Paris, Louvre, dated 1493.) Engagement to Agnes Frey, daughter of the Nuremberg metalsmith Hans Frey (1450–1523), building manager of Nuremberg's City Hall, and his wife, the former Anna Rummel.

1494 Return to Nuremberg (May 18). Marriage to Agnes Frey (July 7). Severe outbreak of plague in Nuremberg (September). Departure (probably before October) for extended trip to northern Italy.

1494–1495 Venice. Return to Nuremberg, probably traveling with boyhood friend, the future humanist Willibald Pirckheimer. Landscape watercolor views of northern Italy and the Tyrol—among first independent landscapes of actual places in Western art. First payments from Friedrich the Wise.

1496 First formal commission: *Portrait of Friedrich the Wise of Saxony,* future protector of Martin Luther. Beginning of activity as printmaker.

1497 Hired sales agents to sell his graphic art abroad. Installed a printing press in the family home "under the Fortress."

1498 Citizenship in Nuremberg. Publication of the *Apoca-*

	lypse woodcut book, utilizing Koberger's typefaces and naming himself as publisher. Beginning of work on the *Large Passion*. *Self Portrait* (Madrid, Prado).
1500	*Self Portrait in Fur* (Munich, Alte Pinakothek). Beginning of interest in theory of proportion. Jacopo dei Barbari arrives in Nuremberg. Hans Süss from Kulmbach joins workshop.
1502	Death of Albrecht Dürer the Elder. Beginning of work on the woodcuts for *The Life of Mary* (finished 1510), dedicated to Caritas Pirckheimer (Willibald's eldest sister), Abbess of the Franciscan convent of St. Clara, Nuremberg. Watercolor of the *Wild Hare* (Vienna, Albertina).
1503	*The Great Piece of Turf* (Vienna, Albertina). Hans Schäuffelein joins the workshop.
1504	Completion of the *Paumgartner Altar* (Munich, Alte Pinakothek). The Fall of Man engraving. The *Jabach Altar* (Cologne, Wallraf-Richartz Museum and Frankfurt, Städelsches Kunstinstitut); the *Adoration of the Magi* for Friedrich the Wise (Florence, Uffizi). Friedrich's household accounts list meals for one week (August 10–17, 1504) for "the painter Meister Albrecht and his wife" in Wittenberg.
1505	Departure for second trip to Italy (late summer), traveling at least partially on money borrowed from Pirckheimer. Outbreak of plague in Nuremberg causes many to leave the city, and Koberger to close his press for the duration. Wife and mother remain in Nuremberg to manage household and sales. Hans Baldung may have been the journeyman in charge of the workshop in Dürer's absence. Wolf Traut (1480–1520) also joins the workshop.
1506	Venice, documented through letters to Pirckheimer. The Rosary Altarpiece (*Feast of the Rose Garlands)* for St. Bartholomew's, the German church in Venice (now Prague, National Gallery). *Christ Among the Doctors* (Lugano-Castagnola, Thyssen-Bornemisza Collection.) Short trips to Bologna (to study theory of linear perspective with Fra Luca Pacioli), Ferrara, and Padua. Possible trip to Rome.

1507 Return to Nuremberg. *Adam and Eve* (Madrid, Prado).

1508 The *Martyrdom of the Ten Thousand Christians* (Vienna, Kunsthistorisches Museum) for Friedrich the Wise. Commission from Jacob Heller of Frankfurt, for the altarpiece of the *Coronation of the Virgin* (destroyed by fire 1729). Correspondence with Heller, and copy by Jobst Harrich (Frankfurt, Historisches Museum) survive. Modello for the *Altarpiece of All Saints* (the *Landauer Altar,* Vienna, Kunsthistorisches Museum), for chapel of old men's home founded by Matthaus Landauer.

1509 Purchase (275 gulden) of the large house by the Tiergärtner Tor (the "Dürer House," now a museum), still with its astronomical observatory and scientific library, from the estate of the mathematician/astronomer Bernhard Walther (d. 1504). Brings his widowed mother from the old family home (now the residence of his goldsmith brother Endres). Membership in the larger (and less prestigious) of the two chambers of the City Council. Beginning of work on the *Small Woodcut Passion.* Exchange of drawings with Raphael.

1510 Commission for the "portraits" of the Holy Roman emperors Charlemagne and Sigismund for the Schopper Haus in the market place, where the Imperial relic collection and coronation regalia were housed on the evening before each public display. (Replacements for paintings made in about 1430.) Not installed until 1513.

1511 Publication of the *Large* and the *Small Woodcut Passion* series, and a second Latin edition of the *Apocalypse,* with Imperial privilege (copyright).

1512 Emperor Maximilian I in Nuremberg; beginning of Dürer's commissions from him, including marginal drawings for the *Prayerbook,* and the *Triumphal Arch.* Purchase of garden plot outside the city wall.

1513 First of the three "master engravings": *Knight, Death, and Devil* (B.98). *Sudarium Held by Two Angels* (B.25).

1514 The two remaining "master engravings": *St. Jerome in His Cell* (B.60) and *Melencolia I* (B.74). Charcoal

	drawing of *Dürer's Mother* in her last illness (Berlin, Kupferstichkabinett); mother's death on May 16. *Virgin on a Crescent with a Diadem* (B.33); *Madonna by the Wall* (B.40).
1515	Completion of the commissions for Maximilian, and grant of a pension of 100 gulden per year, to be paid by Nuremberg city council from tax monies due the Emperor. Woodcut, *Map of the World* and *Map of the Northern Firmament* made in collaboration with Johann Stabius and dedicated to Cardinal Matthaus Lang von Wellenburg. *Christ's Agony in the Garden* (B.19: etching).
1516	The *Sudarium* (B.27) and *Abduction of Proserpina* (B.72: etchings). Portrait of Michael Wolgemut (Nuremberg, Germanisches Nationalmuseum). Wolgemut, then aged eighty-two, died three years later.
1517	Guest of Bishop Georg III von Limburg in Bamberg.
1518	With Nuremberg's Municipal Secretary, Lazarus Spengler (his neighbor and friend), and with Kaspar Nützel and Leonhard Groland, travels at city expense to attend the Imperial Diet at Augsburg, where he portrays the emperor in a life drawing as Maximilian sat presiding over the meetings (Martin Luther was in Augsburg October 12–21, to be interrogated by Cardinal Cajetan). Woodcut, *The Virgin Mary as Queen of the Angels* (B.101.); *The Large Cannon* (etching).
1519	Death of Maximilian (January 12), invalidating Dürer's pension. Using the life drawing made in Augsburg, paints portraits of *Maximilian* (Vienna: Nuremberg; also woodcut version, B.154.) Travels to Switzerland with Pirckheimer; visits former journeyman Hans Leu in Zurich. (Leu, a follower of the Swiss reformer Ulrich Zwingli, is later killed with Zwingli in Battle of Kappel [1531].) *The Virgin Mary Nursing the Child* (B.36: engraving); *St. Anthony* (B.58: engraving). *Portrait of Cardinal Albrecht von Brandenburg* ("The Small Cardinal": B.102 engraving.)
1520	*The Virgin with the Swaddled Infant* (B.38). July 12: Departure for the Netherlands, with Agnes and their

maid, via Bamberg, Frankfurt, Mainz, and Cologne. Records expenses, social obligations, and travel impressions in a diary; also makes a silverpoint sketchbook and numerous charcoal and pen drawings. With headquarters in Antwerp, makes journeys to Brussels, and to court of Margaret of Austria, Malines; comments on fifteenth-century Flemish painting and on the objects sent by Cortez from Mexico to honor Charles V. Meets Erasmus and Peter Gillis; attends coronation of the new emperor, Charles V, in Aachen and is granted renewal of pension. Returns to Antwerp via Cologne and 's-Hertogenbosch. Serious illness (malaria?) contracted on trip to Zeeland, which recurs, and may eventually have led to his death.

1521 Meets King Christian of Denmark; portrays *Lucas van Leyden*. Hears false news of Luther's arrest. Makes drawing of *Agnes* wearing the Netherlandish headdress that he gave her for their wedding anniversary. Departure for home July 12, arriving end of the month. Commissioned to fresco the interior of the Great Hall of Nuremberg's City Hall (destroyed World War II.)

1522 Woodcut, *Portrait of Ulrich Varnbühler* (B.155.), protonotary of the Imperial Diet (later chancellor).

1524 Begins writing family chronicle using notes begun by his father. Portrait engravings of *Willibald Pirckheimer* (B.106) and *Friedrich the Wise* (B.104), shortly before the latter's death.

1525 Publication of first book of theory, the *Unterweysung der Messung*. Woodcut illustrations include the *Monument to a Dead Peasant* and depictions of a *Draftsman at Work with a Foreshortening Device*. Records *Dream of a Deluge* (watercolor: Vienna, Kunsthistorisches Museum).

1526 The *Four Holy Men* (Munich, Alte Pinakothek) presented to the City Council. Portraits of *Hieronymus Holzschuher* (Berlin) and *Jakob Muffel* (Berlin). Engraved portraits of *Erasus of Rotterdam* (B.107, utilizing life studies made in Antwerp), and *Philipp Melanchthon* (B.105), the young classical scholar and reformer who

	had come to Nuremberg to supervise the secularization of the city's school system. Melanchthon would later become the author of the Augsburg Confession.
1527	Publication of the *Befestigungslehre* (Theory of Fortification).
1528	Dürer's death (April 6), leaving a substantial estate of 6,874 florins. Burial in the Cemetery of St. John, in the grave of his wife's parents. Body exhumed three days later by humanist friends to make a clay death mask (now lost). Lock of hair preserved (now in Vienna Academy; first sent to Hans Baldung). Publication of the German edition of the *Vier Bücher von menschlicher Proportion* (Four Books of Human Proportion) in October, seen through press for Agnes Dürer by Pirckheimer.
1538	Death of Dürer's younger brother Hans, in Cracow where he was court painter to the King of Poland.
153	Death of Agnes Dürer. In her will she left money to endow a scholarship fund to enable the son of a craftsman to study theology and the liberal arts.
1555	Death of Dürer's only surviving relative, his brother Endres, in Nuremberg. Endres, a goldsmith, had inherited Dürer's workshop equipment when the artist died in 1528, and also was Agnes Dürer's heir.

Location Guide

PAINTINGS

Augsburg: Staatsgalerie

Portrait of Jacob Fugger (attributed).

Berlin: Staatliche Museen preussischer Kulturbesitz

Madonna and Child with the Siskin

The Virgin Mary in Prayer

Portrait of Friedrich the Wise

Portrait of Hieronymus Holzschuher

Portrait of Jakob Muffel

Portrait of a Young Woman of the Fürleger Family (with braided hair; original canvas version, acquired 1977)

Portrait of a Woman by the Sea (1507)

Boston: Isabella Stuart Gardner Museum

Portrait of Lorenz Sterck

Budapest: Szépmüvészeti Museum

Portrait of a Young Man Cambridge (UK): Fitzwilliam Museum

St. Jerome in Penitence

Cologne: Wallraf-Richartz Museum

Two Musicians (Piper and Drummer: Wing of the Jabach Altarpiece)

Darmstadt: Schlossmuseum

Portrait of a Young Man (Anton Neubauer?) (attributed)

Dresden: Gemäldegalerie

The Dresden Altarpiece (center panel disputed)
The Mater Dolorosa Altarpiece (Seven Sorrows of the Virgin)
Portrait of Bernhard (von Resten?)

Florence: Uffizi

Adoration of the Magi
Madonna with the Pear
St. James the Great
St. Philip
Portrait of the Artist's Father (1490)

Frankfurt am Main: Städelsches Kunstinstitut

Job and His Wife (Wing of the Jabach Altarpiece)
Portrait of (Katherina?) Fürlegerin with Unbound Hair

Genoa: Palazzo Rosso

Portrait of a Young Man

Karlsruhe: Staatliche Kunsthalle

Christ as the Man of Sorrows

Kassel: Gemäldegalerie

Portrait of Elspeth Tucher (1499)

Leipzig: Museum der bildenden Künste

The Holy Family (gouache; ca. 1495)
Portrait of Katherina Fürlegerin

Lisbon: Museo de Arte Antigua

St. Jerome (1521)

London: National Gallery

Madonna with the Iris (no longer accepted)

Portrait of the Artist's Father (1497)

Lugano-Castagnola: Thyssen-Bornemisza Collection

Christ Among the Doctors (Opus quinque dierum, 1506)

Madrid: Prado

Self Portrait (1498)

Adam and Eve (1507)

Portrait of the Treasurer Lorenz Sterck (1521)

Munich: Alte Pinakothek

Self Portrait in Fur (1500)

Inner wings of the Jabach Altarpiece (Left: Sts. Joseph and Joachim; Right: Sts. Simeon and Lazarus)

The Lamentation

Madonna and Child with a Carnation (1516)

Mater Dolorosa (from Kloster Benedictbeuren)

Four Holy Men ("Four Apostles": Sts. John, Peter, Mark, and Paul, 1526)

Paumgartner Altarpiece (vandalized 1988, and restored 1998)

Suicide of Lucretia (1518)

Portrait of Oswolt Krel

Portrait of a Young Man (the artist's brother Hans?)

New York: Metropolitan Museum of Art

Salvator Mundi

Virgin and Child with St. Anne (Benjamin Altman Foundation)

Nuremberg: Germanisches Nationalmuseum

The Emperor Charlemagne
The Emperor Sigismund
Hercules Killing the Stymphalian Birds
Portrait of Maximilian I
Portrait of the Artist's Mother (ca. 1490)
Portrait of Michael Wolgemut

Ober St. Veit: Erzbischöfliches Palais

The Ober St. Veit Altarpiece

Paris: Bibliothèque Nationale

Heads of Two Boys
Head of a Woman (ca. 1520)

Paris: Musée du Louvre

Self Portrait (1493)
Head of a Child with a Long Beard

Parma: Magnani Collection

Madonna and Child in Front of an Archway (1494: attributed)

Prague: Narodni Galerie

The Feast of the Rose Garlands

Schweinfurt: Dr. G. Schaefer Collection

Madonna and Child in Front of a Landscape (1495–1496, attributed)

Toledo, Ohio (USA): Toledo Museum of Art

Portrait of Jobst Planckfeldt's Wife

Vienna: Kunsthistorisches Museum

Adoration of the Trinity (The Landauer Altarpiece, 1511)
Madonna and Child in Half-Length (1503)

Madonna and Child (with a sliced pear, 1512)

Martyrdom of Ten Thousand Christians (1508)

Portrait of Johannes Kleberger (1526)

Portrait of Maximilian I (1519)

Portrait of a Young Man (1507; on reverse, a Vanitas of an old woman with bare breasts)

Portrait of a Young Venetian Woman (1505)

Washington, D.C.: U.S. National Gallery of Art

The Haller Altarpiece (Madonna and Child in half-length; on reverse, Lot and His Family Leaving Sodom)

Portrait of a Clergyman (attributed)

Weimar: Staatliche Kunstsammlungen

Portrait of Felicitas Tucher

Portrait of Hans Tucher

Windsor Castle: H. M. Queen Elizabeth II

Portrait of Burkard of Speyer (1506)

WATERCOLORS

Collections

Basel: Kunstmuseum, Kupferstichkabinett

The Doss' Trent (W.97)

A Young Nuremberg Woman Dressed for Dancing (Pen and ink with watercolor, Inv. 1959.105)

Bayonne: Musée Bonnat

Head of a Roebuck (Inv. N.I.1271, A.I.655)

Berlin: Staatliche Museen preussischer Kulturbesitz, Kupferstichkabinett

Quarry (W.111)

Segonzano Castle (W.101)

Trees in a Mountain Landscape (W.104)

Valley near Kalchreuth (W.117)

Water-wheel (W.103)

Wing of a Lapwing (attributed. Inv.KdZ 1274)

Wire-drawing Mill (W.61)

Bremen: Kunsthalle

Iris (altered by another hand. Inv. 35)

Bremen: Kunsthalle (formerly)

Removed from their wartime storage in Karnzow Castle to the Soviet Union at the close of World War II. Some were first placed in storage in the Shchusev Museum of Architecture, Moscow, in 1947, then removed to the Hermitage in St. Petersburg in 1989; others were stored in the secret depository of the Pushkin Museum, while the "Castle on a Rock" was taken, together with other Bremen master drawings, to the German Embassy in Moscow. Permission has never been granted for their return to Bremen:

Three Linden Trees (W.64)

St. John's Cemetery (W.62)

Quarry (W.107)

View of Nuremberg from the West (W.116)

View of Trent (W.96)

The Village of Kalkreuth (W.118)

Chantilly: Musée Conde

Project drawing for the Landauer Altarpiece (1508: pen and water-color)

The Annunciation (1526: pen with watercolor)

El Escorial: Biblioteca del Monasterio de San Lorenzo el Real

Alpine Road (W.100)

Hamburg: Kunsthalle

Lion (1494: Body color on vellum)

Lisbon: Museu Calouste Gulbenkian

Dead Duck (W.616)

London: British Museum

The Castle of Trent (W.95)

House on an Island in a Pond (W.115)

Fir Tree (W.121)

Nuremberg Woman Dressed for Church (1500)

Pond in the Woods (W.114)

Quarry (W.110)

London: Courtauld Institute, Collection of Count Seilern

Model for the portraits of the emperors Charlemagne and Sigismund (pen and ink with watercolor)

Malibu (CA): The J. Paul Getty Museum

Stag Beetle (W.370, attributed)

Milan: Biblioteca Ambrosiana

Quarry (W.107)

Ruined Alpine Hut (W.102)

Tree in a Quarry (W.112)

Oxford: Ashmolean Museum

Alpine Landscape (W.99)

Paris: Bibliothèque Nationale, Cabinet des Estampes

Head of a Stag Killed by an Arrow (1504)

Paris: Musée du Louvre, Cabinet des Dessins

Portrait of a Bearded Man n a Red Cap (1520: watercolor on canvas)

Jousting Helmet in Three Views (brush drawing with watercolor and body colors)

Mills on a River Bank (W.113)

View of Arco (W.94)

Paris: Musée du Louvre. Collection of Edmond de Rothschild

Lioness (1521: Inv. 16 DR; companion to Vienna's Lion, q.v.)

Rotterdam: Museum Boymans-van Beuningen

Sea Crab.

Vienna: Graphische Sammlung Albertina

The Infant Savior (1493: tempera on vellum)

Arion (brush drawing tinted with watercolor)

Castle Courtyard without Clouds (W.67)

Castle Courtyard with Clouds (W.68)

Covered Bridge at the Haller Gate, Nuremberg (W.223)

Design for the Great Triumphal Chariot of Maximilian I (1518:
 Pen and ink with watercolor)

Landscape Flooded (Dream Vision: 1525)

The Large Piece of Turf (1503: W.346)

View of Innsbruck (W.66)

Madonna with the Many Animals (W.296)

Dead Blue Roller (Inv. 3133, D 105)

Little Chandelier Woman (Lusterweibchen, 1513: pen and brush
 with watercolor)

Sketch for Courtly Garb (pen with watercolor)

Lion (1521: W.824)

Wild Hare (W.246)

Young Owl (Inv. 3123, D165)

Wing of a Blue Roller (1512: W. 614)

PRINTS

Collections

Due to the large number of surviving impressions of Dürer's many woodcuts and intaglio prints it is not possible to list repositories for individual woodcuts and engravings in this volume. The list below is a

highly selective general guide to public collections in Europe and the United States possessing large numbers of Dürer prints of high quality. To locate a fine impression of a particular print, the reader should consult Commentary Volume 10 of *The Illustrated Bartsch* series, Walter L. Strauss, editor (New York, Abaris Books, 1981).

Bamberg: Staatsbibliothek

Basel: Kunstmuseum, Kupferstichkabinett

Berlin: Staatliche Museen preussischer Kulturbesitz—Kupferstich-kabinett

Boston: Museum of Fine Arts

Bremen: Kunsthalle

Braunschweig: Herzog Anton Ulrich-Museum

Brussels: Cabinet des Estampes de la Bibliothèque Royale Albert I

Cambridge (UK): The Fitzwilliam Museum

Chicago: The Art Institute

Cincinnati: The Cincinnati Art Museum, Herbert Greer French Collection

Coburg: Sammlung der Veste

Copenhagen: Statens Museum for Kunst

Detroit: The Institute of Arts

Dresden: Kupferstich-Kabinett

Erlangen: Universitätsbibliothek, Graphische Sammlung

Frankfurt am Main: Städelsches Kunstinstitut

Hamburg: Kunsthalle

Kansas City: Nelson-Atkins Museum

Leipzig: Museum der bildenden Künste

London: The British Museum, Department of Prints and Drawings

Melbourne: National Gallery of Victoria

Munich: Staatliche Graphische Sammlung

New York: The Metropolitan Museum of Art

Nuremberg: Germanisches Nationalmuseum

Oxford: Ashmolean Museum

Paris: Bibliothèque Nationale, Cabinet des Estampes

Paris: Musée du Louvre. Cabinet Edmond de Rothschild

Regensburg: Fürstlich Thurn und Taxis Schlossmuseum

Rome: Gabinetto Nazionale delle Stampe

St. Louis (MO): St. Louis City Art Museum

St. Petersburg: Hermitage

Stuttgart: Staatsgalerie

Vienna: Graphische Sammlung Albertina

Vienna: Österreichische Nationalbibliothek

Washington, D.C.: National Gallery of Art, Rosenwald Collection

Weimar: Staatliche Kunstsammlung

Zürich: Graphische Sammlung der Eidgenössischen Technischen Hochschule

The essential European collections are those in Berlin, Dresden, London, Munich, and Vienna. The most important American collections are found in Boston, Chicago, Cincinnati, Kansas City, New York, and Washington, D.C.

For the study of copies after Dürer's prints, the Bamberg Staatsbibliothek and the Albertina in Vienna possess a near monopoly, with the Sterling and Francine Clark Institute in Williamstown (MA) a distant third.

DRAWINGS

Collections

An enormous number of drawings have been attributed to Dürer at one time or another. For a complete and chronologically arranged catalogue raisonné, see Walter L. Strauss, *The Complete Drawings of Albrecht Dürer,* 6 vols., New York: Abaris Books, 1974. The reference work in more common use, however, is the older and more selective catalogue by Friedrich Winkler (*Die Zeichnungen Albrecht Dürers,* 4 vols., Berlin, 1936–1939). When visiting or corresponding with the curator of a print collection—particularly in the case of a European collection—it is wise to refer to drawings by their Winkler numbers (W.), because all major drawing collections with uncontested Dürers were formed well before the publication of the Strauss catalogue and were accessioned according to Winkler's numbering system.

A selective list of public collections having drawings universally accepted as genuine Dürers includes:

Basel: Öffentliche Kunstsammlung. Kupferstichkabinett

Bayonne: Musée Bonnat

Berlin: Staatliche Museen preussischer Kulturbesitz-Kupferstich-kabinett.

Boston: Museum of Fine Arts

Cambridge (MA): Fogg Art Museum, Harvard University

Chicago: The Art Institute

Cleveland: The Cleveland Museum of Art

Coburg: Sammlung der Veste Coburg

Dresden: Kupferstich-Kabinett

Erlangen: Universitätsbibliothek

Florence: Galleria degli Uffizi. Gabinetto Disegni e Stampe

Frankfurt am Main: Städelsches Kunstinstitut

Hamburg: Kunsthalle

Kansas City (MO): The Nelson-Atkins Museum

Lille: Musée des Beaux-Arts

Lisbon: Calouste Gulbenkian Foundation

London: British Museum, Department of Prints and Drawings

London: Courtauld Institute

Lyon: Museum

Milan: Biblioteca Ambrosiana

Moscow: Pushkin Museum

Munich: Bayerische Staatsbibliothek

Munich: Staatliche Graphische Sammlung

New York: Metropolitan Museum of Art

New York: The Pierpont Morgan Library

Nuremberg: Germanisches Nationalmuseum

Ottawa: The National Gallery of Canada

Paris: Institut Néerlandais

Paris: Musée du Louvre, Cabinet des Dessins

Providence: Rhode Island School of Design

Rotterdam: Museum Boymans-van Beuningen

Sacramento (CA): E. B. Crocker Art Gallery

Stockholm: National Museum

Vienna: Akademie der bildenden Künste, Kupferstichkabinett

Vienna: Graphische Sammlung Albertina

Washington, D.C.: National Gallery of Art

Williamstown (MA): Sterling and Francine Clark Art Institute

Windsor Castle: H. M. Queen Elizabeth II.

Of the above major collections, Berlin, Dresden, and Vienna are by far the richest. The North American institutions of Chicago, Cleveland, Kansas City, New York, and Ottawa have benefited from the dispersal of the collections formerly in the Lubomirski Museum, Lemberg (modern Lwow).

Index
Persons, Places, and Works of Art
Mentioned in the Bibliography

Numbers correspond to numbered items in the Annotated Bibliography on pages 25–339, except those numbers preceded by "p." or "pp.," which refer to page numbers in the other sections of the book.

Abbondio, Antonio, 59
Abduction on a Unicorn (etching: 1516, B.72), 647
Academies (Florentine, Venetian, Roman), 54
Achilles-Syndram, Katrin, pp. 18, 24–27; 1, 2, 3, 4, 232, 586, 725
 acid attack (Munich, Alte Pinakothek: 1988), 771
Ackermann, Peter, 532; p. 346
Acton, David, 5
Adam and Eve (engraving: 1504, B.1), 35, 388, 750
Adam and Eve (Madrid, Prado), pp. 6, 7; 350, 696, 732
Adams, Judith, 907
Adoration of the Magi (Basel, Kunstmuseum), 15
Adoration of the Magi (Florence, Uffizi: 1504), p. 6; 404, 700; p. 349
Adoration of the Trinity. See Landauer Altarpiece
Aeneid (Virgil), 752
Agnes in Netherlandish Costume (drawing: Berlin), 29

Agony in the Garden (engraving: B.4), 38
Agostino Veneziano, 595
Agrippa von Nettesheim, 929 (Yates)
Ahlborn, Joachim, 6
Akinsha, Konstantin, 7
Albers, Joseph, 18, 581
Albert Casimir von Brandenburg, 835
Albert, Duke of Saxe-Teschen, 433, 789
Alberti, Leon Battista
 De pictura, 442 (ms. in Nuremberg); 688; *De arithmetica,* 688
Albertina Passion, 745
Albertus Magnus, 223
Albrecht, Balthasar Augustin, 43
Albrecht, Dieter, 629
Albrecht Dürer Gesellschaft, 581
Albrecht Dürer Haus, pp. 341ff.; 350
 bombardment of, World War II, p. 343
 collection of modern art inspired by Dürer, 527; p. 343
 deed of purchase, p. 342
 dormer, 342

Albrecht Dürer Haus (*cont.*)
 guidebooks, pp. 344, 345
 history and documentation of, pp.
 344ff.
 modern annex, p. 345
 restoration report (1928), p. 345
 role in "cult" of Dürer, p. 346
 souvenir album (1928), p. 344
 views of, p. 343
Albrecht-Dürer-Haus-Stiftung, 35,
 527; p. 342
 medals issued by, 528
Albrecht Dürer Platz, p. 342
Albrecht Dürer Verein, p. 342
Albrecht von Brandenburg (Cardi-
 nal), 351
albums, 116
All Saints Altar. See Landauer Altar-
 piece
allegory, 78, 609
Allihn, Max, 8
d'Almada, Rodrigo, 41, 285
alphabet, 344
Alps, 889
Alsace, p. 1; 93
altarpieces, 17, 144, 167, 171, 393,
 437, 440, 453, 643, 657
Altdorfer, Albrecht, p. 16; 57
Ambrogio de Predis, 883 (influence
 on Dürer's portrait of Maxi-
 milian)
Amerbach, Basilius, 4
Amerbach family, 616
Amman, Jost, 233
Amsterdam, 116
Amsterdam, Museum "het Rem-
 brandthuis," 9
Amt für Schrifttumspflege
 (Reichsstelle zur Förderung
 des deutschen Schrifttums), 10
anatomy, 90
 history of, 508

Anderson, Stanley, p. 346
Andersson, Christiane, 11, 12
Andrea, Zoan, 546
Andreossy, A. W. (General), 547
Andrews, Keith, 13, 470
Andria (Terence), 654
animals, 153, 208, 233, 238, 429,
 476, 477, 685, 686, 851
Anna Selbdritt (*Virgin and Child with*
 St. Anne, N.Y., Metropolitan
 Museum), 283
anniversaries and celebrations, pp.
 9–19, 364, 366, 368, 492, 596,
 611
 500th birthday (1971), 526, 531,
 532, 581, 582, 609, 617, 687,
 773
 400th birthday (1871), 667
 and German chauvinism, 595
 monument dedication (1840),
 316, 520
 300th death anniversary (1828),
 14, 180, 246, 521, 534, 579
 200th death anniversary (1728),
 34
Anonymous (19th century author), 14
anthropomorphic imagery, 560
The Antique, Dürer and, 24, 269,
 751, 882
Antiquity, Dürer and, 134, 410, 606,
 752, 881, 882, 889 (Venus
 Kallipygos)
antisemitism, Pirckheimer and, 133,
 663
Antonio da Brescia, Giovanni (Fra),
 546
Antwerp, 306; Cathedral, 219
Anzelewsky, Fedja, vii; 15, 16, 17,
 18, 19, 20, 21, 22, 23, 24, 25,
 26, 27, 28, 29, 115, 470, 634
Anzelewsky, Fedja, and Hans
 Mielke, 29

Apelles, p. 3; 87, 136, 175, 242, 336,
523, 524, 527, 751, 761
Apocalypse woodcuts, 30, 48, 76,
139, 140, 141, 196, 204, 323,
394, 395, 442, 619, 624, 651,
653, 673 (influence in Siena),
676, 715, 757, 779, 788, 843,
905; pp. 349–350
Apocalypse, German edition, 284
Apollo Saurocthonos, 210
Appuhn, Horst, 30, 31, 32, 33
architecture, 505
archives (Nuremberg), 304, 867
Arend, Heinrich Conrad, pp. 9–10;
34, 35
Arion, 751
Aristotle, *Poetics* (Latin ed.), 442
arms and armor, 572, 574, 906; Three
Views of a Jousting Helmet,
906
*Arms of the Reich and City of Nurem-
berg* (woodblock: Berlin), 67
Arundel, Lord (Thomas Howard),
294, 358, 641, 828
Asia, 416
Assumption of the Virgin (attributed
to Wolgemut), 481
astronomy, 44, 302, 734
Athens (OH), Ohio University,
Trisolini Gallery, 36
attribution, problems of, 81, 435,
593, 789, 887
Auburn, Walter, 37
Augsburg, 124, 221, 509, 510, 678,
776, 922
Augustine, St., Bishop of Hippo, 740
Auld, Alisdair A., 38
Austin (TX, USA), University of
Texas, Archer M. Huntington
Art gallery, 39
Austria, 24, 616, 873. *See also* Vienna
Avila Padron, Ana, 40

Ayrer, Melchior, 214, 616
and *Death of Orpheus* drawing
(Hamburg), 679
Azevedo Cruz, Maria do Rosário de
Sampaio Themudo de Barata,
41

*Babylonian Whore. See Harlot of
Babylon*
Bacchanale (drawing: Vienna, Al-
bertina), 752
Bach, Friedrich Teja, 42
Bachter, Falk, 43
Bacon, Sir Edmund, 687 (*St. Jerome*:
painting, Cambridge,
Fitzwilliam)
Badstubner, Sibylle, 68
Bailey, M., 44
Bainton, Roland, 23, 45
Bakhtin, Mikhail, 763
Baldass, Ludwig, 46
Baldung, Hans ("Grien"), 94, 349,
353, 361, 411, 421, 586, 600,
612, 665, 709, 825, 827, 887,
918; pp. 349, 353
Ballarin, Alessandro, 47
Ballschmiter, Thea, 48
Balus, W., 49
Bänsch, Dieter, 58
Barañano Letamendía, Kosme Maria
de, 50
Barbari, Jacopo de', 156, 413, 597
Barlow, Sir Thomas, 933
(collection)
Baron, Frank, 616
Barrio Moya, José Luis, 51
Bartels, Margarete, 195
Bartsch, Adam, pp. vii–viii, 10; 52,
799, 800
Basel, 119, 348, 439, 500, 557, 655
Basel, Kunstmuseum, 53
Bashir-Hecht, Herma, 54, 55

Bassano del Grappa, Museo Civico, 617

bath attendants (Nuremberg), 905

Battle of Sea Centaurs (Sea Gods) (drawing: Vienna, Albertina), 751, 752

Baudelaire, Charles, 620

Bauch, Kurt, 15, 913

Bauer, Heinrich, pp. 343, 345

Bauer, Kurt, 15

Bauer, Rotraud, 874

Baumeister, Annette, 56

Baumgart, Fritz (Festschrift for), 22

Bavaria, 266

Bayonne (France), 429

Bazarov, Konstantin, 57

Beatus Rhenanus, pp. 1–2

beauty, 79

Beck, Herbert, 59, 235

Beck, James, 562

Beckmann, Max, 184

Beenken, Hermann, 840

Befestigungslehre (Treatise on Fortification), 80, 189, 190, 602, 666, 682, 793, 852

Begheyn, A., 60

Behaim, Martin I, 573, 584, 867

Behaim, Paul III, 899 (inventory)

Behaim, Martin, 584

Beham brothers, 205, 491, 558, 586, 612, 741

Beham, Sebald, 11, 852

Beheim, Lorenz (Canon), 17, 690

Behling, Lottlisa, 61, 62
 Festschrift for, 55

Behrends, Rainer, 860

Beireia collection (Helmstädt), 839

Béla, H., 74

Bellini, Giovanni, 100, 561, 744, 761

Belting, Hans, 198

Benecke, Gerhard, 63, 903

Benesch, Otto, 64

Benzing, Josef, 65

Berbig, H. J., 66

Berghahn, Klaus L., 368

Berlin, Kupferstichkabinett, 29, 67, 246, 259, 295, 422 . *See also* Behaim, Paul III (Inventory)

Berlin (DDR), Akademie der Wissenschaft der Deutschen Demokratischen Republik, Zentralinstitut für Literaturgeschichte, 68

Berlin (DDR) (former Staatliche Museen zu Berlin), 69

Berlin, Staatliche Museen Preussischer Kulturbesitz, 67, 70
 Kupferstichkabinett, 29, 234, 474, 547

Berlin, Technische Universität, 71

Bernhard, Marianne, 72

Bernhard van Resten, 102

Berthold, Gertrude, 337

Bertram, Ernst, p. 15

Betz, Gerhard, 73

Beurer (Peurer), Wolfgang, 25, 820

Bialostocki, Jan, p. 18; 75, 76, 77, 78, 79, 475
 Festschrift for, 23

bibliographies, 65, 66, 75, 106, 526, 589, 613, 754, 755, 782, 842

Biddle, Martin, 80, 190

Bill, Max, 17

biographies (including "art-and-life" books), 9, 20, 75, 220, 231, 341, 366, 498, 516, 604, 615, 662, 806, 852, 853, 854, 871, 877, 911, 924
 documentary biographies, 365, 366, 662, 911, 924

Birke, Veronika, 81

Bjurström, Per, 82

Blake, William, p. 15; 469

Blechen, Carl, 342

Bloch, E. Maurice, 479

Blue Roller watercolor studies, 426, 427, 429, 430, 593
 by Hans Hoffmann, 390, 430, 593
Blunt, Anthony, 601
Bluth, Manfred, 532
Boberg, Jochen, 83
Boehm, Gottfried, 84
Boesten-Stengel, Albert, 85
Böhme, Hartmut, 96, 97
Böhmländer, Christoph Philipp, 342
Boisserée, Sulpiz, and Boisserée, Melchior, 239, 646, 839; p. 342
Bologna, pp. 3, 5, 257; p. 349
Bologna. Palazzo Pepoli Campogrande, 86
Bongard, Willi, 87, 524, 527
Bonicatti, Maurizio, 89, 852
Bonnet, Anne-Marie, 90
Bonsanti, Giorgio, 91
Bora, Giulio, 92
Borries, Johann Eckart von, 93, 94
Boselli, Camillo, 95
Bosl, Karl, 708
Boston, Isabella Stewart Gardner Museum, 285
Boston, Museum of Fine Arts, 786
botany, Dürer compared to Leonardo, 555
Botero, Ferdinand, p. 17; 581
Böttger, Peter, 98
Brachert, Adelheid, 101
Brachert, Thomas, 99, 100, 101
Bradford, William, 477
Braham, Helen, 477
Brand, Erna, 102, 852
Brandl, Rainer, 103, 574
Brant, Sebastian, 681 (*Ship of Fools*), 882; p. 348
brass work, Nuremberg, 920
Braun, Edmund Wilhelm, 344
Braunfels, Wolfgang, 104

Braunschweig and Lüneburg
 Anton Ulrich, Duke of, p. 9
 Ludwig Rudolph, Duke of, 34
Braunstein, Philippe, 105
Bräutigam, Günther, and Matthias Mende, 106
Breitling, Gisela, 346
Bremen, Kunsthalle, vii; pp. 18–19, 24 (note 5); 7, 107, 108, 109, 468, 576, 769, 894
Bresdin, Rodolphe, 664
Breu, Jörg, 535
Brockhaus, Christoph, 869
Bronzino, Agnolo, 765
Brooklyn (NY), Brooklyn Museum, 110
Broos, Ben, 9
Broun, Elizabeth, 461
Brown, David Alan, 111, 112
Brown, Margaret L., 113
Bruck, Robert, 114
Bruegel, Pieter the Elder, 116, 863
Bruggemann, Hans, 31 (Bordesholm Altarpiece)
Brussels, Palais des Beaux-Arts, 115
Buchanan, Iain, 116
Buchner, Georg Paul, p. 346
Büchsel, Martin, 128
Buck, August, 117
Buck, L. P., 629
Buckingham, Clarence, 836
Budapest, Magyar Nemzeti Galéria, 551
Budapest, Szépmüveszeti Muzeum, pp. 25, 26; 862
Budde, Hendrik, 118
Bühler, Wilhelm, 128
Bull's Head (watermark), 636
Burckhardt, Daniel, 119
Burg Katz, 225
Burg Lahneck, 225
Burg Rheinfels, 225
Burghart, Toni, p. 346

Burgkmair, Hans the Elder
 Budapest portrait of, 862
 and Celtis, 927
Burgschmiet, Daniel, p. 342
Burmester, Andreas, 120
Busch, Günther, 107, 109, 910
Busch, Werner, 121, 347
Bushart, Bruno, 122, 123
Butts, Barbara R., 124, 125, 126
Büchsel, Martin, 127
Bühler, William, 128
Byam Shaw, James, 601

cadavers, representation of, 918
Caesar, Elizabeth, 129
Caldenbach, Martin, 627 (and Heller
 Altar)
Calumny of Apelles, 519 (lost work
 for Nuremberg Rathaus)
Calvesi, Maurizio, 292
Cambridge University, Fitzwilliam
 Museum, 130, 686
Camerarius, Joachim (Kammermeis-
 ter), p. 4; 615, 629, 690, 761,
 781, 911
Campagnola, Giulio, 546
 and Domenico Campagnola, 597
Campbell, Lorne, 131, 909
Campe, Friedrich, p. 344; 573
cannon and firearms, 189, 424
Capito, Wolfgang Fabricius, 902
Carnival, imagery of, 371
Carpaccio, 546
Carr, Kathleen W., 378
Carroll, Margaret, 132
Carstensen, Jens, 133
 cartography, 302
Carty, Carolyn M., 134
Cashion, Debra Taylor, 135
Cast, David, 136
Castamagna, Alba, 569
catalogues, 52, 67, 243, 322, 331,
 353, 371, 373, 446, 466, 513,

565, 569, 620, 726, 796, 840.
 See also collections
catalogues (drawings), pp. 10, 17, 23
 (n. 59), 29, 67, 474, 796, 840
 Berlin, 67, 547
 Harvard, Loeser collection. 591
 London, British Museum, 470
 Polish collections, 475
 Washington, National Gallery
 (acquisitions), 887
 Vienna, Albertina, 434, 435
catalogues raisonnés, 182, 474, 796
 (drawings); pp. 10, 17, 23
 (n. 59) (drawings, Winkler),
 15, 16 (paintings), 52, 415,
 799, 800, 803 (prints), 432
 (landscape watercolors)
celebrations, 1828, 521
Celestial Map (woodcuts: B.151,
 152), 584; p. 351
Celtis, Conrad (Konrad) p. 1, 2, 3, 54,
 117, 137, 283, 527, 690, 748,
 925, 926, 927, 928
Cemetery of St. John (watercolor),
 723
censorship, 11, 203
ceramics, influence on, 830 (Italian
 faence)
Cetto, Anna Maria, 138
Chadraba, Rudolf, 139, 140, 788,
 843, 852
chandelier, design for, 422
Chapeaurouge, Donat de, 141
Chapman, George, 929 ("Shadow of
 Night")
Charlemagne, 10, 101, 204, 480,
 483, 566, 580, 831
Charles I of England, 828
Charles II of Spain, 51
Charles IV, Holy Roman Emperor
 X-ray image of, Zurich, 917
Charles V, Holy Roman Emperor, 11,
 209

Chastel, André, 142, 143, 852
Châtelet, Albert, 144
Chelidonius, Benedictus (Schwalbe),
 p. 2; 690
Chicago, Art Institute, 836 (*Young
 Steer,* drawing W.239)
Chojecka, E., 860 (Dürer's influence
 in Poland)
Christ, 45, 93 (as Man of Sorrows),
 142 (as Christus), 903 (Dürer's
 view of)
Christ Among the Doctors (Thyssen
 collection), 85, 132, 142, 700,
 759; p. 349
Christ Before Ananias (B.28) and
 Christ Before Pilate (B.31)
 (woodcuts), 571 (influence on
 Raphael)
Christensen, Carl C., 145, 146, 147,
 148, 149
Christian II, King of Denmark, 132,
 704, 883; p. 352
Cibis, Bernd, 346
Cigoli, Ludovico, 844
City Council, Nuremberg, 12, 103,
 146, 147, 148, 205, 275, 304,
 405, 413, 629, 630, 791, 883
City Hall (*Rathaus*), Nuremberg,
 148, 422, 519
Clark, Anthony M., 150
Clark, T. H., 151
Clark, William W., 525
Clarke, T. H., 153
classics and classicism, 156, 289,
 358, 370, 413, 542, 751
Clauss, Harald, 343, 345
clothing, 245
Coat-of-Arms of Death (engraving,
 1503: B.101), 573
coats-of-arms, 219, 572
Coburg, Kunstsammlungen der Veste
 Coburg, 153, 154, 259
Cochläus, Johann, 690

Cogswell, Elizabeth A., 907
Cohn, Anna, 907
coins, 529
Coleman, Robert Randolph, 579
Coler, Georg, 730
Colescott, Warrington, 522
collecting, 114, 154, 159, 175, 202,
 359 (England), 743 (Nurem-
 berg, Peller)
collections, 2, 7, 29, 67, 82, 86, 98,
 107, 116, 153, 154, 172, 188,
 194, 195, 214, 229, 243, 263,
 279, 294, 379, 387, 434, 435,
 436, 447, 469, 476, 496, 515,
 523, 537, 538, 565, 575, 578,
 580, 581, 585, 616, 644, 647,
 675, 686, 687, 696, 714, 737,
 767, 774, 835, 836, 839, 861,
 865, 867, 876, 885, 888, 897,
 934
 Australia, 203 (Melbourne)
 Austria, 873 (Vienna, Kunsthis-
 torisches Museum)
 Canada, 846 (Toronto)
 college and university, 195 (Düs-
 seldorf), 308 (Dartmouth), 479
 (UCLA), 548, 736 (Princeton),
 600 (Oxford, Christ Church)
 Denmark, 230 (Copenhagen: Print
 Room)
 drawings, 29, 474, 547 (Berlin),
 446 (Milan, Ambrosiana), 475
 (Warsaw), 575 (New York-
 Lehman), 683 (Rotterdam),
 686, 687 (London), 434, 435
 (Vienna)
 early, 18, 203, 214, 232, 286, 586,
 679, 711, 725, 777, 828
 18th century, 286 (Amalie von
 Anhalt), 433 (Duke Albert
 Casimir of Saxe-Teschen), 564,
 725 (Praun), 601 (Gen. John
 Guise)

collections (*cont.*)
England, 130 (Cambridge), 470
(Ruskin gift), 686 (London,
British Museum), 828 (early
British collections), 675
(Windsor Castle), 865 (Sir
Thomas Lawrence)
Germany, 67 (Berlin), 99, 107
(Bremen), 580 (Nuremberg),
563 (Munich, Graphische
Sammlung), 737 (Schwein-
furt), 826 (Stuttgart)
Italy, 86, 95, 570, 579, 673
Netherlands, 683, 685 (Rotter-
dam)
19th century, 119 (Eugen Felix),
229 (Boisserée), 243, 244
(Galichon), 247 (Chambers
Hall), 591 (Loeser); 675 (Sir
Thomas Lawrence); 865 (An-
dreossi theft), 619 (Passavant)
Poland (formerly), 576, 885
(Lubomirski: Lemberg [mod.
Lwow])
Poland, drawings, 475
prints, 110, 230, 514, 616, 619,
790, 826
17th century, 239, 240 (Rudolph
II), 294, 358 (Thomas
Howard), 536, 537 (Jabach),
214, 585, (Praun), 777 (Wald-
burg), 896 (Elector Maximilian
of Bavaria), 899 (Paul III
Behaim)
16th century, 4, 116 (Ortelius),
118 (Endres and Ursula Dürer;
Imhoff), 202, 214, 230, (Chris-
tian II of Denmark), 214 (Wen-
zel Jamnitzer, Martin Peller),
743 (Martin, Peller), 232
(Praun), 265 (Maximilian I),
288 (Tucher), 690 (Pirck-
heimer), 114, 293, 487, 616
(Ferdinand, Archduke of
Tyrol), 710 (Friedrich the
Wise), 835, 841, 861
(Granvella)
Spain, 696 (Madrid, Prado)
Sweden, 194 (Stockholm, Baron
Harald Raab)
United States, 110, 150, 377, 378,
379, 380, 417, 479, 706, 885,
887
colloquia, 156, 386
Colmar, Dominicans in, 93
Cologne, 537 (Jabach), 539 (guild
records, Niclas "Unger" Dürer)
Cologne, Archiepiscopal Museum,
157
color and color theory, 173, 242, 351,
838
comets, 44, 329, 598 (Halley's)
connoisseurship, 224, 228, 331, 431,
485
conservation, 121, 265, 267, 771, 873
Consigli, Adrianna, 112
Consigli, Igino, 112
contracts, 729, 730
convents, Nuremberg, 360
Conway, William Martin, 158, 272
Cooke, Edward W., 346
Copenhagen, Statens Museum for
Kunst, 159, 160, 230, 470
(Italian copyists), 907
Bordesholm Altar, 31
copies, pp. 10–11, 16;
copyists, pp. 10–11, 16; 224, 235,
260, 505 (Wiericx), 533
(Nuremberg, Dürerhaus), 546
disputed attributions, 565, 566
exhibition, Philadelphia, 224
French wooodcut, 510
Glockendon ms., 135
goldsmith work from designs by
Dürer, 588
Majolica, 830

paintings and sculpture, Hanover, 260

paintings, pp. 15–16; 408, 410

paintings, Munich, 98, 266

prints, 594, 800, 817, 907

Raimondi, 594, Antonio Lombardo, 719

by Rembrandt, 37

reproductive prints, 579, 907

sculpture exhibition, Frankfurt, 235

sculpture, 59, 658

copyright, 729

Corinth, Lovis, 524

Cornelius, Peter, pp. 12, 30: 444, 521; p. 342

Cornell, Alan, 161

Coronation of the Virgin. See Heller Altarpiece (destroyed)

Cortés, Hernando, 602

Costescu, Eleonora, 852

costs (foreign travel, freight, postage), 930

costume, 275 (Nuremberg sumptuary laws), 909

couple, as theme, 677

courtship, customs, 677

Covered Bridge (watercolor), 723

Cowslips (watercolor, Armand Hammer), 887 (attribution contested)

Cowslips (watercolor, Armand Hammer, attrib.), 887

Crab (watercolor), and Italian "life" casts, 851

Cracow (Krakow), and Hans Dürer, 376

crafts, Nuremberg, 103, 898

Cranach, Lukas the Elder, pp. 16; 11, 12, 53, 160, 411, 463, 612, 746, 815

workshop: 852, 853, 901

Crato, Johannes, 907

creative process, 42

Cremer, Erika, 162

Cremona, Dürer's influence in, 832

criticism, English, 469

Crown (watermark), 636

Crucifixion, 181, 659 (trial proof, Amsterdam)

Cuno, Jean, O. P., 695

Cusa, Nicholas of (Cardinal Archbishop of Brixen), 393

Cuttler, Charles D., 163

Dahl, Johann Christian Clausen, 579

Dal Canton, Giuseppina, 164

Dalai Emiliani, Marisa, 92

Dali, Salvador, p. 17; 522, 581

Damiao de Goes, 701, 866

Dancing Couple and *Bagpiper* (engravings: B.90, B.91), 660

Daucher, Hans, 59

Daumerlang, Carl, pp. 342, 346

Davies, Alice I., 133

DDR (Deutsche Demokratische Republik: the former "East Germany"), 68, 71, 140, 181, 234, 373, 383, 384, 852, 853, 854, 856, 858, 860, 922

De Benedicti, Cristina, 844

De Grummond, Nancy, 165

Death, as theme, 195

Death and the Landsknecht (broadsheet: Stuttgart), 826

Death and the Young Woman, theme, 918

Death of Orpheus (drawing: Hamburg, Kunsthalle), 454, 679, 735, 762, 881

Death of the Virgin (woodcut: B.93), p. 4

architectural metaphors in, 905

and Bruegel, 863,

Decker, Bernhard, 59, 166, 167, 168, 169, 170, 235, 345

dedications (as forms of artistic
 patronage), 146 (the *Four
 Apostles:* Munich)
Degenhardt, Bernhard, 446
Deifel, Johann Leonhard, p. 346
Dellana, Giovanni, 611, 848
Dellwing, Herbert, 171
Delsenbach, J. A., pp. 343, 346
demographics (Nuremberg), 212
Denck, Hans, 205, 491
Denmark. *See* Copenhagen
The Desperate Man (etching: B.70),
 388
Deutsche Germanistik-Tagung
 (1954), 583
Dillis, Georg von, 98
Dilly, Heinrich, 198
Diodoros, 752
Disertori, Benevento, 172
dissertations and *Habilitations-
 schriften,* 3, 125, 149, 333, 335,
 445, 450, 452, 453, 458, 466,
 485, 502, 627, 632, 642, 657,
 663, 764, 779, 804, 850, 866,
 905
distaff, 934
Dittmann, Lorenz, 173, 905
Dittrich, Christian, 182
Dix, Otto, p. 18; 581, 728
documents, 589 (Nuremberg deeds,
 court and Council), 689, 805
Dodgson, Campbell, 174, 686 (ca-
 reer), 840
Dodwell, Charles Reginald, 175
dog, symbolism of, 208 (Eisler), 668
 (Reuterswärd)
Dolce, Ludovico, p. 4; 546
Dominicans, 93, 157
 "Master of the Dominican Cycle,"
 481
 and rosary, 695
Döring, Hans, 616, 627

Dornberg, John, 176
Dornik-Eger, Hanna, 177, 178, 179
*Draftsman at Work with a Foreshort-
 ening Device* (woodcut illustra-
 tion for *Unterweysung der
 Messung*), p. 352
dragon
 in Apocalypse, 394
 chandelier design in form of, 422
drama, Dürer in, 251 (Gelbcke), 694
 (Rückert)
drawing style, 457 (Landolt)
drawings, 26, 29, 42, 67, 81, 123,
 127, 137, 168, 182, 210, 213,
 217, 219, 222, 225, 245, 247,
 338, 343, 354, 370, 426, 428,
 436, 444, 446, 449, 454, 457,
 474, 475, 478, 511, 513, 530,
 537, 564, 565, 582, 588, 591,
 592, 593, 596, 607, 614, 631,
 669, 679, 683, 686, 687, 697,
 700, 717, 718, 721, 725, 769,
 796, 801, 827, 834, 836, 845,
 849, 851, 861, 865, 866, 881,
 885, 887, 889, 894, 900, 907,
 912, 913, 914
 Berlin, Kupferstichkabinett, 29,
 67, 547 (Mielke)
 catalogues, 213 (Ephrussi), 474
 (Lippmann), 796 (Strauss), p.
 17 and note 59 (Winkler)
 charcoal, 234 (Dürer's mother)
 chiaroscuro, 29, 67
 Chicago Art Institute, 836
 Death of Orpheus, 735, 679, 881
 for decorative arts, 10
 early collections, 865 (Wm.
 Imhoff), p. 26; 725 (Paulus
 Praun II), p. 10 (Carl August,
 Duke of Weimar) 865 (Rudolf
 II)
 Florence, Uffizi, 845

general books, 697 (Salvini), 900
(White)

Poland, 475

portrait, 347 (self), 67, 234, 351
(mother), 596, 607 (Endres
Dürer), 695 (Jean Cuno, O. P.),
352 (Lucas van Leyden), 525,
701 ("Damiao de Goes"), 796
(Sr., "Mechtild), 865 (*Sister
Metzgen*), 530 (Caspar Nützel),
669 (young girl in a headband:
Felicitas Pirckheimer?), 24,
565, 700, 915 (*Windish Peas-
ant Woman*), 67 (an architect),
495 (bearded man seen from
the front), 913 (a high priest),
913 (an executioner)

preliminary, 445

previously unpublished, 26 (*War-
rior in fantastic armor,* ca.
1515/16); 914 (*Head and
hands of a meditating woman,*
Winzinger)

silverpoint, 67 (lions)

Stockholm, 82, 669

United States, 591, 836, 885

Dream of the Deluge (watercolor),
529, 873, 919; p. 352

Dream of the Doctor (engraving:
B.76), 529, 907 (copy by
Wenzel von Olmütz)

Dresden, Albertinum, 181

Dresden Altarpiece, 15, 16, 293, 576,
657, 852

Dresden Sketchbook, 797

Dresden, Kunstverein, 180

Dresden, Kupferstich-Kabinett, 182

dress, Nuremberg, sumptuary laws,
275, 288

Dreyer, Peter, 183

Dube, Wolf Dieter, 184

Duchesne ainé, Jean Baptiste, 621

Dückers, Alexander, 67

Dürer, Agnes Frey, 34, 114, 299, 8,
349, 351, 538, 547, 713, 722,
895, 904
 death, 341, 353
 portrait of in Netherlandish head-
 dress, 29, p. 352
 will, 353

Dürer, Albrecht, 185, 186, 187, 188,
189, 190, 191, 192, 193
 "aesthetic digression," 22
 ancestors, 890
 and Portugal, 41
 appearance, p. 4
 apprentices, 587, 816
 apprenticeship, 73, 757,816, 818,
 908
 art theory, 419, 688, 691, 852
 and "new German art," p. 12
 bachelor's journey, 28, 93, 145,
 218, 347, 499, 915
 boyhood home, p. 16
 character, 34, 852, 858
 as collector, 399
 contracts, 729, 730; 348, 730
 D. and Nuremberg legal system,
 204
 D. in literature, 76, 620, 621, 694,
 879, 895
 death mask, p. 4, 20 (n. 16); p. 353
 death, p. 3, 195, 251, 573, p. 341
 design for shoes, 245
 diary, p. 10, 359, 689, 781, 857,
 930
 Dürer "Renaissance" ca. 1600, pp.
 5–7; 59, 263, 407, 408, 691;
 p. 263
 early education, 461
 early German influences, 25, 484,
 816
 early life, 19, 365, 366, 662, 809,
 818

Dürer, Albrecht (*cont.*)
 early monographs, 34, 35
 early works, 28, 500, 518, 555,
 655, 673, 909, 914, 931
 (attrib.)
 estate, 154
 eulogies, 689
 exhumation, p. 353
 family chronicle, 699
 Food for Young Painters, p. 14;
 689, 691, 793
 Four Books of Human Proportion,
 pp. 4, 13; 186, 689, 691
 in France, p. 6, 76, 226, 227
 godchildren, 341
 grave, pp. 8–9, 16; 738, p. 353
 hair lock, pp. 4, 20 (note 17),
 p. 353
 house in the Zisselgasse ("the
 Dürer house"), p. 14
 influence on Rubens, 381, 473
 inscriptions on works, 185
 letters, 689, 693
 library, 786
 as mathematician, pp. 13–14, 932
 Manual of Measurement, pp.
 13–14; 689, 691, 793
 medical history, 280
 mentioned by contemporaries, 689
 monogram, 596
 monument, p. 15, 520
 as political symbol, p. 12, 369,
 567, 922
 as "Prince of Painters" (Sandrart),
 p. 8
 printing press, p. 343
 as publisher, p. 4
 religious views, p. 5, 902
 reputation in England, p. 6, 76,
 226, 227, 469, 870
 reputation in Spanish America,
 p. 6
 sales agents, 2

 as scientist, 700
 as sculptor, 380; influence on
 sculpture, 59
 self portraits 419, 420, 839, 909,
 927, p. 347
 in 17th century, 175, 241, 268
 to Netherlands, 351–352
 travel to Italy, 514, 694, 762, 830
 See also "Albrecht Dürer House,
 Collections
Durer, Albrecht the Elder, 364, 423,
 584, 634, 662, 689, 828; house,
 345
Durer, Barbara Holper, 29, 234, 341,
 351, 633, 634
Dürer, Endres, 596, 616
 death of, p. 353
 portrait of, drawing, Morgan
 Library, 607
Dürer, Hans
 103, 353 (in Cracow; death), 376
 (in Olmütz), 586, 729 (in-
 jured), 809, 813, 860 (portraits)
Dürer, Nikolaus (called "Unger"),
 364, 538 (Cologne guild
 records)
Durer family, 699 (chronicle); 573,
 890; 341 (genealogical chart),
 388 (in Hungary)
Dürer followers, graphic arts, 813,
 817, 907
"Dürer Renaissance," 3, 235, 259,
 260, 263, 266, 427, 430, 431,
 742
Dürer Year 1828, 261, 520, 521, 534
Dürer Year 1928, 312, 755, 874
Dürer Year 1971, 66, 71, 83, 106,
 383, 385, 461, 469, 523, 526,
 532, 539, 540, 687, 708, 716,
 773, 873, 886
Dürerbund, 437
Dürerhaus, 522, 527, 534; pp.
 341–346

Düsseldorf Universität, Kunst-
museum, 195
Dvořák, Max, 196, 788
Dwyer, Eugene, 197

early drawings, attribution, 914
early German engraving, 105
early monographs, 34, 35
East Germany. *See* DDR
Eberlein, Johann Konrad, 198
Eckert, Willehad Paul, 199, 200
Eckhardt, Ferdinand, 807 (Festschrift)
economic history (Nuremberg), 822,
823
education and education reform
(Nuremberg), 461 (Leder on
Latin schools and *Rechen-
schule*)
Eeckhout, Paul, 115
Egg, Erich, 201
Eichberger, Dagmar, 11, 202, 203,
371, 567, 677, 740, 748, 934,
935
Eichens, Friedrich Wilhelm, 732
(*Age of the Reformation*)
Eichler, Hermann, 204
Einem, Herbert von, 205, 206, 207
Eisler, Colin, 208, 886 (review)
Eisler, William Lawrence, 209
Eitel, Peter, 777
ekphrasis, 133, 222
Eksardjian, David, 210
Elizabethan literature, 929 (Frances
Yeats on Chapman)
Emmer, Michele, 211
emperors (view of in Third Reich), 10
encyclopedia articles, 809 (Strieder:
Dictionary of Art), 75 (Bialo-
stocki: Encyclopedia of World
Art)
Endres, Rudolf, 212
Engelhardt, Helmut, 560
Engels, Friedrich, 857

England, Dürer and, 76, 226, 227,
248, 403, 469, 470, 675
engravings
catalogues, p. 10; 331, 415, 512,
619, 667, 775, 792, 795
collections, p. 10; 381, 514, 617,
687, 706, 885
general works, 52, 96, 174, 197,
198, 207, 220, 243, 254, 255,
328, 358, 363, 371, 418, 456,
457, 466, 506, 543, 555, 614,
615, 651, 660, 661, 671, 710,
768, 802, 848, 894, 935, 936
Ephrussi, Charles, 213
epitaphs (designs for), 787 (Glimm
and Holzschuher
Lamentations)
Erasmus, Desiderius, pp. 2, 3; 132,
199, 324, 613, 644, 690, 781,
907, 911
lost portrait of, formerly Alcazar,
51
Erhard, Johann Benjamin, 531
Erhard, Johann Christoph, 346
Ernstberger, Anton, 214
eryngium, 910
Esterhazy, Miklos (Prince), p. 25
etchings, p. 10; 78, 172, 174, 351,
388, 424, 563, 647, 906
Ettlinger, Helen S., 215
Etzlaub, Erhard, 723
Evans, Mark L., 216, 217
Evers, Hans Gerhard, 218, 219
exhibitions, 36, 86, 108, 110, 115, 131,
160, 178, 181, 188, 312, 340,
383, 434, 447, 470, 477, 498,
532, 533, 540, 570, 611, 618,
687, 707, 763, 790, 817, 886
exhibitions 1971: 15, 17, 36, 230,
434, 496, 549, 582, 585, 586,
587, 588, 609, 610, 611, 617,
652, 684, 685, 686, 687, 706,
845, 848, 872, 885, 907

exhibitions 1995, 737
exhibitions 1997, 777
eye, and window, 77, 273
Eye, August von, 220

Faber-Castell, Roland (Graf) and
 Faber-Castell AG, p. 18; 581
facsimile editions, 191, 793 (Manual
 of Measurement), 193 (Four
 Books of Human Proportion),
 516 (complete woodcuts,
 Mende), 775 (engravings), 794
 (Maximilian's Prayerbook)
Faenza, majolica ware, 830
Faietti, Marzia, 86
fakes. See forgeries
Falcke, August, p. 343
Falk, Tilman, 53, 221
Fall of Man (Adam and Eve, engrav-
 ing, 1504, B.1), 387, 907
 (Ladenspelder copy); p. 349
false signatures, 713
families, Nuremberg (net worth), 823
family background, Dürer, 341, 489,
 539, 608, 857, 891
Family Chronicle, 857, 858 (com-
 pared to Ghiberti); p. 352
Family of Satyrs (engraving: B.69),
 507 (and Giorgione's Tempest)
father. See Dürer, Albrecht the Elder
Feast of the Rose Garlands (Prague,
 National Gallery), p. 7; 143,
 157, 305, 363, 436, 577, 657,
 695, 874; p. 347
Fechtbuch, 187
Fehl, Philipp, 222
Feist, P. H., 860
Felton, Arthur, 933
Ferdinand, Archduke of Tyrol, 616
 (print collection)
Ficino, Marsilio, 254
Ficker, Friedbert, 223

fiction, Dürer in, 25, 251, 297, 299,
 896
Field, Richard S., 224
Filarete, Antonio Averlino, 876
fingerprints (Dürer's), 100 (on
 Madrid Self Portrait), 101 (on
 Kaiserbilder)
Fink, Otto, 225
Finke, Ulrich, 226, 227
Finlay, Karen A., 847
Fiore-Hermann, Kristina, 228
Fiorillo, Johann Domenico, p. 12
firearms, 189. See also cannons
Firmenich-Richartz, Eduard, 229
Fischer, Erik, 159, 230
Fischer, J. G., 98
Fisher, Jay, 907
Five Lansquenets and a Oriental
 [Turk] on Horseback (engrav-
 ing: B.88), 554
Flechsig, Eduard, 231, 712, 912
Fleischmann, Peter, 232
Flock, Erasmus, 786
Flötner, Peter, 918
Fondaco dei Tedeschi (Venice), 753
forgeries, p. 10; 59, 175 (Sandrart),
 214, 235, 266, 369, 390, 505,
 800, 907
Förster, Ernst, 14
Foster, Edward A, 150
Four Apostles (Four Holy Men),
 (Munich, Alte Pinakothek), pp.
 6, 10 (copy), 11 (Lavater); 48,
 76, 104, 142, 146, 147, 185,
 204, 205, 206, 309, 352, 405,
 440, 507, 576, 629, 703, 705,
 708, 732, 744, 805, 810, 825,
 838, 896, 922
Four Books of Human Proportion,
 p. 4; 22, 583, 591, 615; p. 353
Four Horsemen of the Apocalypse
 (woodcut: B.64), 48, 196

Four Naked Women (Four Witches), engraving (B.75), 8, 197, 647 (as Choice of Paris), 751

France, 226, 227, 243, 318, 622, 626, 790, 872

Franciscans, 23

Franconia, 719

Frank, Volker, 233

Franke, Ilse O'Dell, 233

Frankfurt am Main, Dominican monastery, pp. 6, 7

Frankfurt am Main, Liebighaus Museum alter Plastik, 235

Franz Friedrich Anton von Sachsen-Coburg-Saalfeld, 153, 154

Frauenholz, Friedrich (Nuremberg dealer), p. 25; 531, 564 (Praun sale), 725

Fredel, Jürgen, 236

Frederick the Wise (Friedrich der Weise), Elector of Saxony, 114, 150, 179, 281, 293, 300, 393, 405, 454, 466, 487, 658, 690, 710, 883; pp. 347, 349

freight, 931

Frey, Dagobert, 905

Frey, Hans, 573, 920; p. 348

Freyenhammer, Niclas and Heinrich, p. 341

Fried, Joseph P., 237

Friedländer, Max J., 15

Friedmann, Herbert, 238

Friedrich August of Saxony, 514

Friedrich II von der Pfalz (Frederick II of the Palatinate), 623 (portraits)

Friedrich III, Holy Roman Emperor, 714, 807

Friedrich, Caspar David, 534, 579

Friedrich, Ewald, p. 346

Fries, Moritz, Graf von, 725

Frohner, Adolph, 581 (*Four Witches*)

Frueauf, Rueland the younger, 484

Fry, Nicholas, 486

Fucíková, Eliska, 239, 240

Fugger family, 123, 509, 624 (epitaphs), 823

Fugger Chapel, 124

Fugger, Jacob the Elder, 121

Fuhse, Franz, 241

Fürlegerin (Young Woman of the Fürleger family), 175 (both: as copies); 181 (Leipzig: as genuine), 421 (Berlin)

furor teutonicus, p. 2

Gad, Tue, 160

Gadamer, Hans-Georg, 420, 905

Gaertner, Georg, pp. 10, 25 (copy of *The Four Apostles*)

Gage, John, 242

Galeazzo di Sanseverino, Giovanni, 364, 366, 662, 700, 911, 912

Galichon, Émile, 243, 244

Gall, Günter, 245

Galland, Georg, 246

Garlick, Kenneth, 247

Garrett, Albert, 248

Gärtner, Eva, 366

Gatti Perrer, Maria Luisa, 249

Gauthier, Théophile, p. 15; 76, 227, 621

Geertgen tot Sint Jans, 145

Geissler, Heinrich, 250, 826

Gelbcke, Friedrich August, 251 (*Albrecht Dürers Tod*)

genealogy, 341

general works, 20, 72, 363, 806, 829, 853, 854, 925

genius, concept of, 79

geography, 584 (the Behaim globes)

geometry, 211

Gerhaert, Nicholaus, 712

Gerkens, Gerhard, 108

German history, 203
German Romanticism, 156, 175
Germania capta, 258, 712
Germans as barbarians, p. 2; 876
Gerson, Jean, 54, 55 (woodcut:
 Gerson as Pilgrim)
Ghiberti, Lorenzo, 876
Ghiescu, Gheorghe, 252
Giarda, Cristoforo, 919
Gibson, Walter S., 253
Giehlow, Karl, 254, 255
Gilman, Sander, 256
Giordano, Luca, 390
Giorgione, 47, 507, 640, 699, 868
Giosefi, Decio, 257
Giovanni Antonio da Brescia, 830
Giovanni de' Grassi, 851
Giuliano, Antonio, 258
Glaser, Hubert, 263
Glaser, Kurt, 840
Glatz Madonna (Anonymous 14th
 century Bohemian painting:
 Berlin), 875
Glimm Lamentation (Munich, A.P.),
 698
globes, 585
Glock, Karl Borromeus, 644
Gmelin, Hans Georg, 259, 260
goats, symbolism of, 8, 454, 650,
 709, 934
Goddard, Stephen, 261
Goethe, Johann Wolfgang von, pp.
 4–5, 10; 46, 206, 646, 725,
 839
Goes, Damiaõ de, 701, 866
Gohr, Siegfried, 262
Golahny, Amy, 907
Goldberg, Gisel, 15, 263, 264, 265,
 266, 267, 268, 810
goldsmiths and goldwork, 10, 148,
 423, 355, 539, 557, 588, 589,
 904 (wives of goldsmiths)
Goltzius, Hendrik, 5, 515

Gombrich, Ernst H., 269, 270, 271,
 449, 651, 919
Goris, J. A., 272
Gosebruch, Martin, 913
Gossaert, Jan (Mabuse), 253
"Gothic revival" (17th century), 355
Gothic as barbaric, 876
Gottlieb, Carla, 273
Götz, Wolfgang, 274
gourd, symbolism of, 61, 671
Graf, Dieter, 195
Graf, Urs, 918
grammar schools, Nuremberg, 364,
 366, 462
Granvelle, Antoine Perrenot de (Car-
 dinal), 835, 841, 861, 875
graphic art, 19, 373, 542, 547
Grau, Günther, 860
Grautoff, Otto, 877
grave, of Dürer, 738
*Great Piece of Turf (Das Grosse
 Rasenstuck:* watercolor; Vi-
 enna), 21, 349, 356, 674
Greek incunabula published in Ger-
 many, 921
Greek and Roman authors, 133, 136
Green Passion, 407, 426, 511
Greenfield, K. R., 275, 909
Greens (political party), 644
Gregory, Sharon Lynne, 276, 277
Grieshaber, HAP, 522, 581
Griess, Carola, 580
Grimani, Domenico (Cardinal), 279
Grimm, Harold J., 278
Grimm, Reinhold, 368
Groland, Leonhard, 351
Gronau, Georg, 279
Grosch, G., 280
Groshans, Rainald, 70
Grossmann, Maria, 281
Grote, Ludwig, 282, 283, 284, 285,
 286, 287, 288, 289, 290, 712
Grünewald, Matthias, 167, 612, 815

Grünewald, Erika Singsen, 291
Grünling, Josef, 547
Guarino, Sergio, 292
Guenther, Liz, 763
Guillaud, Jacqueline, 610
Guillaud, Maurice, 610
Guise, John (General), 601 (collection, 1765)
Gulden, Andreas, 573
Gümbel, Albert, 294
Gurlitt, Cornelius, 293, 344
Gyula, Hungary, p. 15; 364, 366

Haarlem, Koenigs Collection, 684
Haase, Barbara, 48
Haase, Gunther, 295
Habermalz, Gisela, p. 346
Haden, Seymour, 514, 933
Haendcke, Berthold, 296
Hagen, Ernst August, 297
Hagen, Margaret A., 391
Hagen, Oskar, 546
Hahn, Cynthia, 298
Halbe-Bauer, Ulrike, 299 (*Mein Agnes*)
Hale, J. R., 638
Haletsky, John, 907
Hall, Edwin, 300
Haller, William, 8807
Haller Madonna (Washington, National Gallery), 518
Hallyn, Fernand, 301
Halm, Peter, 912
Hamann, Günther, 302
Hamburg, Kunsthalle, 303, 631, 679. *See also Death of Orpheus*
Hampe, Theodor, 304
Hamsik, Mojmir, 305
Hand, John Oliver, 306
hand-coloring, 259
Hannig, Peter, 307
Hanover, Niedersächsische Landesgalerie, 260

Hanover (NH), Dartmouth College Museum, 308
Hans von Kulmbach, 126
Hapsburg family, 715, 831 (mythology of)
Harbison, Craig, 309
hare, 430
Harlfinger, Dieter, 696
Harlot of Babylon (Apocalypse woodcut: B.73), 651
harmony, 79
Harnest, Joseph, 310, 311, 809
Harper, Michael B., 36
Harrich, Jobst, 25
Harriot, W. H., p. 346
Harris, Max, 933
Harris, Tomas, 933
Hartlaub, Gustav Friedrich, 312
Hartmann, Matthias Christoph, 534
Hartmann, Wolfgang, 286, 315, 316, 805
Hartmann-Wülker, Dürten, 313, 314
Harvard University, Fogg Museum, 591
Hase, Oskar, 317
Hauer, Hans, 241
Haug, Walter, 419, 420
Hauptman, William, 318, 319, 320, 321
Hausherr, Reiner, 323, 347
Hausmann, Bernhard, 322
Haydocke, Richard, p. 6
Hayum, Andrée, 324
Head of an Old Woman (drawing: London), 472
Heaton, Mary Margaret Keymer (Mrs. Charles), 325
Hebecker, Inge, 534
Heckscher, William S., 525
Heffels, Monika, 326, 327
Heffner, David, 328
Heideloff, Alexander, p. 342
Heigl, Curt, 588

Heiland, Suzanne, p. 17; 493
Heimberg, Bruno, 267, 771
Heine, B., 268
Heinse, Johann Jakob Wilhelm, p. 10
(*Ardinghello*)
Heitzer, Elizabeth, 329
Held, Julius, 330, 907
Heller, Jakob, and *Heller Altarpiece*
(destroyed 17th century), pp. 6,
20 (note 16); 167, 170, 345,
433, 627, 657, 815, 896; p. 350
bogus Heller manuscript, 297
Heller, Joseph, p. 10; 35, 331, 344, 563
Henry VIII, King of England, 190
heraldry, 572, 588 (Dürer family)
Hercules, 7, 122, 518, 540, 624, 735,
751
Herder, Johann Gottfried, p. 10
Herding, Otto, 350
Herfurth, Egbert, p. 346
Hermand, Jost, 368
Hermann-Fiore, Kristina, 332, 333,
334, 335, 697
hermeneutics, 410
Hermitage (St. Petersburg), 541
Herrant, Crispin, 841
Hertel, Wolfgang, p. 346
Hesiod, 922
Hess, Daniel, 336
Hesse, Michael, 84, 357
Hessus, Helius Eobanus (Eobanus
Hesse), 524, 703
Hetzer, Theodor, 337, 338, 546
Heusinger, Christian von, 339
Heyduck, Brigitta, p. 346
Hildegard of Bingen, 223
Hilliard, Nicholas, p. 6; 469, 870
Himpelshof (Franconia), 935 (and
Dürer's *Prodigal Son*)
Hinz, Berthold, 340
Hirschmann, Gerhard, 65, 117, 302,
341, 342, 349, 350, 461, 572,
666, 690, 723, 729, 741, 823

historical novels, 299, 895
historicism, 274
Hitler, Adolf, p. 16 (copy of Dürer's
Pond House); 354, 366, 443,
684
Hlavácek, Lubos, 343
Hochfeld, Sylvia, 7
Hoefnagel, Georg, p. 25; 26, 426,
427, 789
Hoenig, Alan, 344
Hoffman, Joseph, 346
Hoffmann, Detlev Karl Ermert, 167,
345, 430
Hoffmann, Konrad, 347, 348
Hoffmann, Hans, p. vii; 1, 3, 25, 26,
81, 118, 390, 391, 408, 420,
427, 432, 594, 819
Hofmann, Hanns Hubert, 349
Hofmann, Joseph E., 350
Hofmann, Walter Jürgen, 351
Hofmann, Werner, 303
Hogarth, William, 175, 468
Höhn, Heinrich, p. 343, 344, 345
Holbein, Hans the Younger, p. 9; 123,
665
Holland, 5, 499
Hollstein, Friedrich Wilhelm Hein-
rich, 352
Holmes, Oliver Wendell, 780
Holper, Heinz (Dürer's maternal
grandfather), 823
Holst, Karen, 353
Holub, Robert C., 367
Holzinger, Ernst, 354
Holzschuher family, 823
homosexuality and homoeroticism,
133, 200, 679, 735. *See also*
Death of Orpheus
Honor, Hugh, 705
Hoos, Hildegard, 355
Hopfer, Hieronymus, 907
Hoppe-Sailer, Richard, 356
horse, 99, 560, 913

Horváth, B. D., 357
Höss, Irmgard, 359
Housebook Master, 819
Howarth, David, 358
Hubala, Erich, 334, 735
Huber, Wolf, 596
Hugelshofer, Walter, 360
Hugo, Victor, p. 15; 76, 156, 226, 621
Hults, Linda C., 361, 362, 886
human proportion, 22, 92, 193, 252,
 794
Humanism, 64, 65, 89, 117, 130, 138,
 200, 255, 289, 303, 366, 368,
 443, 502, 504, 584, 654, 690,
 734, 756, 922, 927, 928, 929
Humanism, German, 852, 925, 926,
 927, 928, 932
Humphrey, Peter, 363
Hungary, 341, 488, 551, 588, 842
Hurlfinger, Dieter, 922
Hüsgen, Heinrich Sebastian, p. 10;
 370 (collection)
Hüsken, Wim, 371
Hutchison, Jane Campbell, 364, 365,
 366, 367, 368, 369, 803
Hütt, Wolfgang, 372, 373
Hutten, Ulrich von, p. 2; 690 (and
 Pirckheimer)
Hypnerotomachia Poliphili
 (Francesco Colonna), 622
 (Dürer's personal copy)

iconoclasm, 692
iconography, 21, 24, 60, 62, 74, 96,
 97, 113, 135, 139, 195, 197,
 207, 208, 222, 258, 270, 273,
 298, 328, 347, 348, 354, 358,
 500, 604, 605, 647, 668, 732,
 735, 934. *See also* individual
 titles, e.g. *Melencolia I;*
 Knight, Death and Devil, etc.
iconography-Death, 195; *Death and
 Maiden,* 919

iconography, snail, 215
idolatry, 185
Ihle, B. D., 685
illnesses, Dürer's, 280
imago clipeata, and the Kleeberger
 portrait, 663
Imdahl, Max, 84, 356
Imhoff family, p. 7; 118, 153, 154,
 155, 200, 214, 220, 232, 387,
 617, 634, 641, 721, 767, 774,
 820, 867
Imhoff, Christoph von, 200, 374, 375
Imhoff, Willibald, 374, 375, 634
Imperial portraits, 10, 480, 483, 566,
 580, 814, 916, 917
Imperial regalia, 101
impressions, quality of, 512 (Meder)
India, influence of Dürer in, 416
Indra, Bohumir, 376
indulgences, 179
influence, 31, 43, 56, 123, 164, 166,
 169, 184, 235, 244, 291, 327,
 332, 381, 407, 408, 416, 437,
 457, 527, 535, 551, 571, 625,
 656, 680, 823, 843, 868. *See
 also* reception
 Austria, 535
 Flanders, 253, 334, 862
 France, 109, 459, 599, 664, 757,
 910
 Germany, 307, 409, 552, 553, 554,
 727, 886
 graphics, 122
 Italy, 47, 249, 276, 346, 441, 460,
 594, 639, 640, 649, 661, 673,
 676, 682, 699, 745, 764, 831
 Netherlands, 9, 37, 70, 145, 330,
 488, 515, 749, 763
 Nuremberg, 585
 Poland, 648
 Scotland, 321
 16th century, 291, 327
 Spain, 40

influence (*cont.*)
 Tyrol, Austria, 626
 20th century, 184
infrared reflectography, 267, 485
Innsbruck, 162, 209
insanity, 256 (and melancholy)
inscriptions, Latin, 165
insects, 27
Iowa City (IA, USA), University of
 Iowa Museum of Art, 377
Ispherding, Eduard, p. 26
Israhel van Meckenem, 365
Italian influence, 216, 453, 638, 851,
 881, 932
Italian Mannerism, 277
Italy, 24, 92, 100, 111, 112, 143, 144,
 183, 216, 255, 257, 277, 332,
 432, 513, 541, 546, 561, 571,
 592, 603, 618, 656, 672, 693,
 735, 743, 751, 761, 830, 843,
 872, 911, 912; pp. 348, 349.
Italy, first trip, 210, 483, 693
Italy, reception in, p. 3; 546, 618,
 626, 832
Ithaca (NY), Cornell University,
 Herbert F. Johnson Museum of
 Art, 378
Ivins, William M. Jr., 379

Jabach Altarpiece, 17, 113, 229, 354,
 404; p. 349
Jabach, Everard, 537
Jabach family, 536
Jacob van Utrecht, 70
Jacobowitz, Ellen, 380
Jacopo de'Barbari, 292, 466, 883
Jaeggli, Alvin E., 189, 191
Jäger, Carl, pp. 342, 343
Jaffe, Michael, 381
Jahn, Johannes, 382, 383, 384, 858,
 860
Janeck, Axel, 385
Janitsch, Julius, 899

Janson, Horst, 318
Jante, Peter Rudolf, 386
Japan, 507
Jászai, Géza, 387
Jatzko, Siegbert, 532; p. 346
Jelinek, Hans, 388
Jenny, Ulrike, 389
Jerome, St., 15, 687 (*Penitent St.
 Jerome,* painting: Fitzwilliam
 Museum), 891 (engraving,
 1514)
Jews, 85. *See also* Antisemitism
Joachim (husband of St. Anne), 60
Job, 113. *See also Jabach Altarpiece*
John, St., 743. *See also Apocalypse*
Jones, Herschel, 151
Jones, Mark, 390
Jones, Rebecca K., 391
journeymen, 587, 597
Junghans, Helmar, 392
Jurascheck, Franz von, 393, 394
Jürgens, Klaus H., 395
Justice (and Michelfeldt Tapestry),
 371

Kade, Max, 826
Kaeppel, Carl Friedrich, p. 346
Kahsnitz, Rainer, 396, 397, 480, 484,
 574
Kaiser Friedrich Museum, Berlin,
 295
Kaiser portraits. *See* Imperial Por-
 traits, Charlemagne
Kalkreuth, 228
Kansas, University of, Spencer Art
 Museum, 261
Kansas City (MO), Nelson-Atkins
 Museum, 429
Kaplan, Alice M., 398
Kareliuss, Johanna, 907
Karl August, Grand Duke of Saxe-
 Weimar-Eisenach, 839
Karl IV, Holy Roman Emperor, 101

Karling, Sten, 399, 400
Karlsruhe, Staatliche Kunsthalle, 93
Karlstadt, Andreas Bodenstein von,
 205, 364, 366, 490, 692, 740
Kassel, Staatliche Kunstammlungen,
 401
Kastner, Joseph, 402
Katzheimer, Lorenz (Master LCz?),
 25, 718
Kauffmann, C. M., 403
Kauffmann, Hans, 404, 405, 406,
 407, 905
Kaufmann, Leopold, 408
Kaufmann, Lynn Frier, 409
Kaufmann, Thomas Da Costa, 410,
 411
Keil, Robert, 412
Kempter, Gerda, 560
Kepler, Johannes, p. 13
Kessler, Nikolaus, p. 348
Kilian, Philipp, p. 9
Kircher, A., 413
Kirchner, Ernst Ludwig, 526
Klauner, Friderike, 414
Kleeberger, Johannes, 663, 873
Klenze, Leo von, p. 342
Kliemann, Carl-Heinz, 532
Klingmann, Renate, 48
Knappe, Karl Adolf, vii; 415
Knight, Death and Devil (engraving:
 1513, B.98), p. 15; 76, 78, 166,
 270, 350, 399, 400, 544, 550,
 557, 560, 707, 739, 837, 889,
 901
Knight on Horseback (drawing,
 1498: Vienna), 433
Koberger, Anton, p. 4; 119, 317, 348,
 349, 921
Koch, Ebba, 416
Koch, Robert, 548
Koehler, Sylvester Rosa, 417
Koella, Rudolf, 910
Koenigs collection, Haarlem, 684

Koepplin, Dieter, 53
Koerner, Joseph Leo, 418, 419, 420
Kohler, Wilhelm H., 421
Kohlhaussen, Heinrich, 422, 423
Koller, Johann, 120, 121
Konecny, Lubomir, 424
Konowitz, Ellen, 425
Koòs, Judith, 588
Kopplin, Monika, 825
Koreny, Fritz, pp. 18, 25; 3, 94, 221,
 234, 239, 250, 264, 345, 426,
 427, 428, 429, 430, 431, 789,
 872
Koschatzky, Walter, 432, 433, 434,
 435, 872
Koslov, Grigorii, 7
Kotrborá, M.A., 436
Kraft, Adam, 6, 39
Kramer, Dieter (*Melancholie*), 581
Kratzer, Nikolas, 740, 793
Kratzsch, Gerhard, 437
Kredel, F., 438
Kress von Kressenstein, Georg,
 Freiherr von, p. 344
Kress family, 867
Krödel, Gottfried, 440
Krohm, Hartmut, 439
Kruft, Hanno Walter, 441
Krug Hans, 658
Krug, Ludwig, 588, 658, 807
Krüger, Peter, 442
Kruse, Christian, p. 26
Kubin, Ernst, 443
Küfner, Abraham Wolfgang (and
 theft of the 1500 *Self Portrait*),
 518
Kuhn, A., 444
Kuhrmann, Dieter, 446, 447, 912
Kulmbach, Hans "Süss" von, 124,
 125, 657, 586, 807
"Kunst," 815
Kuretsky, Susan Donohue, 447
Kurth, Willi, 448, 517, 803

Kurz, Otto, 449
Kuspit, Donald B., 450, 451, 452, 796
Kutschbach, Doris, p. 18; 453

laboratory reports, 265, 267, 305
Ladenspelder, Johannes, 907 (copies)
Lallmann, Abraham, p. 341
Lamentation (Munich), 18, 120, 176, 229, 265, 267, 366, 698 (as theme), 771
Lamentation (unique: British Museum), 698
Lamentation (Nuremberg: Holzschuher), 786
Lampsonius, Domenicus, 515
Lanckoronska, Maria, 454, 455
Landau, David, 456
Landauer Altarpiece (*Adoration of the Trinity,* Vienna), 6, 134, 135, 171, 173, 351, 397, 414, 453, 657, 658 (and Hans Krug), 807 (as Communion of Saints), 838 (and color theory), 852 (possible influence of Lorenzo, Lotto), 873 (restoration), 905 (sacred vs. profane time); p. 350
Landauer Chapel (Nuremberg), 124, 807 (in World War II)
Landauer, Matthias, and Landauer family, 6, 61, 124, 657, 807
Landolt, Hanspeter, 457
landscape, 57, 109, 225, 333, 432, 860, 888. *See also* Watercolors
Landscape with Cannon (etching: 1518, B.99), 78, 425
landscapes, 107, 228, 335, 432, 718, 722, 935
Lane, Barbara G., 524
Lang von Wellenburg, Matthäus (Cardinal), 302, 351
Langhans, Carl F., pp. 343, 346
Langston, D. E., 458

Lanzinger, Hubert, p. 16
Large Fortune (*Nemesis,* engraving, B.77), 8, 255, 419, 608, 907
Large Passion (woodcut series), 30, 406, 648 (*Crucifixion* influence in Poland), 698 (*Lamentation*); 798, 907; p. 350
Last Judgment (frame: *Landauer Altarpiece*), 171
Last Supper (woodcut: 1523, B.53), 731
Laub, Peter, 584
Laughing Peasant Woman (*Vilanda Windish,* drawing, privately owned), 915
Lavater, Johann Kaspar, pp. 10–11; 839
Laveissière, Sylvain, 459
Lavin, Irving, 323, 406, 700
law, Dürer and, 204, 729
Lawrence, Sir Thomas (*St. Eustace*), 675
Lawrence, Kansas, University of Kansas, Spencer Museum of Art, 460
LCz (monogrammist: Lorenz Katzeimer?), 25
Leder, Klaus, 461
legacy, p. 341
Lehmden, Anton, 532
Lehni, Nadine, 790
Leidinger, Georg, 462
Leitner, Friedrich Wilhelm, 257
Leitschuh, Franz Friedrich, 463, 464
Lely, Sir Peter, 912
Lemberg (mod. Lwow), former Lubomirski Museum, 428, 684, 835, 885
Leningrad. *See* St. Petersburg
Lenz, Wolfgang, p. 346
Leonardo da Vinci, p. 6; 57, 655, 699, 833, 851, 883, 911, 912
Leopardi, Alessandro, 597

Lepel, Wilhelm Heinrich Friedrich, Graf von, 465
Lessing, Gotthold Ephraim, 79
lettering, Roman, 324
letters, 358, 364, 689, 780, 857
Leu, Hans, 586, 612; p. 351
Leuteritz, Albrecht, 99
Levenson, Jay Alan, 466, 885
Levey, Michael, 467, 468, 469, 692, 794
Levinger, Matthew, 470
Libman, Mikhail Iakovlevic (Michael J. Liebmann), 471, 472, 852
Liess, Reinhard, 473
"Life and art" books, 20, 72, 220, 231, 282, 325, 331, 363, 720, 806, 809, 810, 829, 853, 854, 925
Life of Mary (Marienleben) (wood-cuts), 30, 60, 298, 460, 563, 826, 849, 907
light, 77
Limburg, Georg III von (Bishop), 351
Limouze, Dorothy, 867
linguistics, 458
Linz (Hitler's proposed museum), 443
Lippmann, Friedrich, 474
Literature, Dürer in, p. 10; 251, 297, 299, 545, 645
Little, Guy Fitch, 39
Little Masters, 558
liturgy, 146
Lobster (drawing), 850
Location Guide, pp. 353–365
Löcher, Kurt, 26, 480, 481, 482, 483, 484, 574, 580
Logan, Anne-Marie, 746
Lomazzo, Giovanni Paolo, p. 6; 546
Lombard, 515
London
 British Museum, 470, 476, 477, 687, 693

Courtauld Institute, 478
 Heim Gallery Ltd., 475
Longhi, Roberto, 478
Looting, 237, 576, 894. *See also* World War II
Lorenz, Stanislaw, 475
Los Angeles, CA, University of California, Grunewald Center for the Graphic Arts, 479
lost works, pp. vii, 7, 18–19, 35–36; 7, 28, 51, 286, 288, 350, 525, 530, 576, 701, 704
Lotto, Lorenzo, 639, 661
lovers, as theme, 8, 677
Luber, Katherine Crawford, 486
Lucas van Leyden, 40, 122, 749, 763; p. 352
Lucie-Smith, Edward, 486
Luckmeyer, Johann Andreas, p. 346
Lucretia, Suicide of, p. 7 (lost paint-ing: Middelburg; and Munich, Alte Pinakothek); 361
Lüdecke, Heinz, p. 17; 492
Ludolphy, Ingetraut, 487
Ludwig I, King of Bavaria, 520
Luijten, Ger, 684
Lukinich, Emerich, 488
Luppe, Hermann (Mayor of Nurem-berg), p. 15
Lurie, Ann Tzeutschler, 489
Luther, Martin, pp. 3–4; 11, 45, 205, 490, 530, 659, 731, 740, 747, 902; pp. 351, 352.
Luther Year 1983, 69
Lutheranism, 595
Lutz, Heinrich, 490, 491
Lynch, Terence, 493

Maas, Herbert, 494
McAuley, James, 933
McIntosh, Christopher, 509

McKittrick, Bruce, 510
Madonna and Child with a Pear
 (engraving: B.41), 907 (late
 16th century copy)
Madonna by the Wall (engraving:
 1514, B.40), 351, 505 (and
 copy Wiericx 750), 817
Madonna dell'Alpe (Schweinfurt:
 Schäfer collection), 482
Madonna in a Courtyard (attributed
 drawing: Rotterdam), 913
Madonna Nursing the Child (engrav-
 ing: 1519, B.36), 505 (and
 Wiericx copies 728 and 729);
 p. 351
Madonna of Bagnacavallo
 (*Madonna and Child in Front
 of an Archway,* painting; Mag-
 nani collection, Parma), 15,
 518, 672
Madonna with the Dragonfly
 (*Damsel Fly; Praying Mantis;
 Butterfly:* engraving: B.44),
 328, 554
Madonna with the Monkey (engrav-
 ing: B.42), 505 (and Wiericx
 copy 751), 554, 580 (copy:
 painting, Nuremberg)
Madonna with the Siskin (Berlin,
 Gemäldegalerie), p. 6
Madonna with Many Animals (water-
 color: Vienna, Albertina), 429,
 700
Madonna with the Swaddled Infant
 (engraving: 1520,B.38), 351
Madonnas, 95, 328, 468. *See also*
 Virgin
Madrid
 Museo Lazaro Galdiano, 50
 Prado, 100, 576, 696, 828
Maedebach, Heino, 154, 155, 495
Magnabosco, Ornella, 496
Magnifico, Marco, 793

Man in Armor (Fantastic Warrior)
 (drawing, previously unpub-
 lished), 26
Man of Sorrows (Karlsruhe, Kunst-
 halle), 15, 93, 518
Manchester (UK), City Art Gallery,
 497
Mander, Karel van, pp. 6, 7; 498, 515
Mann, Thomas, 156, 175, 545, 735
Mannheim, Städtische Kunsthalle,
 312
Mann, Thomas, 535, 735
Mannlich, Christian von, 518
Mansion, Colard, 647
Mantegna, Andrea, 389, 597, 679,
 752
Manual of Measurement, 191, 689,
 793; p. 352
manuscripts (in Dürer's hand), 158,
 187, 689
*Map of the Northern Firmament. See
 Celestial Map*
Marburg, 236, 884
Mardersteig, Giovanni, 499
Margaret of Austria, 202, 466, 625,
 714, 883
Marguillier, Auguste, p. 344
Marienleben (Life of the Virgin)
 (woodcut series), pp. 2, 6; 30,
 60, 406, 460, 563, 665, 826,
 850, 863, 905; p. 349
Mariette, Pierre, 514, 826
Marini, Marino, p. 17; 581
Marlier, Georges, 272
marriage, 713
Marrow, James Henry, 501, 821
Martyrdom of John the Baptist
 (woodcut: B.125), 656
Martydom of 10,000 Christians
 (Vienna, Kunsthistorisches
 Museum), 414, 624, 861; p.
 350
Marx, Alexander, p. 346

Marxist views of Dürer, 852, 859, 860

Mass of St. Gregory (woodcut: B.123), 624, 740

Mass of the Angels (Rennes, Musée des Beaux-Arts), 177, 179

Massing, Jean Michel, 501

Masson, Andre, 522, 581

Master HL, 59

Master IB with the Bird, 546

Master LCz (Lorenz Katzheimer?), 25

Master MS, 552, 553

Master MZ, 291, 554

Master WB, 25, 819

Master of the Caduceus (Jacopo de' Barbari), 466

Master of the Herpin Manuscript, 75

Master of the Housebook (Hausbuch-meister), 25, 820

Master of the Transylvanian Crucifix, 647

Mater Dolorosa (Munich, Alte Pinakothek), 18, 120, 176, 770

mathematics, 350, 493, 733, 783, 793

Matthews, Wendell Glen, 502

Maué, Hermann, 2, 503, 504, 574

Mauquoy-Hendrickx, Marie, 505

Maurer, Wilhelm, 506

Mayer, Ernst, 534

Maximilian I. Elector of Bavaria, pp. 6, 7; 264, 265, 266, 267, 268, 896

Maximilian I, Holy Roman Emperor, 32, 46, 63, 132, 162, 178, 201, 204, 209, 350, 351, 413, 455, 462, 485, 514, 690, 714, 746, 748, 749, 766, 794, 804, 807, 831, 834, 869, 873, 882, 883, 883, 898

 biography, 63, 794, 903

 as "new Apollo," 748

 papal ambition, 831

Prayerbook, 42, 46, 215, 271, 337, 338, 444, 462, 746, 794, 804, 834, 870

Triumphal Arch, 514, 49, 831, 898; p. 350

Mayer, Bernd M., 777

Maykawa, Seira, 507

Mayor, A. Hyatt, 508

Meckenem, Israel van, p. 9

medals, 50, 503, 528, 623, 663

Meder, Josef, p. vii; 511, 512, 513

medical literature, Dürer in, 280

Meerwunder (*The Sea Monster*, engraving: B.71), 5, 24, 74, 357, 387, 751, 907

Meidinger-Geise, Ingeborg, 644

Meij, A.W.F.M., 683, 684

Meiss, Millard, 354, 700 (Festschrift)

Meissen, 152

Meisterstiche (Master Engravings), 306, 613, 731, 733, 891. *See also* individual titles: *Knight, Death and Devil; St. Jerome in His Study;* Melencolia I

Melanchthon, Philipp, 290, 452, 629, 690, 703, 911

Melbourne (Australia), National Gallery of Victoria, 514, 933

Melencolia I (engraving: 1514, B.74), p. 15; 8, 44, 49, 54, 75, 78, 96, 97, 127, 128, 129, 133, 164, 175, 184, 198, 207, 211, 226, 254, 258, 269, 301, 318, 319, 320, 321, 329, 347, 348, 410, 493, 557, 598, 620, 643, 670, 727, 733, 734, 758, 770, 826, 847, 882, 891, 907, 911, 929; p. 350

Melencolia "II," 929

Melion, Walter S., 515

Memling, Hans, 218

memorials, Nuremberg, 720, 721

Mende, Matthias, pp. vii, 18; 34, 35,
 87, 106, 115, 516, 517, 518,
 519, 520, 521, 522, 523, 524,
 525, 526, 527, 528, 529, 530,
 531, 532, 533, 534, 579, 809,
 810; pp. 341, 343, 346.
Mendelssohn-Bartholdy, Felix, 246,
 654
Menz, Cäsar, 535
Merck, Johann Heinrich, p. 10
Merkers (World War II storage), 295
Merlo, Johann Jakob, 536, 537, 538
Mersmann, Paul, p. 346
Mesentseva (Mesenceva; Mezent-
 seva), Charmian Aleksan-
 drovna, 539, 540, 541, 542
Mészáros, László, 546
Mexico, 602
Meyer, Christian, 501
Meyer, Ursula, 543, 544
Meyers, Jeffrey, 545
Michelangelo Buonarotti, 546
Michelfeld Tapestry, 339
Mielke, Friedrich, 22
Mielke, Hans, 29, 67, 547, 610
Mikovinyi, Samuel, p. 343
Milan, 209
Milan, Ambrosiana, 446, 578
Miller, Jo, 110
Minnameier, Klara, p. 346
Minneapolis (MN), Minneapolis
 Institute of Arts, 151 (Jones
 Collection)
minor arts
 ceramics, 152
 19th century, 321
Minott, Charles I, 548
Miracle of the Drowned Boy from
 Bregenz (painting), 15
Mittig, Hans-Ernst, 520, 549
"Mit Dürer unterwegs," 532
modern artists honoring Dürer, p. 14;
 581

Modern Devotion (devotio moderna),
 393
modern works "paraphrasing" Dürer,
 522, 527
Moffitt, John F., 550
Mojzer, Miklós, 551, 552, 553, 554
Molionides, Hercules and the (Her-
 cules and Cacus, woodcut,
 B.127), 540, 624
Mommard, Johann, 907
monogram, Dürer's, 418, 596
Monstrous Sow of Landser (engrav-
 ing: B.95), 624, 882
Montagna, Benedetto, 546, 597
monument, Nuremberg, 520
Monument to a Dead Peasant (wood-
 cut book illustration), 543, 549,
 731, 843; p. 352
Morley, Brian, 555
Morvay, Andreas Johann, 556
Moscow, 7
Möseneder, Karl, 559
Moser, Lukas, 814
Mössner, Wolfgang, 560
Mother. See Dürer, Barbara Holper
motion, depiction of, 905
Moxey, Keith P. F., 133, 558, 559
Mrozinska, Maria, 475
Mühlenhaupt, Kurt, p. 346
Muhlher, R., 670
Mulazzani, Germano, 561
Münch, Paul, 567
Munich, Alte Pinakothek, 23, 98, 120,
 121, 142, 163, 263, 264, 266,
 267, 336, 744, 771, 787, 896
Munich, Haus der Kunst, 562
Munich, Staatliche Graphische
 Sammlung, 563
Münster (Westf.), Landesmuseum,
 56, 522
Müntzer, Thomas, 490
Murr, Christoph Gottlieb von, p. 10;
 564

music, by Dürer, 501
Musper, Heinrich Theodor, 565, 566, 915
mythology, 78, 605, "Nachleben," Dürer's, 621. *See also* individual titles

Nagler, Georg Kaspar, 568
Nagler, Karl Ferdinand Friedrich von, 67
Naples. Museo e Gallerie Nazionali di Capodimonte, 569
Napoleonic War, 547
Narrenschiff (*Ship of Fools:* Sebastian Brant), 354, 583, 681
Nash, John, 37
Nativity (drawing, Coburg), 913 (attribution doubted)
nature studies, pp. vii, 25; 21, 27, 57, 61, 62, 67, 94, 202, 203, 208, 221, 223, 233, 234, 239, 250, 328, 333, 345, 351, 390, 427, 428, 429, 430, 431, 432, 575, 576, 593, 655, 674, 675, 685, 687, 700, 741, 742, 789, 851, 859, 887 (attributions contested), 593, 887
Nazarenes, p. 12; 13, 58, 619
Nazis, 444, 892
Neave, Dorinda, 570
Nemesis (*The Large Fortune:* engraving, B.77), 8, 255, 419, 608 (Panofsky), 907 (copies)
Nerval, Gerard de, p. 15
Nesselrath, Arnold, 571
Netherlandish diary, 41, 272, 330, 689, 849, 857
Netherlandish journey, 115, 225
Netherlandish sketchbook, 849
Netherlands, 102, 116, 218, 219, 872
Netzhaube ("*schwäbische hawb,*" Swabian headdress), 862
Neubauer, Friedrich, p. 346

Neubecker, Ottfried, 572
Neudörffer, Johann, 573
 (*Nachrichten*), 819 (portrait)
Neudörffer, Magdalena, 819
Neue Sachlichkeit, p. 346. *See also* Otto Dix
Neufchatel, Nicolas, 819
Neumann, Carl, p. 4
new attributions, 127
new discoveries, 26, 730
New York, Metropolitan Museum of Art, 103, 203, 396, 397, 503, 504, 574, 575, 723, 897, 906, 920
Nicholas, Lynn H., 576
Nicholas of Cusa, 23, 393, 739
Nicoletto da Modena, 830
Niero, Antonio, 577
Nietzsche, Friedrich, p. 15
Nissen, Momme, p. 15
Nordic race, 823
Notre Dame (IN), University of Notre Dame, Medieval Institute, 578
novels, 1950's, 895
nudes, 90, 108, 210, 369, 749, 784, 880, 889
Nuremberg, 1, 3, 6, 12, 19, 39, 50, 58, 65, 138, 148, 149, 171, 200, 203, 204, 205, 212, 275, 278, 287, 289, 327, 342, 349, 355, 359, 374, 386, 494, 504, 519, 531, 558, 564, 573, 580, 585, 589, 597, 630, 653, 662, 677, 711, 720, 728, 765, 766, 771, 773, 775, 790, 818, 820, 821, 822, 897, 904, 920, 931
 Academy of Art, p. 9
 Albrecht Dürer Gesellschaft, 581
 Apollo fountain, 920
 archives 589, 867, p. 342
 arts and crafts 574, 897
 brass casting, 920

Nuremberg (*cont.*)
 censorship (16th century), 11
 City Council, 147, 883
 City Hall (*Rathaus*) 137, 519,
 p. 352
 collectors, 585
 Dürer monument, 519
 economics 821, 822, 823, 897
 families, 232
 Germanisches Nationalmuseum
 exhibitions, 17, 26, 580
 gold work, 585, 904
 Gymnasium, 702
 helmsmithing, 906
 historic preservation, pp. 345, 346
 history, 574, 791, 814, 866, 897
 humanism, 24, 65, 690
 Imperial regalia in, 897
 Jews, 133
 painting, 484, 574, 586, 815
 patrician patronage, 767
 printmaking, 586, 723
 Reformation in, 39
 Schembartlaufen, 288
 St. Katharine's, church, p. 7
 St. Sebaldus church, 6
 tomb, 920
 sumptuary laws, 275, 288, 909
 city views,723
 St. Lorenz, 720
 in Romantic period, 58
 in Third Reich, p. 16; 10
 women, civic regulation of, 904.
Nuremberg Chronicle, 647, 908, 931
Nuremberg museums
 Germanisches Nationalmuseum,
 pp. 7, 15; 567, 580, 582, 583,
 584, 585, 586, 587, 749, 897
 Museen der Stadt Nürnberg,
 Dürerhaus, 579
 Norishalle, 588
 Stadtarchiv, 589
 Stadtgeschichtliche Museen, 590

Nuremberg from the West (water-
 color), 723
Nützel, Kaspar, 351, 530
Nyvall, Lind C., 907

Ober St.Veit Altarpiece, 657
Oberhuber, Konrad, 431, 591, 592,
 593, 594
Oberman, Heiko, 651
Oechslin, Werner, 595
Oehler, Lisa, 596, 852, 913
Oellermann, Eike, 439
Offer of Love, The (engraving, B.93),
 8
Ohm, Anneliese, 245
Olds, Clifton C., 597
Olmütz, Bohemia, 376 (Hans Dürer
 in)
Olpe, Bergmann von, p. 348
Olson, Roberta Jean, 598
ornament, 271, 275, 449
Orpheus. *See Death of Orpheus*
Orsi, Lelio, 346
Ortelius, Abraham, 116, 863
Orth, Myra D., 599
Osten, Gert von der, 600 (Baldung)
Ostendorfer, Michael, 185
Ostrow, Stephen E., 652
Ottino della Chiesa, Angela, 759
Overbeck, Friedrich, p. 12
overpaint, 265
Ovid, *Metamorphoses,* 679
Oxford, Ashmolean Museum, 247,
 353, 618, 717
Oxford, Oxford University, Christ
 Church, 601
Ozment, Steven, 651

Pacheco, Francisco, p. 5
Pacher, Michael, p. 13
Pacioli, Luca (Fra), 292, 349
paintings, 15, 16, 17, 18, 19, 28, 85,
 102, 133, 170, 181, 229, 265,

282, 286, 300, 361, 392, 395, 404, 453, 483, 487, 518, 580, 582, 657, 687, 703, 759, 851, 896
 attributed, 862
 doubtful, 28
 Madonna dell'Alpe, 482
 Lamentation, Glimm, 786
 rejected, 15, 28, 469
 technique, 305
Paleotti, Gabriele (Cardinal), p. 5
Pallottino, Massimo, 75
Pallucchini, Rodolfo, 641, 868
Palm, E. W., 602
Pamphilus of Macedonia, p. 3
Panofsky, Erwin, 23, 133, 205, 469, 557, 603, 604, 605, 606, 607, 608, 657, 679
paper, 635, 636, 771
Paris
 Bibliothèque Nationale, 609
 Centre Culturel du Marais, 610
 Fondation Custodia, 865
 Musée du Louvre, 116, 210
Parke-Taylor, Michael, 664
Parma, Fondazione Magnani Rocca, Mamiano de Traversetolo, 611, 672
Parrhasius, p. 3
Parshall, Linda, 612
Parshall, Peter W., 457, 612, 613, 614, 615, 616
Passamani, Bruno, 617
Passavant, Günter, 618
Passavant, Johann David, 619 (print collection)
Passion of Christ, 104, 365, 500; *Engraved Passion,* 798, 933; *Large Woodcut Passion,* 798, p. 350.
Passion iconography, 797
pathos formulae, 881 (Warburg)
patronage, 281, 710, 720, 721, 867

Patty, James S., 620, 621
Paumgartner Altarpiece (Munich), p. 7; 18, 120, 173, 176, 264, 265, 267, 657, 700, 770, 786, 896; p. 349
Peasant Monument (woodcut illustration), 855
Peasants' War (*Bauernkrieg*), 68, 205, 349, 542, 855
Peasant with Whip (drawing, Hamburg), 631
peasants, 8, 358, 631, 660, 878
Pechstein, Klaus, 622
Pèlerin, Jean (Viator), 621
Pels, Friedrich, 81
Peltzer, Alfred, 623
Pencz, Georg, 205, 491, 586, 597, 741, 841 (documents)
Penitence of St. John Chrysostom (engraving: B.63), 656
peonies, 431
Perlberg, Friedrich, p. 346
Perlove, Shelley K., 365
Perrenot, Antoine (Cardinal Granvella), 835, 841, 861, 875
Perrenot, Nicolas, 841
Perrig, Alexander, 624
Perrot, Françoise, 625
persona, Dürer's, 245, 384, 529, 857
perspective, 92, 310, 311, 345, 391, 493, 606, 621, 727, 786, 852, 864
Perugino, Pietro, 656
Perusini, Teresa, 626
Peter, Saint (in *Four Apostles*), 744
Petrarch, 876
Peurer (Beurer), Wolfgang, 820
Peutinger, Konrad, p. 2; 530, 690
Pfaff, Annette, 627
Pfeiffer, Gerhard, 628, 629, 630, 631
Pforr, Franz, 13
Pfötsch, K., 632
Philip, Lotte Brand, 633, 634

Philosophy (woodcut: 1502, for
 Celtis' *Amores*), 927
physiognomic studies, 827
Picasso, Pablo, p. 17; 562, 581
Piccard, Gerhard, 635, 636
Piccolomini, Aeneas Silvius (Pope
 Pius II), 117
Pico della Mirandola, 23
Piel, Friedrich, 123, 173, 637, 826
Piero della Francesca, 727
pigments, 267
Pignatti, Teresio, 638, 639, 640, 868
de Piles, Roger, p. 9
Pilz, Kurt, 641
Pilz, Wolfgang, 642
Pingree, David, 643
Pirckheimer, Caritas (Barbara), 200,
 644, 657; p. 349
Pirckheimer, Felicitas, 669 (portrait?)
Pirckheimer, Willibald, pp. 1, 17;
 117, 182, 187, 199, 200, 205,
 232, 294, 358, 386, 506, 572,
 604, 628, 644, 645, 663, 669,
 688, 690, 694, 749, 903, 912;
 p. 348
 heirs, 388
 Kuratorium, 199, 641, 644
 library, 641
 notebook, 693
 portrait, 29
Pirckheimer-Imhoff, Felicitas, 663,
 669
Pirsich, Volker, 645
Pisanello, Antonio, 389, 851
Pius II (Pope: Aeneas Silvius Pic-
 colomini), 117
Pizzetti, Simona Tosini, 611
Plagemann, Volker, 520
plant studies, 27, 223, 554, 674. *See
 also* "nature studies"
plants, symbolism of, 62, plates
 (etched: Bamberg), 563
Plattner, Hans, 819

plays, 251
Pleydenwurff, Hans, 484
Pleydenwurff, Wilhelm, 816
Pliny, *Historia naturalis,* 663
Plummer, Christopher, 700
Plummer, John, 323, 406
Poensgen, Georg, 646
Poesch, Jesse, 647
poetry (1828 festival), 180
Polak-Trajdos, Ewa, 648
Poland
 Dürer drawings in, 475
 Dürer's influence in, 860
 Hans Posse in, 443
political history, 349
political interpretations
 1971 exhibitions, 71
 Knight, Death and Devil, 544
Poliziano, Angelo, 608, 679, 881
Pollaiuolo, Antonio del, 597
Polzer, Joseph, 649
Pomponius Laetus, 608
Pope, Alexander, p. 15
Poppel, J. G. F., p. 346
Portrait of a Carmelite Nun ("Sister
 Metzger," drawing, Paris,
 Fondation Custodia), 796,
 865
Portrait of Caspar Nützel (drawing,
 1517: Munich), 585
Portraits of Charlemagne and Sigis-
 mund (Nuremberg), 10, 480,
 580, 897;
 Zurich version, 916, 917
Portrait of Damiaõ de Goes (?)
 (drawing: W.317), 525, 701
Portrait of Dürer's Mother (painting,
 Nuremberg), 633, 634
Portrait of Dürer's Father, 634, p.
 347 (1490: Uffizi); 828 (Lon-
 don)
Portrait of Elspeth Tucher (1499:
 Kassel), 400

Portraits of Emperor Maximilian
(519) 580 (Nuremberg); 873
(Vienna)

Portrait of Endres Dürer (?) (char-
coal drawing, New York, Mor-
gan Library), 596 (attributes to
Wolf Huber); 607 (accepts
attribution to Dürer)

Portrait of Friedrich the Wise (1496:
Berlin), p. 348

Portrait of the Fürlegerin (young
woman of the Fürleger family),
421 (1497, Berlin, new acquisi-
tion); 28 (Paris: attribution
rejected)

Portrait of Hans Burgkmair (Bu-
dapest), 862 (rejected by
Anzelewsky; accepted by
Urbach)

Portrait of Hans Dürer (?) (silver-
point, W.284, London), 860
(Jahn)

*Portrait of Hans [Johann] Klee-
berger* (Vienna), 663, 873

Portrait of Hieronymus Holzschuher
(1526: Berlin), p. 352

Portrait of Jakob Muffel (1526:
Berlin), p. 352

Portrait of Michael Wolgemut (1516:
Nuremberg), 10, 580, 725

Portrait of Philipp Melanchthon
(engraving: B.105), pp.
352–353

Portrait of Ulrich Varnbüler (wood-
cut, 1522, B.155), p. 352

Portrait of Willibald Pirckheimer, 907
(copy)

*Portrait of a Young Girl in a Head-
band* (drawing, Stockholm),
669 (as Felicitas Pirckheimer)

Portrait of a Young Man (Munich,
Alte Pinakothek: 1500), 8
(attribution rejected)

Portrait of a Young Venetian Woman
(Vienna), 873

*Portraits of Hans and Felicitas
Tucher* (1499, Weimar), p. vii;
237

Pörtner, Rudolf, 483

portrait diptychs, 819

portrait medallions, 528

portraits, 51, 53, 77, 82, 102, 132,
220, 233, 237, 277, 285, 288,
303, 400, 420, 421, 451, 485,
518, 530, 585, 607, 623, 634,
663, 686, 696, 701, 704, 748,
808, 819, 860, 862, 865, 866,
904, 916

portraits of Dürer (supposed), 218,
276

portraits signed "VV" (from life),
165 (by Giorgione, Titian and
Dürer)

Portugal and Portuguese connections,
41, 284, 524, 701, 866. *See
also* Sampayo Ribeiro

Positivism, 325

Posse, Hans, 443

post World War II, 880, 896

postage stamps honoring Dürer, 590
(exhibition)

postal service, 209, 930 (from Venice
to Nuremberg)

Power of Women topos, 650 (and
witch riding)

Prague, 363, 436, 577

Prague, Strahov Monastery, 874

Prague, National Gallery (Národní
Galerie), 305, 874

Praun, family, 1, 2, 3, 4, 232, 564,
766, 819, 867
 Hans I, 585
 Jakob, p. 25
 Paulus II 1, 2, 585
 Sigmund Christoph Ferdinand,
 564

Praun Collection, 1, 2, 3, 4, 232, 585,
 725, 819, 867
Praying Hands (Vienna, Albertina),
 168, 345, 759
Préaud, M., 650
Prechtl, Matthias, 522, 532 (Nether-
 landish sketchbook)
Pre-Columbian art, 602 (influence of
 Montezuma's capital on the
 Befestigungslehre)
Previtali, Andrea, 546
Price, David, 651
prices (in Dürer's time), 105
primary sources, 573, 689
print quality, 224, 512
print sales (by Dürer), 729, 730
print collections, p. 10; 67, 154, 539,
 563, 564, 634, 789, 790, 825,
 828
prints, 86, 153, 159, 161, 174, 178,
 188, 194, 198, 224, 230, 322,
 352, 379, 443, 495, 512, 514,
 548, 568, 571, 583, 609, 616,
 617, 667, 685, 706, 725, 736,
 762, 765, 776, 792, 794, 800,
 803, 845, 852, 855, 886, 891
 catalogues and collections,
 p. 10; 151, 415, 616, 667,
 737, 792, 795, 799, 800,
 803, 891, 933
 exhibitions, 378
 and transfer of images, 855 (Ull-
 mann)
Prodigal Son (engraving: B.28), p. 5;
 830, 935
Profile heads (physiognomic draw-
 ing), 827
Pröll, Franz Xaver, 653
Promenade, The (engraving: B.94),
 554 (and Master MZ)
proportion and proportion theory, 90,
 99, 108, 252, 292, 412, 466,
 688, 782

Protestantism and Protestant clergy,
 34, 35, 45, 145, 147
Providence (RI), Rhode Island
 School of Design, 652
publications (by Dürer), 344, 411,
 582, 689
Publius Terentius Afer (Terence), 654
 (*Andria*)
Pühlhorn, Wolfgang, 584
Pupilla Augusta (drawing), 751
pupils, 125, 813, 841, 922
Puss, Gunther, 655
putti (and disorder), 934

Quadt von Kinkelbach, Matthias,
 p. 1; 241
Quednau, Rolf, 656

Radojewski, Mieczyslaw, 475
Rahl, Carl Heinrich, 534
Raimondi, Marcantonio, p. 5; 390,
 460, 594, 597, 907
Rape of Europa (drawing: Vienna,
 Albertina), 222 (and Titian)
Raphael, p. 4; 398 (drawing), 546,
 561, 571, 592, 618, 649, 656,
 833
Rasmo, Niccolo, 888
Rasmussen, Jörg, 657, 658, 659, 807
Ratdolt, Erhard, 921 (Hesiod edition,
 1484)
Ratgeb, Jerg, 815
Rathaus (Nuremberg), 147, 629
Rau, Johannes (President), 547
 Minister-President of
 Nordrhein-Westfalen)
Rauch, Christian Daniel, pp. 15, 342,
 520
Raupp, Hans-Joachim, 660
Rave, August, 825
Ravenel, Gaillard, 885
Ravensburg, Städtische Galerie Altes
 Theater Ravensburg, Fürstlich

zu Waldburg, Wolfegg'sche Kunstsammlungen, Wolfegg, 777 (exhibition)

Rawson, Jessica, 476

realism, and "laws of production," 852 (Kuhirt, Olbrich), 856

Rearick, W. R., 661

Rebel, Ernst, 662, 663

Reber, Horst, 245

reception, 4, 10, 13, 14, 23, 35, 43, 59, 76, 98, 116, 118, 136, 166, 168, 176, 196, 203, 214, 226, 227, 236, 241, 244, 246, 248, 261, 263, 266, 268, 269, 277, 287, 296, 297, 312, 313, 314, 315, 316, 319, 320, 321, 340, 346, 364, 367, 390, 400, 408, 410, 417, 420, 437, 444, 456, 463, 464, 465, 473, 492, 521, 523, 528, 531, 533, 534, 546, 553, 561, 567, 568, 571, 587, 597, 615, 620, 645, 662, 675, 691, 702, 732, 735, 760, 765, 777, 779, 878, 892, 900, 908, 932, 934; p. 343
 cira 1600, 407, 427
 18th century, 1, 34, 50, 58, 152, 154, 206, 313, 314, 370, 602, 725
 England, 175, 325, 871
 15th century, 551, 554
 Flanders, 381, 505
 France, 164, 213
 Germany, 327, 387
 Holland, 847
 Italy, 479, 638, 679
 19th century, 11, 13, 58, 109, 164, 180, 195, 213, 220, 226, 227, 229, 236, 251, 287, 297, 315, 318, 320, 331, 340, 444, 470, 532, 619, 620, 644, 645, 665, 667, 713, 758, 833, 893, 911
 Russia, 472
 17th century, 1, 9, 37, 235, 259, 266, 332, 334, 359, 490, 499, 516, 551, 674, 713, 743, 847, 890, 896
 16th century, 3, 5, 31, 40, 47, 53, 56, 70, 95, 111, 112, 122, 235, 239, 240, 242, 250, 253, 260, 266, 296, 307, 323, 330, 356, 388, 404, 410, 442, 460, 461, 497, 506, 510, 535, 584, 593, 600, 617, 619, 627, 640, 641, 649, 662, 677, 680, 683, 700, 720, 745, 750, 763, 765, 832, 862, 869, 871, 886
 in Third Reich, 18, 365, 366. *See also* Posse, Hans and Hitler, Adolf
 20th century, 68, 71, 176, 178, 195, 227, 252, 325, 340, 342, 374, 382, 471, 478, 487, 507, 545, 562, 581, 590, 707, 728, 860, 885

Redon, Odilon, 164, 910

Reformation, 12, 39, 48, 53, 68, 69, 75, 104, 141, 146, 147, 148, 150, 177, 185, 196, 278, 290, 303, 309, 364, 373, 440, 450, 451, 452, 490, 491, 506, 530, 612, 624, 628, 629, 630, 659, 689, 692, 705, 740, 746, 755, 824, 843, 851, 856, 886, 903, 918, 923

Regensburg, 185

Regimentstube (Nuremberg, Rathaus), 422

Regina, Saskatoon (CND), University of Regina, Norman McKenzie Art Gallery, 664

Regiomontanus, Johannes, 786

Reindel, Albert Christoph, 534, 579

Reinhardt, Hans, 665

Reitzenstein, Alexander von, 665

rejected attributions, 29, 716

religious life, Nuremberg, 359
religious views, 693, 902
Rembrandt, pp. 4–5; 9, 37
Renaissance reception, South Germany, 776
Rennes, 177, 179
reproductions, 105, 637
restoration, 120, 267
Retberg, Ralf Leopold von, 667
Reuchlin, Johannes, 133, 670
Reupp, Hans Christoph von, 7
Reuterswärd, Patrik, 668, 679, 670
reversal of images (in Dürer's
 graphic art), 614
Reynolds, Sir Joshua, 175
Rhine castles, 225
Rhinoceros (woodcut: 1515, B.136),
 152, 431, 584, 655, 850
Ribeiro, Mário de Sampayo. *See*
 Sampayo-Ribeiro
Riccio, Andrea, 597
Riccomini, Eugenio, 672
Richer, Jean, 156
Riedl, Peter Anselm, 673
Riemenschneider, Tilmann, 815
Rix, Martyn, 674
Roberts, Jane, 675
Robison, Andrew, 887
Robison, William W., 133
Rodiek, Thorsten, 825
Roebuck (drawings), 428, 851
Rollers, blue (watercolors), 429
Roman sculpture, 24, 663
Romanticism, 76, 646, 832, 877
Rome, 85, 210
Ronen, Avraham, 676
Roper, Lyndal, 677
Roriczer, Mathias, p. 13
Rosand, David, 678
rosary and rosary devotion, 157, 288,
 305, 577, 695
*Rosary Altar. See Feast of the Rose
 Garlands*

Rosary Brotherhood, 363, 577
 (Venice)
Rosasco, Betsy, 679
Rosenberg, Charles M., 680
Rosenfeld, Hellmut, 681
Rosenfeld, Myra Nan, 682
Ross, Barbara T., 548
Rott, Herbert Wilhelm, 563
Rotterdam. Museum Boymans-van
 Beuningen, 683, 684, 685
Rouargue, Emile, p. 346
Rowlands, John, 15, 686, 687, 796
Rubens, Peter Paul, 334
Rückert, Günther, 694
Rudolph II (Holy Roman Emperor),
 pp. 6, 7; 4, 35, 118, 171, 239,
 266, 305, 387, 408, 434, 835,
 861, 875, 876
Ruhmer, Eberhard, 888
Rumohr, Karl Friedrich von, 681
Rupprich, Hans, vii, 17; 185, 688,
 689, 690, 691, 692, 693
Ruskin, John, 76, 226, 470
Russia, 7

Sabines, Abduction of (drawing), 217
Saffrey, Henry D., 695
Salas, Xavier de, 696
Sales, 564 (Praun), 855 (by Dürer)
Salvini, Roberto, 697, 698, 699, 700
Sampayo-Ribeiro, Mário de, 701
Sandby, Paul, collection, 469, 675
Sandrart, Joachim von, pp. 7–9; 175,
 653, 679, 738, 789
Sarab'janov, A., 702
Saran, Bernhard, 703
Sass, E. Kai, 704
satire, 12
Satyr Family (engraving: B.69), 409,
 507 (and Giorgione's *Tempest*)
Savonarola, Girolamo, 902
Saxl, Fritz, 705
Sayre, Eleanor, 706

Sbrulius, Ricardus, p. 3; 527
Scalini, Mario, 707
Schade, Herbert, 104, 708, 808
Schade, Sigrid, 709
Schädler, Alfred, 712
Schadow, Johann Gottfried, 579, 710
Schandorf, Wulf, 711
Schapiro, Meyer, 919
Schauder, Michael, 776
Schäufelein, Hans, 586, 597
Schauwecker, Heinz, p. 344
Schawe, Martin, 267
Schedel, Hartmann, 756, 931
Schefer, Leopold, 713
Scheffer von Leonhardshoff, J. E., pp. 12–13
Scheicher, Elisabeth, 714
Schellemann, Carlo, 715
Scher, Stephen K., 652
Scherenberg. Rudolf von (Bishop of Würzburg), 651, 715
Scherer, Valentin, 716
Scherpe, Klaus R., 367
Scheurl, Christoph, p. 3; 503, 526, 653, 689, 823
Scheurl family, 653 (exhibition: Nuremberg Stadtbibliothek)
Schewe, Josef, 717
Schiele, Egon, 526
Schindler, Herbert, 718
Schinkel, Karl Friedrich, 579
Schlegel, Ursula, 719
Schlegel, Friedrich and Wilhelm, p. 12
Schleif, Corine, 720, 721, 722
Schloss Michelfeldt, 371
Schlüsselfelder, Wilhelm, 414
Schmidt, Peter, 776
Schneckenburger-Broscheck, Anja, 401
Schneider, Cynthia P., 133
Schneider, Erich, 188, 736

Schnelbögl, Fritz, 65, 302, 341, 349, 351, 462, 573, 667, 690, 723, 729, 741, 823
Schnorr von Carolsfeld, Julius, 579
Schöber, David Gottfried, 726
Schoch, Rainer, 574, 724, 725
Schön, Erhard, 11, 558
Schöne Maria, 185
Schönert, J., 97
Schongauer, Martin, p. 9; 40, 72, 348, 353, 388, 556, 913
Schongauer, Jörg (Georg), 556
Schreiber, Walter, 581 (*Hasenstall*)
Schreyer, Sebald, 50, 129, 289, 767
Schreyl, Karl Heinz, 343, 590
Schröder, Eberhard, 727
Schubart, Christian Daniel, p. 11
Schubert, Dietrich, 728
Schultheiss, Werner, 729, 730
Schultze, Jürgen, 107, 910
Schulz, Barbara, 731
Schulz, Fritz Traugott, p. 345
Schuster, Peter-Klaus, 303, 587, 732, 733, 734, 735, 817
Schütz, Karl, 873
Schweigger, Georg, 59, 389
Schweikhart, G., 736
Schweinfurth, Bibliothek Otto Schäfer, 737
Schwemmer, Wilhelm, 738; pp. 345, 346
Schwerte, Hans, 739
Scribner, Bob, 740
Sculpture, influence on, 59, 201, 386, 396, 657
Seebass, Gottfried, 741
Segal, Sam, 432, 742
Segeberg, H., 97
Seibold, Gerhard, 743
self image, 5, 84, 420, 909

Self Portrait (painting)
 1500 (Munich), pp. 3, 5; 23, 42,
 163, 336, 395, 420, 518 (theft),
 524, 732, 740, 925, 926, 927,
 928; p. 349
 1493 (Paris); 420, 576, 839, 909;
 p. 348
 1498 (Madrid): 100, 358, 576,
 696, 828
Self Portrait (drawing), 769 (Bremen,
 formerly: as Christ?)
self portraits, 45, 84, 119, 132, 144,
 336, 421, 518, 614, 828, 858,
 910, 929
semiotics, 838
Serlio, Sebastiano, p. 6; 682
Sforza family (Milan), 690 (and
 Pirckheimer)
shadow projection, 411
Shestack, Alan, 886
Ship of Fools, 681
Shoemaker, Innes H., 460
Sickel, Lothar, 744
Sickingen, Franz von, 349, 350
Siebenhühner, Herbert, 745
Sieveking, Heinrich, 746
Sigismund (Holy Roman Emperor),
 10, 101, 204, 480, 483
signature, 165
Signorelli, Luca, 744
Silver, Larry, 39, 485, 514, 747, 748,
 749, 750
Simon, Erika, 751, 752
Simonsfeld, H., 753
Singer, Hans Wolfgang, p. 15; 754,
 755
Singleton, C. S., 270
Skrine, Peter, 756
skull, 670
Sladeczek, Leonhard, 757
Slee, Jacquelynn Baas, 758
Sleptzoff, Lola, 759
Sloan, Sir Hans, 686

Small Courier (engraving: B.80), 554
Small Passion (woodcuts), 31, 33, 37
Smith, Alistair, 760, 761, 762
Smith, David R., 763
Smith, Elise Lawton, 764
Smith, Graham, 765
Smith, Jeffrey Chipps, 12, 39, 410,
 558, 748, 766, 767
Smith, Molly, 768
Smith, Robert, 769
Smith, Susan, 750
Smith, W. R., p. 346
snail, 215 (as symbol of perpetual
 virginity)
social history, 12, 212, 236, 349
Sodalitas Staupitziana, 349
Sohm, Philip L., 770
Sojourn in Egypt (Life of Mary
 woodcut), 298
Sol justitiae, 204
Sonnenburg, Hubertus von, 771
Soreda, Juan, 40
Sorokina, Lenina, 541
Sorrows of the Virgin polyptych
 (Dresden and Munich), 698
Sourieau, Etienne, 905
Soviet Union, 7 ("trophy brigades");
 703 (calendar)
Sow of Landser (engraving), 882
space, three-dimensional, 354, 391
Spagnol, Mario, 390
Spall, Anna, 736
Speckmann, D. Rolf, 107
Speer, Albert, p. 16
Spell, Anna, 188
Spengler, Lazarus, 11, 628, 690;
 p. 351
Spies, Werner, 562
Spohrhahn-Krempel, Lore, 772
Sprigath, Gabriele, 773
Springer, Anton, 774
Springer, Jaro, 775
Springinklee, Hans, 586, 597

St. Anne, 283
St. Anne with the Virgin, 262
St. Anthony Before a City (*St. Anthony Reading,* engraving: B.58), 455, 768; p. 351
St. Barbara (drawing), 801
St. Catherine (drawing), 801
St. Eustace (engraving: B.57), 38, 112, 155, 675 (Sir Thos. Lawrence)
St. Jerome, various, 61, 160, 238, 306, 614, 669, 671, 727
St. Jerome in His Study (engraving: 1514, B.60), 238, 613, 668, 670, 727, 734, 893, 907
St. Jerome in a Landscape (Cambridge: Fitzwilliam), 447
St. Philip (engraving), 309
St. Petersburg (Russia). Hermitage, 539, 540, 541, 542
Stabius, Johannes, 302, 351, 572
Staeck, Klaus, 522
Stafski, Heinz, 776
Stag Beetle (watercolor by Dürer? Los Angeles, Getty), 429 (and copies); 851
stained glass, 125, 397, 625, 721
Stalin, Josef, 7
Standing Apostle (drawing), 29 (study for the Heller Altar)
Stange, Alfred, 15
Staupitz, Johann von, 290, 347, 902
Stechow, Wolfgang, 15, 778, 779, 780, 781, 782, 860, 885, 900
Steck, Max, 783, 784
Stehelin, Robert, 790 (collection)
Steinbock, Wilhelm, 785
Steinmann, Martin, 786
Steinraths, F. J. E., 787
Stejskal, Karel, 788
Stendal (Brandenburg), Marienkirche, 7 (*St. Jerome:* lost painting)
Sternath, Hermann, 789

Stewart, Harold, 933
Sticht, Robert Carl, 933 (collectiom)
still life, tradition, 742
Stockholm, National Gallery, 669
stolen works, 182
Stör, Niklas, 558
Stoss, Veit, 39, 422, 648
Strasbourg, Cabinet des estampes, 790
"Strassburg Master" (of Dürer's *Wanderjahre*), 820
Strauss, Gerald, 791
Strauss, Walter L., pp. vii, 18; 15, 792, 793, 794, 795, 796, 797, 798, 799, 800, 801, 802, 803, 885
Streicher, Julius, p. 16
Strickland, Diane Claire, 804
Strieder, Peter, p. 18; 586, 629, 805, 806, 807, 808, 809, 810, 811, 812, 813, 814, 815, 816, 817, 818, 819, 890, 916
Strobl, Alice, 434, 435, 872
Strocka, Volker Michael, 820
Stockholm. National Gallery, 669
Stromer, Wolfgang von, 644, 821, 822, 823
Strzygowski, Josef, 824
Stucks, Georg, 55
Study Sheet with a Seated Woman and a Man's Head (drawing: formerly Lemberg), 684
Stuhr, Michael, 825
Stumpp, Emil, 346
Sturm, Caspar, 583
Stuttgart, Staatsgalerie, Graphische Sammlung, 826, style, 354, 457, 924
stylistic development, 19
Suckale, Robert, 827
Sudarium Held by Two Angels (engraving: 1513, B.25), p. 350

Sudarium (engraving, B.26), p. 351
sumptuary laws, 163, 275, 288
Surrealism, 486, 933
Susanna of Bavaria (sister of Emperor Maximilian I), 361 (and *Lucretia*). *See also* Durer's portrait drawing, Harvard University, Fogg Museum
Sutherland, Graham, p. 17; 581
Sutton, Denys, 828
Swabian League, 349, 350
Sweden, 194
Swiss journey, with Pirckheimer, 666
Swoboda, Karl M., 829
Swoboda, Ulrike, 26
symbolism, 27, 77, 394
symposia, 342, 428, 708, 852
symposium, DDR, 852
Syphilitic, The (woodcut; Passavant 198), 882
Szabó, George, 575, 796, 830

Tacitus, Cornelius, p. 2; 748 (*Germania*)
Talbot, Charles W., 796, 885, 886
Tanner, Marie, 831
Tanzi, Marco, 832
Tatar, Maria M., 833
Tavel, H.C. von, 834
Taylor, Francis Henry, 835
Tchilingirov, Assen, 852 (influence on art of Russian Orthodox church)
teaching (Dürer's), 367, 777
technical examination of works, 267, 771, 810
techniques, 100, 267, 379, 387, 425, 457
Tedeschi, Martha, 836
Teglio, Palazzo Besta, 249
temperaments (humors), 22, 827
Tenochtitlan (Mexico), 602
Terbrugghen, Hendrik, 489

Terence (Publius Terentius Afer), 119, 348, 437, 499, 654
Thausing, Moriz, 325
thefts, 161 (Lambach print collection); 237, 295, 894 (*Women Bathing,* drawing formerly Bremen, stolen from Soviet Union)
Theissing, Heinrich, 837
theoretical works, 605, 688, 691, 780, 793, 797, 827, 838, 857
theory, 38, 79, 92, 193, 344, 411, 412, 603, 726, 784, 852, 932
Thiel, Helmut, 590
Third Reich, 10, 83, 544, 576, 824, 877, 891
Third Rider (Apocalypse), 139
Thompson, James, p. 15
Thürlemann, Felix, 838
Tieck, Ludwig, p. 11; 13, 58
Tietze, Hans, 839, 840
Tietze-Conrat, Erika, 840
Tilly, Johannes Graf (Field Marshall), p. 7
Timann, Ursula, 841
Timar, Arpad, 842
time, depiction of, 905
Timken-Zinkann, R. F., 843
Titian, 47, 183, 242, 640, 678, 744
Tofani, Anna Maria Petrioli, 844, 845
Toronto, Art Gallery of Ontario, 846, 847
Tory, Geofroy, 599, 621
Tosini Pizzetti, Simona, 848
Traeger, Jörg, 123, 173, 827
transparencies (1828), 261, 521
Traut, Wolf, 586, 657; p. 349
travel, 584, 689, 883, 930
trees, 09
Trent, 107
Tressider, Wayne, 597
trial proofs, 659
Trier, Eduard, 347

Trinity (woodcut, 1511, B.122), 844
(influence on Cigoli)
triptychs, 642, 657
Trithemius, Johannes, 283
Triumphal Arch (woodcuts), 46, 178,
748, 831, 903
Triumphal Procession (woodcuts),
32, 519
Trost, Friedrich, Sr., p. 346
Troutman, Philip, 849
Troyen, Carol L., 850
Trux, Elisabeth M., 851
Tscherte, Johannes, 205, 572
Tucher family, 237, 283, 288, 720, 721
Turf (*Great Piece of Turf,* watercolor,
Vienna), 429
Turks, 189
Two Young Horsemen (pen drawing,
Munich, W.53), 912

Uhr, Horst, 300
Ullmann, Ernst, 89, 144, 384, 825,
852, 853, 854, 855, 856, 857,
858, 859, 860, 922
Ulrichs, Ludwig, 861
*Unterweysung der Messung (Manual
of Measurement),* 132, 191,
350, 458, 726, 792, 864
Urbach, Zsusza, 862, 863

Vagnetti, Luigi, 864
Van der Marck, Jan, 308
Van Gelder, Jan G., 865
Van Mander, Carel, 515 (Melion)
vandalism, pp.vii, 19; 18, 120, 176,
267, 771
Vasari, Giorgio, p. 5; 4, 91, 276, 277,
516, 676, 735
Vasari, on Durer, 91
Vasconcellos, Joaquim de, 866
Vassar College, Poughkeepsie (NY),
Frances Lehman Loeb Art
Center, 867

Vayer, Lajos, 859
Veit, Ludwig, 867
Velius, Caspar Ursinus (Kaspar
Bernhard), p. 3
Vellert, Dirk, 156, 424
Vendramin, Gabriele, 279 (collec-
tion)
Venice, pp. 5, 7; 47, 88, 89, 156, 279,
305, 363, 507, 561, 577, 597,
622, 638, 640, 695, 699, 753,
823, 852, 868, 874, 930
Venice, Fondaco dei Tedeschi, 47,
640, 753, 823
Venice, Gallerie dell' Accademia, 868
Venus Kallipygos, 889 (and Dürer's
drawing W.402, *Nude Seen
from the Back*)
Vergil, 921 (Koberger edition)
Verheyen, Egon, 597
Veronese, Paolo, 546
Verspohl, Franz-Joachim, 236
Vetter, Ewald M, 869
Vey, Horst, 870
Viardot, Pauline (collection), 865
Viasse, Pierre, 871
Vienna, 171, 872, 873
Academie, 370
Anreossy theft, 865
exhibition, 872
Graphische Sammlung Albertina,
p. 7; 27, 62, 187, 427, 429,
430, 432, 433, 434, 435, 436,
548, 656, 695, 742, 835
history of, 789
Imperial Achives, 875
storage in World War II, 443
Kunsthistorisches Museum, p. 7;
616, 873
symposium, 94, 221, 234, 239, 250
Vilana windish (drawing), 565 (Mus-
per, the supposed "original");
700, 915 (London the original;
Musper disproved)

Virgin and Child Crowned by an
 Angel (engraving: B.37), 505
 (and copy Wiericx 767)
Virgin and Child Crowned by Two
 Angels (engraving B.39), 505
 (and copy Wiericx 769)
Virgin on a Crescent with a Diadem
 (engraving: B.33), 505, 907
 (copy); p. 351
Virgin with the Dragonfly (engraving:
 B.44), 328, 554
Virgin Mary as Queen of Angels
 (woodcut: B.101), p. 351
Virgin Seated Embracing Jesus
 (engraving: B.35), 505 (and
 copy Wiericx 748)
Vischer family, 920
Vischer, Georg, 264
Vischer, Peter the Elder, 39
Vitellius (Witelo), 786
Vitruvius, Marcus Pollio, 336, 412
Vlnas, Vit, 874
Vogtherr, Hans, 558
Volckamer family, 868
Volkert, Konrad, p. 343
völkisch movement, p. 23 n. 57; 824
Voltelini, Hans von, 875
von Stromer, Wolfgang, 772
de Vries, Adriaen, 59

Wachinger, Burghardt, 420
Wackenroder, Wilhelm, p. 11; 13, 58,
 725, 833, 911
Waetzoldt, Wilhelm, 876, 877
Wagner, Friedrich, pp. 343, 346
Walker, John A., 878
Walser, Martin, 879
Walters, Margaret, 880
Walther, Bernhard, pp. 14, 341,
 342–3
Wanderjahre, 119
War for Independence (1813–15),
 p. 12

Warburg, Aby, 881, 882, 925
Warning, Rainer, 418
Warnke, Martin, 883, 884
Washington, D.C., National Gallery
 of Art, 885, 886, 887
Watercolors, p. vii; 7, 27, 62, 67, 107,
 118, 162, 223, 228, 233, 247,
 282, 335, 348, 349, 352, 356,
 426, 427, 449, 430, 432, 434,
 443, 446, 513, 518, 529, 576,
 593, 655, 686, 700, 718, 722,
 741, 821, 851, 861, 873, 888,
 919
 animals and birds, 233, 349, 430,
 700, 851
 Berlin, 67, 821
 landscape, 67, 228, 432, 821
 Irises, 576
 Madonna with the Many Animals,
 700
 Mills on a River Bank (Weiden-
 mühle), 228
 Pond in the Forest, 687
 The Pond House, 686
 The Valley at Kalckreuth, 67
 The Wild Hare, 851; p. 349
 The Wire-drawing Mill, 67, 821
watermarks and paper, 322, 635, 636,
 801
Waterschoot, W., 498
WB, monogrammist, 25
Weber, Bruno, 888
Weber, Ingrid S., 889
Weckerle, J., 890
Weichardt, Wilhelm, 891
Weidenmühle (*Mills on a River Bank*:
 watercolor), 228
Weiditz, Hans. 558
Weidner, Karl-Heinz, 892
Weihnachten (Nativity: engraving:
 1504, B.2), 406
Weimar. Carl August, Duke, p. 10
Weimar. Museum, p. vii; 237

Weimar Republic, 874 (and *Feast of the Rose Garlands*)
Weis, Adolf, 893
Weiser, Benjamin, 894
Weismantel, Leo, 895
Weiss, Josef, 896
Der Weisskunig, 209
Weltchronik (Nuremberg Chronicle), 718
Wenderhorst, Alfred, 574, 897
Wenzel von Olmütz, 12, 907. *See also The Illustrated Bartsch,* vol. 9.
Werkner, Patrick, 898
Werminghoff, A., 138
Werner, Alfred, 158
Werner, Johannes, p. 14; 690
Wessely, Joseph Eduard, 899
West German, Leftist views of Durer's celebrations, 83, 715, 773
White, Christopher, 447, 601, 900
White, Lynda S., 901
Wied, Alexander, 888
Wiederanders, Gerlinde, 902
Wiedl, Hermann, p. 343
Wiericx, Hieronymus, 390, 505
Wiericx, Jan (Johannes), 907
Wiesflecker, H., 63, 903
Wiesner, Merry E., 904
Wijntgis, Melchior (Middelburg), 7 (lost painting of *Lucretia*)
Wilckens, Leonie von, 582
Wild Hare (watercolor: Vienna, Albertina), 429, 431, 851
Wildenfels Castle (Saxony), 194
Wilhelmy, Petra, 905
Willens, Johannes, 906
Willers, Johannes Karl Wilhelm, 574, 581
Williamstown (MA). Sterling and Francine Clark Art Institute, 907

Wilson, Adrian, 908
Wilson, Jean C., 909
Wimfeling, Jakob, p. 1; 54, 55, 527
Window, reflected in eye, 273
Wintergerst, Joseph, 534
Winterthur (CHE), Kunstmuseum, 910
Winkler, Friedrich, p. viii; 15, 796, 845
Winner, Gerd, p. 346
Winzinger, Franz, 814, 912, 913, 914, 915, 916, 917
Wire-Drawing Mill (watercolor), 29, 723, 820
Wirth, Jean, 918, 919
Witch Riding a Goat (engraving: B.67), 8, 650, 709, 934
witchcraft, 8, 203, 543. 570, 650, 709, 802, 934
Witelo. *See* Vitellius
Wittenberg, 114, 883
Wixom, William D., 574, 920
Wolfegg, Fürstlich zu Walburg-Wolfegg'sche Kunstsammlungen, 776
Wolfenbüttel. Herzog August Bibliothek, 921
Wolf, Alice, 693
Wolff, Johann Georg, p. 346
Wölfflin, Heinrich, p. 15; 840, 911, 923, 924
Wolgemut, Michael, pp. 9, 16, 347; 73, 398, 484, 724, 816, 818, 904
Assumption of the Virgin, attribution rejected, 481
house, destroyed World War II, p. 16
layout pages for Nuremberg Chronicle, 908
Rayl epitaph, 720
Wolgemut workshop, 634 (painting methods)
Wollgast, Siegfried, 922

women in Nuremberg, 904
women, malevolent, 934 (with
 distaff)
Women Bathing (drawing, formerly
 Bremen Kunsthalle), 894
woodblocks, 67, 119, 379, 516, 517,
 803
woodcuts and woodcut illustrations,
 30, 31, 32, 33, 63, 153, 178,
 183, 196, 248, 284, 298, 326,
 327, 339, 362, 365, 371, 379,
 438, 442, 448, 465, 499, 510,
 516, 517, 624, 625, 649, 654,
 678, 730, 748, 843, 847, 849,
 931
 16th century Nuremberg, 327
workshop, 103, 327, 518, 533, 541,
 586, 596, 757, 812, 886
World Map (woodcut in globe form),
 584; p. 351
World War I, 434
World War II, 7, 182, 237, 286, 295,
 434, 443, 506, 574, 576, 807,
 894
Wroclaw, Ossolineum, 475 (*Head of
 a Bearded Man seen from the*

Front. Formerly Lubomirski
 collection)
Wunderlich, Paul, 522, 581
Wurm, Hans, 723
Würzburg, 358
Wuthrich, Lucas, 888
Wuttke, Dieter, 925, 926, 927,
 928

Yates, Frances A., 929
Young, Eric, 900

Zahn, Peter, 930, 931
Zahn, W. Albert von, 932
Zdanowicz, Irena, 513, 933
Zeitler, Rudolph, 852, 860
Zerner, Henri, 625, 855
Zika, Charles, 11, 202, 203, 371, 567,
 677, 739, 747, 933, 934
Zimmermann, Mac, 522
Zink, Fritz, 935
Zinner, Katherina Frey (Dürer's
 sister-in-law), 341
Zophy, J. W., 629
Zwierlein-Diehl, Erika, p. 26
Zwingli, Ulrich, 692; p. 351